When Animals Sing and Spirits Dance

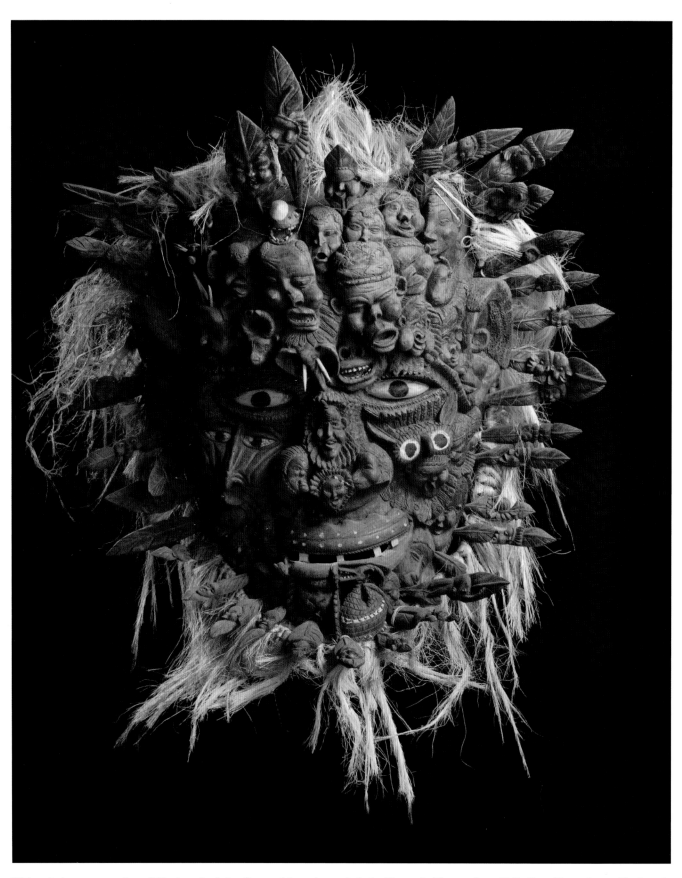

This artistic representation of Chadzunda, father figure of the *gule wamkulu*, by Florensio Mpamu from Kalindiza village, shows Chadzunda as the life giver of the entire spirit world. Within his face and headgear, hundreds of characters feature. In the mind of the artist Chadzunda echoes Christ as the sole distributor of life for the Chewa.

When Animals Sing and Spirits Dance

Gule Wamkulu: the Great Dance of the Chewa People of Malawi

Claude Boucher (Chisale)

Additional text by Gary J. Morgan

Photographs by Arjen van de Merwe

www.kasiyamaliro.org

KUNGONI CENTRE OF CULTURE AND ART

Published in 2012 for

Kungoni Centre of Culture and Art,
Mua Parish, P.O. Box 41, Mtakataka, Malawi
at 52 Chilswell Road, Oxford, OX1 4PJ, UK

www.kungoni.org

ISBN 978-0-9570508-0-8

Design, typesetting and production by
John Saunders Design & Production, East Sussex, BN21 2DX, UK

Printed in China

Foreword

Brian Morris

I deem it a privilege and honour to be asked to write a foreword to this splendid book by Father Claude Boucher, the outcome of a lifetime of study and service spent among the Chewa people of the Mua and Dedza districts of Malawi.

I first met Claude Boucher some twenty years ago, when he was initially involved in the construction of the Chamare Museum, a museum dedicated not only to a depiction of Chewa culture, but to the cultural history of Malawi, past and present. I was immediately struck by Boucher's dedication and personality, for he seemed to combine in a unique way two remarkable talents: that of a sensitive and rather single-minded ethnographer, who appeared to have an almost encyclopedic knowledge of Chewa culture, as well as of Malawian cultural history more generally; and that of a dedicated artist, a creative artist in the widest sense. For the Chamare Museum is indeed a work of art. But one other thing struck me about Claude Boucher; namely that he was a true scholar, viewing cultural knowledge not as a commodity, nor as something to be restricted to an academic elite or cultural enclave, but rather as something to be shared, something to be embraced, and something to be enjoyed by everyone. He has thus become, in Malawi at least, both a pioneer and a beacon in inter-cultural understanding.

This book is about Chewa culture, specifically about the *Nyau* tradition, as manifested in the "great dance" (*gule wamkulu*), a dance ritual of extraordinary complexity and richness. It has indeed been described by anthropologists as a "totalizing ritual system", for like all complex social phenomena the *Nyau* ritual dance has many dimensions or aspects – ecological, social, religious, political, aesthetic and cosmological. It is a phenomenon that has long fascinated European travellers, administrators and missionaries, and throughout the colonial period many short but seminal articles and reports were written on the *Nyau*. Many of these were by no means complimentary.

Although many earlier scholars, such as J.P. Bruner, A.G.O. Hodgson and Samuel J. Ntara had written perceptive essays on the cultural anthropology and early history of the Chewa, one of the earliest detailed descriptions of the *Nyau* was written by the colonial administrator W.H.J. "Bill" Rangeley. Born in Zambia, Rangeley was a blithe spirit who travelled extensively throughout Malawi for more than twenty years, looking for rock paintings, fossils and archaeological remains, as well as gathering material on the cultural history of the country, then Nyasaland. Like Boucher he was a dedicated amateur anthropologist, speaking the language fluently (though he claimed not to) and undertaking researches largely in his spare time. He was particularly interested in Chewa culture, working closely with Samuel Ntara. Rangeley's articles "The *Nyau* of Kotakota district" (1949–1950) were thus an important and seminal contribution to the study of the *Nyau*. He described the *Nyau* as a "secret society", focused mainly around initiated men, and

intrinsically linked, he felt, to the rituals of transition and to the spirits of the ancestors. Rangeley described many of the masks and theriomorphic structures associated with the *Nyau*, though his main interest was in the history and sociology of the *Nyau*. He tended, however, to view the women's participation in the *Nyau* as a recent phenomenon, and as constituting something of a "degeneration" of the original *Nyau* ritual. He noted too the strident opposition of Christian missionaries towards the *Nyau*, as well as towards many other aspects of Chewa culture.

In the immediate decades following Rangeley's contribution, our understanding of the *Nyau* ritual complex was greatly enhanced by the pioneering ethnographic studies of two Dutch missionary-scholars, Father Matthew Schoffeleers (1968, 1976) and Father J.W. van Breugel (2001), both of whom, like Boucher, had worked in the rural areas of Malawi as Roman Catholic priests.

Conducting research studies over many years, Schoffeleers has made an outstanding contribution to our understanding of the religious culture of the matrilineal peoples of Malawi, and his scholarship has always involved a rare combination of theology, history and social anthropology. His early thesis on the symbolic and social aspects of "spirit worship" among the Mang'anja of the lower Shire Valley was indeed path-breaking and it included a wealth of detail regarding the *Nyau* societies. As a Catholic priest Schoffeleers was particularly interested in the religious aspects of the *gule wamkulu* which, like Boucher, he felt to be crucial to a full understanding of its social dynamics. Thus, for Schoffeleers, the *Nyau* ritual was a "storehouse" of symbolic and religious ideas. No other institution among the Mang'anja (and Chewa), he wrote, embodied such symbolic wealth. Schoffeleers also explored the relationship between the *Nyau* and the various rain shrines that are to be found throughout Malawi, and emphasised that the *Nyau* societies embodied an ideology of local autonomy as against the authority of the territorial chiefs.

In 1975 Schoffeleers gave a talk to the Society of Malawi on our present understanding of the *Nyau* societies. In it he outlined the various interpretations of the *Nyau* ritual, specifically that it was a re-enactment of the Chewa creation myth, that the *Nyau* as a "men's group" functioned as a kind of catharsis for the men who married into the village of their spouses, and, finally, that the *Nyau* ritual was typical of and may perhaps be derived from those of earlier hunter-gatherers. I have elsewhere offered my critical reflections on these interpretive theories (Morris 2000: 151-167).

Van Breugel's studies of the *Nyau*, on the other hand, were more limited, and formed part of his ethnographic study on "Chewa Traditional Religion" (2001), undertaken during the 1970s. It has to be recognised that van Breugel, like

Schoffeleers, undertook his ethnographic researches at a very difficult time, for during the reign of President H. Kamuzu Banda political tensions were rife, and Kamuzu Banda specifically prohibited any contemporary social research. Nonetheless, van Breugel gives a very useful account of the *Nyau* societies of the Lilongwe District, describing the *gule wamkulu* as a "ritual fertility dance" that was enacted to please the *mizimu*, the ancestral spirits. He described around twelve theriomorphic structures, and over thirty masked figures. But though noting their spirit associations and personality type, van Breugel devoted little attention to their more symbolic aspects. In his conclusions he wrote, "The *Nyau* is the embodiment of tradition and resistance and by definition is not open to change." (2001: 168).

What Boucher's study graphically illustrates, of course, is that this interpretation is simply not tenable; that the *gule wamkulu* is a dynamic and ever-changing cultural tradition. But what van Breugel did emphasise, like Schoffeleers, is that the *Nyau* is a kind of resistance movement and at the "heart of Chewa identity" (2001: 126). Both of these aspects of *Nyau* – its close association with Chewa identity and its resistance to the Catholic church – were fully explored in Ian Linden's superb historical study "Catholics, Peasants and Chewa Resistance in Nyasaland 1889-1939" (1974).

During the past two decades we have seen the publication of a wealth of studies exploring various aspects of *gule wamkulu*. Three studies are particularly noteworthy – those of Laurel Birch de Aguilar, Peter Probst and Deborah Kaspin.

Laurel Birch de Aguilar's "Inscribing the Mask" (1996) was focused, as the title suggests, on the *Nyau* masks. Drawing on the writings of the French Catholic Philosopher Paul Ricoeur, Birch de Aguilar offered a detailed and sensitive hermeneutic analysis of the meaning and significance of the various *Nyau* masks. These she viewed, quite explicitly, as "texts" to be interpreted, and highlighted the importance of such key ritual masks as Chadzunda and Kasiya maliro. She thus came to explore the relationships between the various ritual personages, the role that the masks played in the *gule wamkulu* performance, and the relationship of the *Nyau* to the Chewa cosmological ideas. The core metaphor expressed in the *Nyau* ritual, Birch de Aguilar contended, was the "image of life and death" (1996: 232). Although eschewing a more explicit sociological analysis, Laurel Birch de Aguilar nevertheless put a central emphasis on the important role that women play in both the *gule wamkulu* performance and the *Nyau* social organization.

While Birch de Aguilar offered an exemplary hermeneutic analysis, Peter Probst (1995) explored the relationship between the *Nyau* rituals and the wider political context, particularly relating the *gule wamkulu* to contemporary social issues such as AIDS and to the ongoing economic and political crisis of the Malawi state. Employing Arjun Appadurai's rather abstract theory of "locality" and the concept of "ritual landscape", Probst explored in an interesting way the contrasting fortunes of the rain shrines – which have declined in importance – and the *Nyau* rituals, which continue to flourish, at least in central Malawi.

A scholar specifically interested in the construction of ethnicity and nationalism, Deborah Kaspin (1993) interpreted the *gule wamkulu* as originally an "old ritual" of the Malawi ("Maravi") chiefdom that had become transformed over the centuries into a ritual of a rural "underclass". It thus came to be emblematic of resistance against "white rule". Like Birch de Aguilar, Kaspin specifically linked the *Nyau* to the Chewa cosmology as a "totalizing frame of reference", but she focused more on gender relationships, on the links between the *Nyau* and Christianity, and on an alleged "hunting motif". She thus comes to interpret the *Nyau* dancers as essentially representing predators or wild beasts, a form of analysis that I have critically reviewed elsewhere (Morris 2000: 161-163).

But it is also important to note that several Malawian scholars have also contributed to our wider understanding of the *gule wamkulu*. For example: Denson K. Mlenga (1982) gave an illuminating account of *Nyau* initiation rites in the Dowa district; Enoch Timpunza Mvula (1992) explored the *gule wamkulu* specifically as a theatrical performance, emphasizing the importance of audience participation; while the late George Sembereka (1996) indicated the close relationship between *gule wamkulu* and such phenomena as dream experiences, spirit possession and nominal reincarnation, the latter involving the reincarnation of a specific ancestral spirit in one of their matrilineal descendants.

For more than thirty years Claude Boucher has been researching into cultural dynamics of the *gule wamkulu* ritual dance. Indeed his M.A. dissertation, presented while studying anthropology at the University of London, specifically focused on "Some interpretations of *Nyau* societies" (1976). What is perhaps unique about Boucher's research is that it is based not only on a close and intimate involvement with the local people of Mua and many years of intensive fieldwork, but on a thorough documentation and a superb collection of several hundred masks and theriomorphic structures. Throughout these years Boucher used his artistic talents to make a detailed photographic record of the *gule wamkulu* and its numerous ritual personages. Thus what is important and perhaps unique about this present text is that it not only offers interesting and critical reflections on the place of the *Nyau* ritual dance within Chewa society and culture, but that it gives a detailed interpretive analysis of more than two hundred *Nyau* masks and theriomorphic structures. These are ordered by Boucher into a number of thematic groupings, relating to such issues as history and politics, community and authority, sexuality and marriage, and witchcraft, initiations and medicines. But what Boucher's book graphically illustrates – and the text is adorned by his superb paintings and the photographs of Arjen van de Merwe – is the creativity, the artistic exuberance and the sheer diversity embodied in both the *Nyau* masks and the ritual performances.

Such creativity and diversity was earlier depicted in Douglas Curran's (2005) excellent photographic exhibition of *Nyau* masks and rituals. But Boucher depicts this cultural creativity and diversity even more vividly as well as offering a cogent and illuminating interpretive analysis of the numerous *Nyau* masks

and theriomorphic structures. In this latter task Boucher indicates the decentralizing ethos and moral probity evident in the *gule wamkulu*, and situates this ritual dance in the wider cultural and political context of the Chewa. The book provides a very informative introduction to Chewa culture, and a quite refreshing and detailed account of the *gule wamkulu* (the great dance), and the numerous ritual personages that perform the dance. It is indeed a remarkable book and a significant contribution to anthropological knowledge.

Brian Morris
Emeritus Professor of Anthropology
Goldsmiths College, University of London

12 December 2008

Contents

Preface

Claude Boucher Chisale

My first contact with *gule wamkulu* (the great dance) goes back to the end of 1967 and the beginning of 1968 during my Chichewa language training in Lilongwe. As a young Catholic missionary newly ordained and newly arrived in Malawi, I was to learn the local language and become familiar with the cultures of its people. Father Noel Salaün, a missionary veteran, was to lead us, a dozen newly arrived missionaries, in this exercise for the first six months of our stay. The mornings were dedicated to the learning of the language while the afternoons were spent in acquiring knowledge about the country and the customs of its inhabitants. As the course progressed and our immersion increased, I recall the giggling of our teacher whenever he touched upon the subject of *gule wamkulu*. One felt that his reaction withheld a secret, a sort of taboo issue that could not be dealt with in public. If we pressed him with questions, his answers became evasive. When a few of us questioned him in private, he revealed his treasure box full of *gule wamkulu* slides, which he showed us in a quasi-religious manner. Some of his comments betrayed his great sympathy for *gule* and his concern at church intolerance towards the secret societies. Though his sympathy never went as far as claiming membership, the fact that he had been allowed to photograph them in the 1960s showed that he had the trust of the chiefs and the communities. From that time on, the name of *gule wamkulu* remained for me an enigma that someone would have to solve in the near future.

I left the language centre in June 1968 and I was shortly posted to Kasina Parish in Dedza District. This was a strong Chewa area where the masquerade was flourishing. This is where I first came face to face with Njovu (the elephant), Kasiya maliro (the antelope), Njati (the buffalo) and encountered the first *anamwali* (initiates) with their *timbwidza* (ceremonial head caps) on their heads. These whetted my appetite. In December 1968 I was transferred to the far end of the diocese at Nsipe Parish in Ntcheu District, which was the heartland of the Maseko Ngoni. The Chewa secret societies had long been banned by Inkosi ya Makosi Gomani. The only *gule* characters I met in the five years of my stay in Ntcheu were those that came from the Mozambique border to perform for the independence celebration at the district. The Ngoni derided Chewa institutions and the great dance, showing openly their sense of superiority and prejudice against them. By pure fortune, while visiting the churches and providing the usual ministry as a priest, I came into close contact with a Chewa informant. He had married in Ntcheu although his home was in the Mua area. Our friendship resulted in my first serious 'baptism' into *gule wamkulu*. This was June 1973. There, away from his secret society, my informant felt secure to talk freely and could introduce me into the intricacy of the great dance without fearing for his life.

The years of 1974-1976 were dedicated to anthropological study in Uganda and England with a focus on secret societies.

On my return to Malawi, at the end of 1976, I was to be appointed to Mua Parish located in Dedza District, close to the original home of the Chewa near the lakeshore and the capital of the *Mwalis* and the *Kalongas* of old. This was with a view to starting the Kungoni Centre of Culture and Art. My new home was to be a bonus for research in culture and history, since the Mua area was a point of convergence of three ethnic groups: the Chewa, Ngoni and the Yao. It was also a hot spot for *gule wamkulu*. *Gule* was danced daily and had a long history of interaction and conflict with the mission that dated back to 1902. The mission diaries were full of clashes between the church and the local secret societies. The training of local artists required the study of traditional art forms and of the masks in particular. The carvers and the workers were often members of secret societies and had at least one foot in this world of secrecy. Exploration of the culture was a difficult task because of the previous history of opposition between the mission and the Chewa institutions. In addition, at that time secrecy prevailed surrounding the world of *gule wamkulu*. Anyone suspected of revealing information concerning the masquerade could suffer a mysterious disappearance. My first interviews in the 1980s were often done at night by the light of a small aladdin lamp. Occasionally I had to move the informants outside the Chewa border where there would be no one to witness and report on the giving of the information.

The mid 1980s brought a major breakthrough with regard to my direct involvement with *gule*. This was prompted by a German television crew (ZDF) which came to Malawi to film the boys' and girls' initiation ceremonies and other Chewa rites in relation to a large painting and the furnishing of a chapel we had made for Missio Munich. Until then, I had never appeared at public ceremonies around Mua involving *gule*. The piloting of the German television crew marked my first public appearance. The Chewa came to consider me as a fully fledged initiate since I was able to master the secret vocabulary and their sign language. Their reaction to the public appearance was one of delight. For the first time, a representative of the mission was to experience the genuineness of the dance. Hopefully I would move away from the prejudices and the lies characterizing the early period of antagonism between the church and their culture.

For the conservative Christians, my involvement was a scandal that would take several years to abate. Some even suggested that I should be subject to a period of penance in order to signify my coming back to the church, since my mere attendance at those rituals should incur excommunication. The reaction of the ecclesiastic hierarchy was more moderate. I had been chosen by them to be the official Malawian representative in Rome for interfaith dialogue, particularly for traditional religion. For the chiefs and the heads of the male and female secret

societies, my presence in their midst had a liberating effect. They could see that the past reproach by the church had significantly lessened, if not disappeared. They perceived that I was, in the name of the mission, going to evaluate, and show a more positive attitude toward, their culture.

After 1985 more occasions presented themselves for me to take part in *gule*. I accompanied a BBC crew for the production of a TV programme on John Chilembwe, the Malawi national hero during the colonial period. My observations and copies of the raw footage of this programme became an added tool in the study of the dance. I never pushed myself forward but abided by the rules of the initiates. I took photographs only when allowed. I consigned interviews to memory and I recorded them in writing in the evenings when back at the mission. More and more chiefs and officials invited me to ceremonies that I knew only by research and reading but had never witnessed. I then had access to burial and commemoration ceremonies, commemoration of the dead (*dambule*), healing rites after possession (*kubwebweta*), enthronement of chiefs (*ufumu*) and other rites in which *gule* was a part. These invitations coincided with the purchase in 1986 of a VHS video camera with which I could film all of the ceremonies. *Gule* dancers were invited to the mission to view their own performance on television behind closed doors.

During the following years I started collecting masks as teaching materials. Though they were never shown in the classroom, their ownership would support further research and assist my teaching particularly with regard to art forms and authenticity. As the 1990s approached, the collection had grown to include several hundred pieces. Interviews were conducted at night as usual while the items were delivered and a process of archiving was put in place. My main collaborators in this exercise were senior chiefs and heads of *mizinda* (rightful

owners of initiation and *gule*) around Mua. Some members of staff of the Kungoni Centre, leading manufacturers of the masks in their own communities, also participated. Regular attendance at various *gule* ceremonies and my video filming of them would determine which masks should be acquired for the collection by order of importance. The video material that had grown to the range of 600 hours of filming had to be documented. Songs were written down, translated and interpreted. Watching the video data, one would discover new characters that needed investigation and documentation.

By 1991 the collection had doubled in size and the space for storing and preserving it had become a real problem. The period of 1992 to 1994 was particularly challenging given the emergence of new masks dealing with political protest. They reflected the transition of Malawi from dictatorship to democracy. Some chiefs even warned me to halt the collection for a while. Many of these new masks were politically 'hot' and their possession could lead to my deportation. As a measure of security I kept the information concerning those characters hidden away far from the actual exhibits. Nevertheless, I felt that this information had to be preserved and investigated. Moreover, new insight into the masks clashed totally with the negative perception of the early generations of missionaries. Despite the risks, I continued, keeping in mind the promise I had made in my initiation as well as the trust the chiefs and informants had placed in me.

The year 1991 saw the beginning of a dream that was to become a reality over the next decade. I was to erect a building that would house the collection and present its information to a wider audience. It was to be a museum focusing on the Chewa culture and that of the neighbouring tribes, the Ngoni and the Yao. I emphasise the word 'dream' because the Centre had not a penny to finance such an operation. With only rough sketches

The Chamare Museum.

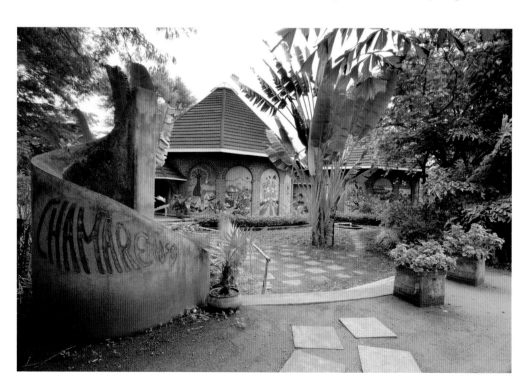

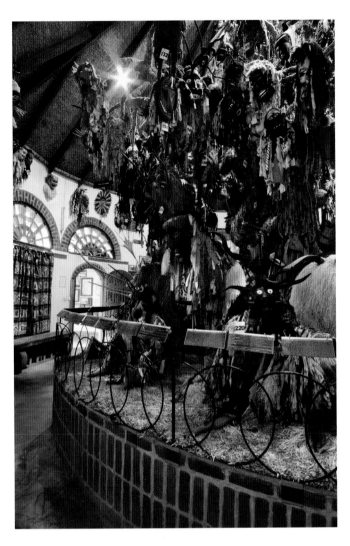

and models, my Malawian assistant, the late Mr Patricio Tambala Mponyani Nsato, and I discussed the best way forward, our over-riding principle being one of self-reliance.

We collected calabashes and painted them with various patterns, displaying them in the Kungoni showroom together with the carvings. We indicated that they were not for sale but could be traded against a bag of cement. Soon we started laying the building foundations. Visiting guests became interested in our endeavour and came forward with financial help. Later the American, British, German and South African embassies, as well as local contributors, also came to our rescue. Local architects and contractors assisted us with technical advice and labour.

By mid 1999, the building was completed and the collection was housed inside the three spacious rooms of the complex. Malawians and foreign visitors now had access to the display, viewing the work recorded over years in secret and with painstaking effort. By then the extreme secrecy concerning *gule wamkulu* had become enervated, but we would still be concerned about Chewa non-initiates entering the Chewa room.

In 2000, I started reviewing the numerous interviews, formalizing in writing the description and the interpretation of the photographs on display. The 240 mask descriptions took the major part of my time. After completing the exercise within the museum, I continued with 260 other characters kept in storage. As I progressed through the interpretation of the various characters, I constantly discussed my writing with the informants, cross-checking if they were able to recognise their *gule* character through my descriptions. If they failed to identify themselves, I

The Chewa Room.

The Chamare Museum.

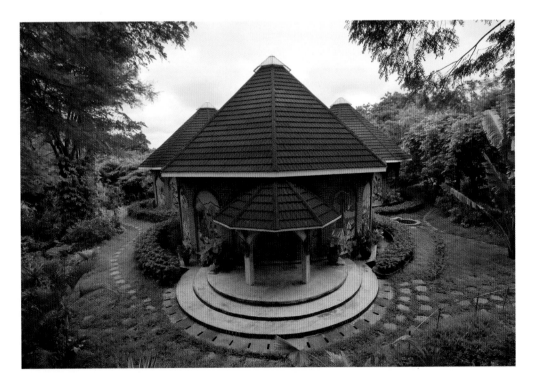

scrapped my text and started over again. My ultimate aim was some sort of publication that would reinstate the Chewa and openly proclaim their genius of creativity and pedagogy within their astonishing storehouse of culture.

The period that followed (2001-2004) saw the creation of an accommodation facility at Kungoni that would receive the numerous visitors wanting to spend more time in the museum and the students of courses on the cultures of Malawi. These studies were open to various NGOs, embassies and bodies that supported the country in the field of development. Each room of our hostel facility carries the mask name of a *gule* character and explanations are provided for the guests as an avenue for entering the heart of the local culture.[1] The courses that I deliver are based on my decades of observation and my understanding of the Chewa and their relationship with their Yao and Ngoni neighbours. A dance troupe was established to offer a glimpse into the rich performing arts of Malawi, including the great dance. My close collaboration with UNESCO Malawi led to the proclamation of the *gule wamkulu* as a Masterpiece of the Oral and Intangible Heritage of Humanity in late 2005. It is timely now to find my decades of research reaching publication.

I feel extremely privileged to have been allowed to share the esoteric secrets of *gule wamkulu* for the last four decades. Over the years, I have been fortunate to be a student of the Chewa pedagogical system, which transmits the history and the values they hold sacred. That transmission was generally circumscribed by varying degrees of secrecy within the Chewa society depending on gender, age and status.

With the rise of President H. Kamuzu Banda and national independence, the Chewa, as part of the mosaic of ethnic groups that comprised the new Malawi nation, benefited from a privileged position and their great dance claimed a place of honour because Kamuzu Banda himself was a Chewa. With the advent of a Yao president, Bakili Muluzi, in 1994, the Chewa did not maintain that position. Soon, their institutions and their great dance were discredited by other ethnic groups. With the advance of Christianity, Islam and a Western type of education, the children of the Chewa were greatly discouraged from participating in initiation ceremonies and various village rituals. Chewa culture and its mouthpiece, *gule wamkulu*, soon became misunderstood or misrepresented. The unfathomable storehouse of wisdom and creativity represented by *gule wamkulu* was perceived as the epitome of immorality and backwardness. In time, it also became synonymous with witchcraft and cannibalism. The parody obscured the reality. As one who has witnessed, as an insider, the depth and the sophistication of these Chewa rituals, I could not remain silent in the face of such unfairness. I am compelled to address this injustice through sharing my own observations and experiences, represented in this book.

In my work I have always striven to respect the promise of secrecy which I accepted as part of my own initiation as a *gule* member. It was this initiation and subsequent research which has revealed how *gule wamkulu* has guided Chewa morality for

centuries and is so central to their identity. I have attempted to decode the visual language that used to be accessible to all Chewa, but has in recent times become the privilege of a dwindling number of initiates. It has become evident that the younger initiates of today do not fully comprehend what they have received owing to the fact that they undergo abbreviated initiations. One will notice in my writing that I avoid using the word *Nyau*, preferring to use *gule wamkulu* or *the great dance*. Only an initiate member knows the significance of *Nyau* and he cannot reveal it in front of non-initiates. My approach to the various characters of *gule wamkulu* is descriptive. It is meant to enable the reader to observe and to discover the hidden world behind each mask. This description is accompanied by an explanation of the pedagogy and the values portrayed in each character. Whenever the information allows, I venture into the genesis of the individual character, its personal history and subsequent metamorphosis. My concern is primarily focused on capturing the message as it is perceived by the *gule* members themselves. In my description, I purposely avoid dealing with the technical side of the dance and the construction of the masks and costumes which is reserved for the initiates and thus confined to secrecy. Nevertheless, I use the word *dancer* to qualify the actor who embodies each of the spirits.

My hope is that this publication will reflect the unique experience I have enjoyed over more than thirty years in the Mua area, and the closeness I have developed with the Chewa communities. This has been strengthened by the opportunity to work on a very extensive body of masks from both male and female societies. Classic publications on *gule wamkulu* rely on general comments and extensive theories about the phenomenon, but they have not made a thorough analysis of the specific characters that make up the world of *gule wamkulu*. My research has also been influenced by my precarious position as a church minister and anthropologist, which has caused me to witness the longstanding hostility between ecclesiastical institutions and the indigenous culture.

I have also been motivated by a realisation that the many characters found in *gule wamkulu* may not be with us for much longer. In the last decade, I have witnessed the growing flexibility exhibited by *gule* institutions and their greater tolerance towards other faiths. At the same time there is a noticeable decrease in the frequency of *gule* rituals owing to economic constraints, a loss of spirituality and the growing commercialization of the great dance. The senior custodians of *gule wamkulu* are slowly disappearing and the younger generation no longer possesses genuine perception and understanding of the meaning it exalts. With the advent of modernity, education and democracy, borders have become blurred and secrecy rules impinged.

This book gives witness to the struggle which exists between the Chewa world and the continual desire for change. Within this dialogue *gule wamkulu* has proven skilful in adapting to the challenges of contemporary society despite the dangers it presents to the institution. I hope that future generations of Malawians will use this book, not as a catalogue of a past or folkloric cultural curiosity, but as a reference to inform them of a living and valued cultural expression.

[1] St-Arneault, S. (2007). *Kungoni. When Water Falls, Sand Becomes Crystal. A Guide to Mua and the Kungoni Centre of Culture and Art, Malawi*. Kungoni Centre of Culture and Art: Malawi.

Dedication

Firstly, I dedicate this book to all those who have contributed to my rebirth in Malawi as a Chagomerana Chisale. My profound gratitude to the families who have adopted me as their child and have made me part of their flesh. I address this book in particular to my blood brothers, the late Mr Patricio Tambala Mponyani Nsato, the late Mr Harry Chafuka Mlauzi and to my 'right arm', Mr Joseph Kadzombe Gama. They have taught me to feel with a Malawian heart.

Secondly, this book originates from the core of the Chewa wisdom, entrusted to me by my informants. I dedicate this work to all the members of the great dance of the Chewa who have allowed me to share with them in the holy of holies of their amazing culture and their profound wisdom. I have attempted to decode and interpret the meaning of the diverse characters of *gule wamkulu* without betraying the trust and brotherhood that they have gifted to me.

Claude Boucher Chisale

Acknowledgements

This book offers a primary glimpse into the mysterious and secret world of the great dance of the Chewa. It is based on a large collection of masks that allows a panoply of images and messages to unfold. The reader is led into the complexity of the Chewa world view. Moreover, the selection that constitutes this book reflects the dream of many Chewa that their great dance should be preserved and documented for future generations. This book, however, presents only a fraction of the rich and manifold variety of *gule wamkulu*. The endeavour, stretching over four decades, is one of communion that has been achieved through perseverance and hardship due to the secretive nature of the information. I should like to express my sincere thanks to the many who have contributed, collaborated in various ways, encouraged and supported my research over the years.

Firstly, I extend my gratitude to the late Bishop Cornelio Chitsulo and the Missionaries of Africa for my appointment to Mua and my presence in the area for more than thirty years. My profound thanks to the late Fr Noel Salaün who equipped me with the command of the Chichewa language and who shared with me his passion for the people and the culture. On the journey that brought me to the academic world, I am particularly indebted to Dr Aylward Shorter and to Dr Matthew Schoffeleers who recommended me for further studies in anthropology at the School of Oriental and African Studies of the University of London and to my teachers, Dr Richard Grey, Dr Paul Spencer and Dr John Pixton, with particular reference to male secret societies. Thanks to all those who have encouraged me to publish, in particular Dr Martin Ott, Professor Brian Morris, Dr Leslie Zubieta, Mr Ian Linden, Bishop Patrick Kalilombe, Dr Joseph Chakanza, Dr Ben Smith, the late Fr Timothy Kabango, my friend His Excellency Nigel Wenben-Smith and the Friends of Kungoni.

My profound gratitude to three generations of Nkhosi Kachindamoto: Theresa, the late Justino and the late Enoch, paramounts and senior chiefs, traditional authorities over the area, for their blessing of my work. My sincere thanks to my colleagues at the mission and amongst the Missionaries of Africa (the White Fathers), who have offered encouragement and sheltered me against the prejudice and the strong 'Christian' spirit that existed at the time of my research: in particular Fr Norbert Angibaud, Fr Jos Kuppens, Fr Andreas Edele, Fr Adelard Munishi, Fr Peter Mateso, the late Fr John Kwezabiro, Fr Jim Green and Fr Serge St-Arneault. The Missionaries of Africa have contributed generously to the publication of this book. My gratitude to the Bizzaro family for allowing me to conduct interviews at their lakeshore residence away from Mua and to write some of my scripts in quiet surroundings. I am also indebted for their technical and financial help. I acknowledge with thanks the support of Mr Jose da Costa in the construction of the museum that hosts the collection described in this book.

I extend my profound appreciation to the long list of informants who patiently, step by step, have helped me to delve into the depths of the rituals and who, day by day, have been describing to me the details of the ceremony and the characteristics of the masks, and dictating the songs that I recorded in small exercise books. Informants are listed at the end of this book. Here I would mention a few: the late Mariko from Sawuzana village, the late Arikanjelo Ndondwe from Kanyera village, Mr Joseph Lusiano and his maternal uncle, the late Piyo Simoni, both from

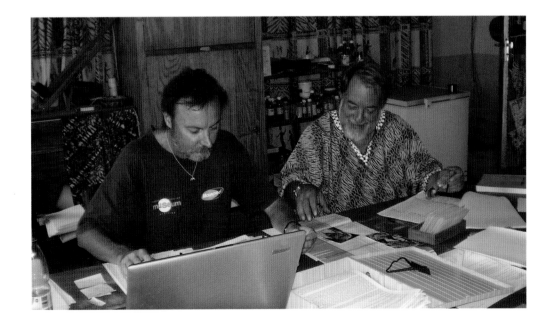

Gary Morgan and Claude Boucher.
Susanna Harders, 2007

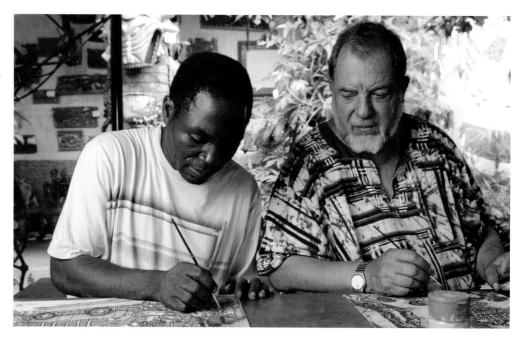

Claude Boucher Chisale with Mr Joseph Kadzombe Gama working on one of the paintings of *gule wamkulu* used in this book.

Msolo village. I thank too my tireless mask collectors, Mr Yakobe Chipojola and his font of wisdom, the late Mr Zakeo Bidasi from Kambuluma village. I am grateful and privileged to have had a close and lasting friendship with the most important custodians and arbitrators of the dance in the Mua area, including the late chief Chitule: he thoroughly loved his culture and was able to perceive the changes of the day. His integrity and wisdom have been my own unwavering guide. The late group chief Kakhome and his first wife Mrs Payima Maliwa, a lifelong initiator, I acknowledge as well. My thanks to Mr Kakhome's successor, who has been appointed by the T.A. as our adviser, replacing the late chief Chitule. I note too the late group village headman of Kafulama, Mr Petulo Magombo, who celebrated my silver jubilee of priesthood with the great dance at his own village. I extend my profound indebtedness to the 'Pope' of *gule* for the Mua area and a renowned herbalist, Mr Kachipapa, for allowing me to become his son and apprentice. Thanks also to his daughter Mrs Edina (Nanyozeka) Kachipapa who became a fully fledged member of the male secret society and introduced me to the female masks used in the girls' initiation.

I have been privileged to have had long talks with the late Mr Harry Panyani from Kafulama village who has been the keeper of the Chewa oral traditions and Mrs Tuwuse Poti Chauma from Kamala village who has been one of the office bearers at the Mankhamba shrine. My boundless thanks to my old friends and pillars of the dance for more than five decades, the late Mr

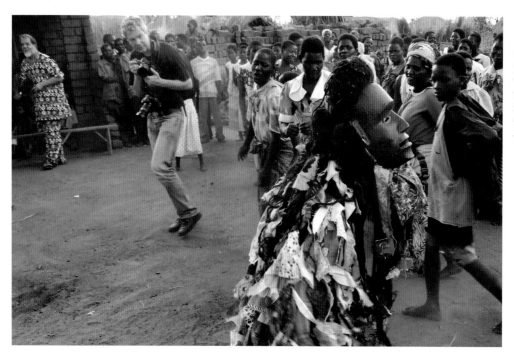

Claude Boucher and photographer Arjen van de Merwe at work at a *gule wamkulu* event, taking some of the photographs included in this book.
Gary Morgan, Kakhome Village, April 2008

Daliel Ndondwe from Kanyera village and Mr Killion Thawale from Kafulama village. These have been my cherished points of reference when it came to the interpretation and the meaning of the more ancient *gule* characters. Thanks to their children in whose blood this culture flows: Mrs Felesita Ndondwe, a fully fledged member of the secret society, the late Mr Gervazio Thawale and Mr Chikwama Thawale. My appreciation to some of the most skilful mask carvers of the area, the late Mr Andrea Wailesi from Mchanja village, Mr Robati James from Kaphala village (Dedza) and Mr Simeon Mkanamwano from Kalindiza village. I feel privileged and enriched to have encountered accomplished drummers such as the late Sapuse from Mlongoti village, Mr Oskar Dafuleni from Njolo village and Mr Joseph Kadzombe from Kanjovu village. My unbounded gratitude to my 'grandfather', the late Mr Petulo Kaso from Munyepembe village, who was the head of the elders' institution (*manyumba*) and who was responsible for my initiation into chieftainship. My gratitude also to my faithful messengers, who were sent to consult the elders when I got stuck with some of the interpretations, notably Mr Charlos Seba from Kanyera village and Mr Levison Gabriel from Bwanali village. I thank the countless chiefs, families and heads of *mizinda* who have welcomed me at their great dance events and have allowed me to video their ceremonies, even at the most secret places where the animal structures were constructed.

I am grateful to the many staff members of Kungoni for typing parts of the manuscript over the years: the late Mr John Chimbiya, Mr Francis Masiye and Mr Boniface Thole. My gratitude to those from Britain, Mexico, the USA, Ireland, Germany, Canada and Australia who have worked at compiling, proof reading and editing my mini *gule* encyclopaedia: in particular Mrs Lona Cowls, Mrs Jannes Gibson, Ms Erin Cosgrove, Miss Marie Heithmar, Miss Andrea Beck, Fr Brendan O'Shea, Mr Murray Katz and his friend Judy Moench, Mr Christopher Venner, Mrs Elizabeth Makepeace, Ms Susanna Harders, Fr Bill Turnbull and above all, Dr Gary Morgan for meticulously reviewing the manuscript and assisting in the final selection for this book. I am indebted to him for organising the material and for writing the introduction for the book and the leads for each chapter. Gary Morgan and Susanna Harders were supported while in Malawi by Australian Volunteers International and AusAID. My sincere thanks to Professor Brian Morris, a pioneer of Malawian anthropology, for giving constructive criticism and his precious time in reviewing the manuscript. I particularly value his foreword to this book. He situates the present study into the academic research on *gule wamkulu*. Mr Richard Hewitt assisted greatly in coordination of the publication to printing. Sincere gratitude to Dr Leslie Zubieta for allowing time to proof-read the final draft of this book. Many thanks to the skill and the patience of Mr Joseph Kadzombe for painting with me some of the illustrations. I am extremely grateful for the tireless work of Mr Arjen van de Merwe, a brilliant photographer and friend of Kungoni. His sensitive images have brought out the authenticity of the *gule* characters which are indispensable for such a publication. All otherwise unattributed photographs are by him. Thanks to my colleague Fr Serge St-Arneault, for drawing the map that situates the origin of the various *gule* characters featuring in this work. Last but not least, my sincere thanks to all the supporters who have made this publication possible and who are listed under the subscribers heading.

Claude Boucher Chisale

Subscribers

The following organisations and individuals contributed generously to the publication of this book.

Air Cargo Ltd., Malawi
Centre for Social Concern, Kanengo
Embassy of Ireland, Lilongwe
JTI Leaf Ltd., Malawi
Missionaries of Africa, Malawi Sector
Missionsärztliches Institut, Würzburg, Germany
Nedbank Malawi Ltd.
Support Malawi, Heidelberg, Germany
The Society of Malawi

ARCHAMBAULT, Aubert
BIZZARO, Alessandra
BIZZARO, Giuseppe
DA COSTA, Jose
EDELE, Andreas
EIDHAMMER, Asbjørn
FRENKEL, Lilo
HEIN-ROTHENBÜCHER, Karl-Heinz
HEWITT, Jeffrey and Pauline
HEWITT, Richard

HOLTE, Irene Wenaas
JONES, David
LANE, Stewart
MORGAN, Gary and Susanna HARDERS
MORRIS, Brian
OTT, Martin and Nicola
RAUH, Birgit
ROYLE, Patricia
SCHEPPIG, Harald
SEWELL-RUTTER, Neil
STEVENSON, Adam
SUEBSAENG, Alexander
TRIEST, Michael and Mia GOOS
WALKER, Chris
WALKER, June
WENBEN-SMITH, Nigel
WHITFIELD, Anthony and Sara
WILSON, Edward
WILSON, John

Claude Boucher and the Chewa

Gary Morgan, using notes from Claude Boucher

Claude Boucher was born on 2 August 1941 in Montreal, Canada. He was ordained as a Catholic Priest on 18 June 1967 and almost immediately moved to Malawi as a member of the Society of the Missionaries of Africa, widely known as the White Fathers. He arrived in Malawi in December 1967. Boucher was an accomplished artist from a young age and revelled in the artistic expression of Africa. His initial postings in the Dedza and Ntcheu Districts saw him engage closely with the Ngoni people who are a dominant group in that region. Boucher is also a trained anthropologist who, after his first seven years of mission work, furthered his studies at the Gaba Pastoral Centre in Uganda (1974-75) and at the School of African and Oriental Studies, University of London (1975-76).

Boucher became intent on establishing an art centre that would draw upon the traditional practices of the local people but infuse into them the themes of the Church and the Gospels. The Centre became a reality but not where Boucher had first imagined. The then Bishop of Dedza, Bishop Cornelius Chitsulo, favoured his home parish of Mua, and in 1976 the Kungoni Art Craft Centre was established. It has grown over the past thirty years into a significant cultural centre, now titled the Kungoni Centre of Culture and Art, offering a fine cultural museum, a small research library, cultural courses and performances, sales of carvings, and onsite accommodation for those wishing to linger at the beautiful site that Mua has become. All of this development was overseen by Boucher, who remains Director of Kungoni today. In his four decades working amongst the local people of central Malawi, Boucher has acquired the clan name of Chisale, an ancient clan associated with the Banda. It is not unusual to hear him referred to as Chisale by Malawians.

The reader is recommended Ott (2000) for a fuller history of the development of the Kungoni Centre.

It was at Mua that Boucher advanced on the unique experiment that Kungoni would be, based on the Catholic principle of inculturation. The inculturation of the liturgy involved experimentation at Mua Parish and its twenty-two outstations. This work was only possible in as far as research into the local cultures and religions was permitted. Boucher found the Mua region to be a paradise in this regard. The area combined the most ancient rain shrine and pool, *mpando wa Mwali*, of the Banda clan, at Mankhamba; the early settlement of the Phiri – Malawi and establishment of their great state near Manthimba; the settlement and capital of the Maseko Ngoni of Kachindamoto near Mtakataka, dating from the mid-19th century; a number of Yao villages along the lake shore and Matengo villages with people originating from southern Tanzania; and the vibrant activity of *gule wamkulu* in nearly every village with strong Chewa populations.

Mua, established in 1902, was the first permanent Catholic mission in the Central Province. Generations of missionaries have left thousands of pages of notes, written in the mission

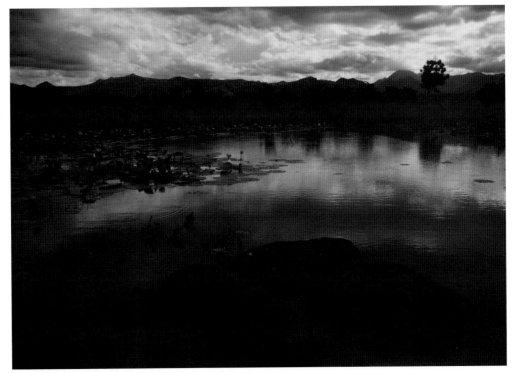

The *mpando wa Mwali*, sacred pool of *Mwali*, is situated a few kilometres from the Mankhamba shrine at the southern end of Lake Malawi. *Mwali* was the Banda spirit wife of Chauta (God). In the pool one can see several large stones called the 'seats of *Mwali*' where she was enthroned as the wife of Chauta.
Claude Boucher, May 1989

diary, on the establishment of the station and with information on the surrounding country and its people. Boucher used these extensively for research purposes. The mission was situated in close proximity to the early South African Presbyterian missions of Malembo, Mlanda and Phunzi. A long stay in the area would favour contacts and accumulation of data of all sorts and Boucher set himself to work.

He was soon also involved in training local artists and promoting various aspects of local cultures. The first years required the erection of buildings and accommodation for training and lodging the artists who came from all over the country. Boucher pursued his interest in the field of inculturation in religious art, catechetic and liturgy at Mua. The main aim of the Centre was to bridge the dichotomy between the Christian expression and the local culture, and this was reflected in various commissions produced for numerous churches throughout the country and, more and more, outside Malawi.

In the late 1960s, Boucher had already embarked on a programme of research in the Ntcheu and Dedza districts. He continued this research, quietly, in Mua. Throughout the 1980s, his membership in the *Nyau* society allowed him to approach informants, to conduct interviews, photograph masks and record songs from the secret society in an unobtrusive way and without 'officially' appearing at ceremonies. At this time, Kungoni staff and Boucher were often seen performing Ngoni dances at the Centre's celebrations.

Soon the influence of this research was to be observed in the architecture and the decoration of the Kungoni buildings. Traditional motifs and proverbs from the Chewa, Ngoni and Yao cultures, from which the artists originated, inspired their work. Ngoni ceremonial dances (*njazo*) were often performed during special festivities at the Centre or during liturgical celebrations at the parish. Since a number of artists and workers came from the Ntcheu District where Boucher had worked before coming to Mua, the interest in Chewa traditions and the *gule wamkulu* influenced artistic expression.

Boucher encountered opposition in several quarters to his ongoing research into the Chewa culture and the *gule wamkulu* in particular. Conservative Christians were wary or hostile to his activities. He and his colleagues at Mua Mission were participating in various ceremonies, including initiations, at a time when the Catholic Church had banned traditional Chewa initiation for Christians. Boucher sanctioned the depiction of Chewa characters on the walls of mission buildings, as we see below.

In 1987, Boucher was asked by the director of Missio Munich to pilot around Mua a German television crew producing a series of programmes on inculturation and the cultural traditions of the Chewa. It was on the occasion of filming an initiation ceremony and a remembrance ceremony for the dead that the involvement of Boucher in *gule wamkulu* became publicly known. His sympathy toward the Chewa culture was clearly appreciated by the Chewa traditionalists but it left some of the Christians perplexed and hostile. For many of the Chewa, it was the first time that Mua Mission had shown a real

interest in their beliefs and was ready to appreciate them. The presence of Boucher and his colleagues of the mission at the initiation was a challenge to the Catholic Church's discipline regarding the ban on the initiation of Christians. From 1909 until recently, any Christian who took part in such ceremonies was culled from the sacramental life of the church and was obliged, if he/she wanted to be re-integrated, to undergo a penitential rite that lasted three days. The Chewa Christians resented this practice and felt that it was unfair on them to be denied the right to engage in ritual traditions. They believed that their traditional initiation interfered in no way with their growth as Christians. The attitude of the Church towards the Ngoni traditional practices was more lenient, compounding the sense of grievance of the Chewa. The presence of missionaries at Chewa initiation was putting a question mark on the longstanding antipathy of the Church and gave hope to the Chewa Christians that one day the ban would be lifted.

In 1989 and 1990, the artists of the Centre executed two large frescoes on the walls of the administration block near the

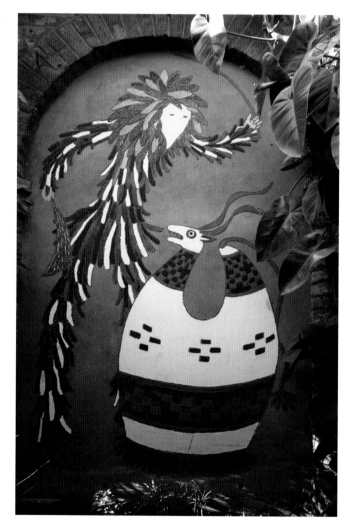

Fresco of **Makanja** and **Kasiya maliro**.
Under Claude Boucher, the Kungoni Centre increasingly incorporated Chewa culture into the decoration of buildings and the cultural programme.

mission buildings. These were depicting **Kasiya maliro** and **Njovu**, respectively the mother and the father images for the Chewa. The Chewa had seen the participation of Ngoni warriors and other features of various ethnic groups at the mission but for the first time, Chewa symbolism was entering the sacrosanct ground of the mission premises. This was perceived as the beginning of the rehabilitation of the Chewa and the *gule* rituals among the Christian population.

In May 1991, the School for Deaf Children was completed on the mission grounds where the leprosarium had formerly stood. Neighbouring villages were invited to the opening of the school in June. They were asked to take part with their traditional dances including their great dance. All of them responded positively and sent members of their *mizinda*. It was the first time in the history of the mission that a mission building was inaugurated with *gule wamkulu*. The atmosphere was festive and the feast was a success. Boucher took part in the ceremony and used the opportunity to produce a documentary video in which *gule* dancers were the prominent feature. Further, Boucher promised the secret society that he intended to have his forthcoming Silver Jubilee celebration solemnized with the same bond of unity among all. Boucher continued to document various Chewa ceremonies close to Lake Malawi, away from the mission centre.

Boucher's Jubilee celebrations were organised by a committee that operated under the authority of the church and parish council. Boucher was asked to give his desideratum for the celebration but he could not be involved in the planning since, according to Malawi custom, as a jubilarian, he was like a *namwali* (an initiate) who was undergoing transition. The chiefs of the area and the church council met to discuss the issue. The Christian body felt that the desire of the chiefs to have *gule wamkulu* performed for such an occasion was out of place, especially as the programme was to happen next to the church and the mission house. The church representatives had their way. The decision was taken that only Ngoni ceremonial dances and some youth dances such as *Malipenga* and *Chimtali* could be performed in keeping with the mission tradition. Nevertheless, the Chewa chiefs and their representatives were invited to the festivities and the banquet that followed. Regardless of their disappointment, the chiefs and their *mizinda* agreed that they would not let the occasion pass unnoticed. They decided to organise their own Jubilee celebration, with *gule wamkulu*, on 28 June 1992 on the grounds of their senior chief Kafulama. All the staff of the mission were invited and Boucher was the guest of honour. Most of the *mizinda* around the mission took part in this memorable and flamboyant event. The Chewa acknowledged that one of their priests was celebrating 25 years of ministry in their land, at their service, in a way that was worthy of their creativity and their appreciation.

The season that followed the Jubilee was dedicated to Primary Health Care sessions. The programme of health was inaugurated by the Mua hospital in the neighbouring villages. Sister Katiati, from the Servants of the Blessed Virgin of Mary, was the instigator of the project. She took the initiative of inviting all the chiefs of the area for furthering health awareness in the villages. Each village took a turn hosting these meetings and inviting guests and the neighbouring villages. The Primary Health Care programmes always began with entertainment that involved traditional dances followed by dramatisations and demonstrations on health issues, inoculation and weighing the children. The day was concluded with a *gule wamkulu* performance and the appropriate speech by the paramount chief or other guest of honour. The response to such meetings was extremely positive. The entire population was mobilised. An element of competition was introduced between villages, as to who would organise the most skilled performances. Boucher followed each of these sessions with great interest and documented each programme with a short video filming. He took particular pride in capturing the *gule wamkulu* sequences. His presence at these meetings elated the population and gave proof that he was indeed aligning with the Chewa.

Since those times, *gule wamkulu* has been performed at several events at Mua, including at National AIDS Days and the opening of new hospital buildings. Nonetheless, there remains something of an uneasy truce between Church hierarchy and more conservative Christians on the one hand and the *Nyau* with their *gule wamkulu* on the other. There are still a few within the Christian community who see no place for *gule wamkulu* in the life of a good Christian.

To the current day, Claude Boucher has continued to document the traditional culture in the Mua area and his studies on the Chewa and their *gule wamkulu* are of particular significance. Researchers, writers and photographers visit Boucher frequently, to have doors opened for them to the world of the Chewa and other tribes in central Malawi. The results of their work have been translated into books, museum exhibitions, art displays and video productions, all heavily influenced by the input and advice of Boucher. Only through the painstaking establishment and cultivation of mutual respect and trust with local peoples, a trust based on living together for 40 years, could such accumulation of cultural data have been possible. Boucher will be one of the very few living *azungu* (Europeans) to have a *gule* character created for him, as we read in the description of **Bambo Bushi**. Not surprisingly, the character is one that promotes understanding, wisdom and tolerance.

As a final word, it is useful for the reader to know that Claude Boucher is also regenerating *gule* characters that have not been seen for many years. His team of artists and artisans at Kungoni have been making masks and structures that were at risk of disappearing forever. The source of inspiration has been his copious notes, photographs and descriptions. Some of these characters have all but disappeared from the memories of living villagers. Incarnate, the spirit messengers take life once more on the *bwalo*, as the ancestors come to visit and remind the living of their obligations to the *mwambo* (moral code).

God willing, the animals will long continue to sing, and the spirits to dance.

Glossary of Chichewa terms

Akafula/Batwa Original inhabitants of Malawi prior to the settlement of Bantu-speaking peoples. A hunter-gatherer society

Akunjira The novice master, who welcomes the initiate and supervises the initiation

Ankhoswe (sing. *nkhoswe*) Guardians of the marriage bond

Anthumba Captives (of war)

Atsabwalo The *Nyau* member responsible for the *bwalo* (dancing arena)

Bwalo Arena for the performance of *gule wamkulu* and other rituals; 'centre' of the village

Chamba The drug hemp; marijuana

Chatuluka Retired village chief

Chibiya Ngoni kilt

Chihata Beaded belt or vest of the Ngoni

Chikafula Language of the Akafula, which sounds like 'coughing'

Chikamwini Uxorilocal marriage system where the husband moves to live in his wife's village

Chikhuthe Shelters where beer is brewed for rituals

Chilale Palm leaves, commonly woven to form outer skin of structures

Chilamu Joking, light hearted relationship between brother- and sister-in-law

Chiliza (pl. *ziliza*) A tomb-stone or cement construction erected on the grave of the deceased two years after burial. Also a bamboo fence which is erected around the grave the day following burial

Chilombo (pl. *zilombo*) Wild animal. A way of referring to *gule* characters

Chinamwali Girls' initiation ritual; coming of age

Chinamwali cha chimbwinda Initiation ceremony for girls already pregnant

Chingoli Cry produced by the male initiate when he presses his throat at the same time emitting a sound

Chipapa Winnowing basket. Also associated with witches as a vehicle

Chipongozi Avoidance relationship between husband and mother-in-law and wife and father-in-law

Chiputula Feather headgear (as worn by Kapoli). The word comes from '*chiputu cha udzu*', a clump of grass with roots difficult to trace

Chisamba A dance of the women, for pregnancy or *chinamwali*. One of the oldest of the Chewa dances

Chitengwa Taking a wife to live in the village of her husband (cf. *chikamwini*). Such a wife is called *ntengwa*

Chitenje (pl. *zitenje*) Brightly coloured printed wrap worn by the women

Chitopole (pl. *zitopole*) A type of scarification on the forehead, often seen as a way of beautifying the body and establishing tribal identity

Chiwongo Clan name (inherited through father)

Dambule Major commemoration for the dead (the ancestors), held annually by a village or villages (now rare)

Dambwe The secret place where *gule* characters are made and where dancers transform into animals and spirits (cf. *chilombo* and *mzimu*). Normally located near a graveyard

Dona A European lady

Dzala Rubbish pit. A liminal area where some of the instruction takes place during girls' initiation and where some *gule* anoint themselves with ashes in order to associate themselves with the dead

Fisi Literally, 'hyena'. A surrogate husband for the purpose of ritual intercourse (to awaken sexually an initiated girl who does not have a husband) or for generating a child in a childless marriage

Galu wanga chimbwala A mini-structure of a dog that fails to follow its owner and is seen as unfaithful

Gocho Term of derision for an impotent man

Gule wamkulu The 'great dance' of the Chewa, involving masked and costumed dancers and structures

Inyago Carved and costumed characters of the Yao. Moulded clay figures used for teaching facts of life during male initiation

Jando Initiation rite for Muslim boys including circumcision (Yao)

Kachipapa Small winnowing basket. Once used to dig and refill graves

Kafunde Series of riddles related to the female menstrual cycle

Kalolo Small structure representing a young girl who is pregnant before marriage

Kalonga King of the Malawi/Phiri people who came to dominate the Banda clan

Kamundi Consort of spirit wife *Makewana*, from Mbewe clan

Katondo Red clay used to decorate some *gule* dancers

Kazukuta A Chewa dance performed during the night vigil preceding the enthronement of leaders, by which village headmen and elders are instructed into their new role as leaders; it is also performed during beer parties to remind the community of the *mwambo*

Kholowa A sweet potato leaf dish

Khunju A dance originating amongst captives of the Ngoni

Kudika Literally, 'to wait'. Ritual abstinence from sexual relations

Kudula maliro To interrupt (cut) the transition of the deceased's spirit to the spirit world

Kudya makanda Literally, 'to eat young girls'. To exploit minors sexually

Kudyera Greed; desire to exploit any opportunity for personal gain

Kukhuza Mourning rites for funerals

Kukhwima, kukhwimira Self-preservation; advancing one's position using evil methods (witchcraft)

Kukuna Manual enlargement of girls' sexual organs (labia) for sexual enhancement

Kulodza Casting of lots or magical spells using medicines

Kulongosola Ritual re-engagement with sexual relations to end ritual coolness (redemption)

Kumangira mimba Ceremony to assist women to have a successful childbirth

Kupana Literally, 'to trap'. Castigation, notably from the ancestors

Kupisira anamwali Ritual intercourse by chief and his wife to release fertility of the girl initiates

Kusempha Literally, 'to miss'. Putting life at risk through failing to follow sexual taboos

Kutchona Verb related to *mtchona*

Kutsirika To protect items with powerful medicine

Kuyangala Special dancing step used as the *gule* character terminates its dance to show reverence to the audience

Liunde Gathering point ('backstage') for *gule* dancers near the *bwalo*

Lupanda Pre-Islamic initiation rite for Yao boys, now replaced by *jando*

Magawagawa Disease involving ulceration of the limbs. It can now refer to HIV/AIDS

Makewana Literally, 'mother of children'. Banda spirit wife of the Msinja rain shrine

Malume Male head of the matrilineal extended family; the senior maternal uncle

Manjerenjeza Ngoni bells worn on ankles

Manyumba Councillors of the village chief; village elders

Masiye Funeral house; house of deceased

Matsano Young virginal maidens at Banda rain shrines

Mbalule The leading (or 'talking') drum at a *gule wamkulu* event

Mbumba The extended matrilineal family

Mchape A non-lethal potion used to purify the taker from witchcraft

Mchili Medicine buried close to the sacred tree where village headmen will judge court cases and where *gule wamkulu* will be performed. This medicine is buried in order to ensure the villagers' protection

Mchome Facial decoration of women made with cashew nut acid

Mdulo The 'cutting (or wasting) disease', caused by breaking sexual taboos (when 'hot' and 'cold' meet)

Mdzukulu An undertaker

Mfiti (pl. *afiti*) A witch; one who is antisocial, user of evil medicines, eater of human flesh

Mfiti mphera njiru An accomplished witch that kills for its own pleasure

Mfumu (pl. *mafumu*) Chief of the village or village headman

Mitala Polygamist marriage

Mkamwini (pl. *akamwini*) Husband or son-in-law in the matrilineal Chewa society residing at his wife's village

Mkangali Solemn girls' initiation which can occur at initiation of a chief

Mkulu wakumadzi The same as *wakumadzi*

Mkulumulo Medicine to protect children from *mdulo*

Mkweteku Love potion/medicine

Mowa Beer brewed from maize and millet. A staple at many rituals

Mphini Cuts on the body or face in which protective medicine has been inserted

Mpindira Initiation ceremony at the funeral of a senior member of the community

Mpumulo A period of ritual sexual abstinence (*kudika*) for a married couple; sexual rest

Mtchona (pl. *matchona*) One who has lost connections with his home

Mtsibweni Another term for *malume*

Mwabvi The poison ordeal used in the past to identify witches. A witch would die while an innocent would vomit the poison

Mwali Banda spirit wife of the Mankhamba rain shrine

Mwambo (pl. *miyambo*) Code of moral values and behaviours set by the ancestors for the living, including rituals, traditions and rules of politeness

Mwambo wa maliro Funeral rites

Mwandionera pati Akafula

Mwini mbumba 'Owner' or 'caretaker' of the extended family; the senior uncle or *malume*

Mzimu (pl. *mizimu*) Spirit or ancestor

Mzinda (pl. *mizinda*) The village unit of *Nyau* and *gule wamkulu*; also meaning 'town'

Mzuli Small cap worn by Muslims

Mzungu (pl. *azungu*) European/White person

Namkungwi (pl. *anamkungwi*) Senior woman instructor

Namkungwi wa ku chinamwali Female instructor for girls' initiation

Namkungwi wa ku mzinda Female instructor initiated into *Nyau* society

Namwali (pl. *anamwali*) Initiate

Nang'omba A ground hornbill. The mother of children

N'dakalira Funeral headband

Ndatola Literally, 'I have picked.' A type of Kapoli who collects (steals) initiates from their homes and dances suggestively with each one, presenting the stick that stands for his sexual organ. He has a reputation for being promiscuous

Ndiwo Relish to add to *nsima*

Ngayaye Reed heads used in costumes

Ngoma Ngoni celebratory dance with men and women in a large circle. Men wear elaborate costumes and head dresses

Ngwetsa Rain dance performed at Banda rain shrines

Njedza Opening dance of a major *gule wamkulu* performance, usually performed by Kalulu and leaders

Nkhono A snail whose trail reminds us that evil follows its owner

Nkhoswe Guardian of the marriage bond/women in a family; the *malume*

Nsima Thick maize meal porridge. Staple of the Chewa diet

Nsupa Gourd used to hold medicines

Ntheko Initiation cap of girls (also called *timbwidza*)

Nyakwawa (pl. *anyakwawa*) Assistant to the village chief

Nyau Secret societies of Chewa men, in which *gule wamkulu* is
the major pedagogical tool

Nyoni (kanyoni) Literally, 'a small bird'. Ngoni headgear. Also a
secret word to talk about a structure made of feathers

Phata Root of a tree or the oldest member of a family

Phungu (pl. *aphungu*) Tutor to initiates

Silambe (pl. *zilambe*) Rattle used to rouse the ancestors and
guide the *gule* dancer, made of a tin tube with stones or
seeds inside

Sing'anga Traditional herbalist and/or diviner of witches

Timbwidza The same as *ntheko*

Tsempho The same as *mdulo*

Tsiku losambula Day when ferment is added to the beer being
brewed for a ritual

Tsimba Seclusion house for initiates

Tsumba Tuft of feathers on head or forehead

Ufiti Witchcraft

Wakumadzi (pl. *akumadzi*) Head of the *dambwe*, who supervises
the performance

Wali Yao Muslim initiates

Zithumwa Small bags of medicine

Ziwanda (sing. *chiwanda*) Evil wandering spirits; the spirits of
witches

Introduction and Background to *Gule Wamkulu*

Gary Morgan

Gule wamkulu is the 'great dance' of the Chewa people. It is a startlingly imaginative combination of dance, song, drumbeat, and extraordinarily diverse and creative costumes and structures, usually incorporating dramatic masks, mostly carved from wood. By the time you have perused this work of Claude Boucher, you will appreciate that *gule wamkulu* is much more than merely a performing art and source of village entertainment, albeit most certainly being both of these things.

The *gule wamkulu* is sometimes called a masquerade because of its reliance on masks and woven structures that camouflage the dancer. It cannot be confused with the more stylised and aesthetic masquerades of the Western and Latin worlds. It is no Italian Carnival, with gorgeous male and female masked figures draped in cloaks, jewels and finery, posed like artworks against a Venetian sunset. Nor is it Rio in full swing with heaving masked bodies pressed close together in joyous but simple expression of youth, passion and sexuality. *Gule wamkulu* has copious manifestations of exuberance and sex, but its characters are from another place from that of us humans. They are often dark and menacing actors in a complex morality play about life, death and everything in between.

First and foremost, *gule wamkulu* is an expression of what it is to be a traditional Chewa.

History of Malawi

For reviews of the history of Malawi and the Chewa people, the reader is recommended Tindall (1968), Pachai (1972), Ott (2000), Boucher (2002b) and Phiri (2004). The following is a brief summary to provide context for the place of *gule wamkulu* in Malawian history and current society.

The Chewa are a sub-Saharan matrilineal Bantu-speaking people. They are one of the most significant ethnic communities of Malawi, eastern Zambia and the Tete province of Mozambique, in terms of both numbers of people and the societal influence of their traditional practices and culture. The Chewa language, Chichewa, is spoken by perhaps 15 million people. It is harder to be precise in estimating how many people *are* Chewa. Through intermarriage, many people from other ethnic groups have become 'Chewa-ised'.

Prior to the arrival of the ancestors of the Chewa, we know from the archaeological evidence that another patrilineal Bantu-speaking people had begun migrating into Malawi in small numbers southeast from the Niger-Congo basin as early as the second century A.D. These people were crop cultivators, had cattle and worked iron (Zubieta 2006, 2009). They encountered the indigenous inhabitants of the area of modern day Malawi, the Batwa or Akafula. The Akafula were small-statured hunter-gatherers, with a probable genealogical relationship to the

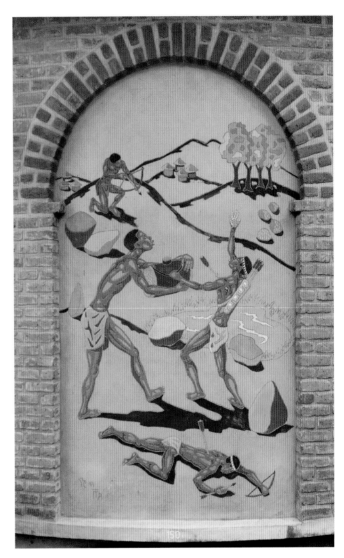

Fresco of the Chamare Museum, painted by Claude Boucher. On its arrival around 800 A.D., the matrilineal Bantu group encountered the Akafula people in what is now Malawi, encounters that would often have been marked by conflict.

Pygmies of the Congo region. With low populations and using stone-age technologies, they were eventually out-competed for land by the ever more numerous later matrilineal Bantu immigrants who brought their iron weapons and tools and their crops around 800 A.D. This matrilineal group eventually absorbed the early patrilineal Bantu.

The Akafula disappeared as a recognisable cultural group in the mid-19th century although their rock art decorates sites around Malawi and their genetic legacy will continue from the inter-marriages that took place between them and the Bantu. Less certain is the extent to which their cultural legacy continues, as we note for the *gule wamkulu* below.

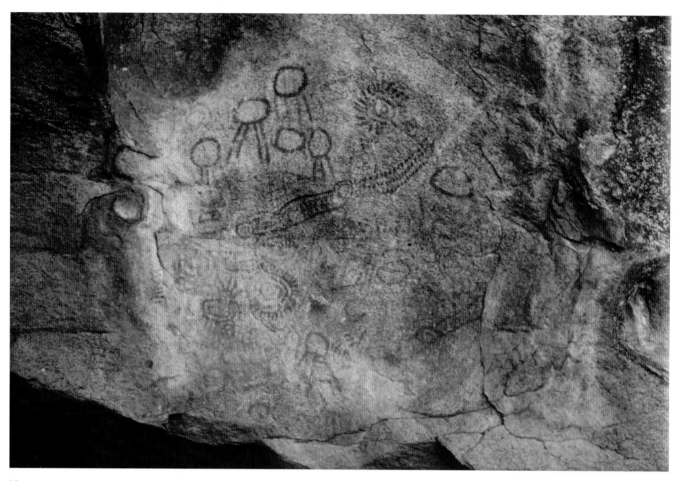

Hunter-gatherer rock art painting, Msana wa ng'ombe site.

Claude Boucher, May 1987

There are a number of interpretations of the migratory history of the Chewa. Around 800 A.D., the hitherto trickle of Bantu people from the north accelerated. In some reviews (such as Phiri, 2004), the movement into the Malawi region of initial leader clans Banda and Phiri is described as more or less concurrent. Other scholars (Ott, 2000; Boucher, 2002b; Smith, 2001; Zubieta, 2006, 2009) include consideration of rock art and pottery, and suggest that the Banda clan group preceded the Phiri into what is now Malawi by two to three centuries. The arrival of the Banda may have occurred around 800 A.D. and the Phiri around 1200 A.D. Assuming at least some temporal disjunction between major clan group arrival, the first of the proto-Chewa were associated with the Banda clan, prominent amongst them being the clans Mbewe, Chisale and Nkhoma. The Banda clans had strong religious links with water, rain, and the spirit of the land. The foci of their spirituality were the spirit wives, mystic women mediums who could communicate in tongues with the ancestor spirits and thence God. As their name suggests, these mediums were also spiritual wives of *Chauta*, or God, their symbolic sexual union generating the fertility manifested in rains. The spirit wives were associated with sacred pools where many of the rain-calling rituals would be held. It is possible that this religious link with sacred pools drew also upon the belief structure of the Akafula. Rain shrines were also Banda loci for religious practices, notably beseeching God

to yield ample rains for the next growing season for the crops. Rains translated to fertility of the land and this fertility was extrapolated to that of the people through initiation ceremonies that imparted both adulthood and fecundity (such as the *chinamwali* ceremony for girls).

A third pillar to the Banda spirituality was the *Nyau* secret society. Its great dance, the *gule wamkulu*, was a further medium for communicating with the ancestors, or more accurately, for the ancestors to communicate with the people. The *gule wamkulu* may have actually preceded the *Nyau*, a male society, as there is more than a little evidence for genesis of the great dance with the women.

The farming Banda clans settled widely in the current Malawi, east Zambia and north Mozambique regions. A people of loose villages and chieftainships, there may have been little strict hierarchy between chiefs although doubtless some established greater spheres of influence than others. There was certainly trade between villages, this linking with outside regions, and tributes would be offered at the rain shrines and sacred pools. In the 12th and 13th centuries, the next major wave of pre-Chewa arrived, these being the Phiri or Malawi peoples. Their social structure was more rigidly hierarchical, with a tiered seniority of chiefs, culminating at the apex of the community power pyramid in the Kalonga. The Kalonga was a hereditary ruler, approximating the concept of

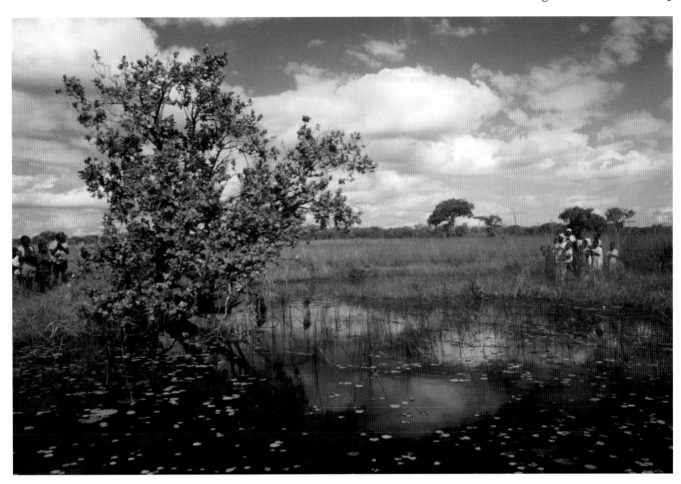

The Sacred Pool of Msinja forms part of the springs of the Diamphwi River that originates from the Kaphirintiwa Mountain, the place of creation for the Chewa.
Claude Boucher, May 1989

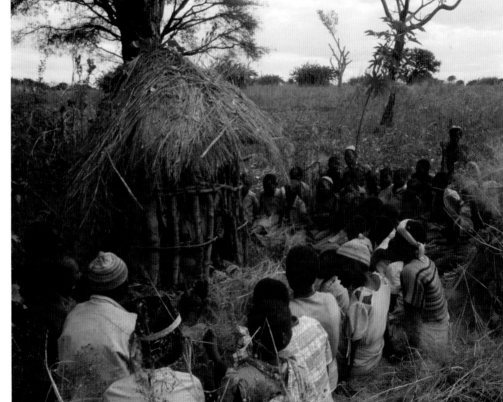

The Msinja shrine surrounded by worshippers. Inside the small hut, Mrs Kwinda, a widow, takes the position of *Makewana*, the Spirit Wife. She presents petitions to both *Chauta* and the territorial spirits. The villagers have their hands outstretched on the ground, and after each supplication clap their hands with respect.
Claude Boucher, May 1989

a king. Chiefs of the clans were required to pay homage and tribute to the Kalonga, and this structure of allegiance gave the Phiri a more formal political framework than that of the Banda clans. The tradition of tribute to the Kalonga continues to this day, with the annual Kulamba festival in eastern Zambia, where Chewa chiefs convey their loyalty and gifts to the current Kalonga, Gawa Undi XXIII.

The Phiri appear to have quickly asserted first influence and then control over the Banda. The formality of their power relations may have contributed to this dominance. The Banda were associated with water and through their settlements with lowlands. The Phiri were associated with fire and preferred the higher country. Fire was seen as a restorer of fertility to the land. The colour red is often a dominant feature of Phiri art and costumes. (It is to be noted that in *gule wamkulu*, the colour red frequently reveals a stranger or outsider.) The Kalonga reinforced his power through associating himself with a senior spirit

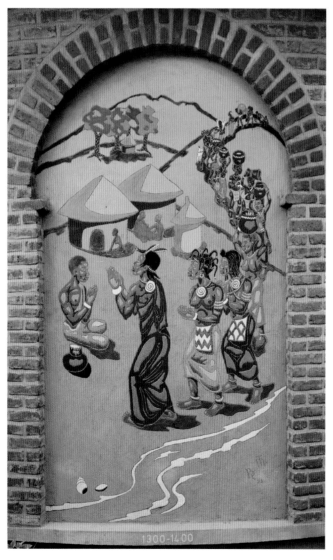

Fresco of the Chamare Museum, painted by Claude Boucher. The Phiri or Malawi people arrive among the Banda beginning around 1200 A.D. The two major clan groups would merge to become the Chewa.

wife, *Mwali*. Their ritual marriage was seen to cement his influence over the rain traditions of the Banda.

The Banda resisted this insidious assumption of political dominance by the Phiri. The Banda contextualised the Kalonga-*Mwali* marriage as a subjugation of the Phiri king to the Banda matrilineal 'son-in-law' paradigm, this being the least important member of a female dominated family. Nonetheless, the control of land, trade and the rain shrines shifted to the Phiri clans. Controlling the *gule wamkulu* was to prove altogether more difficult.

The amalgam of Banda and Phiri clans has resulted in the people we know today as the Chewa. They remained the politically dominant tribal element of present day Malawi into the 16th century. The Phiri, or Malawi, state covered a large area from the Luangwa River half way to the Indian Ocean. Progressively, the ultimate authority of the Kalonga waned and splinter groups established their own centres of trade and homage. Indeed, the lineage of the current Kalonga Gawa Undi is a product of one such succession action. The Chewa kingdom had become disorganised and with little internal cohesion when the Yao and then the Ngoni moved into the area in numbers. The Yao, a trading people from the east with strong Swahili links, had been extending more and more into the Malawi territory through the 17th century. In time, many tribes along the trade routes adopted Yao as the *lingua franca* of trade and the Yao-speakers became a significant linguistic group. The Ngoni, a cattle-herding people of close Swazi-Zulu relations, moved into the region from the south in a number of waves, escaping the bloodbath of Shaka's wars (the *difiqane*, or forced migration) in the mid-19th century. The Yao traders and Ngoni warriors were well organised and militarily superior to the now fragmenting Chewa. Much of the land fell under their control and remains so, in modified form, to this day. By way of pertinent example, the Traditional Authority for the area around Mua is an Ngoni Paramount chief, Kachindamoto (currently Theresa Kachindamoto).

The power base of Malawi shifted again, most significantly, with the increasing intrusion of European colonial powers through the 19th century. Arab traders had operated along the Indian Ocean coastline east of Malawi prior to 1000 A.D. but other than supporting trading settlements, did not make substantial claims on land. Portugal had established trading routes and bases along the eastern coast as early as the 16th century and in the 17th century Portuguese explorers penetrated the interior to present day Malawi. Yet Portugal had not made significant territorial claims over the land of modern Malawi until the British introduced themselves as part of their 'Cape to Cairo' colonial strategy. The British were following on the explorations of the area by David Livingstone and his crusade to introduce the three "C's" – Christianity, Civilisation and Commerce. The British had hopes that Central Africa would provide a lucrative bounty in cash crops such as cotton and coffee, ambitions to be largely unfulfilled in the case of Malawi. In addition, the active lobbying of the church community, notably that of the Scottish churches that had supported and succeeded Livingstone, and Portuguese threats to annexe the

Fresco of the Chamare Museum, painted by Claude Boucher. The Ngoni moved into the country of the Chewa in the mid-19th century, raiding Chewa villages and taking control of large areas of land.

Shire Highlands, put iron into the British spine. A number of private companies established operations including the African Lakes Corporation. Slavery had evolved into a scourge through much of what is now Malawi and became a primary target for British suppression. The dual goals of eradicating the slave trade and making the territory firmly British saw the British authorities extend their control through commerce, duress or military action, and often all three. The establishment of a British Central African Protectorate in 1891 sealed the British power over the former lands of the Chewa. The Nyasaland Protectorate was declared in 1907.

With its eventual eradication of slavery and curtailment of internecine actions by Ngoni and Yao raiders on the Chewa, the British administration imposed a period of greater security and, by some measures at least, peace than had characterised the preceding centuries. The *Nyau* had been suppressed under the Ngoni and with the lighter touch of the British authorities the secret societies regenerated and grew in membership once

more. Of course, there is always a high price to pay for colonial peace, and the Chewa and other tribes paid that price.

White settlers bought land from local chiefs but this benefited a few at the expense of the many who lost their plots and were forced to work on the properties of other landlords. A 'hut tax' introduced by the authorities compounded the situation. Many young men were forced to leave Nyasaland in search of cash and work in neighbouring countries such as the then Northern and Southern Rhodesia and South Africa. This migrant workforce grew through the colonial period and reached a peak in the 1950s, with around 150,000 workers leaving the country each year. The haemorrhage of young men had significant impacts on village communities. Some of the lost youth did not return and those that did often brought back not only cash but new ideas and attitudes, for both the good and the bad of the communities. Conscription of men into the British forces in World War I caused further disruption to village life. It also precipitated the one significant act of political insurrection under the British rule, that of Reverend John Chilembwe and his supporters in 1915. Short lived and ruthlessly suppressed by the British, the rebellion catapulted Chilembwe to the status of martyr and national hero, a standing he retains today.

In 1953 Nyasaland was politically assimilated into federation with Northern and Southern Rhodesia, present day Zambia and Zimbabwe. This inflamed African opposition to colonial rule and enhanced the standing of the Nyasaland African Congress, later to be renamed the Malawi Congress Party. Its head was a Chewa, Dr H. Kamuzu Banda.

Through the early 1960s, discussions with the colonial authorities and Kamuzu Banda's party saw progressive moves to independent rule. The Federation was dissolved. Malawi achieved its independence in 1964 and in 1966 became a republic. Kamuzu Banda was its first president and would remain so for nearly 30 years. In a sense, the Chewa had regained control of the country, as Kamuzu Banda proclaimed his indigenous roots and 'Chewa-ness'. Yet his rule was to become one ever more detached from the people as autocracies always do. The Kamuzu Banda years are remembered today with very mixed emotions and equally variant assessments by ordinary Malawians, the media and political figures and parties. There was economic growth, notably in the early years and with South African patronage, Kamuzu Banda being a rare African supporter of the South African apartheid state. Yet the stories of political oppression, corruption and exploitation, and the ever diminishing tolerance of any form of opposition, real or perceived, cloaked the era with a darkening aura. Growing public opposition to his rule was ignited by the Lenten Pastoral letter of 1992, written by the Catholic bishops of Malawi at considerable danger to themselves. Their call for political change triggered countrywide expressions of protest. Donor countries, no longer needing a so-called ally against communist elements in the now dead Cold War, and seeing the civic frenzy, forced Kamuzu Banda to accede to the calls for change. A referendum in 1993 endorsed a multiparty democracy for Malawi and the first multiparty election was held in 1994. The United Democratic Front led by Bakili Muluzi won a majority of seats.

The Kamuzu Banda era had passed. He was probably aged in his late 90s when he was relieved of the presidency.

Post-Kamuzu Banda Malawi has endured some troubled times, if not so much in civil disorder then in variable economic performance and slow growth of jobs and infrastructure. Like much of southern Africa, the country has relied heavily on international aid. The current president, Bingu wa Mutharika, elected in 2004, and his government face major challenges in confronting the economic and social problems which have arisen in Malawi in recent years. Nevertheless, Malawi remains a relatively peaceful and orderly country, largely free of the insurrection and violence that stained so many of its regional neighbours in blood through the late 20th century.*

While the Chewa lost their pre-eminence as a political power, first to subsequent tribes, then to colonial rule of Nyasaland and adjacent territories, and finally to centralised democratically elected government, they have remained the major demographic group of Malawi, especially in the central and southern regions. Their matrilineal family set-up has retained a social dominance over much of Malawi. There is a stoic element of survivorship in the Chewa way of life. Invasions may have happened repeatedly but their societal practices have remained strong. They have absorbed the invaders and made them Chewa. Amongst the cultural practices that have fortified the Chewa against change and turmoil has been the *gule wamkulu*.

Origins and history of *gule wamkulu*

We have seen above that *gule wamkulu* may have arrived in Malawi around the time of the Banda migrations, circa 800 A.D. Just how much older elements of the great dance may be is unknown. There is some suggestion that *gule* may have evolved through contact between the Bantu and Akafula/Batwa people, and that it might even have been originally an Akafula practice. The Akafula religiosity extends back for thousands of years into an unknown origin. Certainly, therianthropy is a common element of the spirituality of the San, a hunter-gatherer society further south, with perceived and artistically depicted human-animal mutations arising through altered states of consciousness notably associated with the San trance dance (Lewis-Williams & Pearce, 2004). There is no trance dimension to the creation of Chewa *gule wamkulu*. If the origins of the human-animal morphs lie in entoptic phenomena and hallucinations, then those origins have been lost. There is some linkage between *gule wamkulu* and spirit possession, however, in that the healing rites of the possessed will avail of the services of masked dancers. This is a little known function of *gule wamkulu* that has been observed by Boucher on several occasions. The *gule* thus can have the powers of healing. Whether this stems from any Akafula influence we cannot say. Today the Chewa great dance is very much a conscious choice of themes and symbols, reflecting traditional values but also contemporary issues.

It is more conservative to regard the Banda as the *gule* progenitors, but even then, some form of the great dance could have existed over 1000 years ago. There is no substantive evidence that this is so. It is speculative but it gives a notional starting point, and in any case our interest here is more with the documented *gule wamkulu* of this century.

The great dance is the primary manifestation of the *Nyau* secret societies of the Banda clans and now the Chewa people. There is considerable speculation that *gule wamkulu* was important originally to the women rather than the men. This is discussed further under gender relations. The ancient nature of many of the characters associated with female initiation lends some weight to this option but it is unlikely that the true origins of *gule* will ever be confirmed with certainty. The multifaceted nature of the dance will be evident from Boucher's descriptions but its role remains what we assume it has always been, namely a mechanism for communication with the ancestral spirits. At major events in the village, the dance was performed by the masked *Nyau* and a small number of senior women who could be initiated into the secret society. Their secret was their identity behind the masks, the coded references used for communication between initiates, and their creation of the fantastic figures that are the characters of *gule wamkulu*.

With the Phiri intrusion and progressive political dominance, the *Nyau* societies were a strong point of Banda resistance. The *Nyau* organisation applied a 'grass roots' principle, at the village level rather than imposed from above via any political hierarchy. The mysterious nature of the dance served only to highlight the Phiri suspicion of it, a reaction mirrored by all subsequent occupiers of Chewa country. The Phiri banned the *Nyau* from many major rituals including those of the sacred pools and rain shines, but the societies and the *gule wamkulu* remained bastions of resistance. Over time, the societies and the dance became infused throughout the integrated Chewa society. During subsequent Chewa history, the *gule wamkulu* has been not only a channel to the ancestors, but also a vocal and effective mode of village level expression and protest. It has also been subject to repeated efforts from dominant political elements to extinguish it. The mystery of the great dance, its use of cryptic symbols and songs, the threatening and often hideous masks and structures, and its use as a medium for protest have consigned it to perennial opposition and persecution from occupying powers.

Under Ngoni dominance around the 1850s, the *Nyau* continued their role as defenders of Chewa traditional values. Ngoni suppression and general Chewa instability saw something of a decline in the great dance (van Breugel, 2001). The greater peace and stability of the colonial times resulted in a renaissance of the *Nyau*, but they continued their tendency to undermine the alien occupying power, now the British. The attitude of the Christian churches was universally negative towards the *gule wamkulu* (Schoffeleers & Linden, 1972). To many of the missionaries, *Nyau* represented a barbaric brand of paganism and the *gule wamkulu* was seen as a performance of witchcraft and black magic. Once the representatives of the churches began to perceive some of the overtly sexual content

* President Bingu wa Mutharika died on 5 April 2012 as this book was going to press. Joyce Hilda Ntila Banda, the Vice President, took the oath of office on 7 April to become the fourth President of Malawi.

of the dances and songs, their opposition hardened. They concentrated on the perceived profanities of the great dance, rather than its role in supporting community values. The *Nyau* responded to church attempts to extinguish their societies by pressing younger boys into initiation. There was little engagement between the camps. Boucher's base for the past 30 years, Mua, has been a centre of *Nyau* – church conflict and mutual intolerance for much of its history.

Under the British administration too, the flux of young men from the country to work as migrants in South Africa and other counties depleted the *Nyau* pool of active initiates. It also infused the *gule wamkulu* with new themes that related to the pressures on the community of losing its young men and the dangers of temptation that faced them in the 'outside world'. These threats included the intrusion of a money based system of values, increasing promiscuity and increased rates of sexual diseases. All of these were prime targets for the great dance.

The push to an independent Malawi was supported by the voices of the ancestors through the *gule wamkulu*. Malawi achieved this independence in 1964 and on Independence Day, *gule wamkulu* was performed in front of Mua church. However in a self-governing Malawi, under the regime of President Kamuzu Banda, the rights of citizens to self-expression on matters pertaining to government were eroded and a free press quashed. There were few avenues of protest that did not engender extreme risk of retribution from the government and its agents. In this environment, the *gule wamkulu* regained its role as a voice of ancestral protest, but often with extreme codification of the message. We shall see this in Boucher's descriptions of the political masks of the time. In post-Kamuzu Banda Malawi, the options for self-expression have increased and the media provides avenues of mass communication of diverse views on issues political, economic and social. Consequently, the role of the *gule wamkulu* as a political correspondent of the spirits has diminished, and there are far fewer political masks than in the Kamuzu Banda era. Matters of social and community good remain primary themes however and HIV/AIDS has attracted a number of *gule* sermons.

The great dance has, almost without exception, been interpreted by the non-Chewa as evil, for political, social or religious reasons. In the political sense, there is some justification for this view as the dance has been a medium for first the Banda clan and then broader Chewa resistance. On social and religious grounds however, the perception of *gule wamkulu* as fundamentally wicked and corrupt has been the product of considerable ignorance and prejudice, and that is one of the great ironies of the great dance.

Today, *gule wamkulu* remains a significant aspect of village life in central and southern Malawi. The nature and extent of its practice varies greatly as one would expect in a country subject to rapid social and economic change. Yet this variation would have always been a characteristic of *gule wamkulu* as the secret societies were based at the village level and organised locally. There has not been any strong form of coordination or orchestration of *Nyau* across large areas and while some *gule* characters have very widespread appearance many others reflect local

issues and have evolved at a local level. The causal mechanisms for variation between *gule* characters will be considered later but it is this localised focus that has always made the *Nyau* and *gule wamkulu* impossible to usurp and control by any centralised external power. It is also what makes *gule wamkulu* of such pertinence to the people of the village.

Outside of Malawi, *Nyau* societies and the great dance have remained variously functional across the lands of the Chewa, notably in parts of eastern Zambia and the Tete province of Mozambique. That the diversity of *gule* characters and the application of the dance are strongest in Malawi reflects the concentration of Chewa and the continued influence of their cultural practices in that country.

Chewa religion

The reader is recommended Schoffeleers (1997), Morris (2000), van Breugel (2001) and Ncozana (2002) for an insight into African Traditional Religion and the traditional beliefs and religious practices of Malawi. Ott (2000), too, gives a succinct overview of religious orientation in Malawi and Boucher (2002a) provides an easy to read synopsis of Chewa traditional religion and cultural practices. Most of the above authors make some allusion to and discussion of the *Nyau* and *gule wamkulu*. More detailed publications on the *Nyau* and the great dance include Schoffeleers (1968, 1976), Kaspin (1993), Yoshida (1993) and Aguilar (1996), together with other references noted by Brian Morris in his Foreword to this book. Curran (2000) and Probst (2000) discuss the *Nyau* and *gule wamkulu* in their depiction by and through images. Here, only a succinct and much simplified summary of Chewa traditional beliefs is provided, to give some context to understanding the great dance.

Central to African religion in Malawi and elsewhere is respect for, and communion with, the ancestors. This has sometimes been called 'ancestor worship' but ancestor veneration is a more accurate depiction. At least in so far as the Chewa are concerned, respect for the ancestors is at the heart of traditional spirituality, but more in petitioning for their support and assistance, than to worship them as demi-deities. Becoming an ancestor is the inevitable lot for all of us. We are born, we live a span of time and we die, and with the last transition, we enter the world of the spirits, the ancestors.

The world of *mizimu*, the spirits, has certain similarities to our own. After death, we move to a village much as we have lived in during our lives and the community is comprised of those who were together in life. Our roles are parallel in the living and spirit worlds; a chief in life will be a chief in death. Chiefly spirits will thus have greater responsibilities than those of deceased relatives, who may be thought of as domestic spirits. For its similarities, the spirit world is far more nebulous and insubstantial than that of the world of flesh and blood. Spirits are ethereal and their village lacks the physicality, for good and bad, of our lives. The ancestors do not suffer hunger or thirst, or the ravages of disease. But then, neither do they enjoy the physical pleasures of life, such as sexual relations. No child is born to their village, and so there is no pain of child-

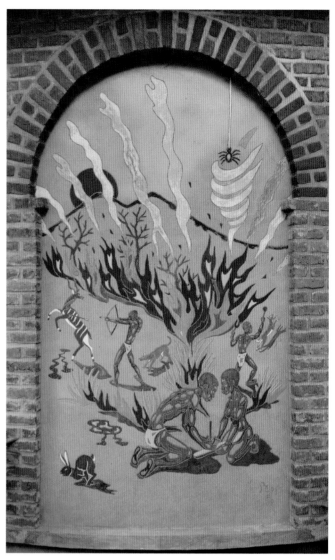

Frescoes of the Chamare Museum, painted by Claude Boucher. The Chewa creation myth describes God, humans and all animals descending from the sky and living in harmony. . .

. . . until humans discover fire and resort to hunting the animals around them, thus creating chaos.

birth, but neither the immediacy of the birth. Yet the ancestors are sensitive to the sorrow and joy of their relatives in the land of the living, and share in those human pleasures and pains. They are displeased with their relatives who neglect the *mwambo* and change into witches harming the community (the enemy within).

There are some spirits for whom the afterlife is less sublime. The *ziwanda* are evil spirits that wander the earth, outcasts from the village of the ancestors (they are the enemy without). Such spirits are those of people whose behaviour in life has cursed them to eternal homelessness. In the African set-up, having the security of a home and family around you is seen as essential to life. Consequently, being a spiritual vagrant is as close to damnation as African religion indulges. The *ziwanda* continue their evil ways and are the cause of much suffering for the living, even deaths. They must be warded off with special spells and medicine.

Communion with the spirits is both a personal and a com-

munal affair. At a personal level, one wishes to have contact with those who were part of one's circle in life, usually former members of the extended family, the domestic spirits noted above. For more significant matters, notably relating to areas of territory, the chiefly spirits may be conjoined. The important events for spirit contact are community-based, where the entire village, or at least a major part of it, comes together to communicate with those now dead. In this way, the dead remain prominent in the memory of the living, and thus very much alive in their own right. The spirits have powers and can assist in providing good fortune and happiness for those of their family in the living world. If angry, however, ancestors can be problematic, and cause hardship, anguish and confusion for the living who do not please them. The ancestors are also a conduit for petitioning God.

African religions frequently recognise a deity that approximates a monotheistic one, an absolute power responsible for creation of all things and an omnipresent controller of the

worlds of the living and the dead. By name, God is variously known. Boucher (2002b) notes three names for God in a single paragraph relating to the creation story of the Chewa: Chauta, the big bow (rainbow); Mphambe, the lightning; and Namalenga, the creator. Not surprisingly for an agrarian people in a land dry for much of the year and subject to periodic drought, God is frequently associated with the sky, from whence he once dropped to earth, and the making of rain, the ultimate gift to sustain life. Without it, there is only death. God is seen as both male and female; the female dimension is evident in the Godly virtue of motherly love for the people.

The creation story of the Chewa has striking echoes of the Biblical Genesis. God created a world and blessed it with rain. God, all the animals and man and woman descended from heaven at the mystical Kaphirintiwa Mountain to settle and to live in harmony. This tranquil co-existence in paradise was sundered by the humans who discovered fire and set the bush aflame. They turned as well to hunting and most of the animals fled in panic although a few, such as the dog, chose to remain with humans as domestic companions. God was dismayed and turned His back on the destructive humans, returning to heaven up the silken strand of a spider. From that time, the earth has seen violence and hardship, and rain must be begged from God through prayer and tribute. Only in death do men and women rejoin God in the afterlife.

This fragmenting of a perfect world through the actions of man is a common thread in many African creation stories. So too is the notion of the dead, the ancestors, being closer to God than are the living. Thus, to achieve the major goal of continued existence of the living village, that is the return of seasonal rains, people have prayed to God and asked their ancestors to act as intercessors, lobbyists, on their behalf with the supreme being. To be on good terms with one's ancestors is seen as crucial to survival.

The relationship of the living to the dead, and indeed much of Chewa ritual practice, is characterised by a balance of opposites, a kind of yin and yang of the universe. We see this balance throughout the life-cycle of the individual and in the relationships and practices of the community. The balance of opposites is evidenced in references to colour, temperature and proper behaviour. Life is a continued series of events marked by rites of passage, from birth through to death. At times of major consequence for the individual, the kin group or the entire community, it is natural to want the spirits in close proximity and supportive. The spirit world is devoid of the rigours and the passions of life, and is regarded as 'cool', while life is 'hot'. The most intense heat in general life is generated by that age-old focus of human attention and desire, sex. As well as temperature, colours can suggest the opposing balance. White is commonly associated with the cool spirit world, red with the hot world of the living. If we want our ancestors to be as close as possible, to be generous and attentive to our pleas, then it is strategic to cool down our lives and thus to lessen the differential between the worlds. In consequence, periods of significance that require ancestral attention are marked by various degrees of cooling off, and this reduction in temperature is most effec-

tively achieved by avoiding sexual relations. The intensity and extent of that self-imposed sexual denial will reflect the significance of the event and how close the individual is to the event. Births, initiations, chiefly instalments, funerals and so on will all be marked by sexual abstention in those who are related to the subjects of the ritual. Close family members will generally abstain for longer than those more distantly related. The instigation of abstinence is called *kudika*; the re-engagement with sex, often through a ritualised sexual act, is *kulongosola*. There are many references to these in Boucher's descriptions because the *gule* messengers have a lot to say about sex.

There are other ritualised actions required at many rites of passage. The shaving of the head of the person in transition, and sometimes of family members, is common. Equally common is the brewing of beer using maize and millet. This is for celebration but it is also for communion. And that com-

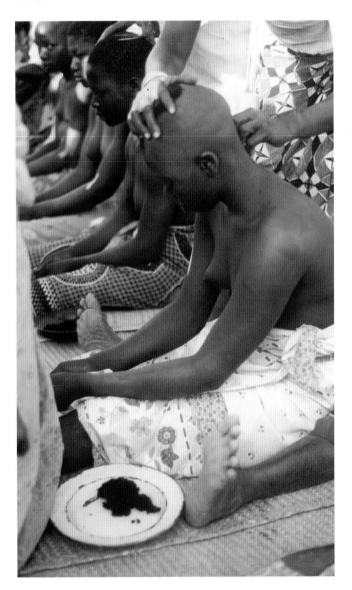

The heads of the initiates are shaved by the tutors to mark the end of their transition and to confirm them as fully grown women.

Claude Boucher, Kakhome Village, May 1988

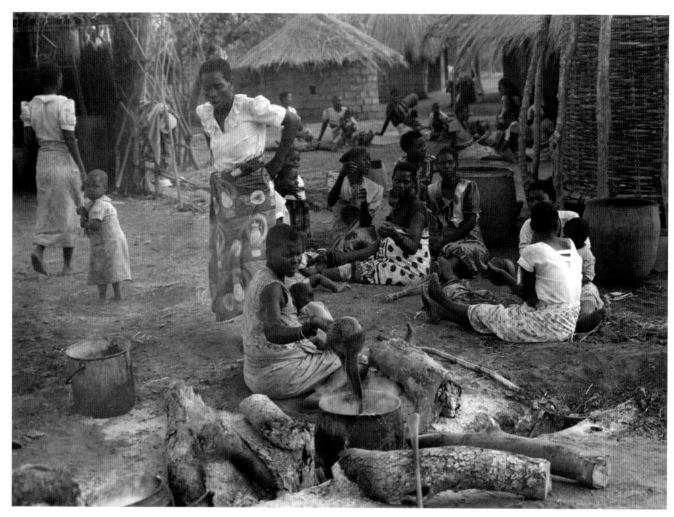

Women who are ritually cool (not involved in sexual activity) can orchestrate the five day process of beer-brewing that accompanies any ritual in which *gule wamkulu* is involved.

Claude Boucher, Kanyera Village, September 1995

munion is not only between members of the community; it is also for communion with the spirits who will 'share' the beer, thus strengthening the bonds between the living and the dead. There are even *gule wamkulu* visitors who will check that the beer making process is properly advanced and supply firewood for the brewing!

Most of the major celebrations and rituals of the village take place in the season following the maize harvest, when there is little work in the fields and, assuming rains have fallen that year, there is food in the *nkhokwe* (granary). Large quantities of food and drink are consumed on such occasions. The feeding of the dead is understood as the feeding of the living community. Through their sharing of food and drink, communion is achieved. The major events of one's life are subject to ritual and each is seen as a transition, a passage, a rebirth, into a new individual. The child who enters initiation comes out as an adult, educated and ready to take on the new responsibilities of adulthood. The individual is reborn to be a chief, with all the duties obligate on him or her, this transition being marked by the assumption of the name of the village as was held by the lineage of chiefs before him. The deceased is passing from this life into the ancestors' village and must be

assisted in the passage. There are many symbols of transition and *gule wamkulu* has a vitally important role in the process.

The role of *gule wamkulu*

There have been a number of studies of the *Nyau* and the *gule wamkulu*, some of them noted above. This introduction does not attempt an analysis of those studies nor of their findings relative to those of Boucher as set down in this book. That task deserves to be done but this is not the place. From this point, the discussion of the great dance draws rather upon the descriptions of the characters that Boucher has amassed and interpreted. Thus, the discussion is very much through Boucher's eyes, but they are the eyes of one who has lived with and studied the Chewa for over thirty years, a person who has become partly Chewa himself.

The *gule wamkulu* is many things. It is a form of extraordinary artistic expression, through masks, costumes, dances, songs and drum support. It is the ultimate form of audience participation, particularly in the interaction between the dancer and the women and girls of the village. Most importantly to the village, it is a conduit to the ancestors. Having cooled the village

down and readied the stage by ritual acts to encourage ancestral attention, the characters of the *gule wamkulu* perform the role of mediums and mentors. They are the embodiment of the spirits themselves, the ancestors incarnate, in bizarre forms derived from humans, from animals, and from the heights and depths of human imagination.

Their appearance coincides with events and rituals, ranging from the very intimate to the community-wide. Typically *gule wamkulu* was and continues to be a feature of initiation of boys and girls to adulthood, the appointment of new chiefs and other community leaders, funerals, and commemorations for the dead including the *dambule*, the major commemoration of ancestors of the village. With the increasing construction of tombstones (*ziliza*) on graves, following the practices of first the Ngoni and then Christian westerners, *gule* has appeared at such events. In recovery after an evil spirit possession (*azimu*), the *gule* dancers can attend to assist the patient. The possible links of this function to an origin in altered states of consciousness has been touched upon already. The great dance can be commissioned for special occasions, such as remembrance for an ancestor, this being known as *gule womema*, a 'called dance'. It has also been incorporated into social and political events to enliven the proceedings.

It is common practice to combine certain ceremonies, such as initiation of young people with a funeral. This has the attraction of reducing costs of staging separate events and taking advantage of the proximity of the ancestors (coolness) for more than one purpose. *Gule wamkulu* is not generally associated with births or marriage ceremonies. However, it must be remembered that initiation to adulthood is seen as an immediate precursor to both marriage and having children, and thus the ancestors have sanctioned both of the latter through their endorsement of the child becoming the adult.

Each of the *gule wamkulu* characters has a defined role and message. The coverage of those messages, their themes and intents, is the subject of this book by Claude Boucher, as much as or more than the masks, costumes and structures themselves. Devoid of an understanding of the messages, the *gule wamkulu* is merely a spectacle, albeit a striking and unforgettable one of shape, colour and noise. This dimension of entertainment has been exploited by political parties that have used the dance to attract people to political rallies and entertain them once there. In such instances, the entertainment value can tend to swamp the profound nature of *gule wamkulu* that is in its stories and meanings. It is in the songs and the dances that the messages are held, often cryptic and concealed to the uninitiated. The messages are further reinforced by semiotics in the masks and costumes, that otherwise are merely a matter of artistic curiosity. If the living want help and support from the ancestors in their lives, then they must be prepared to hearken to the advice and counsel of those who have gone before. It is through the *gule wamkulu* that the advice is delivered.

There is little about life that is not addressed by the great dance. The catholic nature of its attentions is noteworthy but so too is the mix and balance of emphasis, with certain areas of life very heavily addressed and other aspects little if at all. It is in this mix that so much can be learnt of the Chewa world view.

This book therefore explores the ancestors' views on power, politics, community values, marriage and sex, parenthood, health and the desirable traits for an individual. And we will hear much about witchcraft, such a permeating dimension to traditional village life. Not surprisingly, the ancestors' advice is overwhelmingly conservative. It is to be expected that those who have gone before will prefer to see life lived as they had done, and still do in their village 'on the other side'. It is also not surprising that the advice is so heavily weighted towards maintaining harmony and unity, within the village and within the family. A key role of the dance is to ensure that the community remains stable and coherent, in an environment that can be hard at best and brutal in bad times. In this, the dance reinforces traditional values and the code of practice that has underpinned community life for generations before. This code of morality and ethics is the *mwambo*, and the *gule wamkulu* spectres are the masters, teachers and judge and jury of the *mwambo*. The *Nyau* society members, through the dance, comment upon life in the village and sometimes more broadly, and provide through song, dance and costume parables for how one should or should not behave in this environment.

In doing so, the *gule wamkulu* has a place at many of the events in people's lives. They will be reminding us of when, and when not, to have sexual relations with our partners, in order to avoid the transgression of sexual taboos and contraction of the deadly *mdulo* disease. They will warn us about being arrogant, cruel, lazy, selfish, and innumerable other weaknesses of the human condition. They will explain the dimensions of good leadership and why we should all obey the rules and codes of practice that have kept the community together for many generations. They tell us about witchcraft and its hideous repercussions for the individual and the community. They escort us on our journey through this world and finally when we depart it to join the ancestors themselves.

If the above suggests extreme specialisation of the *gule wamkulu*, each character with a specific message for a specific event, that is true only up to a point. Characters generally blend several themes or topics into their messages, so that any one character can have a number of themes. There must always be some degree of artifice in the taxonomy of themes, and Boucher has attempted to distil the key themes for each character. There can be subtle or significant variation between two characters addressing the same generic theme, so that, for example, promiscuity may be condemned by a character that is also warning against new western values and materialism (**Madimba**), or it may be combined with a profiling of the risk of sexual disease (**Njolinjo**), westernisation and sexual profligacy being perceived as irrevocably linked. Sometimes several themes can be, at first impression, entirely unrelated, but incorporated into a single spirit messenger. This is often the case for characters addressing issues of power and authority; they will commonly include references to other themes such as arrogance, selfishness, greed or even sexuality. Often the themes can have multi-level application. For example, power in the village may be a parable for power at higher levels of government. There is neither a hard and fast formula to the parcelling

of themes nor any absolute in identifying the key themes for each character. Boucher recognises the degree of subjectivity inherent in the classification of themes.

A second way in which specialisation is blurred is in the range of events at which a character may dance. Some characters are event-specific, rarely appearing outside that ritual. More often, a character can appear at different types of events, although his message remains essentially the same at those various occasions. This flexibility reflects that major gatherings are opportunities for the community to address a number of rites, as noted above. There is an economy of scale in this. Further, quite a few of the characters are simply not associated strictly with any particular ritual; instead they are generic reminders of good and bad behaviour and thus have their place any time. Lastly, the masks that appear are those that exist in the area. Large events can attract *Nyau* members from farther afield but there is still a finite catchment of masks in any district at any time.

A notable feature of the form of expression in *gule wamkulu* is that of irony and reversal of roles. This will be considered in more depth later but it suffices to say here that a certain attitude or behaviour can often be advocated by way of demonstration of the negativity of its opposite. Thus, a character may admonish the community for rude and violent behaviour by enacting just such behaviour. Indeed, there are many more characters that are the embodiment of bad behaviour than of good.

One may ask, just how many *gule wamkulu* characters exist? The simple answer is that no one knows. Boucher documents some 200 characters in this publication. He has described a further 250 masks and structures.[1] Most are from the Mua-Dedza area of central Malawi, one of the richest zones for *gule wamkulu*. Yet outside this cultural basin, many other characters exist as each district, even each village, has its own unique history of *gule wamkulu*. Considering too the chronological perspective, where masks have appeared, lived their lives and then faded into disuse, one can only conclude that there have been thousands and possibly more than ten thousand *gule* characters in what is Malawi, Zambia and Mozambique today. A comprehensive coverage of the characters is thus impossible. What Boucher does here is to document the range in physiognomy, song, dance and message, of multiple and diverse characters from the very heart of *gule wamkulu* territory.

The nuances of the *gule wamkulu* are many. This generic introduction is intended as merely a facilitation as to where the real stories and details lie, namely within the character descriptions documented by Claude Boucher over more than 30 years. Some of the masks described are still common elements of traditional rituals in the villages around Mua. Others have become rare, and there are those that are no longer to be seen. *Gule wamkulu* has always been an evolving cultural practice, with certain central and mainstream characters addressing universal issues but many others that have been prompted by the events of the day, contemporary commentators as it were. With a change of scene, those characters may evolve or disappear, as is particularly evident amongst the political masks. New ones

have then appeared, providing a refreshingly dynamic dimension to what is a largely conservative practice. Each provides a measure of events, recent or historic, against the yardstick of the ancestors' *mwambo*.

The form of *gule wamkulu* characters

The reader will first and foremost be aware from this book of the extreme range within the masks and structures of the great dance. In simple taxonomy, there are three main classes of characters and objects:

- masked and/or costumed characters, as a single dancer but sometimes dancing in pairs or groups;
- structures (usually woven) within which one or more men can operate the structure from a standing or crouching position (there can be as many as 12 men in a large version of **Chimkoko**);
- structures operated remotely, some of which can be quite small.

With masks and occupied structures, there can often be two versions, a day and a night alternative with different characteristics. The last category of remotely operated structures was most commonly used at night, for mysterious effects in the darkness.

The costumed dancers are probably the best recognised of the *gule* repertoire. A dancer's face is never revealed on the *bwalo*; the profanity of the man cannot be allowed to be confused with the spirituality of the ancestral messenger. Most characteristically, the character's head is covered by a mask of carved wood. Choice of wood for the masks is largely motivated by those trees that are readily available in any given area although a pragmatic preference is shown for lighter woods.

Less frequently, other materials can be moulded into masks. For example, **Kamano** of the Mua region can have a mask made of black cardboard or of black cloth stretched over a wire frame, or, on occasion, can be performed without a mask at all. The perennial **Kapoli** family (including **Chintabwa**, **Kachipapa** and many others), is typified by its helmet of feathers; the remainder of the costume can vary but is often only a loincloth. Other characters such as **Kadziotche**, **Mbonongo** and **Pinimbira,** perform with undefined head gear such as woven banana leaves or jute or cloth bags, but lack the carved mask. **Nyata** lacks any form of head gear, but the dancer has his eyes and lips tied back, distorting the face that is further blackened with charcoal. Where masks are worn, they will reveal certain characteristics of the danced character. There can be quite a nuanced code to the interpretation of the characters, and it is only after formal initiation into the *Nyau* and three decades of study that Boucher has been able to act as code breaker. Even then, Boucher acknowledges that there can be some degree of supposition and informed guesswork in interpreting some of the more arcane or lesser known characters.

In derivation, the masks draw on human and animal features, plus an array of artistic improvisations. Broadly speaking, there are three derivational categories of mask: those that are essentially human, those that are part human-part animal (theri-

[1] Many of these are described and illustrated on the accompanying web-site: <www.kasiyamaliro.org>. **Kasiya maliro** is the great mother of *gule wamkulu*.

anthropes) and those that are very much the beast. Most masks are recognisably human, although the human traits are often embellished, exaggerated or set in unlikely combinations. **Kapirikoni** and **Chauta amulange** have a double face resembling the Roman god Janus, both of them literally and metaphorically 'two-faced'. The human-animal therianthropic fusions are variable in their combination of features but common animal traits are horns (symbols of power, see below), animal-like teeth or the protrusion of a snout. **Chipembere** personifies the half-human, half-beast, with rhinoceros horns protruding from a substantially human face. **Maino** is a human with warthog tusks. Typical amongst the animal masks are **Bokho**, one of several characters based on the hippopotamus; **Njati**, the buffalo (which can also have a part human-part animal version); **Kanyani**, the baboon; **Nyanyanda**, the kudu; and **Gulutende** based on a cow or bull (the two last characters with rather sharp teeth for herbivores). Non-mammal inspiration is also common. **Tsokonombwe** alludes to a grasshopper (notably the Dedza version; the Golomoti version has little resemblance to the insect), as does **Nkhumbutera**. **Bongololo** uses the millipede as a parable for laziness. Certain creature masks are clearly ensembles of various species and include some of the most dramatic and bizarre of the *gule* characters. **Chimbano** and **Kwakana** exemplify unnatural fusion in brandishing the aggressive features of both bull and crocodile. Where animal characteristics are assigned the character, they will reflect also in his behaviour and his story.

The sizes of masks range significantly from small, barely 15 centimetres in length (such as **Sirire**), to enormous visages in wood, some exceeding a metre in length and often weighing over 20 kilograms (see **Kwakana, Chinsinga**). It goes without saying that dancing the latter characters can pose significant physical challenges. On occasion, horns can extend so far from the mask (perhaps two metres to each side for **Ali n'nyanga nkhadze**) that negotiating crowds and obstacles can require extreme judgment and more then a modicum of good fortune. The masks are always painted, sometimes in a near monotone but more commonly in multiple colours. The colours used will usually have semiotic meaning. Most masks will be fringed by some form of headgear, which can include various combinations of animal skins and furs, jute, calico and other rags, and thin strips of fertiliser bags. Where skins are used, the choice of skin can be important. Goat skin will often represent domesticity and the village, while a wild animal skin will reflect the bush. Needless to say, some types of wild animal skin cannot be easily secured today. Fertiliser bags have become near ubiquitous to *gule* costumes, being easily cut and long lasting. For certain masks, real human hair may be used.

The body costumes can include the same range of materials. A *gule wamkulu* dancer may be fully covered or appear almost naked. Prior to Ngoni influence and the prudery of colonial times, quite a number of the characters (**Akumanda samalira, Ali n'nyanga nkhadze, Kachipapa, Kamatuwa,** and probably many others) were danced naked. Today those characters and others will wear a loincloth, or a kilt of rags, sisal or fertiliser bag laces. Strips of plastic bags can also be used. Where a large

amount of the body is revealed, it is often covered with mud or ashes, and this will have a semiotic value. The most common, and certainly most characteristic, outfit today is arguably the 'tatter suit', as Boucher terms it, an outfit comprised of all manner of fabric strips, often garishly colourful in its kaleidoscopic hues. The tatters have their own semiotic: rags are the clothes of the dead. A full tatter suit will generally suggest a character of some status, or one who aspires to power. Fringes of tatters or fertiliser bag strips on the arms and legs ('armlets' and 'leglets') are commonplace. It is not uncommon today to see characters dressed in western attire such as shirt, trousers, overalls or even a suit. This can reflect deliberate imagery of the character and its message, or the easier availability of such everyday clothes over the painstaking task of making a tatter suit.

Many characters carry an implement of some type. Weapons are common, and can symbolise the nature of the character, for example, as a hunter (**Msakambewa-Kondola**) or his aggressive tendencies (such as **Chinsinga** and **Gomani**). Clubs, spears and knives are all commonly held. The father figure of *gule wamkulu*, **Chadzunda**, will lean heavily on his walking stick until he reaches the *bwalo*. The staff symbolises his seniority as chief. Leadership, or aspirations for power, can also be depicted through that common designator of the chief, the fly whisk or medicine tail (**Chikwekwe, Gomani**). The **Kapoli** variation, **Adagwa ndi mtondo**, confirms his name ('he fell with the mortar') by carrying and dancing with a maize mortar that he will climb, fall off and roll with on the ground. His message, of course, has nothing to do with maize or flour or mortars!

A number of the characters have more striking accessories. The iterations of the stilt dancer **Makanja-Kananjelezi-Titilande**, have seen the early two to three metre high stilts reduced for safety to the one metre versions most commonly seen today. With reduction in stilt height has come more flamboyant dancing steps, which can include rolling on the ground and re-standing; with the long stilts, merely staying erect was challenging and dangerous enough (the latter for dancer and audience alike).

The plotting **Mbaula** reveals his bribes for the target family by the glowing coals in the cooking pot on his head, which during his performance is used to pop corn or roast nuts. **Kadziotche**, who has 'burnt himself' with AIDS, physicalises this by waving two flaming torches under his arms and legs, over his bare body and finally his groin clothed in a loincloth.

The structures housing dancers are typically woven affairs. Palm leaves, grasses and maize husks have been the common materials, woven onto a framework of bamboo. As well as being readily available materials, this construction minimises the weight. Today, one sees many structures using canvas, jute or fertiliser bags as the skin, reducing the effort of weaving. Making a large structure is a major undertaking and can take weeks for a number of *Nyau* members. This has significant community value, as the shared labour encourages collaboration, bonding and fraternity. With the pressures of a modernising, cash-based society, such shared unpaid activities are becoming increasingly rare. Structures used typically to be constructed for a single event, as their primary materials are natu-

rally ephemeral. As they had little longevity in a hot, humid climate, most structures would be burnt after the event, returning the character to the spirit world as it were. There were some exceptions such as **Chimkoko**. Structures that would formerly have been burnt or allowed to decay after appearance at a ritual, are now more likely to be stored for serial use if space can be found.

As is to be expected, there are far fewer structures employed than masked dancers, but the variety is still striking in size, appearance and thematics. Some of the structures are essentially human in form although highly stylised, often to reveal attributes of the character, including **Akutepa** and **Mfiti ilaula**. Many of the structures resemble and derive from some type of animal, amongst them: **Kasiya maliro**, the antelope mother figure of *gule wamkulu*; **Njovu**, the elephant, symbol of the chief; **Mkango**, the lion; **Kalulu**, the hare; **Ng'ombe**, the cow; **Nthiwatiwa**, the ostrich; and **Chikuta**, a fish. **Ayenda n'chamutu** devolves from an indeterminate animal and is, in effect, a walking monster's head. Others are based on items of technology, and these reflect more recent origins: **Chigalimoto**, the motor car; **Basi**, the bus; **Bangolo**, the lake steamer; **Ndege** and **Ndege ya elikopita**, the aeroplane and helicopter respectively; **Njinga yabwera**, the bicycle or motor bike. The largest structures may be **Mdondo** at up to six metres long, close to two metres high and one metre wide, and **Chimkoko-Chiwoko**, which can reach up to 12 metres long and may resemble a strange hybrid of indeterminate animal and a large bus! The larger the structure, the more dancers required to operate it. **Chimkoko** may have ten to 12 dancers inside. **Njovu** has a delightfully simple yet evocative presentation of the dancers, in which one occupies each of the four legs of the structure. Very big structures tend to be seen only at major events, and all structures are becoming less common.

The decoration of the structures can vary significantly, and day-night differences can be marked, with day structures emphasising detail and night versions contrasts in shading. In the case of many animal-inspired structures, the body can be topped by a head that is carved or constructed of mixed media.

There are a few characters that have both mask and structure avatars. **Njati**, the buffalo, a very old structure possibly dating from the early Banda times, has been seen in both mask and structure form. **Gandali**, based on the rhinoceros, can be danced as a mask or take the form of a three metre long structure; the two forms, while physically very different, have the same message.

The small and remotely operated structures can be very clever devices to create special effects using the most basic of materials. They are mostly used at night when the operating mechanisms will be least visible. The intention is to create an impression of independent movement. **Asongo** is a typical example and features on dark, moonless nights. Here two *gule* members in plain clothes hold a long bamboo pole to which is fixed a bark cloth string. The string is set alight, creating an impression of a red snake, which is then dragged by the two operators through the bush at some distance from the observers.

For all of the *gule wamkulu* troupe, there is a sensible level of 'make-do' in the outfitting. Most household effects or articles of clothing could find their way into a *gule wamkulu* performance. Modern materials have become assimilated into the wardrobe of costume materials. Paint is expensive and if one shade of a desired colour is not available, another may be used. What is clear is the pragmatism used in choosing materials, and that in itself can lead to some evolution and heterogeneity in characters.

Symbolism of *gule wamkulu*

While conveying an impression of spontaneity to the unversed observer, nothing in *gule wamkulu* is entirely without plan and meaning. There can be considerable variation for any character but some elements will remain the same wherever that ancestral messenger approaches the *bwalo*. The attributes of the masks, the form of the costume, the implements used, all will have meanings to the initiated.

In his descriptions of masks, Boucher includes colour reference early, and this is for good reason. The colours used are a first and meaningful impact of many masks. Some masks are consistently performed in one colour while others have marked variation, noting the pragmatic colour deviations noted above. While colour carries semiotic significance, the same colour can mean different things for different masks.

The colour red features very prominently in *gule* masks. Red in its many shades, and its variants of pink and orange (and sometimes yellow), is most often an indicator of strangeness, that this character is not a local or not one with the community. As being a part of the community is a paramount consideration for the Chewa, to be a stranger is to be a thing of concern, to be feared or suspected, or an object of ridicule if the separateness is self-inflicted. We see the manifestation of this disjunction in masks of many themes where the character is presenting a background or behaviour out of keeping with mainstream community expectations. **Gomani**, the Ngoni ruler, arrogant and condescending, is red; **Chinsinga**, the aggressive serial prisoner, is cast in red, as is **Am'na a chamba**, the drug-smoking *mkamwini* (husband or son-in-law) and **Kamvulu-vulu**, the new husband using witchcraft against his marriage family.

The attribution of strangeness to the *mkamwini* – the husband or son-in-law – is a particularly insightful revelation of one of the foundations of Chewa society. The matrilineal set-up, where the husband marries into his wife's family and will normally move to live with them for all or at least a substantial time of the marriage (uxorilocality), casts the *mkamwini* as an outsider. He is not truly part of the extended family but merely a guest, one who is expected to know his place and behave according to the rules of the family. This odd liminal situation is discussed more fully later, but suffice to say here that red is typically the colour of the husband when he is not adapting well to this set-up. Where the role model of the husband, the ideal example of the *mkamwini*, is explored, however, his colour changes, as we see for **Greya** from the Mua-Mtakataka area

(depicted in yellow, also a colour for a stranger but perhaps less threatening than red).

Those who are local and would normally be seen as part of the community can exclude themselves by their actions. This can be shown by red/orange masks with Chewa tribal marks, illustrating the paradox of a local who does not belong. This self-induced separation will generally be sparked by unacceptable actions. This can be any form of extreme antisocial behaviour or through abuse of power for those in positions of authority (**Chimnomo lende**). We see a number of characters that explore the political scene of the early 1990s, as Malawi shifted from a single party state under President for Life Kamuzu Banda, to multiparty democracy. At this time, many masks addressed these changes and what they meant to the village. In this context, the President, a Chewa himself, could be cast as a stranger, owing to his improper use of power and past links with overseas countries (see **Mtchona** and **Mai Mtchona**). In effect, Kamuzu Banda had forfeited his right to be a member of the Chewa community.

Kasinja's pink-red face expresses sexual prohibition and witchcraft, enhanced further by two red horns signifying the transition to being a witch. The face of **Chiwau** is divided vertically into a black and red side. The black side expresses that the person was 'burned' by breaking sexual taboos and using bad medicine. The red side shows a healthy face but is that of a stranger, distanced from his people by the very ordeal of his disfigurement. In **Kwakana**, black and red signify sexual taboos – when to have, and not have, sexual relations. Dramatic colour variation in a mask will generally have a strong semiotic intent. In **Chauta**, the contrast of black and white highlights a character's dark deeds committed under the pretence of respectability. Black or brown as the dominant colour can be associated with honourable Africans as for **Chadzunda**, the father figure, where as an ancient mask the colour can also link to the early Banda rain cults (black for clouds). **Njolinjo** is black to demonstrate fertility (and in his case promiscuity); the linkage of black to rains and thence fertility is not unexpected. In marked contrast, black can also symbolise evil intentions and bad medicine, applied under the cover of darkness (such as **Mantchichi**, **Mbaula** and **Mfumu idagwa n'nyanga**). In **Yayawe**, the yellow of the mask represents the party colour of the political party being critiqued, in this case positively.

Structures, too, rely heavily on colour for their encrypted meaning. Boucher places repeated emphasis on the triad of colours – red, black and white – and their relationship to the cycles of life in the village, most particularly for the menstrual cycle of women and the sexual taboos that this engenders. Red enforces the notion of heat, frequently sexual heat or menstruation, and black and white reflect the phases of the village life that enter periods of abstinence and then re-enter normality, according to ritual practice. This colour code can be seen in **Kasiya maliro**, the great mother figure, and **Nthiwatiwa**, the ostrich. The black or red colours of the elephant **Njovu** refer to both sexual taboos and fertility, and the conflict for power between the Banda (black) and the Phiri (red).

The carved masks of *gule wamkulu* reflect the skill and creativity of the carver and the painter(s), who may not always be the same person, as well as the message of the character. Thus there can be very considerable variation in the features of a character in different places. Some attributes will remain more or less consistent, however, as they are core to the message. This can best be illustrated through characters that are geographically widespread.

Chadzunda and **Mariya** will be two of the most widely danced characters of the *gule wamkulu*. Representing the aged chief and his (rather younger) wife, the couple typically appear together although they can also be danced separately. **Chadzunda** appears in many forms; the collection of the Kungoni Chamare Museum has multiple versions of **Chadzunda**, each distinct. What is common is the depiction of an old man, with copious wrinkles (carved or painted) on his brow and cheeks. He will be bald or nearly so. His face will be painted black. He will walk slowly with a long staff until he reaches the *bwalo*, when he throws the stick aside and explodes into energetic dancing, arms and legs casting the dust in all directions around him. The common features are the key aspects of his message: that the *mwambo* is ancient but vital, that the chief as agent for the spirits and the *mwambo* is to be respected, and that the strength of the old man devolves from his commitment to the moral code. **Mariya**, his wife, is the perfect spouse, caring and attentive. Like most female *gule* characters, she is danced by a man, but his presentation emphasises her femininity. She dances in a womanly but not unduly provocative way, befitting a married woman, and may mop her husband's brow from time to time. She is representative of the importance of the mother and of initiation for girls into adulthood. Her depiction is of a small carved face with European features that may be in many different colours. In the Kungoni Chamare collection alone, there are **Mariya**s in pink, white, yellow, orange, green and blue. She is comely and feminine, often with exaggerated false breasts that accentuate her figure. She will wear a scarf or scarves on her head and typically will dance with one or more in her hands. Together, the two are a loving couple, a model for the village, and may hug at times during the dance. There can be all manner of variation around the above depictions but the essential attributes should remain. There is another version of **Mariya** in some parts of Chewa country that presents her more cynically, with reference to the Virgin Mary who has had a child not to her husband Joseph but to Simon Peter. This story mocks the Virgin birth, placing Joseph as a cuckolded husband, and may reflect early *Nyau* resistance to Christian teachings. It is not a depiction of **Mariya** now seen in the Mua region.

Most of the *gule wamkulu* characters are recognisably male. This is reflected in masculine traits in the mask and costume but also in the songs and stories associated with the character. The *Nyau* are a male society and thus a skew towards male characters is not surprising, but there may be more to the gender imbalance than merely an informal preference for depicting one's own sex. This is discussed further for gender and *gule wamkulu*.

Advanced age is typically reflected by characteristics associ-

ated with the old, as one would expect: wrinkles, bald head, and a dancing style revealing advanced years. Youth in turn can be shown by a clear skin, contemporary hair styles and modern accessories such as sunglasses. The simple depiction of associated attributes need not be so apparent however. A common theme is deafness to the advice of others, for a person who is stubborn, stupid or pre-occupied with his own importance. This deafness can be shown by small or absent ears (**Golozera**), but also, more satirically, it can be reflected by oversized ears (**Chinsinga**). The latter trait can also depict physical deafness (**Pedegu**). Exaggeration of pertinent features, either over- or under- stating them, is a common *gule* approach.

Horns are very common attributes of *gule* masks. Typically horns are a symbol of power, which in turn may have magical origins. Horns are used as containers for medicines (*mankhwala*) that can have secret, dangerous powers. Thus witches often bear horns (**Chauta, Kasinja, Mdzopendeka** from Dedza, **Mfiti ibuula, Mfumu idagwa n'nyanga**) and so too those who are playing with magic and medicines (**Mbaula**). It takes power to control witches so witch hunters can also be depicted with horns (**Lumwira**). The power of the chief can be shown in this way (**Lambwe**). Conflicts over power between authorities can be exposed by horns (**Asawa manda**). In discussing the submissive role of the son-in-law in the wife's family set-up, even men with horns (that is, powerful men) are expected to acquiesce to the matrilineal brokerage of authority (**Koweni**). The orientation of the horns can be revealing. By way of example, drooping or falling horns can depict waning powers (**Valani dzilimbe**).

The reference to powers can be more oblique. Money has assumed the status of power in a cash economy, as evidenced in horned characters such as **Ndalama n'ndolo**. In a related vein, the multiple horns of **Chuma cha ana** refer to the monetary and asset inheritance left by a deceased person, over which people are prepared to fight to gain their share. Sexuality is powerful and horns can hold medicines that can kill. Breaking the sexual taboos can act like evil medicine. Extending from this esoteric logic, the long horns on **Ali n'nyanga nkhadze** represent the female genitalia, the labia, which can kill if those sexual taboos are broken.

Protrusions and bumps, usually highlighted in a contrasting colour, over the head or face can have various meanings and it is difficult to distil any broad consistency in their use. Occasionally, they can depict a positive attribute, usually power, such as the role of the chief as the guardian of the sexual code (**Mdzopendeka**). More commonly, such features indicate a negative aspect of the character, often of a sexual nature such as sexual disease (**Chiwauka, Ndakuyawa**).

Other sexual themes will frequently reflect in the features of the mask or structure. Depictions of male and female sexual organs are not uncommon, and may be stylised as in **Thunga** or graphically depicted as for **Golozera**. There is no mistaking the subject matter of the structure **Chimbebe** or the hooded character **Chiudza**; in contrast, for **Kasiya maliro** the symbolic womb is more subtly intimated in the structure's shape. On some characters, both male and female genitalia are repre-

sented, often in a state of suggested coitus or accented to emphasise their separateness as for sexual taboos (**Chimbano, Chinkhombe**).

In the mask descriptions, Boucher frequently refers to tribal marks and scarifications painted or carved on the masks. These marks on the forehead, temples, cheeks and chin were for previous generations a form of permanent make-up intended to beautify and enhance the owner's face and body and qualifying the person to be the member of a certain tribe. Tribal marks were common to both genders but were more frequently found on women. They consisted of small incisions made in the skin in which pounded charcoal was inserted. After the wound had healed, the skin protruded slightly and the black marking was prominent. Generically termed *mphini*, the marks had specific names depending on their motive and form. The *chitopole* was a half crescent surrounded with short rays usually adorning the forehead; the *mapazi a njiwa* (the footprints of turtle doves) could adorn the cheeks or the temples; the *akonde* (love me) or the *mitsamiro* (the pole supporting the roof) decorated above the eye brows. Other markings called *mchome* were made by rubbing the acidic juice of cashew nuts on the cheeks. The acid slightly burned the skin and left a dark stripe across the cheeks considered to be a beauty mark. Men could sport short black lines on the back of their neck called *mikondo* (spears or arrows).

Tribal markings could be first executed on children at pre-pubescent age by village specialists renowned for their skill. As the child grew older, other marks were added on different parts of the body. Each of these signs had a specific meaning and piece of advice attached to them. For example, three strokes on the forearm were called *kapereke madzi* – go and give water for your husband to wash. These marks were a reminder of the advice given to the young initiates to provide water for the bath of their future husbands. As the girls reached puberty, more tattoos were added on the breasts, the chest, the waist, the buttocks, the thighs and the pubic area. This practice was part of their sexual education and also a preparation for marriage. Maidens were expected to beautify their bodies for their future husband. The small protrusions made on their skin would arouse their husband's sexual desire and hopefully result in a pregnancy.

Mphini can also be made for medicinal purposes. Small cuts on the face or other parts of the body have medicine inserted as a treatment for illness or as a protection for the patient. Such rituals are conducted by important family members or by a ritual specialist called *sing'anga* – medicine man. The cuts are made on a suffering limb or on a strategic part of the body, chosen for protection against sickness or evil influences, particularly witchcraft. In a tense social setting in which fear, conflict and competition are common, villagers can be tempted to abuse such treatments. They might request the help of one or several medicine men in order to seek extra protection against an unknown enemy. This is called *kukhwima* – to protect oneself with a perceived body armour against evil influences. This habit of seeking extra protection can be interpreted by the Chewa community as a potentially lethal weapon in that the person becomes entangled in the practice of witchcraft and in turn threatens the rest of the group.

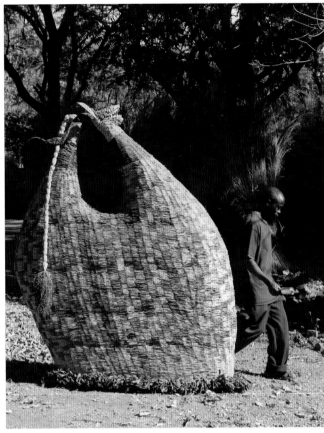

(*Left*) **Kasiya maliro**, night version.
Claude Boucher, Mchanja Village, August 1993

 (*Above*) **Kasiya maliro**, day version.

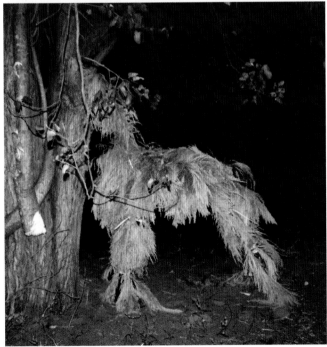

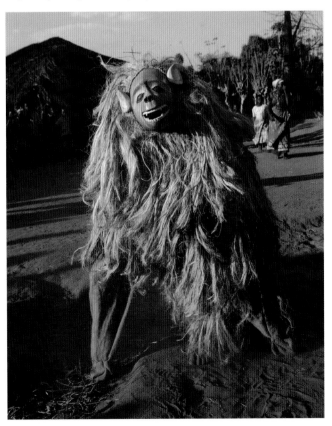

(*Above*) **Matako alingana**, night version.
Claude Boucher, Mchanja Village, August 1993

 (*Right*) **Matako alingana**, day version.

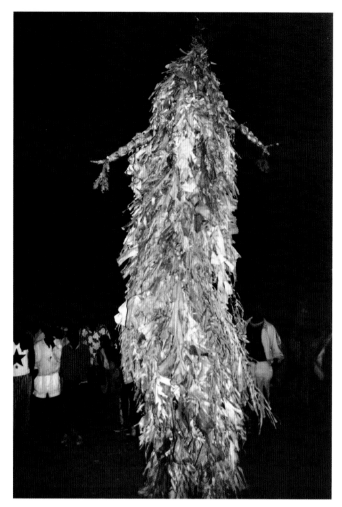

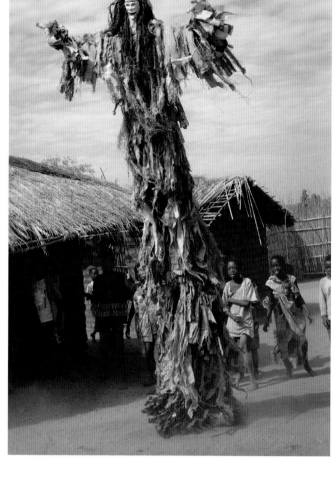

Mfiti ilaula, night version (*left*); day version (*right*).
Night version by Claude Boucher, Mchanja Village, August 1993

With the advent of colonial rule and western education, especially through the 1950s, the beauty canon changed. Younger generations objected to having these indelible marks on their face. They were replaced by earrings and necklaces that were less painful to acquire and manifested that the young person belonged to a new generation. Today, tribal scarifications are largely restricted to some older villagers. Nonetheless, the traditional tribal marks appear on many *gule wamkulu* masks, evoking the values and behaviours of the ancestors, and also doubtless adding decoration to the mask as a work of art.

While exaggeration, caricature and semiotic markings are common tools in *gule wamkulu*, the consistent coding of attributes can be assumed only up to a point. Much of Boucher's work has been in unlocking highly cryptic codes in the physical attributes, songs and pantomime of the dancers. Yet there can be considerable artistic license employed by the carver. As well, the irony of the *gule* may be evident, with the attributes shown being those opposite to the message advanced by the character.

Allowing for the significant variation that can occur for any character based on regional and artistic differences, many if not most of the characters can appear in two forms, one for day time events, and one for the night. Chewa rituals can extend from night to day and into the next night, and the *gule wamkulu* adapts its messengers to the different ambient conditions to achieve maximal effect. The message may be the main intent of the dance but to convey that message well requires drama. For masked dancers, the diurnal version will be the most elaborate and is the one mostly described by Boucher. Night versions may be characterised by woven headcovers that are more visible than a painted mask in dim light. The day-night variation is described at greater length for structures. Day versions will be more detailed in their depiction of the character than those used at night. Physical details will be painted and the head and face will generally show definition that is lacking on the more stylised night equivalent. Night versions can utilise stronger contrast in tones, in order to be visible in dull light.

Many of the small structures, operated remotely, were restricted to the night rituals. Darkness obscured the operating mechanisms of twine or bamboo, and gave the impression of self-animation. Fire could be added for effect.

Some *gule* characters contribute to the day-night organisation of the event by their presence. The appearance on the *bwalo* of **Kulipire,** for example, signals the changeover from night to day costumes for rituals that extend over 24 hours or more.

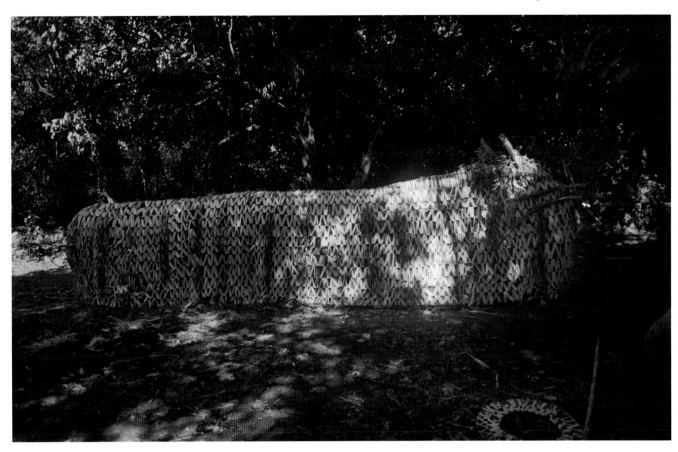

(*Above*) **Mdondo**, night version.

(*Below*) **Mdondo** with **Kanswala**, day version.

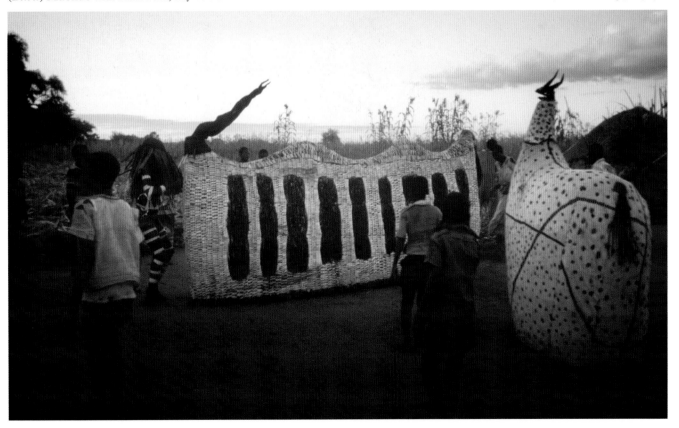

At the *bwalo* – the dances, songs and drums

The great dance is much more than a display of masks and costumes. It is a morality play, complete with actor(s) well versed in his (their) mime and dancing steps, informal choir for the accompanying songs, and a rhythm provided by several drummers to one side of the dance arena. All components have a crucial part in the holistic *gule* experience.

Gule wamkulu has form and structure and an organisational framework but it has no formula. There is no prescribed number or nature of characters for any type of event so one can never be sure which characters will attend, although this will certainly be influenced by the nature of the occasion, the seniority of the person if a funeral, and, more pragmatically, by which characters exist already in the surrounding area. Boucher (pers. comm.) observes that *gule wamkulu* events are tending to be less formally controlled than in the past, and that popular characters will turn up to a very wide range of rituals.

Typically, the *gule* spectre arrives 'from the bush', that is, it has come from the wilds outside the village. One of the analogues for the *gule* visitors is that of wild animals, *zilombo*. The bush in practice will be the *dambwe*, the gathering and dressing place for the dancers, that is out of sight to the general audience. The *dambwe* will often be located at or near a graveyard, a place that people do not normally visit. Some very special *gule*

The *dambwe* is the site where the *zilombo* (wild animals) gather, where structures are made, and dancers put on their costumes, before entering the village for a *gule wamkulu* performance.

characters such as **Njovu** and **Mdondo** require their own *dambwe*, separate from the other characters. Structures normally will have been built at the *dambwe* site.

Dancers and structures can appear quietly in the village, materialising almost imperceptibly from the surrounding fields and trees, or can make their arrival with great fanfare, depending on the character. They will head for the *liunde*, the gathering place, a kind of backstage for the performance that is near the *bwalo*. To the uninformed outsider, there can appear little organisation to the event, but the *bwalo* (dancing arena) will have its manager, the *atsabwalo*, and the dancers know their cues for when to perform (including the drumbeat). A characteristic element is the *silambe*, the rattle, usually a metal tube holding gravel or seeds that is shaken throughout the dance by a dancer's assistant. The rattle serves to attract the ancestors and, more pragmatically, gives aural guidance to the dancer, who will generally have very poor visibility from within the mask, often via the mouth slit. The rattle acts as the 'eyes' of the *gule*.

The dances of the masked characters vary from restrained and little more than a shuffle, through to dazzling displays of energy, endurance and power, the feet sending up dust in choking plumes, or with frantic sprints, arms flailing, and chasing members of the crowd. They may leap or limp, and some characteristically roll about on the ground. Each character has its own dance, although some have similar moves, or sequences of moves, as Boucher notes. Most characters dance alone but there are some that typically dance in a group, usually a pair (see below). If two of the same character arrive at the same event, it is not unusual for them to dance together. Perhaps the most characteristic style of *gule* dance step is the sideways, alternate sliding of the feet, a kind of frenzied chicken scratching as it were. Boucher refers to this as a swerving of the feet. In this execution, the dancer is often hunched forward with knees bent during the motion and cocked arms thrust alternately backwards to balance the jutting of the feet. It is this dance movement that particularly projects clouds of dust around the *bwalo*. Village *gule wamkulu* is a dusty affair.

In addition to visual effect, the dance moves will usually capture some essence of the character. An aggressive character will have aggressive moves, typically chasing and threatening the audience (**Chinsinga, Galu wapenga**); an arrogant or egotistical man will prance about and reveal his aloofness with elevated head and cocky mannerisms (**Akulu akulu adapita**); a womaniser will flirt closely with the women (**Bwindi, Ndalama n'ndolo**); a chief or aspirant chief will boldly incorporate his symbols of power such as fly whisks in his dance (**Kapolo wa onsene, Mfumu yalimbira**).

Boucher's descriptions highlight just how interactive is the dancing with the female crowd. Typically, the number of women in attendance increases as the event advances. At first, there may be little interaction with the *gule* dancers, but gradually the women will enter into the spirit of the day, often led by one of the senior women. It is not long before dozens of women, at times more than a hundred, will be engaging with the dancer, singing in response, clapping hands, and running

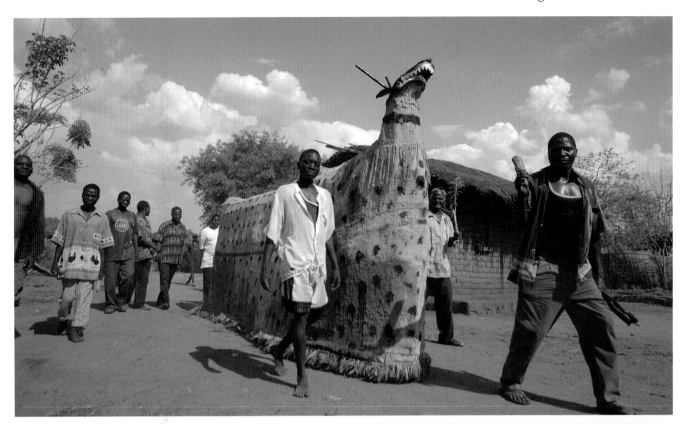

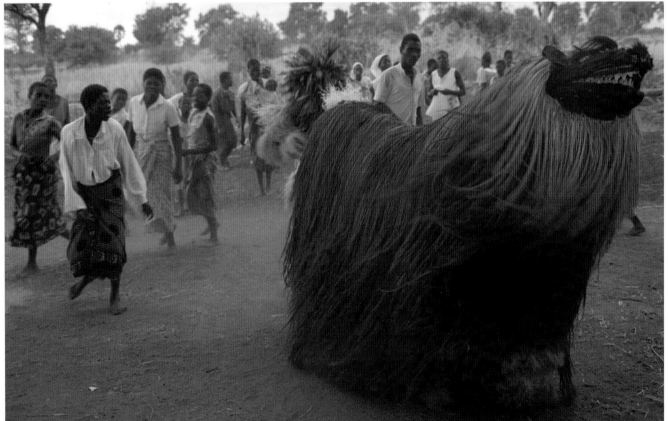

Dancing the structures can prove especially difficult because visibility for the dancers is often very limited and the extremities of the structure can be hard to judge relative to the crowd and buildings. The noise of the rattle acts as the dancer's eyes.
(*Top*) **Chimkoko**. (*Bottom*) **Mkango**.

Mkango by Claude Boucher, Lumwira Village, June 1995

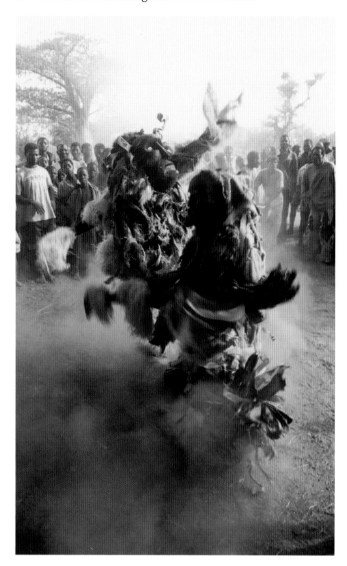

Chadzunda. A typical *gule wamkulu* event is a dusty, noisy and flamboyant affair where the village comes together and villagers shed their inhibitions.

Claude Boucher, Munyepembe Village, September 1994

in retreat from his advances. Boucher's repeated reference to obscene, lewd and lascivious pelvic movements of so many characters, and his interpretation of the content of the songs, reveal the sexually charged nature of many of the *gule* messages.

While most masked dancers usually dance one at a time, there are many combinations that can apply. Some typically dance in pairs of the same character (such as **Nyolonyo**). Some dance as a married couple (**Chadzunda** and **Mariya**; the **Gomani**s; the **Mtchona**s). Some associate via the message (such as the **Ajere** pair with **Njovu**, and **Kasinja** with **Kasiya maliro**). More informally, and as we note above, if more than one of the same character turn up to the same ritual, they may be required to dance together.

There are some characters that actually change during an extended performance. For example, **Lute** shows in her features and dress the progress of a pregnancy over three consecutive days.

The dancing style of structures will reflect their size, shape and number of operators. Acrobatics are scarcely possible. It is hard to steer them in a crowded village environment; the attendant sound of the rattle assists in their navigation. They can be heavy. Most move forwards and backwards and turn when and where they can. **Kasiya maliro**, the mother figure antelope, typically moves about by spinning like a top. **Kalulu** is compact and more mobile and can move quickly about the *bwalo*. **Mkango** will barge about the dancing ground, rotating on its axis from time to time, and squatting on its haunches. The towering **Mfiti ilaula** is operated semi-remotely, with the arms of the five to six metre structure moved by long poles, but the 'witch' does not dance.

Songs accompanying the dance can be sung by male and female choruses. Where there is a men's song, it is consistent for the character. The songs reported by Boucher for the women are also those associated with a given character, but women may also improvise their songs to comment on recent events in the village or by whim. The random songs of women are not part of the descriptions. *Gule wamkulu* messengers can sing for themselves, the song often then being taken up by the women, or they can be mute. Most characters wearing a full wooden mask do not sing as the sound would be muffled. **Kapoli** and his derivatives typically sing in a high-pitched *falsetto* or *castrato* tone, expressing affinity with the women of the village. The songs of the men and women can be simple, repeated choruses of a few words, or lengthy passages that reveal the story of the character. The true story may require substantial interpretation however. It is rare for the *gule* song to say what it actually means. There is much implication, metaphor, double entendre, and codified and euphemistic expression. The songs can deal with all manner of human behaviour. In the sexually related songs, the lyrics can address very intimate themes, either by way of implication, euphemism and metaphor (**Adagwa ndi mtondo**, **Ali n'nyanga nkhadze**) or with explicit and sometimes graphic references (for some indication of the latter, one can peruse the songs of **Chigalimoto**, **Chimbebe**, **Mleme** and **Yiyina**). Some of the lyrics have an element of ribald humour. The *gule wamkulu* event provides an opportunity to discuss matters publicly that are usually covert and clandestine, too sensitive for decent conversation. It can thus be a form of release of tensions that build in a close-knit community, especially between men and women. As Boucher would say, one can truly 'let off steam' at the great dance. We shall discuss this aspect of *gule wamkulu* further in the section on *gule* and gender.

For the political masks, the songs were often heavily coded, and ostensibly set within the framework of day-to-day life in the village, when in fact, targeting powers at the highest level in the land. This was a dangerous game to play under the regime of Kamuzu Banda, and great care had to be exercised, as we discuss further in the chapter on political masks.

A few masked characters are detached from dedicated songs and dances. The ancient **Kampini** utters only high-pitched sounds and has neither song nor dance. **Kamano** has no song of his own and the Mua version does not dance at the *bwalo*.

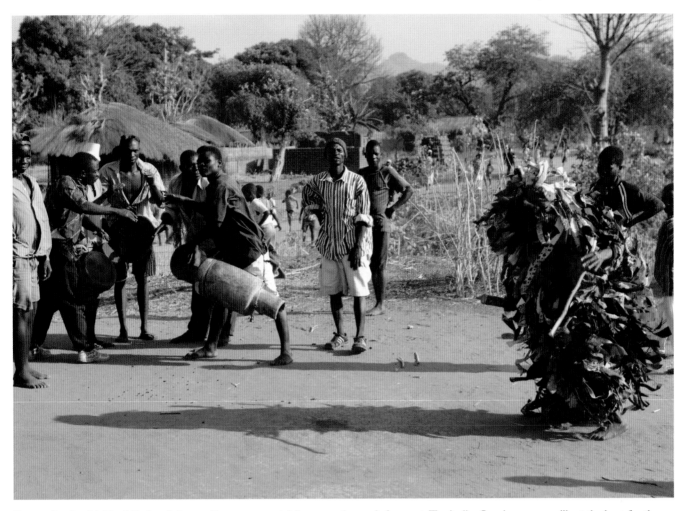

Drumming is a highly skilled and demanding art, essential for any *gule wamkulu* event. Typically, five drummers will set the beat for the dance, with dancers knowing their own particular rhythm.

Structures will have songs sung for them by the male and female choirs.

There can be some regional diversity in the complexity of songs. For example, Boucher observes (pers. comm.) that the songs of the Dedza area are notably longer than those from around Mua, where repetition of shorter lyrics is the norm.

Drumming is essential to any *gule wamkulu* event. Typically five drummers (sometimes more) will provide the background rhythm to the dance. In general, two drums act as base, one is mid-tone, one is high-pitched, and the fifth is the leading or 'talking' drum that drives the unique beat for each character. The drummers will periodically warm the skins of the drums over a fire to maintain the correct pitch. There is a specificity of beat. A dancer will recognise their rhythm and wait for it as a sign to occupy the *bwalo*. It is improper for a dancer to perform to the wrong drumbeat.

The total impact of a *gule wamkulu* performance is one of movement, colour, dust, noise, screaming and chanting women, and general pandemonium. There is no mistaking that the ancestors are in the village. By way of tokens of appreciation, people will place coins and small notes of currency in the hands of the dancers, or with their minders.

The evolution, spread and origin of *gule* characters

We have seen that *gule wamkulu* is a locally based form of cultural expression, without any overarching set of standards or governing body. It is to be expected that there will be very significant regional variation, and this is so. Characters that occur over large areas will be variable, exemplifying a type of vicariant radiation in form, and different localities will have characters that do not appear in neighbouring areas. It is often difficult to identify a specific archetype for a character, although for any mask or structure there will be certain characteristics that will be depicted with some measure of consistency.

Each region and locality has its own concept of what the mask or the structure should look like. For instance, **Kasiya maliro** in the lakeshore region is represented with a curved back leading to two apices, one at the head and one at the tail. The Linthipe region has a hump added on the neck close to the head. The Dedza and the Nkhoma areas tend to portray the antelope with a flat back.

In some cases, Boucher has documented the movement of a character from one district to another. Often this involves some changes to the character, which may be subtle or profound.

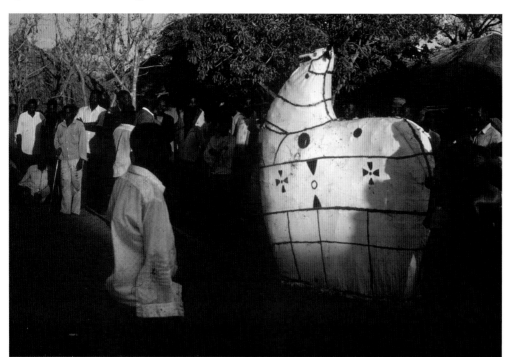

(*Left*) **Kasiya maliro**, Nkhoma area.
Claude Boucher, 1968

(*Bottom left*) **Kasiya maliro**, Dedza.
Ben Smith, 1992

(*Below*) **Kasiya maliro**, and **Njovu**, Linthipe.
Claude Boucher, 1968

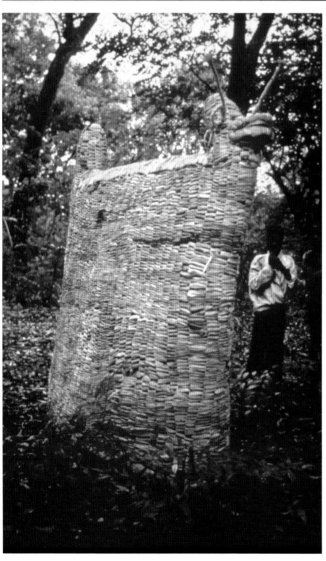

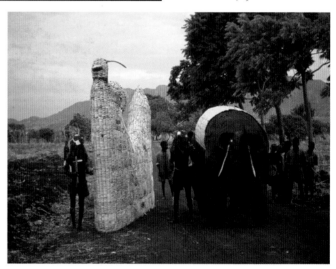

Take **Greya** for example. This character appears in two almost diametrically opposite forms, one in the Dedza area, one around Mua and Mtakataka. The former version condemns the irresponsible and promiscuous wastrel, back with money from outside the country and now exploiting women. The second version is its antithesis: **Greya** the role model for the ideal husband, responsible and hard-working. Why such a variation? The two opposites in fact engage with similar issues of responsibility but as mirror images. It is unclear which is the older version or why the inversion has occurred.

Adapundula appears in the Kaphuka and Mua areas with different physiognomies, one human and the other transforming into a beast, but the messages, songs and dances are very similar, with only small variations. Versions of **Koweni** at Mua and Dedza have fundamentally the same message but minor differences in physical appearance and song. In its Dedza version, **Mdzopendeka** bears six long red horns on the

head to emphasise power, particularly with regard to witchcraft. Six short black warts protrude from his forehead to convey the role of the chief as the guardian of the sexual code. The Mua version has the warts but it lacks the long horns.

There has been some syncretism across major cultural groups. For example, **Basi/Minibasi** appears to have been born from changing socio-economic times but also from a syncretic fusion of Yao and Chewa practices.

The materials used in *gule wamkulu* costumes have been discussed above. Some of these materials are becoming difficult, or impossible, to secure. Notably, wild animal skins are extremely difficult to source and characters that have used them, often with symbolic value, have had to evolve to the use of other materials or have gone into decline.

There have been historic points of rapid appearance of new characters. The political masks of the early 1990s are discussed below, but here we can note that the *Nyau* societies can respond quickly to changing events and engage the ancestors in dialogue with the living on matters of immediate and recent importance. If the masks lose their relevance with the course of events, they may fall into disuse and disappear. Labour migration to South Africa and other countries was at one time a primary impact on Malawian villages. It was naturally then a subject for the ancestors' voices, as evidenced in **Kwanka anyamata** and **Ndalama n'ndolo.** When former President H. Kamuzu Banda terminated the labour migration scheme in the 1970s, those characters became ever less relevant, and some have died out.

In some cases, a character is too good to disappear. The evolution of form of the stilt dancer **Kananjalezi-Makanja-Titilande** reveals a combination of pragmatism (safety) and the greater flexibility of shorter stilts. Over time, the message of the character has also evolved, reflecting a changing social milieu, perceived in the very wide range of themes that have been addressed by this versatile character. It is a shame to lose a crowd pleaser like **Makanja**, so modifying his message to stay relevant is a natural response to both pedagogical need and entertainment.

Certain masks have shown notable evolutionary changes in their appearance and message, reflecting a changing social and political environment. A popular character is the near-ubiquitous **Simoni**, including his variations of **Kalumbu** and **John watchyola mitala.** He has had a truly extraordinary evolution, not so much in physiognomy, but in message. In many ways, **Simoni** reflects the changing relationship of the Chewa to *azungu* and western values, including Christianity, and in so doing, has manifested a near-complete reversal in persona. To an only slightly lesser degree, **Msakembewa-Kondola-Chizonono** reveals changes in theme that reflect significant social evolution and movement of workers.

Other drivers can motivate the decline of characters. The increasingly cash-based society of Malawi has placed pressures on many aspects of traditional life. The construction of large structures can require a great deal of time for a number of men. This is unpaid work, with strong community bonding value, but no cash return to the participants. Finding initiated men willing to devote their efforts in this way is becoming more dif-

ficult. This is one of the primary reasons why all structures, and especially the very large **Chimkoko** and **Mdondo**, are making their appearance less and less often.

The impact of cost can be pervasive. Boucher observes that a number of the characters danced with bodies smeared with dark mud (such as **Chiudza**) have become less popular because of the cost of soap required to remove the mud. Initiation ceremonies are being shortened to reduce the costs of catering for so many participants. An event that once might span the better part of a week can be concluded now in two days. Fewer *gule* characters will appear and some dedicated initiation characters are rarely seen today. In the past, arguably the most all-embracing event for the village, and one where the *gule* messengers would appear in profusion, was the great commemoration for the dead, the *dambule.* Boucher observes that this ceremony has been on the decline, certainly in the Mua area, for at least the past ten years, and today is rare. Again, cost, other priorities and less commitment to unpaid community involvement have conspired to make redundant the day of ancestral remembrance. The evolution of societal practices and of the *gule wamkulu* go hand-in-hand.

While all characters have their role in the great dance and each their message, some are simply more popular amongst the villagers than others. This may relate to the nature of the mask and costume, the style of dance and the skill of the dancer, the popularity of the songs, the extent to which women enjoy engaging with the dancer, or any number of other variables. At the instalment of a new chief, the new appointee can express preference for those characters he or she would like to take priority at the investiture. While scarcely a route to fortune, dancers can earn a useful sum from the small donations of cash left with them at the *bwalo.* Popular characters attract more offerings, and thus are a better income source, acting as a firm incentive to the promulgation of some characters over others.

There are characters that make demands of the dancer that have become increasingly less tolerable in a modern world. As we saw above, **Kananjalezi** was a life-threatening performance, and its evolution to **Makanja** is partly the result of this. Some characters have very strong sexual taboos associated with them. For these, the dancer is required to abstain from sex for an extended period to achieve the coolness required of him. Young generations have found this sacrifice less tolerable than their predecessors and such characters are danced less and less.

At the most pragmatic level, a mask can disappear from a district if the owner moves away or dies. There is no orchestrated process to replace a character automatically; *gule wamkulu* is more organic than that. With the death of a maskmaker, his skills run the risk of being lost as well. Boucher refers to several informants who express fears that a certain character may have been lost forever with the death of its artist.

Within an organic creative milieu like *gule wamkulu*, with decline there is also renewal. Although the overwhelming majority of the themes and messages of the great dance maintain a cultural continuum with the past, contemporary changes can and often do ignite new creations. The insidious catastro-

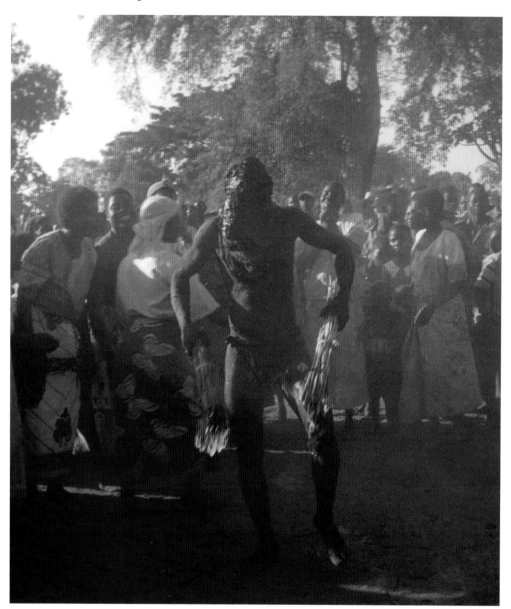

Kadziotche is one of the characters that has addressed contemporary issues of community health, in this case the pandemic of HIV/AIDS.

Claude Boucher, Masinja Village, May 2002

phe of HIV/AIDS in sub-Saharan Africa cannot avoid the concern of the ancestors, and recent characters convey the age-old message of faithfulness in marriage and anti-promiscuity. **Kadziotche** burns himself, literally with torches, as a result of HIV/AIDS.

We have seen that characters can change and evolve to adapt to the social milieu of the Chewa. So too can new characters appear, to convey the ancestors' views on a contemporary matter or to repackage more traditional teachings in a new exemplar. How does a new *gule wamkulu* spirit character come into being?

There will be an instigator or instigators, men within the *Nyau* who have observed the need or opportunity for a new *gule* model. This need may be a forthcoming special event or it may be the encroachment of some new influences on the village community. A small ad hoc 'committee' of *Nyau* men is likely to be established to refine the nature of the character and the physical attributes that should be shown. For a masked dancer, the instigator(s) will commission a mask to be carved by a

carver who will generally have established some reputation in producing *gule wamkulu* masks. Amongst the Chewa, carving is not traditionally a dedicated craft. It is a skill developed by certain members of the community. In some cases, the instigator and carver are one and the same. The characteristics of the carving will reflect the themes of the new character, the proclivities of the instigator and the artistic license and skills of the carver. This exercise will be a paid commission and the mask will then belong to the contractor.

The colours of the mask are a vital aspect. The mask could be painted by the carver or by the contractor. The remainder of the costume, the song(s) and the nature of the dance and drumbeat will also be subject to discussion and review by the committee. These attributes will be considered against the purpose of the new character and the messages it will convey from the ancestors. A dance may be modelled on that of an existing character with minimal or significant amendments. The song will have to link with the rhythm of the drumbeat.

As we have seen, some songs can be very straightforward and easily interpreted; others can be highly cryptic and codified. This can in turn reflect the sensitivity of the issue and the fashion in which the matter is best dealt with, bluntly or by metaphor. Costumes can be very simple bags or loincloths, or ornate tatter suits. There is much individual preference shown here and much that will be influenced by available materials, and, as for so much of the *gule wamkulu*, little that is formula. Thus every new character can hold a surprise or two.

The contractor may also be the dancer but this will depend on his dancing skills and interests. Alternatively, the mask owner may act as a patron of the character and effectively rent out the mask to another dancer or dancers.

The small group of *Nyau* involved will decide on the proper event to launch the new member of the *gule* pantheon. The drummers will need to be primed in advance as to the rhythm required and it can take some practice for a new character to fully gain its stride on the *bwalo*. The new songs must be introduced as well. For dissemination of a dedicated women's song, the *Nyau*-initiated *namkungwi wa ku mzinda* (an older woman teacher) will act as a communicator to the women. She is a liaison point between the male committee and the female community.

In the Mua area, many new characters have appeared in the time that Boucher has been researching the *gule wamkulu*. One recent example was the development of **Kapolo wa onsene**, which represents the ideal chief, modelled on the recently deceased Chief Chitule who had been a strong collaborator with Claude Boucher over many years. Boucher and his team had a leading role in the crafting of this new spirit messenger and had to consider not only the appearance of the mask (made to resemble the deceased chief) but also the song and dance to convey the messages of humility, service to the community and profound wisdom that were to be key to the character. At its launch at one of the post-funeral shavings (commemorations) for Chitule, **Kapolo wa onsene** was received ecstatically by the people of his village. Its appearance was analogous to the popular chief returning to the village to bestow again his wisdom and tolerance.

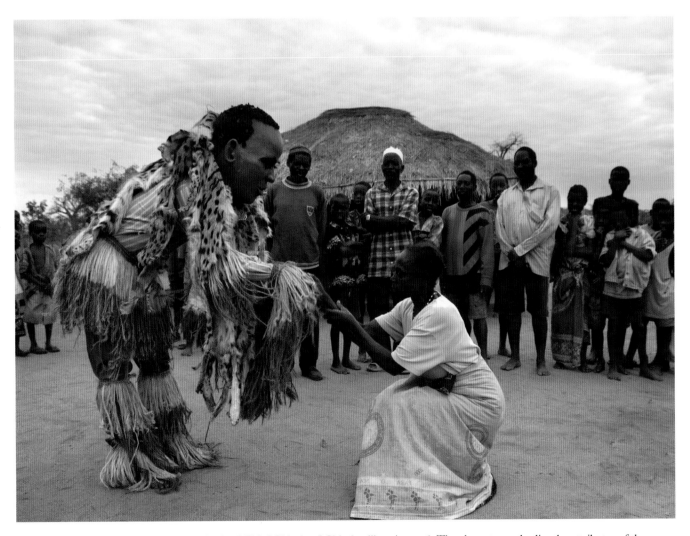

Kapolo wa onsene was born with the death of Chief Chitule of Chitule village in 2006. The character embodies the attributes of the Chief.

Rituals of transition

Life is an inevitable and largely preordained journey for the Chewa, from birth through a number of key events as rites of passage, and finally the ultimate transition, to the village of the ancestors. Life is thus punctuated by sessions of rebirth, each a transition that sees one emerge as a new individual. Boucher discusses a number of these rebirths for **Chabwera**. Hardly surprisingly, the *gule wamkulu* has a place at most of these seminal events of life. It should be remembered that event specificity is not acute for most characters today. The characters discussed below are some of those that have messages specific to the event in question but many other spirit dancers can also appear with more generic pedagogy.

Funerals have a particular significance in the rituals of the Chewa. In dying, one must be assisted to pass over to the next plane of existence. The village of the dead seems scarcely paradise to Western sensibilities, but it is comfortingly familiar and, so importantly for the family-oriented Chewa, populated with those with whom one shared life. There are many rituals associated with safely conveying the deceased to their new home. The *gule wamkulu* has a fundamental role in these.

First and foremost of the characters at the funeral is the structure **Kasiya maliro**. Possibly the most universal and recognisable of all *gule* characters, the mother figure of the great dance escorts the deceased to the graveyard. She has another key role in rebirth, at the initiation of boys. Numerous other dancers will evoke aspects of the funeral ritual. **Akulamulo** represents the family head, the *malume*, and oversees the burial in the role of spiritual undertaker. **Akumanda samalira**, dancing as a pair, emphasise respect for the dead. **Chabwera** recognises that earthly physical pleasures may be past but the dead bestow the living with their blessings and their ongoing name and wisdom.

Other rites of passage also constitute forms of rebirth. Initiation of girls is discussed later for the place of women in *gule wamkulu*. For boys too, initiation requires a rebirth to emerge as a man. Central to this transition is the accession to the secrets of the *Nyau*. The seminal act of passage is enacted under the woven skirts of the great mother figure **Kasiya maliro**. The boy enters the symbolic womb to be born again, and emerges as a man.

Assumption of a position of leadership in the village, and most particularly of chieftainship, is another rebirth. In pre-colonial days, Chewa chiefs were subordinate and, to some extent at least, answered to a king (Kalonga), but today they are part of a traditional system of authority that stands alongside the Western style of parliamentary government. At the

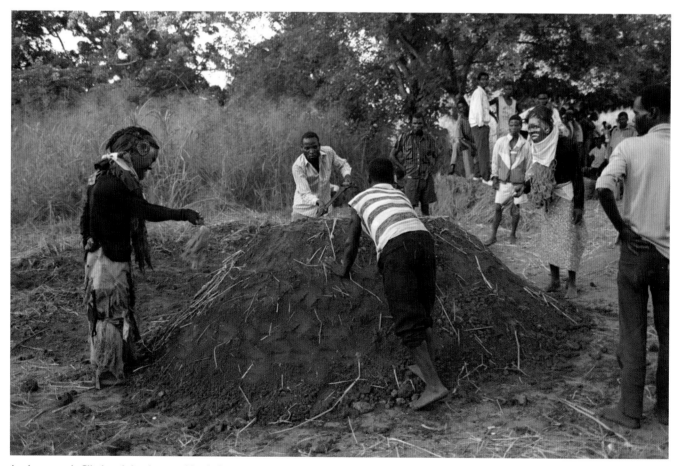

As the grave is filled and the deceased buried, a mound is erected on the graveside and the *gule* characters (here **Pombo m'limire** and **Mariya**) show their grief and pay their last respects.
Claude Boucher, Msekeni Village, March 1995

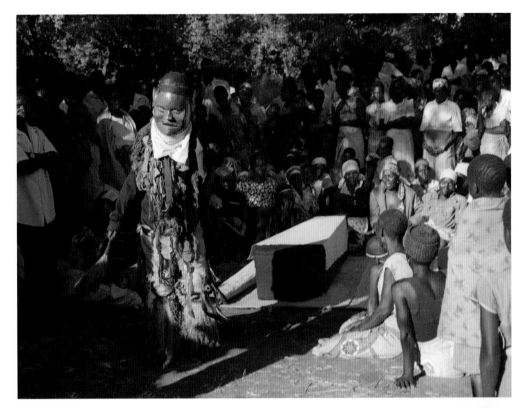

A *gule* character (**Pombo m'limire**) stands near the coffin which has been placed in the open after removal from the house of mourning before going to the graveyard for burial.
Claude Boucher, Msekeni Village, March 1995

A *gule* character (**Pombo m'limire**) circles the mound with the initiates and their tutors, who are beginning their puberty rite on the occasion of the funeral of an important member of the community. They take advantage of his journey to the spirit world to channel their plea for fertility. Their dancing celebrates the triumph of life over death.
Claude Boucher, Msekeni Village, March 1995

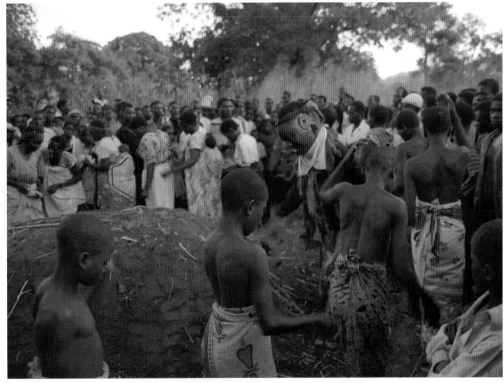

village level, they can retain significant influence and responsibility. Typically the chief will assume the name of his or her predecessors. While male chiefs are more commonplace, women can also achieve chieftainship, but in either case, the line of succession is matrilineal for the Chewa, that is through the descendants of the women's extended family. The chief is a leader for the community, resolves disputes and conflict, oversees the moral code (*mwambo*) and acts as a medium to the spirit world, imbuing the village with the ancestors' support and fertility. Many *gule* characters can assist in the passage to this vital position of secular and spiritual authority. The primary character is doubtless **Njovu**, the structural embodiment of the

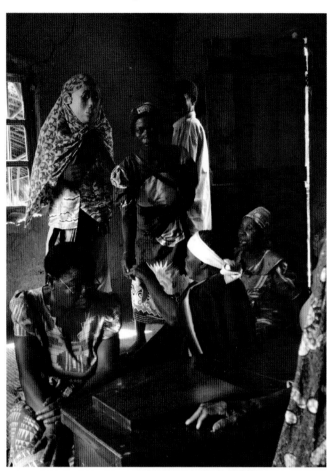

Each of the *gule* characters, representing the spirit world, comes to pay his respect to the deceased lying-in-state inside the house. Here we see **Mariya** showing grief. The women crowd around the body to signify the rebirth of the person in transition.

Mourners waiting for the funeral procedure.

The master of ceremonies raises the calabash of beer, thus proclaiming the name of the ancestors which the elder or the chief adopts in view of leading the community. He is given a sip of beer so as to enter into communion with the ancestors that have preceded him or her.

Claude Boucher, Munyepembe Village, August 1993

Mariya leads the new chief and his wife from the house of seclusion to the *bwalo*. It is here they will receive public advice while they are covered with a cloth, conveying the idea of rebirth.

Claude Boucher, Msekeni Village, August 1996

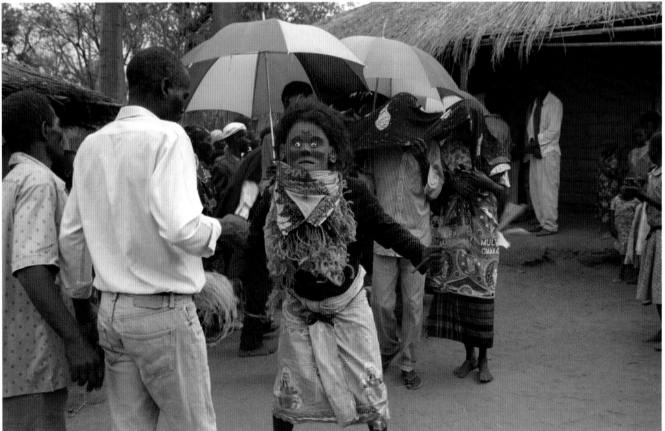

chief as father figure in *gule wamkulu*, and male equivalent to **Kasiya maliro**. Other figures include **Chilembwe** and **Mkango**. We have seen that in the Mtakataka area, the newly created mask **Kapolo wa onsene**, based on a well loved and insightful chief recently deceased, has emerged as an advocate for the role model of the perfect chief. The near-ubiquitous **Kalulu** has strong messages for the new chief as well.

Social change and contemporary issues

Admonishing bad behaviour and steering people onto the correct behavioural path is at the very core of *gule wamkulu*. The ancestors are conservative. They like the world as they knew it when alive. In reading Boucher's descriptions, one soon perceives the force of this conservative message, which may be paraphrased, "If it was good enough for us, so too for you." Few of the spirit messengers advocate change from accepted long-term or traditional practice or adoption of new ways. Generally, the adoption of new practices is seen as unwise and threatening to the status quo of a healthy village, or so the ancestors believe. Innovation is threatening. Nonetheless, from time to time characters have appeared that make the case for change.

One such character is **Sirire**, who suggests that modernity can bring some advantages. In contrast, Boucher documents numerous characters in this book that warn of the dangers of modernity and how it can undermine the peace and harmony of the village (see for example **Akulu akulu adapita**, **Bwindi** and **Chibale n'chipsera**). The matrilineal system of extended family through the women's lineage remains a foundation of Chewa society but some recent characters have expressed a degree of advocacy for the nuclear family and the rights of the children (see **Chuma cha ana**).

The conservatism of *gule wamkulu* can be overstated, suggesting it to be a static mode of cultural and spiritual

expression, ever looking backwards. The truth is that while its messages are strongly conservative, the great dance is continually directing its gaze at the daily life in the community and the contemporary issues that are confronting that community. There are few secrets in the village and everyone is under constant scrutiny from the fellow community members. There is considerable pressure placed on individuals to conform and the *gule wamkulu* is one mechanism of this pressure.

Today we see Malawi undergoing arguably more rapid change than at any point in its preceding history. The 20th and 21st centuries have instilled the ever-accelerating pace of urbanisation. The population of Malawi living in the cities is still relatively low at around 15 per cent and the country continues to be heavily agrarian, but the rate of urbanisation is now one of the highest in Africa. The relentless intrusion of cash-based systems into all areas of life has seen the replacement of traditional virtues by monetary affluence as the measure of personal success. The options of choice for village-based Malawians are still restricted by low income but are expanding. The weekend football match between local teams will be as much the grist for discussion as the funeral of a village elder.

Gule wamkulu may be an artifact of those earlier days but it can adapt and can make meaningful comment on this changing world. The pandemic of HIV/AIDS in sub-Saharan Africa remains one of the region's greatest disablers. *Gule wamkulu* has had many characters that have dealt with the threats of venereal disease, notably after the movement and return of young men in search of work. **Chiwauka** and **Kwanka anyamata** are amongst them. More recently HIV/AIDS has attracted specific attention, with **Ayemwe atsale adzamange** and **Kadziotche**. Population and cost pressures and an increasing, if still nascent, desire for smaller families has seen a growth in the use of contraceptives such as the oral contraceptive pill, and this attracts comment from **Malodza**. Certain masks remain very relevant to contemporary issues although they have fallen into disfavour or are shunned as too 'primitive'. Child abuse attracts extensive media coverage in Malawi today. **Chiudza** grapples with this contentious issue but has lost out to modern media discussion. Boucher ponders as to the relative efficacy of the two media, old and new.

Technology has been a common source of *gule* inspiration, with bicycles, cars, trains, steamers and planes all captured in the great dance. Usually objects of technology are depicted to illustrate other, more profound, issues relating to Chewa society. **Njinga yabwera** is warning people of the hazards of both riding and of being ridden amongst by bicycles and motor bikes, but its true role is to advocate respect for the elders and to admonish arrogance amongst those youngsters who have acquired the trappings of the modern world. Aeroplanes and helicopters, totally beyond the personal experience even today of most Malawians other than as distant spectators, can be an up-close and personal part of the great dance in **Ndege** (the mini-structure) and **Ndege ya elikopita** (the dancer-structure combination). As for **Njinga**, their messages are less about technology itself than in using technological artifacts as symbols of deeper community values, in this case love and death.

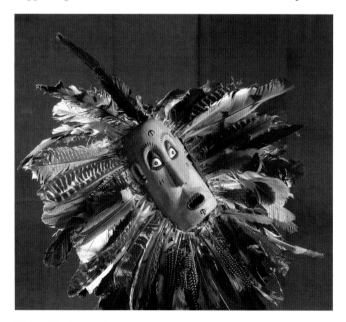

Sirire, Dedza version.

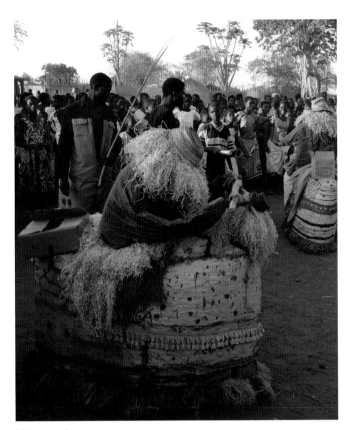

Njinga yabwera.
Leslie Zubieta, Chagontha Village, October 2011

The point of relevance here is that *gule wamkulu* can respond rapidly to societal, political and technological changes. If a contemporary issue is subject to widespread discussion, gossip or concern in the village, then so too will it be a subject for the commentary of the ancestors.

There are also topical themes that could potentially attract more attention from the great dance than is the case. These under-represented themes give us further insights into Chewa society.

In Western popular media, the pre-eminent theme, without peer or competitor, is love. Not so much love on the grand scale, as in love for one's fellow humanity, or love of the community, or even God's love for us all, but love between a man and a woman, a very personal and personalised love. This theme in its myriad variations permeates popular music, opera, theatre and drama of all kinds (be it tragic or comic), and the written word in poetry or prose. We seem to be obsessed by the most commonplace of all emotions, and it might be admitted, its physical enactment, sex. In the gay culture of the West, much the same can be said for same-sex relationships; they too are the subject for eternal fascination. For the Chewa, we have noted that they share a pre-occupation with sex, and the ancestors have to give a lot of advice to keep everything in proper order. Sexual taboos and fertility are key elements of life for the Chewa. Yet what about passionate love between two people? It is noticeable for its near absence from ancestral advice. There is considerable pressure to have a marriage based on sound values like hard work and responsibility (**Chakhumbira**),

sobriety (**Am'na a chamba**), faithfulness (**Bwindi**), and production and care of children (**Lute**). Yet little is said about having a 'chemistry', a spontaneous and indefinable mutual love for each other that is irrespective of life's practicalities and domestic expectations. There are no Abelard and Heloise, no Tristan and Isolde, amongst the *gule wamkulu* characters. The Chewa expression of love is manifested in practical ways. Something close to obvious affection is approached by **Chadzunda** and **Mariya** as the attentive married couple. **Sirire**, the ideal husband, is a loving one. **Abwerako** advises older people to enjoy platonic love after their sex lives are over and **Ndege** reveals the heartbreak in losing a loved partner of many years. Overall, however, the focus of the great dance is on the place the couple have within the matrilineal *chikamwini* system, and providing the pair are sound members of the community, are respectful of each other, produce offspring and the husband knows his (limited) standing, the rest seems to be of lesser concern to the ancestors. They are not anti-love; they simply appear not to assign it much import, and love's demonstration is far more in domestic, mundane and very applied behaviours than in the passionate, amorous and often romantically idealistic and impractical inclination of the Western world.

Same-sex love and relationships are entirely unaddressed by the *gule wamkulu*, a further contrast with prevailing attitudes and debate in the West. Homosexuality is largely regarded by villagers as non-existent in the village scene of Malawi. Whatever the possible and latent inclinations of some individuals, there is no ancestral voice that deems the subject justified for even passing comment.

Compassion to one's fellows is expressed, but selectively. As we will read more in the chapter on sexuality, fertility and marriage, procreation is the primary purpose of sexual union and there is little sympathy for the infertile individual, especially the impotent husband. Many *gule* characters treat such a blighted individual with mockery and ridicule. What are the ancestors' views on the disabled and incapacitated? There appears a little more flexibility for such unfortunates, and though it is scarcely a flood of empathy, the ancestors are somewhat more inclined to their plight than to their impotent companions. Some get a raw deal – **Am'na a chironda** is denied marriage for his lameness and **Ali n'matekenya** attempts to hide his disability so that he may have the pleasures of a family life but to no avail … he is outed and condemned, not only for his incapacity but for his ruse. The disabled **Chiuli** is advised to resign himself to his situation, and his wife's family are taught to treat him with respect. **Pedegu** is deaf and a figure of fun and light mockery (compounded in one version by the worse stigma of impotence). In another vein altogether, **A mpingo chokani** highlights lack of compassion within the Christian Church. The ancient character **Kampini** prevails on the community to show compassion to each other and to assist each other when in need and **Pali nsabwe** more pointedly admonishes those who do not assist the disadvantaged and poor. **Adapundula** suggests that lacking compassion to the crippled may in turn cripple the hard-hearted. Showing compassion at events of mourning such as funerals is promoted by a number of characters including **Kachipapa** but

Beer brewing.
Claude Boucher, Kanyera Village,
September 1995

one suspects this is as much about binding the community together as it is about heartfelt grief.

Alcoholism and drug addiction are identified by the West as fundamental problems of society. In the world of *gule wamkulu*, drug addiction receives a little attention and criticism in the volatile **Am'na a chamba** and the all-round rogue **Ndakuyawa**. Alcoholism as a problem is arguably even less discussed. Being drunk is one of the unsociable habits of the worthless husband **Zoro**. **Chokani** slips into alcoholism but here the poor wretch is drowning his sorrows over his affliction of impotence. The drinking of beer or *mowa* is a fundamental part of most rituals and there are even spirit messengers who take a particular interest in the making of the beer (amongst them, **Chimkoko** and **Kanswala**). Both the making and the consumption of beer serve a vital role in binding the community and in placing it in communion with the ancestors. Perhaps the lengthy sessions of beer-drinking that now take place in the village outside of rituals are yet to be seen by the ancestors as a potentially destructive element to the community; or perhaps the ancestors have yet to convey that message to the members of *Nyau*, who, as men, are the primary consumers of the alcohol.

Around the world, the excessive consumption of alcohol is toxically linked with domestic violence. There are many *gule* characters who are mad, bad and dangerous to know. Not a few of these are depicted as the husband, *mkamwini*, living with the family of his wife. The volatile and sometimes violent *mkamwini*, frustrated by his lack of authority in his wife's family, is a common subject of the great dance. Yet there is relatively scant attention to the specific issue of gender-based violence between men and women within marriage. This is widely recognised as a problem, and probably a growing problem, in Malawi today. No character in Boucher's ensemble takes up this issue specifically, although there can be reference to the possibility of violence to wives as part of generally bad behaviour (see for example, **Am'na a chamba**, **Chikalipo** and **Galu wapenga**). **Kapoli** in his many guises can also identify problems in the village that relate to the women. Yet overall, the medium for the message of *gule* is controlled by men, and as with alcohol abuse, domestic violence is yet to warrant the ancestors' dedicated concern.

With a high incidence of HIV/AIDS, and resultant deaths of people in their middle age, the number of children who have lost their parents has increased. Yet orphans, or the caring for them, are a very minor theme in the great dance. **Akumanda samalira** from Dedza is the only one of Boucher's characters to consider this theme specifically, and then it is conceived as an excuse, a crutch, for not taking responsibility for one's own life. This paucity of discussion by the ancestors reflects the attitudes to children in the extended family set-up of the traditional village. Children have multiple mothers, including the sisters of their biological mother, and thus the death of one's own parents may be ameliorated by the assumption of the role by others.

As we saw earlier, many characters derive from animals and the perceived attributes of those beasts translated to humans. While harmony within the community is paramount, no character suggests that people should live in harmony with the natural world. Is this something of an anomaly? The Chewa creation story has humans bringing suffering onto themselves by splintering the harmony of God and all creation, as people turn from being amongst the beasts to hunting them. One must assume that this transition from mythic empathy to entrenched battle with the natural world is more or less complete in the Chewa world view. The ancestors lived in such a world of conflict, and

make no expectation of the living to move from it. In a country now ravaged by land clearing and deforestation, where are the characters that might advocate the preservation of the trees? While the dangers of HIV/AIDS may be transparent, and the value of sexual conservatism plain, is deforestation perceived as an imminent disaster and what solution is yet visible for the ecological desecration of Malawi? With few affordable choices for cooking fuel, what option for a villager other than to cut and burn? The ancestors are as devoid of alternatives, and thus as mute – as silent as the grave – as the living.

Given the use of *gule wamkulu* as a defence against external change and as a voice of protest towards imposed authority, there is a further area of *Nyau* history that displays a surprising paucity of *gule* coverage. This is the relationship between the *Nyau* and the Christian Church, ironically significant too in that the author of this volume on *gule wamkulu* is a Catholic priest.

Gule wamkulu and the Catholic Church

We have noted already that the *Nyau* and early missionaries were entrenched antagonists (Schoffeleers & Linden, 1972; Linden, 1974; Ott, 2000) and an active Church opposition to the secret societies has continued to the current day. The Catholic Church has softened its stance in recent times, notably since the Second Vatican Council (Vatican II) elevated the concept of inculturation and the notion that assumption of Christianity need not necessitate rejection of traditional cultural values. The theory of inculturation has many dimensions but a relatively concise definition is that of Quack (1990) as cited by Ott (2000):

Inculturation [is] the dynamic relationship between Christian faith and culture. It refers to the insertion and adjustment of Christian life within … a given culture. It is a process of critical reciprocal effort resulting in the mutual adaptation of Christian life to the culture encountered by it. Inculturation … becomes the force that stimulates and enlivens the culture … [and] thus a new unity and community rises within a given culture, which at the same time is enriching for the universal church.

The interpretation and application of inculturation is open to significant variation. It is however a theological platform for progressive engagement with local culture. The African Synod in Rome that followed Vatican II declared an urgent need for inculturation in the African context (Ott, 2000). In many respects, Claude Boucher and the Kungoni Centre of Culture and Art have been at the cutting edge of inculturation in Malawi. Inculturation by action, if not by title, is variously embraced by other denominations of the greater Christian Church in Africa; however, in the more orthodox and fundamentalist churches, it can remain shunned.

In the early days of Catholic Church-*Nyau* conflict, the Church sanctioned against membership of the *Nyau*, asserting that traditional initiation and participation in the secret societies was anathema to a Christian life. The *Nyau* responded by initiating children at ever earlier ages and pressuring families to keep their children away from church-operated schools.

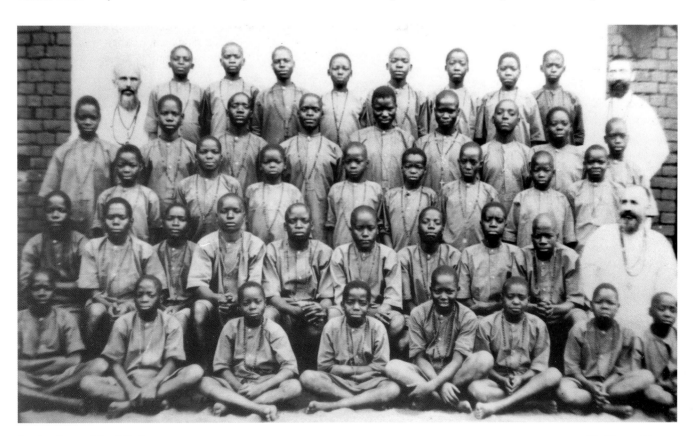

Seminarians at Mua Mission, 1913.

The Chamare Museum

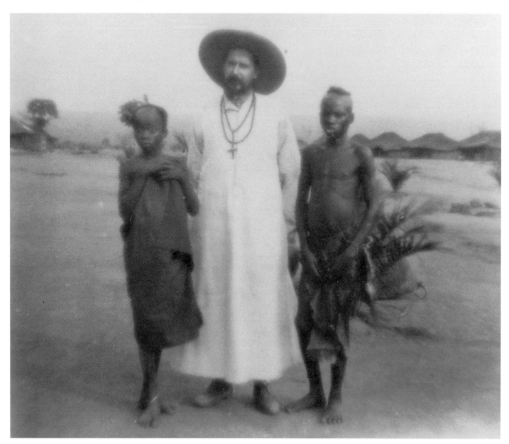

Fr Guilleme, a White Father, photographed in Nyasaland in 1907.
The Chamare Museum

(*Right*) The interaction between the *gule wamkulu* character and the women of the village underpins not only the dance as a performance, but its role as a pedagogical tool.

At times, violence flared. In this environment, one might expect that there would be a plethora of *gule wamkulu* characters expressing a view on this spiritual power struggle. Yet there appear to be few.

Boucher has recorded only a handful of masks that address the Chewa relations with the Church. Half of them are recent. **Apapa** refers to the 1989 visit of the late Pope, John Paul II, to Malawi and **Bambo Bushi** expresses the ancestors' favourable impressions of Boucher himself. **A mpingo chokani**, criticises Church attitudes to parishioners and **Agulupa** looks at political events in light of the Lenten Pastoral letter, but neither show particular emphasis on *Nyau* – Church conflict. **Mwayamba mpandira sukuluyi** relates directly to the early struggles between Church and *Nyau* (as well as between different Christian churches) and this in the Mua area. As a secondary theme, **Mdzopendeka** makes allusions to the *Nyau* – Church discord. Doubtless there will be other church-related characters elsewhere in the Chewa territory, but nonetheless, given the intensity of the animosity that once existed between the opponents, one wonders why there are so few manifestations in the great dance. Perhaps with increasing Christianisation of the population, other masks that addressed this era of conflict have died out or evolved into less acerbic morphs. The character of **Mariya** was in the past often aggressively critical of the church, with cynical allusions to the virgin birth of Jesus, but this version has given way to a **Mariya** who is a primary mother figure and advocate of the *mwambo* and cultural values. Possibly too there was increasing hesitancy to risk Church

wrath by performing characters critical of it. There has been some ongoing entrenchment of the disparate camps of *gule* and the Church, but one manifestation is an increase of church-like processes within the *Nyau*. This can be seen in the Church of Aaron, as discussed by Boucher for **Simoni**.

Women, gender relations and *gule wamkulu*

While *gule wamkulu* is the product of the *Nyau* male secret societies, the synergies between the great dance and women are many and strong. On the *bwalo*, the interaction between the women and the dancer is striking. Typically, men form a ring of relatively passive spectators, sometimes providing a male chorus, and a small subset provides the drumbeat rhythm for the dance. Male helpers also attend the dancer with its 'eyes', the rattle.

The participation of the women is far more energetic. They will follow the character, run from him, clap hands, sing and ululate. Boucher's research reveals how vital the women are to the holistic *gule* experience; without them, there can be no true *gule wamkulu*. This is different from the *gule* of the Kasungu-Lilongwe plain where only the *namkungwi* takes an active part. The women's songs often reveal the true nature of the character. Those songs can be lively, comic and sometimes sexually graphic. There is often the exchange of insults and lewd suggestions between the male *gule* characters and the women. In the great dance, it is allowable to say and do things that normally would be shunned and disavowed in the conservative village setting. Boucher sees this as a type of community safety valve.

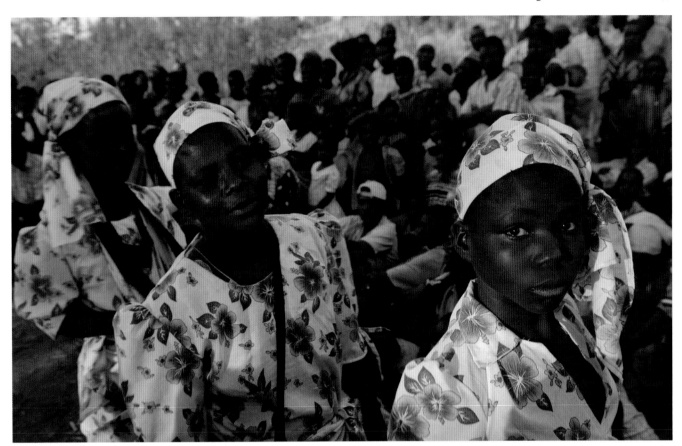

In a closely knit society where secrets are few and everyone is under continual scrutiny, social events where the people can let off steam serve an important function in maintaining harmony.

There is some lingering suggestion, unproven but of note for its repetition, that the *gule wamkulu* may have begun as a dance of the women. It is to be remembered that the original Banda clan leadership was women based and spirit wives have been seminal to Banda spirituality. **Kasiya maliro**, one of the oldest and arguably the single most significant of all the *gule* manifestations, is a mother figure, a symbol of the womb. One of the old stories of the creation of *gule wamkulu*, dating from early Banda times, is of the crafting of **Chadzunda**, the father of all *gule*, by the spirit wife *Mwali* from a burnt stump of wood (Boucher, pers. comm.)

In this theory of female origins, men progressively usurped the great dance until now it is a male-owned ritual, with most of the characters being male and most of those characters that are female being danced by men. **Mariya, Hololiya, Mai Gomani, Mai Mmwenye** and so forth, are female in presentation but performed by men. The theory of women origins gathers some credibility in that many of the oldest characters, to the extent that age can be determined, relate to women and women's business. These include **Kapoli, Lute** and **Namwali tiye**. The ancient, ever-present and multi-faceted **Kapoli**, 'master of ceremonies' for most *gule* events, is a spokesman for the women, highlighting any recent injustices that have been inflicted on them in the village. The character derivatives of **Kapoli** frequently attend to women's cycle issues and matters

of sexuality (see **Adagwa ndi mtondo, Chintabwa, Kachipapa** and **Nyolonyo**).

The women too have their secret "society" and masks. The *chinamwali* initiation of girls into adulthood is 'women's business' and this instruction is overseen by an older woman, the *namkungwi wa ku chinamwali*. There are some individuals in the village who span and connect the secret worlds of men and women. Some older women are *namkungwi wa ku mzinda*, who are initiated into the *Nyau*. They assist in the initiation of boys to men by serving food to the males in seclusion. They also dance some of the women's characters of *gule wamkulu*. In addition, those men who dance some of the characters with particular application to *chinamwali* will have a knowledge of secret women's business, and can be effectively initiated as a kind of *namkungwi* (see for example **Chintabwa, Mphungu**).

Arguably the most important ritual occasion for a woman is her initiation into adulthood. Many ancient *gule* characters and structures dance to the *chisamba* rhythm, which belongs exclusively to the women. They will have roles at the *chinamwali*, although most of them can appear at other types of ritual as well. **Ali n'nyanga nkhadze, Chinkhombe, Chintabwa, Chapananga, Mphungu** and numerous others have messages for the young initiates. **Chimbano** and **Njovu** act as agents of fertility for the girls, links between the ancestors and the village chief in unlocking the girls' reproductive capacity. With the decline in length of the typical *chinamwali*, there has been a consequent decline in the appearance of many of the initiation characters.

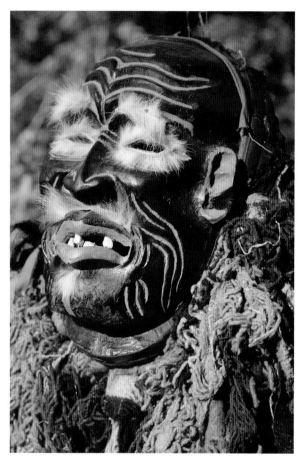

One of the stories which explain the origins of *gule wamkulu* comes from a Banda source and is linked to *Mwali*, the spirit medium of Mankhamba shrine. One day, *Mwali* set some food on the fire and while she was busy with something else, the nearby tree caught fire, the tree trunk became charred and produced **Chadzunda**, the most important mask of *gule wamkulu* and the head of the Chewa pantheon. The Banda clan claims that *gule wamkulu* was first the property of the women and that later on, it was stolen from them by the men. This statement could well suggest the historical development by which the Banda institutions were absorbed into the Malawi political system.

Top right, Leslie Zubieta, Mankhamba, 2006

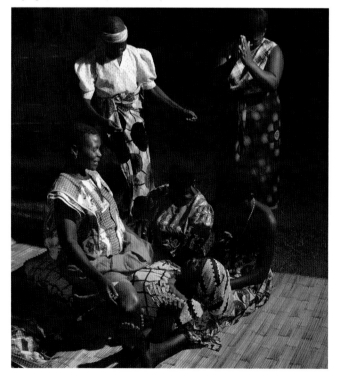

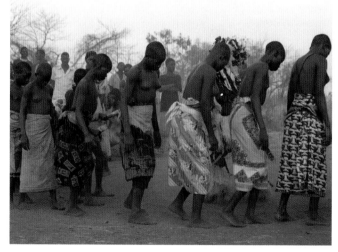

(*Above*) The initiates circle around a *gule* character in single file to emphasise their first contact with the spirit world. They are led by the *namkungwi*, mistress of initiation.

Claude Boucher, Kakhome Village, May 1985

(*Left*) After having her blouse removed, exposing her breasts, to show that she is now grown up, the initiate will be given a practical demonstration of how to perform the duties of marriage.

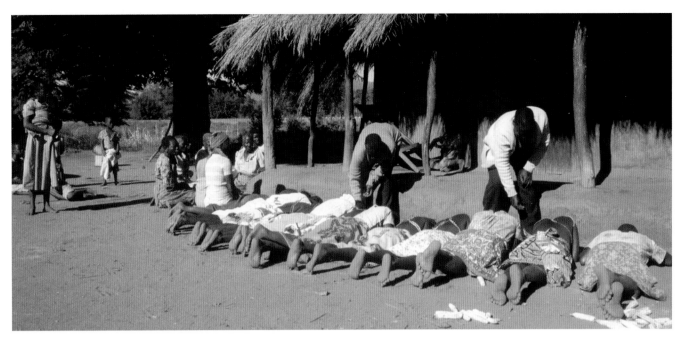

At the end of their initiation, the initiates accompany their tutors to pay their respects to the chief of the village by lying flat on the ground in front of the chief's house. The chief slips a coin into the initiates' hands to signal their coming of age.
Claude Boucher, Kakhome Village, May 1985

There is only a small suite of characters that are danced by women. These are exclusively associated with intimate women's business, notably the *chinamwali*, and include **Chinkhombe, Liyaya, Namwali tiye, Yiyina** and others. In effect, these characters merge in role and substance with the *namkungwi*, and it is the *namkungwi wa ku mzinda* who will dance these masks. The dancer will be past child-bearing age and no longer sexually active and thus seen to be 'cool'. Those *anamkungwi* who are initiated into the *Nyau* also act as a symbolic bridge between the male and female communities of the village.

There is a small suite of characters that are danced by women: this study presents only a selection. They could well have been the beginning of *gule wamkulu*, which was later taken over by men. The characters are exclusively associated with intimate women''s business.

The focus of the *gule* messengers at initiation rituals is on

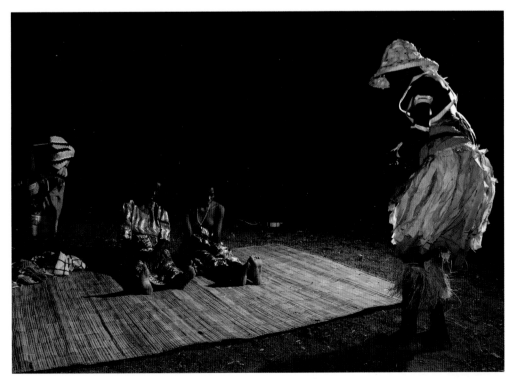

Kanamwali kayera with her white head represents a girl who has failed to listen to the initiator's advice. The pale tone of her skin reveals her pregnancy.

matters of female hygiene, dealing with the menstrual cycle, fertility and other sexual instructions including body preparation for marriage. The importance of keeping sexual taboos is a paramount theme among the most ancient characters and structures. Perusal of the associated songs documented by Boucher shows the messages may be codified and euphemistic, or they can be explicit and graphic in their reference to sexual organs, the menstrual cycle and sexual activity. In either case, the instructions have to be understood and remembered, and instilling some fear into the initiates facilitates this. The risks of failure to abide by the *mwambo* will include sickness and death, for the girl or her partner, from the infamous *mdulo*.

There is a legion of *gule* characters and female masks that address issues pertinent to male-female relations and the extended family. However, some issues of considerable social import such as gender-based violence receive little attention by the male-dominated *Nyau* society. Boucher observes (in the description of **Chiwau**) that "Shifting blame to women is typical of Chewa mentality. The men deny their social responsibility in this way," and (for **Madimba-Salima m'madimba**), "... women (are held) responsible for cheating and enticing men. This accusation is frequent within Chewa society." Mtonga (2006) discusses the *gule* from the point of view of protest from the men, aimed at the matrilineal system that denies them power. He observes that "It is this (the matrilineal) social and political structure that *gule wamkulu* appears to parody and satirize." While this opportunity to rebel publicly against the social oppression of matrilineality may be an aspect of the great dance, there are possibly further and more subtle elements at work. Overwhelmingly, the characters side with the woman and her matrilineal extended family over the hapless *mkamwini* who is frustrated and failing in his duties as a husband. The dancer may represent the *mkamwini* in his frustration, rage or profligacy, but the messages in the songs typically condemn him. In *gule wamkulu* infertility is rarely ascribed to a woman; it is usually the man who has failed to produce children. When sloth, greed, aggression and irresponsible behaviour in all of its guises are discussed, the protagonist is most often a man, not a woman. In condemning promiscuity, it is uncommon for the messenger to represent a woman (**Hololiya** of Dedza); far more often the sexual dissolute is a man. Sexual indiscretions by women may be regarded as more serious than those by men, but men are presented as the primary causal agent. In these leanings, one can interpret that the *gule wamkulu* is biased to men in the character depictions but presents men as the source of most disharmony, conflict and antisocial behaviour in the community. The women consequently suffer the actions of their men. Time and again, women are beseeched by the *gule* spirits to fend off their husbands who are demanding sexual favours in times of taboo, such as during the woman's menses, and thus to save her irresponsible husband's life. As the song of **Kasinja** recounts, "*Men are like wild animals.*" Men may in a sense be victims of the system and depicted as protesting at their lot, but then, unable to control their passions, become the causal agents for all manner of problems. This in turn places extra expectations on women. If the

man is viewed as chronically uncontrollable, an 'animal', this may be seen as excusing his behaviour … what more can you expect from a mere man? Thus the responsibility shifts heavily to the woman to keep the peace and taboos. The *gule wamkulu* may be a manifestation of a largely male world view but it is one of a world where women are expected to carry so much of the responsibility that men have abrogated through their debauched and dissipated ways. If indeed the *gule wamkulu* is at least in part a vehicle for male protest in a female dominated power hierarchy, then we can add one more irony to the great dance: that of reinforcing the very power base that the indignant men may berate and bemoan.

The themes of *gule wamkulu: mwambo*, unity and everyday life

The *mwambo* is, as close as can be paraphrased in English, the complex framework of moral codes and values that define the world view and proper lifestyle of the Chewa. The *mwambo* is all pervasive. Every action of every individual can, and will, be assessed by the community against the yardstick of the *mwambo*, and 'success' in life is defined more by adherence to the *mwambo* than to any achievement of personal gain.

As such, the *mwambo* is not so much a theme of the *gule wamkulu* as the universe in which the *gule* is set. The great dance is the physical pedagogy for the *mwambo*. Through *gule*, all dimensions of the moral order are confirmed.

While the *mwambo* permeates every aspect of one's life as a traditional Chewa, there is an over-arching driver to which the moral code is committed. This is, ultimately, the unity, stability, peace and harmony of the community. Individuals have their place, and life can be good if the *mwambo* is obeyed, but the community is far more than the simple sum of the individuals as parts. The community has a life of its own, and it is this life that the *mwambo* seeks to protect. This integration of the members of the community into a whole underpins much of the message of *gule*. Indeed, one can distil from Boucher's descriptions that all of the messages of the great dance are, finally, about binding the villagers together, through shared beliefs, values, activities, rituals and commemorations, and to no small extent, participation in the *gule wamkulu* itself.

It is thus no surprise that the greatest risk to the community is the loss of unity. Unity can be threatened by outside forces of change and power, and the *gule wamkulu* has been a well-tested mechanism for resisting the intrusion of external influences. Yet unity can also be at risk from within the community, from individuals who do not abide by the *mwambo*, and who pursue personal gain at the expense of the community. Any such behaviour can be branded as antisocial, and the extreme manifestation of this destructive conduct is witchcraft. Thus, witchcraft is in effect the incarnate antithesis of the *mwambo*.

The concerns of the ancestors are very much those of the living. The emphases of attention for the *gule wamkulu* are hence an insightful indicator of what issues are seen as relevant and important to daily life in the Chewa community. In scanning Boucher's documented characters, it is not hard to observe the

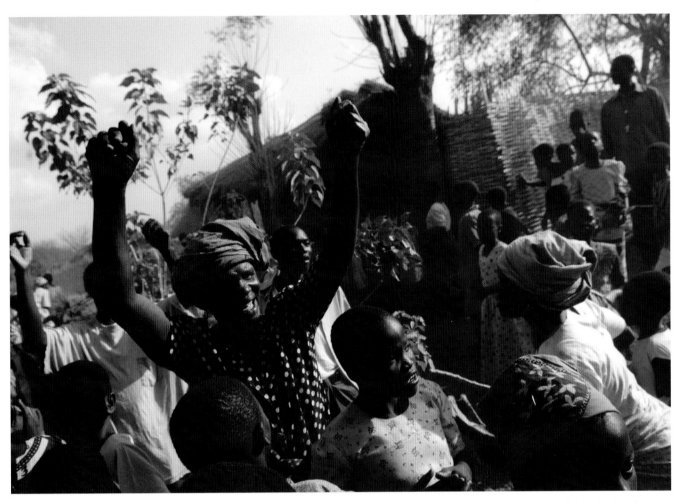

The primary message of *gule wamkulu* is that of unity and harmony amongst the community, as embodied in the traditional code of morality, the *mwambo*.

value systems of traditional agrarian village life that comprise the *mwambo*.

As is immediately evident from reading Boucher's descriptions, most characters address multiple themes. Those themes can be diverse, and, on first impression, may appear unrelated. There must always be some subjectivity in identifying the key themes for any character. Nonetheless, there are several major themes that can provide some framework into which the more specific subjects may be set. **History and politics** considers the origins of the Chewa and their changing relationships with their political masters over time. **Community, authority and the ancestors** reviews the unifying principles that bind and hold a community together, in communion with the ancestors, and the traditional power base within the Chewa village. **Sexuality, fertility and marriage** considers the myriad of sexual rules and taboos that underpin Chewa society, and that are manifested in the family structure and broader relations in order to promote stability and fertility. **Childbirth and parenthood** are

an extension of fertility, and here the *gule wamkulu* instructs new parents on how to care for their children. In the major theme of **health, food and death**, the ancestors advise on issues of mortality, longevity and the inevitability of death. **Witchcraft** is a vital dimension to traditional beliefs and takes many forms. In that chapter, we learn how pernicious and destructive witchcraft can be, and how entrenched is the opposition in *gule wamkulu* to its practices. Finally, in **personal attributes**, the ancestors give us good advice on what sort of traits make for a valuable member of the community or, more commonly in *gule* pedagogy, which traits make for a non-productive and disruptive community member.

The character descriptions that follow are set in chapters according to these major themes. The reader should be aware that selecting a single major theme for many of the masks is not clear cut, and many of the characters address themes in more than one major category.

Form and content of the descriptions

The descriptions of characters are based heavily on those of the Mua area of central Malawi, including the Dedza District. Many of the masks illustrated are held in the collection of the Chamare Museum of the Kungoni Centre. Given character variation over distance and time, and artistic licence of the carvers, the precise details of a mask will not necessarily apply to interpretations of a character at other places. The key attributes should, however, have application. Songs can also vary between sites but again, in most instances, the general intent of the message will be consistent.

Introduction to the chapters

Characters are grouped under seven major theme headings. A brief discussion of the chapter precedes the detailed descriptions. Many characters are relevant to more than one major theme. Where characters are referred to, but are described in another major theme, their theme of entry is footnoted.

Name or names

Each entry includes the name of the character, with the most accurate spelling that can be determined. The names were all orally transmitted in the past and in many cases, this will be the first time they have appeared in print. In some cases, a character can have multiple names. The source area for information is noted.

Themes

The key themes of the character's message are listed. These have been distilled from the songs and the semiotics of the character's appearance and performance. There is some intrinsic subjectivity in classifying the themes; and the themes are clearer and less ambiguous for some characters than for others. The translation of themes into an English context from the Chichewa songs can be less than precise. Hundreds of themes have been identified, set within a framework of seven major themes which attempt to give some structure and phylogeny to the stories. Most characters have multiple, sometimes eclectic, themes. It is not unusual for a character to address themes from more than one major category. Some of the themes are closely related to each other but listed separately, to reflect nuances where Boucher has interpreted them and the significance of some issues.

Etymology

The etymology of the name is given. Boucher has attempted to convey the closest equivalent English meaning to the Chewa expression, and then to interpret its true meaning, sometimes very different from the literal translation (if there is indeed a literal translation).

Description

The description includes not only the physical appearance of the character but also its dance style and associated songs. The songs are those that are dedicated to a given character. There can also be more generic songs sung by the women that may be used for a variety of characters; these are not recorded. Most importantly, Boucher interprets the often arcane *Nyau* codes, in mask, dress, song and dance, into terms that we can all understand and set within the history of Malawi that has so influenced the *gule wamkulu*.

Boucher acknowledges that much of his research has been based on the knowledge of his informants (see below). Often the information provided to Boucher was incomplete, and on occasion conflicting, and he has had to interpret the omissions and inconsistencies by way of analysis of the form, song and history of the character. In all cases, translation of the Chichewa songs to English has required substantial understanding of the Chewa world view. Often the wording is oblique and veiled as to its true meanings, and certain concepts can have poor equivalence between Chichewa and English. In all cases, Boucher attempts to convey the underlying meaning of the songs and character, rather than over-emphasise the literal translations of songs that can be subject to some variation in any case. A version of the Chichewa original has been provided in footnotes as a resource for those who wish to pursue the fascinating subject of *gule* songs.

Sources of information

The primary source of information has been members of the *Nyau* who have had close involvement with the *gule wamkulu* in various capacities. Some are chiefs, some dancers, some carvers of the masks. Quite a number of the informants are now deceased. All of the interviews were conducted by Boucher in Chichewa. A list of informants is provided at the end of this publication, without reference to any specific *gule* character, in order to maximise confidentiality.

Maps

Places referred to in this book

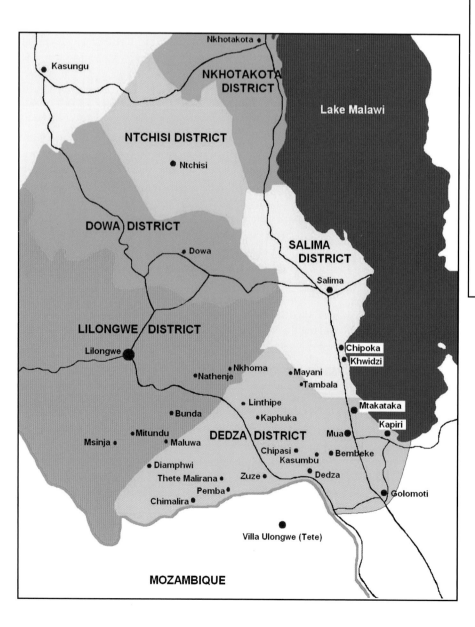

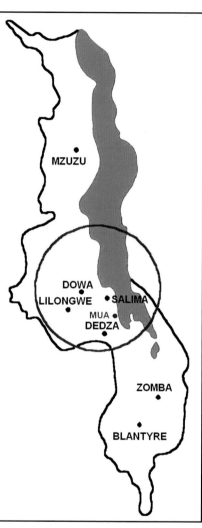

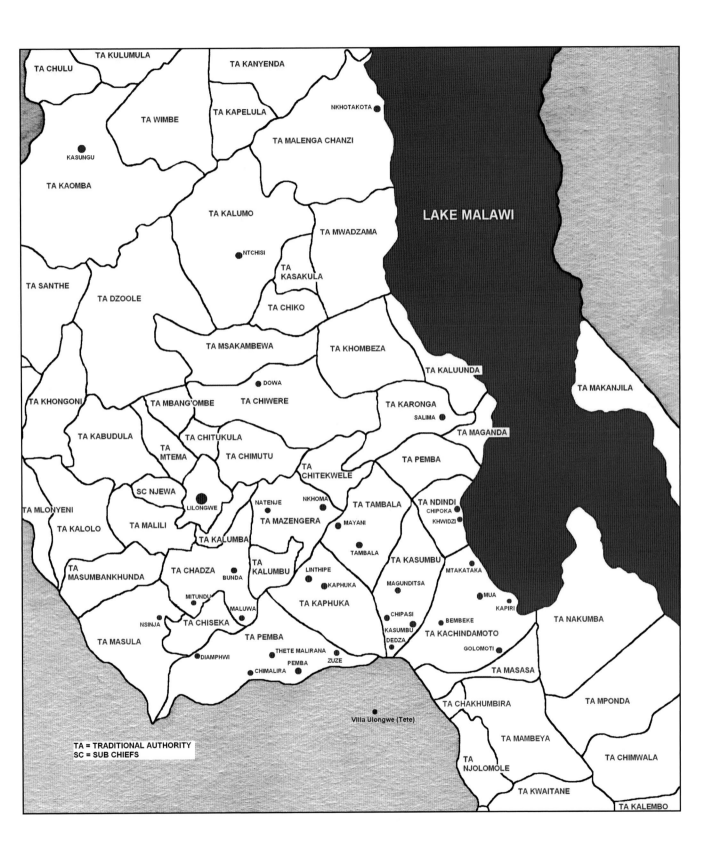

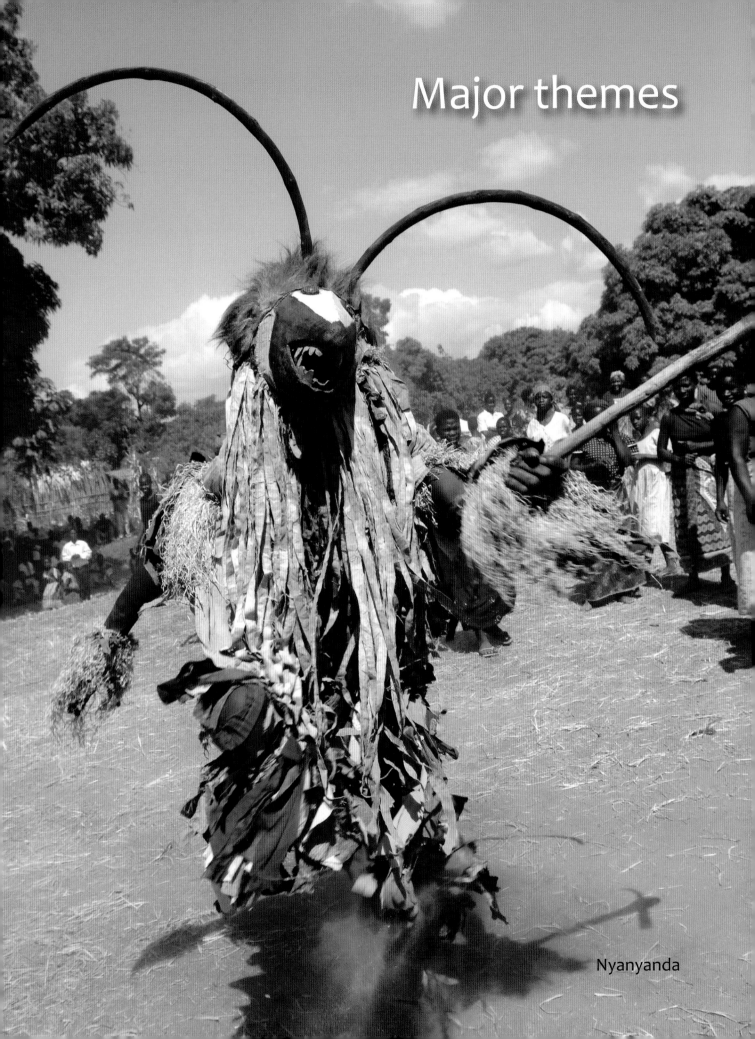

Major themes

Nyanyanda

1. History and politics

Here the *gule wamkulu* considers the history of the Chewa and their inter-racial relations, and relative power base, over time. The *mwambo*, the moral code of practice for the Chewa, underpins all power in the community and informs the ancestors' analysis of historic events and behaviour of authorities, including the politics of the day.

Some characters make a possible allusion to the Akafula-Batwa people. It is very hard to know how much influence the Batwa have had on the great dance as is discussed in the Introduction. The references are vague, and more through features and characteristics of the characters than in any defined narrative about the indigenous occupants of the country. However, there is some resonance of the original spirits of the land and of a lingering perceived presence of the small cantankerous hunters who preceded the Bantu (**Kamano**[1], **Nanyikwi**[2], **Pinimbira**[3]). The Banda–Phiri power struggle is referenced in several characters. The Banda fought to retain control over the *gule wamkulu* as the Phiri (Malawi) assumed control over the land and sacred shrines (**Njovu**[4] and **Ajere**[5], **Dumbo Achembe, Mkango**[6], **Njati**[7]). The invasion and dominance of the Ngoni in the mid-18th century spawned a number of characters that still persist (**Gomani** and **Mai Gomani, Madzi adalakwa, Sitilankhulana**) which criticise or ridicule the Ngoni and satirize their perceived arrogance. **Wali wabwera** is an interesting mask of historic context, setting themes of hypocrisy within the context of the rule of the Jumbe at Nkhotakota at the peak of the slave trade. The period of British colonialism sees a number of characters that similarly denounce the presumptions of the British to own a land so far from their own home (**Kanyoni, Kuliyere**[8], **Makanja, Simoni-John watchyola mitala**). **John watchyola mitala** set the soon to be first president of Malawi, Dr H. Kamuzu Banda, in a hero-like role for splitting the Rhodesian Federation.

Amongst these commentaries of political dominance is a sprinkling of characters who discuss the Christian church and its changing relationship to the *Nyau* over time. These include **Apapa, Agulupa, Mwayamba mpandira sukuluyi** and **Bambo Bushi**. The relative paucity of masks on Church-*Nyau* relations is discussed in the Introduction.

All of the masks that engaged with political and quasi-political themes, such as the dominance of a foreign authority over the Chewa, reinforced the intrinsic values of 'Chewa-ness', and acted as bulwarks against the intrusion of the external authority's power. They diluted the external agent of change. And then the agent of power became the Chewa's own.

Malawian independence arrived in 1964 and with it the political masks relating to the Kamuzu Banda years, including the veritable explosion of characters in the early 1990s. Kamuzu Banda was a Chewa and well received as the first African ruler of this small, rather artificially defined country. He was seen as something of a national hero in the establishment of the free country of Malawi (as exemplified by **John watchyola mitala**). It was not long, however, before evidence of his megalomania could be discerned at the village level and certain masks revealed this, often under heavy disguise and strong codification (**Chipembere, Mwalipeza** and **Msandida**). With his regime's relentless descent into oppression and curtailment of human rights, the tide of opinion turned ever more against Kamuzu Banda until the early 1990s when the Lenten Pastoral letter, the Referendum for multi-party democracy and the first free elections of 1994 followed in quick succession. Kamuzu Banda's popularity was in free fall and not only amongst the living. The spirits more and more rallied against him, sealing his fate. Within the coverage of Boucher's studies, the Diamphwi area in particular was a hotbed of political revolt. At first, the *Nyau* and *gule wamkulu* were substantively in support of the 'old man' who was, after all, a Chewa, and the devil known. This support dwindled until the early 1990s onslaught of anti-Kamuzu Banda characters advocating political change. The ancestors and the Catholic Church, old adversaries, conjoined in battle with a common foe. Multiple characters suggest with various emphases that change was due. Caution had to be exercised in condemning the rule of Kamuzu Banda and many of the anti-Kamuzu Banda characters are heavily disguised, both physically and in their messages. Take the **Mtchona**[9] couple for example; their political message is inserted into a melange of several other themes. Critiques of Kamuzu Banda include reference to his entourage of women through parables of the *mbumba* (**Valani dzilimbe**) or sexual relationships (**Ndeng'ende**). Political advocates could even assume the likeness of locusts (**Nkhumbutera**). Criticisms of national rule were frequently imbedded within the ruse of commentary on the village, including power plays between the chief and contenders (**Chimnomo lende** of Pemba, **Chipembere**). Conversely, they might refer to an international context and even the Queen of England becomes a foil for the *gule* wit (**Elizabeti** and **Edwadi**). In a parallel to Orwell's 'Animal Farm', Kamuzu Banda was compared to the dictators of the colonial period (**Weresike**). A few were more direct in their lyrics, as with **Polisi** and its criticism of the party card abuses and **Chipolowe** in describing events of violence in the Kamuzu Banda era.

Gule political observation has diminished under more liberal post-Kamuzu Banda governments. Alternative options for political debate have been permitted, including a free press, and the societal need for *gule wamkulu* as a political satirist is less acute. **Abingu, Adapatsa ufulu, Dziko lafika pa mtendere, Wamkulu ndine** and **Yayawe** are examples of more recent political advocates, and include comment on the Muluzi and Mutharika presidencies. A certain healthy cynicism about politics persists as we see in the two-faced **Kapirikoni**. The weaknesses of the multiparty system attract comment in **Yaduka ngolo**.

[1] Sexuality, fertility & marriage
[2] Sexuality, fertility & marriage
[3] Community, authority & the ancestors
[4] Community, authority & the ancestors
[5] Community, authority & the ancestors
[6] Community, authority & the ancestors
[7] Sexuality, fertility & marriage
[8] Community, authority & the ancestors
[9] Community, authority & the ancestors

A mpingo chokani

(a day cloth mask from the Bembeke and Mua areas)

Themes 1) Relations with Christian church; 2) Compassion & kindness; 3) Tolerance of differences

Etymology **A mpingo chokani** means, 'You, from the church, go away!'

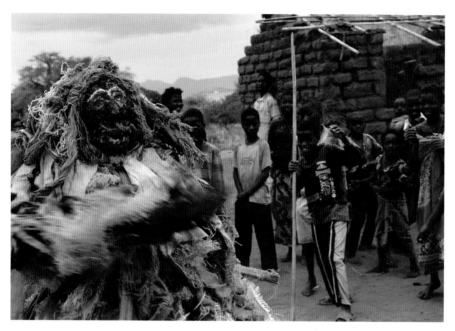

This particularly ugly mask is made of sack-cloth stretched over a wire frame. The cloth is coated with glue and human hair. The features are partly human with narrow fore-head, white painted eyebrows, red eyes (made of battery caps) expressing fury and a flat nose (moulded in the wire frame). Animal features include a baboon-like jaw and mouth (with missing teeth) expressing discontent. The mask displays no ears, to stress deafness towards others. The head-gear of the mask is made of shredded fer-tiliser bags, sackcloth and dirty tatters. The head is topped with a straw hat. The costume of the dancer is made of a bamboo frame in a funnel shape, covering the body from the armpits to the knees. The frame is hidden with sackcloth and tatters. Underneath, the dancer wears tatter trousers that conceal the feet completely. A heavy winter coat or army coat covers the arms and back of the dancer, slightly over-lapping the skirt. **A mpingo chokani** carries mini medicine tails as a mockery of power and authority.

In the *bwalo*, **A mpingo chokani** swerves his feet with aggression while moving forward. He then stretches his arms while waving his medicine tails, moving back-wards and shaking his skirt in all directions. This mime suggests he is chasing someone away. This mimicry is reinforced by the words of the men's song, *"You, from the*

church, go away from here! You have come after sunrise (late) *today,* (while the person already died during the night). *You, from the church, from the church, go away from here!"* [1]

A mpingo chokani first appeared in the Bembeke area at the beginning of 1990s. After a scandal at that mission, a similar version of the character was brought to the Mua area around 1994. The character per-forms at funerals and commemoration rites to denounce or rebuke church leaders who neglect their responsibilities of bring-ing backsliders or sinners back into the fold. A Christian may be involved in an 'ungodly' act, such as taking a second wife, resulting in his suspension from the church. When such a person falls ill, he may send for a priest or other church leader for confession. Out of sheer negli-gence or lack of care for such lost sheep, the priest or church leader may take too long before he visits. Sometimes the sick person dies before they arrive. When that happens, the church leaders will refuse to conduct the funeral service because the person was still under suspension. The scenario described here refers to the situa-tion of a parish that was started under foreign missionaries. When the mission was handed over to local ministers, the people compared respective dedication with regard to the care of the flock, partic-

ularly delay and negligence in care of the sick. People's judgement tended to be harsher towards their own priests.

Gule wamkulu is telling the church people to leave the funeral service to the traditional religious leaders. As the church men have failed to care for the living, they will be in no position to care for the dead. **A mpingo chokani** dramatises the conflicts that some-times exist between Christian churches and traditional practices, such as those of funer-als. This is particularly true when church leaders are intolerant towards Chewa culture, fail to have dialogue with the 'grass roots', and resist introducing cultural prac-tices into pastoral services. People can look at rituals as belonging to the culture and resent the interference of the churches in these matters.

A mpingo chokani represents both the maternal uncle (*malume* or *mwini mbumba*) and a negligent church leader. The ugly and angry features embody them both. The anger of the maternal uncle is towards the church leader who was requested to assist the sick person; ugliness because he failed in his duty by coming late and refusing to perform the burial rite. The angry family head chases away the church leader and voices his dissatisfaction with the church. When a minister is called to visit the sick, he should make haste lest that the sick person dies before his arrival. Failure to do so can lead Christians to abandon the church for traditional practices. The seeming lack of concern of the minister aggravates the long-standing cultural misunderstandings that exist between the church and the local com-munity. This is particularly true in a geo-graphical context where Ngoni, who have become Christians, dominate a Chewa minority, who as a whole have remained more traditionalist. The church has the duty to be sensitive to both cultures and tribal groups. Dialogue and compassion are an essential part of the church's ministry. As the Chewa proverb says, *"Chakwathu n'chakwathu adamangira nkhokwe m'nyumba – The one who keeps saying, 'This is the way we do it at home,' built his granary inside the house"* (foolish actions stem from stubbornness).

[1] *"**A mpingo chokani** pano mwabwera kutacha, A mpingoo, A mpingo chokani pano."*

Abingu

(a pink day mask from the Mua area)

Themes 1) Recent politics; 2) Mutharika/DPP; 3) Cynicism about politics

Etymology **Bingu** is the first name of the current Malawian President, Dr Bingu wa Mutharika*. The letter 'A' that precedes the name expresses respect.

The character refers to, and is named for, the President of Malawi, elected in June 2004. The pink colour alerts the audience that the character is an outsider, a non-Chewa. **Abingu** displays a youthful face, short nose, medium sized ears, thin clean moustache (made of black goat skin), fine beard under the mouth and a rounded chin. His cheerful, small eyes are elongated like those of a foreigner and suggest that he might be shortsighted. This effect can be enhanced by the addition of spectacles. The character appears content and self-assured. No tribal marks appear on **Abingu**'s face since he is L'homwe and not a Chewa. The headdress of the mask features a wig with straight hair that forms two long sideburns. The mask exposes some of the neck bordered by a piece of cloth. **Abingu** wears a tatter suit and an impeccable white kilt, leglets and armlets made of fertiliser bag laces.

Abingu appears in all kinds of rituals, funerals, commemoration ceremonies and at political rallies. The character of **Abingu** originated towards the end of 2005, after President Mutharika came to power and established the Democratic Progressive Party. **Abingu** enters the arena holding two medicine tails and an umbrella. He walks with dignity through the *bwalo*, moving slowly with restraint, measuring his steps and brandishing his switch tails. As the drums reach their peak, he swerves his feet sideways with great assertiveness and pride. He rotates both medicine tails simultaneously. He displays his power but then slows and kneels down. This sequence is repeated. **Abingu**'s movements are clearly ambiguous. It is unclear whether he is conveying strength or weakness, good manners or fragility. He stirs up the dust in the *bwalo* and the crowd becomes excited. The male choir acclaims its new President: "*Abingu, Abingu, Abingu, Abingu has come!*" [1] Soon their song is covered by the voices of the women: "*Abingu, you gave us some popcorn ae, come nearer ae, let us discuss ae, Abingu, we have received some popcorn ae.*" [2] While the men are busy welcoming their President, the womenfolk are more reserved in their praise and critical of the government's apparent generosity. The songs initially celebrate their leader's positive qualities such as his good manners and being well dressed and groomed. Beyond this first impression, the audience reveals some scepticism. The population, under the guise of being grateful, protests the government's performance during the famine of 2005. The women's song states that the President did not distribute enough maize to prepare *nsima* (thick maize porridge), but only enough for roasting as popcorn. The actions of the government are seen as too little and the people are hungry.

The duality of praise and scepticism reflects a measure of uncertainty amongst the people regarding the new President and **Abingu**'s behaviour in the *bwalo* is purposely presented as ambiguous. The dance contrasts power and politeness. This is shown with the character falling to his knees suggesting potential weakness and is a reflection of the initial testing period for the new leader of the country. The Chewa are waiting to see the President's capabilities. They have had hard experiences of politics in the past and retain a certain cynicism towards politicians. Other *gule* depictions of Mutharika show a more solid support for him, reflecting that he has demonstrated his capacity to take the country forward (see Adapatsa ufulu).

* See footnote on p.6
[1] "*Abingu (3x) Abingu abwera.*"
[2] "*Abingu munatipatsa chimanga chokazinga ae, tabwerani ae tikambirane ae, talandira chimanga chokazinga ae.*"

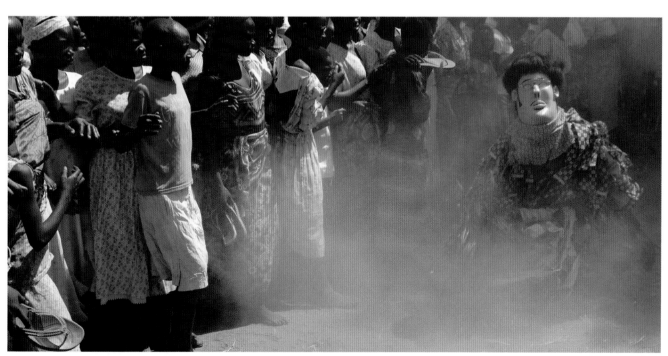

Adapatsa ufulu

(a red day mask from the Golomoti area)

Themes 1) Recent politics; 2) Mutharika/DPP; 3) National interests; 4) Rivalry for authority

Etymology **Adapatsa ufulu** means, 'He gave freedom.'

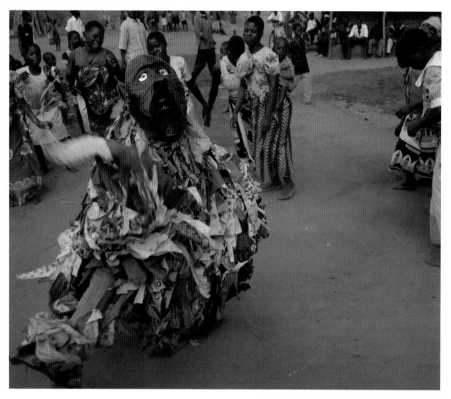

The large 60 centimetre red mask portrays a non-Chewa, a stranger of high political standing. The character is a middle-aged person with receding hairline, sideburns, wrinkles on the forehead and the cheeks, and long drooping moustaches reaching the chin. Frown lines crease his forehead. His western nose shows he has some separation from the people. His half open mouth expresses that he is not yet in a position to talk but the smile on his lips suggests that his time will come soon. His large eyes depict a man of vision. His big ears emphasise his importance. His affirmative chin highlights his strong personality. The headgear of the mask is made of tatters and topped with a

black goatskin to show his black hair and inner vitality. **Adapatsa ufulu** is well dressed in a tatter suit and carries a staff, reflecting his power and authority.

In the arena, **Adapatsa ufulu** is dynamic, lifting the dust by swerving his feet sideways with great energy, acting as if he is the owner of the *bwalo*. The male choir welcomes him: *"He gave* (them) *freedom! He gave* (them) *freedom!"* [1] The song implies freedom of speech and being able to speak one's own mind. **Adapatsa ufulu** was introduced in 2005. The character was not created for any specific ritual. It responds to the political changes following the 2004 election. After completing his second and

last term as President, Dr Bakili Muluzi was no longer eligible to seek the presidency unless he changed the constitution. As an alternative, Muluzi chose Dr Bingu wa Mutharika to be the candidate for the United Democratic Front party. Mutharika won the election and became the third president of the country. Muluzi had expected to remain the dominant political authority, the 'power behind the throne'. This did not happen! Soon after becoming president, Mutharika showed that he had a mind of his own. He separated himself from Muluzi and even launched his own party, the Democratic Progressive Party (DPP).

The character of **Adapatsa ufulu** reflects this chain of events. The members of *gule wamkulu* around Golomoti were in a position to understand that Bingu was no longer the puppet of Bakili, whom they perceived as a retired chief (*chatuluka*). The frowning on the forehead of the mask and the wrinkles on his face give witness to the hard time Mutharika has had in establishing his power and escaping Muluzi's grip. Now the time had come when he was able to support the villagers in defending their interests by talking openly in their favour. He made the alleviation of poverty a priority instead of building his own empire. People recognised his honesty and put their trust in him. They pay him tribute in acknowledging, *"He gave* (them) *freedom."* People liked his straight talk and his practical approach to socio-economic development at the grass roots of Malawi. Mutharika was no more the stranger but had turned into an authentic leader who had the courage to tackle the misery of his people. The ancestors' teaching reaffirms the commitment required of the chief and his deep concern for his people's welfare.

[1] *"Adapatsa ufulu ede ede (2×)."*

Agulupa

(a pink mask from the Maluwa area)

Themes 1) Recent politics; 2) Supporting Kamuzu Banda/MCP; 3) 1992 Lenten Pastoral letter

Etymology **Agulupa** means, 'local church elder'.

This tall 40 centimetre mask depicts a local church elder. The colour red or pink identifies the character as a stranger or a foreigner,

although tribal marks typical of the Chewa are seen on the face. This is a senior man with a narrow face, a balding head crowned

with hair and long sideburns (made from baboon fur). Facial features include a long narrow nose, thin red lips, salient chin and a

long neck that is a continuation of the shape of the mask. The headgear of the mask and the neck attachment are made with black tatters. The mask has severe features and an open mouth, suggesting one who reprimands or lectures. The ears are of average size. The gentleman wears a clean jacket but filthy trousers made of sackcloth, and carries a whip. It is a character of many contrasts and redolent in sarcasm.

Agulupa appeared around Diamphwi towards the middle of 1992 and performs at any kind of ritual. **Agulupa**'s dancing style resembles that of Kapoli, bent forward and swerving his feet sideways and backwards. The significance of moving backwards is interpreted by the male choir: "*The local church elder* (of our days) *should not go backwards. No! The local church elder* (of our days), *my friend, should not go backwards. No! The local church elder.*" [1] The song discusses the behaviour and the poor example set by a local church elder. The people accuse him of immorality and crimes, such as stealing, drunkenness, womanising and subversive talk. Members of the congregation are shocked. He causes shame and weakens the community. He is unworthy and cannot continue as a church leader or a member of the church hierarchy. His behaviour is worse than a common citizen who is not a churchgoer at all. As a church elder he should be setting an example instead of embarrassing the community.

The character of **Agulupa** is a parable of a local church elder reacting to events that took place in March 1992. At this time, the Episcopal Conference of Malawi (ECM) published a pastoral letter dealing with some social issues of the country. Their Lenten admission pointed to concerns and discrepancies between the practices of Malawians and the Gospel values. They were especially

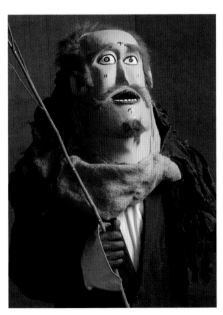

emphasising the social doctrine of the Catholic Church worldwide. The letter was read in all Catholic churches of the country on 8 March 1992, the first Sunday of Lent. Though their criticisms of the political, social and economic status of Malawi were mild, this was the first time a church body had dared to question the ruling Kamuzu Banda regime. The pastoral letter was highly controversial and inflammatory. The following days were chaotic and on 10 March the seven Catholic bishops of Malawi were investigated and questioned. The following day the letter was officially banned and defined as seditious. The Malawi Congress Party convened an emergency meeting at its Lilongwe headquarters and began conspiring against the bishops. On the 12th of the same month, the bishops' movements were severely restricted; they were put under house arrest and interrogated.

By 13 March support for the bishops from various Christian churches and denominations was growing both within and outside the country. Canada, the USA and many European countries had instructed their ambassadors to Malawi that aid would be suspended until freedom of speech was improved and political detainees were freed. The Red Cross visited the prisons to monitor their treatment. Demonstrations of support for the bishops were organised in different cities of the country. The students of Chancellor College in Zomba were marching and singing hymns. Students of the Polytechnic in Blantyre took to the streets. On 17 March the parliament met to discuss the food situation in the country, which was becoming desperate. Between 20 and 22 March, Dr Chakufwa Chihana was addressing prominent politicians in Lusaka on the prospects for democracy in Malawi. After the conference, Chihana was elected the spokesman for a united resistance movement known as the interim committee for a democratic alliance. A new political party, the United Democratic Front (UDF), was launched in Lilongwe. Public dissent and anti-government sentiment within Malawi was growing with more demonstrations at Bunda College. The government requested apologies from the bishops but the latter refused to accede to the conditions, convinced of the correctness of their actions. On 24 March, the MCP organised mass demonstrations in Zomba, Blantyre and Chikwawa, protesting the bishops' actions and the multiparty system. Slogans like 'Multiparty means multiproblems' and 'Multiparty is poverty, war and tribalism' were heard in the streets of Lilongwe.

Prominent members of the Church of Central Africa Presbyterian (CCAP) Blantyre and Livingstonia Synods and the

Anglican Church requested an audience with President Kamuzu Banda to inform him about widespread Church and popular support for the bishops. Support for the bishops was forthcoming from the Muslim community as well. The month of May was marked by public riots and recrimination over the poor rates of public sector pay. Blantyre and Lilongwe counted 38 dead. On 13 May, donor countries decided to suspend long-term development aid until tangible and irrefutable evidence of progress on human rights was secured.

It was in this political climate that the character of **Agulupa** was born. The Church was perceived by the local Chewa as responsible for the chaos following the publication of the pastoral letter. The Kamuzu Banda government was critical of mixing religion and politics and was relentless in putting down this new involvement by the church in state matters. Kamuzu Banda and his government officials took to the streets to discredit the bishops and sell their propaganda to the people. The pastoral letter politicised and radicalised many ordinary Malawians and presented a serious challenge to the Kamuzu Banda dominance in Malawi. The government hold on the media loosened and the changing tide of public opinion forced Kamuzu Banda into public debate and his popularity dwindled. Other political *gule* characters started appearing but these advocated for change. They would not shelter Kamuzu Banda any longer. They showed in their performance that significant portions of the population had become reconciled with the idea of the multiparty system and democracy. On 13 October, Kamuzu Banda gave a press conference in the evening and announced that a referendum was to be held the following year.

Agulupa remained prominent and continued together with Kamuzu Banda to campaign for the ruling government and the party until 17 May, the day of the election. **Agulupa** was among the many *gule* characters that were hired by the government and given the role of bringing Kamuzu Banda's message to the people. Many people were forced to attend MCP rallies and intimidated to vote for MCP. Nonetheless, on the 19 May 1994 President Kamuzu Banda contemplated defeat in Malawi's first democratic presidential election. With Kamuzu Banda's decline and defeat, **Agulupa** lost meaning and purpose. It was now clear that church leaders have a moral responsibility to comment on matters that affect their communities and congregations. Through their actions they must set a good example and care for the rights of the people.

[1] " **Agulupa** *sayenda chambuyo, iai!* **Agulupa** **Agulupa** *sayenda chambuyo, mbale wanga. Ine iai lero!* **Agulupa**.*"*

Apapa

(a pink day mask from Mua area)

Themes 1) Recent politics; 2) Injustice; 3) Relations with Christian church; 4) Lenten Pastoral letter

Etymology Apapa is the Chewa name for the Pope.

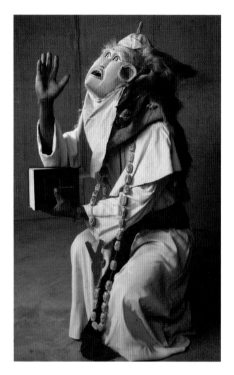

Apapa represents Pope John Paul II. The character of the Pope was introduced in *gule wamkulu* on the occasion of the Pope's visit to Malawi in May 1989. Several regions of Chewa country produced their own version of the Pope. The people from the Mua area express the excitement of the population for the Pope's memorable visit in the following song, "(Welcome! Welcome!) *The Pope has come!*" [1]

The Pope is commonly represented with an orange, yellow or pink mask with a smiling face, large mouth and no beard.

The head is often bald and covered with a little purple calotte (skullcap). The dress varies from a white cassock, purple sash and ostentatious rosary made of clay beads to the *gule* tatter suit on top of which a chasuble-like garment is added. A red cross made of cloth is stitched on the chest or on the back. The dancer carries a medicine tail in his hands and blesses his audience with the sign of the cross. The Pope of the Diamphwi is given a crosier in the form of a wooden cross and a bible to carry instead of the medicine tail.

Apapa dances with energy and dignity while kneeling periodically and blessing the 'congregation'. Although there was tremendous excitement for the Pope's first visit to Malawi in the Mua area, no representatives of the Chewa traditional religion were among those official representatives of churches and religious groups who were introduced to the Pope. Nor was the Pope exposed to any cultural programme in the area where the *gule wamkulu* is performed. Even though Chewa traditionalists were not part of the welcome programme, they celebrated the event at village level. The Diamphwi version seems to be more recent since the central message exposed in the men's song makes indirect reference to the Pastoral Letter of 1992: "*Yohane, since the beginning of our history, when the country was still whole, has never paid us a visit. One wants to know the reason why he never came to this country before? But now that he has come to Africa, people's eyes are wide open, people are astounded. Yohane, you have caused great turmoil to those who like crooked things and like to hide the truth. Everything is now in the* open *because of Yohane. Thank you! Thank you, our Pope. What was hidden has been revealed. The Pope, the Pope!*" [2]

The song suggests people of Malawi were not fully aware of their situation prior to the Pope's visit. They did not appreciate that their churches were interested in their daily life and their difficulties. After the Pope's visit, people realised that he had come to bring new light to their situation. They better understood their oppression. It is interesting to see that the *gule* members who composed these songs were able to establish a connection between the Pope's visit and the publication of the Pastoral Letter by the Catholic bishops. They looked at the coming of the Pope from Rome as being close to their own spirit world. The purpose of his visit was understood as a form of castigation proper to the world of the ancestors and was interpreted as correction of the behaviour of Malawi's political leaders. Ultimately, the Chewa viewed the Pope's visit as a unique occasion of putting Malawi at the centre of the world map. Accordingly, the world media helped the Malawian on this occasion to discover what was happening in his own country.

[1] "*Apapa wabwera e.*"
[2] "*A Yohane kuchokera kalekale, dziko likali lonse, kuno sankabwera, nanga ndi chifukwa ninji iwowa? Toto ine. Koma pano kubwera kuchikuda? Anthu kuyera maso ndipo kudzidzimuka. A Yohane mwasautsa anthu okonda mwano, obisa zinthu. Toto! Zonsezi zili poyera chifukwa cha Yohane! Zikomo zikomo Apapa athu! Chobisika chaululika, Apapa, Apapa!*"

Bambo Bushi or Luwimbi

(a red day mask from the Mua area)

Themes 1) Unity & harmony; 2) Reconciliation & mediation; 3) Development; 4) Chewa identity; 5) Relations with Christian church

Etymology Bambo Bushi derives from the name of Father (*Bambo*) Boucher, a Catholic missionary based at Mua.
Luwimbi is the name of an Ngoni chief in the Mtakataka area.

Bambo Bushi – Luwimbi is featured with a large red, orange or pink mask with black European hair, thick moustache and full beard made of goatskin. His eyes are wide open to portray a man of vision. His straight nose is that of a Westerner. His mouth is slightly open and reveals small teeth on both jaws. His strong chin makes his beard protrude. His ears are well-shaped and of normal size. The mask represents a stranger in his middle age who does not have wrinkles or grey hair. The headgear of the mask features black hair made of goatskin or can be a black wig or rags, depending on the area. The neck of the dancer is always hidden with rags of various colours.

Sometimes the mask is carved to include a piece of the neck that shows a pronounced Adam's apple. The dancer wears a tattered jute suit. He commonly carries a handbag or a branch with leaves. He performs for any occasion. As he dances, he swerves his feet with great dignity and energy. He blesses the audience.

This recent character appeared around Mua in 1986 and again in 1993. The men sing for him, *"Luwimbi, he went by plane, Luwimbi."* [1] While the women acclaim him with the following praise song, *"They say the chitenje is beautiful and bright."* [2] The name **Luwimbi** refers to the Ngoni chief who rules near Songwe, on the north of the Nadzipulu River. He belongs to Kachindamoto's aristocracy. In the past, this famous chief used to anoint the Ngoni King. The mask of **Luwimbi** was first created in 1986 and then resurrected at the end of the rainy season of 1993 in the village of Kalindiza where the chief was related through his father to Chief Luwimbi's line in Songwe. This explains the Ngoni name of the character. Chief Luwimbi's brother (Pascal Luwimbi) had a son (Selestino Luwimbi). He was well educated and was piloting a plane at Mtakataka airbase at that period. He died in 1998. The reference to travelling by plane in the song does not likely refer to Selestino since the red mask does not portray a Malawian. Selestino never kept a beard, though he did have a light complexion. The European outlook of the mask (his straight nose and his Western hair and beard) and his Ngoni name seem to be pointing at someone else in the area who is of foreign origin but is not Ngoni. These details, and the name, are part of a coded language that spells out the ambiguity of his character and his interaction with the Chewa.

Some time after its creation, the mask of **Luwimbi** was re-baptised by the villagers as **Bambo Bushi** after Fr Claude Boucher, a Canadian missionary of the Missionaries of Africa who has worked at the Mission of Mua since 1976. Boucher was sent to Mua to start an art and cultural centre later called

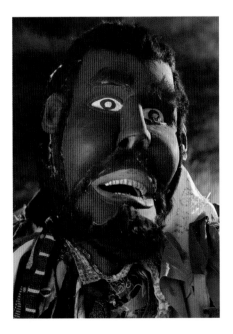

Kungoni Centre for Culture and Art. Soon after his arrival Boucher, also known as 'Chisale', was involved in training local artists and promoting various aspects of local cultures. The first years were spent setting up buildings for training and accommodation for lodging the artists who came from all over the country. Boucher is also a trained anthropologist who, after his first seven years of mission work in Dedza and Ntcheu Districts, had taken the decision to further his studies at the Gaba Pastoral Centre in Uganda (1974-75) and later at the School of African and Oriental Studies, University of London (1975-76). During the years that followed these studies, Boucher pursued his interest in the field of inculturation in religious art, catechetic and liturgy at Mua. The first two priorities were followed up through the training of the artists at the Centre and the production of culturally-based art. The main aim was to bridge the dichotomy between the Christian expression and the local culture, and this took form in various commissions produced for numerous churches throughout the country.

In the late 1960s, Chisale had already embarked on a programme of research on *gule wamkulu* in the Ntcheu and Dedza districts. He continued this research, quietly, in Mua. Throughout the 1980s, his membership in the *Nyau* society allowed him to approach informants, to conduct interviews, photograph masks and record songs from the secret society in an unobtrusive way and without officially appearing at *gule wamkulu* ceremonies. At this time, Kungoni staff and Boucher were often seen performing Ngoni dances at the Centre's celebrations. The first version of **Luwimbi** was created (1986) to celebrate the development and skill achieved and displayed at the Kungoni Centre. **Luwimbi** portrayed a chief of vision who was active at promoting people's culture and developing their wellbeing. Nevertheless, the name **Luwimbi** carried an Ngoni bias because although Ngoni dances were performed at the Centre, Chewa dances (like *gule wamkulu*) were forbidden on mission grounds. The character had a brief appearance and vanished the following year, because the character's owner had found employment away from the area.

Boucher encountered opposition in several quarters to his ongoing research into the Chewa culture and the *Nyau* in particular. Conservative Christians were wary or hostile to his activities. He and his colleagues at Mua Mission were participating in various ceremonies, including initiations, at a time when the Catholic Church had banned traditional Chewa initiation for Christians. Boucher also sanctioned the depiction of Chewa characters on the walls

of mission buildings. In 1991 the Mua School for Deaf Children was inaugurated with *gule wamkulu*. Slowly, in the face of Church uncertainty, Boucher cultivated the confidence and trust of the Chewa. As a further demonstration of faith, Boucher committed to having his Silver Jubilee celebration of 1992 include *gule wamkulu*. This was vetoed by local Church leaders but a subsequent celebration organised by Chewa chiefs for Boucher included the great dance.

Luwimbi/Bambo Bushi reappeared in May 1993 at Kalindiza village. This was concurrent with Primary Health Care programmes which involved entertainment as well as education. A *gule wamkulu* performance would conclude the day's events. **Luwimbi** was present and danced at many of the performances in 1993 and 1994. He often stood next to Boucher on the outskirts of the arena, waiting his turn to dance. It was at that period that the character was re-baptised, by the local population, as **Bambo Bushi**. **Luwimbi/Bambo Bushi** still represented Boucher as an Ngoni chief as his commitment to the Ngoni was beyond question. His commitment to the Chewa, still judged as uncertain, was seen as changing. Boucher's participation in the Primary Health Care events cemented confidence amongst the Chewa that he, and possibly the Catholic Church more broadly, were supportive of their traditions and the *gule wamkulu*. **Bambo Bushi** became a fixture at performances and was seen moving about with his handbag, in which he carried his video camera. One informant stated that in his bag, **Bambo Bushi** stored his readiness to help people who came to him with genuine complaints. Boucher documented most of the performances by video until 1994 when he took leave and departed Malawi by plane for three months. This departure by air is referred to in the song for **Bambo Bushi**.

The population saw in **Luwimbi/Bambo Bushi** a peaceful chief who fought inequalities, prejudice and discrimination between Christians and non-Christians. He was a peacemaker and a reconciler between both. His ability to make contact with and to be interested in all peoples was drawing people together, despite their differences, and making them one. **Bambo Bushi** had rehabilitated Chewa identity and encouraged them to celebrate their values proudly. For the Christian Chewa, **Bambo Bushi** was providing a deepening of faith. He gave them hope that one can be Christian and Chewa at the same time. One did not need to deny one's culture in order to become a follower of Christ.

[1] " **Luwimbi, Luwimbi** *wakwera ndege Luwimbi.*"
[2] " *Ea amati chowala chitenje.*"

Chimnomo lende

(a pink day mask from Zuze village, Pemba area)

Themes 1) Recent politics; 2) Opposing Kamuzu Banda (supporting political change); 3) Responsible leadership; 4) Promiscuity

Etymology Chimnomo lende means, 'the long hanging (drooping) lips'.

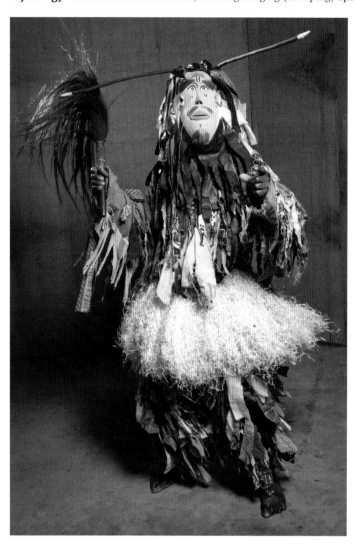

The **Chimnomo lende** character from Pemba is recent (1993). The ancient Mua version of **Chimnomo lende** (see Adapundula) represents an antisocial person who is being transformed into a witch. The Pemba version of the character was added to the Chewa pantheon in response to the political events of the early 1990s. It appeared at the frequent political rallies that were held while various parties campaigned in preparation for the referendum and general election.

Unlike the Mua mask, the Pemba version has two long (50 centimetre) black horizontal horns with white tips. The 40 centimetre mask is long and oval and has a prominent jaw. The features suggest this is a senior Chewa, with tribal marks. The eyes are small, the nose pointed, the ears tiny and the chin is exaggerated. He sports a minuscule moustache and small goatee made of Samango monkey skin. The upper lip recedes, while the lower lip droops, manifesting shyness or shame. His general expression is blank and uncomprehending. His forehead is frowning, showing that he has been contradicted or criticised. The headgear of the mask is made of black and white plastic strips. The dancer wears a tattered jute suit and carries a walking stick and a medicine tail to show that he is elderly and a person of high status. He enters the arena to the rhythm of the *chisamba*. Dancing into the crowd of women, he moves his hips as if he wishes to entice them. As they follow him, he waves his medicine tail to show that he has become their hero. At the end of the performance,

he quits the arena overcome by shame, and the women disband, leaving behind only the drummers. While the drama takes place, the men sing, *"Some keep showing long hanging lips! Who is this one? No one but the chief with his typical bad behaviour. Today he met his match, with people who do not take nonsense anymore and do not allow things to be hidden. Oh. The one who has long hanging lips, you chief,* **Chimnomo lende.***"* [1]

The song criticises a village headman, but this is a metaphor for the then leader of the nation, Kamuzu Banda. In 1993, Kamuzu Banda was encountering opposition, with the advent of a multiparty system of government. He is disappointed and thus his lower lip droops. The song's reference to "typical behaviour" refers to Kamuzu Banda's tyrannical leadership, resistance to criticism, and his refusal to share responsibility. These characteristics, also found in the Mua version of **Chimnomo lende**, explain the red or pink colour of the mask, signifying witchcraft.

In 1993, as the nation moved toward the referendum, various political parties were exposing the scandals of the ruling Malawi Congress Party (MCP). This is referred to in the song by "people who do not take nonsense anymore". Kamuzu Banda's lack of honesty is portrayed with the contrast of black and white tatters on his headgear and the black horns with white tips. His reputation has been tarnished and little white remains. His obscene dance moves and his exaggerated familiarity with women call into question his moral standing with the *mbumba*. **Chimnomo lende**'s performance concludes with him running away in shame.

Through this character, the Chewa of the Pemba area anticipated that Kamuzu Banda would run away from politics. The drooping horns express that Kamuzu Banda's reign has ended. By 1993, a desire for political change had ceased to be the exception. When measured against their *mwambo* (culture, rules of behaviour), Kamuzu Banda's behaviour had become unacceptable to the people and it was time for him to go.

[1] *"Angochita* **Chimnomo lende** *ena tate, kodi ndani amenewo tate nanga? Koma afumu. N'khalidwe lawo lija. Akomana ndi anzawo wokana bodza, osafuna kupsyinja zinthu tate oh,* **Chimnomo lende,** *afumu tate* **Chimnomo lende."**

Chipembere or Mfumu Chipembere

(a grey day mask from the Salima area)

Themes 1) Recent politics; 2) Thirst for power; 3) Opposing Kamuzu Banda (supporting political change); 4) Limits & restrictions of *chikamwini* system

Etymology **Chipembere** is the Chewa word for rhinoceros. **Mfumu** means, 'chief'.

The grey mask represents a rhino's head with human features. The forehead is unusually high and crowned with two long ears resembling those of a rhino. The nose is human-like but projects two long white horns, signifying political leadership. Low-set, half-moon red eyes express fear or awe. Near the nose, the corners of the eyes point down toward the mouth and indicate surprise. Instead of the elongated snout of the rhino, the mask features a wide, human, toothless mouth. A pink tongue as long as the nose protrudes from the mouth. No eyebrows, facial hair or tribal marks are displayed. The animal skin headgear indicates that **Chipembere** was chased away like a wild animal. The dancer wears jute trousers and a shirt, but not the customary kilt, leglets and armlets. His plain costume is not stitched with tatters. He carries a club for self-defence. He roams around the *bwalo*, chasing those who antagonise him. He defends himself during the dance with his large club by banging it on the ground. He jumps but he does not swerve his feet.

Chipembere performs at political meetings or commemoration ceremonies for deceased politicians and important village members who held a leadership role. The character of **Chipembere** was created soon after independence in 1964. The word *chipembere* is also used as a surname. Mr Masauko Chipembere was the son of an Anglican minister from Malindi village near Mangochi. He was Chewa-Yao. His mother is said to have come from the central district of Salima. Masauko Chipembere was one of the junior ministers of the new government at the time of independence. During the cabinet crisis meeting of September 1964, he disagreed with Kamuzu Banda, the first President of the new Republic. Chipembere had to resign and flee the country.

In the 1940s, long before independence, young Malawian nationalists had formed the National African Council (NAC) to break the Federation and pave the way for independence. A group of young, well educated men in their thirties – Dunduzu and Yatuta Chisiza, Kanyama Chiume, Masauko Chipembere and others – were leading the battle. They felt they needed a senior figure to give them credibility with the rural, conservative local population. During 1956-57 they called for the services of Dr Kamuzu Banda, a Chewa medical doctor, who had worked in Britain and Ghana. Kamuzu Banda accepted their proposal by joining their party and the struggle for independence. After his return in 1958, Kamuzu Banda started to dominate the political scene. He changed the NAC into the Malawi Congress Party (MCP).

After Kamuzu Banda assumed power in 1963, he realised he had little personal following among key party leaders whose loyalties were to the group of young men who had led the party in the early 1950s. Kamuzu Banda gathered an informal group of senior but less well educated men in their fifties, from the central province, who were to replace the younger ones. After independence, Kamuzu Banda became Prime Minister, monopolising power by pushing aside those who had recruited him. Divergent views were not tolerated.

On 26 July 1964, Kamuzu Banda was returning from the African Unity meeting held in Cairo. At Chileka Airport he publicly humiliated the members of his Cabinet by inviting the nation to take the future into their own hands and save the country from the machinations of "traitors who were compromising it". Kamuzu Banda was speaking about his own Cabinet members. He exhorted the people to be vigilant and scrutinise the traitors, dealing with them accordingly. After all, he alone had broken the Federation. Tensions peaked during the Cabinet meeting of 16 August 1964. Some of the Cabinet members tried to force Kamuzu Banda to modify his policies and stop his humiliating treatment and his interference in their ministries. They wanted to suppress the adulation of Kamuzu as 'saviour'. Kamuzu Banda set about destroying the opposition in his own government. On 8 September, he called an emergency session of parliament and dismissed Bwanausi, Chirwa, Chiume and Rose Chibambo. Yatuta Chisiza and Willie Chokani resigned. Chipembere, on an official visit to Canada, was called back by a cable from Chiume. He arrived on the evening of the 8th, too late for the meeting. He sent his resignation to Kamuzu Banda that same evening. Only John Tembo, a fringe member of the young graduate group, was left in office. The large crowd that gathered outside the parliament building on 8-9 September jeered Kamuzu Banda by using anti-federation songs. Instead of singing 'Welensky–zi', they said 'Banda-zi, Banda-zi' to show their support for the ex-ministers. (Refer to the entry for Weresike for an explanation of this association).

Soon after the meeting, Chipembere went home to Mangochi district and gained an immediate following. He was soon restricted to the area by Kamuzu Banda and began life on the run. His wife and family escaped to Likoma Island and then crossed to Tanzania for safety. On Kamuzu Banda's order, the party machine started to react. A reign of terror was created throughout the country in which many lost their lives, many were beaten and many fled into exile. Albert Muwalo was the executive head of the whole campaign. All the ministers, their relatives and friends left the country, except Chipembere. He stayed behind trying to organise a coup d'état, an

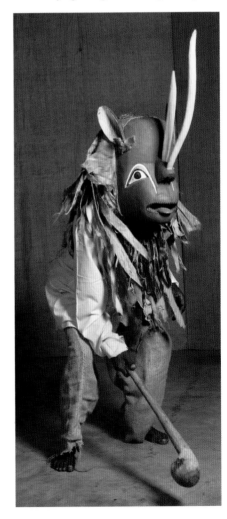

abortive attempt. Chipembere went into hiding in his father's district. He was then eased out from Zomba (with Kamuzu Banda's knowledge) through the efforts of Sir Glyn Jones, the last governor-general of Malawi, and other British and American diplomats. A small aircraft flew him to Dar es Salaam. Other members of his area who provided a hiding place for him and his family and helped them to escape were punished. Kamuzu Banda sent the police of Mangochi to burn down their houses and pour lime over their fields so no crops would grow for years. The same treatment was meted out to Chipembere's entire extended family, scattered over the country as far as Likoma Island and Salima. Kamuzu Banda's wrath was virulent, preferring Chipembere and his family dead rather than contemplate the prospect of his return as a political rival.

Chipembere died from diabetes in California in 1975, after ten years in exile. Even after his death, Chipembere's ghost seems to have haunted Kamuzu Banda until the time of his own death in 1997. A photo of Chipembere was found in Sanjika Palace in Blantyre in Kamuzu Banda's personal residence. The song of **Chipembere** transposes the conflict from the national political scene to the village level to camouflage the issue. Kamuzu Banda's grip on the country was such that Chipembere's case could not be mentioned openly in public for fear of reprisal and imprisonment. The song says, *"War! Mr Chipembere* (Mr Rhino)*! This is what has happened to you within a post in which leaders* (chiefs) *were rivals. Mr Rhino went away! This is true! Mr Rhino went away to a foreign land* (in exile). *No,* (he said) *I am fed up of being a husband (mkamwini). Let the one who stays, build!* (Stay with the leadership and lead the government in your own way!)"[1] The women

reply, *"Yes, Mr Rhino, is mad. Come back, come back! Why are you running away? He has just gone away* (but he will be back)."[2] Both songs refer to Chipembere's disagreement with Kamuzu Banda in a veiled manner. They sing about his escape but do not spell out the details since they are common knowledge. The first song prefers to twist the story talking of competition within the village hierarchy. In the end **Chipembere** is addressed as a husband married at his wife's home. Kamuzu Banda's name is carefully omitted.

The skilful disguise of **Chipembere** as an anonymous local husband or as a chief in competition with others carries a strong tone of irony and mockery. The community puts the ethnic composition of Kamuzu Banda's government under scrutiny in this way. The first song cleverly insinuates that Kamuzu Banda has surrounded himself with Chewa/Ngoni ministers or others he could manipulate. He attacks the non-Chewa and those with strong views and personalities as outsiders, epitomised in the image of a husband. The absence of tribal marks on the mask indicates they have no status or credibility. In Kamuzu Banda's Cabinet they were outsiders like the husband from another village and bloodline. Denied any position of responsibility and power, they have to show servility and submission. Once they realise they cannot put up with these limitations, they are forced to leave the family for fear of endless quarrels or even death. Here Kamuzu Banda is portrayed as the obsessed leader of the extended family group (the *malume*, maternal uncle). Acting like an uneducated villager, he rules the new government as if he was directing a family enterprise. Even a local chief would take into consideration the advice of his council! Kamuzu Banda is so afraid of his collabora-

tors' capabilities that he forces them out. The second song blames Kamuzu Banda for assuming all power for himself and refusing the advice of others. It mocks his jealousy, his paranoia and his childish fear of losing power. The women invite Chipembere to come back into the country to take over the government and challenge Kamuzu Banda's dictatorship.

The mask from Salima shows that as early as 1964, the Chewa criticised Kamuzu Banda's abuse of power in their subtle way. They denounced his behaviour as not in keeping with their own wisdom and understanding of authority and government. Kamuzu Banda's dictatorship and supremacy were understood as being above the spirit world, therefore displeasing the ancestors. The retaliations that Chipembere's family endured provided the *gule* members of Salima area with a reason for voicing the injustice of the regime even though they were committed by a leading Chewa.

Chipembere discourages such abuse of power at the local level and national level. The shameful behaviour of Kamuzu Banda is an example of vices that should be eradicated within the *mbumba* and from the village leadership. Once the *mkamwini* leaves the family group or the chief leaves the village, the door is open for strangers to manipulate the situations. Family and village can fall prey to people who thirst for power and have no interest in the well-being of the community. This message is even more pertinent when the parable is transposed to the political health of the whole nation.

[1] "*Nkhondo a* **Chipembere** *tate, ndizo zomwe mwaona tate ufumu wolimbirana. Achoka a* **Chipembere**, *zoona. Zoonadi achoka a* **Chipembere**, *kupita kwa eni ake, toto de kukakhala mkamwini tate de tsala umange.*"
[2] "*Eeae* **Chipembere** *msala (3x) bwera (3x) bwera (3x), nanga umathawiranji, wangothawa e.*"

Chipolowe

(a brown day mask from the Kaphuka area)

Themes 1) Recent politics; 2) Incitement to violence; 3) Murder; 4) Evil reaps its just desserts (*choipa chitsata mwini*); 5) Hypocrisy/split personality/duplicity; 6) No one is above the law

Etymology Chipolowe means, 'violence' or 'public unrest'.

The brown mask with tribal marks and long drooping horns portrays a prominent politician fallen into disgrace. His age is revealed in missing teeth, wrinkles, goatee and glasses. The man has numerous scars on his face to signify that he has been beaten because of his violent behaviour (indicated by the headgear made of wild animal skin). Horns mean power and responsibility. The two horns are banded in black and white.

This and their declination express moral degradation that is almost complete. The character wears a tatter suit. He carries a long knife and a club.

As soon as **Chipolowe** enters the *bwalo*, he runs amok. His presence inspires fear. He chases both men and women. He may slap some of them. His madness can extend to chasing the drummers. He swerves his feet without coordination. The men sing,

"*Some prominent people in the hierarchy are well known, as you may remember, for having killed their friends who belonged to the same group.* **Chipolowe**! *public unrest! violence! Public unrest has been seen* (all over the place). *He started it himself. Public unrest! violence! These prominent people instigate violence and then vanish. Where are they? They are locked up because of public unrest, violence, oh!*"[1]

This character was created around 1993

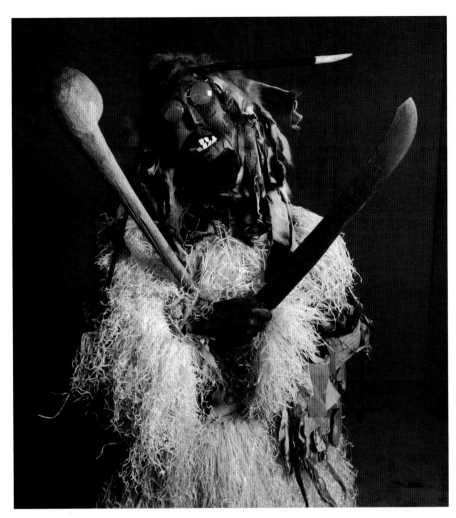

showed support for it. At the instigation of Mlombwa or other MCP officials, multi-party partisans or sympathizers were brought to the Dedza police station on several occasions in 1992. They were casually released without charge. This 'irresponsible' behaviour of the police officer in charge did not remain unnoticed. A few months later, the same policeman was ambushed at Mlombwa's residence at night and shot in the back. Mr Mlombwa was jailed as a possible suspect. He was tried, found guilty and sentenced to a life term in prison. None of his friends in high places could commute this sentence. Mlombwa remained incarcerated until 1998 and died of diabetes at home in Dedza in January 1999, soon after his release. While in prison, Phiri was severely beaten and ill treated (hence, the many scars on the mask).

Chipolowe warns people in authority that those who are responsible for implementing the law are not above the law. For the sake of peace in families, villages or governments, no one has the right to create disturbance and incite people to violence. Mr Mlombwa Phiri was responsible for violence and murder and met a very severe punishment. Indeed, one recalls Phiri's frequent use of a proverb in his political speeches: *"Choipa chitsata mwini – Evil follows its owner."* This proved to be true even for himself. Despite his wealth and his power, he could not avoid justice and the wrath of the ancestors.

[1] *"Wena, wena akuluakulu de, amalamulo, paja apha anzawo, amalamulo omwe.* **Chipolowe, Chipolowe** *zaonekazi tate apa achiputa* **Chipolowe. Chipolowe** *akuluakulu de oh, iwowo sakuonekanso, atani de e. Alowa, alowa tate e* **Chipolowe, Chipolowe** *oh."*

and only performs at political rallies. **Chipolowe** appeared in *gule* for the first time after Mr. Mlombwa Phiri was jailed. Mlombwa Phiri was the local Malawi Congress Party chairman in the Dedza District at the end of 1992. He was conducting a strong campaign against the multiparty system. Mr Mlombwa was so

dedicated to the cause of the government and the MCP that he became involved in subversive and criminal activities that he then attributed to the advocates of the multiparty system. In the local party meetings, he warned the population against the dangers of multiparty democracy and threatened those who were in favour or

Dumbo Achembe

(an orange day mask form the Mua area)

Themes 1) Nepotism; 2) Witchcraft; 3) Banda – Phiri relations

Etymology **Dumbo Achembe** means, 'the jealous Chembe'.

The red or orange mask features the face of an old man. It has a bald head, wrinkles and headgear made of rags and shreds of old blanket. Some villages replace the rag headgear with chicken feathers. The eyes are lifeless, the nose flat, the mouth caved in with no teeth. Long hair sticks out of the nose and whiskers grow at the corner of his mouth and fall down on his round chin. The character wears a tatter suit. He dances with two medicine tails. He imitates the

dancing style of Kanyoni while the men sing for him: *"The jealous **Mr Chembe**. He is jealous! He is jealous!"* [1] As he swerves his feet, he seems to chase people away with his medicine tails, sweeping them in front of him. He performs mainly for funerals and commemoration rites.

The name of Chembe is well remembered in Chewa oral history. Mr S. J. Ntara, who collected these stories in the 1940s, mentions that Chembe Banda was the

brother of *Mwali*, the spirit wife of Mankhamba (Ntara 1973). This Banda official was appointed by Kalonga (King) Chidzonzi to distribute the land that belonged to the Banda clans to the Malawi (Phiri) chiefs. In return, the recipients of land had to pay homage to their king, by offering him tributes. Chembe and his brothers Mgawi and Mphunga were the official receivers of these tributes because they were the principal councillors of the

Kalonga. Because of intermarriage between the Kalonga lineage and that of *Mwali*, Banda officials like Chembe enjoyed a perpetual kinship relation of cousin with the king and could perform the duties of councillors, and judicial and religious officials. Their relationship with him was informal. They lived in great familiarity and could tease and reprimand the king, without fear. On some occasions, they were able to enjoy the right of seizing property. Their privileged position enabled them to exercise an important check on the king's power and could, at times, provide a means of manipulating and undermining his authority. Economically, the positions of Chembe, Mgawi and Mphunga were attractive. After sending to the king his share of the tribute, they divided the remainder amongst themselves. Most of the land was to be distributed among the Malawi chiefs. Chembe's

position as first councillor and representative, acting for Kalonga, seems to have provided him with the opportunity of favouring some of his Banda family members. He sent his nephew Chimutu to occupy the land at Chirenje.

The growing economic and political influence of Chembe could have alarmed some of his Banda competitors and made them envious. Ntara (1973) mentions that, at the time of Chembe's death, the people of his villages (Dziwe and Thambani) did not want to chose a successor to his name because they were tired of carrying him in a *machila* (hammock). His position of closeness to the king, and the interest of the Malawi state, conferred a character of ambiguity on Chembe. That ambiguity was to be caricatured in *gule wamkulu*. History has shown that *gule* has been used as a powerful weapon of resistance for the Banda, in

sustaining their identity and protecting their interests. Chembe, a Banda, brother of *Mwali*, was sitting as a councillor and as acting Kalonga. He was distributing Kalonga's land to the Malawi chiefs, becoming wealthy on the tributes paid to the king for the land he distributed. Above all, he was favouring some close members of his own family group (*Chimutu*). These motives were enough to depict him as a foreigner in red and convey to him the identity of a Malawi. The *Nyau* members mocked his high position (the medicine tails) and gave him the nickname of 'Chembe the Jealous'. The character of **Dumbo Achembe** would have been created to remind him of where his true allegiances should lie and warn him about the danger of being tied up with the Malawi political system. He was profiting from his position and practising nepotism. The historical details described would suggest that the origin of this *gule* character is to be found in the early period in which the Malawi were trying to consolidate their power over the land (possibly around 1500 A.D.). The Mua area has testified to his popularity from 1914 until the beginning of the nineties. Today this character is no longer performed.

The memory of Chembe Banda has faded since the 1940s, when Ntara did his research on the oral traditions of the Chewa. With the disappearance of the elders in the villages, the younger generation of *gule* members is unable to link the character of **Dumbo Achembe** to an historical person. This character is understood as the prototype of a jealous leader who favours some privileged members of his village and family group and neglects others. **Dumbo Achembe** is often portrayed as an old man, who favours the children of his own family group and chases others away. He is an old man who lacks wisdom. He is quarrelsome, bad tempered and anti-social. His advanced age is often perceived as the result of powerful medicine connected with witchcraft. People think that he prolongs his own life by killing young children in his family group. He is responsible for their premature death. Today the character of **Dumbo Achembe** is perceived as an elder who is warning his contemporaries against practising witchcraft and antisocial behaviour. The character wants to remind elders of their old Chewa wisdom, as the proverb says: "*Mwana wa mnzako ngwako yemwe – The child of your neighbour is also yours.*" One should not show partiality or practise nepotism, as did their distant ancestor Chembe Banda.

[1] "**Dumbo Achembe** *o tate tate pali dumbo, pali dumbo.*"

Dziko lafika pa mtendere

(a yellow day mask from the Golomoti area)

Themes 1) Recent politics; 2) Muluzi/UDF; 3) Thirst for power; 4) Injustice

Etymology Dziko lafika pa mtendere means, 'The country has reached peace,' or 'The country has reached prosperity.' Following Chewa ironic pedagogy, the real meaning of this phrase is to be inverted: 'The country is in a mess.'

The yellow mask portrays a non-Chewa, a senior person, baldish with a little black hair forming a crown around his head. The forehead is wrinkled and the slanting eyes are squinting. The nose is that of a Bantu. The large cheerful mouth filled with teeth manifests a forced smile. Two small dimples border the corner of the mouth. The face lacks a beard, moustache and tribal marks. The yellow face signifies a stranger and in this case identifies him with a political party, the United Democratic Front (UDF) that uses yellow as its official colour. The ears are tiny and convey his inability to listen. The general features suggest corpulence and wealth but underneath the character is prone to be naïve and foolish. The headgear of the mask is made of baboon skins and conveys that he is a thief. Instead of carrying a staff, **Dziko lafika pa mtendere** holds up a branch with leaves, a mock sceptre.

The character of **Dziko lafika pa mtendere** is recent. It appeared around Golomoti towards the end of 2002. The character performs at any type of ritual though he shows a predilection for commemorations of funerals. He enters the arena like a whirlwind. He is assertive and militant. He swerves his feet with self-assurance and great determination, to the point of exhaustion. He jumps and swings around on one foot. He is ostentatious and showy. As he is about to close his performance, he loses his balance and weaves in a last effort before collapsing. As **Dziko lafika pa mtendere** is getting on with his vibrant pantomime, the men sing, *"The country has reached prosperity!"* [1] The women acclaim him with: *"Praise! Praise!"* [2]

The satire is both shocking and subtle. It predicts the downfall of an important and well-known personality to the villagers. He is a non-Chewa and an eminent member of the UDF party. He rules with a mock sceptre and deceives people with his broad, insincere smile and sweet talk. By 2002, President Bakili Muluzi was midway through his second term as president of the country. By then, the country had fallen prey to famine (2001-2002) and the government had done little to alleviate the situation. In February 2002, Muluzi was returning from a trip overseas. He was asked at the airport by the media to comment on the hunger situation. The President denied that there was such a problem in this country. Villagers were shocked by his comment. No food was available in the local markets at this time. People had perished as a consequence of food shortages. The villagers also knew that Muluzi's collaborators had sold the food reserve outside the country. The international aid sector came to the rescue of the village population by importing maize and providing free distribution locally. The local UDF member of parliament became prosperous but was rarely present in their community to hear the people's concern. Their Yao president was too busy trading their maize abroad to attend to their needs and develop the countryside. Already by 2002, people had their mind set on changing their president and the political party he represented. Debates on the Malawi constitution had reached the villagers. They knew, through the media, that the president was not eligible for more than two terms. President Muluzi was therefore not entitled to run for the presidency without amending the constitution. Despite this fact, Muluzi tried to manipulate himself into a third term but the opposition to this move was too strong and he had to abandon his dream.

Dziko lafika pa mtendere addresses political leaders who pretend that the land is peaceful and that their people are prosperous. Their claim is simply false and ignores the voice of the population and neglects their needs. **Dziko lafika pa mtendere** attacks leaders who are busy enriching themselves and who forget about their own people. They enjoy prosperity while closing their eyes (squinting) to the poverty, the famine and the dreadful pain that surround them. They fail to hear the outcry of the ancestors who are the voice of the voiceless. Peace can only be restored through justice for all.

[1] " *Dziko lafika pa mtendere (2×) ee.*"
[2] " *Maulemu e maulemu e.*"

Elizabeti and Edwadi

(red and orange day masks respectively from Dedza)

Themes 1) Limits & restrictions of *chikamwini* system; 2) Recent politics; 3) Aggressive-submissive relationships

Etymology The name **Elizabeti** stands for Queen Elizabeth II of England.
Edwadi stands for King Edward VII of England.

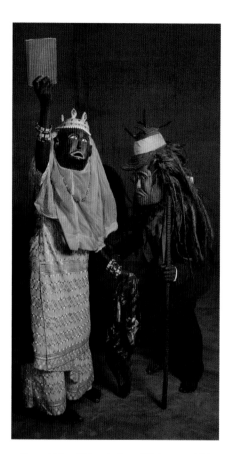

Queen **Elizabeti** is presented with King **Edwadi** as though they are wife and husband. **Edwadi** is a notional husband figure to **Elizabeti**, rather than her true husband, Prince Philip. **Edwadi**'s association with **Elizabeti** stems solely from his being remembered from his image on colonial era coins. The royal couple enters the dancing ground in full pomp. King **Edwadi** shows a weak orange face, the colour of strangers. He has small eyes, no teeth, a slanting chin and he is clean-shaven. His hair is made of sisal dyed black. He wears a black suit and a black tie. He is crowned with a five-pointed cap, like a crown. He carries a staff and a medicine tail as signs of authority. Queen **Elizabeti** shows a round, red affirmative face with large powerful eyes and a wide open toothless mouth. Her features convey a strong personality, a powerful queen. She wears a golden crown and displays all her royal jewellery. She is dressed in a full-length gown. An elaborate veil made of mosquito netting hangs from her crown, sometimes reaching the ground. She carries in her hands a book of law and a fancy handkerchief. Both characters are escorted to the dancing ground by the royal court, made up of different *gule* characters, which shake their rattles (*zilambe*) to announce their coming. The royal couple dances together, following due protocol. **Elizabeti** bows low to her husband **Edwadi**, showing submission. However, she then holds the book of law high, presenting it to the public as if it were her own. Then she grabs her husband by the jacket, to show that she is in charge.

His submissiveness and her sudden display of power betray a struggle within the royal family, with direct relevance to the Malawi context. The Chewa are a matrilineal people, where the husband moves to the wife's village (*chikamwini*). Chiefs of villages are not spared these rules. They lead their village without necessarily residing there. This is a difficult situation because they do not have a daily interaction with their councillors, who assist them in carrying out their leadership. Some councillors can take advantage of the chief's absence for their own advantage and can even seek to seize power. The husband who resides at his wife's village never enjoys the status of being a full member of that village. He is always seen as a stranger who is at the mercy of his

wife and his wife's relatives. He has to abide by their rules and has no power. This is the position of **Edwadi**, as the husband of **Elizabeti**, and as the king who resides at her home rather than at his own kingdom. He would rather have chosen to live at his own village (*chitengwa*) and rule there with the support of his blood ties, instead of hoping for support from strangers. **Edwadi** is a weak husband and powerless chief. His wife and her relatives rule him.

The example of the British royal couple provided the Chewa with a political statement about their leader. When Kamuzu Banda left England to take the leadership of Malawi, he first took residence at State House, in the capital of Zomba. Early in the 1970s, he shifted the capital to Lilongwe, where a new State House was built. This move was interpreted as taking residence at the central region home of the official hostess (Mama Kadzamira). People believed that decisions were made at her request. The **Elizabeti** song says, *"What*

kind of leadership is this (that belongs to a woman)*? Elizabeti? Elizabeti? This is why he refuses to stay at her place! Edwadi said no, but he failed to impose his will or rule over Elizabeti after he came back from England.* (She answered), *Come to my home, old man, come to my home! You can't rule in somebody else's country where you have no power base. He went with Elizabeti."*[1] The royal couple was recently introduced in *gule wamkulu*, on the occasion of funeral rites of important people, in order to show that **Edwadi** had ultimately become weak and powerless. After all, it was **Elizabeti**, the queen, who ruled the king and the country under the strong grip of her own family members.

[1] *"Ufumu wanji tate Elizabeti Elizabeti dede? Zomwe adakana kukhala kwa eni ake toto de aye Edwadi ayi, iwo adalephera kuwalamula Elizabeti, Elizabeti, Elizabeti toto de kuchokera ku Mangalande. Kwathu andala tiyeni, andala tiyeni tate, tiyeni ufumu sukhala kwa eni tate! Tiyeni tate, sakhala kwaeni tate! Kulibe maziko kwa eni tate. Adanka Elizabeti."*

Gomani and Mai Gomani

(red and orange day masks from the Dedza area)

Themes 1) Chewa – Ngoni relations; 2) Colonial period politics; 3) Chewa identity; 4) Aggressive-submissive relationships; 5) Pride/arrogance; 6) Obligation to attend funerals

Etymology **Gomani** and **Mai Gomani** depict the early 20th century Ngoni Paramount Chief Gomani and his wife.

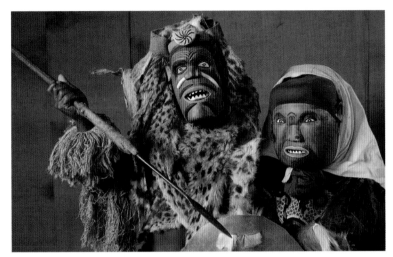

The two characters dance together as a couple on the occasion of funerals and commemoration ceremonies of chiefs and other important people. **Gomani**'s mask has a ferocious red face, with a horn across the nose and pierced ears. The eyes and the mouth bristling with teeth express fierceness. **Gomani** wears a skin head ring and a miniature gallbladder, like those that Ngoni paramount chiefs receive during their coronation. The headgear is made of genet cat skins. He wears an imitation of an Ngoni kilt (*chibiya*), made of striped layers of wild animal skins. The sporran of skins and beads completes his kilt. Two bands of leather cross his chest to imitate the bead belt of the Ngoni (*chihata*). He wears leglets and armlets and bells at his ankles (*manjerenjeza*). He carries a spear, a shield and a medicine tail. A quiver full of arrows is on his back. His wife, **Mai Gomani**, shows healthy features evident in her portly figure. She has many tribal marks, a nose plug and a soft mouth. Over her black sisal hair, she wears a black or white scarf depending on whether she dances for funerals or other occasions. Sometimes she adds a funeral band around her head. She wears bangles and a long cloth around her waist with another one attached on the shoulder and draped under her arm, following Ngoni fashion. She carries a small stick and a skin that she beats together in order to praise her husband.

Gomani vigorously and arrogantly stamps his feet in the arena. He jumps, spreading his legs far apart, mocking the

Ngoni dancing the *ngoma*. The audience is threatened with his weapons. His wife rotates around him in a very noble manner, beating her skin and bowing, and showing general respect for her husband. The men sing, *"Gomani and his wife died on the way from Domwe Mountain."* [1] The women answer, *"King **Gomani** and his wife, are never seen at funerals. Today they have been seen on the way from Domwe Mountain* (for the first time). *They were coming from Domwe Mountain."* [2]

The costumes and performances of the pair reflect the pride and arrogance of the Ngoni, who ruled the Dedza and Ntcheu districts under Paramount Gomani I in the late 19th century. Before the Ngoni appeared, the land belonged to the Chewa. The songs identify the Ngoni with the Domwe Mountain, the place of their arrival from across the Zambezi River before their dispersal to other parts of the central region. In 1894, the British entrusted much of the central region to Gomani, to be his zone of influence. He was killed by the British in 1896 for plotting against British interests and his son, Gomani II, was not allowed to succeed him until 1921. The British feared that the son was plotting a rebellion as his father had done. The colonials forced the Ngoni to locate their capital at Mpira, near Ntcheu, so their activities could be monitored. It was not until after the First World War that the Ngoni were allowed to shift their capital to Lizulu, in the midst of Chewa country. While Gomani inherited the throne of his father in 1921, his position

as Paramount was not officially recognised by the British until 1933. A Christian, Gomani banned *gule wamkulu*. The Chewa never accepted this and continued to resist and claim their rights that were officially granted under the leadership of Kamuzu Banda after independence. One of the songs expresses Chewa resentment over the issue of funerals: *"King Gomani and his wife, you never see them at funerals."* Following Ngoni laws, the king is forbidden to attend funerals. The only funeral he attends (in the song) is his own. *"They have been seen on the way from Domwe Mountain."* The song emphasises the contrast between Ngoni and Chewa customs over the obligation to attend funerals. The Chewa chief does while the Ngoni chief does not. The Chewa were forbidden the involvement of *gule wamkulu* at funerals, while the Ngoni conducted affairs with their *ngoma* dance. The Chewa protested against such intrusions by creating the *gule* characters **Gomani** and **Mai Gomani**. Through these characters, they objected to the rule of an Ngoni king and protested against the interference with Chewa culture. Strangers are welcome in Chewa country provided they behave as guests. They should not impose their wishes or threaten Chewa culture. Even an Ngoni king can be tolerated, provided he is not arrogant or proud and is willing to make compromises with the owners of the land. He must not treat them as slaves. The *Nyau* reaction to **Mai Gomani** is definitely more positive than that to her husband. The Ngoni women showed more submissiveness in a patrilineal society, as is evident in the **Gomani**s' dance. Ngoni women were not very involved in politics and their position was secondary in village life compared to the Chewa. The Chewa men (who live as strangers in their wives' villages) showed great admiration and envy for the way Gomani was treated by his wife. They wished that their own wives would show the same submission and respect. Thus **Mai Gomani** is praised for her exemplary behaviour in public.

[1] " *A **Gomani** ndi akazi awo tate de adafera m'njira ya Domwe (3x)."*
[2] " *A **Gomani** ndi akazi awo dede saoneka m'maliro. Lero aoneka e (3x). Lero aoneka tate de achokera ku Domwe."*

John watchyola mitala

(a red day mask from the Mua area)

Themes 1) Colonial period politics; 2) Supporting Kamuzu Banda/MCP; 3) Good of the community; 4) Compassion towards women; 5) Polygamy; 6) Determination

Etymology John watchyola mitala means, 'John, the breaker of polygamist marriages'.

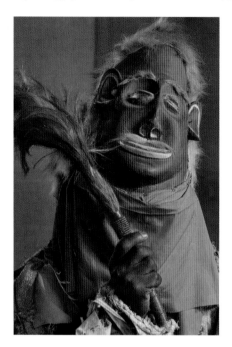

John watchyola mitala is seen as a variation of the Kalumbu and Simoni characters. The red mask is elongated, narrow with both European and African characteristics. The forehead is wide, tall and straight. The ears are prominent. He has a moustache. His hair is made of a thick baboon skin that falls along the back like long, European hair. All these details stress John's foreign origin. In contrast, the African features include a nose that is wide and short, protruding cheekbones and thick, heavy lips displaying a broad and contented smile. The eyes are fringed with hair for eyelashes. The neck of the dancer is covered with a red scarf. John wears western clothes, usually a nice clean shirt and a fashionable pair of trousers. He carries two medicine tails, to show his pretensions to power and authority. His performance resembles that of Simoni. However, instead of pointing his finger to the sky, he raises his medicine tail while swearing to God that he will succeed in breaking the unhappy marriage of his cousin. The song that the male choir sings for him is different from that of Simoni. They say, *"He broke a polygamist union,* **John!** (He is disconsolate: what is he going to do with the land?). *Since he left, he broke a polygamist union!"* [1]

The mask portrays a successful worker who left the country and returns after many years with large sums of money and great fame. His ambition is to marry his cousin and start a family. When he returns, he finds that his beloved is already the third wife of a well-known polygamist who is unable to provide for his three wives. To his horror, **John watchyola mitala**'s former girlfriend is suffering the most. Secretly, he courts her. **John** breaks the unhappy polygamist family, marries his love and cares for her tenderly.

The story of **John watchyola mitala** is a parable about Dr Kamuzu Banda, who returned to Malawi in 1958 and broke Malawi free of the polygamist 'British marriage' manifested by the Federation of Rhodesia and Nyasaland and led the nation to independence in 1964. In August 1951, the first meeting to explore the feasibility of the Federation was held at Victoria Falls. In general, Africans were strongly opposed to it, as they were afraid of losing their land. The mere act of holding a meeting was viewed as an endorsement of Federation. Though African discontent provided a major obstacle, the British were convinced that Africans would accept the Federation once the details were worked out. Despite the complete opposition of the Nyasaland representative, the Federation was imposed on 1 August 1953. African political power was decreased, taxes were increased, social discrimination was introduced, and selective partnership was practised. Educational facilities for Africans were inadequate and unequal in relation to 'white' schools. Nyasaland was not advantaged and was arguably worse off than before the Federation. Little was done in the way of improving direct representation of the people.

As years passed, African discontent became more open in its denunciation of the situation. With the return of Dr Kamuzu Banda in July 1958, people saw an opportunity to force the issue. The Nyasaland African Congress (NAC) proceeded to embark upon a campaign that was to lead to complete independence within six years, much sooner than the British had expected or wished. Tension was high and violence was anticipated. The Prime Minister of Southern Rhodesia declared a state of emergency in February 1959. Governor Robert Armitage proclaimed the state of emergency in Nyasaland in March 1959, arresting 208 NAC members, including Dr Kamuzu Banda, during 'Operation Sunrise'. Twenty NAC leaders were killed at Nkhata Bay. The Devlin Commission was appointed to investigate the reasons behind these events. The commissioners judged the Nyasaland population to be not inclined to violence and came to the conclusion that the Governor had employed 'unnecessary' force.

Despite the widespread opposition to the Federation, it was maintained by force until Ian Macleod was appointed Colonial Secretary. Macleod felt that his role was to work himself out of his job. He deliberately accelerated procedures that would lead to an independent Malawi. The criteria for independence revolved around choosing an indigenous political elite, possessing some degree of political support, even if Macleod did not consider Nyasaland fully prepared for independence. Macleod's first task was to arrange for the release of the detainees still being held by the authorities. By April 1960, almost all the detainees, including Dr Kamuzu Banda, had been freed. Macleod then moved on to revise the constitution. The conference at Lancaster House in London in July and August 1960 helped create an agenda promising that Africans would have a government characterised by solid representation, direct democratic elections and an African majority in the legislature. It was also recommended that more Africans be trained for civil service. The issue of Nyasaland's relationship with the Federation was judged outside the scope of the conference.

In August 1961, a year after the conference, a series of elections was held in Nyasaland. The Malawi Congress Party, successor to the NAC, achieved an outstanding victory. In the following years, Kamuzu Banda and his party continued to voice their opposition to Federation. In 1962, after several meetings held in London on this issue, it was accepted that Nyasaland could secede from the Federation. Kamuzu Banda had achieved his goal. In February 1963, he became Prime Minister. A year later, in July 1964, Dr Kamuzu Banda brought the independent nation of Malawi into being.

Through the mask of **John watchyola mitala**, Kamuzu Banda is viewed as the hero, who, because of his western educa-

tion and his long stay in Britain, was able to disguise himself amongst the British (the red) but is nevertheless a true African from Nyasaland. He comes back to his homeland to chase the British away and take the country for himself – the recurring story of Kalumbu. He frees the country from a useless union and leads his people to development and prosperity. He leaves the two other countries (modern Zambia and Zimbabwe) to continue their unhappy mar-

riage with Britain. The character of **John** celebrates the courage of Kamuzu Banda and his determination in breaking the Federation. He manifests great compassion in delivering his people from suffering and poverty. At the village level, the character of **John** invites the Chewa to show compassion towards women. It argues against polygamy, insisting that it is wrong to pretend that one can care for many wives when one does not have the necessary eco-

nomic security. Furthermore, one simply cannot love all of the wives equally. As with all of the variations of the Kalumbu – Simoni character, ambition exceeds the individual's ability to nurture properly what is conquered and controlled.

[1] " ***Watchyola mitala** de iwe de de iwe tate **John** iwe, chimkire maye iwe tate, **Watchyola mitala**.*"

Kalumbu

(a black, red or brown day mask from the Dedza area)

Themes 1) Danger of ambition; 2) Rivalry for authority; 3) 'To be' versus 'to have'

Etymology Kalumbu is the name of a chief of the nineteenth century, meaning 'Mr Harp'.

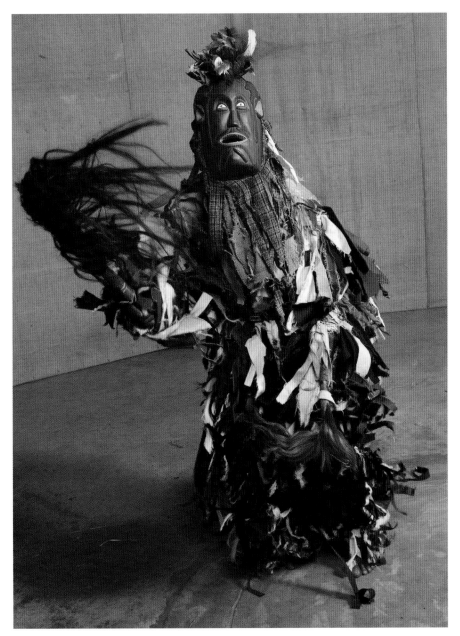

The Mua area has three names (**Kalumbu**, Simoni and John watchyola mitala) to identify an evolving character, indicating that he has undergone a long historic metamorphosis. The Dedza region represents **Kalumbu** and Simoni as unique characters and John watchyola mitala is depicted as a variation of Simoni. The description here is of the Dedza **Kalumbu**; Simoni and John watchyola mitala have separate entries.

In Dedza the **Kalumbu** mask is black or a dark reddish-brown. It depicts an older chief with a pronounced receding hairline. The aggressive nature of the face is embellished by a cruel expression. **Kalumbu**'s face is distorted because of his greed for power. The eyes are small and piercing, the nose broad and strong. The slightly open mouth has teeth missing from the lower jaw and looks hostile. He has a trimmed moustache and a tiny, inverted, v-shaped beard on the chin reinforces a look of arrogance. The headgear made of rags topped with a fan of feathers reminiscent of Ngoni headgear (*nyoni*). The feathers are loosely affixed and flap wildly onto the forehead. This indicates he is a weak chief of questionable moral character. He is more concerned with his personal pursuit of power than the well-being of his people. **Kalumbu** wears a jute suit (sometimes covered with rags) and a large belt. He carries medicine tails, to rebuke what may be legitimate challenges to his authority. Since he is a usurper with no respect for boundaries he intrudes into any type of ritual. **Kalumbu** dances with a great intensity and impressive stamina. Determined to push others out of his way, he swerves his feet and jumps fiercely on one leg. He moves his arms and shakes his medicine tails threateningly, to chase people away from his land, as all land is his own. During the dancing the men sing a variety of songs relevant to issues of land dispute and ownership.

The name of **Kalumbu** has a significant historical lineage. Kalumbu Mwale, born Chidamphamba, rose from undistinguished origins to become a chief. Before enthronement, Chidamphamba lived at a place called Nthumbo, close to the lakeshore south of Golomoti. His relative, Kaziolo, asked him to occupy the land of Dembo Nkhoma, the son of Chadza. Dembo had married Kaziolo's sister, who was a spirit-wife and thus should not have taken a human husband. Dembo violated the social code and had intercourse with her, which led to her death. Dembo was forced to abandon his land and cede it to Kaziolo in compensation for the death of his sister. For unknown reasons, Kaziolo passed the land to his relative, Chidamphamba, who was only too happy to be enthroned under the name of Kalumbu ('Mr Harp'), thus taking authority over the people of Dembo. This derogative name implied that Chidamphamba was a chief of no significance who rose to power from unknown origins. Indeed, Kalumbu became a minor chief under Chadza's authority. He ruled the land adjacent to that of a chief named Mazengera. Kalumbu re-baptised his new territory with the name of Nyanja, meaning 'the lake'. Several songs from the male repertoire for the character emphasise his eagerness to expand his territory: *"**Kalumbu** is fighting for the land as if he had power* (horns). *No, **Kalumbu**, No!"* [1] Or, for those who may have taken advantage of Kalumbu's ambitious plan, *"For me I will sleep at your village, **Kalumbu** **Kalumbu**!"* [2] A third song takes a more jeering tone, *"**Kalumbu**, why so much hurry? Your heart is full of jealousy. **Kalumbu**, why so much hurry?"* [3]

In the mid-nineteenth century, Kalumbu began developing a commercial link with the Bisa and Chikunda. These traders assisted him to withstand an Ngoni invasion, by helping to build strong fortifications around his village. The Ngoni chiefs, Chiwere Jere and Gomani Maseko, had recently settled in the centre of Malawi and were struggling to overcome Kalumbu. These efforts failed owing to his impressive fortifications. Oral history remembers that both of these Ngoni chiefs ultimately developed links of friendship with Kalumbu. In an unfortunate turn of events for Kalumbu, the friendship with Gomani came to an abrupt end. During an official visit, twelve emissaries of Gomani, guests of Kalumbu, were mistaken for spies and murdered by Kalumbu's elders. Gomani sent a large army to retaliate. Gomani's army succeeded in forcing Kalumbu out of his country. Kalumbu and his people sought protection with the Chiwere Ngoni of Dowa where they remained until the arrival of the colonials. After *Pax Britannica*, Kalumbu would have returned to Nyanja, to reoccupy his land, but found that his neighbour Mazengera had extended his kingdom into Kalumbu's domain.

Mazengera himself had obtained his chieftainship from Chauma who controlled the rain shrine of Chauwa on the Linthipe River. The Ngoni had been unable to defeat Mazengera in the Nkhoma Hills. Success in battle earned Mazengera the reputation as an important and powerful chief in the beginning of the colonial days.

Kalumbu needed to fight in order to reclaim ownership of Nyanja. Three other songs sung by the men record this period in Kalumbu's history: *"**Kalumbu**, yes **Kalumbu**. What does he want to do with the land that is also disputed by Mazengera? **Kalumbu**, **Kalumbu**."* [4] Or, *"**Kalumbu**, **Kalumbu**. What do you want to do with the land that already belongs to Mazengera? **Kalumbu**, **Kalumbu**."* [5] In a final song, Kalumbu's position with regard to the land is made clear: *"**Kalumbu**, **Kalumbu** refused to go to the court of Mazengera."* [6]

All the supporting details of the mask – the costume, the songs, the style of the performance – come together as evidence of Kalumbu's unwavering ambition. Through questionable acquisition of land, Kalumbu believes he will become a powerful chief. The *gule wamkulu* character of **Kalumbu** warns members of the community against plotting to become more important than their status by birth. The character of **Kalumbu** also questions the method by which his objective was achieved. His single-mindedness to possess land and power ignores completely the qualities valued by the ancestral wisdom.

[1] *"**Kalumbu** alimbira dziko ngati ali nyanga. Toto **Kalumbu** toto."*
[2] *"Ine ndidzagona kwanu **Kalumbu** … **Kalumbu**."*
[3] *"**Kalumbu** liwilo de (2×) ndiwe mtima wa nsanje! Liwilo a **Kalumbu** (2×)."*
[4] *"**Kalumbu**, inde **Kalumbu**. Amati alitani dziko o tate? Lomweli la Mazengera e a e **Kalumbu**, **Kalumbu**."*
[5] *"**Kalumbu**, umati ulitani dziko, dziko la Mazengera ae **Kalumbu**?"*
[6] *"**Kalumbu** e **Kalumbu** adakana ku bwalo la Mazengera. **Kalumbu** e **Kalumbu**."*

Kanyoni or Njaule or Pope

(a red, orange, yellow or black mask from the Mua area)

Themes 1) Colonial period politics; 2) Chewa identity; 3) Abuse of power; 4) Promiscuity; 5) Recent politics

Etymology The name **Kanyoni** derives from Henry Kenyon Slaney, the British District Commissioner (DC) in Dedza from 1929 to 1931.
Njaule means, 'to rejoice'.
Pope is a pun on hunting dog (puppy), as is explained below.

The character was created around the period of Henry Kenyon Slaney's administration to voice the conflicts that existed between the *Nyau* secret societies and the colonial government. Slaney's position brought him to the Lake Malawi plains and the Mua area regularly. He implemented government policies, collected taxes, punished defaulters and wrote reports to the colonial office. These roles made him unpopular. In addition, he had a reputation for being quick tempered, quarrelsome and intransigent in his duties concerning the government programme to reform *gule wamkulu*. He imposed a strict 10 shillings fee on each *gule wamkulu* performance. Slaney sent his messengers to collect the drums of the villagers, and apprehend the dancers and any others who broke the law. He is reported to have jailed them and fed them with grass instead of *nsima* because he considered them wild beasts (*zilombo*) and

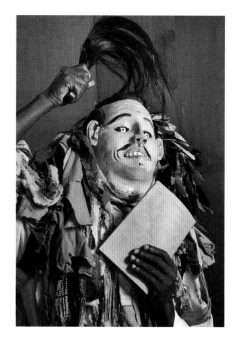

not humans. For these reasons **Kanyoni** is also known as **Pope** (Puppy), the hunting dog, the hunter of *gule* dancers, as it is expressed in the song sung by the men, *"Pope, Pope, Pope catch game!"* [1] He slaps villagers, and even corpses, that he says avoided paying hut taxes. Members of *Nyau* portrayed him in red, orange, yellow and even black masks with a tuft of hair (feathers) hanging on the forehead. They dressed him in European clothes and gave him a medicine tail as a sign of authority and castigation. He carries a book to read the government laws and to write down the names of the defaulters. The dance movements are suggestive of a sexual predator. The character probably showed more aggressiveness when it was created than it does today, though the dominant tone is one of ridicule. **Kanyoni** mocks an authority that implements inhumane and arbitrary laws. **Kanyoni** is described as a trouble-maker and an arrogant leader. He is an enemy of Chewa culture. **Kanyoni** reveals the antagonism between the two systems of authority and leadership. He identifies the threat of the colonials and the missions.

After independence, **Kanyoni** became identified with Kamuzu Banda, the new ruler of Malawi. His European clothes signify development, education and an example of proper leadership to be imitated. However, his character continues to be ambiguous. His bad temper, thirst for power, pride and arbitrary authority were expressed in a recent song from the Golomoti area: *"You **Kanyoni**, you **Kanyoni**, what did you do with Chief Chinyama* (big game)? *You were confined for six months in jail, yes **Kanyoni**, in jail."* [2] The song refers to the detention of Kamuzu Banda in Gwelo prison (Zimbabwe) at the time of the Federation of Rhodesia and Nyasaland . The song implicitly voices that although Kamuzu Banda broke the federation and won the independence of the country, people were not better off. Kamuzu Banda behaved like a dictator. Moreover, his abuse of authority was coupled with loose behaviour and a tendency to snatch other men's wives. Another song of **Kanyoni** annunciates this beautifully, *"There are plenty of hens, oh rejoice* (**Njaule**)*!"* [3]

The Dedza area has a **Kanyoni** character of a very different presentation and meaning (refer to that entry).

[1] *"Pope pope pope wagwira nyama!"*
[2] *"Kanyoni iwe (2×) unakatani kwa mfumu a Chinyama, myezi sikisi kukhalira kuseweza tate de ku jele Kanyoni iwe ku jele."*
[3] *"Tate e tate e pali msoti oh Njaule."*

Kapirikoni

(a yellow or orange day mask from the Mua and Kapiri areas)

Themes 1) Recent politics; 2) Cynicism about politics; 3) Hypocrisy/split personality/duplicity; 4) Lies, trickery & deception

Etymology **Kapirikoni** is a deformation of Capricorn. The word was originally used in the political context of the Federation of Rhodesia and Nyasaland. The term mocked those who were pro-Federation. Subsequently the name Capricorn was adopted by President Kamuzu Banda to discredit his own political enemies. Later, the villagers borrowed the word to describe liars and people who propagate conflicts within the community. In the context of *gule*, **Kapirikoni** qualifies Malawians who have no real political allegiance and shift from one party to the other.

The large 40 centimetre yellow mask features a person with a double face and dual political allegiance. This is rendered by the double physiognomy portrayed on two sides of the mask. The top of the head is adorned with a black goatskin as hair for both faces, each being equipped with its own set of ears. **Kapirikoni** looks forward and backward so that one cannot tell whether it is coming or going. Similarly, the dancer's movements forward and backward accentuate the imbroglio. The persons featured on both sides are of middle age though they show no moustache and no beard. The expression of the two faces varies: one is cheerful, the other sad. On the cheerful side, the face is youthful; arched eyebrows, naïve eyes (made of silver paper and resin), straight western nose, protruding lips and chin with a reserved smile. The headgear below the smiling face is made of yellow tatters of United Democratic Front cloth, identifying it to the UDF party. On the sad side, the face displays heavy wrinkles, descending eyebrows, dull eyes, a similar nose to that of the other side, pointed chin and drooping mouth. The headgear below the sad face is made of red, green and black tatters from the Malawi Congress Party cloth. The initial colour of the mask was red. Later, it was changed to yellow. In some areas it is portrayed in orange. The change of skin tones manifests also a shift of political allegiance. **Kapirikoni** dresses with tatter shirt made of the MCP colours and his trousers are by contrast tattered with UDF cloth. The dancer carries nothing to the arena.

In the *bwalo*, **Kapirikoni** moves forward and backward following the rhythm of the *chisamba* and shifting directions suddenly. He swerves his feet tenaciously and moves with perseverance as the male choir sings for him the following: *"What makes you behave like this, **Kapirikoni**?"* [1] The song highlights **Kapirikoni**'s ambivalent physical appearance. Both his speech and his look convey that he is committed to more than one party. He shifts from one to the other like he changes shirts and trousers.

The character of **Kapirikoni** is recent in the *gule* rituals. He was introduced in 1994 after the UDF party had won the general election. In 1993 already, the year of the multiparty referendum, villagers were defecting from the MCP party in order to join the UDF and the AFORD parties. The character of **Kapirikoni** was introduced in any type of ritual, including party meetings. At its beginning, **Kapirikoni** showed a strong MCP bias as it was deterring villagers from shifting their allegiance to other parties. This was the first function of **Kapirikoni**. Later, when the popularity of

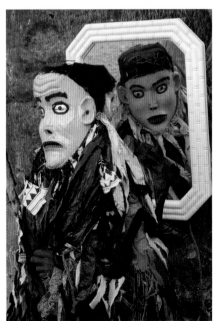

the UDF party and the government started increasing, **Kapirikoni** rallied behind the ruling party and the UDF. This would explain the shift from the red colour of the mask to yellow. By then, the function of the mask had changed. It emphasised the necessity of sticking to only one party, the UDF, and to be committed to it. It ridiculed people who embraced all parties and were changing skins like the chameleon or showing a double face like the Capricorn.

With time and political changes in the country, villagers were more and more exposed to politicians and ministers changing political affiliation and parties. They soon came to the conviction that their polit-ical leaders were less and less driven by strict political motives but had become opportunists; they followed their own per-sonal interests and the pursuit of power instead of the well-being of the nation. A decade later, **Kapirikoni** had practically disappeared from the arena and deserted Chewa rituals. It did not attract the popu-larity it had under Bakili Muluzi's reign. With the registration of more than thirty parties and their various coalitions for the last presidential election of 2004 and the success of President Bingu wa Mutharika who left the UDF party and started his own, the Democratic Progressive Party (DPP), villagers have been taken aback on the issue of party affiliation and loyalty. People in the villages were now able to recognise how deceitful manifestoes and party promises can be. They were also able to realise how short-lived parties may be. They saw in **Kapirikoni** the individual, group or party that set people against each other through lies and deceit for selfish ends. Such a person or group was to be feared as a threat to the community. **Kapirikoni** had turned orange, neutral, as it had become ridiculous to lay down one's own life for the sake of any party at all.

[1] "*Kapirikoni iwe tate, ukuyenda bwanji kuti udzitero Kapirikoni?*"

Madzi adalakwa

(a red day mask from the Mtakataka area)

Themes 1) Chewa – Ngoni relations; 2) Chewa identity; 3) Recent politics

Etymology **Madzi adalakwa** means, 'The water (the lake) did wrong.'

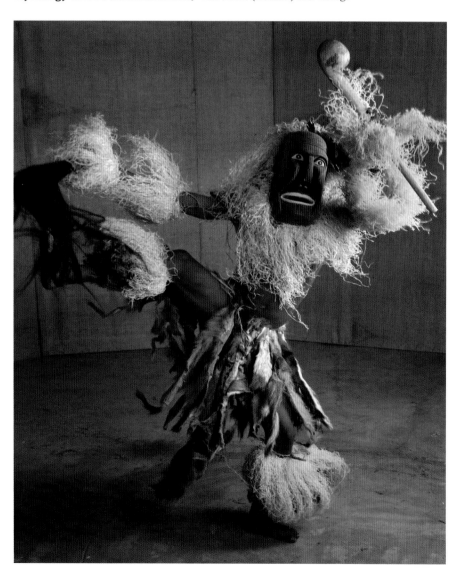

This large red mask portrays a stranger. It has an angular face with large fierce eyes, a square nose and a very wide mouth. The mask has neither beard nor moustache but displays distinct tribal marks and wrinkles. The headgear is made of heavy white strips from fertiliser bags, with an elaborate bunch of feathers standing erect on the head. The feathers recall the Ngoni head-dress (*nyoni*). The dancer wears a kilt, armlets and leglets made of the same fer-tiliser bag material. An alternative costume consists of a tattered *gule* suit. **Madzi adalakwa** carries a medicine tail and a club. These details stress that he is an Ngoni conqueror, who has come to wrest political power from the Chewa. He swerves his feet pompously while the male choir sing: "*The lake did wrong.*"[1]

The Maseko Ngoni, under Chief Kachindamoto I (nicknamed Dzinthenga, 'the big feathers'), moved into the country near the lakeshore around 1894. Kachindamoto had raised an army of merce-naries and was trying to usurp the throne of his cousin, Gomani I, who chased him down towards the lakeshore between the Ngodzi and Nadzipulu Rivers. In 1894, Chimbalanga, son of the last Chewa Kalonga Sosola, welcomed Kachindamoto to the lakeshore and provided him with land to settle at Mtakataka. Kachindamoto was desperately regrouping his forces and wanted to counter-attack his cousin Gomani. He asked the British for help. They were only too eager to settle the problem but without bloodshed. On 12 November 1894, the two Ngoni leaders were forced by the British to make peace with each other near

Masasa. The British solved the tribal war by granting Gomani and Kachindamoto their respective zones of influence. Gomani was to occupy Ntcheu while Kachindamoto was given part of Dedza and the lakeshore. He was to rule near Mtakataka over the entire Chewa population. The Chewa had lost their last king Sosola around 1870, after a long history of *Mwalis* and *Kalongas* dating back to 800 and 1200 A.D.

The Chewa never acquiesced to the imposition of an Ngoni ruler over them, although they had lost their political and religious authority. During the subsequent period, their culture was put under severe pressure. The Ngoni would interfere with their practices of *gule wamkulu*. The character of **Madzi adalakwa** was created as a protest against the foreign leadership of the Ngoni. This is why this mask is red. The dance and the aggressive look of the character and his weapons express this protest.

During the colonial period, the Ngoni ceremonial dress used for the *ngoma* increasingly influenced the *gule* costumes. The Ngoni Paramount often made coalitions with the Mua (1902) and the Mtakataka (1908) missionaries. Missionaries often challenged the great dance and counted on the Ngoni kings to support them.

Through the character of **Madzi adalakwa**, the Chewa claim their traditional rights. They have lost their spirit wives (*Mwali*) and their own Kalonga kings. *Gule wamkulu* was one of the few institutions that gave the Chewa cohesion and a sense of identity. Kachindamoto's rule was seen as an impediment to their own freedom and practice of culture. Open resistance was impossible, since Ngoni authority had been imposed by the colonial powers.

Around the 1950s, the Nadzipulu River started changing its course and disturbed the Mkosini (the Ngoni royal village) and

its protective ring of Ngoni villages. All the Ngoni villages were impacted by the floods and had to move to higher ground, settling among the Chewa. The two ethnic groups living in close proximity to each other exacerbated the tensions between them, and conflicts increased. After independence, the Chewa continued to live in hope that their Kalongaship and Mwaliship could be re-established. Soon after Kamuzu Banda was proclaimed President of Malawi and started imposing his dictatorship, the Chewa realised that they had to abandon their dream. They kept up the protest through the intricate and hidden corridors of *gule wamkulu*. Again 'the lake did wrong'. It sent a more powerful leader, a Chewa like them, who would not allow any rival king to exist beside him. He was putting an end to their hopes of a traditional renaissance.

[1] *"O, de tate de **Madzi adalakwa** (4x)."*

Makanja or Titilande or Kananjelezi
(a day character from the Mua area)

Themes 1) Protection; 2) Success in marriage; 3) Faithfulness; 4) Fertility; 5) Care of the sick; 6) Privacy for parents; 7) Chewa identity; 8) Dangers of modernity; 9) Colonial period politics; 10) Recent politics

Etymology Makanja derives from *kanjanja* meaning 'short clothing that does not cover the legs completely' or *kanja* meaning 'to jump'. Kananjelezi comes from *ka* meaning 'small' and *njeleza* meaning 'lime' or 'to be white'. Titilande comes from a contraction of *'Tiyeni tilande'*, which means, 'Let us snatch (the land) (the owner is gone).'

These characters exemplify the common Chewa approach to ironic pedagogy in showing the effects opposite to those desired. Similarly, use of the diminutive in one name belies their exceptional height. These names refer to three Kapoli danced on stilts that are seen as one character today. Elders testify that **Kananjelezi** is the most ancient of the three. **Makanja** derives from the earlier **Kananjelezi** and only appeared in the 1930s. It took on a more political tone

with regard to the colonial government. Formerly they were dressed with a head cover made entirely of bird feathers, to evoke the spirit world. Today a variety of helmets are designed, made of jute, cloth and feathers. Sometimes details like eyes, mouth, nose and ears are added to the face. The hair is sometimes made of sisal or feathers can be added as a wig. The **Kananjelezi** of the past used to be completely white and was made of material like

palm leaves for the night performance and white cloth for the day. The costume of **Makanja** today consists of a tattered suit of any colour covering the entire body including the stilts. **Kananjelezi** used to be taller than the present **Makanja** character. His stilts could reach up to two or three metres high, while those used by **Makanja** today are barely a metre high. Usually these characters carry a bell and a medicine tail. **Kananjelezi** used to whistle when he

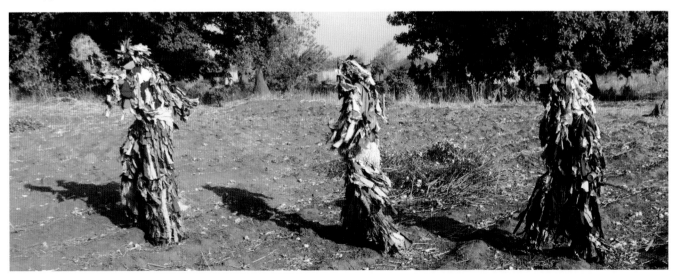

moved among the crowd. The whistle warned the people of his approach so that nobody would be hurt. With time, a bell replaced the whistle. The medicine tail (originally containing medicine) had the purpose of cleansing the ground, removing evil influence and protecting the dancer against falling. The stilts were so tall that a fall would injure or kill the dancer. He could not be mourned because of the secrecy concerning the dancer's identity. In the past, these dangerous performances were only executed after a period of sexual abstinence. The medicine tail nowadays has become an emblem of status rather than protection, since the dancer performs closer to the ground. Many performers have now specialised in falling on purpose and standing up again on their stilts in order to show their skill. **Kananjelezi** used to walk about the arena, jump and swerve his stilts as he would do with his feet. In contrast, the performance of **Makanja** today follows the *chisamba* rhythm. It shows a predilection for the swerving of the stilts and a moving of the hips while dancing. At the end of the dance, **Kananjelezi** used to jump and show reverence to the audience at the sound of the *mbalule* drum alone (*kuyangala*). **Makanja** has copied this. **Kananjelezi** mainly performed at night during funerals, commemorations and initiation rites. **Makanja** can appear during similar occasions but performs particularly during daytime, taking advantage of the better light conditions and minimising the risk of accidents.

Elders say that in the past **Kananjelezi** sang his own song instead of it being sung for him, as it is for **Makanja** today. He also had a repertoire of his own. **Makanja** has borrowed some of his songs. One of his oldest songs says: *"Bad luck is at the feet, wait and see for yourself that bad luck is at the feet."* [1] The women answered, *"Kananjelezi was the father of children* (he died from falling).*"* [2] **Kananjelezi** is portrayed in the songs as a protective spirit who warns the dancer about the danger of falling. Any round object like a stone or a maize cob could bring him down and be fatal for him. Because of his height **Kananjelezi** was also seen as the spirit of important people and the spirit of foresight. He played the role of *namkungwi*, a wise instructor who warns the initiates and others about the danger of unfaithfulness in marriage. He advised the women saying, *"Come, come, men are calling you. Come, come, tell her that she should come first,"* [3] or *"Kananjelezi, don't snatch someone else's husband."* [4] He also exhorted the men, *"I am going to reveal* (what my husband gets up to). *My dear, I found him having sex* (with another woman). *They had just finished."* [5] **Kananjelezi** also gave practical advice favouring success in marriage, *"You there! he encountered an earthquake, oh!*

he was carried away (by sexual pleasure)! *I found the woman to carry me."* [6] In metaphorical terms, the song teaches that a wife has to co-operate with her husband during sexual intercourse. *"When your husband is sick, take him back to his family group."* [7] This means that the sickness of her husband should be reported to his own family members, so that they can also care for him. During the girls' initiation, **Kananjelezi** used to escort the girls to the dancing ground with the following song, *"White, white, white, here he comes behind,"* [8] or *"White, white, white, initiates are like unto Jere."* [9] The songs talk about the initiates who are preparing themselves for marriage. Both Jere and **Kananjelezi** stand for white, meaning a good future husband who will be potent and righteous. Before closing the initiation **Kananjelezi** gives a last advice to the initiate, *"Don't go to your parents' bedroom, you will find them having sex."* [10] The initiates have now discovered sexuality, they should show their parents respect and not intrude into their intimacy. The exceptional height, the foresight and the bird-like head of **Kananjelezi** conferred on him the role of a protective spirit, a wise guardian who puts all his skill and concern into giving good advice to the younger generations, preparing them for happy married life. When **Kananjelezi** is performed for the burial of senior people, he accompanies them to the spirit world with due respect to their rank.

The character is also called **Titilande**, which derives from his favoured song, sung for him by the men: *"He hasn't come back home, Titilande, tall like the blue gums of Zomba Mountain. He hasn't come back, Titilande."* [11] The song talks about a man who went to seek employment or join the army in Zomba and never came back. He most likely died there. The name **Titilande** comes from a contraction of '*Tiyeni tilande,*' which means, 'Let us snatch (the land) (the owner is gone).' Other people connect the word to England, as a reference to the British. Further reference is made to being tall like the blue gums, which surround the Governor's State House and the government administrative buildings on the slopes of Zomba Mountain. Zomba was the centre of the colonial administration. The British here are compared to a Malawian who left his home and never came back. The song mocks the British because they have forgotten about England and have taken over control of a foreign land they do not want to leave. The allusion to being tall like blue gums is derogatory, and suggests pride and arrogance. It also contrasts their attitude of superiority to the insignificant size of their country.

By the 1930s the British were enforcing restrictions on *gule wamkulu* and imposing a fee on its performance. Defaulters were

punished, beaten, fined or put in prison. Sometimes the District Commissioners or their representatives confiscated masks and drums. **Kananjelezi – Makanja – Titilande**'s tall stature provided him with an eye of supervision over the Chewa villages. He could detect, from afar, the presence of the enemy and warn his members about their evil intentions. Drums and masks could be saved and the dancers and the audience could scatter before the trouble arrived. **Makanja**, like **Kananjelezi**, was perceived as a protective spirit, assisting the community and safeguarding its freedom and identity. After independence, the anti-colonial tone of **Makanja**'s character seemed to vanish. However, he could still have been connected with warning the population against some of the abuses of the Kamuzu Banda regime. No new songs were created during this period. The Chewa continued to express their criticism via the same song, reinterpreted according to current political milieu.

Today **Makanja**, like his predecessor **Kananjelezi**, continues to be the wise adviser who keeps reminding the young people of the *mwambo*, which leads to happy family life. He pleads for mutual understanding and dialogue between husband and wife. He discourages teenagers, and those who act like teenagers, from taking life and sex too lightly. He deters them from using their appearance, height, fashion, money and sex appeal to fall into promiscuity. The advantages resulting from modernity have enhanced their stature but at the same time have made them more vulnerable. Elders say, *"Chinyamata chiphetsa – Childish behaviour kills."* One can die young because of behaving like a teenager. Modernity and western development have brought undesired pregnancy, abortion, divorce and misery of all kinds. They also brought a multitude of mysterious and frightening sexual diseases that have decimated the Chewa population.

[1] *"Tsoka lili ku mwendo. Taleka n'taliona n'taliona, tate tsoka lili ku mwendo."*
[2] *"Kananjelezi amna a ana e."*
[3] *"Kodo kodo wamuna achita kuitana, kodo kodo tauza at'amba abwera."*
[4] *"Kananjelezi mwamuna wa mwini wake de Kananjelezi."*
[5] *"Ede ede ine ndekha ndikuululani kuti ndapeza ali dayidayi, akwatana, atha."*
[6] *"Ede ede iwe, oh oh oh, chamtenga chivomerezi oh oh oh. Chamtenga chinyamulira oh oh oh, ndampeza chinyamulira."*
[7] *"Mwamuna akadwala, kamtule tate de kwa abale ake."*
[8] *"Oyera de ede ede oyera de oyera kudza mbuyomu."*
[9] *"Oyera de ede ede oyera de, oyera anamwali akunga a Jere!"*
[10] *"Kwa mako usapite tate de mwanawe kuli gule."*
[11] *"Adatchona Titilande; wamtali wina ngati bulugama wa pa Zomba e, adatchona Titilande."*

Mwalipeza and his wife Msandida

(a grey day mask and a brown day mask from the Pemba area)

Themes 1) Recent politics; 2) Opposing Kamuzu Banda (supporting political change); 3) Cynicism about politics; 4) Weak leadership

Etymology Mwalipeza means, 'You have found it.' In this context, it is an abbreviation for, 'You have found it … the country of ignorant and stupid people.' **Msandida** means, 'Don't blacken my name!'

The characters form a couple. The grey mask of **Mwalipeza** shows that he comes from the land (Malawi). He has a heavy beard and moustache made of sisal. His eyes are swollen and his open mouth displays his bottom teeth, expressing surprise or anger. He wears a hat representing a bowler, from which protrude three horns; one is red, the other two black (discussed later in the description). The dancer wears a smart jacket and overalls. He carries a stick and a medicine tail to emphasise leadership.

The woman, **Msandida**, is portrayed in a brown tone mask with distinctively Malawian features. She has tribal marks and scarifications. Her mouth and ears are small, to express dumbness and deafness. Her greyish sisal hair shows that she is no longer young. She wears a sophisticated turban, like those of the Women's League, and an expensive necklace and earrings. Her dress consists of a stylish blouse and a *chitenje*, recalling the Malawi Congress Party (MCP) uniform.

They appear together in the arena. **Mwalipeza** walks quietly around the *bwalo* like an old man, holding a stick and moving his medicine tail to instil discipline. **Msandida** circles around him, shaking her bottom and hips with great excitement. She tries to entice **Mwalipeza** with all her charms. While the couple entertains the audience, the men sing, *"Someone has taken the land when it was still intact* (undisturbed and without competitors). *He moves around with his wife* (or women). (People gossip:) *No, for me, it is not acceptable. What kind of kingdom is that, oh dear, the kingdom of* **Mwalipeza** *and his wife* (or women)*? As a matter of fact they are coming to an agreement.* (Msandida says:) *Let us go to my home, old man.* (Mwalipeza answers:) *One cannot rule if he stays at his wife's village.* (Msandida replies:) *No,* **Mwalipeza**, *for me I refuse, no! no!* (Mwalipeza disagrees:) *I say no! People will blame me. We shall see who has the last word. This is it!"* [1] The song portrays the ruler and his wife in conflict. They are arguing about residence. Their discussion voices the dilemma faced by the Chewa concerning the residence of the chief. The chief (if he is male) cannot follow the *chikamwini* rules if he wants to rule effectively. If he takes residence at his wife's village, he will have no power and will be under the authority of his wife's relatives and the chief of her village. His own leadership at home may fall into the

hands of competitors and he will lose his position. **Mwalipeza** and **Msandida** argue over the custom of the chief taking residence at his own village where he can enjoy full authority over his village or his kingdom. His wife should follow him to his home for the good of the people he leads.

These two characters appeared in the mid 1960s, soon after Independence. They came from the Kingdom of Kachere (Ngoni), where the chief was rumoured to have been buried alive at the instigation of the MCP and the new Malawi government. His leadership was then abolished and replaced by that of the government via Pemba. The characters of **Mwalipeza** and **Msandida** portray the leadership of Kamuzu Banda and 'Mama' Kadzamira, the official hostess of the country. They were created in order to mock the king who is being ruled by women. **Msandida** represents Mama and the *mbumba*, the women's group that was on the move with him every time the President toured the country. The Chewa from Pemba perceived that the country was under the leadership of 'the woman' even if she claimed that it was not her doing (*msandida*). She was seen to be responsible for the turmoil and the injustices caused to the people. Through the character of **Msandida**, they were protesting against the entourage of the President who manipulated and duped him to rule unfairly and to protect their positions. They kept him in ignorance while innocent people were condemned and exploited.

Mwalipeza's hat displays three horns. These represent the three regions of Malawi. The North and the South are 'dead' (black). The government of Kamuzu Banda was perceived to care for and develop only the Centre, making it live (red). **Mwalipeza** ruled a country of submissive people who did not dare to challenge his authority and who revered his 'divine' power. This submissiveness reflects the Chewa way of thinking and Chewa religious ideas. However, it is interesting to note that the Ngoni element from the Kachere Kingdom proved to have had a determining influence on the Chewa. They have been instrumental, in times of crisis, in broadening the Chewa understanding of authority and stimulating them to be critical, even cynical, of Kamuzu Banda's regime soon after independence. This critical spirit toward the MCP, masked by an apparent submissiveness, was maintained throughout the most oppressive period of the Kamuzu Banda dictatorship. It led to an explosion in new masks in the time preceding the political transition of the country in the early 1990s. The Chewa did not use direct language but instead the powerful weapon of satire and ridicule. Many masks give extreme and biting witness to this spirit.

[1] *"Ena adapeza lili lonse dziko tate e tate ee tate. Kuyenda achita kutenga akazi toto ine. Kodi ufumu woterewo ngotani diyere? Afumu* **Mwalipeza** *ndi akazi tate, paja apangata. Tiyeni amdala kwathu tate. Akakhala mfumu sachita chikamwini ai tate. Koma inenso toto toto ine* **Mwalipeza**. *Ndikuti toto asada ine, alamula toto ine zonse zonse basi."*

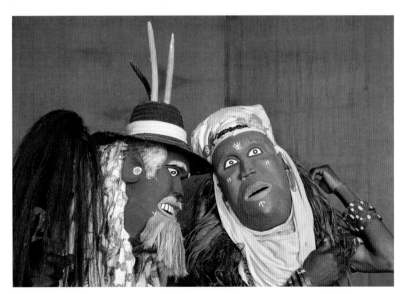

Mwayamba mpandira sukuluyi

(a black day mask from the Mua area)

Themes 1) Relations with Christian church; 2) Chewa identity

Etymology **Mwayamba mpandira sukuluyi** means, 'You, the school (mission), have started to criticise hurtfully.'

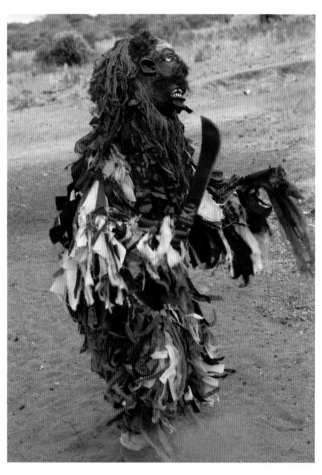

The mask portrays the face of an old Chewa who is now totally crippled. His face and personality are split into two. Half the head is bald, the other half has hair. His deformed mouth shows missing teeth. Hair grows on his flat nose. He has a moustache on one side only. His eyes look rheumy. The character wears a tatter suit and a large belt made of animal skins. This shows that, in spite of his decrepitude, he still claims a status and dignity. He sometimes smokes a pipe and brandishes his medicine tail, reminding his audience that he is their chief. The character appears at funerals in order to voice his complaints and claim his rights.

The character of **Mwayamba mpandira sukuluyi** was born sometime in the 1920s to 1930s when controversy between the Mua Mission and the *Nyau* was at its peak. At Mua's inception in 1902, the founders of the Mission sought acceptance among the local population. They spent the first years installing themselves and erecting the Mission buildings. With the help of the local community, they also spent a lot of time and energy developing an elaborate programme for catechumens. The first Fathers did not baptise adults immediately but concentrated on training their first catechumens who received baptism around 1909.

During this period, their daily mission diaries reveal little antagonism with local culture. It is only later, after their first baptised Christians were starting to return to local rituals, that controversy started. The period of the 1920s to 1930s brought the hostilities to a climax. The missionaries tried to put pressure on the colonial government to have some local customs banned, particularly *gule wamkulu*. They went around the villages at night and pierced the *gule* drums, stole their masks and forbade them to dance. They felt their rituals were obscene and contrary to education and development. The *Nyau* members retaliated by burning churches and forcing Christians into their membership.

Mwayamba mpandira sukuluyi voiced the right of the Chewa to his culture. The dancer walked proudly around the arena and swerved his feet with supreme energy. The male choir sang aggressively, *"This Mission is breaking us up. Mother* (church), *do not pour the water* (of baptism over me). *I have had enough."* [1] From that period, the Chewa villages were divided into two camps, the initiated and the non-initiated. From 1909, the missionaries forbade the Chewa Christians and their children to be initiated into the puberty rites under the penalty of excommunication. The Chewa chief who had been baptised could not run his own *Nyau mzinda* for fear of the same penalty. The missionaries and their lay collaborators, the schoolteachers, spied on the *Nyau* activities and boycotted their performances. The youngsters who attended the mission schools were brainwashed and told that they could not be initiated and could not continue their *Nyau* membership if they were initiated. The hair on the nose of the mask signifies that the road to the *dambwe* has been closed. The Chewa felt that they were being ruled by the Mission, that their values were being buried and their culture suppressed. They felt that they had to resist. **Mwayamba mpandira sukuluyi** embodies this resistance. Mother church, do not baptise us because you are unjust and selfish! You force us into your own foreign culture and suppress others! The Chewa were reacting against the church that imposed her ideas, laws and culture on them. People were forced to abandon their own culture and their *gule* in order to become Christian. In this process, they were made crippled, they grew 'bald and deformed' and hair grew on their nose. The mask vividly portrays this. It shows a split personality, a split *dambwe* and a split village.

The mask of **Mwayamba mpandira sukuluyi** fell into disuse at the beginning of the 1970s, after the first timid introduction of Vatican II was implemented at the local level. From that time, people were assured that they could be both Chewa and Christian, although tensions remain to this day.

1 *"Mwayamba mpandira sukuluyi, amai wanga, musatsire madzi. Adakola tate (2×)."*

Ndeng'ende

(a black day mask from the Dedza area)

Themes 1) Recent politics; 2) Cynicism about politics; 3) Hypocrisy/split personality/duplicity

Etymology Ndeng'ende means, 'the ringing of a bell to call people for an event'.

The mask portrays a leader who affects cleverness in order to hide his incompetence. The mask is black, stressing ugly or immoral behaviour committed by local people as opposed to strangers. His tribal marks emphasise he is a Chewa. The face appears to be that of a senior, supposedly wise and respectable person, except for the red eyes that portray evil. The bald head displays a wrinkled forehead. The hair, the moustache and pronounced goatee are made of long, white sisal. The eyes and the mouth (with teeth) betray stupidity and aggression. The dancer wears a jute suit without rags, to appear as a smartly dressed European gentleman. However, he performs like a licentious gigolo who chases women all over the dancing ground. He moves his hips and shakes his pelvis obscenely, in such a way that his genitals may be revealed through the open fly of his white shorts (to be seen by the women). The song sung for **Ndeng'ende** recalls a well-known Chewa proverb: *"The fool played the drum for the clever to dance. Others laugh: (This) fool is (like) a bell. Oh! Oh! A bell, for men or for women? When the women see it they run away. My goodness! As for them, what have they seen? They only saw a penis and some balls. You children, (some) men are like a (stupid) bell!"* [1]

Like Shakespeare, the song (proverb) questions the identity of the fool and the wise man. The performance of the dancer depends on that of the drummer. This old Chewa wisdom is applied here to the political and domestic scenes. A leader is like a bell that should gather people together. Clever, wealthy politicians or landowners may appear formal and correct in front of the community. Yet they discredit their subjects or employees and call them stupid, and behave worse than their subordinates. They satisfy their base instincts, taking advantage of their position and wealth. Such people break up families and seduce other people's partners. Promiscuous people such as this expose other people's indiscretions, while hiding their own under an expensive suit or dress or a respectable reputation. They depend on the faithfulness and the dedication of those they call 'stupid' to carry out the work on their estates or in their businesses. These 'stupid ones' may also have to give them support for their electoral campaigns.

The issue here focuses on the sale of party cards, which were imposed on the people by the Malawi Congress Party (MCP). Cards were sold by the ordinary party members, who were building up the politicians' popularity and self-image under the MCP regime. Despite their lack of education, these simple party supporters expected their leaders to set examples that everyone could follow. People recall that in 1959, before independence was granted, and before the MCP party prevailed over the Nyasaland African Congress (NAC), the colonial government distributed anti-independence propaganda from planes (*ndege*) over some of the cities. The colonials felt that Malawi did not have the right national rulers to lead the country into independence. For some

Malawians, the 'sky planes' brought this confirmation. Even after independence was granted in 1964, many remained sceptical. The after-effects of the cabinet crisis in 1964 (plus the painful abuses over the sale of party cards in the 1970s) confirmed such suspicions. Malawi had chosen her leaders. The *Nyau* members decided to expose their behaviour in public through **Ndeng'ende**, whenever the great dance was performed and especially on the occasion of party meetings.

[1] *"Chitsilu chinaimba ng'oma tate. Wochenjera kumavina. Ena naseka tate de tate chidzete **Ndeng'ende** oh oh. Kaya lamphongo tate eee kaya lalikazi tate eee. Kuona akazi akuthawa ogo nanga iwo aonanji tate? Angowaona chimbolo, chende. Ana inu tate wamuna **Ndeng'ende**."*

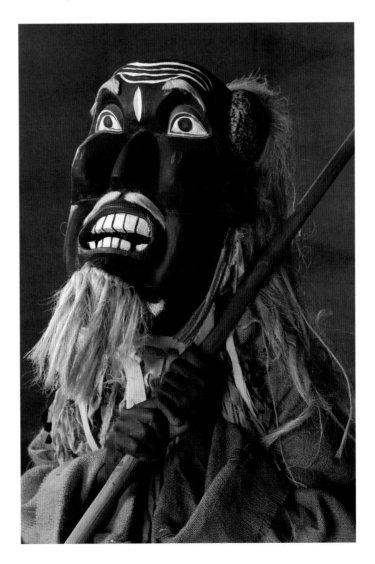

Nkhumbutera

(a grey-brown day mask from the Maluwa and Pemba areas)

Themes 1) Recent politics; 2) Opposing Kamuzu Banda (supporting political change); 3) Injustice

Etymology **Nkhumbutera** is a type of locust.

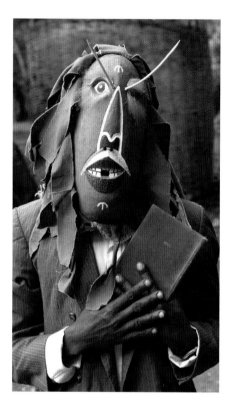

The long oval grey mask portrays a type of insect. The face is flat. Fur surrounds the oval eyes imitating eyelashes. Two thin, curved antennae protrude from the inner corners of the eyes. The nose consists of a v-shaped groove in white with a dark tip. The oval mouth has flat teeth on both jaws. The front teeth are separated by a large gap. Tribal marks decorate the forehead and the chin. The head is earless like an insect but this emphasises deafness in the moral sense. The headgear of the mask is made of rags. The dancer wears smart black trousers and a white shirt partly covered with a stylish jacket. He carries a book to the arena, which he reads before dancing.

At the beat of the *chisamba*, the dancer runs quickly on the tips of his feet to suggest he is an insect. He has imaginary wings and he 'flies'. He circles around the *bwalo* in this manner. He does not swerve his feet or shake his pelvis. Suddenly he falls down on the ground and starts shivering, as if he is overcome by fear.

The character of **Nkhumbutera** was introduced into the dance recently (1992) and performs at political party meetings

and rituals. An informant suggests that the character was introduced after one of their *gule* members had been jailed in Lilongwe without cause. The men sing, *"Listen to me all of you! He says: Out there, the locusts have come. They have fallen in the early hours of the day; or in the east. They have fallen at midday; or in the central region. They have fallen into the evening; or in the west. Some say they have caused damage; others say they have not! It is better to go out and get some relish, since the locusts have fallen!"* [1]

The song begins like a proclamation by the spokesman of the chief in the village. He announces the coming of the locusts. He tells people not to worry about the damage and invites them to collect the locusts for food. The Malawi political situation in 1992 provides an interpretation for this riddle. Political changes began in the country with the circulation of the Catholic bishops' Lenten letter in March of that year. The unionists launched the Alliance for Democracy (AFORD) in September. This 'interim committee' campaigned for the peaceful introduction of multiparty democracy. In October, they were supported by the United Democratic Front (UDF). The same month President Kamuzu Banda was announcing a referendum on the issue that was to take place on 15 March 1993. Meanwhile, AFORD and UDF had decided to campaign jointly. The Malawi Congress Party (MCP) and the government were resisting multiparty democracy, favouring the one party state. This succession of events was echoed at the village theatre of *gule wamkulu*, through the introduction of **Nkhumbutera**. The coming of the locusts parodied for the villagers the activities of pressure groups and the campaigners for the multi-party system who carried an official mandate (the book the dancer holds). The chiefs of the Chewa villages were therefore authorised to make a public announcement about the legitimacy of their activities. Fear was set in the minds of people conditioned by the one party state for more than thirty years. They had been brain-washed that the advent of opposition parties would bring civil war to Malawi. This is suggested in the song by the three periods of the day when the locusts invade the land and the different regions where change has taken place; in the east, the centre and the west. The character of

Nkhumbutera wants to alleviate their fears and suggests that fair competition is possible. Besides introducing multi-party democracy to the community, the character of **Nkhumbutera** accuses the MCP and the government of refusing change and discrediting the opposition. They may call the opposition 'black locusts' but they forget that under the present regime the country is prey to a worse kind of 'ferocious locust' that keeps people in fear (shivering) and that has consumed large portions of the country already. Moreover, this kind of locust is not even good for eating. Their thirst for wealth has made these locusts lose their sense of justice and honesty (the white shirt hidden under the jacket).

The character of **Nkhumbutera** warns the population against refusing change without a reason. It is too easy to be coerced by the MCP and the government into boycotting the multiparty political system that will favour the population tomorrow. People should be the supreme judge in these matters and remember the teaching of the locust. They may create damage but they are also a delicacy. When they befall the land, villagers rush to collect this delicious *ndiwo* (relish) for their meal. Under the guise of a locust called **Nkhumbutera**, the Chewa demand that multiparty democracy be given a fair chance. The final result of the 14 June 1993 referendum showed that 63% of the population was in favour of the multiparty system.

[1] *"Tamverani nonsenu de (2×) akuti kunja kuno de* **Nkhumbu** *zatera ku m'mawa, akuti zatera. Pakatinso akuti zatera. Oh tate de zatera mpaka ku madzulo zatera. Ena akuti zaononga. Ena akuti iai iai tate de ndipabwino tipate ndiwo aye tate de zatera* **Nkhumbu**."

Polisi

(a red day mask from the Mua and Golomoti areas)

Themes 1) Recent politics; 2) Party cards; 3) Manipulation/exploitation

Etymology **Polisi** is a police officer.

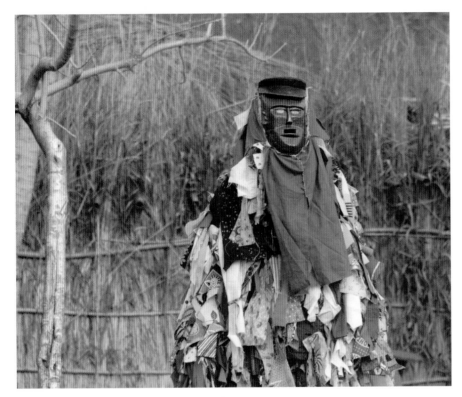

The small 20 centimetre red mask appears in a police cap, carved from the same piece of wood. The cap is painted black or other colours to convey a police uniform. The colour red for the face signifies an aggressive intruder into the village. His small eyes betray suspicion. His tiny mouth signifies arrogance and condescension. The nose is squared and does not belong to a human. **Polisi**'s headgear and suit are made of tatters.

In the arena, **Polisi** is rude and shows no manners. His dancing style is energetic. **Polisi** performs on any occasion including party meetings. The male choir whispers his arrival: *"The **Polisi** has come...when you give him* (your party) *card, he tears it to pieces."* [1] **Polisi** appeared in *gule* in the 1980s during the Life President's reign. Under Kamuzu Banda's rule, the Malawi Congress Party was the only political party permitted. Citizens were encouraged to contribute to the party by purchasing a party card and showing their allegiance. The 1980s were marked by an increase in coercion by the government to ensure their proprietary place in Malawi politics. Party officials, members of the Women's League and the Young Pioneers (a paramilitary group) were invading the villages and the public places (markets, shops and bus stages) to catch defaulters and force them to buy party cards. These groups operated without reproach and with considerable freedoms. They searched homes like a police force at any time of the day or the night. They woke people before dawn. Failure to produce cards led to summary punishment. People could be prevented access to the market and stopped from buying food. They might be denied travel on public transport or left by the roadside without money. The song even mentions that Kamuzu Banda's agents could tear up cards in order to extort more money from the villagers.

The character of the policeman opposes abuses of this kind and unveils the ruthless machinery of the party and ultimately of the government. Kamuzu Banda's puppets behaved like thieves and shamelessly extorted money from a powerless population. Resistance was near impossible at that period. People had to comply and be silent. To resist and speak out would land you in prison. *Gule* took up this case using the subtlety of cryptic language and secret codes. **Polisi** implied indirectly that the government and the party had lost their respect for the population. People had been turned into slaves. The population had realised that the fruits of independence were not for them but for a chosen few.

[1] *"Wafika **Polisi** n'kumpatsa kadi nang'amba."*

Simoni

(a red or pink day mask from the Mua and Dedza areas)

Themes 1) Colonial period politics; 2) Pride/arrogance; 3) Abuse of power; 4) Relations with Christian church; 5) Polygamy; 6) Promiscuity

Etymology **Simoni** is a personal name devolving from Simon; it is an abbreviation of Simon Peter, the apostle.

The red or pink mask (40 centimetres) portrays a young man with western features. The reddish colours (pink-orange-red) emphasise that **Simoni** is a foreigner. His face displays clever eyes, pointed nose and a smiling mouth with or without teeth. A mini moustache in various shapes can give him a Charlie Chaplin or an Elvis Presley look. The large pointed ears appear western. Details manifest the acute observation of the artist. The character may wear spectacles, a western symbol. The well-combed hair, commonly rendered with sisal dyed black, imitates western hairstyles and often will even show a parting. A hair lock protrudes, commonly rendered with sisal or with feathers. **Simoni**'s features manifest openness and welcome and do not suggest

hostility or aggression. **Simoni**'s clothes are also western: shirt, trousers or tatter suit. This outfit is at times completed with a wide belt. The Dedza area sometimes has a white dustcoat as a symbolic mini cassock. As a rule, **Simoni** holds a medicine tail to convey his high status. When he is portrayed as a priest, he holds a book representing a Bible.

Simoni's dancing style is stereotyped and is germinal to a great variety of *gule* characters. It consists of a variety of movements, including the swerving of the feet and a succession of small jumps that are interpreted by the audience as signalling his pride and arrogance. While swerving his feet, **Simoni** holds his right index upright to indicate his pride and that the land will be his. This typical gesture conveys **Simoni**'s ambition and relationship to Kalumbu (refer to that entry). In the arena, **Simoni** shows good manners, politeness and even distinction 'à l'anglaise'. In Dedza, **Simoni** is accompanied often by a group of small children following him.

The character of **Simoni** is, after Chadzunda and Mariya, one of the most popular all over the Chewa country. He is involved in a great variety of rituals. He often presides over funeral rites, particularly those of important members of the Chewa community. In Dedza, **Simoni** is given the role of a priest. He blesses the coffin and the deceased with his medicine tail and imitates the sprinkling of holy water. His very name points at a Christian origin and emphasises the caricatured features of the apostle. **Simoni**'s appearance is enhanced with a vast repertoire of songs, most of them emphasising his foreign origin, the colour of his skin or his marital status.

The Mua area views **Simoni** as part of a triad of characters whose names demonstrate a fascinating historical evolution. These are Kalumbu, **Simoni** and John watchyola mitala. The Dedza area equates **Simoni** to Kalumbu. Other parts of the Chewa country tend to treat **Simoni** as a separate character. Both Kalumbu and John watchyola mitala have been described at length in two separate entries. The discussion here concentrates **Simoni** as an individual personality.

The Mua area witnessed the appearance of **Simoni** in the 1930s, though his presence was known on the plateau in the 1920s. Along the lakeshore, the character of Kalumbu was definitely active for decades before the advent of **Simoni** and Kalumbu persisted for a full decade after **Simoni**'s introduction in the plain. The young red features of Simoni then replaced Kalumbu's black face. The mask ceased to

represent anymore the Chewa chief who settled on the lakeshore and usurped the land but instead reflected foreigners from overseas. One of **Simoni**'s songs highlights this: *"**Simoni** navigated over seas and found small children on the sea shore."* [1] The meaning of those children will be considered further down in the description. A second song emphasises the colour of skin of the foreigner. *"The orange one has come, the orange one has come!"* [2] **Simoni**'s foreign origin also comes across in his dancing style and points to common traits of character with Kalumbu. One is arrogant and the other has unwavering ambition in acquiring land. This highlights the very reason why **Simoni** becomes a reincarnation of Kalumbu. Kalumbu's conflicts with Mazengera and his ambitious dream of increasing his domain is reread in the light of the advent of the colonial powers. These are the strangers who crossed the sea and established themselves on the shore of Lake Malawi. The mention of small children near the water refers to the young initiates of *gule wamkulu* and evokes the numerous frictions between the colonial officers and the *Nyau* secret societies. The advent of **Simoni** to the lakeshore coincides with a massive movement of population from the plateau to the lake prompted by the arrival of the Maseko Ngoni on the high country and the fertility of the soil credited to the lake basin. The Dedza plateau and the Dowa hills were the raiding ground of the Maseko and the Jere Ngoni before the advent of the colonials and the missionaries. Mua Mission was established in 1902 by the Missionaries of Africa. Its foundation predates the District Commissioner's office in Dedza. Bembeke Mission, on the plateau, starts in 1910. The Dedza area portrays **Simoni** as a priest. He wears a cassock-like garment, holds a bible and blesses the people in the arena. The arrival of the missionaries was a major challenge to the Chewa population with regard to their *chinamwali* and their *gule wamkulu* and their cultural values as a whole. A third song focuses on **Simoni**'s matrimonial status: *"My **Simoni**…is single."* [3] The Catholic missionaries were also single. Their permanent celibacy did not align well with the Chewa culture that accentuated the values of marriage and fertility. Moreover, the government officials who pioneered the new posts in remote areas were often not accompanied by their wives at the beginning owing to the hostile surroundings in which they were based. Thus the mention of being single could also apply to them. The song of that period interprets the fact of being single as the paradigm for selfishness and arrogance. The foreigner

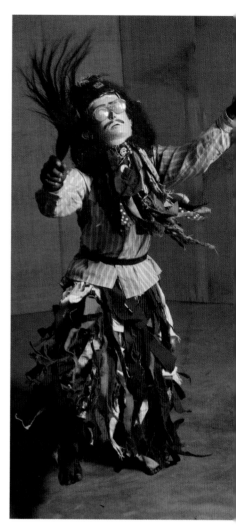

did not marry because he could not put up with a wife.

The reference in the first song to *"the children on the sea shore"* (initiated *Nyau* members) finds its interpretation in the light of the numerous conflicts between the missions, the government and the members of secret societies. The song implies that the foreigners encountered Chewa who were already members of traditional societies. The strangers had no right to interfere with their customs and culture. The Mua Mission diary has documented in detail how the missionaries tried to make use of the local District Commissioner and the government machinery in order to enforce a ban on *chinamwali* and *gule wamkulu*, particularly in the 1920s and 1930s. They acknowledge that they used subterfuge such as altering the words of the *gule* songs in order to enhance their perception as obscene and depraved. The missionaries' intrusion went as far as unmasking dancers in public, capturing masks and structures and putting them on display in the church building and ripping open the drums of *gule wamkulu*. The DC and the colonial officials

were then enforcing the hut tax and a special tax on *gule wamkulu* performances. Such conflicts and interference were strong enough motives for pushing the local Chewa communities to cast the old ambitious Kalumbu in a new context. The enemy was now found in the arrogant young British and the authoritarian missionary. The population gave him a Christian name, **Simoni**. They changed the colour of his skin from black (local) to red, pink and orange (of foreigners). They clothed him in western garments. They made him dance with restraint but nevertheless emphasising arrogance, pretension and ambition. They placed in his hands a 'Holy Book' stressing that his claim on authority was derived from the spirit world and even from God himself. This pretension had become obvious in the construction of schools, prayer houses and churches. Such buildings suggested ostensibly that God was nearer to the new arrivals than to the Chewa themselves. They assumed the right to confiscate land, to build mission stations, and to establish forest reserves and estates. Furthermore, they could mix in village affairs, challenge the hierarchy and even tamper with traditional education and culture.

In short, the colonial authorities held power over what was right or wrong, over life and death. **Simoni**'s image and dance is loaded with all of these themes and offered in the arena a caricature of the foreigner whose real power was questionable.

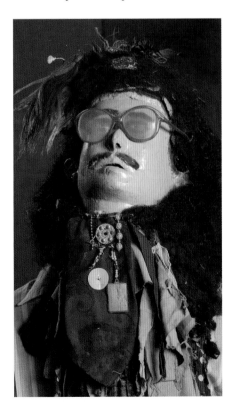

Simoni indirectly reclaimed for the audience their rights over their land, over their institutions and over their culture.

Towards the end of the 1950s, Nyasaland exited the Federation of Rhodesia and Nyasaland and slowly moved towards independence in the 1960s. The hero of these battles happened to be a Chewa who had lived in Britain for most of his life. He spoke the language of the foreigners and dressed like them. In an ironic twist, **Simoni** found a new meaning and personification in the hero of the day: Kamuzu Banda. During this period, **Simoni** was to be re-baptised in the name of John watchyola mitala – John who broke the polygamist marriage (the Federation). He was to be the new liberator who was to restore the land and self-government to his own people. This vision was captured in a new song for **Simoni**: *"You will not rule here, this is my land!"* [4] Then, Kamuzu Banda was credited for having ousted the colonials from the country. This new image of **Simoni** focused on the praise of Kamuzu Banda for his heroism in restoring freedom and self-rule. Because he was a Chewa himself, Kamuzu Banda would give back to the Chewa their respectability and allow them to perform freely their rituals and dances, with an insistence on *gule wamkulu*. Kamuzu Banda reinstated *gule* and put it on the foreground of independence celebrations and national events. By then, John watchyola mitala had become a particular type of **Simoni** who had a life of his own. A more detailed entry concerning John watchyola mitala appears in the body of this work.

Meanwhile, **Simoni** continued to be present in the arena independently of John watchyola mitala. He inspired numerous other characters of *gule* that developed after independence. Nevertheless, after this period, **Simoni** came out weakened and had lost his virulence as an anti-British and anti-Christian critic, despite Kamuzu Banda's frequent attacks denouncing the colonials and the missions. Today, **Simoni** still continues to weave his presence in village rituals but his appearance is less frequent. One feels that his teaching has somehow moved closer to the Christian spirit. Forty years after independence, one observes that a large bulk of the Chewa population around Mua has converted to Christianity and their children have moved on to education and development. Traditionalists continue with their *gule wamkulu* but have become more tolerant of the Christian presence. They perform their traditional ceremonies with less regularity but with minimal interference from the Christians. The particular song of **Simoni** referring to his status as a single person had now transferred to advice discouraging

polygamy and promiscuity. Traditional funerals involving *gule wamkulu* have incorporated many features of Christian rituals within their proceedings such as office bearer uniforms, money collections for the deceased family, and, one of the more recent innovations, the introduction of a homily during the funeral. Dedza has added the presence of a priest, **Simoni**, to burial rites. It has also become common for many areas where *gule* is practised to give to their own office bearers titles originating from the Catholic Church structure such as Pope, Bishops and the catechists of *gule*. Though this recent phenomenon still witnesses to a fair amount of tension and competition between the Chewa traditional religion and Christianity, it does emphasise the capacity for traditional religion to modernise itself and to search for a new identity. The *Nyau* voice their aspirations to align with an organised body, like a church. The Dedza members of *gule wamkulu* identify themselves as the Church of Aaron.

In summary we see in **Simoni** a remarkable evolution in meaning and application of a *gule* character, motivated by changing circumstances and perceived community needs. From one who condemns arrogance and the usurpation of the land, embodied in the physiognomy of the colonial invader, **Simoni** has metamorphosed into a variety of avatars drawing upon the changed Chewa – *azungu* relationship. In one phylogeny, **Simoni** becomes the restorer of the land his earlier incarnation had stolen. In another line of evolution, he comes to embody now widely accepted Christian values and repackages his unwed status, once a pejorative, into a positive message against sexual profligacy. He can even wear the mantle of a priest, the old adversary. **Simoni** is the very embodiment of the adaptability of the *gule wamkulu* to tailor its message to meet the needs of the day. In this way, the advice of the ancestors retains topicality and relevance.

One may also discern a possibly less appealing dimension to **Simoni**'s transmogrifications. One cannot help but sense a certain insidious takeover of the Chewa identity by Western values, a pernicious dilution of traditional practice in the face of now accepted Western standards. Some might suggest that **Simoni** has not merely adapted to the day … but that he has actually changed sides.

[1] *"**Simoni** tate de adayenda pa madzi tate de, adapeza tiana **Simoni** tate de mphepete mwa madzi tate de."*
[2] *"Olanje (3x) olanje wabwera. **Simoni** tate de olanje (3x) olanje wabwera."*
[3] *"**Simoni** wanga ere ere mbeta."*
[4] *"Simudzalamula kuno, kuno ndi kwanga."*

Sitilankhulana

(a red day mask from the Mua and Mtakataka area)

Themes 1) Chewa – Ngoni relations; 2) Colonial period politics; 3) Political hegemony; 4) Unity & harmony; 5) Reconciliation & mediation

Etymology **Sitilankhulana** means, 'We do not talk to each other.'

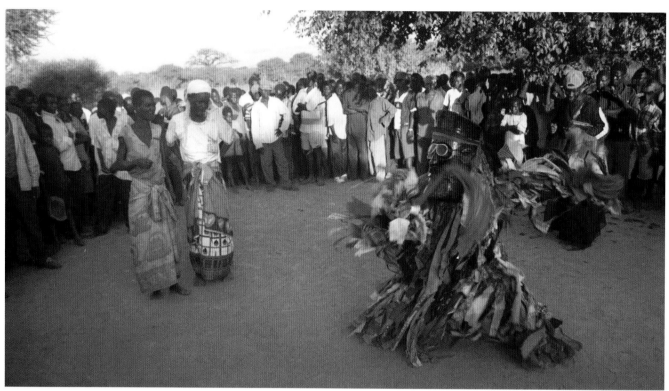

Claude Boucher, Masinja Village, May 2002

The mask is red representing a foreigner. The features are angular and can have an aggressive look. Some villages represent him with a flat head and a strong, affirmative chin. He sometimes has a tuft of feathers on his head like the Ngoni head dress. The dancer wears a tatter suit and carries a large medicine tail. He represents an Ngoni chief. His entry into the arena is pompous. Appearing abruptly, he imposes himself on the crowd and shows no manners. He swerves his feet in a clumsy and aggressive way, mimicking military movements. He is uncouth. He flaps his medicine tail brutally. He dances vigorously trying to convince the audience that he is the king. The women surround him and tease him by clapping hands and singing, *"You, the assistant of the chief, how are you? We give you greetings, how are you? How can I greet you – a chief in a foreign land?"* [1] The men's song questions his authority, *"What are you seeking in a foreign land? You only stay in someone else's land because of your big mouth* (bullying threats), **Sitilankhulana** (we do not talk to each other)."* [2]

The songs ridicule the Maseko Ngoni, who ruled a country that was not their own.

In 1894, the British gave dominion of the Chewa country along the west shore of Lake Malawi to chief Kachindamoto, after he had turned to them for help in the wars against his cousin, Gomani. The British were eager to resolve the Ngoni rivalry, with expediency. The British were looking for allies who would accept indirect rule and collaborate with them in ruling the country. Kachindamoto, who had already titled himself the king, was offered the land by the British with the support he needed to achieve peace with Gomani. In return, he could not antagonise the colonials and had to pledge allegiance and submission to them. He ruled the Chewa with the authority conferred on him by his British masters and with the pretension and pride typical of an Ngoni king. From the Chewa point of view, the Ngoni rule was oppressive. They saw their new king as an intruder and called him (as the song says) 'big mouth'. An Ngoni king being supreme ruler over a large indigenous population created many problems that were epitomised in the tension between him and *gule wamkulu*. Interference into *Nyau* matters was mocked by the very name of **Sitilankhulana**. From the 1950s, floods of

the Nadzipulu River forced the Ngoni to live among the Chewa population. This increased the tensions. The character questions the origin of the Ngoni authority and voices the Chewas' right to rule their homeland. Nevertheless, it was impossible to reverse history. The two cultural groups intermarried extensively. They had no other choice but to cooperate and make compromises. Today, the character urges both groups to get along, to talk to each other and to live in harmony, despite their cultural differences. They should forget their wounded egos. The character preaches reconciliation, a message in tune with the Chewa values of harmony and neighbourliness. The advice given by this mask does not only relate to political life but to a whole range of social and family relations. Reconciliation is the key to happy living and guarantees peace with the world of the ancestors.

[1] *"Inu anyakwawa muli bwa? Tipereke moni muli bwa? Ndipereka bwanji m'dziko la eni ake?"*
[2] *"Iwe e tate kukhala bwanji kukhalira pakamwa…**Sitilankhulana**?"* or *"**Sitilankhulana** eae mukufunanji m'dziko la eni ake. Mungokhalira mtopola m'dziko la eni ake, **Sitilankhulana!**"*

Valani dzilimbe

(an orange or brown day mask from the Malirana and Kasumbu areas)

Themes 1) Recent politics; 2) Opposing Kamuzu Banda (supporting political change); 3) Limits & restrictions of *chikamwini* system

Etymology **Valani dzilimbe** means, 'Dress up and be strong! (Do not fear!)'

The character is recent to *gule wamkulu*. Both versions appeared in 1993 in response to the referendum and to the general election that followed. **Valani dzilimbe** is one of the many new characters that arose in that politically charged period and appeared at rallies in order to support the new parties and discredit the ruling government of President Kamuzu Banda.

At Malirana, the orange 40 centimetre mask portrays an old Chewa man with tribal marks and a flat nose. The features of the mask include a bald head, baggy eyes, wrinkles, deep nasal lines, a shrivelled mouth with no teeth, and a long grey moustache and goatee made of dyed sisal. The expression on the face is distorted and worried. The headgear of the mask is made of baboon and monkey skin to show that the man is losing status and reverting to the anonymity of the wild. The black sisal hairpiece atop his bald head shows the man's tendency towards youth and potency. Four horns adorn the mask, with two upright red horns and two black horns at a slight angle. The two red horns represent Kamuzu Banda's strong political showing in the central region of Malawi and support for Mama Kadzamira, the official hostess. The red horns also emphasise Kamuzu Banda's position as husband (*mkamwini*) and that in the family unit the position of leadership is not his, but belongs to his wife's family in keeping with the matrilineal line. The black angled horns show Kamuzu Banda is losing his authority over the northern and southern regions.

Valani dzilimbe does not wear the smart clothes one might expect. Instead he dons a kilt, and leglets and armlets made of fertiliser bag laces that suggest he is soon to be demoted. He holds a club like a hunter instead of carrying a staff and a medicine tail, the usual symbols of authority. The orange colour of the mask hides the character's real identity and shows he has become a stranger to his people.

In the arena, **Valani dzilimbe** moves his hips suggestively, mesmerised by the women who dance the *chisamba* with him. The male choir questions, "*What kind of behaviour is this my friend that stirs noise even up to the point of involving his wife* (or family group)*? This husband is greedy, yes he knows how to beat and to slander* (his opponent). *No this is not for me! Today he is running*

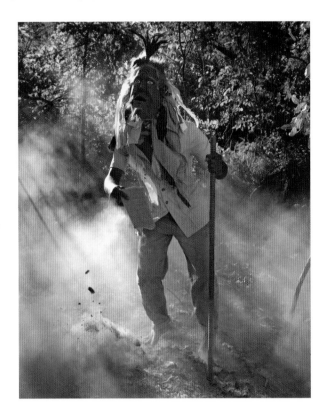

against someone (called) *Mr Dress up, Mr Dress up and be strong.* (The latest) *has beaten him up* (in the election) *to the point of stripping him* (of his position of leadership)*! People are witnesses, even the children, that Mr Dress up and be strong has started* (this row) *purposely. Mr Dress up and be strong!*" [1]

The Kasumbu version of the mask has many similarities to that of Malirana. The Kasumbu mask is smaller, brown, and represents a Chewa man. The facial features are those of a young man with a pointed head, slightly receding hairline and some wrinkling, curved nose and open mouth expressing surprise. The mask's concentrated look is fearless and determined. The facial features are emphasised by the long moustache, a goatee and deep creases around the nose. His ears are disproportionately large and pointed meaning he listens and will take advice from his constituents and the whole population. The headgear of the mask is made of tatters, evidence of his ancestor's origin. This Kasumbu version of **Valani dzilimbe** wears a clean shirt and smart trousers and carries a book and a staff to show he campaigns legitimately. In the arena he per-

forms like Simoni. He swerves his feet and jumps energetically as the men sing: "*You children, when Mr Dress up and be strong comes, be strong! Ladies and gentlemen, let us all be strong! You chief and assistants, be strong for what is to happen* (multi-party politics)*! Dress up and be strong, be strong! Dress up and be strong! Oh dress up!*" [2]

Valani dzilimbe's dance and message invite the people to accept the multi-party concept and predict the fall of the Kamuzu Banda regime. The character reminds the voters of the neglect they suffered under the rule of Kamuzu Banda and his MCP party. They are encouraged to be strong and make a decisive choice for their future. This is a call for courage and action.

[1] "*Kukhala kotani, anzanganu, komwe aputa phokoso lokopa banja limene abambowa ndi mbombo eya, kumenya kuli pomwepa, mtukwano m'pakamwa. Toto ine! Lero aputa wina, **Valani dzilimbe**, wampweteka mpakana kumvula ufumu, anthu kuona ndi ana omwe. **Valani dzilimbe**, dzilimbe waziyamba dala, **Valani dzilimbe**.*"
[2] "*Ana inu, chikabwera **Valani dzilimbe**, dzilimbe azimai onse, amuna onse valani, valani afumu, manduna, nanga chomwe chilikudzachi, **Valani dzilimbe**, **Valani dzilimbe**.*"

Wali wabwera

(a yellow or red day mask from the Mua area)

Themes 1) Hypocrisy/split personality/duplicity; 2) Colonial period politics; 3) Slavery; 4) Polygamy

Etymology **Wali wabwera** means, 'the one who flashes like lightning has come'. In Chichewa the word '*wali*' conveys the flash of light-ning. Thunderstorms are frequent during the rainy season (October to March) when Chewa farmers are busy cultivating their fields. '*Wali*' is also a Swahili word for rice, and was the title given to the representative of the Sultan of Zanzibar. Both of these meanings are linked with the Jumbe of Nkhotakota, an Arab dynasty that began in 1845.

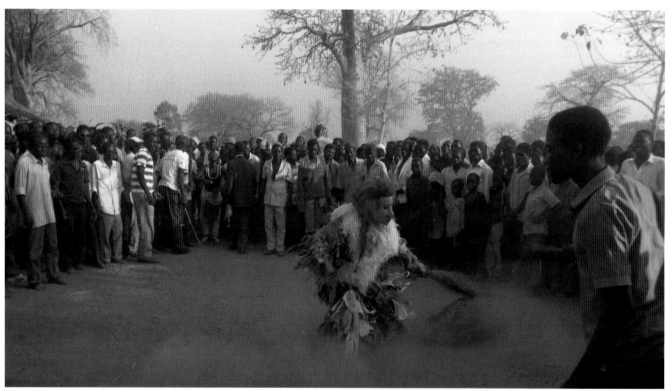

Claude Boucher, Munyepembe Village, September 1994

In 1845, a Swahili from the Indian Coast, Salim bin Abdallah, settled near Nkhotakota and conquered the country of Marimba. He set himself up as the Sultan of Marimba and later assumed the title of *Jumbe*. Salim bin Abdallah used indirect rule over the Chewa population. He main-tained the local Chewa chiefs and headmen, consulted them in his council, and pro-tected them when they were under threat. He also formed alliances with his neigh-bours to ensure his political stability and the expansion of his trade. He traded in ivory, copper and salt, and, toward the end of his life in the 1860s, in slaves. To increase the volume of his trade, he built dhows and a harbour, and employed a large body of slaves to build storage space for goods and slaves. He also controlled agricultural pro-duction and hunting.

The arrival of the Ngoni in the hills west of Nkhotakota forced the Chewa in these areas to seek refuge with Jumbe. After his death, he was succeeded by Chief (Mwenye) Mguzo, another Swahili from the Eastern coast. Like his predecessor, Mguzo was a Muslim but did not prosely-tise. He pursued trade in goods and slaves, and was known for flying the Sultan of Zanzibar's flag over his house though it is not clear that he was an official Wali. Mguzo, who died sometime between 1875 and 1879, was succeeded by Mwenye Kisitu, a descendant of a good Zanzibari family. He is known in British records as the Jumbe of Kotakota and the Wali of the Sultan of Zanzibar. Though he practised slave trading, he signed a treaty of amity with Sir Harry Johnson, the British Governor of Nyasaland. Despite his Islamic beliefs, he allowed the Universities Mission to Central Africa to settle in his territory.

Kisitu was regarded with affection by whites and blacks alike, and is remembered for his charm, hospitality and cooperative character. Because of these qualities, he was able to deceive the British, leading them to underestimate the extent of his involvement in the slave trade. This Jumbe was different from the other Swahili in both his political and economic interests. He was liberal with his wealth, dividing one third among his chiefs, headmen and subjects. He was spoken of as a man of mercy. Jumbe's terri-tory was involved in the production of a large surplus of food, especially rice (*wali*) used as provision for his caravans. The scale of his agricultural production was probably one of the highest at the time in Central Africa. His prosperous image put him in good standing with the British, who preached that legitimate trade was more profitable than the slave trade. As a matter of fact, Kisitu, toward the end of his life, made more profit from the sale of ivory and other provisions than he did from slaves. He valued trade with the African Lakes Company and may have perceived himself as the head of a new type of distribution network, allied with the whites.

Kisitu's pro-British policy and his declin-ing participation in the slave trade stirred

opposition with some of his headmen. British troops were called to support him in fighting against his economic competitors and his political enemies. Kisitu died in 1894 when he was about to begin a large campaign against his enemy Mwase Kasungu.

Kisitu was succeeded by his son Kheiri, who was in all ways the opposite of his father. He continued to be called Wali, but by then, the position had become a mere title. Soon after his enthronement, Kheiri plotted with local Arabs and Yao to kill the headmen of his late father, a British government collector and an Anglican missionary in preparation for an uprising against the British administration. In May 1895, he was deposed by the British, deported to Zanzibar, and the Jumbeship lapsed.

In the area of Mua, the character of **Wali** has been known for about thirty years and is said to have come from along the lake, between Chia Lagoon and Senga Bay.

In *gule*, **Wali** is represented with a yellow-orange or red skin tone to portray a stranger. His long straight hair resembles that of an Arab or an Indian, and is often rendered with a piece of black goat skin. His face does not depict the features of a local man. His eyes are almond shaped and suggest an oriental origin. His nose is long, straight and pointed and is cut geometrically. His mouth is often cut in a slit with narrow lips and no visible teeth, suggesting a deep sadness. The chin is angular but not prominent and the ears are usually big and pointed. He looks smart, clever and clean, and has neither beard nor moustache. His headgear is made of tatters. In some areas, he wears a robe and a broad sash at his waist and in others is attired in Western clothes (clean shirt and showy pair of trousers) or a tatter suit. He inevitably carries a staff, a medicine tail or a whip as a sign of his status as an authority or disciplinarian.

The performance of **Wali** is not linked to any specific ritual. In the arena he swerves his feet with dignity and energy, moving steadily forward. The movement of his feet is matched by that of the arms and is accentuated by a strike of the medicine tail, following which **Wali** jumps backwards, as might a wise man who apprehends danger. He repeats this cycle. His dancing style betrays no sign of aggression and the women follow him and show familiarity. The men welcome him with the following songs, "*Wali, no, no. Wali has come,*" [1] or "*Wali, Wali, here is an Indian; here is a European, no, no, Wali has come.*" [2] These two songs reveal that he is an outsider, a stranger like an Indian or a European. The repeated "no" expresses that his presence in the land is ambiguous and that he is not entirely welcome. Other songs add to this, "*Wali has come; the young man of the shop, Wali has come.*" [3] In this song, **Wali** is portrayed as a trader. In other songs, his business meets with interference, "*Who has supplanted you, Wali? The Mission!*" [4] The women who dance with him sing ironically, "*Wali, Wali has employed me to shake my buttocks.*" [5] suggesting that **Wali** exploits and abuses women's favours. This trait is supported by the historical record. The long line of Jumbe was known for its intermarriage with local women and for having large harems. The members of the Mponda Mission who visited Jumbe III (Kisitu) on 18 June 1891 on their way to Bandawe mention that he had ten wives (Linden 1975: 134). Captain E. D. Young and Dr Robert Laws visited his predecessor Jumbe II (Mguzo) in September 1875 and mention that he "was suffering from what was diagnosed as syphilis and Dr Laws gave him some medicine to relieve the pain".

Though people appear to welcome **Wali**, the songs sung by both the men and women betray a certain ambivalence toward the man who was known as 'Mr Rice', 'the representative of the Sultan of Zanzibar' and 'the flash of lightning'. The dancing steps could convey the charm and the cleverness of Jumbe III (Kisitu) in dealing with the colonial government, the local chiefs and the people, and which he also used to hide his slavery practices from the British. His generosity with his chiefs and the local Chewa population concealed his crime in keeping and selling Chewa slaves and his injustices toward women. **Wali** portrays a person who disguises his dishonesty under a good appearance, using food, the offer of protection, trade and money to smooth over his activities. Several Chewa proverbs elucidate such an attitude: "*Achimseka pa maso, pa mtima pali zina – Outwardly a friendly person, on the inside it is different,*" "*Chibwenzi cha mphaka chobisa zala – The friendship of the cat hides its claws inside*" and "*Mkome adakadza – When he arrives, he gives a very good impression.*"

[1] "*Wali toto Wali wabwera.*"
[2] "*Wali, Wali, pano pali mwenye, toto pali mzungu, toto de Wali wabwera!*"
[3] "*Wali wabwera mnyamata wa sitoro, Wali wabwera.*"
[4] "*Wali adakuposa ndani iwe (2×)? ndi Aroma!*"
[5] "*Wali, Wali andilemba nchito yogwedeza matako ee.*"

Wamkulu ndine

(a pink day mask from the Mua area)

Themes 1) Recent politics; 2) Muluzi/UDF; 3) Pride/arrogance; 4) Aspiring to be greater than the spirits

Etymology **Wamkulu ndine** means, 'I am the greatest.'

Wamkulu ndine appeared in the villages of the Mua area in 1998 and performed at any ritual. The pink mask shows a prosperous fat face. He has fluffy and well-coiffured hair, a long moustache, extravagant eyebrows and a long thin nose. The mask displays an ambiguous smile projecting satisfaction and arrogance. His ears are exceptionally large to convey deafness to those who surround him. His neck is decorated with a collar made of United Democratic Front (UDF) strips of cloth. The character wears the customary tatter suit, with rags coming from the UDF *chitenje*. He performs with a medicine tail. The mask is depicted in pink or red in order to emphasise status and portray that though a Malawian, he is not Chewa.

Wamkulu ndine enters the *bwalo* very sure of himself. He solemnly surveys the ground, like the chief, and throws one leg at a time to the side. He waves his medicine tail simultaneously to convey that he intends to usurp the power of the chief. The male choir sing: "*This one, this one is a child! I am the greatest!*" [1]

His song stresses the theme of power struggle. The mask is meant to portray the

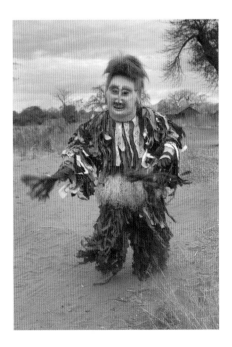

then President of Malawi, Dr Bakili Muluzi, who triumphed over Dr Kamuzu Banda in 1994 in the general elections and was re-elected President for a second term in 1999. The song expresses that although he is younger than Kamuzu Banda, by triumphing over the older man he has become more important than anybody else, even the ancestors. Though the character appears to pay a tribute of honour and thanks to the new President in his high office of Head of State, it carries an undertone of subtle criticism. **Wamkulu ndine**'s power is greater than Kamuzu and also greater than Chadzunda. Following the Chewa pedagogy, this is a direct attack on Chewa leadership that pretends to be above the spiritual order. The proverb says, "*Wamkulu ndine, wamkulu ndine, adagwa padzala – The one who says, I am the most important, fell in the rubbish heap.*" Chadzunda is to be emulated as a chief but he is not to be competed with as the head of the Chewa pantheon. **Wamkulu ndine**'s presumption is seen as blasphemous to the Chewa traditional believer and will be proven wrong in the future.

[1] "*Yawa yawa ndi mwana (2×)* **Wamkulu ndine!**"

Weresike

(a red day mask from Chimalira village, Pemba and Maluwa areas)

Themes 1) Recent politics; 2) Opposing Kamuzu Banda (supporting political change); 3) Colonial period politics

Etymology Weresike is a deformation of the name, Welensky. Sir Roy Welensky had been the Prime Minister of the Federation of Rhodesia and Nyasaland in the 1950s. He was a strong personality and a staunch defender of colonial interests. During his term of office, he made virulent attacks on the African nationalist leaders and made sure that the government would remain in 'civilised hands'. He promised he would deal firmly with irresponsible agitators and extremists like the emerging Kamuzu Banda. He attempted to crush all opposition to the Federation. Kamuzu Banda and Welensky became personal enemies. Kamuzu Banda's strong nationalist commitment saw him triumph over his opponent by removing Nyasaland from the Federation in 1959. The character of **Weresike** casts simultaneously the two opponents as one *gule* mask across a span of 30 years.

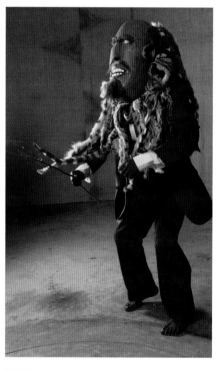

The large 45 centimetre oval mask superimposes simultaneously the faces of Welensky and Kamuzu Banda 30 years later. A strong neck carved from a single piece of wood supports the mask. Both personalities are featured as old, half bald with sparse hair on the temples, a moustache and a bushy goatee. The features are ravaged by age, hard work and ambitious plans. The eyes are pensive and are shielded by the bushy eyebrows to give the character a sad and disappointed look.

Deep grooves border a long western nose and run down the face to show distress. The ears are high on the head. The drooping mouth is populated with protruding teeth to emphasise dismay. A white cowlick (made of sisal) hangs on the anguished forehead confirming surrender. The headgear of the mask is made of baboon skins and the red colour of the face reveals that **Weresike** has joined the world of the outsiders and belongs to the bush. **Weresike** however is characterised by a British outfit, typical for both personalities: a smart pair of trousers, a white shirt and a tie. The whip he holds suggests obstinacy and scolding that are characteristics of both personalities.

Weresike is recent (1991) to the world of *gule* and his role is not specific for any ritual. His main function is designed for political rallies. In the *bwalo*, **Weresike** imitates the dancing style of Simoni. He displays tremendous concentration in the sideways swerving of his feet but then seems to lose his memory and stops. He exits the arena carrying the drums. Then, the drummers remind him that the performance is not yet over. They bring back the drums and he continues to dance and repeats the same choreography. The pantomime shows the audience that both Welensky's and Kamuzu Banda's duties are over and that they should be thinking of going home. Their farewell forms the content of the song sung by the men: "*Welensky used to say: Let me go home! As for me, since I am a stranger, I just take my luggage and go. Stay well and experience what lies ahead…but one day you will remember me, Welensky, Welensky!*" [1] These fictional words of farewell apply to both personalities though they are separated by a thirty year span and by mutual hostility. Welensky exited Nyasaland and Malawi with the end of the Federation and the beginning of independence. Kamuzu Banda relinquished power 30 years later with the advent of multiparty activism.

The mood of the 1960s preceding independence was exemplified by the nationalist slogan, "Europeans out." Following the independence of Malawi in 1964, many colonials left the country. At this time the villagers were able to compare and contrast the old and the new regimes. Many were wishing that the Europeans would come back. The cabinet crises of August 1964 and the persecutions that followed were the vanguard signs of a regime of oppression that would last for more than three decades. The period of the 1990s marks a turning point in Malawi politics. Kamuzu Banda is perceived as the reincarnation of Welensky, the enemy of freedom and self-rule. Kamuzu Banda's abusive regime and the deeds of his entourage had exhausted people's patience. The independence and the better life they had been promised did not materialize. They only gained a new kind of nightmare. The slavery they were enduring had become worse than the *thangata* (forced labour) system of old and the Federation itself. The dissatisfaction and the grievances of the masses were later expressed in the Catholic Bishops' pastoral letter of March 1992 and the series of events that led to the 1993 referendum. This prompted the *gule* members,

at the beginning of the 1990s, to bring back the ghost of Welensky. They had certified that it fit to perfection the dark shadow cast by Kamuzu Banda's reign of terror and his MCP killing machine. **Weresike** reveals that the word 'freedom' had come to mean

exploitation, slavery and marginalisation. Kamuzu Banda had reasons to worry and carry a gloomy face. He was indeed on his way out. He could only recall the last words of Welensky. *"Experience what lies ahead…and one day you will remember me!"*

[1] *"**Weresike** amanena (2×): ine ndapita tate ye! Chikhala ine ndine mlendo tate, ndingochoka ndi zangazi tate ye. Tsalani tsalani muone zina tate ndiye mudzakumbukira ine tate ye **Weresike**, **Weresike**."*

Yaduka ngolo

(a pink day mask from the Mua and Malirana-Magunditsa areas)

Themes 1) Recent politics; 2) Failings in multiparty democracy; 3) Rivalry for authority; 4) Cynicism about politics

Etymology **Yaduka ngolo** means, 'The cart is broken down.'

The mask portrays a young, smart and cheerful man. His eyes are bright with expensive spectacles. He has a straight nose. His smile shows even teeth on the top jaw. His chin is strong. The ears are erect. He is well groomed with shiny black hair made of goatskin. He is beardless but has a well trimmed moustache. His face resembles that of a European (pink) but nevertheless exhibits some African features (broad nose and thick lips). The headgear comprises rags. He wears a tatter suit and a wide belt. The mask lacks tribal marks indicating he is a Malawian but not necessarily a Chewa. Two medicine tails demonstrate his status in the running of the government. **Yaduka ngolo** is a well-educated and affluent Malawian who has been chosen for a high position.

The character usually appears in a group of five or six. Together they perform a mime suggesting they are driving a cattle cart. The first three dancers imitate flogging the cattle and pulling the imaginary cart. The last two stay far behind the cart. The groups argue and the cart cannot proceed. **Yaduka ngolo** performs on any occasion especially at party meetings. The men sing, *"The cart is broken down! The cart is broken down!"* [1] The parable of the cart symbolises the journey of the Malawi nation towards the future, in particular the political scene after the second democratic election of 1999. In 1994 the country had committed itself to democracy and a multi-party system, breaking the long regime of single party rule. The 1999 elections were hoped to affirm the wisdom of this choice and the areas in which efforts were needed (such as human rights, empowerment, gender equality, poverty reduction, political participation and sustainable development). Though the elections were judged substantially free, fair and acceptable, the commitment of Malawi to democracy showed weakness. The post election period manifested apathy and an apparent lack of commitment towards freedom and social and political order. The

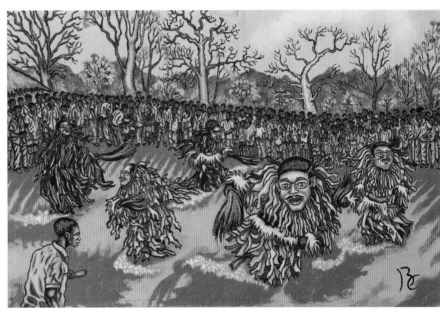

Painting by Claude Boucher and Joseph Kadzombe, 2009

various parties distributed along regional lines were more concerned with their own success than with the good of the country. Losing parties contested the election results and sued the President and his party in court. The Malawi Congress Party showed little interest in political collaboration and instead descended into internal dissension concerning the presidency of their own party. The factions held their convention meetings separately (Blantyre and Lilongwe). Some prominent MCP representatives defected to the United Democratic Front. It was widely held that some at least were inspired by monetary payment. This weakened the opposition and reduced their ability to act as a check on the government policies. They failed to serve the interests of the people. The character of **Yaduka ngolo** represents a divided parliament and the harmful struggle between various parties. The UDF is running the cart while some of the MCP MP's remain behind, withholding their collaboration and preventing the country from

going forward. They are only interested in their own success and forget about the people they should be representing. They appear in smart dress, wearing glasses, brandishing their medicine tails of power but they reveal their own selfishness. They talk about poverty alleviation but are primarily preoccupied with their own wealth. Once they have acquired economic security they drop the cart and forget about the interest of the people they should serve. **Yaduka ngolo** is a protest that multiparty democracy is reverting quickly towards the model of dictatorship practised in the Kamuzu Banda regime. The Chewa ancestors always side with the community and discourage the selfish pursuits of the individual. A person who is motivated by ambition and greed can easily become a witch (*mfiti*) because he sucks the life from others. The Chewa believe that such witches transform into evil spirits (*ziwanda*) after death and continue compromising the peace of the community by sending misfortune.

[1] *"**Yaduka ngolo, Yaduka ngolo**."*

Yayawe

(a yellow day mask from the Tambala area near Dedza)

Themes 1) Recent politics; 2) Opposing Kamuzu Banda (supporting political change); 3) Muluzi/UDF; 4) Courage/fearlessness

Etymology **Yayawe** is an abbreviation for *Yayawe adakatero*. Literally it means, "Rejoice, if things would change." It expresses the joy of people in meeting somebody, here someone who is not afraid to fight for change.

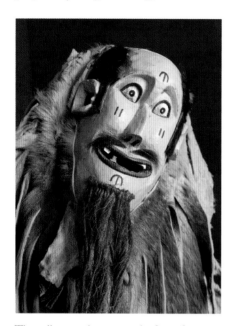

The yellow mask portrays the face of a senior man whose shiny bald head displays a white circle, here used as a sign of wisdom. The eyes and the mouth with gaps between the teeth show aggressiveness. The nose is narrow and aquiline. The ears are prominent, signifying that he is alert. A small clean moustache and long bushy goatee suggest that he is educated. The clothes he is wearing (a clean white shirt and a smart pair of trousers without rags) reinforce this image. The headgear of the mask is made of goatskins and the character has local tribal marks on his face showing he is a real Malawian. He holds a medicine tail and a scarf to show that he aspires to the ruling position. He enters the *bwalo* to the rhythm of the *chisamba* and swerves his feet and waving his medicine tail with great energy. He then sits on the ground, assumes an upside down position and walks on his hands. After walking upside down for a while, he falls on the ground. Then he stands up again and starts dancing with unrivalled vigour. The men sing, "*Yayawe, rejoice* (if things would change). *Rejoice! Keep showing energy inside the bwalo so that more people may support you,* **Yayawe!** (They sing the name loudly:) **Yayawe**. *If your group fails, it is your problem. It is not my fault,* **Yayawe**, *rejoice* (if things would change). *Oh!*"[1]

The character of **Yayawe** was introduced in *gule* around 1993 and was performed mainly during party meetings. This was the time immediately after the Lenten Pastoral letter that marked the onset of a period of activism by multi-party advocates such as Mr Chakufwa Chihana and Dr Bakili Muluzi. By January 1993, President Kamuzu Banda had officially announced that the referendum would take place in March of the same year. The Alliance for Democracy (AFORD) and United Democratic Front (UDF) parties held their first rallies in Blantyre and then moved out around the country. They were attracting huge crowds. The referendum outcome favoured the multi-party system by a majority of 63%. Following the referendum, the churches and their official body, the Public Affairs Committee (PAC), were busy preparing the ground for the general elections scheduled for May 1994. In December 1993, the Malawi Army launched a raid on the Malawi Young Pioneers (MYP) headquarters and disarmed them. Meanwhile the various parties (MCP, AFORD and UDF) were busy campaigning and preparing for the general elections. In March 1994 the Catholic Bishops issued another pastoral letter called 'Building Our Future' that explained to the population the Christian view of democracy. The same month a new constitution was being written and voters were registering for the forthcoming election of 17 May. On the 19 May 1994, President Kumuzu Banda conceded having lost the presidential election. The old man congratulated Dr Bakili Muluzi on his victory and wished him strength and cooperation. Dr Bakili Muluzi, the head of the UDF party had become the new President of the Republic of Malawi.

The mask of **Yayawe** is yellow. The colour yellow manifests the support of some *gule* members for the UDF party and Bakili Muluzi. The choice of the colour yellow by UDF was inspired by their motto of the lamp and the light and also by the *chitenje* that was printed in the papal colour of yellow-gold and became so popular in commemorating the Pope's visit to Malawi in 1989. It is interesting to contrast a character like **Yayawe** to the literature and the news in the country that painted the *Nyau* of the central region as allies of the MCP party. They reported that *gule* dancers were hired to force the people to attend MCP rallies and to intimidate them to vote for the MCP and oppose the multiparty democ-

racy. The present character of **Yayawe**, and several others created in that period, shows that this perception is one-sided. The reality is more complex. *Nyau*'s allegiance to the MCP cannot be denied, especially in the early period, but one has to recognise also that the *Nyau* members were part of the Malawian population that was undergoing momentous change. The secrecy of *gule* and its elaborate set of coded language were providing the ideal channel for raising new and discordant voices. Moreover, *Nyau* is an organisation that has not favoured centralisation. Each group is substantially independent and enjoys its own freedom and history. Some groups may have been easy to bribe by the ruling MCP. However, others with stronger convictions regarding change were able to use the institution of democracy for voicing their ideas. By the early 1990s, the dominant message of *gule* was to replace Kamuzu Banda.

Yayawe does not only manifest support for a multiparty system and democracy through its colour but also through the whole appearance and performance of the character. **Yayawe** represents a senior Malawian, wise and educated, who is not afraid to oppose the regime of fear and terror that ruled the country since independence. The pantomime of the dancer predicts the change of power in Malawi. His unrivalled performance reflects that the UDF showed superior dynamism to that of the MCP. The old government was turned upside down (dancing on the hands) and was about to collapse (the dancer falling to the ground). The new parties were ready to take over and do their best to put the country right again. The song instructs the population to overcome fear and give their support to the new parties. Failure is possible but it is worth trying something new. The character's name anticipates the joy of those who will be liberated if a new government is successful. **Yayawe** shows the joy of those who welcome change and who are ready to rally behind a few men who do not tremble with fear but who have the courage to fight tyranny and establish freedom.

[1] "*Yayawe, Yayawe, oh tate* **Yayawe**! *Talimbikani m'bwalomo kuti anzanu akuthandizani tate* **Yayawe**! *Yayawe* (x2) *ngati kuli kulephera kaya n'zanu. Sindine tate* **Yayawe**, *Yayawe oh.*"

Zachitika

(a black day mask from the Maluwa area)

Themes 1) Recent politics; 2) Opposing Kamuzu Banda (supporting political change)

Etymology **Zachitika** means, 'It has happened.'

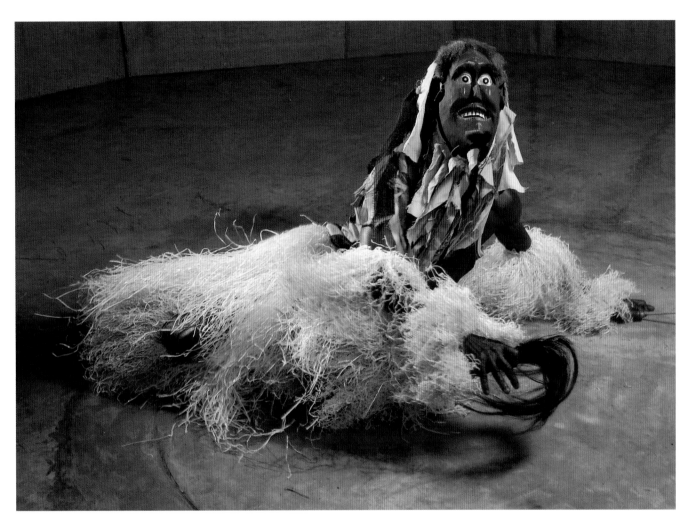

This black mask portrays a middle aged Chewa with local tribal marks, a curved nose and salient cheeks. His hair is black and comprises goat hair, to imitate curly African hair. He has a small moustache, sideburns and a goatee. His eyes are open in awe and his mouth has a wide smile. His pointed chin affirms his personality. The dancer wears a strange combination of a fibre kilt with a vest, leglets and armlets. He carries a mini medicine tail and a whip to show that he will soon be removed from the position of leadership.

As **Zachitika** goes around the *bwalo*, he swerves his feet with excitement and power until he falls, exhausted, among the women. He stands up and falls again and again to demonstrate his name, 'It has happened.' People laugh as he keeps falling, cheering his downfall. The men sing for him, *"God has*

looked upon the wretched. It has happened! It has really happened! As for us, these things (are impossible). *Let them see for themselves. For us, we know, it has really happened! Some state that it is happening in the east and in the west* (everywhere). *It has happened! It has really happened!"* [1]

This character was created around 1993 and was very popular at political rallies. The song expresses the excitement surrounding the referendum when the new politicians advocating the multiparty system started to appear on the scene competing for the referendum and for the general election of June 1994. The character predicted the downfall of the government and the Malawi Congress Party (MCP) and the victory of multiparty democracy. God has pity on people's misery. Under Kamuzu Banda so many

innocents were jailed and perished. **Zachitika** was created in order to invite the new generation to rally behind change and to cast away the thirty years of oppression under the dictatorship of Kamuzu Banda.

Zachitika's dance and features represent both the Kamuzu Banda regime and the dynamism of the new political leaders who believed that they could overrun the old hegemony and make it crumble. The song voices the hopes shared by many Chewa who had suffered the inhumanity of their so-called 'saviour'. **Zachitika** is more than a dream, it is a miracle!

[1] *"Chauta waona alombo tate!* **Zachitika**, *zachitikadi! Aja akuti ayi chikhala ife toto zimenezo tate* **Zachitika**, *zachitikadi! Kodi inu ea akuti zachitikadi kum'mawa konseko, kumadzulo konseko, ede tate* **Zachitika**, **Zachitika!**"

2. Community, authority and the ancestors

Unity and harmony in the village are vitally important themes for the great dance, associated with a variety of characters which explore what evils can befall a community where the harmonious coexistence of the group has been fractured. Many *gule* characters set this theme within a diverse array of contexts. This harmony extends across all levels of the village, from the married partners, to the extended family, through the family head (the maternal uncle, the *malume*) to the chief (*mfumu*). There is a strong linkage between harmony and the role of the chief, as the latter's primary function is twofold: firstly to be a vector for the ancestors and their fertility and good will, and secondly, to keep peace amongst the living. The two roles are closely conjoined as the ancestors are happy when the living villagers are happy and unified amongst themselves and with their neighbours, whatever the origins of those neighbours (the **Mmwenye's**[1], **Ng'ombe, Sitilankhulana**[2]).

The village is a small community and everyone knows each other. There can be few secrets. In this environment, local power, its application and impact, are very visible and felt by all. In a conservative community, there must be brakes on improper change in community values, and underpinning both power and values is the *mwambo*. So this too is a major topic for the *gule wamkulu* (**Chadzunda** and **Mariya, Chigalimoto**[3], **Chilembwe**[4], **Kapoli**). As a corollary to this, the great dancers give instructions on the role of the chief and what constitutes a wise and effective community leader, overseeing the *mwambo*, as well as being a conveyor of fertility from the ancestors (**Chimbebe**[5], **Kalulu, Kapolo wa onsene, Mdondo, Mkango, Njovu**). There are examples of poor and irresponsible chiefs and elders who betray the trust of their community and may use medicines to retain their power (**Mdzopendeka, Mfumu idagwa n'nyanga**[6]). A number of these caricatures of village leaders have a parallel application to the national politics

of the day (for example, **Chimnomo lende**[7] of Pemba). The spirit messengers also advise everyone to respect the *mwambo* and thereby the authority of the chief, thus binding the village into a law-abiding community. Many characters reveal the dangers in power struggles and rivalry over authority (**Chikwekwe, Lambwe, Mfumu yalimbira**). Such conflict can even impact upon the recently deceased (**Asawa manda**). The spirit dancers also remind the villagers that punishment awaits those who flaunt the laws of peace and harmony, be it social or sexual harmony (**Kuliyere, Sitiona mvula**).

Below the chief, the family head, the *malume*, has a vital role within the extended family, as the primary authority and guardian of the group. In this, he is both blessed and cursed, as he has the support of the family, notably the older women, as long as the family enjoys stability and success. Once there are trials and tribulations, and in particular, deaths in the family, it is the family head who bears both the responsibility for failure and, worse, often the blame for causing the ill fortune (**Akulamulo, Asongo**[8], **Kasinja**[9], **Sajeni**[10]). The *malume* has many responsibilities, including a symbolic and practical role at funerals, where he is the one who designates the site for the grave (**Mzikamanda**).

As the basic unit of the village, the extended family requires protection, and advice is provided by the ancestors on the importance of maintaining familial and filial links and the risks inherent in their decay (**Akulu akulu adapita, Chibale n'chipsera, Kwanka anyamata, Mtchona** and **Mai Mtchona**). Movement of people away from their village (as in the labour migration movement for employment) is seen as a particular risk, in that the family ties can be weakened and, should the people return, they can bring with them unhealthy new ideas from the outside world (**Ndalama n'ndolo, Kwanka anyamata**). In a stable, conservative community of

extended families, the wisdom of the elders is more reliable and the old people are to be respected and cared for (**Namkwanya, Njinga yabwera, Pombo kuwale**). This care for the aged is in contraposition to the suspicion that the elderly use witchcraft to extend their lives (see Witchcraft & medicines).

In the Chewa world view, the community is both that of the living and of the dead. The ancestors are to be respected and venerated, and their messengers, the *gule wamkulu* dancers, are to be received and heard. In this way, the blessings of the ancestors will be forthcoming and their wrath avoided. Not surprisingly, a significant number of *gule* characters address the process of communion with the ancestors. As part of this, the brewing and sharing of beer has been a longstanding tradition for rituals, and the ancestors have their interest in their portion. (**Ayenda n'chamutu, Basi-Minibasi, Chimkoko, Kampini, Kanswala, Pinimbira** and numerous others).

In the Introduction, we discussed the rites of passage that define a person's life from womb to grave, and indeed, beyond the grave. These rites bind the community as well, as many are shared events that serve to reinforce ties and mutual dependencies between the village members. There is a recognisable set of characters who assist in that ultimate transition, from this world to that of the ancestors. **Akulamulo, Chabwera**[11], **Chadzunda, Kachipapa, Kasiya maliro** and **Njovu** are prominent in this regard.

[1] Personal attributes
[2] History & politics
[3] Sexuality, fertility & marriage
[4] Sexuality, fertility & marriage
[5] Sexuality, fertility & marriage
[6] Witchcraft & medicines
[7] History & politics
[8] Witchcraft & medicines
[9] Sexuality, fertility & marriage
[10] Sexuality, fertility & marriage
[11] Sexuality, fertility & marriage

Akulamulo

(a red day mask from Mua)

Themes 1) Responsibility of family heads; 2) Assisting transition of deceased to spirit world; 3) Sexual taboos (*mdulo*); 4) Compassion of ancestors for the living; 5) Unity & harmony

Etymology **Akulamulo** means, 'the custodian of the customs that regulate the family group (the guardian of the law)'.

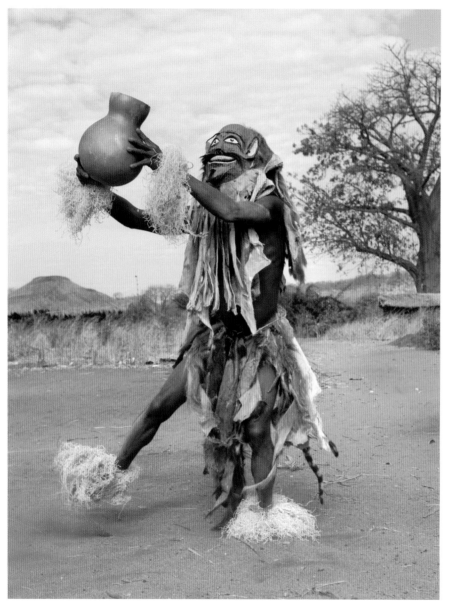

This mask portrays a *malume*, the head of the family group. His face shows wrinkles, a broadly smiling mouth lacking teeth, pointed ears, a strong chin and a moustache and beard. The headgear and costume are made of various kinds of skin that were the garments of his family members who have passed away. He carries a gourd of medicine. The red colour of the mask reflects that he is here to advise on the rules of sexual conduct. As he enters the ground at the rhythm of the drums, he throws the

right leg forward, three times repeatedly, and then does the same with the left. In this manner he moves solemnly about the *bwalo* as the men sing, *"Akulamulo (guardian of the law) go and give your orders so that your family members may rest in peace, Akulamulo."* [1]

Akulamulo dances only at funeral and commemoration rites. He plays an important role as the family head. During funerals, he acts as undertaker (*mdzukulu*). He offers his service to any member of the

secret society. His presence is required from the moment the grave digging starts until the closing of the last mourning rite. As the head of the family group, he has to show sympathy to the deceased and the bereaved relatives. He expresses the compassion of the spirit world for the dead. As an undertaker, he welcomes the body of the deceased to the grave and puts it to rest.

Akulamulo is the keeper of the gourd of medicine used for the shaving rites and for the preparation of the medicine that will allow the family members to return to normality. The medicine is made of the water with which the gravediggers washed their hands after the meal at the gravesite. That water is kept in a small gourd and will later be mixed with medicine. Some of this water is poured in the food consumed by the family members to mark the end of the period of mourning. Sex has been prohibited during the funeral rites. The handling of this gourd by **Akulamulo** is interpreted as the final acknowledgement by the spirit world to cease mourning and to resume normal life, including sexual relations. Through this gesture, he puts the spirit at rest.

Shaving of the head of close relatives of the deceased is repeated three times during the whole mourning process. The first shaving takes place a few days after the burial and frees those who are less closely related to the deceased. The second shaving is after three months and frees the immediate family members. The last shaving after a year frees the widow/widower, helping her/him to readjust to a new life. At each of these stages, **Akulamulo** presides over the shaving ceremonies with a gourd of this same medicine. At the final shaving, **Akulamulo** crushes his gourd in front of the home of the deceased to show that the mourning rites are over. His role is that of a wise spirit who strengthens the cohesion of the community. He enforces the separation between cold and hot and regulates sexual activity during this trying period. Through these rules he leads the family group beyond the experience of grief and sorrow to the joy of renewed life strengthened by their own solidarity.

[1] "*Akulamulo ede, mukalamule anzanu akause, Akulamulo.*"

Akulu akulu adapita

(a cloth mask from the Golomoti area)

Themes 1) Social changes/insecurity; 2) Lack of community spirit; 3) Importance of family ties; 4) Chewa identity; 5) Pride/arrogance; 6) Promiscuity; 7) Dangers of modernity; 8) Selfishness/self-centredness

Etymology Akulu akulu adapita means, 'The elders have gone.'

The character of **Akulu akulu adapita** is new, appearing in the Golomoti area in 2005. The mask and headcover are made of a fluffy grey cloth. The eyes are marked by two beer bottle caps. A fold in the cloth suggests the nasal bridge and two similar folds form the mouth. Improvised cloth ears are stitched loosely on to the mask and appear as useless appendages. The dancer shows no *gule* regalia but wears a blue and grey tracksuit heavily padded around the belly, the buttocks and the sexual organs. He carries a dandy handkerchief to show that he comes from town. The fat belly and bottom caricature town-dwellers who are bloated by the rich western food and their daily beers. The enlarged sexual organs hidden in the tracksuit suggest promiscuity and lack of self-discipline. Town life is associated with free sex and with a complete break from the *mwambo*.

Akulu akulu adapita appears at funerals, commemoration rites and sometimes at the enthronement of chiefs. He enters the *bwalo* radiating arrogance and selfishness, and proudly exhibits his big belly and exaggerated bottom to signify that he eats well in town, better than in the village. His dancing style epitomises the chaotic and inconsistent behaviour of the younger generations. He is so poor in manners that he does not even attempt to hide his vulgarity. **Akulu akulu adapita** swerves his feet briefly and then gyrates his hips obscenely before lowering himself close to the ground. This movement and the padded sexual region express that he is a liberated person enjoying casual sex. The male choir sings to him: *"The elders have gone!* (In those days) *we found a place to stay!* (When we went to town) you *dropped me!* (You turned me away!) *You dropped me!"* [1]

The character of **Akulu akulu adapita** is critical of the new Malawi, a modern generation that lives selfishly and refuses to keep its bond to the village. After the death of the grandparents and the parents, their town-dwelling children cut their link with the village and behave like strangers. They do not visit their relatives and let the flame of brotherhood die. They do not attend funerals, commemorations and enthronements. They ignore the suffering, poverty and misfortune of their family members. If one visits them in town and is looking for a

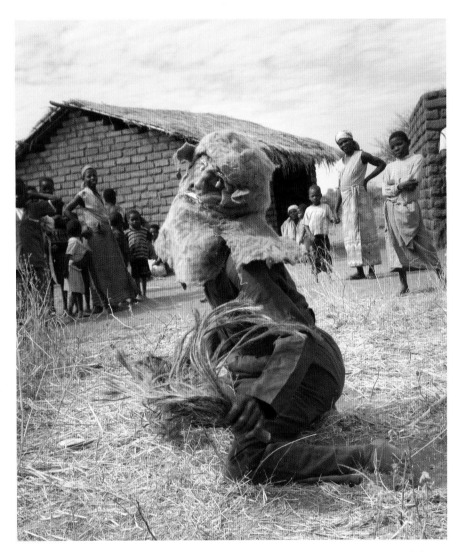

shelter, one is made to feel unwelcome. They make the guest feel that he is disturbing their peace and intruding on their privacy and freedom. They pretend to be busy and their doors are closed. They live without discretion, falling victim to sexual diseases such as HIV/AIDS.

Akulu akulu adapita criticises the arrogance and self-obsession of the new generations who ignore family relations and instead invest their energy to pursue power, money and individualism. They value their freedom and economic independence more than their own roots. They sacrifice their culture, their identity and their family relationships in order to appear western and superior to their relatives in the village. Sometimes their

success becomes their downfall. Their fat belly and bottom, and their sexual appetites and behaviour, kill them. They are buried away from home, mourned by no one (demonstrated by the anonymity of the face). **Akulu akulu adapita** looks with suspicion on some of the social changes that are affecting Malawian society and Chewa society in particular. The turn of the third millennium has fractured the strong community bonds. The elders have gone and with them their community spirit and close relationships. Now the children remain isolated and self-centred.

[1] "*Akulu akulu adapita, tikaona pofikira, mwamtaya, mwamtaya.*"

Akumanda samalira or Mbiya zodooka

(brown day masks from the Mua area)

Themes 1) Piety for the dead; 2) Sexual taboos (*mdulo*); 3) Do not cry over the past

Etymology Akumanda samalira has a double meaning: 'Those from the grave do not complain,' or 'Look after them.' Mbiya zodooka means, 'the broken pots'.

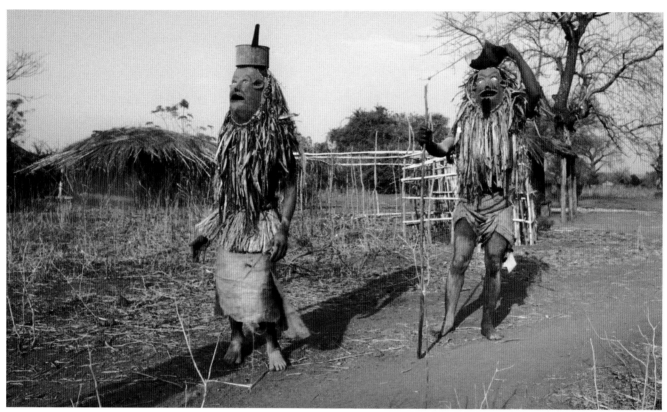

Claude Boucher, Kanyera Village, October 1993

These two brown masks represent a pair of Chewa ghosts coming from the graveyard. In the night version, the dancer wears a white head covering made of cloth or a sisal headgear on which he holds a piece of broken pot. The day version features two masks carved of wood which portray a male and a female ghost with thin faces, salient cheeks, broad toothless mouths, pointed chins, flat foreheads, wrinkles and a tiny bit of hair left on the head. The headgear is made from chicken feathers for the male and banana fibres for the female. In the past, the pair would dance naked. Today, they wear a loincloth made of woven banana fibres or sackcloth. Their bodies are smeared with ashes and both carry ashes in their potsherds. The pot shards represent the world of the dead. Before the funeral, the deceased's body is washed from a clay pot. The same pot will be used at the shaving of the mourners and then broken on the crossroads at the end of the last shaving ceremony to express that the deceased now belongs to the world of the dead.

The characters appear at the time of funeral and commemoration ceremonies. The dancers who perform these characters have to keep ritual coolness. They dance at some distance from the crowd. They perform as a couple, with the woman ghost taking the lead. They move their hips, facing each other, as if they were having sexual intercourse. Then they spread the ashes around the *bwalo*. Like the ashes thrown on the ground, the dead will not return. Through their daring dance, they demonstrate that the dead no longer have sex and that marriage is a reality that belongs to the world of the living. The men sing, *"The ghosts of the grave do not complain,"* or *"The ghosts, look well after them. They have long gone by."* [1] or *"Go home, your home is the graveyard, the broken pots."* [2]

The song signifies that these ghosts have gone and are not to be seen in the village any longer. *Chapita, chapita – What is gone has gone.* They are not to come back. The dead do not complain about leaving sex and material possessions behind. They have settled

into a new village and live a new existence in the graveyard, where the broken pots (*mbiya zodooka*) lie. Mourners should not unduly fear them, provided they show piety for the spirits. This is a warning to the relatives of the deceased to keep the *mwambo* and to observe the sexual abstinence imposed on such occasions. The graphically sexual dance of the two **Akumanda samalira** characters stresses this. Piety for the dead is also expressed in terms of caring for the grave and performing the subsequent rites after the funeral. The erection of the tombstone a few years after the burial has become compulsory. Neglect in these matters can result in misfortune or spirit possession for the family members, reminding them of their obligations to the deceased.

There is a second version of **Akumanda samalira** from Dedza, with different physiognomy and message (refer to that entry in Personal attributes).

1 *"Akumanda samalira de (2×) adanka kale."*
2 *"Tiye kwanu, kwanu kumanda, Mbiya zodooka."*

Am'na a chironda

(a feather mask from the Mua area)

Themes 1) No marriage for the handicapped; 2) Rights of/respect for the handicapped; 3) Social stigma

Etymology Am'na a chironda is an abbreviation for *amuna a chironda*, meaning, 'the husband of wound' or 'the husband of grief'.

Am'na a chironda is a type of Kapoli that dances on one stilt about a metre long. His mask consists of a feather headcover *(chiputula)*. He dresses in a jute suit stitched with tatters and a kilt, with leglets and armlets made of fertiliser laces. **Am'na a chironda** represents a handicapped person with one leg longer than the other. The character exaggerates the disproportion between the legs. The healthy leg (the left) is lengthened by a stilt hidden within his tattered trousers. The lame leg is simply the dancer's normal right leg. When **Am'na a chironda** walks, he lurches grotesquely. He carries a two metre long walking stick so he can support himself during the dance. In the arena, **Am'na a chironda** jumps two steps on his stilt, then two steps sideways on the right leg and then he pauses for a short time. He resumes jumping, two steps on the left side and pauses again. In a third movement he falls from the tall leg onto the normal leg and then somersaults on the ground, rolling and rolling like a madman expressing his frustration. As he begins his dance, he starts his own song with a high-pitched voice typical of Kapoli to which the male and the female choir continues, "(A girl says:) *No, do not call me. What are you calling me for? No, do not call me* (since you are) *the husband of wound* (handicapped)."[1]

 Am'na a chironda can appear in all kinds of rituals. His song voices the prejudice of the villagers towards a lame person who is denied the right of marriage. When he proposes to girls, they refuse him. They say, with your handicap how can you provide a living for us? **Am'na a chironda** is hurt both in his body and in his heart since he is denied marriage and being a husband. That is why he is called 'the husband of wound/grief'. He cannot reconcile the idea of remaining a child for the rest of his life by not being allowed to marry normally. He will never have the pleasure of having a home, a wife and children of his own. His handicap prevents him from working the land and producing his own food. He is forced to live with his mother and depends on her for everything. The character of **Am'na a chironda** protests against a society that stigmatises him because of his handicap. He may be lame but he is full of energy and possesses other gifts.

 Even the ancestors seem to approve of

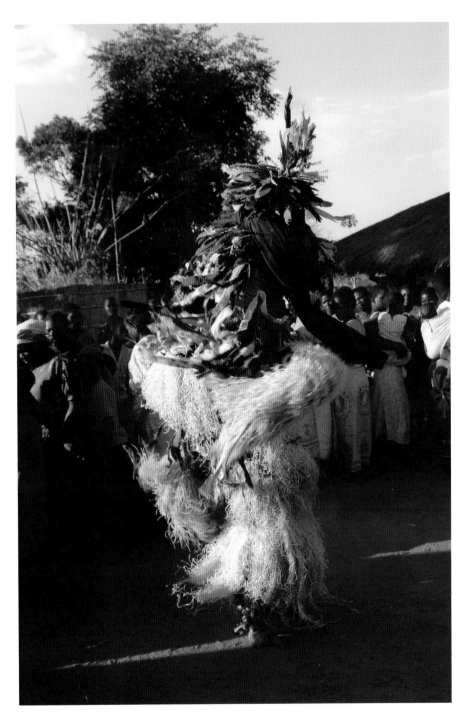

his grievance and invite the community to look beyond appearances. As the Chewa proverb says, "*Munthu wolumala ndi Chauta. Mumpembedze – The lame person is God. Worship him!*"

[1] "*Toto kundiitana, wandiitanira chia? Toto kundiitana Am'na a chironda.*"

Asawa manda

(a red day mask from the Dedza area)

Themes 1) Conflict between two local authorities; 2) Role & powers of the chief; 3) Sexual taboos for funerals

Etymology **Asawa manda** means, 'he who designates the grave site'.

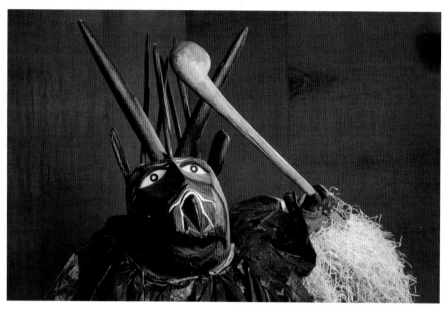

The large red mask displays a combination of animal and human characteristics. Red symbolises authority and power, and the character also brings the message of sexual prohibition at the time of funerals. The characteristics of the ram are seen with the head and horns, the ears and the muzzle. The ram is featured with eight horns instead of two. The two heavier and larger horns (about 40 centimetres long) point sideways and represent those who fall under the authority of the chief. These people are typically the traditionalists and those who belong to various Christian churches. The two thinner horns stand erect on the forehead, signifying the two assistants of the village headman. Four horns point symbolically to the four corners of the world and represent the community and its numerous funerals. The forehead of the mask is human, with wrinkles and two black protrusions to show that the person is senior in age and rank. The protrusions highlight that his authority has been consolidated with the help of special medicine (*kukhwima*). The eyes show diligence and control. The headgear of the mask is made of baobab bark, the clothing of earlier generations before the introduction of cotton cloth. **Asawa manda** wears a plain sack suit without tatters and a long kilt, leglets and armlets made of jute or sisal. He carries a club to remind the audience that nobody should challenge his authority.

Asawa manda joins most celebrations or rituals, except funerals. Entering the arena, he leaves no doubt of his dominance by roaming quickly around the dancing ground, swerving his feet with great confidence. Shortly after this display of power, he chases the women away, especially those that are pregnant. This gesture emphasises to the audience that a pregnant woman should not go to funerals, the graveyard or anywhere near death. Life and death should not meet. The male choir clarifies his aggressive behaviour with the following songs: "(The family head of the deceased says:) *Mr He who designates the grave site, let's go, let's go* (to the graveyard)! *How is it that people must argue and pay a fine to Mr He who designates the grave site?*" [1] In this first song the family head of a deceased is demanding that the assistants of the chief open the gate to the graveyard. The permission is refused because the chief has not allowed him to do so. The second song continues: "(The chief's assistant says:) *It is the gate-keeper* (the chief) *who is in charge of the village.* (Do you think that) *those who have stopped seeing and breathing* (the dead) *can designate the grave site?* (The deceased's family head says:) *What can I do? I went to the gate!* (I could not open it because I had no permission.) (The chief's assistant says:) *He does not belong here! Even if it is far, let us take him to his home village, Mr He who designates the grave site.*" [2] The second song follows the discussion between the assistant of the chief and the family head of the deceased who comes from another village. The chief's assistant refused to open the gate to the graveyard and allow the deceased to be buried in the village. The deceased is a stranger who married into his village without proper formalities in front of the village headman. The chief refuses him a burial ground since he has never entered the village officially. The maternal uncle, the head of a family group, has the duty to designate the grave site but since he is not in his own village this permission defers to the authority of the chief in the village where the deceased had married. The song portrays the conflict between two prominent authorities and their respective roles. The local chief is the sole authority who can grant this permission and allow his assistant to open the gate for the family head to designate the gravesite. If he refuses permission, the body will not be buried in the village of the deceased's wife, but at the deceased's own home village. If permission is granted, the family of the deceased will be required to pay a heavy fine for assimilating into the village without the chief's endorsement.

The message of **Asawa manda** focuses on the responsibility of strangers marrying into the wife's village to settle their business while they are still alive. The fine should have been paid to the chief when the deceased was living. **Asawa manda** reminds the villagers about the customs concerning funerals and access to the graveyard. The character stresses the importance of settling such matters promptly, and not waiting for an emergency situation like death to deal with old issues. The red colour of the mask emphasises sexual prohibition at the time of funerals. The chasing of the pregnant women (who are considered hot) is to distance and remove them from any proximity to the dead (who are considered cool). These prohibitions remind the village of the *mdulo* complex that forbids hot and cool to come together. The character of **Asawa manda** comments on conflict, allegiance and power struggles between two village authorities, within the context of death and sexual taboos.

[1] "***Asawa manda** tiyeni tiyeni! Kani achita kuzenga, nalipira kwa **Asawa manda**?*"
[2] "*Izika mudzi (2×) akuchipata azika mudzi. Monga n'kuzika mudzi wanthu, wanthu osapenya, osapuma azika mudzi? Iwo akuti: nditani ine? Ndapita kuchipata! Sakhalanso kuno! N'kutali, tikatule azika mudzi.*"

Ayenda n'chamutu

(a night structure from the Mua area)

Themes 1) Unity & harmony; 2) Communion with the ancestors; 3) Sharing of beer

Etymology Ayenda n'chamutu means, 'the walking head'.

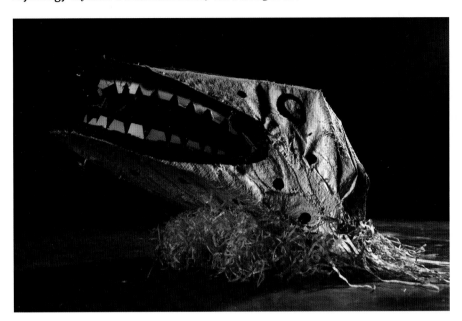

This structure is about a metre and half high and represents a monster's head on the move. It is made of a bamboo frame on which a sack is stretched to form a wide-open mouth with numerous sharp teeth.

The sack is painted white and embellished with black spots. Large eyes are added to complete its frightening effect. The structure is activated by only one dancer who is in the neck moving the head in different directions. The head races about the *bwalo* and spins around rapidly like Kasiya maliro. As it moves towards the audience, the mouth opens and closes. At the peak of the performance, some of the masked dancers are even 'swallowed' and disappear into the mouth of the ravenous monster.

This structure, forgotten today, appeared during night vigils of commemoration rites after the burial. For these occasions large quantities of beer were prepared. **Ayenda n'chamutu** circled around the house of the deceased and went to the shelters (*chikhuthe*) where the beer was brewed. It opened its mouth wide in order to show that the spirits were thirsty and waiting for their share of the sacrificial beer brewed for them. The ladies involved in the beer-making then brought large pots full of beer out of the shelter for the mourners to share.

Ayenda n'chamutu was a symbol of unity fostered by the spirits of the dead. The 'walking head' called the people in communion to share drink with one another and with the spirits.

Basi or Minibasi

(a day or night structure from the Golomoti and Dedza areas)

Themes 1) Communion with the ancestors; 2) Manipulation/exploitation; 3) Witchcraft; 4) Greed; 5) Danger of modernity; 6) Road accidents

Etymology The names are a corruption of the English for bus and minibus.

The structures consist of bamboo frames covered with a variety of materials to give an impression of a bus or a minibus. The bus structure may be four metres long, two metres high and one metre wide. It is activated by four dancers. The minibus is slightly smaller (two metres long, two metres high and one metre wide) and is danced by three dancers. In the night version, the bamboo frame is covered with grass and woven palm leaves to delineate the windows from the body of the bus. For the day version, the frame is covered with cloth, canvas, fertiliser bags or jute painted in any colour. Other details like spotlights, bumpers, registration plates, windows and doors are added with black paint. At times, the door can be opened. Normally, the driver is hidden inside and invisible to the audience. The structure may be accompanied by Kapoli, who guides it into the arena. The bus structure takes its origin from Chigalimoto (the motor car) and Chimkoko (the antelope/train). By the 1930s, bus and passenger train services had developed throughout the country. The motorcar structure became modified into a bus and the antelope was transformed into a passenger train. The minibus structure is definitely more recent (2000), since minibuses became the dominant form of public transportation in the country in the 1990s. For the last decade, the Golomoti area has witnessed the discontinuation of the passenger train service and its replacement by privately owned minibus services.

In addition, the appearance of the minibus in *gule* around Golomoti seems to have been influenced directly by Mwanambera of the *jando* ceremony practised by the neighbouring Yao communities. The *jando* is a form of Islamised rite of boys' circumcision adopted by the Yao, that takes its origin from the east African coast. It came to replace the *lupanda* rite practised by the Yao before their adoption of Islam. The *jando* is concluded by the burning of the *ndagala* (bush camp) whereby the childish behaviour of the initiates *(wali)* is destroyed and buried in the stomach of the mystical monster. Mwanambera devours the *wali* and vomits them as adults on the last night of their seclusion. The monster has adopted various visual representations over the evolution of the *jando* according to the areas where it was practised. In a pre-Islamic phase, the structure was fashioned in the style of Chimkoko (possibly influenced by the Chewa or the Nyanja *gule* complex).

Later, with the progress of Islam, the animal shape was simplified and stylised. It was replaced by yards of cloth or blankets

Painting by Claude Boucher and Joseph Kadzombe, 2009

as a cover for the initiate. The Zomba and the Makanjira areas substituted the *liunga* hat (a wide brim hat) to conceal the *wali*. At the end of the seclusion, these hats are destroyed to mark their transformations. Mwanambera fulfilled, to a large extent, the function of Kasiya maliro for the Chewa boys; it symbolized rebirth. Recently among the more tolerant group of Muslims (*Quadirriah*), the Mwanambera structure has undergone a substantial transformation in an attempt to modernise the initiation rites. In some Yao villages near Mangochi, it metamorphosed into the shape of an aeroplane *(ndege)* or a minibus. The Muslim communities around Mua and Golomoti have opted for the latter.

The Chewa living a few kilometres from these Islamic communities felt that they could not be left behind with their *gule wamkulu*. The minibus structure was introduced around Golomoti in 2006. It resurrected the older structure of the bus known in Mua and Dedza and forgotten by the 1950s. The new version of the minibus structure contributed to give to *gule wamkulu* a new look that matched the aspirations of the youth.

Both the bus and the minibus structures

dance in the *bwalo* imitating the dancing style of Chimkoko and Chigalimoto. They move forward at a high speed, brake and reverse unexpectedly, continuing this backward and forward motion. At times, they hit a bump and bounce. They chase people and warn against the danger of road accidents. The minibus was first produced at Kafisi village for the enthronement of the chief in September 2006. In October of the same year, the village of Chagontha carried its initiates to the *bwalo* in the minibus. Around Dedza, the bus structure is designed to transport the coffin to the graveyard at funeral rites.

The drum beat and the songs are those of Chimkoko and Chigalimoto. None of the words has been changed to fit the new reality. The male choir sings: *"Chimkoko, oh! the rapid beast."* [1] For the bus from Dedza they sing: *"The big car! Inside there are two Europeans; the third one is an African."* [2] The Golomoti song conveys that the minibus drives at high speed. The Dedza song stresses that the bus has a driver and carries a passenger or passengers. A third song for Roman Cathlics (*aroma*) is normally sung by the women and comes as a reply to the song of the minibus. *"The*

Romans , the Romans, a collection each year (church tithe) *a little more money and they would have bought a minibus…with the church tithe (mtulo)!"* [3] The last song, though not specifically for the minibus structure, is adopted because of its explicit reference to the vehicle. It makes allusion, with great sarcasm, to the yearly collection of the church tithe for the Roman Catholic Church and the presumed intention of the priests to purchase a minibus out of the maize sale. In fact, the maize collected had been sold to a Blantyre businessman for the running of the parish, while the local population had kept secret hope of buying food at a cheap price. This event has to be seen in the context of the 2001–2002 famine when food supply was low in the country. The biting tone of the song expresses the growing reality of Malawi by which the wealthy were getting richer at the expense of the poor. The mission staff coupled with the business people were profiting from the misery of others. The criticism by the women targets inequality and discloses the identity of those who profited from the system. Their blood money was used to buy minibuses that drive fast and leave victims behind. The owners of these vehicles were

becoming wealthier and selfish and lacked sensitivity to the misery of others. By contrast, the songs sung by the men for **Basi** and **Minibasi** feature Chimkoko and Chigalimoto. This represents a means of transportation to facilitate the ancestors return to the community and for moving the deceased to the spirit world. The multiple images used to convey this vary from the antelope to the railway carriage, the motorcar, the bus and the minibus. These representations show the Chewa adjusting and modernising their thinking about transport as depicted in the great dance and adapting them to those used in their land today. From the mystical figures of the past, they switched to the latest machines of the western world. Because of changes to public transport over the years, they felt obliged to adjust their Chewa world view and to imagine the ancestors return to this world in more modern types of public transport. The

spirits would have enjoyed them if they had lived at this period of history. Similarly, the initiates recover their new identity, as mature men, through a minibus journey from the spirit world to the village. The deceased gain access to the land of the ancestors through a minibus trip from the graveyard.

It is fascinating to observe that the Chewa and the Yao, who have lived as neighbours for close to a hundred years, have been borrowing cultural features from one another and sharing world views that enable them to articulate their distinct beliefs. The minibus is a striking example. Recently, the minibus has provided the ancestors with a more modern means of transportation to reach out to their respective communities. Besides providing a new vehicle for them to visit and assist their family members (as protectors and teachers of the *mwambo*), the minibus structure

engages in a social critique towards those who enrich themselves during famine or catastrophe and profit from the misfortune and the poverty of others. The acquisition of minibuses at this period of Malawian history has become a powerful symbol for the increase of wealth and a sign of disparity between the haves and the have-nots. Additionally, owing to the frequency of road accidents caused by excess speed, overloading and poor maintenance of the vehicles, the minibus owners are frequently perceived as witches that are motivated by greed and ambition. The bus structure of Dedza opposes a mentality pervasive among the youth, that of envying the west and dreaming of riches without effort.

[1] "*Chimkoko de oh nyama yaliwilo.*"
[2] "*Chigalimoto dede chokwera azungu awiri, m'modzi n'wakuda de Chigalimoto.*"
[3] "*Aroma aroma e watsala pang'ono kugula* **Minibasi***, za mtulo.*"

Chadzunda

(a black day mask from the Mua and Dedza areas)

Themes 1) Guardianship of the *mwambo*; 2) Father Ancestor; 3) Fertility; 4) Wisdom; 5) Sexual taboos (*mdulo*); 6) Assisting transition of deceased to spirit world; 7) Colonial period politics; 8) Recent politics

Etymology **Chadzunda** derives from the verb '*kudzunda*' which means, 'to be miserable', 'to be deprived of authority', or from the verb '*kudzundira*' which means, 'to endure'.

Chadzunda is one of the best known characters throughout Chewa country. The large wooden black mask is considered the most ancient and most prominent of all the masks of *gule wamkulu*. His outfit is typical of the oldest *gule* masquerade. He wears the conventional kilt made of jute laces with armlets and leglets made of sisal or other similar material. It is difficult to establish when the wooden carved masks originated among the Chewa. Oral tradition relates them to the period of the *Mwali* and Banda migration (800-1300 A.D.). That a mask of **Chadzunda** is coloured in black pigment strengthens this tradition and links it to the rain cult of the Banda. The Chewa view the character of **Chadzunda** as the ancestor and the progenitor of all the other *gule* masquerades. In this regard **Chadzunda** resembles Mariya, his wife, who is perceived as the mother of *gule*. **Chadzunda**'s prominence is emphasised by the size of the mask, normally larger than other masks. This stresses his importance with regard to village hierarchy and the position he holds in the spirit world. Consequently, **Chadzunda** embodies law and order, the code of morality (the *mwambo*) and the power of fertility.

The chief does not lose his status at the

time of death. He or she settles in the spirit world and becomes a chiefly spirit, continuing to care for the well-being of the village or territory. The chief grants his people rain and fertility, symbolised by the colour black. Chiefly spirits act through their immediate representatives on earth, the ruling chiefs, who continue to be called by their name.

Chadzunda is portrayed as an old man, emphasising the seniority and wisdom proper to the ancestors and to the chiefs. Baldness, wrinkles, white hair and white beard are often present on the mask. The mouth always shows missing teeth. He enters the arena with a walking stick, which expresses both castigation and old age. He hobbles like an old man. As soon as he starts performing, however, he jumps and bounds about, showing tremendous energy that demonstrates the vigour of his leadership and power of his mediation with regard to rain and fertility. He dances with Mariya, his wife, in a manner that reveals they are a perfect couple. They dance together during puberty rituals, in order to portray the rules surrounding marriage and fertility. In this context, **Chadzunda** becomes the example of a considerate and faithful husband, the father of many chil-

dren, and the ideal of a hard-working person. As the prototype of the chief and the husband, he has the duty to keep ritual coolness in order to 'redeem' his subjects or his children. This is why the name of **Chadzunda** came to mean 'to endure' or 'to show perseverance and strength of character'. **Chadzunda** also appears during the enthronement of a chief and at the time of funerals. On such occasions, he fulfils a more official role. As the head of the spirit world and the head of the village, he is the one who presides over the events, showing wisdom and compassion. The men express this in the following funeral song: "*You,* **Chadzunda***,* (the supreme head) *the big head; you have come to tear down our village. Our village is collapsing* (because of losing an elder)." [1] The women answer with the following: "*Here comes the compassionate from the nether world, here he comes, the compassionate.*" [2] **Chadzunda** welcomes the deceased into the spirit world and acts as an undertaker (*mdzukulu*) at the funeral. As the head ancestor and the chief, he leads the dead into the community of forefathers and helps them to adjust and settle into a new life. The settling down of the dead and the return of the community to a normal life depend ultimately on the capacity of the

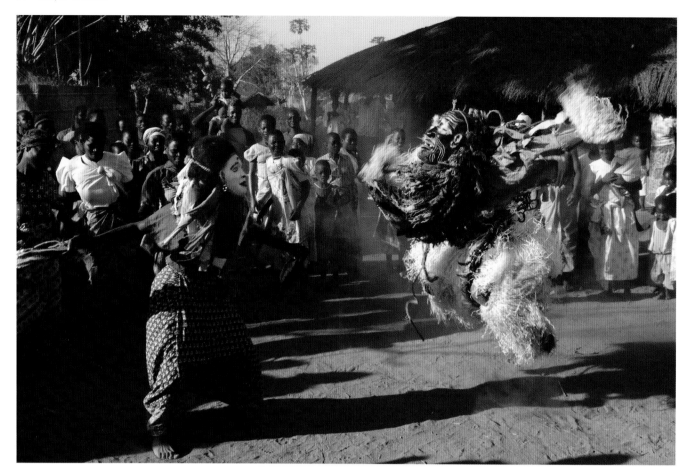

chief. He must observe and remain faithful to the sexual taboos. When the period of mourning is over it is his potency which reintegrates the mourners to normality. In a way, **Chadzunda** summarises and encapsulates the messages of all the other masks of *gule* and has an equivalence to the elephant structure (Njovu). He carries similar meaning because he simultaneously represents the chief and the husband. His ability to endure sexual restrictions in order to unlock fertility gives him the position at the summit of the Chewa pantheon. His role consists of keeping morality, law, and order and of being the guarantor of unity among the living and among the dead.

The etymology of the name **Chadzunda** as 'being miserable' and 'deprived of authority' conveys a derogative note, a tone of mockery. This probably comes from the political changes after the settlement of the Malawi (Phiri) people (1400 A.D. onwards). We know that *Mwali*, and other spirit wives of the Banda, relied heavily on village headmen to carry their authority. After the Malawi had confirmed their power under their King Kalonga, these positions were given to Phiri incumbents. In this context, the name **Chadzunda** would make the Banda aristocracy a laughing stock. This pejorative meaning was

slowly lost over the centuries. During the colonial period, **Chadzunda** married a European wife, called Mariya. This name came to replace the former character of Angali or Mkwanyisi, Mariya's predecessor. Plausibly, the Chewa are expressing the after-effect of indirect rule. They see their chiefs in the position of the *mkamwini* and look at them as being married to the colonial government, in the person of Mariya. Nevertheless, **Chadzunda** and Mariya continue to teach Chewa traditional values.

After independence, the new Malawian leaders, who were perceived as the centre of national unity, showed great similarities to **Chadzunda**, the chief and head of the spirit world. This is particularly apparent in the case of Kamuzu Banda, the first President of Malawi, who was Chewa himself and had been involved in a relationship with a European (Mrs French) before he became President. He played the role of 'saviour' and patron of Chewa culture. During public political rallies, where **Chadzunda** appeared, the *gule* members of Kasungu Boma were substituting the traditional content of **Chadzunda**'s song with new words that cast the President into the very position of the head of the spirit world. The men sang, *"Kamuzu, the greatest chief, come and see Kamuzu, the greatest chief."* [3] The

women, emphasising his spiritual role, repeated the song. Each year, President Kamuzu Banda would travel the country, inspecting crops. He was credited with the power of bringing rain. Under the new leadership of Bakili Muluzi, a recent version of **Chadzunda** was created, in pink tones. It is called Wamkulu ndine, meaning 'I am the greatest,' which proclaims: *"This one is a child* (he is nobody). *I am the greatest."* [4] Wamkulu ndine's power is claimed as greater than Kamuzu and also greater than **Chadzunda**. Following the Chewa pedagogy, this is a criticism of political leadership that assumes to be above the spiritual order. A proverb says, *"Wamkulu ndine, wamkulu ndine, adagwa padzala – The one who says, I am the most important, fell in the rubbish heap."* **Chadzunda** is to be emulated as a chief but he is not to be competed with, for his role as the head of the Chewa pantheon. Such a presumption is seen as blasphemous to the Chewa traditional believer.

[1] *"**Chadzunda** iwe, wamkulu mutu ana inu, mwadzapasula ku mtunda (2×) mdzopendeka."*
[2] *"Kwadza a Chakoma ku mtunda, ana inu, tate de kwadza a Chakoma."*
[3] *"Mfumu yayikulu n'Kamuzu e tate de, m'dzaoneni mai m'dzaoneni , m'dzaoneni ede mfumu yayikulu n'Kamuzu."*
[4] *"Yawa yawa ndi mwana (2×) wamkulu ndine."*

Chibale n'chipsera

(a brown day mask from Mua area)

Themes 1) Importance of family ties; 2) Dangers of modernity; 3) Social changes/insecurity

Etymology **Chibale n'chipsera** means, 'Kinship is like a scar.'

The brown mask portrays a senior man. His features include a distorted face and balding head and suggest a man of advanced age. Numerous scars and wounds appear on his forehead and his chin. The gums surrounding his teeth are bared and the character appears menacing. One of his eyes is tiny as if it has been damaged. The twisted face and the atrophied features liken him to a cripple or even to a monster. The headgear of the mask is made of tatters. **Chibale n'chipsera** dresses in a tatter suit and carries the switch tail, which is the emblem of authority.

Chibale n'chipsera appears at funerals, commemoration rites and even initiation ceremonies. His dancing style resembles that of the character Simoni. He alternately swerves the feet, first the left foot striking the left arm holding one medicine tail, then the right foot striking the right arm holding the other medicine tail. The feet and the arm movement emphasise pride and youthfulness. The attire worn by the character is highlighted by the words sung by the male choir: "*Kinship is like a scar, no matter how much one boasts, oh!*"[1] To this song, the womenfolk respond with their own: "*Why are you looking at me? What did I do wrong? We are all dead meat!*"[2] The men's song quotes a well known Chewa proverb: "*Chibale n'chipsera, sichitha – Kinship is like a scar, it never disappears.*" Nobody can put an end to brotherhood, just as a scar never entirely fades. Whatever happens in life, bloodlines remain forever. The reply of the women says that whatever blunders are made in life, the journey with certainty ends in death and we are judged or rewarded accordingly.

The character of **Chibale n'chipsera** has been part of *gule* for a long time, but has been forgotten in recent decades. The village of Kalindiza close to Mua decided to restore the character in 1999. The lifestyle of the village has changed with the coming of democracy and increased exposure to the western world and foreign values. In a more modern Malawi, the Chewa feel the need to recapture the value of blood ties and brotherhood. The younger generation is showing less interest and feels little obligation regarding the extended family. The focus for parents is exclusively on their own children and the family rarely makes time for visiting relatives. Emphasis is on the nuclear family unit and on oneself. Money has become the supreme value measuring everything and everyone. They have abandoned the *mwambo*, which has mentored brotherhood and community, and perhaps has been the salvation of rural, subsistence level, small-scale societies like that of the Chewa. The character of **Chibale n'chipsera** argues that Chewa secular wisdom (embodied by the mask) must be embraced by the new generation (embodied by the costume and the dance). The young generation are swept up by the winds of change, disconnected, lacking the roots and wisdom provided by extended families and community.

[1] "*Chibale n'chipsera eae ngakhale mutanyada bwanji e oh.*"
[2] "*Ae mundiyang'ana ndatani? Tonse ndife maliro.*"

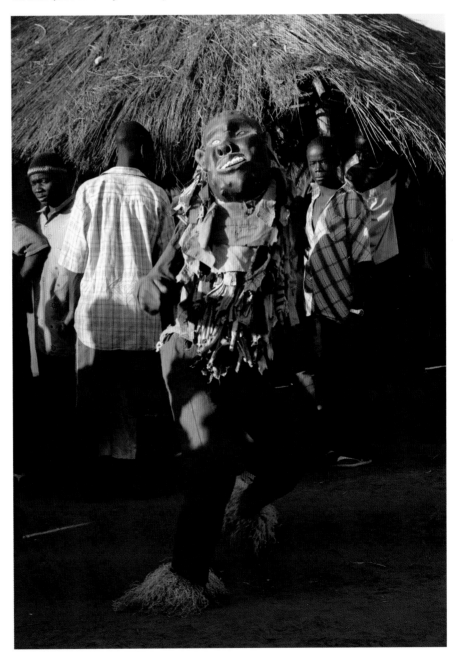

Chikwekwe

(a red day mask from the Mua area)

Themes 1) Rivalry for authority; 2) Unity & harmony; 3) Witchcraft

Etymology Chikwekwe means literally, 'a trap', and can describe a person who pulls to himself certain advantages or pushes himself into a position of power.

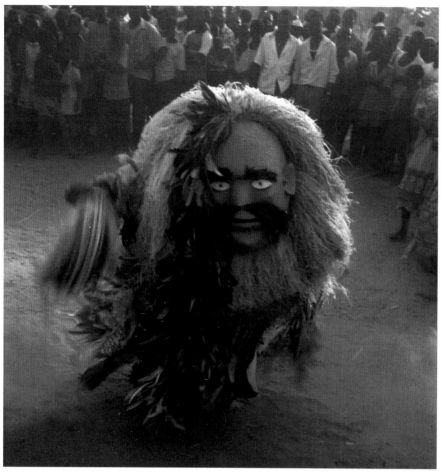

Claude Boucher, Chenjero Village, September 1993

This large mask portrays a person who challenges and undermines those in power. The size of the mask, the red colour and the long dangling tuft of hair on his otherwise bald forehead symbolise that he has assumed the position of chief against the will of the village. The dancer wears the usual tatter suit and a belt. He carries a medicine tail and a rattle. These items and the belt signify that he has already seized the position. He smiles and is happy to proclaim it loudly in public. His dance exhibits extravagant movements of the feet and of the medicine tail to demonstrate pride in his achievements. The character performs on the occasion of a chief's enthronement. The men sing for him, *"What kind of chieftainship is this ... of struggling against each other? The chief is on the road* (he receives honour). *You Chikwekwe were given a position of authority* (by the women). *I refused. (But ...) The chief is on the road!"* [1] The song talks about two candidates who contest the position of the chief. **Chikwekwe** is the elder (he is bald) but his rank in the matrilineal line is lower. His competitor is younger but qualifies for the position because he belongs to a senior rank. In a Chewa village, the women who belong to the matrilineal line choose the chief. The women's choice goes to a candidate who belongs to the 'senior breast' (the senior rank). Though he does not fully qualify, **Chikwekwe** assumes the chieftainship and receives the honour outside his village before he has been officially enthroned. Consequently, his junior competitor, the rightful heir to the throne, does not seek the position. He chooses to avoid conflict and the possibility of becoming a victim of witchcraft (the red colour of the mask). **Chikwekwe** warns those who aspire to a position of leadership not to become rivals. Rivalry compromises the peace of the village. The chief must have the blessing of the spirit world.

[1] *"Ufumu wanji wolimbirana? Ufumu uli ku mseu. Chikwekwe iwe kuwapatsa mpando ndakana (2×)."*

Chimkoko or Chiwoko

(a day or night structure from the Mua area)

Themes 1) Compassion of ancestors for the living; 2) Communion with the ancestors; 3) Mother Ancestor; 4) Sharing of beer

Etymology The word **Chimkoko** comes from *kukokolola* meaning, 'to sweep together'. **Chiwoko** was the name of a Banda chief.

Chimkoko is one of the largest structures used in *gule*. It is up to 12 metres long, two metres high and one metre wide. In the Lilongwe area the same structure is called **Chiwoko**, a Banda chief associated with Chief Mkanda in pre-colonial times.

The structure is a large bamboo frame covered with a thin coat of grass, woven with palm leaves in a zigzag pattern (for the night performance) and with maize husks or jute bags (for day events). Up to ten or twelve dancers activate the structure. Not all the dancers are required to be married as is the rule for structures like Kasiya maliro, Njovu and Mdondo. **Chimkoko-Chiwoko** comes in a variety of shapes depending on the area of origin. The back is usually horizontal but at times it has humps like that of

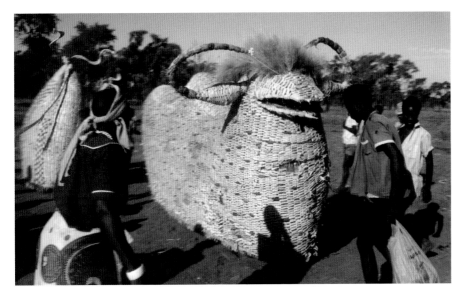

Claude Boucher, Chitole Village, December 1990

Mdondo. The head is a bull with long curved horns, round ears and a tuft of hair made of grass on top of the head. The muzzle is elongated (40 centimetres) and the mouth has numerous teeth. The neck is short and stout. There is a long tail like that of Kasiya maliro. Halfway up the body of the structure, the artist has drawn a thick black horizontal band (made of black mud) making the animal resemble a Coachline bus. At the bottom of the structure, the dancers' feet are concealed with fringing made of maize husks.

When **Chimkoko** enters the *bwalo* at dusk or at night, he races at high speed forwards and backwards like a bus going in and out of reverse. When it stops for a short while, it sways left and right, then moves on again as the men sing, *"**Chiwoko**, Oh! **Chiwoko**, Oh! **Chiwoko**, the wild animal from Johannesburg!"* [1] or *"**Chimkoko**, the rapid beast, give us some space!"* [2] During this time the women run frantically across the *bwalo*, trying to avoid being knocked over by the enormous structure.

The structure is used at various important

rituals like *dambule*, initiation, funerals and commemoration rites of senior people. After these ceremonies the structure is left at the *dambwe* to rot slowly and disintegrate. Unlike other structures, it is not burnt. **Chimkoko** in the *bwalo* behaves like a coach bus returning from afar carrying legions of passengers. As it moves the dust of the dancing ground, it sweeps with it everything in its way. The entire spirit world invades the village for **Chimkoko** represents the root of the village. **Chimkoko** rallies the crowd. The men, women and children follow it to welcome the arrival of their ancestry. When this structure appears, it symbolises the connection between the spirit world and the villagers. At a funeral rite or at a commemoration of the dead (shaving ceremonies or *dambule*), **Chimkoko** portrays the compassion of the ancestors for the living. When beer is brewed in honour of the dead, **Chimkoko** reassembles them all together around a pot of beer and allows them to share in each other's lives. **Chimkoko** is like the mother or the grandmother, the first ancestress, who gathers her children from the four corners of the world and certifies that she is in their midst, always ready to help them and care for their needs.

[1] *"**Chiwoko** (5x) oh **Chiwoko**, chilombo cha ku Jubeki."*
[2] *"**Chimkoko Chimkoko** de, nyama yaliwiro de e, tipatseni bwalo de e e."*

Chiuli

(a grey day mask from the Thete area)

Themes 1) Rights of/respect for the handicapped; 2) Deafness as a handicap; 3) Handicaps as pretext for bad behaviour; 4) Limits & restrictions of *chikamwini* system; 5) Endurance; 6) Fairness to *mkamwini*

Etymology Chiuli is a name for the honey badger or ratel.

This grey mask portrays a honey badger's head. It has swollen sharp eyes, tiny ears, small open mouth and numerous bee stings on the face. The dancer is entirely covered in black skins and has a short tail painted in red. His hands and feet are covered with gloves and socks and have long claws attached. He carries a big knife. He appears at funerals and commemoration rites. He swerves on only one foot and falls. He keeps falling and rolling himself in the dust to show that he has fits. He is also utterly frustrated. The men sing for him, *"**Chiuli**, this honey badger is the cause of many troubles* (or discussions). (People say:) *Even if he has strength, he has been completely deaf for a while. In order to hear he has to look carefully*

(lip read). *He has small ears and one is completely dead, **Chiuli**. When the moon moves this way, he falls; that way and he falls again **Chiuli**, **Chiuli**."*[1]

The character represents a husband who resides in the village of his wife. He is suffering from various handicaps mentioned in the song: he is epileptic and deaf (shown by the small ears). Owing to his double infirmity plus his condition of being a stranger (as a husband living at his wife's home) he feels despised and mocked. Because of his deafness he relies on his eyesight (resulting in the swollen eyes) but he frequently misinterprets what is happening around him, misjudging his wife's relatives' reactions. He is quick to read mockery into their dealings

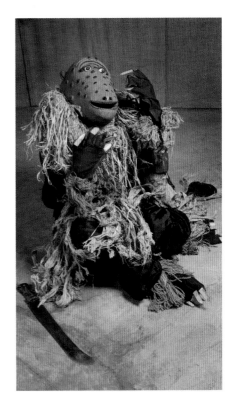

with him. His frustration and paranoia prompt him to be rude and confrontational with his wife and relatives (symbolised by the small open mouth and knife). At times, he thinks of leaving and going back to his own village.

The character of **Chiuli** tells the people who suffer from handicaps to learn from the honey badger. The animal has a tough and thick skin. This is symbolised in the costume of the dancer. They should not be hurt too easily. The badger endures a lot of bee stings because it wants the honey. The disabled husband should show perseverance

and accept some hardships if he wants to continue enjoying the company of his wife and children. After all, the sweetness of marriage is found in the intimacy of the bedroom. A person has to accept his disabilities with resignation. He should refrain from using them as an excuse for his bad temper and his impossible character. Childish reactions and quick decisions will revert him to a bachelor despite the fact that he has been married and has had children (the short red tail signifies his progeny).

The character of **Chiuli** not only encourages the disabled husband to show more

determination and patience but also invites the in-laws to show more sensitivity to their *akamwini*, treating them more humanely and valuing their qualities. Through the mask of the badger, the ancestors condemn the derision of the disabled.

[1] "*Chiuli, chiuli, aja ayamba anzawo tate e. Ngati ali n'nyonga tate. Kumva adaleka kale toto de, kumva achita kuyang'ana tate. Timakutu ting'onong'ono tate e. Ndipo iwo afa ndi mkunkhu umodzi, umodzi tate e* **Chiuli, Chiuli**. *Mwezi ukatere agwa. Ukatere agwa, agwa eyaye, eyaye,* **Chiuli, Chiuli**."

Kachipapa

(a day or night headcover from the Dedza and Mua areas)

Themes 1) Sexual taboos for funerals; 2) Assisting transition of deceased to spirit world; 3) Compassion of ancestors for the living; 4) Unity & harmony; 5) Compassion at funerals

Etymology **Kachipapa** means, 'a small winnowing basket'. These baskets were used in the past (before the advent of shovels) for removing the soil or filling the grave at the time of burial. **Kachipapa** is known as an undertaker (*mdzukulu*) who takes care of burial rites. Oral tradition acknowledges a chief **Kachipapa** who received land from chief Kalumbu Mwale close to Dedza.

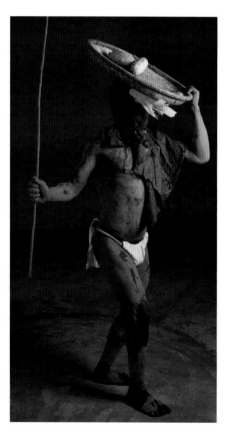

The character is very ancient and used to perform throughout Chewa country. Originating on the plateau it reached the lakeshore at the beginning of the 1900s. However, it had disappeared from the arena by the mid-1950s. **Kachipapa**'s function was concentrated on funeral rites, the commemoration ceremonies that followed and

initiation rituals that were sometimes an integral part of funeral rites. Accordingly, **Kachipapa** appeared in both day and night disguise and in a great variety of outfits.

Kachipapa belongs to the Kapoli family and therefore sings his own song with a high-pitched voice to which both men and women reply. His appearance and costume varied from area to area and changed according to the light conditions. At times, it consisted of a shaved blackened goatskin and headgear of woven dry banana leaves covered with mud. A cowlick made of feathers or of a sugar cane bloom adorned the top of the head to stress that he is a male and to emphasise sexual prohibition during the period of grief. A small winnowing basket was attached to the headgear to collect the offerings of the community. At other times **Kachipapa** appeared with a feather helmet like that of Kapoli. His entire body was covered with ashes or mud. In very early times, he danced naked. With the growing opposition of the church to the character's nudity, **Kachipapa** was made to wear a kilt or a loincloth of skins (*mtemwende*). Later still, this costume was embellished with leglets and armlets.

Kachipapa never entered the arena but stayed at a distance from the crowd. He sometimes carried a medicine tail or a whip to remind villagers that sex is forbidden during funerals. **Kachipapa** danced in a subdued manner, swerving his feet solemnly to emphasise the grief of the spirit world over the loss of one of the villagers. **Kachipapa** sang a variety of songs befitting the occasion. For a funeral, one would hear,

"*Did you see him,* **Kachipapa**, *the one who takes corpses away* (buries them)?"[1] He would dance leading the corpse to the graveyard. He crossed his arms on his chest holding his medicine tail and showing sorrow. As a representative of the spirit world he took part in the burial and assisted the undertakers in burying the corpse. People rewarded his compassion by putting foodstuffs, beads or coins in his small winnowing basket as a way of expressing condolences to the family. The participation of **Kachipapa** at the subsequent commemoration rites was more relaxed and entertaining. He would tell sexually explicit jokes and use obscene language or perform daring sketches to stress sexual prohibition or to notify the community that the taboos were about to be lifted.

The role of **Kachipapa** was to assure the safe passage of the deceased and ensure that the entire community abided by the *mdulo* rules that safeguard his transition into the ancestors' world. **Kachipapa** grieved with those in mourning and rejoiced and entertained when people were relaxed from their duty. His teaching was focused on the importance of the *mdulo* as a fundamental means of building solidarity and unity within the village. He emphasised the need for compassion and reciprocity within the community when neighbours must depend on each other. **Kachipapa**'s concern extended beyond the world of the living, forming a link of compassion with the world of the dead. It is possible that he will yet be revived if interest in him returns.

[1] "*Mwamuona* **Kachipapa**, *mtenga maliro*."

Kalulu

(a day structure from the Mua area)

Themes 1) Role & powers of the chief; 2) Unity & harmony; 3) Guardianship of the *mwambo*; 4) Wisdom; 5) Promptness; 6) Protection

Etymology **Kalulu** is the Chewa word for hare or rabbit.

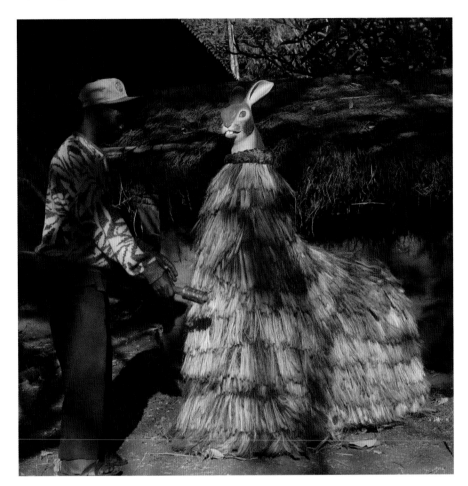

The character of **Kalulu** features a hare. A single dancer animates the one metre long structure often made of grass darkened with black mud. The ears are long and erect. This structure is remarkable for the speed of its movements and its ability to quickly spin around the *bwalo*. **Kalulu** typically opens and closes each performance of *gule wamkulu*.

Kalulu is likened to the sacred tree or the powerful medicine of the chief at the centre of the *bwalo*: "*The hare, tree of the bwalo* (owner of the bwalo) (the village), *running, running smoothly, oh! The hare, tree of the bwalo.*" [1] The images refer to the village headman or the chief who is the owner of the sacred ground of the arena and the village. A few days before the chief is enthroned, he has the duty to bury secret medicine (*mchili*) around the village at night, ending at the sacred ground . There he buries the last of the medicine or hides it in the sacred tree at its centre. This is done

in order to protect the village. He circumnavigates the entire village and finishes at the *bwalo* that is often the physical centre of the village. This has a deep symbolic meaning: the centre is what ties the different parts and families together and makes them whole (*kufungira*). These ritual gestures unite the village. When the community gathers at the sacred ground for the dance, for meetings, or for settling disputes, their unity is reinforced. The *bwalo* is symbolically a microcosm of the village. It is the symbolic centre giving meaning to the parts. Here the unity of the whole is celebrated. At the same time, it binds the village to the ancestors. The sacred tree at the centre of the *bwalo* is a symbolic representation of the graveyard and the grove that shades it. Only the chief and one of his sisters know the place where the medicines are hidden. This secret directly connects him to the world of the ancestors. On their behalf, he holds the authority of the village.

He has the duty to survey his people and look after their well-being, especially at times of transition or crisis, like puberty and death. He has to teach them the *mwambo* that, if observed, will become a source of blessings. He passes on the fertility of the ancestors by keeping these sacred rules himself. Above all, he has to foster peace between the villagers, which in turn ensures harmony with the dead. In return, the chief receives fees in the form of chickens from each household, a small token for the services he renders to his people.

All of these duties are given a symbolic expression in the character and performance of **Kalulu**. The structure circles the *bwalo* in order to guarantee protection against an enemy. It leads its dance, *njedza*, and the people follow it in a single file as if they are born from the same mother. The people dance *njedza* at the beginning and the end of *gule wamkulu*, whether or not **Kalulu** is present, demonstrating their unity under the chief and the ancestors, and showing their promptness to serve the community. As they dance the *njedza* (*nje-* 'quiet', *dza-* 'come on' or possibly a word coming from Luba country) the elders serpent the *bwalo* at a fast pace imitating the chief who medicates the sacred ground. They stop in a straight line formation and make a series of forward steps followed by a movement of the legs alternately in order to remove the evil spirits (*ziwanda*) and to protect the performers. This is interpreted as sweeping (*kusesa*).

The hare symbolises the ability of the Chewa chief to listen (*akumva*) to the voice of the ancestors and to the complaints of his people. This is reflected in the long erect ears of the structure. Another quality that the hare evokes is the eagerness of the chief to serve the community on behalf of the spirit world. The chief should also be clever and shrewd like the hare. He should attend to people's needs promptly, preside over the transitions of their lives and finally accompany them during their last voyage through death to the spirit world. It is through his diligence and patience that he can preside over disputes and judge fairly.

[1] "***Kalulu*** *mtengo wa bwalo mwa ndende ndende oh, mwa ndende ndende oh!* ***Kalulu*** *mtengo wa bwalo.*"

Kampini

(a night mask from the Mua area)

Themes 1) Communion with the ancestors; 2) Cooperation; 3) Compassion & kindness; 4) Sharing of beer

Etymology Kampini means, 'a small hoe handle'. In Chewa history the name of **Kampini** has been linked with the Phiri and Malawi clans. One of the *Msinja* shrine's officials was called Kampini Phiri. He had the duty to carve the hoe handle for the cleansing of the shrine. His children were iron smelters and blacksmiths and made hoes. The penultimate Chewa king was called Kalonga Kampini Phiri.

In the *gule wamkulu* pantheon, **Kampini** is one of the oldest characters. He could possibly have a link with the Malawi ancestors (as Kalonga and as smiths) since they are connected with kingship and fire. **Kampini** does not sing or dance; he only makes high-pitched sounds. His sketchy costume is made of dry or green banana leaves. His mask is a simple headcover of the same material showing no detail of a face. In the dance, **Kampini** plays the role of messenger, and like the hoe handle, he is the go-between for the hoe and the farmer. He is the caretaker at the shrine, cleansing the sacred ground, a role he may have fulfilled as a Banda official before the arrival of the Malawi. **Kampini** is the messenger of the ancestors to the living. His mere presence announces to the village that a major event is about to take place involving the interaction of the spirit world and *gule wamkulu*. At any of these rituals, he is the go-between for the living and the dead. He provides the *Nyau* members with food, eggs, chickens and goats. He begs flour from the villagers in order to feed the grave-diggers and the dancers at the time of funerals and commemoration rites. At the time of *dambule* (commemoration of the dead), he brings firewood for brewing the sacrificial beer. When the beer is ready he carries some back to the graveyard for the dancers to drink. He is friendly with the women and likes to entertain them. They acknowledge his petition when he asks for food.

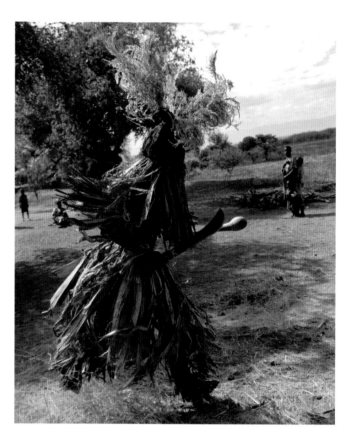

Kampini is an example of compassion and cooperation. Through his behaviour, he invites people to be kind and attend to each other's needs. As opposed to the hoe that is made of steel and has been forged in the fire, the wooden hoe handle is cool and attuned to the world of the spirits. **Kampini** can commute between the village and the spirit world, the living and the dead.

Kanswala

(a day or night structure from the Mua area)

Themes 1) Unity & harmony; 2) Reconciliation & mediation; 3) Communion with the ancestors; 4) Sharing of beer

Etymology Kanswala means, 'a small giraffe or impala'.

This structure is one and a half metres long and is characterised by a neck that can easily reach up to one metre above the shoulders. The animal portrayed is most likely an impala, since giraffes have not historically existed in Malawi. However, the animal is sometimes given the characteristics of a giraffe. The horns of **Kanswala** are shorter than those of the impala. The ears are large and the mobile tail is 50 centimetres long. The construction is similar to that of Kasiya maliro and only one dancer animates the structure. The back is flat and the body is sometimes decorated with horizontal or vertical bands or spots.

The structure is mostly used during the night vigil of funerals and commemoration ceremonies. Sometimes a day version appears before dusk of the day the beer is in its last stage of preparation. The day version is made with maize husks or sackcloth while the night one is made with palm leaves forming a zigzag pattern. **Kanswala** spins around like Kasiya maliro and moves quickly about the *bwalo* while the men sing, "*The small impala has been sent to fetch water in the bush, this one,* **Kanswala**,"[1] "*Let us go, Mdondo, let us go! They* (Chadzunda and Njovu representing the spirits) *have sent them* (us)."[2] **Kanswala** (day version) goes from house to house throughout the village, detecting the huts where beer is being brewed. "*Let us go and check on the beer,*

Kanswala, it has fermented. The small impala is the best!" [3] **Kanswala** is praised for its cleverness, its promptness, its resourcefulness and its trustfulness. Around four o'clock in the afternoon, **Kanswala** goes to the places where the beer is brewing to inspect it on behalf of the spirits. **Kanswala** acts as the eyes of the ancestors to certify that beer is brewed for them and has been sent by the head of the spirit world, Chadzunda or Njovu (the elephant). **Kanswala** moves swiftly from door to door and goes back to the *liunde* after knowing the beer-brewing will be successful and appreciated by the ancestors. Later that night the beer will reach full maturity. While the *gule* is being performed into the night, **Kanswala** (night version) reappears and proceeds again to visit each house where the beer has been prepared. As soon as **Kanswala** appears, the ladies carry large pots of beer to their doorstep. Young boys take them to the open ground where it will be shared among the actors, the musicians and the spectators. The purpose of this last visit is to collect the beer so that the spirits may taste it. This is done in a symbolic manner.

The sharing of the drink between the villagers expresses their reconciliation and unity. Their oneness pleases the ancestors and puts them at peace. Their concern for the living becomes effective and their bond with them is made real. The ancestors, in whose honour the beer is brewed, taste and welcome the villagers' gifts. They 'sip' to their cohesion and oneness that will persist throughout the night through singing, dancing and drinking. **Kanswala** embodies this unity and interconnectedness between the living and between the living and the ancestors.

[1] "*Kanswala achita kukutuma katunge madzi mdondo. Iyo **Kanswala**.*"

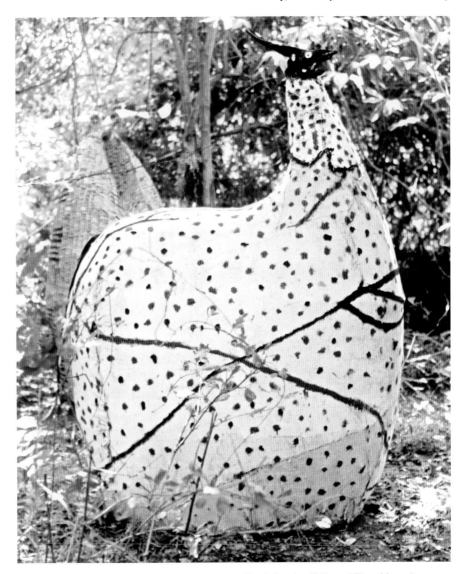

[2] "*Tiyendere mdondo. Iwo, iwo tikayendere, achita kuwatuma, **Kanswala**.*"
[3] "*De de kayendere mowa **Kanswala**, wawira, **Kanswala** kopambana.*"

Claude Boucher, Kakhome Village, May 1985

Kapoli

(a feathered day mask from the Mua area)

Themes 1) Protector of women; 2) Unity & harmony; 3) Righteousness; 4) Faithfulness to the *mwambo*

Etymology The name **Kapoli** derives from the word that means, 'to be erected' or 'to stand up in the midst of the group'. It could also be related to *kapolo* meaning 'servant'.

Kapoli is the most popular, frequent and ancient of all the *gule wamkulu* characters. This mask is adorned with feathers all over the head. Sometimes a small cloth face is stitched within the feathers. **Kapoli** is dressed with a short kilt made of fibres or sisal. He wears armlets and leglets of similar material. His body is smeared with mud or ashes symbolising that he comes from the world of the dead. From him derive a family of characters known today in *gule*,

many described in this book. **Kapoli** has the largest repertoire of songs used in the dance and he is omnipresent at any type of ritual. He intones his songs with a high-pitched voice and the women take over the singing. The high-pitched voice conveys that he is the protector of women's interests just like the *malume* within the matrilineal family system. After anointing himself with dust, **Kapoli** starts dancing with the characteristic sideways swerving of his feet in

fast, alternate fashion like a chicken looking for food. Following the rhythm of the leading drum, *mbalule*, he moves from an erect to a crawling position. This gesture is read as a dialogue with all the spirits, possibly including those of the first owners of the land: the Akafula. The women surround him and join in his performance. He is friendly and shows no sign of aggression.

Kapoli's role is that of the mistress of initiation, a *namkungwi* of moral behaviour. In

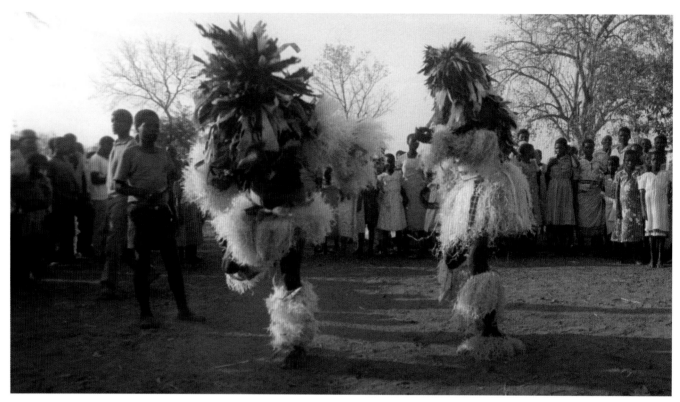

his tall-feathered headgear, he emerges as the greatest of the *namkungwis*. His advice often takes a comic tone. **Kapoli** is the joker who gears his teaching to the mood of the occasion. Without him, there is no *gule wamkulu*. He is the owner of the *bwalo* in the spirit world, as the chief is in the world of the living. He weaves the performance of the other characters into the *gule* ritual. He is like the assistant (*nyakwawa*) of Chadzunda by correcting any type of incorrect behaviour that deviates from the *mwambo*. He is a kind of satirist who detects incongruities within the community and exposes them playfully in public. His proximity to Chadzunda and his interplay with the women in the arena shows his closeness to the chief and portrays him as the family head, the 'senior uncle' (*malume*) responsible for the *mbumba* whose interests he defends. Many of his songs voice the women's complaints and injustices that are done to them. "*No, I do not want to go to my parents-in-law, I am afraid to be despised. I refuse to go and live at my husband's village following the chitengwa custom.*"[1] Another song says, "*Some married women wear only one dress just like they wear one wedding-ring. (Is this a good marriage?) Cry, Cry!*"[2] **Kapoli** frequently unveils scandals in the village and the conflicts within a family. His language is often crude, profane and provocative. He will refer to sexual conflicts, which are tabooed from discussion in daily life. He adds a comical tone to his remarks, making fun of and defusing the

situation. Through his obscene language (that the women answer back with even spicier words), he dispels the hidden tension in the community resulting from the fact that males are denied full integration. His advice is completely centred on the *mwambo* (the moral rule coming from the ancestors). He mocks people's wrong-doings and allows the ancestors to caricature their foolishness and their lack of wisdom through his intervention. **Kapoli** is the enemy of lies, backbiting, injustices, adultery and witchcraft. Instead he fosters righteousness, unity and harmony. "*Throw away your horns because we will all die. They are calling for us at the graveyard. We will all die* (if we continue bewitching each other)." [3] In another song he says, "*You women, you refused your husband his sexual right, you insulted him. There was a tree* (a woman) *in this village; it died* (she died) *this morning. Let us reconcile with each other, there is no point living in hatred and with the wish – if she could only die, I would be happy.*" [4] On the occasion of the enthronement of the chief, he sings, "*The former chief was a good leader. What about the one of today? You say he has a knife in his hand … some people would like to return to the previous one.*" [5] For a divided family, he sings, "*This is on purpose. What kind of behaviour is this to stay at the doorstep of your relatives with whom you share food? This is on purpose, on purpose.*" [6] **Kapoli** rejoices with those who are happy and grieves with those who mourn. "*I do not have a brother to rescue me,*

I do not have a sister to rescue me. The pepper is hot!" (Life is hard because all her relatives have passed away.) [7] In another song he says, "*There is a burial at Njolo village. Let's go! Let's go! Attend your friend, death has come for him – tomorrow it will come for you.*" [8]

In some cases, **Kapoli** can appear with other characters and play a role in their interpretation. One can refer to Chigalimoto or Ndege ya elikopita for examples of just how versatile **Kapoli** can be.

Kapoli is the faithful servant of Chadzunda and the family group who escorts people through the human journey with his advice and shows compassion at the hour of death. Above all, he is the one who invites people to take life with a pinch of salt.

1 "*Ai dee ae sindipita kwa apongozi ndaopa kundinena ae. Sindipita ku chitengwa.*"
2 "*Okwatiwa amene, nsalu avala imodzi ngati mphete imene ae oh lire oh lire ae.*"
3 "*Tayani nyanga titha inu ee ae. Kumanda kwaitana e titha iwe.*"
4 "*Inu amai mwakana mwatukwana (2×). Munali mtengo wokhala m'mudzi muno: wafa m'mawa. Adzukwa tikhale nawo, tiyanjane.*"
5 "*Mfumu ya kale inkadziwa anthu, koma ya leroyi, chimpeni kumanja, ena afuna wakale.*"
6 "*Dalatu ilo dala! Kukhala kwanji kokhalira mnzako wa pakhomo amene ukudya naye. Dalatu ilo dala, lomwelo dala.*"
7 "*Ndilibe mbale wondiombola iwe, ndilibe mlongo wondiombola, n'gowawa tsabola.*"
8 "*Maliro kwa Njolo, tiyeko tiye (2×) Chaona nzako chapita mawa chili pa iwe.*"

Kapolo wa onsene

(a brown day mask from the Mua/Mtakataka area)

Themes 1) Role model for leadership; 2) Spirit of service to community; 3) Chewa identity; 4) Social changes/insecurity

Etymology **Kapolo wa onsene** means, 'Myself, the servant of everyone'. This title is applied to Chief Chitule, who died in January 2006. Chief Chitule had been the village headman at Chitule village (Mtakataka) for a quarter of a century. He had also been a councillor of TA (Traditional Authority) Kachindamoto, the Ngoni Paramount. Chitule was the authority responsible for all the *mizinda* of *gule wamkulu* under the supervision of Nkosi Kachindamoto until his death on the 4 January 2006.

The brown 30 centimetre mask features the likeness of Chief Chitule's face. The wooden mask is painted in brown tones to render that he was a Chewa, a middle aged person who had been ravaged by ill health, including high blood pressure and diabetes, for a protracted period. He is portrayed with a receding hairline made of human hair, wrinkles on the protruding forehead, baggy eyes, deep labial lines, dimples and jowls. The face is serene and open. During his lifetime, Chief Chitule never wore a beard or a moustache, and consequently the mask does not display them. The eyes are sharp, alert and filled with kindness and intensity. The mouth shows a welcoming smile and suggests the utterance of words of wisdom. The ears show the chief's eagerness to listen to his people's complaints. The headgear of the mask is made of skins of serval (a spotted cat) to manifest his highly respectable ancestry as a grand descendant of the *Mwali* family, the spirit wife of the Mankhamba shrine. **Kapolo wa onsene** wears clothing resembling those of Chief Chitule when

alive: short-sleeve shirt and a pair of grey trousers. To this outfit, the *Nyau* has added a dyed sisal kilt, armlets and leglets. The chief carries two large flywhisks to recall the two important responsibilities he assumed as a Chewa, that of village headman and the head of all the *mizinda*.

In the arena, **Kapolo wa onsene** integrates with the crowd and shows closeness to the villagers as Chief Chitule did in life. He shakes hands with people and acts as if he were chatting with them. He has no pretensions and deals with the villagers as an equal. His attitude betrays humility and wisdom. The male choir sing for him: *"Myself* (I am) *the servant of all! I am off! You children* (villagers) *keep the mwambo* (the tradition the culture)*; I am gone!"* [1] To this song, the womenfolk continue: *"This is the old man who is coming!* (You children,) *do not press him.* (You children,) *do not press him. This is the old man who is coming!"* [2] The first song recalls Chief Chitule's last wish of his fellow villagers. As the chief, the servant of the village, he wants the *mwambo*,

the tradition and the culture to be respected. As the head of *gule wamkulu* over the entire territory, he insists that through *gule*, the *mwambo* of the Chewa may persist through time, in a spirit of understanding and collaboration with the different churches and with all those involved in developing the country. As a chief and a custodian of the *mwambo*, **Kapolo wa onsene** beseeches those he leaves behind to value their culture and traditions. He urges them to keep the unity of the tribe (the generations that have preceded and the generations to come). In the second song, the women acknowledge that Chitule's spirit is still present in their midst (*"This is the old man who is coming!"*). Through the appearance of **Kapolo wa onsene**, their beloved chief is back in the village or has never really left. He is among them serving their interests and blessing them with his commitment and wisdom. In an extraordinary interplay, the cloud of dust embraces the entire village, women dance and ululate, and men beat the rhythm on the drums. They acclaim their hero, their chief, their servant and their companion. Chief Chitule is alive! He exults with them in the *bwalo*! As the drummers beat the rhythm of Mfumu yalimbira, **Kapolo wa onsene** starts swerving his feet with great vigour and dedication, dancing in a crouched position that has his head below those of his people. He then genuflects to the crowd to acknowledge that he is eager to help anyone as he is the servant of all. He flaps his flywhisks with determination to emphasise that he is not afraid to serve and give of himself. While swerving his feet with energy, he moves among the men and the women demonstrating that he leads his village with equity and understanding.

The character of **Kapolo wa onsene** was created in May 2006, on the occasion of the first shaving ceremony of Chief Chitule's funeral rite. His burial on 5 January 2006 drew thousands of people from all ethnic groups, all religious affiliations and ranks. The huge gathering was a witness to his extraordinary qualities of leadership and wisdom. He was loved by all because of his tireless dedication and humility. He was willing to help all who required his service without expecting anything in return. The

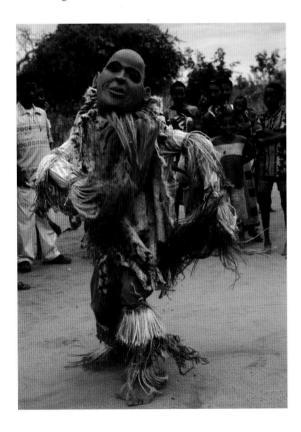

creation of **Kapolo wa onsene** confirms his reputation and his influence in the communities close to the lakeshore. The character of **Kapolo wa onsene** certifies that Chief Chitule was a genuine servant, a man for all seasons, a living example of what the title 'chief' stands for. In their coronation of chiefs, the Chewa state, "*The chief is the people, the chief is like the rubbish heap* (he welcomes everybody), *the chief is like the lowland where the fire is quenched.*" Chief Chitule was the living example of all these statements. **Kapolo wa onsene** gives witness to his presence and influence beyond death as an authentic ancestor of the people.

In summary, the character of **Kapolo wa onsene** portrays a chief or leader who is wise, humble and open to all. These qualities have moulded him into a genuine servant of the community. He is attentive to others' needs and ever ready to help. He smiles on his people and his face breathes peace, serenity and openness. He is an authentic Chewa, fully rooted into his culture. He is proud of his origin and respectful of his traditions, including *gule wamkulu*. He wishes those traditions to persist beyond his own generation and to reach beyond the border of his own tribe. Furthermore, **Kapolo wa onsene**'s costume and dance manifest a person who

moves with development, with new political trends and with the influence of the churches. He can dialogue with them all because of his openness and availability. He is out-going and unselfish. He is thus a role model for chiefs, politicians and church leaders. The *Nyau* communities around the lakeshore propose him as a vibrant ideal of leadership and use funeral and commemoration rites to anchor his image in the minds of young people who struggle with change and western influence.

[1] "***Kapolo wa onsene**, ndapita ana inu, sungani mwambo, ndapita ae.*"
[2] "*Ndi andala abwerapo, aleke aleke, asiye asiye, ndi andala abwerapo.*"

Kasiya maliro

(a day structure from the Mua area)

Themes 1) Mother Ancestor; 2) Rebirth; 3) Fertility; 4) Assisting transition of deceased to spirit world; 5) Unity & harmony; 6) Sexual taboos (*mdulo*); 7) Chewa identity

Etymology **Kasiya maliro** means, 'the one who accompanies the corpse to the graveyard'.

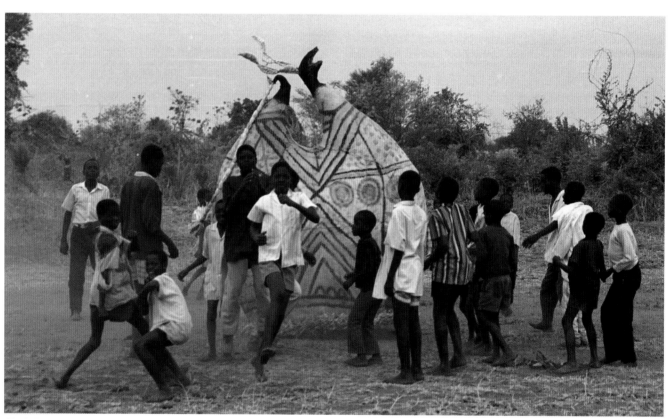

Claude Boucher, Kafulama Village, September 1993

Kasiya maliro is the most important and the most ancient of all the *gule* structures. This narrow structure is a couple of metres in height and length. It is made of maize husk cloth for the day performance or palm leaves for night time. The husks or leaves are stretched on a bamboo frame. It is activated by one married dancer, spinning the

structure as he drives it around the *bwalo* during various types of rituals.

Kasiya maliro is associated with the sacred pools of the Banda. As the great mother of *gule wamkulu*, she comes from the primeval pools of water where the spirits reside. God periodically visits these pools in the form of a mythical snake (*Thunga*). The

Chewa consider **Kasiya maliro** as the mother of *gule* and the mother of the tribe. In this respect, she is the origin of all the other characters including even the elephant (Njovu) that represents the chief.

Her general appearance is in the shape of an antelope of unidentified species. The animal representation with its head bearing

long horns, ears, and muzzle with teeth, and a slender dangling tail, obscure the true meaning of the construction to the non-initiate and the children. The basic shape of the body is abstract and portrays the female pubis and her sexual organs in an inverted position. **Kasiya maliro** represents the mother of the *mbumba*, the matrilineage. She is the head of the women's group that forms the village and she is entrusted with the fertility of the group. This can be made more explicit by her sometimes being followed by smaller versions of **Kasiya maliro** that represent her children. As the mother ancestor, she gives cohesion to the entire group and represents the succession of generations. She is the maternal womb that conceives, nourishes and tends the Chewa from birth to death and even beyond death itself. It is from her womb that the Chewa is born and to which he must return regularly during each stage in his life in order to mature into a full human being.

Kasiya maliro is not only the mother but also the wife. In this regard, her advice is geared to a husband who is responsible for a pregnancy. She teaches him about the women's cycle and the responsibility of the man at times of the woman's menses or when pregnant.

The presence of the womb is evoked at every rite of passage leading to a change of status and personality. When introduced to puberty through the initiation rites, both boys and girls are called to go back to the maternal womb in order to receive her advice and to correct behaviour. They are then reborn as a man or a woman. For the boys this manhood is achieved through their formal incorporation into the *Nyau* (*gule wamkulu*). The boys must enter the belly of **Kasiya maliro** as if they were entering the womb of the mother of the tribe. This is a sort of 'baptism' in the primeval waters of human kind, a return to the place of origin of the tribe. A small image of **Kasiya maliro** made of clay and thick porridge is fashioned on the head of the girl initiates. This signifies that they have become the fertile wombs through which the *mbumba* can increase.

The presence of **Kasiya maliro** is required when leadership is conferred upon a new chief or an elder. One of the elders 'knocks' the commoner over the head, thus his name and personality die and he is reborn to the position and the name of his predecessor. People die but the name and the position continue. **Kasiya maliro** assures this continuity.

Kasiya maliro appears at the time of death, for the burial and commemoration rites. This is the privileged moment when the last rebirth takes place and the spirit of

the person joins the ancestors to become a protector for his family or village. During the burial, **Kasiya maliro** accompanies the deceased to his last home. She dances around the gravesite. She mourns, bidding farewell as a mother for a child before she entrusts him/her to mother earth and to the ancestors. Her song voices the grief of the relatives, *"God, the creator, I would have gone to meet him/her, I would have gone to meet him/her."* [1]

Elders recall that, in the past, the Ajere symbolically slaughtered **Kasiya maliro** at the gravesite. She was buried with the deceased in order to escort him/her to the ancestors. When a deceased person is in transition, his spirit is like an embryo that needs protection. Sexual taboos imposed on the relatives and the community guarantee his rebirth as an ancestor. Three months later the mother earth will manifest, through the sinking of the grave mound, that her child has undergone transformation and is waiting for the commemoration rites to take place.

After a year, **Kasiya maliro** reappears during the last commemoration ceremony. She once presided over the destruction of the house of the deceased (now rarely done) and his return as a protector spirit. On this occasion, festivities involve *gule*, dance, food and drink. **Kasiya maliro** comes to close the mourning period, celebrating the triumph of life over death and giving the okay for the return of the community to social normality, which includes freeing the widow or widower for another marriage.

Kasiya maliro is the great mother who gives birth and rebirth at all these stages. She is also the great *namkungwi* who shows concern for the fertility of the group and makes sure that it is well protected with rules that will optimise the group's success. These rules take the form of sexual taboos that help regulate the period of fertility and infertility, protecting its members against the *mdulo* disease. This period of sexual abstinence closely follows the physiological cycle of a woman and is expressed in terms of a temperature and colour code – the opposition between cold and hot, white and red, safety and danger. When a person or the community as a whole draws near a period of danger, the Chewa demand an hiatus in sexual activity. These periods of danger include initiation to puberty, menstruation, birth and death. At the end of such periods, sexual taboos are lifted in order to allow married couples to resume normal activity.

Kasiya maliro's construction involves the use of bark strings that are soaked in water and make the water turn red like blood. These strings are compared to the

cervix that controls the opening of the womb for generating the pregnancy. The blood-like substance produced by the bark is likened to the mother's blood that binds the tribe into one family. The protruding chest of **Kasiya maliro** evokes the pregnancy. It is called the *mpumulo* (the time of rest, the period of sexual abstinence for the couple). As another of the character's songs expresses, *"To have sex! He had sex with a mother of children – and with a baby on her back! You have really created great damage."* [2] A healthy baby will only be born if the fetus and the mother are well protected. Sexual intercourse during a time of sexual taboos can be a threat to all.

Usually the figure of **Kasiya maliro** is decorated in three colours: white, red and black. These signify the period of sexual restrictions and that of their release. In some areas **Kasiya maliro** is accompanied by the *gule* dancer Kasinja (refer to that entry) at the time of sexual bans but performs alone when the ban is lifted.

Death and life are interconnected for the Chewa as part of the same reality. The presence of death emphasises the value of life and fertility. Their concept of fertility is all-embracing and permeates the entire world of nature: the coming of the rain, the productivity of the land and the livestock. The women's cycle is seen to be part of this natural pattern of fertility. Through their sexual taboos, the Chewa express their solidarity towards each other, their hierarchy and their unity with nature and the animal world. How can one rejoice when his neighbour is in grief because of death or sickness? Older generations defer to the younger ones by holding back from sexual relations. In waiting for the rain, the maturing of certain crops and the birth of young livestock, one has to take care through observing such taboos. All these prescriptions are part of the Chewa moral code and are embodied in **Kasiya maliro**. As a representation of the matrilineage she expresses above all the solidarity of the Chewa in life and death. Through the process of tying and untying (sexual abstinence, *kudika*, and return to normality, *kulongosola*), the Chewa experience unity and solidarity. The presence of **Kasiya maliro** in their midst renews their solidarity at times of crisis. **Kasiya maliro**, the mother of the clan, the great ancestress, gives reassurance and gathers all her children from all generations and from all times (those from the distant past, those who are alive and those from the future) into one family. She calls all to unity and communion in both life and death.

[1] *"Wa m'lenga ndakamuona, ndakamuona nawo."*
[2] *"Kukwata. Akwata nchembere, mwana ali kumbuyo tate, mwaonongatu inu."*

Kulipire

(a white day mask from the Mua area)

Themes 1) Discretion in keeping the secrets of *gule*; 2) Secrecy in sexual matters

Etymology **Kulipire** means, 'Let him pay a fine.'

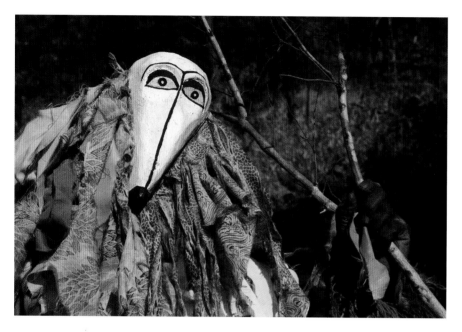

This is a white mask in the shape of a cone, with a black painted nose and the eyes carved as half moons. It portrays the coming of dawn. The appearance of dawn is also expressed in the way the dancer smears his body with white flour. The character of

Kulipire is used to mark the transition between night and dawn, when *gule wamkulu* dancers have to change costumes. As dawn appears, the dancers must discard the sketchy night costumes because the light will reveal the identity of the performers.

They switch over to the day costumes that are more elaborate and more adapted to conceal the dancer's identity. **Kulipire** appears at around 5 am or so, towards the end of the night ritual, and he sings at a distance, *"Let him pay a fine!"* [1] The women respond with these words, *"When you practise witchcraft, look in the direction of the lake where the sun rises."* [2] (You will soon be exposed to the daylight, meaning also, You will be caught.) The literal meaning of **Kulipire** signifies to the dancers that they will have to pay a fine if they reveal the secret of the dance and the identity of the dancers. The character of **Kulipire** is the last warning given to the performers to go and change their costumes if they wish the performance to continue. The same character also gives a piece of advice to people who are married, particularly with reference to their sexual behaviour. **Kulipire** warns that sex should be avoided when children are awake. Parents should keep secrecy in sexual matters.

[1] *"Kulipire!"*
[2] *"Ukatambatamba umayang'ana kunyanja, ukuchera."*

Kuliyere

(a yellow or pink day mask from Mua)

Themes 1) Exile; 2) Patience; 3) Sexual taboos (*mdulo*); 4) Colonial period politics; 5) Recent politics

Etymology **Kuliyere** means, 'It is clear,' 'It is bright,' and 'It is okay.'

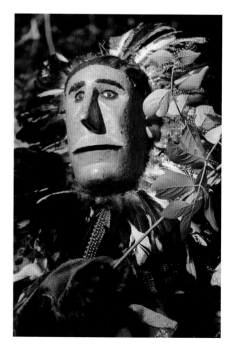

The yellow or pink mask of **Kuliyere** suggests that his long absence from the village has made him a stranger. Two kinds of feathers are in his headgear (chicken and guinea fowl), implying he moved from the village to the bush and then back to the village. His general appearance stresses the effect of foreign influence. He has fine features and is clean and well dressed in a smart tattered suit with pretty feathers. The movements of his feet and hands during the dance are described as casting away the past and leaving behind the place of exile. The small whip that he holds in his hand betrays the harsh treatment that he has experienced.

This character depicts a person who was forced into exile and left the village. During the colonial period, hut taxes were intro-

duced to the local population by the British. At the time of the First World War, Malawian men were conscripted into the British army. Men would disappear in order to avoid both impositions. As well, harmony in the village could be compromised by major disputes and conflicts. These disputes could be forgotten after a long stay away from the village. The song of **Kuliyere**, *"Kuliyere, it is bright…bright…bright. Your husband, who was kept at Mdzaleka, is on his way back,"* [1] means there is no more reason for you to mourn. Enough time has passed, the husband's case has been forgotten and he is on his way home. Mdzaleka is a well-known prison in Dowa. During colonial days this prison was used for people who committed severe offences like manslaughter

and murder. After independence, it became reserved for political prisoners and those suspected of plotting to overthrow the government. The mention of Mdzaleka in the song suggests a more political interpretation of the character of **Kuliyere**. **Kuliyere**'s pleasing appearance and his graceful dancing focus on the joy of his return. The message he received while in exile or in detention is obvious. The situation has changed and he should not fear returning home. All the allegations have been dropped. There is no more danger. Peace has

returned. After independence, the character of **Kuliyere** adopted a political overtone backed by the slogan, 'Come back home.' This was an invitation to those politicians banned or imprisoned by the Malawian Congress Party regime.

At the level of the village, the name of **Kuliyere** signifies return to a situation of peace, calm and safety without fear or danger. This means good social relations between villagers. Moreover, the character of **Kuliyere** provides a married couple with a charter of sexual conduct. *"It is bright"*

means that the wife has ended her menstrual cycle and sexual relationships can be resumed without any danger for the husband. Ultimately, the character of **Kuliyere** focuses on the fact that any breaking of rules leads to punishment. This is the teaching of the ancestors, especially in the field of social and sexual relationships. One has to show patience and determination, knowing that all things pass with time.

[1] *"**Kuliyere** dede **Kuliyere** de, oh e tate **Kuliyere** akum'dzaleka."*

Kwanka anyamata

(a day or night headcover from the Mua area)

Themes 1) Importance of family ties (*kutchona*); 2) Labour migration; 3) HIV/AIDS & sexual diseases

Etymology Kwanka anyamata means, 'The youth have gone.'

During the day event, **Kwanka anyamata** consists of a white skin mask to which is affixed a rudimentary face of a nose, eyes and long moustache. The headdress is rendered with cooked chicken feathers as a hairstyle. The dancer dresses with a kilt, armlets and leglets made of white sisal or woven maize husks. The rest of the body is smeared with ashes. He holds a medicine tail in his hand but does not dance with it. During the night performance, he dons a palm-leaf hat, woven with a zigzag pattern. **Kwanka anyamata** appears at funerals and commemoration rites and dances imitating the Ngoni dancing style, notably stamping the feet. The character sings with a low-pitched voice: *"The youth have gone on the way to Harare!"* [1] A second version of the song modifies slightly the meaning:

"The youth have gone on the way to the graveyard!"[2]

Kwanka anyamata appeared in the Mua area in the 1950s or earlier and disappeared from the arena after Kamuzu Banda stopped labour migration to South Africa and other countries in the mid 1970s and 1980s. The character was created as a protest against the large number of youths who left for neighbouring countries to seek employment. Many of them never returned. Some continued employment away from home and cut family ties (*mtchona*) with Malawi. Others were victims of accidents in the mines or elsewhere and never saw their homes again. A third group got lost in the civilised world and died from syphilis, gonorrhoea or other sexual diseases, following 'the way to the graveyard'. **Kwanka anyamata** arrived at

the peak of labour migration and deplored the number of young men who were deserting the country to seek employment elsewhere. The women were alone at home with the children and the elderly. By the 1970s, entire villages of the central region were the responsibility of women and children. **Kwanka anyamata** saw that Malawi was being sapped of its strength and energy. He reacts to the alarming number of young men who never came back to their families for one reason or another, leaving behind a weak human potential that had to cope with poverty and hardship. **Kwanka anyamata** was in turn a victim of changing social circumstances, and vanished when his voice was no longer needed.

[1] *"**Kwanka anyamata** m'njira ya Halale!"*
[2] *"**Kwanka anyamata** m'njira ya ku manda!"*

Painting by Claude Boucher
and Joseph Kadzombe, 2009

Lambwe

(a red or orange day mask from the Mua and Mtakataka areas)

Themes 1) Role & powers of the chief; 2) Fertility; 3) Enthonement of chiefs; 4) Sexual taboos (*mdulo*); 5) Rivalry for authority; 6) Recent politics

Etymology **Lambwe** refers to a large bull buffalo that watches over the females of the herd.

The bull buffalo uses its two horns to defend the herd. Yet the character of **Lambwe** has only one horn. Several versions of **Lambwe**'s song refer to his having lost one horn in a struggle and being left with only one. Other versions say that he gave one horn away or that one was taken from him. Another song again uses the image of an arrow instead of a horn.

Lambwe features a red or orange mask, depicting a fierce hunter or husband, or a village headman. This person is likened to a bull buffalo. At the apex of his head stands a single erect red horn. The mane is made of wild animal skin. The dancer always carries a long knife and a club. When he dances, he bends his head forward and runs after the women as if he wants to gore them with his horn. Women stay away from him because of his fierceness. His movements show a clear sexual connotation evoking a hunter or husband shooting arrows. The theme of a hunter and arrows is used by the Chewa as a euphemism for sex and marriage leading to pregnancy. Moreover, the image of the bull buffalo protecting the herd suggests the position of the chief as guardian of the females of his village and his

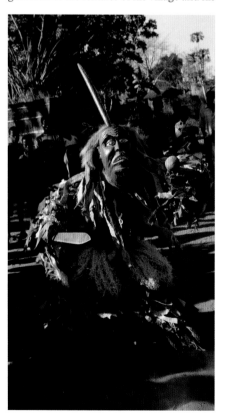

concern over their fertility. These duties he fulfils as representative of the ancestors.

Lambwe resembles the characters of Chadzunda and Njovu that portray the role of the chief and father in the Chewa community, responsible for imparting fertility and protecting it. The horn of **Lambwe** and the trunk of the elephant have similar symbolic meaning, linked to fertility and sex.

The chief is assisted by two councillors (*anyakwawa*). They lighten the burden of authority and strengthen the chief in his service to the community. The councillors are compared to the testicles which empower the penis for reproduction. The reality in Chewa villages is often very different. Instead of supporting the chief, the councillors may show rivalry with each other and sometimes with the chief himself. Horns can depict witchcraft used to usurp power and authority. A version of the song of **Lambwe** reflects this: *"Lambwe (the chief) was given a (councillor). (He died through medicine.) Another was taken away (through witchcraft), Lambwe."* [1] We learn more about **Lambwe** if we look at the ritual role of the chief in the village environment. His first duty is to pass on the *mwambo* (rule of morality) and the fertility that comes from the ancestors. He accomplishes this through sexual abstinence (*kudika*) and through resuming sexual relations (*kulongosola*) with his wife during any major events that affect the life of his village. Any failure in these matters is seen as 'cutting the village' and affecting the life of his subjects. The failure of the chief to keep sexual continence is said to have 'lost' or 'scattered' the village. He is like the bull buffalo which has failed to keep vigil over the herd and lost his horn. This is what the redness of the mask signifies. The antagonism of the women with the dancer in the arena stresses such an interpretation. The obsessive nature of the dancer who chases the women with his single horn epitomizes the chief's penis, in full erection, which is denied sexual contact, expressed by the red colour of the horn.

The chief and his partner have an important role in redeeming the girl initiates after a period of continence, but they cannot do so alone. The rules regulating sexuality bind each adult married man in the village at the time of rituals, sickness and death in the family. For example, a father or a

husband has to watch over his own sick children, and those of his sisters, in-laws or any member of his wife's family, by respecting these taboos. Any failure to keep continence is seen as a type of witchcraft (*ufiti*). Other rules restricting sexual activities are internal to each family like the time of menstruation, after the birth of a child or when a child is away from home.

The Lilongwe version of the song emphasises the prohibition on sex when the children are not yet asleep. Chewa houses are usually small and lack a parents' bedroom. Adults often have to share a room with their young children. The women from the Golomoti area sing the following song when **Lambwe** performs: *"Lambwe is the one who makes an advance concerning sex! Come closer, my dear, so that we may have intercourse."* [2] Among the Chewa, this initiative is left to the husband, but his condition of stranger affects even his private life. He is subject to his wife's family. The well-being of his wife's family members will determine when sex is allowed and when it is prohibited. The same applies to the chief with regard to the well-being of his village. Both the husband and the chief are perceived as the **Lambwe**, the buffalo bull who has to protect the herd and watch over its safety. This task requires that they do not 'lose the horn'. Sex among the Chewa is not seen as a privilege of the individual but as a gift of the ancestors to the family group. The group has the duty to determine the optimal condition for the reproduction of its members. Sexual taboos and abstinence (*mdiko*) open the path of fertility.

There is also a political interpretation of the songs and character of **Lambwe**. The post-independence period and the cabinet crisis of 1964 provided the Chewa with a perfect case. Henry Masauko Chipembere and other early politicians were sent into exile by Kamuzu Banda in order for him to achieve exclusive power and control of the new government. The chief had exiled the competing councillors before they could challenge him. This can also be seen as relevant to power struggles in the local village setup.

[1] *"Wampatsa imodzi Lambwe, ina adamtengera Lambwe."*

[2] *"A Lambwe ee a Lambwe ndiye amayamba m'nyumba, sendera kuno bwanawe, chimbwiza."*

Madimba or Salima m'madimba

(a red or orange day mask from the Mua and Dedza areas)

Themes 1) Social changes/insecurity; 2) Dangers of modernity; 3) Sexual favours for money; 4) Faithfulness

Etymology **Madimba** means, 'vegetable gardens'. These are normally lower patches of ground close to a riverbed where the soil is rich and where moisture sustains the growth of vegetables and fruits. **Salima m'madimba** is translated as, 'He does not work in the vegetable gardens,' implying that the person spends his time on other suspicious activities. **Madimba** can also be used as a personal name, an equivalent of 'the gardener' but suggests a derogatory connotation.

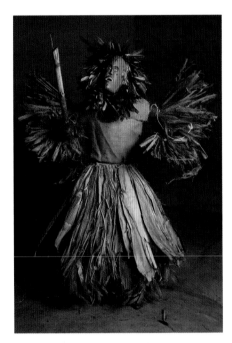

The double appellation refers to variations on a single reality. It is impossible, at this stage of our research, to know which of the two appeared in *gule* first. They differ only slightly in details; general appearance, dancing style and messages are one. **Madimba** from Mua is red to portray sexual heat and foreignness. **Salima m'madimba** from Dedza is coffee or orange, the colour of an African or of a stranger. The latter is given Chewa tribal marks but the orange colour of the mask betrays that he is unfaithful to the *mwambo*. Both **Madimba** and **Salima m'madimba** portray an androgynous face, slender nose, curved painted eyebrows, small eyes, delicate toothless mouth, gentle beardless chin and pointed ears. The headgears of the masks are made entirely of feathers to emphasise that they are sent by the spirit world and are not aggressive characters. In the case of **Madimba**, the feathers could be likened to the Ngoni headgear (*nyoni*) to emphasise that he is good looking. The dancers of both characters wear a singlet, a kilt, leglets and armlets. The kilt, leglets and armlets are made of dried banana leaves to emphasise that he is a gardener of vegetables and fruits. Moreover, **Madimba**

(Mua) wears bells at his ankles, an Ngoni feature stressing his foreign origin as an excuse of his behaviour which is not in accord with the *mwambo*. **Madimba** carries a whip (the power of castigation for reprehensible deeds) and a shaker while **Salima m'madimba** holds a piece of sugar cane or a stalk of maize with a green cob on it (the product of his garden).

In the arena, **Madimba** moves in a sexually provocative fashion. He swerves his right foot continuously four times in synchrony with his right arm. He repeats this with the left foot and the left arm. As he unites all these movements, he wiggles his pelvis in a lewd manner. In reaching the climax and the chorus of his song, he ends up swerving his right foot and waving his right arm, as a finale, as if he has reached orgasm. The male choir of Mua sheds some light on the meaning of this cryptic pantomime. *"Women have cheated us* (or) *women have enticed us; they have bought cattle! Madimba has bought cattle for them! Women have cheated us* (or) *women have enticed us!"* [1] The Dedza choir sings the following: *"He does not spend his time in the vegetable garden…what kind of behaviour is that? He does not spend his time in the garden."* [2] To these songs the womenfolk reply: *"The vegetable garden is good because it provides a lot of money* (or) *Mr Gardener is a gentleman because he gives a lot of money.* (The gardener says:) *I have no money!* (The women answer:) *I was just in need of a chitenje* (wrap around)."* [3] The song talks about a gardener who produces vegetables and fruits for the support of his family. He abuses his position by flirting with pretty women who purchase his products. He does not spend his time in the garden but wastes it at other dubious games. **Madimba** uses his income in exchange for sexual favours. The song from Mua reveals that those who have profited from his 'generosity' have been able to buy cattle with the money he gives them. The rest of the song comments on their bargain: he pretends that he has no money and she requests for a blouse and a wrap around. The women's song comments sarcastically on the vegetable garden as a great source of revenue and on the gardener who is never short of money.

Both **Madimba** and **Salima m'madimba** can appear at any ritual of *gule*. Both characters were prominent throughout the colonial period and are still seen today though with less frequency. **Madimba** and **Salima m'madimba** present a promising, attractive young husband, who is a competent gardener. He is an example of success with regard to access to cash but his downfall resides in his sex appeal and urges. He cannot resist the pretty girls who make him advances. All his income goes into women instead of bringing it home to his wife. The tragedy starts when the wife and the neighbours discover that the girlfriends have acquired cattle with the husband's money.

The same song holds women responsible for cheating and enticing men. This accusation is frequent within Chewa society. It betrays a strong male bias and serves as an excuse for irresponsible behaviour amongst men.

Through **Madimba/Salima m'madimba**, the ancestors address both genders. They denounce the husband who abuses his position and sinks into a vulgar promiscuity that deprives his wife and family of their necessities. They condemn, too, women who tempt men with sexual favours for material gain. Ultimately, **Madimba** protests irresponsibility and the money economy that clashes with traditional wisdom and spirituality. **Madimba**'s birth into *gule* coincides with the arrival of the cash economy in Malawi that has sparked dissolute behaviour in direct confrontation with the *mwambo* that values faithfulness and family life.

[1] *"Ana aakazi atinyenga pogula ng'ombe ee. Madimba pogula ng'ombe, ana aakazi atinyenga."*
[2] *"Salima m'madimba tate de. Chiani chotere? Oh iai tate de. Salima m'madimba."*
[3] *"Madimba ngabwino amapatsa ndalama. Ndalama ndilibe! Ndidakagula chitenje."*

Mariya or Esitere or Pali Dona

(a day mask from Mua, which may occur in many colours)

Themes 1) Mother Ancestor; 2) Guardianship of the *mwambo*; 3) Chewa identity; 4) Model of virtue; 5) Faithfulness; 6) Fertility; 7) Polygamy

Etymology **Mariya** derives from the name, Mary. **Esitere** derives from the name, Esther.
Pali Dona means, 'There is a lady (a European lady).'

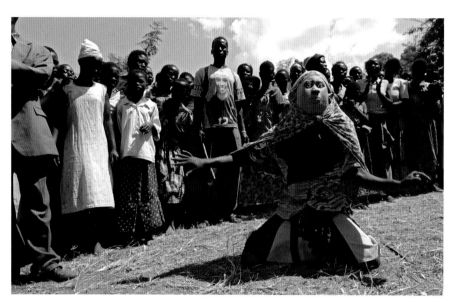

The female character of **Mariya – Esitere – Pali Dona** is danced by a man and is very common in Chewa territories in Malawi, Mozambique and Zambia. The mask of **Mariya** (Mary) appears in a variety of colours. Usually it is red, pink or yellow but it is also found in white, blue or black. It depicts a European lady (*dona*), with striking western features to which local tattoos have been added. She wears earrings, necklaces and bangles. She often has long hair like that of a European woman (sometimes replaced by feathered headgear). Her dress is always very elaborate and smart: a fancy skirt, an attractive blouse and an expensive scarf on her head. She has a well-shaped body, heavily padded with false breasts and buttocks. She waves in her hand a delicate handkerchief. For night events, **Mariya** can wear a woven hat of palm leaves that reflect light.

Mariya is known as the mother of *gule wamkulu*, something of the mask equivalent to Kasiya maliro. She is the mother of Chadzunda (the head of the spirit world and chief of the village) and of all the other *gule* characters. She dances with Chadzunda and, in this context; she is also seen as his wife and as wife of the chief and as the *namkungwi* (mistress of initiation) of the village, as is stated in one of the songs: "*The wife of the chief wears a terylene dress, the wife of the chief.*" [1] The *namkungwi* is the most prominent female position in the

village, after that of a female chief. Like Kasiya maliro, **Mariya** is the ancestress of the tribe and the guardian of the *mwambo*. She teaches about identity, unity and continuity in this world and that of the ancestors. Equally, **Mariya**'s role as a wife refers to that of motherhood. As she dances with her husband Chadzunda, she circles around him and shows him undivided attention and love. She performs with all her ability and skill in order to please and captivate him completely. She kneels down in front of him and wipes the sweat from his forehead. Together they form the perfect couple. They are united and deeply involved, a model of happy married life. **Mariya**'s attractiveness and sex appeal are never vulgar and cheap.

As the *namkungwi*, during the initiation rites, she dances to the *chisamba* while teaching sexual matters and rules. She does so with dignity. She teaches the initiates the *mwambo*, the rule of decency, the secret to fertility and to a happy marriage. The songs that are sung for her show what happens when her advice is not taken seriously.

Mariya, as the wife of Chadzunda, is also a mother. She sometimes carries a doll to which she shows much attention and love. She demonstrates that she is fertile and a good mother. She is hard-working, clean and presentable, well behaved, clever but not arrogant. She follows her husband at public functions and likes to accompany

him on his outings. The Chewa have been puzzled by the way a European couple always walks together. *Gule* depicts this as an example of modern life. However, it is presented with a touch of humour knowing that such behaviour can be misunderstood in a rural community. A wife who often follows her husband can be seen as a jealous woman who does not have a deep and unconditional faith in him.

The name of **Mariya** was introduced in the 1920s at the peak of controversy between Christianity and *Nyau*. To some extent it has superseded an older character called Angali, Mkwanyisi, Mtunduchi or Mzaamba, which had a similar function. The name **Mariya** was adopted in order to mock the Christians who were suppressing the *gule wamkulu* activities, thus interfering with Chewa morality and culture. One of the most contentious issues focused on the rules of sexual abstinence (*kudika* and *mdulo*) which forbid sexual contact at the time of funerals and initiation rites. Christians regarded the disease *mdulo* as mere superstition and they seemed to depart from the *mwambo* of the ancestors and put at risk their own identity and culture. This is exemplified in one of **Mariya**'s songs: "*In the middle of the ocean, there is a lady. Let us remind her that the child's cloth got lost.*" [2] Sexual abstinence should be applied when the child or its clothes are missing from the house. In spite of or because of this opposition, the character of **Mariya** gained tremendous popularity since the 1920s and has spread all over Chewa territory. Its modernisation as a European woman contributed partly to its success and popularity.

Today **Mariya** remains a model of virtue for both Christian and *Nyau* members. She has even incorporated teaching against polygamous marriage. Chadzunda and **Mariya** are role models for the Chewa community. They exemplify the ideal of the perfect couple in the chief and his wife. They put forward a model of proper behaviour and unity in marriage and parody misconduct and promiscuity.

[1] "*Akazi a'mfumu adavala tiriyo eae akazi a'mfumu adavala.*"
[2] "*Pakati pa nyanja **Pali dona**. Apo tikauze amai, nsalu ya mwana yataika!*"

Mdondo

(a day or night structure from the Mua area)

Themes 1) Father Ancestor; 2) Role & powers of the chief; 3) Symbol of fertility & redemption; 4) Sexual taboos (*mdulo*); 5) Promptness; 6) Unity & harmony; 7) Sharing of beer

Etymology Mdondo has two meanings. It means, 'the bush (men's territory)'. It is also a derivative of the word *kundondozana*, meaning, 'to follow each other (like a train), to push one along, to help one along (like helping a child to walk)'. Scott (1892) noted the word is also used to speak about 'a little man that runs very fast'. All of the meanings could relate to this structure.

This structure, like that of Chiwoko/Chimkoko, is one of the largest of *gule wamkulu*. It can reach five or six metres long, close to two metres high and one metre wide. The number of dancers varies according to its length. The structure can only be danced by married men abstaining from sexual contact. Like the elephant structure, it is constructed at a special place (not the regular *dambwe*), where only senior men have access. The shape varies according to the regions. Some make it with a flat back, others with humps. Some construct the head like that of Chimkoko with an open mouth full of teeth, horns, ears made of fan palms, a tuft of hair, and a short neck. Others construct a long mobile trunk like that of the elephant. The rear end of the structure displays a short tail (c. 60 centimetres long) resembling that of the elephant. The body is often decorated with patches smeared with black mud, like windows. This contrasts with the white maize husk weaving pattern (day performance) or the glittering palm-leaf zigzag pattern (night performance). A fringe of maize husks attached to the bottom of the structure hides the dancers' feet.

The fact that the structure shows humps, windows and a trunk like a chimney indicates that **Mdondo** is conceived like a passenger train with its different carriages: its steam engine leading, the windows in the passenger waggons and the flag on the last carriage that looks like a tail. In Malawi the first railway line was opened between Blantyre and Port Herald (Nsanje) on 31 March 1908. The Blantyre line was extended to Salima in the mid 1920s. The residents of Mua saw their first train on 29 September 1933. Some of the labour migrants could have witnessed their first train earlier in Blantyre, South Africa or Southern Rhodesia (Zimbabwe). It is impossible to give a precise date for **Mdondo**'s introduction into the dance. The Chewa were so impressed with the power of the train that they equated it with that of their elephant from the bush. They converted the locomotive chimney into a trunk and transformed the flag at the rear of the train into a tail.

In the arena, **Mdondo** behaves very much like a train. It runs quickly, goes backward and forward, swaying left and right when stopping. At the time of the funeral and commemoration ceremonies including the *dambule* it goes around the funeral home (*masiye*) or surveys the shed where the beer is brewed (*chikute*). It is often accompanied by the structure of the small impala Kanswala that symbolises the sharing of beer between the living and the dead, *"Kanswala* (small impala), *they have sent you. Go and fetch some water in the bush* (Mdondo), *mother!"* [1] Like the mother ancestor who looks over the brewing of the beer, Mdondo, who represents the chief or the chief's ancestors, shares in this responsibility by tasting the beer before sharing it with his guests.

At the time of puberty rites, the initiates who are blindfolded have to come and touch the trunk at the front of **Mdondo** as they would do with Njovu. On this occasion, the usual song of **Mdondo** is replaced by that of the elephant. Various other songs sung by the men accompany its appearance on other occasions. *"You, **Mdondo**, you **Mdondo**, you forgot your mother-in-law!"* [2] or *"I only heard about the animal from the bush* (nyama m'**Mdondo**), *the game from the bush, the game from the bush,"* [3] or *"My big **Mdondo** belongs to my wife. Would you like to experience it?* (Appearance can be deceptive)." [4] **Mdondo** is first of all male because he is identified as being from the bush. Second, he is linked to the position of authority because he represents the elephant or the train.

Its association with the train evokes other symbolic features. The locomotive is endowed with power to pull the other buggies and lead them on. The train moves quickly and promptly. All of these details are applied to the Chewa social setting and their code of behaviour. **Mdondo** features simultaneously as the head of the spirit world, as the village chief and as the married man in his role of husband and father. As head of the spirit world he represents Chadzunda who embodies all the other spirits. As the locomotive pulls the rest of the train, **Mdondo** with his impressive size carries all the territorial and domestic spirits within him. At all these rites, particularly at the commemoration rites, he brings them all to share the beer with the living, making peace between them all, unifying and guaranteeing their continuity. **Mdondo** also represents the living

Claude Boucher, Mlongoti Village, 4 December 1993

head of the village who acts as the link and representative of the spirit world. He has the duty to pass on the *mwambo* and keep peace between all its members. In periods of crisis, such as when a member reaches puberty or experiences death, he must lead them through 'cool' and 'hot' zones by abstaining from or resuming sexual contact. The experiences of both puberty and death are seen as dangerous zones that require sexual abstinence for all touched by the events. The chief is the leader who introduces the initiate to the realm of fertility and opens it up for them or leads the mourners to resume sexual life after a long interruption. He does this by having ritual intercourse with his wife at all those occasions. These are called *kulongosola anamwali*, 'to redeem the initiate' or *kulongosola mudzi*, 'to redeem the village'. **Mdondo** symbolises these duties epitomised in the trunk of the elephant or the chimney of the locomotive. By the same token the power of the male and the chief is also stressed and praised at the family level

in the role of the father and the husband. He is seen as the head of the family who is responsible for fostering children and for their healthy upbringing. He achieves this by observing the *mwambo* and keeping the rules concerning the *mdulo* complex. Sexual contacts are regulated by rules of abstinence, particularly at the time of menstruation, at the end of pregnancy, after birth and at any other important ritual occasion demanded by the family group. Such periods of interruption are usually concluded with a ritual 'redeeming' of the person in transition. The first quality of a father or a husband is to possess both potency and self-control. This quality is exemplified in **Mdondo.** As the engine pulls the carriages behind, so the father brings up healthy children. In addition to the three major levels of symbolism, **Mdondo** emphasises more social virtues like promptness in action. He teaches the village not to delay at fulfilling one's own task. Such a message is aimed at farmers and the members of *Nyau* as suggested in

the first song, *"You, **Mdondo**, you **Mdondo**, you left your mother-in-law behind!"* A good *mkamwini* should not wait for his mother-in-law to go to the field. Let his mother-in-law find him already at work. Similarly, the members of *gule* should not needlessly delay starting the dance.

Together with Njovu and Chadzunda, **Mdondo** is a leading character of *gule wamkulu*. The fact that it is seldom seen today indicates that *gule* is undergoing a major shift. *Gule* structures are vanishing and are being replaced by new masks of a more contemporary nature, forcing aspects of the *mwambo* to sink into oblivion.

[1] *"Kanswala, anachita kukutuma, katunge madzi m'Mdondo."*
[2] *"**Mdondo** iwe **Mdondo** iwe, mwaiwala apongozi."*
[3] *"Ndimangokumva nyama ndi **Mdondo** ndi **Mdondo** (2×)."*
[4] *"**Chimdondo** ali ku mzako, kumati akhale wokoma?"*

Mdzopendeka

(a day red mask from the Mua and Dedza areas)

Themes 1) Responsible leadership; 2) Rudeness; 3) Witchcraft; 4) Relations with Christian church

Etymology **Mdzopendeka** is an abbreviation of *Mudzi wapendeka* meaning, 'The village is tilting.'

This large red mask portrays the chief or an elder in a position of authority. The details of the face, costume and performance emphasise how he fails his duties as the leader of the community. Instead of keeping his people united, he divides them through his self-centred preoccupation. The red colour of the mask symbolises this disruptive behaviour. The mask shows the face of a person of mature age, bald, with a greyish beard and wrinkles. His headgear is normally made of wild animal skins of various types that identify the chief with the power of animals. In the Dedza version, **Mdzopendeka** displays six long red horns on his head that emphasise his power, particularly with regard to witchcraft. Six short black warts protrude from his forehead to convey the role of the chief as the guardian of the sexual code. The Mua version also has warts but it lacks the long horns. The eyes and the ears are emphasised, in order to portray blindness and deafness. The mouth is sometimes shown with an ambiguous, cunning smile, and teeth that express aggression. **Mdzopendeka** wears the traditional tattered jute suit and carries a club, instead of a medicine tail. This suggests that his leadership is carried out through arbitrary orders and coercion. He

dances mainly at funerals and at commemoration ceremonies of important people. In the arena, he performs with sustained energy but also chases people away. Several songs capture his character. The Mua version mentions, *"What kind of chief insults his people? **Mdzopendeka** – the village is tilting."* [1] The Dedza version says, *"All people have died. This is the work of **Mdzopendeka** – the village is tilting. What has happened? Here was a house* (here also another)*; everybody has gone; the village is tilting."* [2]

Mdzopendeka portrays a leader or chief who fails to show the qualities of leadership that are expected. The chief lacks humility, dedication and honesty. He is rude with his people, exposing their weaknesses in public. He exhibits favouritism towards immediate family members and children. He promises to attend to the villagers' complaints but is unreliable and the help is limited to words. **Mdzopendeka** judges cases unfairly, accepts bribes and holds grudges against those who refuse to offer him bribes. This chief fails to keep the sexual taboos imposed by the mystical role of chief and is held responsible for the death of children and adults in the village. Powerful chiefs are often credited with

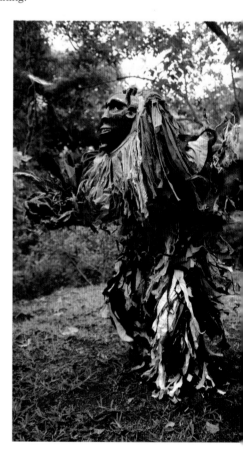

magical powers (*kukhwima*) that they express through witchcraft (in *gule* often depicted by horns). The Chewa believe that thirst for power, envy and ambition, can motivate chiefs to kill. This kind of behaviour results in the splintering of the village. The discontent, fear and suspicion of the villagers cause them to leave the village, one by one. Unexplained deaths, attributed to the chief's hidden power, increase the number of vacant houses. **Mdzopendeka** means, 'The village is tilting,' tipping the people out, and after a while the village is empty. Consequently, the ancestral spirits become upset. The funeral ceremony and the commemoration rites are moments to remind such leaders that 'the village is tilting' because of their lack of responsibility. They have been entrusted to be the supreme representative of the ancestors and the guardian of the people.

The nickname of **Mdzopendeka** was also applied to some of the missionaries who were bitter enemies of *gule wamkulu* during colonial days. Fr E. Paradis, who was based at Mua from 1907 to 1910, left the mission with a reputation for putting curses on people as well as being the enemy of the secret societies. Fr P. Roy, who worked at the Mua mission from September 1923 to November 1925, was also known as a dangerous threat to the *Nyau* activities. He was transferred to Likuni where he continued his anti-*Nyau* campaign and was forced by the governor (who put pressure on the apostolic delegate) into exile in Zambia in 1928.

1 *"Mfumu yanji yotukwana anthu Mdzopendeka!"*
2 *"Anthu adatha tate de (2×). Tiona pa m'dzi pano tate de, Mdzopendeka. Mudzi wapendeka tate de (2×). Nchiani chachitikacho tate de apa panali kanyumba tate de Mdzopendeka."*

Mfumu yalimbira or Yalumbira or Mfumu ili ku msewu
(a pink, red or orange day mask from the Mua and Dedza areas)

Themes 1) Witchcraft; 2) Jealousy/envy; 3) Rivalry for authority; 4) Underage sex

Etymology Yalimbira means, 'rival'. **Mfumu yalimbira** means, 'the chief's rival'. **Mfumu ili ku msewu** means, 'The chief is on the road.'

The general name of chief here is applied to any position of authority within the Chewa village structure. **Mfumu yalimbira** is depicted in tones of red, pink or orange in order to show he is an intruder into the village hierarchy. The face portrays a senior man with wrinkles. Sometimes he has a black beard and moustache. His head is often bald but topped by a small tuft of hair or a few feathers to signify his pretension to power and authority. Small protrusions are sometimes added to the side of the head indicating that he intends to use witchcraft. The headgear of his mask is made of goat and baboon skins indicating that although he belongs to the village, he is a thief like the baboons that raid people's gardens. He wears the characteristic suit of the *gule*, with or without rags. He carries medicine tails and whips to show that he envies someone's position of authority and that the ancestors are displeased with his envy.

Mfumu yalimbira enters the *bwalo* proudly. He rushes to sit in the chief's chair, pretending that he has taken his place. He solemnly surveys the ground like the chief and throws one leg at a time on the side. He waves his medicine tails simultaneously to convey that he intends to usurp the power of the chief. The men's song from Mua unveils his intention, *"Mfumu yalimbira* (the chief's rival), *you the chief's rival! He challenges the chief's authority, as if it is his own, the chief's rival!"* 1

The Golomoti area portrays the same behaviour under the name of **Mfumu ili ku msewu**, 'The chief is on the road.' They sing, *"The chief is on the road. What kind of*

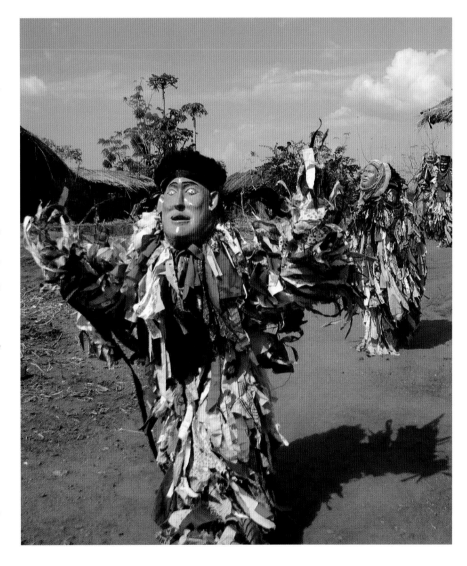

chieftainship is based on rivalry? The chief is on the road." [2] The name expresses the idea that the chief has been dethroned. He has lost his authority and someone else has taken his position.

Both characters, as agents of the spirit world, want to stamp out the behaviour of individuals who are envious of someone's position or possessions. The Chewa village is based on a hierarchical system that puts the maternal uncle (*malume*) at the head of each family group; the assistant of the chief (*nyakwawa*) in charge of several families; the mistress of initiation (*namkungwi*) at the head of the women's group regarding puberty ritual; the boys' initiator (*wakumadzi*) in charge of boys' initiation; and,

the chief (*mfumu*) as the supreme authority over the entire village. People who are subordinate to the chief and motivated by jealousy and envy can abuse their positions and disrupt the system. One might even bypass the chief's power and take the duties of the supreme leader such as distribution of land, judging court cases and promulgating false laws. The usurper may not belong to the chief's bloodline. Witchcraft may be used in order to achieve his perverse aims. Hidden powers may be tapped through immoral and antisocial behaviour (*kukhwimira*), such as committing incest or adultery with a young girl who has not yet reached puberty. There can be danger for the villain in this strategy however. The song of the Dedza

version of this mask draws the moral message behind such short cuts: *"Yes, what kind of hurry is this, **Mfumu yalimbira** – the chief's rival? He failed, the chief's rival, who coveted young girls. He died because he had intercourse with a child who was not yet mature, the chief's rival."* [3]

[1] *"**Mfumu yalimbira** tate de tate de iwe tate e, **Mfumu yalimbira** tate e iwe de, **Mfumu yalimbira** tate e, **Mfumu yalimbira** ngati ngwawo tate e, **Mfumu yalimbira**."*
[2] *"**Mfumu ili ku mseu** tate…ufumu wanji wolimbirana tate? **Mfumu ili ku mseu**."*
[3] *"Inde tate de, liwilo lanji lotere **Mfumu yalimbira** chalaka awa chofuna anamwali ede **Mfumu yalimbira**, afa mfumu nyini wosakoka, nakwata diyere de **Mfumu yalimbira**."*

Mkango

(a day structure from Mua)

Themes 1) Guardianship of the *mwambo*; 2) Role & powers of the chief; 3) Royalty; 4) Fertility; 5) Banda – Phiri relations

Etymology **Mkango** is the Chichewa word for lion.

This large two metre long structure is activated by two dancers. It appears for day and night rituals on occasions of funerals, initiations and chieftainship ceremonies. A bamboo frame in a series of rings is covered with a special reddish-brown grass that reaches close to the ground. The grass is thatched to simulate the lion's fur. The black goatskin head has round skin ears, red eyes and a tongue also made of shaved and dyed skins to complete its realism. Sharp teeth are often featured inside the wide mouth. The tail is made of a curved stick (one metre long) covered with skins or with the same grass as the body. The legs and the feet of the two dancers are concealed with leglets of the same long '*mpuntha kalulu*' or '*ndingi*' grass. The animal is constructed in a secret place away from any habitation. After it is built, the two dancers take it to the *dambwe*, to wait for the date of the performance.

The lion enters the *bwalo* to its own drum rhythm and runs quickly, prancing and moving backwards and forwards. The crowd cheers and becomes wild with excitement. When the lion rests, it squats down, balances its body from side to side and swings its long tail. Inside the structure the head dancer uses a pierced calabash tied around his mouth to produce the roaring sound of the lion. After a short rest the animal stands up and begins chasing the crowd. It roams around backward and forward, kicking up its haunches while the choir sings, *"Here is the lion, it roars from the pool (the swamps or the forests), from the*

pool." [1] Another version of the same song says, *"Here is the lion, it sleeps by the pool."* [2] The women enthusiastically reply, *"Chief _____, you are the best! Your colleagues do not know gule! Chief _____ , you are the best! You are the best!"* [3] Through this song the womenfolk praise their chief and the men of the village for their skills.

The wild beast that roars or sleeps by the swamps or in the forest is the messenger of the spirit world (territorial spirits). That is why it only appears at funerals, initiations of important people and for the enthronement of village leaders. Its roaring inspires fear and is connected with correction of behaviour. The lion is the whip of the ancestors, particularly the chiefly ones, who have the duty to teach the *mwambo* in the ancestors' name. Initiates must listen or they are whipped. When the lion appears they are told they will be bitten if they neglect the *mwambo*. As servant of the spirit world the lion inspires fear and encourages obedience to the moral code.

The lion structure is probably very ancient since it often appears (like Njovu the elephant) at the climax of ceremonies. It seems to have a very close connection with fertility because of the reference to the pools. During the Banda period (800–1300 A.D.) the village headmen were perceived as the custodians of fecundity on behalf of the ancestors. They were like the lion as the father of the pride. The animal was commonly connected with a large progeny. This symbolic link is still made explicit during the ritual intercourse that takes place

between the headman and his wife on the night following his enthronement. The chief is told he is the lion and he has to do '*kupolama*' – to take his wife from the rear and grab her like a lion. During this intercourse, he shows his domination over his subjects (represented by his partner) but he also imparts the power of life and fertility to the entire village. This symbolic gesture is also repeated for girls' initiation ceremonies. The village head and his wife have to complete the '*kulongosola*' for the girls who belong to the village. This ritual intercourse (*kupisira anamwali*) is meant to put an end to the chief's sexual abstinence and simultaneously liberate the power of fertility for the girls. This is only made possible if the chief and his wife keep the *mwambo* and follow the sexual taboos prescribed at such times. The chief's closeness to the spirit world enables them to impart this fecundity that ultimately comes from God himself.

After 1300 A.D., the Banda lost their spiritual and political hegemony. The Malawi (Phiri) rulers took over their political control. Kalonga became the supreme king. His political authority was shared with his sub kings and the village headmen belonging to the Phiri dynasty. Within this context of rivalry between the Banda and the Malawi, the lion of *gule* (an institution that belonged to the Banda) underwent a substantial change of meaning. The lion became the king as protest against their lost authority. At the same time, the mask was meant to boost the authority of their Banda headmen and discredit the centralising

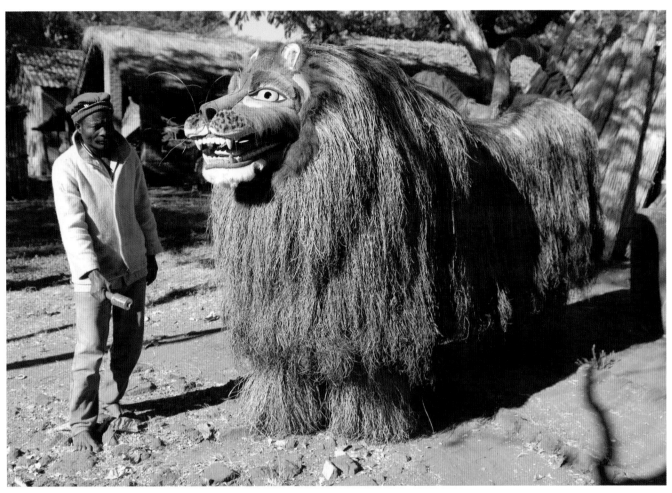

power of the Malawi. We know that once the Kalonga (the Malawi King) had consolidated his power after monopolising the shrines and the sacred pool, he was able to enforce the collection of tributes from the local population. Some of the items collected were lion skins and lion vocal cords (*mtulu*). Both the lion skin and its vocal cords were symbols used by the Banda to back the authority of their headman. The vocal cords, especially, were used as medicine to affirm their authority when they addressed their people publicly. These together with certain red objects (symbolising fire) were the king's monopoly as the supreme owner of the land (*eni dziko*) and the great fire keeper. The colour of the lion (in *gule*) may have changed during that period from black to red in order to mock the king, the Phiri supremacy and to boycott such tributes.

After a succession of Kalongas, the Banda voice of rebellion became fainter. **Mkango** slowly lost its derogatory character and remained simply associated with royalty. The fertility rite concluding the chief's enthronement and its ritual intercourse were more and more interpreted as domination of the chief over his subjects.

Today the lion figure is portrayed simultaneously as father and king and used in the rituals that are connected with status and chieftainship. The kingly animal represents the status of the chief. Both the chief and the lion are seen as dangerous and awe-inspiring because of their link with the ancestors. People recall that the chiefs of the recent past talked through a small gourd that amplified their voices. This instrument was compared to the roaring of the lion. It amplified their voices and raised their status to that of representatives of the spirit world. During the ceremony of enthronement the newly crowned chief is washed with various medicines including ingredients derived from the lion's anatomy. They are meant to protect him against the evil power of those who envy his position. The medicine also contains ingredients to stimulate fertility. The people are supposed to believe that their leader has transformed into a lion after his or her coronation. When the chief is buried, lions' foot prints found at the grave side are interpreted as the chief being reincarnated as a lion. When the lion structure enters the village from the bush, people must show him due respect.

After independence in 1964, the lion

structure was identified with Malawi's first President Dr H. Kamuzu Banda, commonly designated as the 'Lion of Malawi'. This title meant he was the father and the king of the Malawi nation. The *gule* lion, besides highlighting this and praising Kamuzu Banda's power, also voiced less positive aspects of their leader's personality. *Nyau* members implied their political leader was a cruel tyrant and a womaniser. They were able to use the lion's song in a derogatory context: *"Here is the lion, it sleeps by the pools."* The song also means that the person of high status is promiscuous. He takes advantage of living in a polygamous arrangement to have an affair elsewhere while pretending that he is with the second wife. This biting remark would be targeting Kamuzu Banda's ambiguous relationship to his *mbumba*, the extended family of women followers. In this context, the **Mkango** would remind any person of high status that such behaviour is unworthy of his position.

1 *"Suwo **Mkango** ukulira m'maiwe, maiwe maiwe e."*
2 *"Suwo **Mkango** wogona m'maiwe, maiwe maiwe e."*
3 *"A Bwanali mwawina, ndani sadziwa, sadziwa gule a Bwanali mwawina mwawina."*

Mtchona and Mai Mtchona

(a pink and a brown mask respectively, from the Maluwa area)

Themes 1) Importance of family ties (*mtchona*); 2) Selfishness/self-centredness; 3) Recent politics; 4) Kamuzu Banda's identity

Etymology Mtchona refers to a word of South African origin, identifying people who have lived in a foreign land for a long time and are no longer in touch with their homeland.

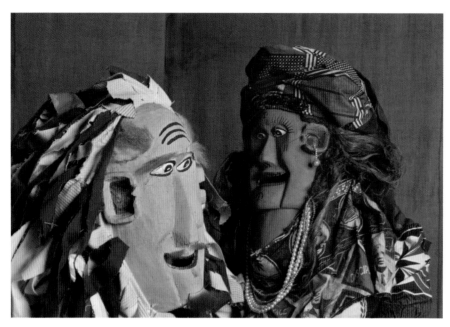

The **Mtchona** couple always appears as a pair. She is a Malawian (brown colour) and he is a European (pink colour). **Mai Mtchona** has a round face supported by a short, stout neck adorned with a beautiful necklace. Her face is flattish. Her nose is broad and her enigmatic eyes squint. Two large jowls frame a forced smile. Her large ears display flashy earrings. Scarifications and Chewa tribal tattoos appear on her face. She has black hair made of dyed sisal. An elaborate turban is tied in the fashion of the Malawi Women's League. The turban is made of a *chitenje* fabric used by the Malawi Congress Party (MCP) and worn as political propaganda. **Mai Mtchona** is smartly dressed. She wears a fine blouse and a long wrap-around *chitenje* of the same motif as her turban. Her bare arms are adorned with an impressive number of bangles. **Mtchona** is old, bald and wrinkled. His pink face is triangular in shape and has a severe expression. The crown of hair surrounding his bald pate is made of tatters of various colours. His face shows no tribal marking as he represents a foreigner. His nose is long, thin and square. His eyes appear dazed and vague as if he has been bewitched or charmed by his wife. Long jowls frame a stupid smile that shows missing teeth. A small moustache, thin goatee and short sideburns made of

monkey skins give him a British aspect. **Mtchona** wears a smart tatter suit and carries a walking stick and medicine tail, signs of his advanced age and his high position.

Mtchona is hypnotised by his wife's beauty and follows her into the arena to the rhythm of the *chisamba*. From behind, he grabs and slaps her buttocks, as she wiggles her hips suggestively and dances provocatively. The male choir sings, *"Mtchona, (the one who has forgotten his home) owing to labour migration, has forgotten everything! He has even remarried where he went to work. (He writes:) Dear maternal uncle, I will not go back home! (This is what he does,) the one who has forgotten his home! The one who has forgotten his home!"* [1]

The **Mtchona** couple is recent in the history of *gule*. They were introduced to enhance party meetings during the transitional period of 1992. This is the time when multiparty pressure groups and the MCP were campaigning and competing for the referendum of 1993 and the general election of 1994. The theme of forgetting one's own home is very familiar to *gule* and has been addressed with a number of masks. Malawians, and the Chewa in particular, have long been affected by labour migration. For generations, young men have been seeking employment outside the

country and never returned. They vanished in Zimbabwe, Zambia and South Africa. Some made a new life there without informing their relatives. The **Mtchona** couple wants to address this situation. They warn young people and married husbands who seek employment outside the villages or outside the country that it is wrong to forget one's family and not to be in touch with them. Some become lost in a foreign world and lose their sense of purpose. They are seduced by wealth and novelty. They marry, raise a family and even reach old age without informing families and relatives at home. The migrants pretend they will return but instead abandon their families. Such people betray the family spirit and the filial attachment binding them to their families, relatives and countrymen. At home, people wonder if they are still alive. They mourn them and struggle with poverty and despair while the *mtchonas* are selfishly enjoying life, with no intention of returning. They have cut ties with their home and deprived parents, relatives and wives of the joy of a letter or of news of a prompt return. Such a selfish attitude is also found among people who move within Malawi borders but to a distant region and never return to their village. The **Mtchona** couple warn such people that their behaviour displeases the ancestors, the jealous guardians of family ties. A genuine Chewa values family ties above all. He prefers to grow old among his relatives and neighbours. He likes to support them when the experience of death draws near. He wishes to be buried by his own family in the village cemetery and sleep among his own ancestors.

The fact that the **Mtchona** couple was introduced in *gule* toward the end of the reign of President Kamuzu Banda is most revealing and adds a political twist to the interpretation given above. The beginning of the 1990s is characterised by a general dissatisfaction towards Kamuzu Banda's leadership. People became curious about the real origin of their president. Rumours circulated that he was not a Malawian at all, but that he came from the United States of America or from the United Kingdom in order to usurp power and the position of the presidency. **Mtchona** portrays Kamuzu Banda as an outsider who came to Malawi in 1958 and then fell for the charms

of Mama Kadzamira, (**Mai Mtchona**), who became the official hostess of the country. Kamuzu Banda married the country and forgot to return to his homeland (England), where he had left a wife (Mrs French) and possibly children and other relations. He enjoyed **Mai**

Mtchona's company so much that he also neglected the running of the country. He would not leave the leadership to younger and more capable candidates. The **Mtchona** couple portray Kamuzu Banda and the Official Hostess with a note of ridicule and suggest skilfully that Kamuzu

Banda's time is over. He should go back where he belongs and allow someone else to take over the leadership of the country.

[1] " *Mtchona tate de,* **Mtchona** *a ku nchito ndiwo wochita kutchonera zonse tate. Iwo achita kukwatira ku nchito ukwati. Amalume inu, sin'dzabwera ku mudzi o tate ye atchona* **Mtchona**."

Mzikamanda

(a red or black day mask from Mua)

Themes 1) Importance of family ties; 2) Responsibility of family heads; 3) Protection against evil spells & wishes; 4) Assisting transition of deceased to spirit world

Etymology Mzikamanda means, 'the person who designates the grave site'.

This large mask portrays the head of an unknown wild and fearsome animal. It has an elongated muzzle and a large mouth showing rows of protruding teeth. Multiple red and black striped horns of different sizes protrude from his head close to the erect ears. Sometimes a long beard hangs from the chin. The mask is predominantly red stressing the prohibition of sex around the time of a burial. The mask's headgear is made of skins of various types. The dancer wears a tatter suit. He carries a small ceremonial axe and a whip. He dances with vigour, swerving his feet one leg at a time and chases the women. The male choir calls, " *The person who designates the grave site.*" [1]

This character traditionally performed at the time of funerals. **Mzikamanda** represents the head of the family who designates the site where the grave should be dug. Soon after the chief has opened the gate of the graveyard, the family head takes a tool to mark the spot with the first stroke.

Mzikamanda takes his origin in the Salima District and is rather recent to the Mua area. **Mzikamanda** personifies the authority of the head of the family. He has the duty to care for each member of the family group during their lifetime and to grant them a burial site. The longer horns of the mask act as a safe carriage taking the corpse to his last home. The shorter horns demonstrate protection for the grave and the deceased against witchcraft. The deceased is in good hands on his journey to the spirit world since his own family head and the ancestors he represents escort him. **Mzikamanda**'s involvement at funerals reminds family heads of their duty as guardians of the *mwambo* and of the family.

[1] " *Tate (2×) a* **Mzikamanda** *(2×) a* **Mzikamanda**."

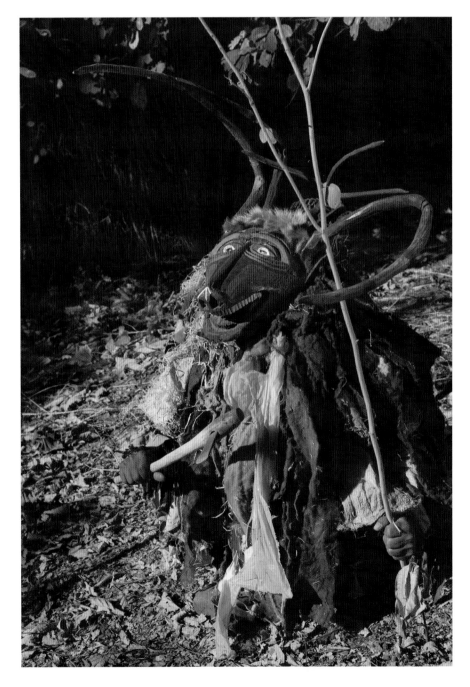

Namkwanya

(a banana headcover from the Mua area)

Themes 1) Respect for/wisdom from the elders; 2) Decency & good manners; 3) Marriage, preparation & instructions; 4) Compassion of ancestors for the living

Etymology Namkwanya derives from *kukanya*, 'to knead'. In this context it is applied to the correction of character of girls at the time of their initiation and their subsequent wedding night.

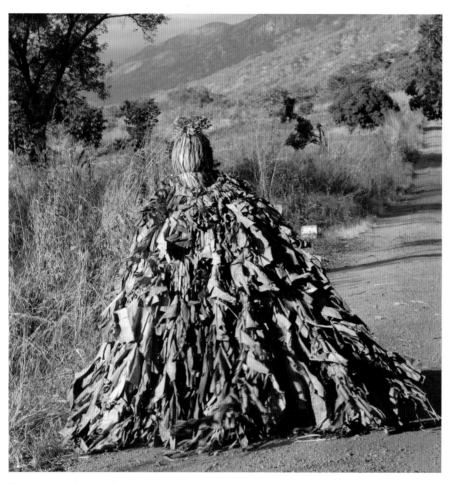

Namkwanya is one of the ancient characters of *gule wamkulu*. It is mentioned in the Chilembwe entry as one of the triad of characters, together with Chimbebe, that attended the enthronement of *Mwali*, the spirit wife of Mankhamba. It is difficult today to relate that Namkwanya structure to the character described here. Somehow the Namkwanya of today does not match the splendour of the other two. The phallic shape of Namkwanya does, however, suggest a close link with the fertility invested in *Mwali* at the time of her enthronement.

The Namkwanya of today is a night or day mask of very plain appearance. The dancer's head is hidden under a headcover made of dry banana leaves tied at the apex and smeared with black mud. The costume also consists of a large quantity of dry banana leaves, attached at the neck and extending to the ground, thus concealing the entire body. The arms of the dancer are hidden under the leaves. Namkwanya's general shape is that of a large cone, narrow at the head, and widening to a metre plus at ground level. It appears as a ghost that resembles a stylised phallus.

Namkwanya usually appears in a group of eight or nine. They invade the *bwalo* like a whirlwind at a variety of rituals, though in the past they had a predilection for funerals and initiation ceremonies. They seem to have had a particular function in correcting the girl initiates' behaviour. Today, they sweep the arena, spinning and careering about with no apparent sense of direction. They disperse the crowd and create total chaos. People run to avoid being in Namkwanya's path. Though Namkwanya's performance provides great entertainment for all, their unpredictable moves across the *bwalo* cause apprehension and

fear. The drummers beat a rhythm proper to them and the male choir sings a variety of songs: *"Namkwanya, Namkwanya, oh!"*[1] or *"Namkwanya, stop being rude to your mother* (or wife)*, Namkwanya!"*[2] or *"Today you will learn the hard way! your husband will not sleep! you will meet his sharpened knife* (his penis)*."*[3] To this song the women answer: *"This little initiate is so proud, she is rude to her own mother; she is impudent, that little deaf thing!"*[4] All the songs address a person who has not yet grown up and has no manners. The women laud good behaviour with, *"Here is a person who genuflects* (shows good manners)*."*[5] The character personifies the right behaviour recommended for the initiates.

Namkwanya portrays a compassionate spirit that teaches good manners and politeness. Young girls undergoing puberty have to be moulded to obedience and politeness. Their parents request the service of Namkwanya to inculcate such values. The final test will come when they meet their husbands who have been 'sharpening their knives'. There, they will be forced to submit and obey. In other ritual contexts outside puberty, Namkwanya fulfils a similar function for adults who pretend to be mature but still behave like children. They get involved in quarrels, fights or slander because they have forgotten the advice from their youth. They show disrespect toward authority or towards people who are senior to them, such as the family head or the village headman. If they are married into someone else's family or reside at someone else's village, they are sent away because of their lack of manners.

Though Namkwanya is involved in castigation, his real function is to demonstrate the compassion of the spirit world for the deceased and his family members left behind. The fact that Namkwanya appears in a group emphasises his solidarity with the living community and his eagerness to teach good behaviour and politeness.

[1] *"E Namkwanya e (2×) Namkwanya."*
[2] *"Namkwanya uleke kutukwana amako Namkwanya."*
[3] *"Kwanya lero kwanya, amuna sagona kwadza mnolera."*
[4] *"Kanamwali aka kunyada, katukwanatukwana amake, kali n'mwano, ikoka kanambulenje."*
[5] *"Suyu akutewa."*

Ndalama n'ndolo

(a red day mask from the Mua area)

Themes 1) Labour migration; 2) Dangers of modernity; 3) 'To be' versus 'to have'; 4) Pride/arrogance; 5) Faithfulness; 6) Luring appearances (beware of)

Etymology Ndolo means, 'earrings', baubles of no value in this context, and **ndalama** means, 'money'. **Ndalama n'ndolo** can be interpreted then as, 'Mr Worthless Money'.

Ndalama n'ndolo portrays a man of counterfeit wealth. The red mask reflects a stranger, someone who neglected the teachings of the ancestors, thus losing his Chewa identity. The headgear of the mask is made of rags or fertiliser bag laces. The head is crowned with numerous horns made of long, curved forked branches painted red and striped in white or black. The branches spring from a skin that hangs behind the mask. These form a hat of sorts, thought to be fashionable in South Africa, and expressing status and wealth. The face of the stranger is middle aged with a few wrinkles on his forehead. His eyes are bright and arrogant. Normally they are made from silver paper or pieces of mirror. His nose is straight and the cheeks are angular like those of a European. He is smiling . A heavy moustache covers his top lip and a goatee adorns his square chin. **Ndalama n'ndolo** wears a collar, a kilt, leglets and armlets made of fertiliser bag laces. He carries a whip, rattle and a club that emphasise his maleness and express the power of castigation of the spirit world. In the arena he manifests pride, self-righteousness and promiscuity. He roams around the *bwalo* gathering the womenfolk like a playboy looking for his next conquest. He tries to impress the women with his appearance and wealth. He swerves his feet alternately with great energy while the men sing, *"Mr Worthless Money, it is like he is minting it. This is the way I treat him, Mr Worthless Money!"* [1]

This character performs at any type of ritual. It originated in the first or second decade of the 20th century when many young people went outside the country to seek employment in southern Africa. They returned with money, wealth and status. The Chewa greeted the money economy with ambivalence since it offered a challenge to traditional life and the hierarchy of the village.

Horns are usually equated with power and authority. For this character they are the symbol of wealth and money. They spring in all directions from the apex of his head to show that our young man does not lack anything. **Ndalama n'ndolo** displays his horns like a crown. He tries hard to impress and to seduce. He is the new image of success and happiness. Traditional

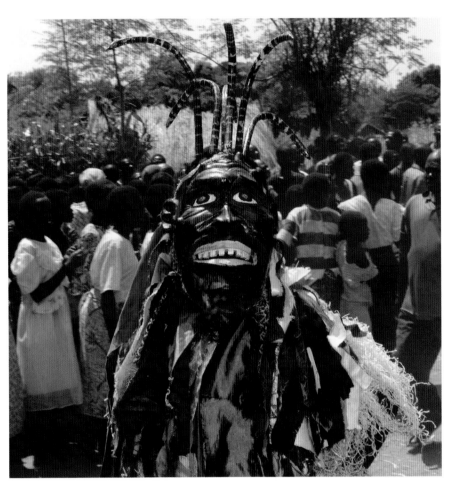

wisdom unmasks this lie and **Ndalama n'ndolo** teaches that, in the eyes of their Chewa forefathers, it is better 'to be' than 'to have'. He emphasises that you should not base your marriage only on the appearance of the partner. He discourages men from the habit of frequent marriages. Such marriages often lead to poverty and misery for innocent wives and children. Young women should remain faithful to their husbands and resist the temptation of strangers who come with wealth and worthless possessions. They are quickly gone, like cheap earrings that do not last. Young women should value their husbands for the qualities of the heart. As far as work is concerned, people of the village value a steady job with a regular income within the country more than higher paid work outside. The Chewa proverb says, *"Chikomekome cha nkuyu, mkati muli nyerere – Oh the beauty of the fig but inside it is full of ants."*

[1] *"Ndalama n'ndolo aee ndalama achita yosula, ndim'tere ae **Ndalama n'ndolo**."*

Ng'ombe
(a day structure from the Mua area)

Themes 1) Responsible use of inheritance; 2) Greed; 3) Unity & harmony; 4) Chewa – Ngoni relations

Etymology Ng'ombe is Chichewa for cow or bull.

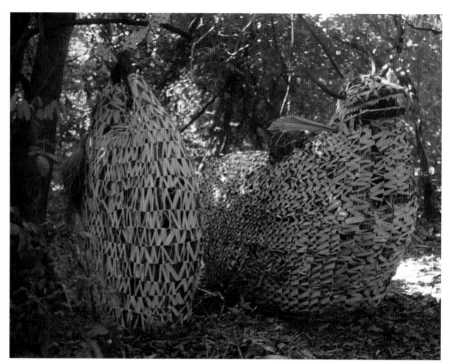

(*Left*) Kasiya maliro (*right*) **Ng'ombe**
Claude Boucher, Mlongoti Village, 4 December 1993

The Ngoni consider cattle a form of permanent wealth. Cows were used as a bride price in the Ngoni patrilineal marriage. Cattle were slaughtered at funerals and transferred as part of the inheritance at the end of the mourning period. The Chewa originally owned goats but not cattle. The fact that cattle made their way into *gule wamkulu* was not without stressing Chewa resistance to their Ngoni neighbours.

The **Ng'ombe** structure performs at day or night events for burial and commemoration ceremonies. The construction is made of bamboo and is two to three metres long and over a metre high at the shoulder. It imitates the shape of a cow with long horns. The back carries a big hump like that of a zebu. The long tail can swing in different directions. The day version is made of maize husks; the night version of palm leaves woven in a zigzag pattern. The overall colour is very pale or white.

Two dancers activate the cow structure. It races around the *bwalo* at high speed and chases the crowd like a fearsome bull. It scratches the dust with its front feet. It swishes its tail when it starts moving backwards. The fury of the animal is described in one of the men's songs: *"My husband,*

come out and see the bellowing wild beast. It has pulled down the fence, the bull, the bellowing bull." [1] The song refers to the pulling down of the deceased's house at the time of the last shaving rite. Soon after this ceremony, the deceased's possessions will be distributed among the relatives.

Several other songs are focused on the ceremony of inheritance. *"Joy at the sharing of the inheritance! Is it believable, Jere? Some have bought cattle, cattle, cattle."* [2] The next song says, *"Cows, my cows are disappearing! Some will turn green, Sir* (the colour of the money after they were sold). *What will I do in the grave* (without) *cows, my cows."* [3] Both songs refer to an Ngoni who is about to die. Though he realises that he cannot take his wealth with him, he is afraid to leave his cattle to his relatives. He has saved all his life to build a herd and he is worried about who will inherit them. He thinks they will sell them and spend the money carelessly.

The structure of the cow was created in order to reveal those who spend the family inheritance quickly without showing the same care that the owner did. This is a form of disrespect for the dead and a sign of immaturity in dealing with wealth. One should not waste what another has

painstakingly acquired. The structure instructs those who are granted an inheritance to manage it conscientiously. The fury of the structure expresses the discontent of the dead over the fact that their heritage is being wasted.

The sharing of wealth at the end of the funeral rites is often an occasion for dissension and quarrels among the Ngoni and the Chewa. Members of the family group often fight over the inheritance, leaving the family irrevocably divided. The wife and the children of the deceased may be left without support as the other close relatives grab everything. The songs manifest a certain cynicism with regard to the wealth that one has painfully accumulated only to be wasted by members of the extended family. The structure satirises the Ngoni because they accumulate cows that will become the cause of division and quarrels after the sharing of the inheritance. This cynicism is expressed in the women's song that is sung as a reply to those of the men. They sing, *"Chief Kalindiza keeps cows,* (particularly) *a white one! Do you think you can keep one too? A white cow!"* [4] This is referring to the colour of the **Ng'ombe** structure. The Ngoni may have cows that bring division but the Chewa have only one white cow (the structure) that brings them together in joy. It is better to be unified in poverty than to be rich and divided.

[1] *"Amuna anga taturukani dzaoneni chilombo chalalata, chachola mpanda* **Ng'ombe**, **Ng'ombe** *yalalata."*
[2] *"Yerere ku masiye toto de! A Jere anagula* **Ng'ombe**, **Ng'ombe**, **Ng'ombe**.*"*
[3] *"***Ng'ombe**, **Ng'ombe** *e tate ziyera* **Ng'ombe**! *Ya grini bwana tate tate! Ku manda n'katani* **Ng'ombe**, **Ng'ombe**?*"*
[4] *"A Kalindiza adaweta* **Ng'ombe**, **Ng'ombe**, **Ng'ombe** *yoyera! Monga inu kuweta* **Ng'ombe** *yoyera?"*

Njinga yabwera

(a night structure from the Mua area)

Themes 1) Respect for/wisdom from the elders; 2) Prestige; 3) Pride/arrogance; 4) Dangers of modernity

Etymology Njinga yabwera means, 'The bicycle has come.'

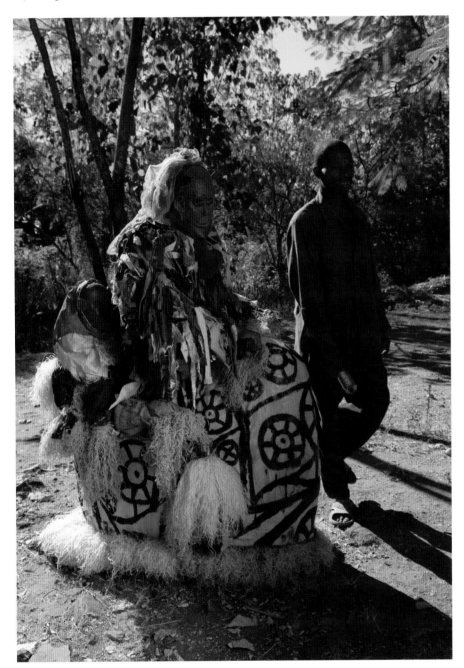

out of the way. The crowd becomes wild with excitement. People run in different directions while the drums beat with full vigour. In the background, the men sing, *"The bicycle has come! The bicycle has come!"*[1] The women answer, *"The bicycle has left me behind. I thought of riding it but it left me behind."*[2] The Golomoti women answer: *"The bicycle, the bicycle, this bicycle, let us climb on. Oh, let us climb on, the bicycle!"*[3]

This structure was introduced in the Mua area around the 1970s, coming from Salima district. History shows that bicycles were introduced in Malawi much earlier. The first bicycle with a large front wheel was introduced in Nyasaland by 1883. From the 1920s on, many Malawians went to work in South Africa. This structure describes their return, after many years of absence, with the precious object. The young men who came back with the 'treasure' were proud and ostentatiously showed their sense of achievement and superiority. Their experience in riding was limited. Moreover, bravado enticed them to speed and ride dangerously. Consequently, pedestrians were hit and damage was done. The local population interpreted such accidents as the result of the riders' pride and ostentation (*kunyada*). The early perception of people was that a bicycle had a life of its own. A young Yao, Amini Bin Saidi, is quoted in 1914: "I look after my bicycle very well indeed but, in the end, he hurt me very much" (Bin Saidi, 1936). The young men who owned the bikes were endowed with powers beyond their status and age. Their careless driving and selfish pride needed to be curtailed and corrected. The song of the women points to the greed of their husbands who do not want to take them for a ride. The *Nyau* members created **Njinga yabwera** in order to inculcate a sense of respect for the elders.

[1] *"Njinga yabwera tate! Njinga yabwera tate! Njinga yabwera!"*
[2] *"Njinga yandisiya, Njinga yandisiya, ndimati ndikwere nawo Njinga, Njinga yandisiya!"*
[3] *"Njinga, Njinga, Njinga iyo, tikwere nawo. Oh! tikwere nawo, Njinga!"*

This structure portrays a bicycle or motorcycle. It is used at day or night ceremonies. The bike is made from a large woven basket (a metre high) within which stands the dancer Kapoli whose head, torso and arms emerge. Wheels (two, three or four) and handles are attached to the basket to give the appearance of a bicycle or motorcycle. A woven fringe made of fibres attached to the base of the basket hides the feet of the dancer. Artificial legs dangle over the side of the basket, giving the appearance of the dancer straddling the vehicle. Sometimes **Njinga yabwera** carries a 'passenger' behind Kapoli: a dummy made of grass and dressed with clothing. The dancer holds the handles and runs forwards and backwards. The bicycle goes around the *bwalo* at full speed, reverses and changes direction, hitting those spectators who are slow to get

Njovu (and Ajere)

(a day structure and accompanying masks from the Mua area)

Themes 1) Father Ancestor; 2) Guardianship of the *mwambo*; 3) Fertility; 4) Sexual taboos (*mdulo*); 5) Redeeming (*kulongosola*); 6) Communion with the ancestors; 7) Marriage, preparation & instructions; 8) Sharing of beer; 9) Assisting transition of deceased to spirit world; 10) Banda – Phiri relations; 11) Chewa identity; 12) Role & powers of the chief

Etymology Njovu is the Chewa word for elephant.
Ajere portrays an elephant hunter of the past. It is also a clan name associated with the Malawi (Malavi) or Phiri people.

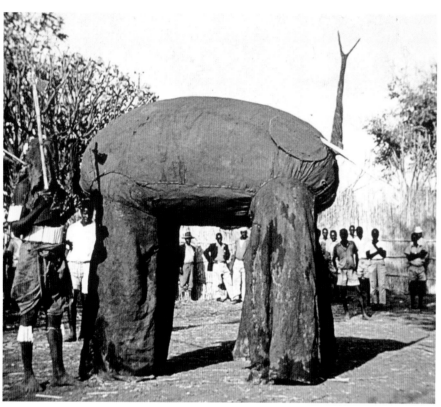

Noel Salaun, Lilongwe, 1960s

After Kasiya maliro, the elephant is the most important structure of *gule*. It represents the father ancestor and the chief. Kasiya maliro, the mother ancestress, is the origin of all male and female members of the community including the chief (elephant). However, **Njovu** is the greatest structure in terms of authority. Within the hierarchy of structures, **Njovu** is the equivalent of Chadzunda within the pantheon of spirit masks.

The elephant structure is common throughout Chewa country. It is ancient and possibly originates from the Batwa culture. It performs for initiation ceremonies, for enthronements, funerals and commemoration rites of chiefs or other dignitaries such as sub-chiefs or mistresses of initiation. These ceremonies are often combined with puberty rites to highlight their importance and their role with regard to fertility.

The structure is constructed at a special

dambwe, away from junior initiates. Only senior people who have been through the highest degree of initiation construct it. There can be a night and a day version showing slight variations in construction. The structure consists of a bamboo frame (two metres long and one metre high) animated by four senior dancers. The body is an oval shape. The frame is thatched with grass. The grass cover is smeared with red or black clay, depending on the region. At times the frame is covered with jute that is also smeared with clay and it is common today to see **Njovu** made of canvas over a frame. The front part of the egg shaped structure is designed to be the head of the animal. A long flexible trunk, two straight tusks, two large ears, a nose (as well as the trunk), a mouth and eyes are added. The rump is adorned with a short mobile tail.

The trunk is made traditionally of bamboo rings tied together with strings and covered with some grass or jute smeared

with mud. A curved stick is attached inside the rings allowing one of the dancers to activate the trunk, moving it in different directions, stretching it or shrinking it back inside the head. The snout of the trunk is v-shaped, forming two lips. The elephant trunk symbolises the male organ and the power of fostering life as father and chief. Below the trunk, two tusks protrude forward. They are carved of wood and covered with jute (painted white) or slippery stems of the banana plant. These also symbolise the male organ and the two lips of the vagina. The ears are made of two large bamboo rings woven with strings and palm leaves in a zig-zag pattern or covered with sack or alternatively are made of old winnowing baskets smeared with mud. The nose's angular shape resembles a human one. The mouth is a small opening curved in a smile. The eyes are made of maize husks and the iris is formed by a little bit of black resin. The tail is made of small bundles of mud-smeared grass tied together with a stick used for activating it. The end of the tail resembles a small broom.

The four legs (about 130 centimetres long) of the pachyderm are made of bamboo rings linked together with strings. The legs are covered with jute or grass (these days, often canvas) and smeared with mud. Each leg is wide enough to accommodate one dancer, allowing him to walk and to bend.

In some *mizinda*, the elephant appears in tones of black or red. Besides expressing fertility and prohibition these two colours focus on Banda or Malawi identity. The elephant from the Banda period would have been black and focused on the power of fertility of their spirit wives and headmen. The red elephant could have expressed the Banda protest against the Malawi rulers (*Kalongas*) and their imposition of tributes (in the form of ivory tusks).

Two other characters called the **Ajere** (the elephant hunters of the past) usually accompany **Njovu**. They sing, *"The animal has gone to the hills, it escapes the hunters."*[1] The Jere clan has been identified historically with the Malawi and the Phiri clan. Perhaps the presence of the **Ajere** next to the elephant is a political statement about the effort

of the Malawi at centralising their state and controlling the Banda. The elephant is the highest symbol representing the village headmen and their link with fertility. In the process of reorganising within the Malawi hierarchical system, many Banda were forced to operate under the authority of Malawi rulers. Their headmen often played the role of minor chiefs and assistants (*nyakwawa*) under these important chiefs. Today the **Ajere** are seen as the messengers of the elephant. Symbolically, they are compared to testicles and the power they embody with regard to the penis (the trunk of the elephant) that is seen as a figurehead. **Njovu** enters the *bwalo* with its trunk moving in all directions. The flaccid organ relies on the power generated by the testicles to stiffen and transmit the sperm.

The two **Ajere** wear a very short kilt made of palm leaves (for the night) or a short fertiliser laces kilt (for the day). Their arms and legs are striped with bands of palm leaves reflecting the light at night. Their heads are covered (for the night performance) with a headgear made of the same palm material. For the day rituals they wear small red masks that have bald heads like those of wise men. They carry small ceremonial axes or a mini whip, a mock symbol of their diminished authority. The two **Ajere** dancers accompany the elephant, one walking in front, the other at the back. They are like the eyes, the strength and the messengers of the animal. They do not dance but keep jumping.

The elephant enters the *bwalo* majestically. The animal roams around the ground slowly, dangling its tail and rotating its trunk. Inside each leg, the dancers take very small steps or jump in unison. The performers are always senior men who must take the rules of sexual abstinence very seriously since the animal is directly connected with fertility and the chief. The obvious male sexual symbols of the trunk and tusks emphasise the headman as the archetypal father, father of children and father of the tribe. The performance of the beast in the arena and his dancing style reveal the father and the chief's main duties with regard to fertility. Conferring life for the Chewa presupposes 'tying' and 'untying'. Both sequences are part of the same process by which fertility is accumulated, stored up and then released. This is also made obvious in the red or black colouring of the animal stressing either prohibition or release of fertility.

At the night vigil of the girls' initiation ceremony, the animal roams slowly around the arena with a sleeping mat on its back to show that the husband or the chief is tied by sexual taboos. A little later the mat is taken from its back and spread on the ground. The elephant moves onto the mat and the dancers kneel so the legs are not visible. The elephant sways from side to side showing the period of abstinence is over. At this point the blindfolded initiates are dragged near the elephant one by one. With the help of a leader they are made to touch one of the tusks briefly. The frightened girls run away quickly as someone beats the ground simulating they are going to be beaten. During this episode, both men and women sing the following song, *"The elephant* (4 times) *is without tusks, without tusks, without tusks here. The initiates touch the tusk! It* (he) *is without tusks."*[2] Or, *"E, e, where there is water, there is the elephant, there is meat/game* (sex). *If there is meat/game there could also be an old elephant without tusks."*[3] The songs seem to express a contradiction or a conflict. The elephant *"is without tusks"* refers to the fact that the chief is practising sexual taboos and cannot have any sexual activity. The phrase *"the initiates touch the tusk"* implies the girls are having sex when the chief cannot. According to the Chewa moral code this is a crime. Anyone who bypasses these rules of solidarity is risking the life of the chief (*mdulo*). Such forbidden sex is interpreted as 'cutting' the chief and killing him. One of the songs of **Ajere** is revealing, *"Nobody told me that there is a child's funeral."*[4]

The songs are a warning to the initiates (or to any of the villagers) that sexual activity is not left to the discretion and pleasure of the individual but has to be regulated by the directives of the group, of which the chief is the head. It is the duty of both the chief and the father to 'redeem' (*kulongosola*) a child after birth or initiation. The head of the village has to 'redeem the village' every time one of the initiates of his village has undergone her 'second birth'. During the initiation ceremony, the chief and his wife, the parents of the initiates and their tutors are submissive to such rules. These rules are lifted in due time when these actors perform ritual intercourse unlocking the fertility of their children or putting them back into the life stream of the tribe. Both the song and the ritual of touching the tusks express this.

After completing this dramatic ritual, the girls retire to the house of seclusion (*tsimba*) and the *namkungwi* explains the symbolic meaning of this gesture. They are told that the elephant's anatomy represents that of their future husbands. Then she unveils the *mwambo* of family life for them. They are told before intercourse they must caress and excite their husbands' sexual organs in order to provoke an erection and facilitate intercourse. Through this manipulation the woman who is deprived of sex because her husband goes to bed early can claim her right. She learns to wake him by touching his genitals and requesting him to comply with her demand. The handling of the tusk is also a lesson to the husband. He also has to manipulate the sexual organs of his wife to stimulate excitement and prepare her to reach orgasm. The tusks have a phallic shape and are made with a white, smooth and slippery material to suggest these inner organs. Their whiteness symbolises the end of menstruation. It is the appropriate time for caressing and handling (*kukuna*) these organs. Such a practice is discouraged during menstruation. It may lead to sexual relations that would endanger the life of the husband or the life of third persons like the chief, parents, or children. The handling of the tusks teaches the initiates the rules of hygiene. Through this gesture they are reminded that the wife has to wipe off her husband's organ after intercourse. The handling of the tusks is an essential part of any girl's puberty rite even if it is performed during a funeral context. If a *mzinda* in which this event is to take place does not have a **Njovu** of its own, the structure will be replaced by another type called the Mdondo (refer to that entry) that will convey the same meaning. Despite the fact that this structure looks like the waggon of a train, it projects a long phallic organ at the apex of the head that resembles the trunk.

This ritual is part of the funeral or commemoration ceremonies for a chief or someone else of high rank. Through this rite, the role of the chief as giver of fertility is remembered and his high position acknowl-

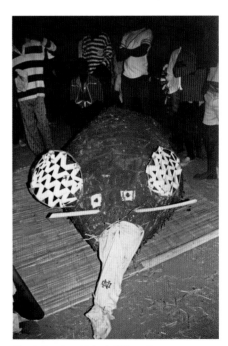

Claude Boucher, Mchanja Village, August 1993

edged, particularly his connection to the spirit world. As soon as the coffin is taken out of the funeral house and lain on the mat the elephant structure appears. It moves in a circle around the coffin and the initiates are requested to come forward and touch the tusks. *"Nobody told me that there is a child's funeral"* is sung to remind the girls (and the community at large) that though they are informed of sexual matters no one in the village should consider getting involved in sex. This behaviour would cut the deceased chief and compromise his transition into the spirit world. After this brief episode, the elephant, representing the father and the chief ancestor, leads the deceased and the mourners to the graveyard. On the occasion of a native authority's or king's funeral, each neighbouring chief sends his own elephant to mark the event. They all dance together and follow one another to the cemetery then disappear back to the *dambwe*. In the past the elephant structure 'swallowed the corpse and defecated it' at the graveyard …the four dancers inside had to hold and carry the corpse to the graveyard. At other times, the dead body was tied to the back of the structure and carried (as if on a bier) to the cemetery. The fact that the elephant led the high ranking deceased to the grave stressed that the king of the animals represents the father ancestor and the aristocratic spirits of the Chewa tribes.

During subsequent rites of commemorations, the elephant is commissioned by the spirits to survey the beer. It sends Kanswala and Mdondo to make sure that it is shared between the living and the dead. Early in the morning the animals set themselves to go to every house where beer has been brewed while the men sing, *"Let us go from house to house. The elephant has sent us for beer. Let us look around for beer."* [5] After **Njovu** appears, pots of beer are gathered from each home and brought out to the *bwalo* for people to drink together expressing their solidarity with the ancestors. Through this rite, the elephant is perceived as the centre of communion and reconciliation between the village and the spirit world.

Besides teaching the *mwambo* and guarding its observance in the name of the ancestors, the chief protects the peace and harmony within the community and with the ancestral world that guards over it. The involvement of the elephant in the dance reveals it as the father image who is the progenitor of every Chewa. It is a symbol of authority representing first the Banda headmen and then the Kalonga under the Malawi system of ruling his tributary kings and headmen. The elephant emphasises the spiritual dimension of authority as the representative of the ancestors, particularly the territorial spirits of the dead chiefs. These are also the founders of the various chieftainships and villages, besides being father ancestors. They look after the fertility and the well-being of their people. They achieve this by transmitting and keeping the *mwambo* in the name of those who have installed them into their positions of authority, their ancestors. It is in the ancestors' name that they have to guard over the peace and the harmony within their own territory bringing about reconciliation among their members. Furthermore, the chiefs have to maintain the communion with the ancestors by providing them with the beer of placation and their favourite entertainment, the *gule wamkulu* rituals in which the elephant plays the central role. There, **Njovu** teaches the *mwambo*, particularly that of the respect for authority and the secret for optimum conditions of fertility within married life. This is summed up in the focus on tying and untying: *kudika* (to wait) and *kulongosola* (to redeem). In this regard, the sexual taboos enforced by the *mdulo* are the core of this teaching. These have to be observed by all adult members of the community. As the heads of villages or territories and the representatives of the spirit world, the chiefs have to guide the way in these matters and beg the help and benevolence of the spiritual forces. Any breach of these taboos can compromise maturing and the transformation of their deceased leaders on their way to the spirit world. At the time of death, the elephant structure acts as the father ancestor or the chiefly spirit who brings his children or fellow villagers into the communion of past generations and God Himself.

[1] *"Nyama yakwera mtunda, yasiya alenje."*
[2] *"Kuli nyungwa yerere nyungwa kuli nyungwa kuno! Namwali agwire nyanga, kuli nyungwa."* [*Nyungwa* means, 'elephant with no tusks' (Hetherwick 1951: 428).]
[3] *"E ee pali chuwa chuwa pali* **Njovu** *pali nyama, pali nyungwa."*
[4] *"Palibe ondiuza e (2×) maliro a mwana."*
[5] *"Tikayendere, a* **Njovu** *adawatuma akayendere mowa."*

Pinimbira

(a night headcover from the Mua area)

Themes 1) Respect for the ancestors; 2) Protection against evil spells & wishes; 3) Care of property; 4) Discretion in keeping secrets; 5) Batwa – Bantu relations

Etymology Pinimbira means, 'to be small' or 'reduced in size'. This may refer to the association of the Akafula/Batwa people, indigenous inhabitants of what is now Malawi, with the land.

Pinimbira masks are an ancient element of *gule*. They are used by a group of members of *Nyau*, perhaps as many as 20-30 on one occasion. Like a whirlwind, they enter the village at night during the preparation of the beer at the time of commemoration ceremonies for funerals, enthronement of chiefs and *dambule* (remembrance of the dead). They wear headcovers of sisal, banana leaves, sack cloth, or other materials, often covered with mud. The rest of their costume is loincloths, and their bodies are covered in mud. They invade the village from the graveyard, hunching low in a crouched position as they run. They clap hands and generally making a hubbub. They move from house to house. If the residents are not asleep, they collect pestles, mortars, firewood, pots, bundles of grass, and so forth, and barricade the house door with these items. Finally, they return to the graveyard.

The black faceless headcovers and bodies smeared with mud, and the posture of bending forwards to lower their height, seem to recall the presence of spirits older than the Bantu. One might think of the first inhabitants of the land, the Batwa. The Batwa were small in stature and had dark complexions, but also had a reputation as fearsome antagonists. Although the Bantu progressively occupied the land, the Batwa were perceived as the original owners. When the first Bantu farmers began cultivating their crops, they had to invoke the spirits of the land, which had occupied this place since time immemorial. With the arrival of the Banda clans, the Bantu took over the Batwa shrines and their sacred drum, the *mbiriwiri*. Eventually the Batwa disappeared as a recognisable cultural entity.

The **Pinimbira** represent the passage of the spirits through the village inspiring awe and forbidding any one to look out at them. It is tempting to imagine these spirits to be

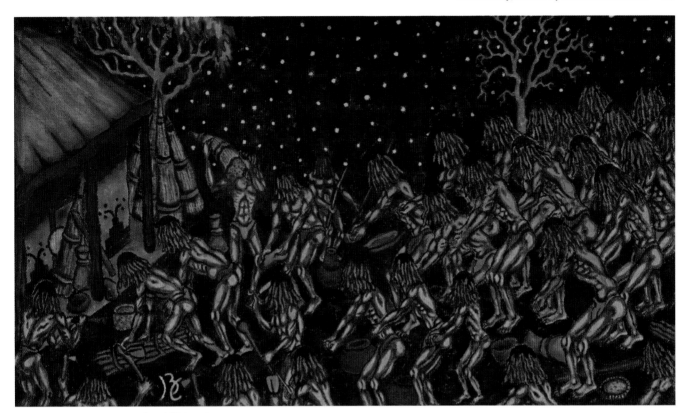

Painting by Claude Boucher and Joseph Kadzombe, 2009

those that predate the Bantu, as the original protective spirits of the land. They continue through time to manifest their concern for the living community. By the same token, they teach care for property, the art of discretion, and keeping secrets in matters of *gule wamkulu* and marital life. They also offer protection against witches and evil spirits during the rituals.

Pombo m'limire or Pombo kuwale

(an orange day mask from the Dedza area)

Themes 1) Respect for/wisdom from the elders; 2) Importance of family ties; 3) Greed

Etymology **Pombo** refers to a taproot of a tree, meaning also the oldest person in a community.
Pombo m'limire means, 'to cultivate (the field) of the old man'.
Pombo kuwale means, 'to make the old man shine'.

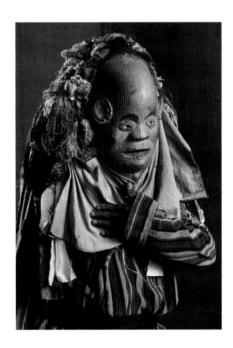

The character of **Pombo** appears in the Dedza area in a number of versions in addition to the two described here. Another is Pombo kulipire, 'to pay for the old man'. All of the versions are ancient. **Pombo m'limire** was introduced in the Lake Malawi plain around the 1940s, after a renowned medicine man of Dedza, Mr Kachipapa, came to settle in Mua in 1939.

The masks of **Pombo** are always orange. Their colour portrays an old man, whose skin pigmentation has begun to change to an ochre colour. The character of advanced age is always depicted with a bald head, painted sideburns and hair moustache, and sometimes with wrinkles on the forehead. He displays a cowlick, at the apex of his head. The cowlick is made of cow-tail hair for **Pombo m'limire** and chicken feathers for **Pombo kuwale**. This is to stress that he is the progenitor of the group. The expression of the eyes and mouth vary. **Pombo m'limire**'s eyes show signs of cataracts or blindness. His mouth is caved in, toothless and bordered with deep jowls. **Pombo kuwale**'s eyes are slanted and deceitful and his mouth is scornful with teeth on the top jaw. The features of **Pombo kuwale** suggest that the character is cunning and somehow dishonest. The characters of **Pombo** often have salient cheeks, a pronounced chin and a protruding Adam's apple. Their headgears are always made of rags. Both characters wear tattered suits, a wide belt, with a heavy army-coat or smock over the top. Both carry a medicine tail.

They perform at funeral and commemoration rites. Both display tremendous energy in the arena by swerving their feet and flapping their medicine tails. The men sing for each of them a specific song: *"Cultivate the field of the old man"* [1] (for **m'limire**) and *"Give these expensive clothes to the worn out* (to the old man)*"* [2] (for **kuwale**).

The word *pombo* refers to the taproot of a big tree. The most senior person (male or female) of a family group is seen as the root (*phata*) of the group and is highly respected owing to his age and position. The children and the grandchildren of such elders have to show their respect and devotion, by attending to their needs (water, food and clothing). The songs suggest that their senility is no reason for economising and providing them with cheap quality or secondhand clothes. Even if they cannot wash and look after themselves properly, one has to take good care of them because they are

the taproot of the family. The ancestors' morality requires that their descendants provide such respect and filial affection.

The character of **Pombo** stresses this duty for younger generations with regards to the elder's total needs. The song of **Pombo m'limire** emphasises cultivating his/her garden owing to the elder's lack of strength to hoe. Such piety is rewarded by the ancestors and is understood as a guarantee that they also will be provided for by their descendants when they grow old.

Pombo kuwale is addressing a slightly more specific situation. The context of his song refers to a funeral rite of an elder. The song is advice to an official undertaker (*mdzukulu*) who does not show due respect on an occasion of an elder's funeral. Traditionally an elder goes into the grave with his possessions. To keep some of his belongings for oneself or to give them to others (children and grandchildren) was

seen as bad luck and as a manifestation of greed. **Pombo kuwale** stresses it is wrong for an undertaker to dress the dead body of an elder with rags in order to keep the elder's possessions for himself or for a relative. This behaviour shows disrespect for the dead and lack of filial piety towards one's own ancestors. One must care for them while they are still with us. One has to pay them due respect when they leave us for the spiritual world. They must be remembered once they have settled with the ancestors, by listening to their advice and teachings. Greed is disgraceful, especially when at the expense of people who warrant such a high status and dignity.

[1] *"**Pombo** m'limire, **Pombo** (2×)."*
[2] *"Nsalu ya mtengo, n'kuipatsa kwaule aye ee kuipatsa kwaule koma a **Pombo**."*

Sitiona mvula

(a night structure from the Mua area)

Themes 1) Respect for parents; 2) Respect for the ancestors; 3) Faithfulness to the *mwambo*; 4) Drought as a consequence of sin

Etymology Sitiona mvula means, 'We will not see the rains (there will be drought this year).' The name can also be spelt as Simuona, meaning, 'You will not see the rains.'

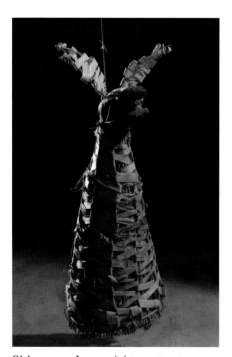

Sitiona mvula are miniature structures, 30 centimetres tall, in the form of inverted cones. They are made with bamboo and palm leaves stretched on a frame. The apex ends with a tuft of palm leaves like a small broom, or sometimes an animal head made of grass projecting two long ears like those

of the hare. These puppet-like creatures represent ghosts from the graveyard, angry ancestors.

Two young men, standing apart from each other, play rattles (*silambe*) and move a string between them to activate the ministructures, following the rhythm of the drums. The puppets become animated and move and dance freely in the air 50 centimetres above the ground. They dance sideways, backwards and forwards depending on the position taken by the two shaker players. These miniature structures can only be shown during night performances. Darkness conceals their mechanism and reveals the magical reflection of the palm leaf's patterns in motion. While the structures dance, the men sing, *"Children of God, Children of God, we will not see the rains* (this year). *You have offended God, you have offended God. We will not see the rains."* [1]

This type of ministructure is seldom seen today. They were common at the time of *dambule* or funeral and commemoration ceremonies of important people. Their small size and their very name spell out a curse. The angry spirits voice their discontent with regard to the deeds of their children, the villagers. Their miniature representation symbolises how children attach less importance to the advice of their

parents and the ancestors. The Chewa proverb says, *"Mako ndi mako usamuone kuchepa mwendo. – Your parents are your parents even if they have thin legs,"* meaning they are your parents in spite of their defects. Their wisdom is superior to that of their children. These structures move mysteriously. Their motion is regarded as magical and clever. Only parents and ancestors can manifest such wisdom and cleverness. The failure of their children to follow the *mwambo*, to obey their advice, has brought a severe curse upon them. The Chewa believe that a person who does not listen and obey does not receive blessings and bad luck follows them. Drought in this context is seen as a consequence of evil deeds, such as disrespect for the sexual taboos or for the ancestors by not keeping their memory alive. Drought could be seen as an offence to God Himself for not caring for the rain shrine or its reconstruction. Another Chewa proverb summarises **Sitiona mvula**'s message very well: *"Ali ndi mayi (Tate) adadala, ayenda modzitama – Those who have a mother-father are lucky, they can walk with pride or without fear."*

[1] *"Ana a Chauta ae ae ana a Chauta, **Sitiona mvula**, mwatukwana Chauta ede ede mwatukwana Chauta, **Sitiona mvula**."*

3. Sexuality, fertility and marriage

In reading Boucher's descriptions, one can soon discern that the ancestors have a certain preoccupation with sex. The major theme of sexuality, fertility and marriage is nearly omnipresent amongst the *gule wamkulu*, and sexual themes are often linked with other observations on power and personal behaviour. For a farming people, fertility of the land delivered through its crops is the foundation of life. That fertility is also directly linked to God, the deliverer of the rains. The adjunct to a fertile land is a fertile people, and large families are admired and pursued in the traditional village set-up. The act of sex is not primarily for the pleasure of the individual; it is for the survival of the extended family. It is a community responsibility to beget children, and many of them, as they are the future, who will in turn generate more children and, in a world deprived of social security, will support the old. (There is some recent *gule* recognition of population control by contraceptives but, in the one example to hand, the ancestors do not appear to support it). It is to be expected that sex and its related topics of marriage and relationships within the family are dominant ones for the *gule wamkulu*. If sex and fertility are important to the community, then the ancestors want community members to be obeying the rules of the *mwambo* and they give copious advice.

Almost every detail of sexual relations comes under scrutiny from the ancestors. They will instruct when to have sex, and when not. They demonstrate just what the penalties can be for sex at the wrong times, and the price is very high indeed ... the dreaded *mdulo* disease. The single most common theme for the characters documented by Boucher is that of sexual taboos. In particular, they address the prohibition of sexual relations at certain times, determined by the condition of the individual or the state of the community and its rituals. Sexual activity is 'hot' and people at times can be 'cool', and hot and cold are dangerous reagents.

The ancestors instruct soon-to-be-weds and those already in marriage how to ensure that their fertility will not be endangered, as procreation is the driving force behind marriage, its raison d'être (**Chivuwo**, **Njovu**[1], **Thunga**). The ancestors are conservative in their sexual proclivities and there are many characters that admonish the village for any improper practices such as under-aged sex (**Mfumu yalimbira**[2]) and incest (**Bokho**[3], **Chauta**[4], **Chiudza**). They support the family unit (with some provisos noted below) and have strong warnings against promiscuity and polygamy. The pandemic of HIV/AIDS in southern Africa is attributed to many synergistic causes: economic, social and behavioural. Unprotected sex with multiple partners is clearly one of the key causal agents for the spread of the disease, and women are at more risk of infection than men, frequently through their own marriage partners. Prior to the recognition of AIDS, the *gule wamkulu* had identified the links between promiscuous sex and many social ills, including instability in the family and village (**Hololiya** in both Mua and Dedza versions), abandonment of the family (**Madimba**[5]) and the infection of innocent partners by venereal diseases (**Chiwauka**). Partner faithfulness (**Bwindi**, **Gulutende**) and modesty (**Mfiti ilaula**[6]) are virtues. One of the commonest perceived causes of profligate sexual behaviour is the impact of modernity. Polygamy, too, is the subject of *gule* doubt and scepticism (**Gulutende**, **Wali wabwera**[7]) as it is seen to dilute the capacity of a man to properly attend to the needs, sexual and material, of each of the wives. The dangers of a wide generation gap in marriage do not avoid the ancestors' scrutiny, as we see with **Chizinga** and **Msalankhulitse**.

The ancestors' conservative views on sexual practices and fertility have extended recently to the use of oral contraceptives, where the judgment is that their use can actually increase the numbers of children (**Malodza**[8]).

While supporting the immediate family and the importance of a strong relationship between husband and wife, the ancestors are firm believers in the strengths of the matrilineal extended family. Some commentators view the *gule wamkulu* as largely a mechanism for the men to parody and satirise the matrilineal system. Certainly, the *Nyau* secret society can be seen as a form of brotherhood, a men's club so to speak, that provides fraternity even for the husband who is a stranger in his wife's village. Nonetheless, while male protest may be a factor within the great dance, it does not fully reflect the complexity of the messages on family matters. The pillar of matrilineality supports the Chewa community and impacts on all aspects of life, from choice of chiefs, inheritance of property, 'ownership' of children, to day-to-day decision making. The husband or son-in-law, the *mkamwini*, is something of an outsider in the village of his wife and certainly has little role in the decision-making processes overseen by the matrilineal uncle, the *malume*. Many *gule wamkulu* characters address the *chikamwini* system. Some appear to satirise and mock the system, such as **Elizabeti** and **Edwadi**,[9] where the woman lauds her dominance over the meek male. In **Mai Gomani**[10] the *Nyau* men show some admiration for the more submissive role of a woman in the Ngoni patrilineal set-up. We see characters that recommend that more courtesy, compassion and care be shown to the *mkamwini* (**Koweni**). The important role of the husband in the procreation of children is recognised and praised (**Chilembwe**, **Chimbebe**). Yet most characters support the status quo of matrilineal power, or at least, issue strong warnings of what can happen when it is not respected. The husband/son-in-law is often portrayed in a predominantly red mask, to emphasise that he is seen as a stranger (see **Am'na a chamba**[11] or **Koweni**), or with animal features that betray his frustrations and rage (**Maino**). Many *gule* messengers describe the dangers of the *mkamwini* who is above his standing, who cannot adapt to his secondary status and who descends into antisocial behaviour (**Chokani**, **Golozera**[12] and **Zoro** are but a few examples) and is consequently a threat to the family and the village. The ambitious son-in-law may even pay the price of being killed by medicines if he persists in his ill judged behaviour (**Kanjiwa**).

The angst of the disenfranchised husband does not motivate the ancestors to consider significant changes to the matrilineal set-up. Other than recommending that the man be shown courtesy and care, there is no alternative proposed. This is exemplified by the ancestors' view on *chitengwa*, where the wife and children move to live with the husband at his village. In practice, this is not so uncommon after a period of the *chikamwini* option, and especially if the husband's prospects are notably better at his home. **Chakola** warns the women against this move, as the wife away from her own *mbumba* will be eventually ignored and discarded.

In contrast, the ideal husband works hard for his wife and her family and is responsible and tolerant of the *chikamwini* set-up in which he is a guest. We see this in **Greya**[13]

of Mua and **Sirire**. The common message is loud and oft repeated: while it may be galling at times, if you are a husband, know your place in your wife's household, enjoy what privileges it can offer, do not interfere in family politics and do what is expected of you. First and foremost amongst those roles is the fathering, and subsequent supporting, of children.

The production of children is the primary function of marriage in the eyes of the ancestors. A sound partnership that recognises the *mwambo* and sexual taboos will result in many offspring as gifts from God, as we hear from **Chigalimoto** (in a supremely coded form), **Chimbebe** and many others. This fecundity requires that the woman has had her fertility released through proper initiation (**Chimbano, Njovu**[14]). It also requires a potent husband. In this scenario, we see a corollary dimension to the male and fertility, namely the callous and relentless critique of the man who cannot have children. Infertility from any cause is a source of distress and shame in the village. Children are the future. To do other than produce them is to betray that future, not only for oneself but for the entire community. There is little traditional appreciation of the possible physiological causes of infertility. From the *gule wamkulu* it is apparent that the single primary culprit in the eyes of the ancestors is the impotent husband. For the Chewa, the concept of impotence differs somewhat from the common Western perception. Impotence in the West is frequently associated with erectile dysfunction and has a broad implication of a man who has no sexual capacity, that is, is unable to have penetrative sex. For the Chewa, the impotent can be active sexually, and indeed, rampant promiscuity is often a symptom or a camouflage for the impotent (**Mandevu, Tsokonombwe** of Dedza). In some cases, the promiscuous behaviour has resulted in contracting a sexual disease that in turn has made him sterile (**Chiwauka**). While engaging in sex often and voraciously, the impotent Chewa is unable to beget children, and that is his weakness. The powerful man in contrast has many children. There seems little sympathy for the sexually dysfunctional from the living (including, as the *Nyau* are men, from other men in the community) or the dead. Impotent characters are typically figures of fun and mockery, subject to ribald jests and condescension. The impotent is often the comic relief for a *gule wamkulu* event. They are condemned for their procreative inability, and may be advised to forget about living a normal life with a family, as their infertility will damn them and their wives to a purgatory of self-

recrimination and community rejection (**Adagwa ndi mtondo, Chikalipo**). Young women choosing a marriage partner are advised against the man who may be impotent (**Chidodolo**). Just how a man or his prospective wife might know of his impotency *before* getting married and attempting to produce children is not elaborated on. Some wives of an impotent man will in desperation engage in adultery (**Kholowa** and **Mai Kholowa**) or take a surrogate husband in order to generate children (**Chikalipo**). Overall, the ancestors appear to have little compassion for the man who cannot fulfil his procreative duties. To have suffered such a condition in the Chewa village must have been, and presumably remains today, a cruel fate indeed.

The extended family is constrained by many rules that define the relationship between individuals. Nothing escapes the scrutiny of the *gule wamkulu*. The relationship between a husband and his mother-in-law is one of mutual avoidance (known as *chipongozi*) and this is reiterated by **Nyanyanda**. In contrast, the husband can have a friendly, joking relationship (known as *chilamu*) with his sisters-in-law, yet there is risk in this should the platonic friendship metamorphose into something sexual (**Ndomondo**).

As a recognisable subset of the sexuality characters, there are those that advise the young girl initiates about their future as wives and mothers. The female initiation or *chinamwali* is a major event that attracts many *gule wamkulu* messengers. The key advice is not about finding love and emotional satisfaction in the arms of a young Romeo, one's true love, but to have a stable marriage and produce many children. The instructions for initiates were explored in the introductory section on women, gender relations and the *gule*, but here we can reiterate that sexual instructions can be open, frank and frequently graphic.

The do's and don'ts of sex are dictated by sexual taboos that permeate all areas and times of the village life cycle. To break the rules that apply to sexual activity can risk the dreaded slimming or bloating disease, *mdulo*. Dozens of characters warn about breaking the sexual taboos that can bring down the disease upon oneself or other members of the family. This may relate to possible origins of the great dance with the women, and thus with sexuality, as is discussed in the Introduction. Some of the sexual masks are ancient, and may refer back to early contact between Bantu and Batwa peoples (**Kamano**). Others link more definitely with the Banda – Phiri power struggles, where control of rain shrines and associated initiation rituals was

at stake (**Njati** and **Mzimu ndilinde**). For the traditional Chewa, one of the commonest ways to risk *mdulo* was to have sexual relations when the woman was menstruating. The common message to the man was to abstain from sex with his partner at this time and for the woman to deny her husband his conjugal privileges even if he demands them. Bad things happen to those who force themselves on their wives at this time and women have responsibility to enforce the taboos (see **Chilenje, Gandali** and **Namalotcha, Kwakana, Mphungu, Nyata** and **Nyolonyo** as a small subset). The stories of sexual risk can be explicit or almost lyrical, as in the symbolic linkage of the woman's sexual organs and the graveyard (**Ali n'nyanga nkhadze**). Third parties can be impacted by transgression of the taboos: a woman may lose her child if she has sex in the final stages of pregnancy (**Chiwawa**); a family head or elder can kill his family members, such as a pregnant niece or a child, by breaking the taboos (**Kasinja, Ndapita ku maliro, Salirika**); or a husband kills his own child by not adhering to the rules of redemption, *kulongosola* (**Sajeni**). Even the recently deceased can be badly affected by the poor sexual practice of their relatives. Transition of the dead to the spirit world is dependent on the living keeping sexual taboos (**Chabwera**).

While avoidance of sexual relations during a woman's menses may have little demonstrative health benefits to Western minds, other areas of sexual advice reflect robustly wise practice. Promiscuity is universally condemned by the ancestors and the *gule* characters depicting sexually voracious men (such as **Chiwau, Mandevu, Ndomondo, Njolinjo**, and many others) and, far fewer, women (**Hololiya** of Dedza, **Kanchacha, Liyaya**) are subjects of ridicule and warning. The playboy is a dangerous commodity for the individual woman who may fall for his charms or money and for the village at risk of splintering because of his social destructiveness.

A number of the sexual masks address issues of feminine hygiene and modesty, emphasising the use of hygienic towels and disguising the effects of menstruation. These characters are strong performers at the girls' initiation when they are taught how to be responsible, and modest, women and mothers-to-be (**Chapananga, Chinkhombe, Chintabwa**). It is at the girl's initiation too when most of the small suite of masks danced by women perform. The dancers are usually older women, the *namkungwi* or instructors, who link the secret worlds of the men and women. Women-danced characters include

Chinkhombe, Chiwekuweku, Liyaya, Mai Kambuzi and **Yiyina**.

It is remarkable to observe the Chewa capacity to inculcate a message about sexuality or the family in what might appear the most unlikely of objects. Even objects of technology have been recruited into the legions of *gule* teachers. The automobile (**Chigalimoto**), the aeroplane and helicopter (**Ndege** and **Ndege ya elikopita**) and the lake steamer (**Bangolo**) are amongst the machine-inspired pedagogues.

1 Community, authority & the ancestors
2 Community, authority & the ancestors
3 Witchcraft & medicines
4 Witchcraft & medicines
5 Community, authority & the ancestors
6 Witchcraft & medicines
7 History & politics
8 Childbirth & parenthood
9 History & politics
10 History & politics
11 Personal attributes
12 Personal attributes
13 Personal attributes
14 Community, authority & the ancestors

Adagwa ndi mtondo

(a feather mask from the Mua area)

Themes 1) Infertility – impotence; 2) Caution against infertility in marriage/infertile people should not marry; 3) Choice of marriage partner (choice of *mkamwini*); 4) Social stigma

Etymology Adagwa ndi mtondo means, 'He fell with the mortar.'

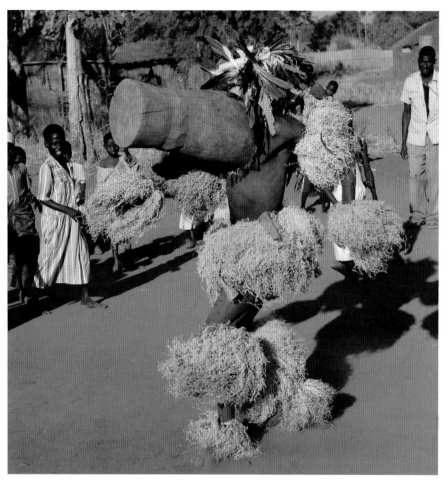

difference from other Kapoli is that he carries a mortar that he places at the centre of the *bwalo*. He kneels in front of it, rotates around it, grabs it with extreme determination, and falls, rolling with it back and forth with both arms clutched to it, pressing it hard against his chest. He sometimes puts the mortar back and stands up, climbs on it and falls down. These movements are repeated several times during his performance. At the end, he goes away frustrated and ashamed and leaves the mortar behind. **Adagwa ndi mtondo** (like Kapoli*)* sings his song with a high-pitched voice that both male and female choirs continue: *"He fell with the mortar, oh! He fell with the mortar. Get up! Get up! Get up! He fell with the mortar."* [1]

The song uses the euphemism of the mortar to describe someone who suffers from impotence. The mime of the man who wrestles with the mortar ends with him leaving the mortar behind, signifying his abandoning the prospect of a married life. The theme of infertility and impotence in particular provides easy entertainment at the time of funerals and commemoration rites where the character **Adagwa ndi mtondo** is featured. He also appears during puberty rituals to warn those who suffer from infertility not to marry or for young people who are about to enter family life to choose carefully their partner in order to avoid the tragedy of the man who left the mortar behind.

[1] *"Adagwa ndi mtondo eae Adagwa ndi mtondo, tiya tiya tiya Adagwa ndi mtondo."*

Adagwa ndi mtondo is a variant of Kapoli. He appears in the arena with the conventional outfit of Kapoli: feather head-gear (*chiputula)*, kilt, armlets and leglets made of fertiliser laces and the body is smeared with mud. The only noticeable

Ali n'nyanga nkhadze or Kadyankhadze

(a yellow day mask from the Mua area)

Themes 1) Sexual taboos (*mdulo*); 2) Body preparation for marriage; 3) Marriage, preparation & instructions

Etymology Ali n'nyanga nkhadze means, 'She has horns like the branches of the *nkhadze* tree.' Horns are usually containers for powerful medicine. Evil medicine leads to the grave. The Chewa graveyard is usually situated in a forest of *nkhadze* trees (a type of *Euphorbia*) which shade the graves and are planted nowhere else around the village. **Kadyankhadze** means, 'the one who eats *nkhadze*'.

The yellow, red or orange mask depicts a severe androgynous face with two long horns, up to a metre or more in length, in a horizontal position and painted with red, white and black stripes. The colour of the mask stresses sexual prohibition. The androgynous face shows that the teaching of this mask is meant for couples. The horizontal horns describe the female sexual physiology, showing that the woman is in her menstrual cycle. The headgear of the mask is made of black and white chicken feathers or guinea fowl feathers bordered with a string of black and white beads. A wife will usually decorate her waist when her menstrual period is over, signalling to her husband that she is ready for intercourse. This is the meaning of the white feathers or the white spots of the guinea fowl feathers of the mask. The black feathers stand for the pubic hair.

The dancer wears the ordinary tatter suit of *gule*. Elders recall that the character used to dance naked or with a loincloth. In his hand, he carries a whip, used by the ancestors for the correction of behaviour. In the dance, **Ali n'nyanga nkhadze** emphasises by the motion of his arms the idea of tying and untying. The men sing the chorus, *"The nkhadze tree has* (branches that protrude like) *horns* (similar to those) *of my brother's wife. She has horns like those of the nkhadze tree. They are white* (like those) *of my brother's wife."* [1] **Ali n'nyanga nkhadze** points at the horns with the index finger of each hand.

The character was primarily performed at initiation rites. During the girls' initiation, the horns refer to the female genitalia and the candidates are taught to prepare their body for marriage. Among the Chewa, this included the elongation of the labia, which are manipulated and extended with the help of certain medicine. The girls are also taught about menstruation and its function. Many of the instructions deal with the rules of hygiene and precautions to be taken on such occasions. Above all they are taught to wear a hygienic towel and to avoid having sex at such a time. Sexual relations during menstruation are believed to endanger the life of their partner from *mdulo*.

These prohibitions are also at the centre of the boys' initiation rite. The female cycle is explained to them, particularly in relation to these taboos. They are also taught correct sexual conduct for marriage. The boys are told that they can play with the beads and pull these organs only if the labia are white. A menstruating woman exhibits red organs covered with a viscous liquid that is comparable to the sap of the *nkhadze* tree. The handling of these organs at this period can result in wounding the woman and forcing her to treat herself with medicine made of bat wings. A woman who has just delivered often uses the *nkhadze* sap to aid in recovery from childbirth.

Traditional sexual life consists of a repeated sequence of abstinence (*kudika*) and re-engagement (*kulongosola*) with sex, embodied in these taboos. The character of **Ali n'nyanga nkhadze** reinforces this teaching with the gesture of tying and untying. The horns of the mask draw a link between the female sexual organs and the graveyard. The pubic hair surrounding the labia suggests a grove of *nkhadze* trees. The *nkhadze* tree is symbolically linked to graveyards, sexual abstinence and women. In the past, an *nkhadze* sapling was planted on the grave the day of the funeral. Women normally keep the sexual taboos for a longer period following the different shaving ceremonies, between three months and a year after the burial for close relations. Female anatomy is seen as the image of the *nkhadze* tree. The Chewa associate the protruding of its branches to the shape of the elongated labia and associate its latex and colour with the various stages of the menstrual cycle.

Ali n'nyanga nkhadze reminds men and women of the imperative of keeping the *mwambo*. Failure to do so will mean the *mwambo* drives man to the grave (*nkhadze*) instead of being life giving.

[1] *"Ali n'nyanga nkhadze (2×) mkazi wachimwene. Ali n'nyanga nkhadze oyera, mkazi wachimwene."*

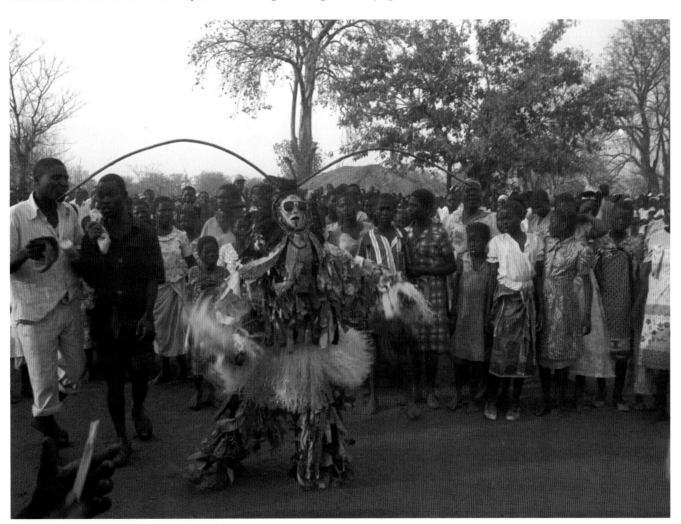

Claude Boucher, Munyepembe Village, September 1994

Bangolo
(a day or night structure from the Mua area)

Themes 1) Fertility; 2) Sexual taboos (*mdulo*)

Etymology **Bangolo** means, 'this reed', a euphemism for the male sexual organ.

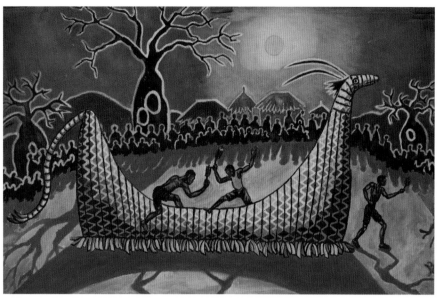

Painting by Claude Boucher and Joseph Kadzombe, 2009

Two dancers at each end of the construction activate this large four metre long structure. The general shape resembles that of a lake steamer, disguised as an animal. The structure loosely resembles the shape of Kasiya maliro with its head, horns and tail. The construction is high at the head (three metres) and at the tail (two metres). The waist between the two high points is less than a metre high and very flexible. The bamboo frame is concealed by grass and palm leaves in a zigzag pattern (for the night performance) or maize husks (for the day events). A palm-leaf fringe hides the base of the structure. **Bangolo** appeared at funeral and *chinamwali* rites. It entered the *bwalo* at the rhythm of the *chisamba* and roamed around the arena. The guide leading the structure with the rattle would repeatedly jump over the low part of the steamer from one side to the other. The male choir introduced the steamer with the following words: *"This reed, reed, reed, in the middle of the lake."* [1] The cryptic song uses the image of the lake steamer to describe sex and marriage. The reed and the lake are familiar symbols for both male and female organs. The general shape of **Bangolo** duplicates that of Kasiya maliro and emphasises its teaching concerning the sexually induced slimming disease, *mdulo*. **Bangolo** celebrates sexuality and marriage in a puberty context and emphasises the triumph of life over death in a funeral set-up. It also stresses the importance of the *mdulo* regulation at the time of puberty and funeral rites. The structure of **Bangolo** was introduced by the old timers of *gule* who had been outside Malawi, working in the mines in South Africa. By the end of the 1960s, structures were becoming rare in *gule* and **Bangolo** vanished around that period.

[1] *"Bangolo, Bango Bango pakati pa nyanja."*

Bwindi or Wamangana nthambwe
(a red or white day mask from the Mua area)

Themes 1) Adultery & rape; 2) Promiscuity; 3) Faithfulness; 4) Luring appearances (beware of); 5) Dangers of modernity

Etymology **Bwindi** is a colloquialism for, 'the rapist'.
Wamangana nthambwe means, 'he got back together with the paradise flycatcher'.

Informants state that **Bwindi** is a recent character dating from the end of the 1980s. It has evolved from the more ancient character called Nanthambwe, meaning, 'the paradise flycatcher', a bird that is very active in catching insects. **Bwindi** features a red and white caricatured face. The red colour emphasises sexual heat as **Bwindi** is a man who rushes into endless love affairs. His head is almost completely bald showing only a little black hair at the temple running down onto the neck. His face is cunning with sly slanted eyes and a broadly gaping mouth with an exaggerated forced smile revealing only three teeth. Strips of rag hide the neck. **Bwindi** wears overalls without rags. White wristlets and anklets decorate his outfit. At times he also wears a mini kilt of fertiliser bag laces on top of his overalls. Occasionally his overalls are padded at the crotch to simulate he is having an erection and ready for sex. He often carries a bag to the arena, pretending he is returning from the mines with his bag full of wealth. He dances with medicine tails to show his status and fortune.

His erotic dancing includes moving his hips frenetically, spending his time chasing after women and looking for new partners. The men sing, *"Bwindi, no, no! I have already seen what is wrong with you,"* [1] or *"Hurry, hurry, he got back together with the paradise flycatcher (his first wife)"* (they are

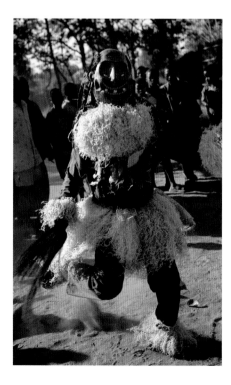

in a hurry to marry).[2] This proverb/phrase expresses what is made in a hurry leads to confusion (in this case, to an unhappy sexual pact). These words refer to a person who makes quick liaisons, confusing them with marriage. **Bwindi** uses charm and false promises to cheat women and take sexual advantage of them. His European clothes, attractiveness, broad smile and wealth make him popular with women. They quickly fall prey to his charms and agree to marry him. Soon they will face disappointment as they will be abandoned and left alone, often pregnant and helpless.

With the growth of a money economy, **Bwindi**'s character was created to warn women against such so-called marriage prospects. **Bwindi**'s broad smile shows that the young men of our times are unwilling to change. Warnings and correction are wasted on them as they listen only to the voice of modernity. The attraction of the outside world seems to overpower the voice of *mwambo*, the traditional morality.

Bwindi performs for any occasion. In the Mua region, he is sometimes called **Wamangana nthambwe**.

The recent creation of **Bwindi** and many other new characters of *gule* highlighting promiscuity and prostitution is a response to the growing confrontation of the Chewa world with western culture and values, particularly the influence of individualism and the sexual revolution that characterise western countries. The Chewa tend to consider this influence deadly to their philosophy and lifestyle.

[1] "*A Bwindi toto choipa ndachiona kale!*"
[2] "*Liwilo (2×)* **Wamangana nthambwe**."

Chabwera or Zambezi

(an orange day mask from the Mua and Mtakataka areas)

Themes 1) Sexual taboos for funerals; 2) Unity & harmony; 3) Imitation of qualities of the dead; 4) Assisting transition of deceased to spirit world; 5) Rebirth

Etymology Chabwera means, 'that which has come (from the grave)'. Zambezi refers to the Zambezi River.

This small mask appears in red, orange or yellow, signifying sexual prohibition. The fine features resemble the sun spreading its rays. The headgear is made of flamboyant feathers, particularly those of guinea fowl. This dominance of guinea fowl feathers emphasises a harmonious personality. The androgynous face is peaceful and attractive and appears compassionate. The eyes are clear and the nose is straight and delicate. The mouth, small and slightly open, is toothless. The chin is soft and beardless. The ears are proportionately well shaped and adorned with pretty earrings. The broad forehead indicates intelligence and is bordered with a black goat skin hairline.

The character performs at funerals and commemoration ceremonies. The dancer wears a short kilt, leglets and armlets made of grass or of white fertiliser bag laces. His body is completely smeared with white ashes. He carries two small whips representing chastisement. He comes quickly into the arena and is surrounded by women. Rapidly twisting his hips, he alternately extends each arm and whirls the small whip. Then he backs up a few paces, swiftly swerving one foot at a time sideways, quickly followed by a backward kick.

The performance of **Chabwera** is accompanied by a wide range of songs sung by the men. In the first song we hear: "*The corpse sleeps in the Zambezi, oh! The corpse sleeps in the Zambezi.*"[1] The Zambezi is a major river that flows south of Malawi into the Indian Ocean. The Chewa men who went to work in mines in South Africa and Zimbabwe had to cross this huge river. Its size, far greater than the rivers in their own country, inspired them. In this song, the Zambezi River is compared to the flow of life, ending up in the ancestors' world once the deceased has undergone rebirth. For the Chewa, death is perceived as a time of rebirth. Both birth and rebirth are symbolically centred on the seclusion hut (*tsimba*), an image of the maternal womb. After the birth of a child, the house provides a safe shelter as an extension of the womb. Both the child and the mother are kept 'cool' inside, awaiting the child's maturation into a strong human being. No sexually active people are allowed to enter the house and handle the child. At puberty, the young girls who experience their first menstruation are also kept 'cool' inside the house of seclusion where they are instructed while awaiting their coming of age. The same sexual interdicts also apply then. When a chief (*mfumu*) or an elder (*manyumba*) is enthroned, they are kept indoors and are instructed by people who have abstained from sex, before taking up their new names and responsibilities. Finally, at the time of death, after the washing of the body, the corpse is kept inside the funeral house surrounded by all the women who re-enact the ritual of birth. The whole night long, the women wail and keep vigil to symbolise that the deceased is on a journey: he is going back to the mother's womb. In order to be

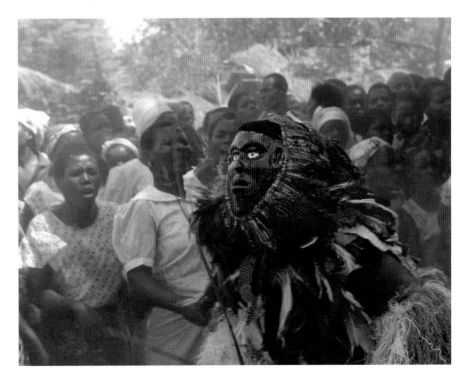

reborn inside the house, all have to be ritually 'cool' and have to keep the sexual taboos. No man sleeps inside the house since the secret of birth and life belongs to the women. The entire village must abide by such rules for the duration of the burial rite. The third day after the burial marks the end of the mourning period for those who are not immediately related to the deceased. In the past, some female relatives continued sexual abstinence for the three months following the burial. These precautions were to assure the correct transformation of the deceased into an ancestor. The widow, mother or elder sister of the deceased would continue to keep ritual coolness for a year after his death. Today, the periods of abstinence tend to have been reduced as funerals have become more frequent.

The funeral and commemoration rites emphasise that the process of rebirth for the deceased depends on abstinence of others ('to tie') as opposed to that of conception that presupposes sexual activity ('to untie'). The corpse 'sleeping in the Zambezi' stresses the seclusion and sexual taboos that bring about this actual rebirth.

The second song of **Chabwera** refers to the beauty of the mask, the headgear, the costume and the grace of his dancing: "*There is nobody in this country who can rival Chabwera, there is nobody who can rival Chabwera.*"[2] **Chabwera** is called 'the spirit from the grave'. He embodies the name, the deeds and the qualities of every deceased person in transition. Both his appearance and his performance pay tribute to and praise the sacredness of the personality of each individual. He testifies as to what the person has been to the community and the joy and enrichment he/she provided for others. Deaths and funerals are moments of crisis in the village. The funeral is a privileged moment when a public statement is made about the individual's life, and his deeds and qualities remain with those who have lived with him/her. This tribute is often manifested during the burial ceremony when the deceased's name is passed on to another living member of the family or soon after the burial when the name is given to a child recently born within the family group. The transfer of the deceased's name and qualities is most commonly done on the occasion of chieftainship (*ufumu*) or eldership (*manyumba*) ceremonies. This is when the name of the chief or the ancestor is passed on to those who are enthroned. These ceremonies clearly emphasise that the name, the deeds and the qualities of the deceased, now an ancestor, are passed on to his descendants or to the person who assumes his name and position. Individuals may die but their

name and achievements continue through their descendants. Their qualities live on.

The third song of **Chabwera** highlights the sexual proscriptions required for the rebirth of the deceased into ancestorhood. "*A barren woman does not drink the okra's juice, the juice from the penis, a barren woman.*"[3] The juice is a metaphor for semen, the juice of the penis. The song plays on the image of the infertile woman who is unable to welcome the male fluid as a symbol of the dead who will no longer enjoy sexual activity. Therefore there is need for intensifying solidarity amongst living members of the community. In practice this means that the villagers and the family members of the deceased must abstain temporarily from sexual activity (*kudika* – to wait) and attune their behaviour to that of the spirit world for the duration of the funeral and the commemoration rites. These rituals enforce strict sexual taboos for fear of compromising the transition of the deceased into the spirit world.

The fourth song of **Chabwera** conveys a similar meaning: "*Look at the fire inside the bush* (the house)."[4] The song recalls grief for death. The experience of death implies the same rule of abstinence.

The four songs of **Chabwera** focus on three main themes reflected in the costume and the style of dancing. First, at death the person who was part of the flow of life leaves behind this world of sex and reproduction. The deceased is in transition to the spirit world where he will be reborn as an ancestor. The women who have the duty to shelter life assist him/her in this by keeping 'cool' and away from the 'heat' of sexual activity. In the arena, **Chabwera**, surrounded by the women, manifests the reborn spirit who has completed his journey after a long transition. As the dancer rotates his pelvis, he acknowledges that there is no sex where he comes from. The community has shown support for him by abstaining from sex for the duration of the funeral rites. The whiteness of his costume and body symbolise his 'cool' condition. His androgynous face expresses that people of either gender are called to become ancestors and to undergo this transformation. Second, the name, the deeds and the qualities of the deceased follow his/her owner to the spirit world and simultaneously are bestowed upon the descendants. They must be publicly acknowledged and proclaimed at the burial ceremony and the commemoration rites that follow. They are to be imitated and cherished. The naming ceremony makes their transmission possible and allows the deceased's spirit to reappear in the midst of the community. The beauty of **Chabwera's** mask and costume

celebrates his name, deeds and uniqueness among his descendants. The vigour and the grace of his dance console the bereaved and transform their sadness into joy. His qualities and cheerfulness are alive among the community. The swerving of **Chabwera's** feet followed by a backward kick and a brief pause, shows that he has left behind his energy even if he and his friends belong to different worlds. His sideways movements reflect the women's gestures as they depart from the cemetery leaving behind his ghost (*kusasa ziwanda*) but taking with them his spirit. Villagers and especially the family members have to show solidarity with the stream of life. They abstain from sexual activity in order to empathise with the new condition of the deceased and support him to settle among the ancestors. The red colour tones of the mask emphasise this. The rotating movement of **Chabwera's** pelvis is an invitation to those who have loved the deceased to engage with him or her for a while, in order to allow the deceased to tap the springs of fertility and the prodigious blessings from above.

[1] "*Maliro agona m'Zambezi erere, maliro agona m'Zambezi.*"

[2] "*Palibe wokoma pano ngati a Chabwera m'dziko lino (2×) palibe wokoma pano.*"

[3] "*Mkazi wa chimbwirira sakumwa telele, telele ndi madzi a mbolo, mkazi wa chimbwirira.*"

[4] "*Onani moto m'mgala de e de tate de, onani moto m'mgala.*"

Chakola

(an orange day mask from the Nathenje area)

Themes 1) Residing at husband's home (*chitengwa*); 2) Irresponsibility in marriage; 3) Promiscuity

Etymology **Chakola** means, 'I have had enough.'

The orange mask has wrinkles, a bald head, tribal marks and a clean moustache. Two curved, red horns top the mask. The dancer wears the usual tatter suit atop a kilt made of sackcloth and a white belt made of shaved skins. He enters the *bwalo* like a chief, holding his medicine tail and circling proudly in the dancing ground. He performs with tremendous energy. The men sing **Chakola**'s wife's grievances: "*Chakola* (I have had enough). (I will tell you.) *Why is it that I have had enough of him? He took me* (to his village). *I have nothing to do. At home there was peace. Why did he take a wife to his village, Chakola? This is not the way to behave, Chakola, Chakola* (I have had enough, I have had enough). "[1]

Chakola's wife complains that she was taken to her parents'-in-law village (*chitengwa*) after her marriage, where **Chakola** was to show all his love and affection. Since she moved to his home, **Chakola** does not look after her. He pays her no attention. He is even violent at times and beats her. She feels like a stranger (this

is the reason why the mask is depicted in an orange colour). He leaves her alone most of the time and consorts with other women. **Chakola** displays a double heart. This is the meaning of the two horns: he wants her at his home but at the same time he is irresponsible and does not care for her.

Chakola tries to prevent marriages from ending in divorce due to the pressures of living at the husband's village. He advises young husbands who want their wives to take residence at their own birthplace to think twice. At the beginning, their love burns brightly. Later, the flame lowers. They can begin to show little concern for their wife and even resent her presence at their own home. The chief and the guardians of the marriage (*ankhoswe*) tire of resolving marital disputes and counselling the husband. **Chakola**'s behaviour is immature and annoys everyone in the village. He has isolated his wife in a loveless marriage and made her regret leaving her home to marry this worthless man.

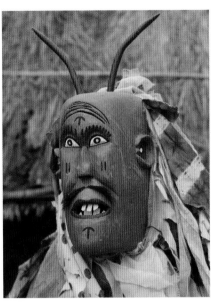

[1] "*Chakola, chandikoleranji Chakola? Kukhala ndili khale ndingopenyatu ine (2×) kwathu kuli khale. Kutenga mkazi chifukwa Chakola? Uku sikukhala tate Chakola, Chakola.*"

Chapananga

(a black day mask from the Mua area)

Themes 1) Sexual taboos (*mdulo*); 2) Women's hygiene cycle; 3) Avoidance of an early (illegitimate) pregnancy

Etymology **Chapananga** means, 'that which has trapped my children'.

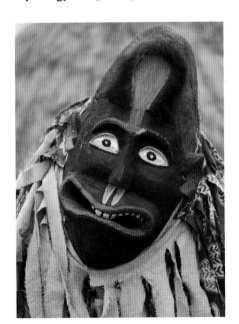

This old mask is no longer danced in Malawi. The last dancer to perform it in the Mua area died in the 1950s.

The black mask has an elongated head, rather like the shape of a squash. The forehead displays an oval red area surrounded by fur. The very wide mouth is deformed in the shape of a figure eight, and has teeth in the upper jaw. The headgear of the mask is made of rags of various colours. The dancer wore the usual tattered suit of *gule* and carried a piece of cloth in his hands.

Chapananga appeared in the *bwalo* to the rhythm of the *chisamba*, moving his hips in a very sexually suggestive manner. He chased the women with the intention of 'raping' them. **Chapananga** instructed the girls at the time of initiation and at funerals that included initiation. He taught the girls that they should run away from men for fear of becoming pregnant before

marriage. The male choir sings the following: "*Chapananga, the dance* (sex) *is your own, when you meet the chief* (a man), *run away, Chapananga.*"[1] The reddish mouth in the shape of the figure eight symbolises a trap and the protruding teeth warn them to be careful during their menstrual period. Once married, they should avoid having sex with their husbands when menstruating, for fear of causing his death through the slimming disease (*mdulo*). The red oval shape on the forehead surrounded with fur portrays the female sexual organ in menstruation. A woman having her period should keep clean and take care of herself. The cloth that the dancer carries evokes the hygienic towel.

[1] "*Chapananga gule ndi wako. Ukamaona afumu udzithawa tate (2×) ae Chapananga.*"

Chaponda

(a yellow day mask from the Nathenje area)

Themes 1) Sexual obsession; 2) Responsible parenthood; 3) Sexual taboos (*mdulo*); 4) Spacing of childbirths by sexual abstinence (*kudika*)

Etymology The word has a variety of derivations. *Chapondaponda* expresses the idea of walking about. It often means, 'to have sexual relations'. *Chapondana* conveys the fact that children are born following each other. Literally, 'one steps on the previous child's head'. The song voicing the character of **Chaponda** plays on the various meanings.

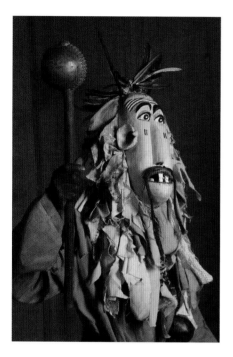

This long, narrow yellow mask portrays a senior man with wrinkles on his forehead, protruding eyes, swollen eyelids, and a sharp-edged long nose. The mouth protrudes and has missing teeth on the bottom jaw. Large ears express deafness. He bears Chewa tribal marks, and a short goatee and long moustache made of black-dyed sisal.

The headgear is made of rags. A small tuft of chicken feathers stands erect as a hair lock to show he is obsessed with sex. Black, tube-like horns 20 centimetres long protrude on either side of the hair lock to convey that he is beastly. Beastly sexual behaviour is connected with witchcraft. Our character wears plain overalls without rags and a large belt in which he carries several clubs. He also holds a bigger club. He can perform on any occasion when *gule* is danced; his presence is not connected to any specific ritual.

He enters the *bwalo* to the rhythm of the *chisamba*. In the arena, he rotates his hips and moves his pelvis erotically, testifying to his sexual obsession. He chases the women and follows them outside the arena. His behaviour is supported by the song sung by the men, voicing **Chaponda**'s wife's complaint and his own response to her. The wife: *"Mr Chaponda (Walkabout) is a beast! During the night, he does not sleep. Don't you dare to do this!"* The husband: *"You are the one who arouses my appetite."* The wife: *"Sex should stop! We will have another (child soon) and the previous one will swell (because of consecutive close pregnancies). There is no reason for him not to swell, if (our child) is followed (by another baby so closely). Mr Walkabout is a beast!"* [1]

Chaponda is a selfish husband who has no consideration for his wife and children.

He impregnates his wife each year. The Chewa practise a form of family planning by forbidding sexual relationships for a long period after birth. They believe that pregnancies should be sufficiently spaced so as not to compromise the survival of the child and stop lactation. This practice is sanctioned by the *mdulo* belief. Sexual contact during this period could mysteriously kill the husband and provoke the swelling and death of the child. Therefore the mother has the duty to protect both husband and baby by refusing her husband sexually. **Chaponda** is not eager to collaborate. He forces his wife to have sexual relations risking a new pregnancy, his own death and that of their last child.

Irresponsible parenthood, a condition of abject poverty, compromises the survival of children in a developing country like Malawi. High birth rates combined with poverty lead to malnutrition and increase the risk of infant mortality. Among the Chewa, these issues are often attributed to the breaking of the *mdulo* complex and to infringing sexual taboos.

[1] "*Ya ee **Chaponda** ponda n'chinyama. Usiku wonsewu osagonatu! Iwe e e tate iwe – usati utero – chiukhala iwe umandiyamba dala tate – Chileke chiponde tate de tiona pano wina. Wina atupa tate, apandirenji kutupa atapondedwa tate e wamuna a **Chaponda**. **Chaponda** n'chinyama.*"

Chidodolo

(a white day mask from Mua area)

Themes 1) Infertility – impotence; 2) Caution against infertility in marriage

Etymology **Chidodolo** means, 'delaying' or 'hesitation'.

This white oval shaped mask features drooping cheeks, eyes and mouth and portrays a very sad woman. Her face displays tribal marks but has no ears. The headgear of the mask is made of rags instead of hair. The dancer wears a *chitenje* from the breast to the knees and bangles on his wrists and ankles. He carries nothing in his hands but keeps lifting the corner of his *chitenje*.

Chidodolo comes into the arena to complain about her husband. Through her song she says, *"He spends his time caressing me,*

*Chidodolo, 'the one who delays'. My husband is a **Chidodolo**, **Chidodolo**.*" [1]

In this context, the word 'to delay' or 'to hesitate' is a euphemism for being impotent. She complains about her husband who is not able to fulfil his marriage duty and give her children. She dances the *chisamba* lifting one leg at a time and touching the corner of her *chitenje* to show that her husband is only able to caress her after stripping her, but achieves nothing else.

This character is performed only at the

girls' initiation ceremony. In recent times it is rarely seen and it may have disappeared in the 1950s. **Chidodolo** decries an impotent man who cannot hide his handicap within Chewa married life. Society pities a woman married to a person marked with this kind of social stigma. **Chidodolo** advises unmarried girls going through their initiation rites to be careful in choosing their future partner if they do not want to be without children and have their husband ridiculed in public.

[1] *"Chisisita* **Chidodolo**. *Amuna anga* **Chidodolo** *(2×) ae* **Chidodolo**.*"*

Chigalimoto

(a structure from the Mua area)

Themes 1) Fertility; 2) Marriage, preparation & instructions; 3) Hygiene in marriage; 4) Faithfulness to the *mwambo*

Etymology **Chigalimoto** means, 'the big motorcar'.

The motorcar night structure is made of a two metre long bamboo frame on which strings are tied and palm leaves are woven in a zigzag pattern. The day version is woven with maize husks. The day version, though uncommon, shows wheels, mirrors and lights. The night structure has none of these details. Only one dancer activates the structure. The motorcar is accompanied by the Kapoli character, dressed in his night or day costume according to the occasion.

The dancer, completely hidden, drives the motorcar into the *bwalo*. **Chigalimoto** moves very quickly, repeatedly reversing and going forward again. It circles the *bwalo*. Kapoli dances following the movements of the car. While the car is in motion the men sing, *"The big car! Inside there are two Europeans; the third one is an African."* [1] Suddenly, the car stops in front of the drummers and they become silent. The crowd hears a faint voice from inside the car. It whispers an incomprehensible language, imitating a European speaking in his mother tongue. Kapoli stands outside the car, like a Bwana's clerk who translates the words of a stranger. He says, *"The Bwana has come with some articles for sale."* The women come closer and gather around the vehicle, listening to the Bwana's whispering words. Kapoli translates for them, *"The Bwana has come with some razors to shave your vaginas. It is up to you to buy."* People laugh and enjoy this great piece of entertainment. The Bwana whispers again. Kapoli explains, *"In this village, there are women who need a penis. The Bwana has come with some penises for sale or for lending."* The crowd bursts into laughter again. The Bwana continues to utter incomprehensible noises. Kapoli goes on explaining, *"The Bwana says that you have to keep your sexual parts clean. He has some soap."* This game continues for ten or fifteen minutes. At the end, the drums start again. The motorcar and Kapoli begin dancing as before. Eventually, they retire to the *dambwe*.

This structure is used mostly during night vigils of funeral, commemoration and/or initiation rites, when there is plenty of beer and no inhibition.

The origin of the structure dates back to the advent of the motorcar in Chewa country. A young Yao, Amini Bin Saidi, describes his first encounter with the machine in 1914. "I saw the motorcar for the first time. I had gone to Blantyre and the car was there. I asked what it was and how it could go by itself. I was told it was a war machine. Therefore, I thought that when the war was over there would be no more cars in Nyasaland. I heard it growl and I saw a man in it. I thought he made it cry out and go. I did not know that it made the noise of its own accord" (Bin Saidi 1936).

The first motorcar was introduced to the Mua area on 17 May 1927. The White Fathers mention its appearance in their mission diary. "Today we received a visit from Dedza, via the new Balaka-Litumbule road. Colonel McKarty and Mr Waull are responsible for checking the new roads by car. It is the first time we see a car. This is the beginning …we will see more." This first encounter for the villagers of the *chigalimoto* must have been surprising, their reaction resembling that of Bin Saidi.

The advent of colonial tax collectors and European missionaries transformed these vehicles into 'machines of war'. Around that time the *gule* members created their own parody of the motorcar. They mocked their oppressors by invoking the image of the Bwana and his slave. Because this new machine was imagined to have a life of its

own, it was an object of fascination. The *Nyau* used it brilliantly for teaching their initiates the wisdom of the ancestors. The parable of the motorcar and the Bwana became a symbol for the home, the wife and the institution of marriage. The husband builds a home at his wife's village so that he may stay and sleep with her. Their intimacy later develops into a third person, a child. The Bwana's clerk (in the person of Kapoli) is not only an entertainer but the supreme initiator and instructor of the Chewa who unfolds the wisdom of the ancestors, transmitting the *mwambo* to their descendants.

The song sung during the performance of **Chigalimoto** is like a riddle. It does not speak about the car with two Europeans and an African driver but describes a home, in which a couple live and give birth to children. In addition, the image of the driver and two Bwanas can be interpreted as a male sex symbol (the penis and testicles). The movement of the car in the dance (backward and forward) suggests sexual intercourse. The faint voice of the invisible Bwana symbolises the birth of the child and its first utterances. The presence of Kapoli next to the car (or home) is most revealing. Kapoli represents the mistress of initiation (*namkungwi*), the one responsible at the dancing ground (*atsabwalo*), and the instructor at the *dambwe* (*akumadzi*). The secret vocabulary of *gule* describes his position as the leading tool used for the creation of any mask or structure. The three roles

mentioned above are like the function of Kapoli, whose duty it is to give advice and transmit the *mwambo*. Besides being entertaining, his use of sexual language and spicy jokes show his involvement as a sex educator. Kapoli may be disguised as a peddler employed by the Bwana. In fact, he represents the collaborators of the chief and the ancestors who teach the *mwambo* and advise people in matters of family life. He tells them to shave their pubic hair, if they do not want to feel discomfort in having sexual relations. He instructs unmarried women to find a husband instead of giving in to prostitution (lending a penis). They should marry according to the prescriptions of the tribe (to buy a penis) with a formal marriage in front of the chief (*ukwati ogwirizira*). Finally, Kapoli admonishes married people who have been involved in sexual activity to keep clean and maintain good hygiene. These practical rules assist the couple in enjoying a happy sexual life, bringing forth a healthy child. Ultimately, the function of Kapoli is compared to that of a midwife who delivers the child and the parents who are responsible for its education. The baby will be instructed until he/she reaches sexual maturity. The child will be told, "Wash your hands. Do not touch fire," and so forth. Such instruction will go on until the young person reaches marriageable age and becomes involved in the process of procreation. Like Bin Saidi, the *gule* members have been instructed that the motorcar has a life of its own and reac-

tions that follow its own *mwambo*, inner logic and mechanism. This perception has been applied to the field of sexuality and married life. Both must be regulated by the *mwambo*, the inner mechanism of marriage. A man negotiates for a wife and then builds a house for her. The outcome is automatic: they will produce a child of their own, provided they have sexual relations (climb into the car). The *mwambo* will inform them about all the ways this is possible. They are instructed on how to perform the sexual act including the methods and positions required for fostering life.

This entire process is summarised in the teaching of **Chigalimoto**. The motorcar model is an allegory about the woman who invites her husband to live in her home and build a house for her. Together they will bear children who will belong to her family group. **Chigalimoto** reminds the couple of the purpose of married life. It is a parable chosen by the Chewa to show that the spirit of the ancestors will bless them with a descendant, provided they follow every detail of the advice offered them. One can only be impressed at the creativity of the Chewa, who were able to draw moral lessons not only from the world of nature and their own environment but even from an imported world and items of technology such as a motorcar.

[1] "*Chigalimoto chokwera azungu awiri winayo ngwakuda…Chigalimoto.*"

Chikalipo and his wife **Honoria**

(red and orange day masks from the Dedza area)

Themes 1) Infertility – impotence; 2) Infertile people should not marry; 3) Promiscuity; 4) Jealousy/envy; 5) Selfishness/self-centredness; 6) Surrogate husband for children or ritual (*fisi*)

Etymology Chikalipo means, 'It is still alive (still exists).' **Honoria** is a woman's name.

Chikalipo and **Honoria** are husband and wife. His red, ugly face demonstrates the ambiguity of his character. The person is bald and the headgear of the mask is made of a combination of wild animal skins, sisal dyed black and purple rags. This signifies his wild behaviour and inability to conform to the Chewa code of morality. A long, straight, red horn stands at the top of his head, portraying his impotence. Two smaller curved red horns on the side expose his quarrelsome personality and bad temper. These curved horns simultaneously symbolise the testicles that are deprived of semen. They also manifest **Chikalipo**'s lack of determination and ambition. His face is fearsome and aggressive. Heavy wrinkles and brow ridge domi-

nate his forehead. His close-set eyes slant downward and are suspicious. They are fiery and the iris is bright red. Black warts protrude from his temples. The short, broken nose shows he has been involved in numerous fights. His mouth is disproportionately wide, snarling and aggressive. The upper and lower teeth are very large and demonstrate that he is violent, quarrelsome, domineering and cruel. His big mouth also stresses that he uses obscene and abusive language. His small ears indicate deafness to advice, particularly that of his wife, Honoria. Whiskers and a goatee add to his sinister look. **Chikalipo** wears a long kilt made of jute reaching the ground and a shirt made of the same material covered with rags. He

carries a club and medicine tail, conveying he is a false lord and a woman hunter.

Honoria has a small orange mask that resembles Mariya in a number of respects: small eyes, mouth and teeth; tribal marks; earrings; and black hair made of sisal covered with a white scarf. Her way of dressing copies Mariya's except that she appears pregnant. She often carries a handkerchief or a winnowing basket symbolising her femininity. This female character is danced by a woman, the *namkungwi*, who instructs the initiates at the time of puberty.

They enter the *bwalo* and it is clear that **Honoria** is advanced in her pregnancy. In front of her, he displays fierce behaviour. He swerves his feet with frenetic energy. He

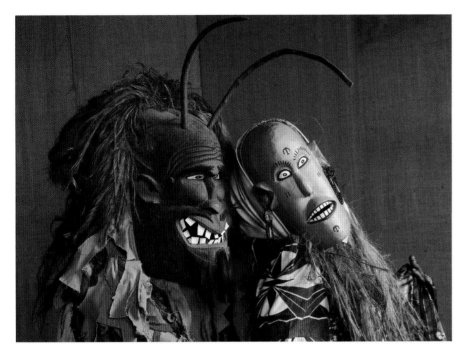

approaches his wife and grabs her buttocks shamelessly. She pushes him back and is clearly uneasy. Through this gesture she indicates she is in her last months of pregnancy and should not have sexual activity. Intercourse at this stage can endanger the life of the child and that of her partner (through the *mdulo* disease).

The couple dances on the occasion of funerals and commemoration rites, for initiation ceremonies and in some rare cases of spirit possession when their service is requested. Responding to the energetic rhythm of the drums, the men start their song voicing **Honoria**'s complaint: "(She says:) *He marries* (many) *women because he is incapable! I need* (desperately) *a child, a child at the breast. My husband is like a child.*

Allow your friend to make love to me so that I can have a child of my own and (rejoice over) *a miracle.* (The wife's own family members mock him saying:) *He failed, Mr He is still alive! You big clitoris, you big girl's clitoris. He failed, Chikalipo!*" [1]

Chikalipo's wife complains that she has been married for a long, long time but has never fallen pregnant because of her husband's infertility. She wishes one of her husband's friends would give her a child, since he cannot. The presence of a child would alleviate her misery and make life more bearable. In spite of her husband's virulent jealousy, **Honoria** managed to become pregnant by another man and is in her last month. **Chikalipo** is extremely cruel to her. He demands sex all the time.

He does not care whether his wife is well or bound by sexual taboos. Although he is spending time with other women, he still forces himself on her, endangering her pregnancy and risking his own life. If she attempts to resist and refuse him, he abuses her and forces her into submission. **Chikalipo** is an ugly person whose behaviour is repulsive. Promiscuous, unfaithful, and stubborn, he has no manners or love for anyone. He is selfish and frustrated. The dread of his handicap has made him completely wild. His wife, her family and the neighbours wish he were dead or would go back to his own village so that they could experience peace again. That is why they have baptised him **Chikalipo**, questioning why he is still alive. Despite their secret wish, **Chikalipo** is still driving everyone crazy with his terrible behaviour and failure to realise his own inadequacy.

The character of **Chikalipo** warns those whose behaviour is a burden to others. **Chikalipo** advises that they recognise the error of their ways and invites them to change. People who suffer from impotence should not marry at all. If they do, they ruin the lives of their partners. Because of their handicap, they may turn to promiscuity, jealousy and possessiveness, and prevent their partners from remarriage. Their frustrations transform their own lives and the life of others into misery.

[1] "*Akwatira akazi tate (2×) chifukwa chosakwata de. Ndasowa ndine mwana woyamwitsa tate. Wamuna m'kulera ede. Talekani anzanu andikwate. Ndione mwana n'laule. Chalaka a **Chikalipo** chimkongo… chimkongo chanamwali tate. Chalaka a **Chikalipo**.*"

Chikuta

(a day or a night structure from the Mua area)

Themes 1) Infertility – impotence

Etymology **Chikuta** is the name for a variety of catfish. The same word is also used for talking about birth. The structure of **Chikuta** plays on both meanings.

The structure portrays a large catfish. The frame is constructed with bamboos two metres long and the width of a man in a prone position. The man lies on his belly and is concealed completely. For the day performance, the bamboo frame is covered with grass. Maize husks are woven onto the surface on strings to simulate the smooth skin of the fish. Other features include an open mouth, 'moustache' (the barbels), fins, backbone, eyes, gills and tail. The

night structure resembles the one described but is more schematic and shows no detail. A zigzag pattern made of palm leaves is woven over the grass and hides the bamboo frame. The dancer inside the structure crawls on his hands and feet and carries the construction on his back.

The catfish moves quickly forward and backward across the arena. It appears on any occasion or rituals involving *gule*. **Chikuta** was often featured in *gule* up to

three decades ago. When **Chikuta** appeared, the men welcomed it with the following song: "*Lend me an axe that I might crack the head of **Chikuta*** (catfish or birth). *Is the catfish not sleeping in the pools? Oh.*" [1] The fish image serves as a ruse for discussing hidden issues. The song addresses the case of a husband who cannot beget children. The members of a family group have had their daughter married for several years and she has not yet experienced

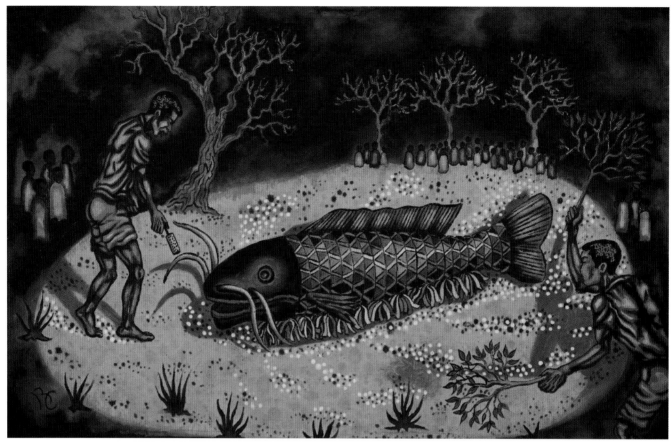

Painting by Claude Boucher and Joseph Kadzombe, 2009

pregnancy. They are convinced that it is the fault of the husband. They are petitioning for another *mkamwini* who is potent. This double entendre is built on coded language such as, "*Lend me an axe that I might crack the head of the catfish*," meaning that my daughter may experience childbirth. The axe is an artifact that represents the husband. It is paraded at the time of the marriage to symbolise male potency. The other expression, "*Is the catfish not sleeping in the pools?*", can be read as, 'Is birth not the product of the semen?' Through a world of fantasy in which the fish glides across the gathering place, the adults discuss their own serious problems and mock the infertile.

The reason behind **Chikuta**'s disappearance from *gule* is not to be found in the rarity of impotence and infertility but in the scarcity of a labour force. Young men go to school and are therefore not available for the task of making structures. This situation is not specific to **Chikuta** but to all the structures of *gule* that have become rare in recent decades. In the past, the construction of large masks and structures was an exercise in collaboration and community spirit. Today as people feel the pinch of inflation and economic pressure, *gule* members are too busy surviving and attending to the basic needs of their own family. Little time can be spared for enjoying this creative exercise of community building. Large and popular structures (like Kasiya maliro, Mdondo, Mkango and Njovu) are still made occasionally for special events, particularly for funeral rites of important people in the community.

[1] "*Bwerekeni nkhwangwa n'katemere **Chikuta**. Si mlamba kuti ugona m'maiwe oh.*"

Chilembwe

(a day structure from the Mua area)

Themes 1) Fertility; 2) Enthronement of chiefs; 3) Guardianship of the *mwambo*; 4) Privacy for parents

Etymology **Chilembwe** is the Chewa name for the roan antelope.

The two metre long structure resembles the shape of an antelope. The details of the roan are missing, owing to the rarity of this species today. The head is made of skin or carved of wood with large ears and curved horns. Sometimes the head is mobile and can be activated by one of the two dancers inside. The body is made of a bamboo frame covered with various materials depending on the region. It can be woven with maize husks or made of grass, rice stems or sisal dyed black (the colour of fertility) to imitate the animal's fur. It may also include a short mobile tail. The maize husk structure is one and a half metres high and reaches the ground to conceal the dancers completely. The second type made of grass, sisal or rice stems, allows the legs of the two dancers to appear as the front and the hind legs of the animal. The legs are covered with the same material used to cover the body. When the antelope's head is mobile, the neck stretches out and can reach the ground to portray that the animal

is browsing or eating maize. The animal is used at initiations and at funeral rites of important people that combine the two rituals. Elders recall that in the past **Chilembwe** was reserved for the enthronement of *Mwali*, the spirit wife. Today it can be used for the enthronement of chiefs (like Njovu, the elephant). **Chilembwe** has (like the elephant) a *dambwe* of its own. The phallic shape of its neck resembles the trunk of the elephant and the roan can be substituted for the elephant in any performance when the latter is not available. The dancers who perform **Chilembwe** have to be protected by keeping the sexual taboos. This reflects the importance of the character.

Chilembwe enters the *bwalo* to the rhythm of the *chisamba* and runs about quickly. It jumps and sways, sweeping aside whomever is in its path. It particularly likes chasing women. Depending on the region, various songs are sung for its appearance. Here are a few samples: "*You, the roan antelope! Come out of the reeds, roan antelope!*" [1] or "*War, Chilembwe! I thought I would go and see the lake! It is dawn, Chilembwe…I thought I would go and see the lake!*" [2] or "*Chilembwe, where have you taken the girl* (initiate)*? Should I not be initiated? Where have you taken the girl, Chief Chilembwe?*" [3] The first song celebrates fertility with elusive language. It praises men's qualities as entrepreneurs, and their skills within the family group or the *mzinda*. This is epitomised in the male organ that metamorphoses in order to produce children and 'redeem' them through ritual intercourse. The roan also epitomised the fertility of the spirit world who ensure this fecundity in the village through the chief. The second song uses the euphemism 'seeing the lake' for having sex, to give a warning to the couple. Dawn has broken and the children are awake. In a Chewa hut (often with no partitions), sex is to be hidden from the eyes of the children. The third song states a non-initiate cannot marry. She first has to be initiated into puberty.

The teachings given in **Chilembwe**'s songs are typical of Chewa emphasis on the sexual code and its importance in initiation. The teaching is directed primarily to the women, the core of the matrilineal group. This is emphasised by **Chilembwe**'s pursuit of women at the *bwalo*. His energy and the movement of **Chilembwe**'s neck glorify fertility. Males (husbands) are praised by women despite the fact that they have to keep a low profile in the affairs of the family group. **Chilembwe** allows us to reflect on the matrilineal dilemma. The husband's position as an outsider is necessary for the propagation of the group. That is why his fertility is exalted. This seems to be the key message of **Chilembwe**. This was definitely more obvious in the past when **Chilembwe** used to be accompanied by two other masks, Namkwanya and Chimbebe. This trilogy highlighted clearly the power of the male sexual organs (penis and testicles). (We see a similar association of Njovu and Ajere) The male principle validated the spirit world and the social order (particularly after the arrival of the Malawi). That is why the roan was presiding over the enthronement of *Mwali* and is still present at the enthronement of chiefs today. **Chilembwe**'s presence for the occasion invests the chief with the power of assuring fertility for the land and the people.

[1] "*Chilembwe turuka mu nsenjere (5x) Chilembwe.*"
[2] "*Nkhondo a Chilembwe tate ndimati n'kaone nyanja, kwacha kwacha a Chilembwe ndimati n'kaone nyanja.*"
[3] "*Chilembwe mwantenga kuti mwana? kumadzi ndisapite? Chilembwe mwantenga kuti mwana mfumu Chilembwe?*"

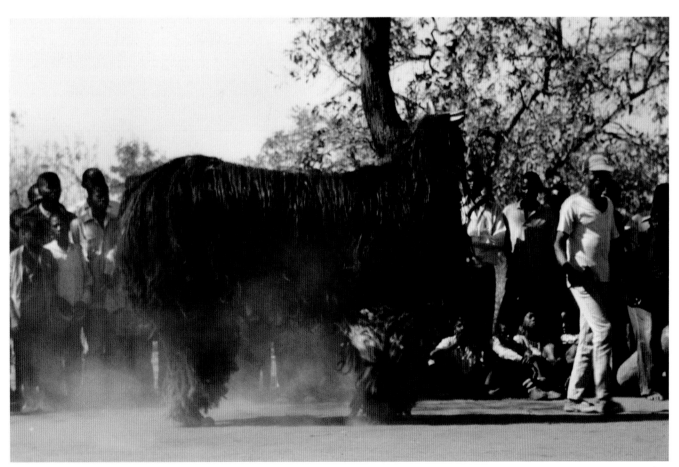

Jannes Gibson, Lilongwe 2000

Chilenje

(a day or night structure from the Mua area)

Themes 1) Sexual taboos (*mdulo*); 2) Women's cycle instructions

Etymology The etymology of **Chilenje** is obscure. It is a foreign clan name common in the south of Malawi close to the Mozambique border. (The railway line originated from Nsanje and went northwards to reach the Mua area in the 1930s.)

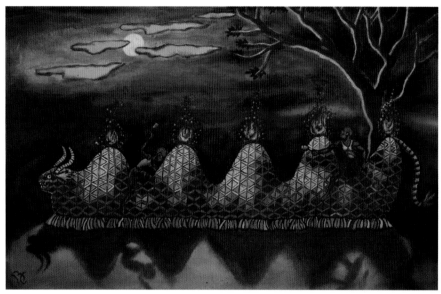

Painting by Claude Boucher and Joseph Kadzombe, 2009

The **Chilenje** structure resembles that of Mdondo. It can reach four or five metres long and two metres high. Five dancers activate the structure. Each dancer stands in one of five humps that form **Chilenje**'s back. The curves between the humps are only 50 centimetres or so above the ground. The front displays a bull-like head with horns while the rear end bears a long tail like that of Kasiya maliro. The structure is constructed with a bamboo frame concealed with grass and palm leaves in a zigzag pattern (for the night performance) and a weave of maize husks (for the day events). **Chilenje** used to be part of funeral and initiation rites but disappeared from the arena in the mid 1960s. The construction goes back to the advent of the railway and portrays a train with its various carriages. The top of each hump bears a flame to simulate the internal lighting of each of the waggons. **Chilenje** races through the arena at high speed; it moves forward and backward. Its guide, holding the rattle, can jump over the low slung waists between the humps, adding to the acrobatic effects of **Chilenje**. The structure dances on the *chisamba* rhythm while the male choir sing: "*Hit **Chilenje**, hit, hit, there is a hump* (up) *here, while there is a hollow* (down) *there. Hit **Chilenje**.*" [1] While ostensibly describing the structure of a train, **Chilenje** elaborates on the sexual rules of family life and the female cycle (*mdulo*). The humps topped with fire indicate that women are undergoing menstruation, while the bottom of the curve shows that their menses are over. Thus the rattle player can demonstrate a joyful mood and celebrate the return of sexual activity. **Chilenje** provides a teaching aid for the couple as to their sexual behaviour during the taboo time when women experience their monthly period.

[1] "*Gunda **Chilenje** (2×) ide **Chilenje**, gunda **Chilenje** pakwera pena patsika, gunda **Chilenje** (2×).*"

Chimbano

(a black day mask from the Mua/Mtakataka and Dedza areas)

Themes 1) Fertility; 2) Adultery & rape; 3) Sexual morality; 4) Sexual taboos (*mdulo*); 5) Role & powers of the chief

Etymology **Chimbano** means, 'the big pincher, grabber or thief'.

The mask portrays an animal head that is a combination of a crocodile and a bull. The muzzle is armed with large teeth that do the catching and trapping (*kupana*) or the stealing (*kubana*). The Mua version has two horns, whereas the Dedza version has four. The tip of the nose can depict the sexual organs of a couple in coition. A long moustache over the nose represents pubic hair. During the dance, the character carries weapons such as a long knife, a spear or a club. He dances in the company of women. Like the chief of the village, **Chimbano** appears as the supreme authority over the women and has the duty to pass fertility on to them. His horns and teeth symbolise this role and stress that castigation (*kupana*) is an essential part of it.

The chief is the head of the community and the official representative of the spirit world. In this capacity, he has the duty to remind the community of the *mwambo*, the rule of morality. During the girls' initiation ceremony, the women and the initiates gather at the chief's house for a night vigil and they sing and dance fertility songs that have a pronounced sexual content: "*Come with it* (the penis) *so that I may touch it. He is a hunter…she was hurt.*" [1] During the singing, the chief and his wife retire to their bedroom and perform the ritual intercourse redeeming the initiates and unlocking their fertility. At the peak of the night vigil, **Chimbano** joins the women. He dances for them and then lies on his back for each of the initiates to come and touch his long moustache (cf. Njovu). The candidates are asked what they have handled. If they answer 'the nose', this is the wrong answer; they are going to be chastised. They are told to answer 'the penis of the chief'. Then each one is taught to use a cloth and wipe the moustache. This mysterious rite is a practical lesson in sexual behaviour, where the woman is to manipulate their husband's genital organs and wipe them clean after intercourse.

The symbolic sexual intercourse between the girls and **Chimbano** clarifies the meaning of the ritual intercourse between the chief and his wife. The girls' fertility has

first to be 'unlocked' by their chief, their parents and their tutors before their future husbands can bring their fertility to reality. Besides, sexual relation implies a mystical relation to the chief and the village as a whole. A girl who has reached her first menses should not have sex for fear of endangering the life of the chief or the village (*kudula mudzi*). When the village is touched by the death of one of its members, sexual activity can affect the well-being of the chief or the transition of the deceased. As the *namwali* undergoes this mysterious rite with **Chimbano**, the *namkungwi* warns her that if she has sex during prohibited periods she will 'hurt' the chief. As **Chimbano** moves towards the chief's house, the male choir sings the following: "*Scold till dusk; this young maiden does not listen to her mother. Till dusk…scold…till dusk. Obstinacy, and not listening, will force Chief Chimbano to go away and leave for later his unresolved family duty towards these children (kulongosola) because of this young maiden …scold till dusk.*" [2] The song deters the maiden from adultery and enforces the importance of sexual taboos. An initiate should choose well her marriage partner and the head of the family group will inform the chief when this has happened. Having sexual relations before the official ceremony is considered a risk to the well-being of the chief. The initiation rite is performed to reinforce the value of obedience and teach her the proper rules of conduct to avoid court cases that might befall her and her family group.

Chimbano also performs at other rituals. His teaching focuses equally on sexual and moral behaviour. He warns married people about the danger of adultery. Such behaviour upsets the harmony of the village and breeds jealousy and dissension. In his song, **Chimbano** is asked why he carries a club. It is because he fears the husbands of the women he has seduced. **Chimbano** is full of desire and covets all women. He engages in intercourse with the wives of other men. "*Chimbano, what do you think you will do? It is bad luck what you have started. This is provocation, Chimbano. It is out of fear he took his club and knife as he is afraid of the husbands of his mistresses. Oh!…what will you do? Bad luck is waiting for you, Chimbano.*" [3] Once the affair is known, married life becomes a hell and the village turns to chaos.

The Mua area recalls an old version of **Chimbano**, very different from the mask. It is in the form of a day or night structure, representing a large crocodile, four to five metres long. This structure used to appear at special initiation ceremonies (*chinamwali cha chimbwinda*) for girls who were pregnant before their first initiation to puberty took place. The structure was used to correct the girls' bad behaviour. The men's song asked, "*What did you do, Chimbano, on your way from the lake to make them pregnant?*" [4] The girls responded that they were looking for trouble: "*May the crocodile bite me!*" [5] During the initiation these girls were chased by the crocodile structure and the women sang, "*Come, come, let Chimbano pinch you. (You foolish girls, since you did not want to listen or obey.)*" [6] This **Chimbano** or crocodile (*ng'ona*) decried sexual misconduct (being grabbed) and emphasised the need for punishment (being pinched).

The Mua area also performs a second type of **Chimbano** (the thief), similar to that of Dedza. This black mask featuring a bull's head is a late introduction in the area. The senior members of *Nyau* confirm that this version is derived from the character of Kwakana that also has horns but has features more like a crocodile. Kwakana's song talks about a wife who refuses her husband sexually because she is in her menstrual period. Nevertheless, he rapes her. Both masks caution against adultery. **Chimbano**'s vigorous performance shows friendliness towards women but not promiscuity. However, the black colour reveals his intention of seduction. This mask suggests a bull that cannot stay in the kraal. It breaks the fence and leaves the cowherd to find a mate in another herd. Its intrusion causes noise, bullfights and death at times. The adulterer is seen as a person who upsets the peace of the village by creating jealousy or rivalry. **Chimbano**'s horns and weapons are meant to be for both self defence and attack.

[1] "*Bwera nayo ndiigwire, nd'alenje…walira walira nayo.*"
[2] "*Kadongolole dzuwa pati? (2×) Kanamwali aka kosamva amake. Dzuwa pati kadongolole (2×) dzuwa pati? Chikhala mfumu a Chimbano angochoka pano n'kusiya maphindi a ana chifukwa cha kanamwali aka. Kadongolole (2×) dzuwa pati?*"
[3] "*Akwata mkazi wa mwini a Chimbano. Waona ena tate de a Chimbano (2×). A Chimbano amati atani? Tsoka mwaliyambalo. Ichi n'chidani tate de a Chimbano. Kaya mantha kaya? Atenga chibonga ndi chikwanje tate kuopa mwini mkazi ogo. Amati atani tate? Tsoka a Chimbano.*"
[4] "*Chimbano mudakatani pobwera kunyanja, Chimbano.*"
[5] "*Ng'ona ng'ona indigwire ng'ona.*"
[6] "*Bwera bwera akupane Chimbano.*"

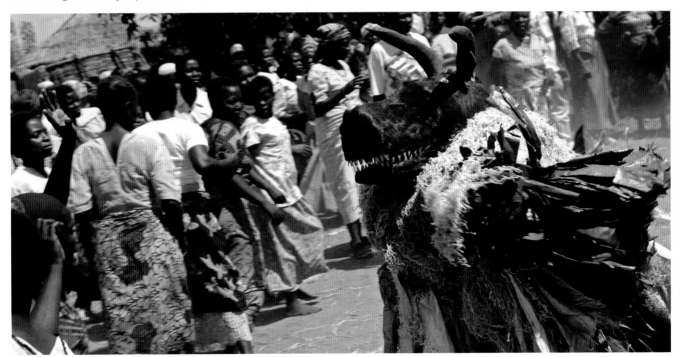

Chimbebe

(a day or night structure from the Mua and Dedza areas)

Themes 1) Fertility; 2) Sexual taboos (*mdulo*); 3) Adultery & rape; 4) Body preparation for marriage

Etymology **Chimbebe** means, 'great heat'.

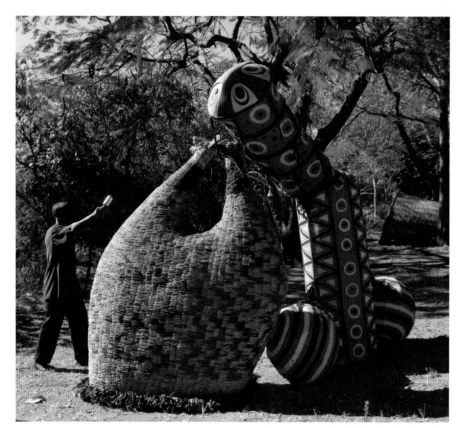

Chimbebe is a day or night structure. It is made of a bamboo frame on which either sackcloth has been stretched or maize husks and white sisal have been woven for the day appearance. For the night performance, the frame is covered with sackcloth. **Chimbebe** can perform at any type of ritual in which *gule* is involved but in the past was featured only during the enthronement of *Mwali*, the spirit wife of Mankhamba. It used to be part of a triad of structures that formed a procession leading *Mwali* to the place of her anointment called the 'seats of *Mwali*' (cf. p. xxiii). **Chimbebe** together with Namkwanya followed Chilembwe (the great roan antelope). The triad of structures had the duty to preside over *Mwali*'s enthronement and also over the puberty rite of young girls that took place at the same site. Chilembwe was the leading structure representing the male organ (like Njovu, the elephant) followed by **Chimbebe** and Namkwanya representing the testicles (like the Ajere who accompany Njovu), the power behind the male organ. The triad of structures symbolised the power of the spirit

world (likened to the human semen) strengthening and anointing *Mwali* or the young girls. Originally *Mwali*'s coronation fell under the authority of chief Chitule and the village of Kafulama had the duty to provide the spirit wife. This suggests that the **Chimbebe** of Mua-Mankhamba is more ancient than that of Dedza. In recent history, **Chimbebe** was divorced from its original triad and often appeared at initiation rites and *dambule*, the annual festival for the dead. **Chimbebe** was last observed around Mua in 1989. After the 1990s the *dambule* ritual started falling into disuse and with it vanished **Chimbebe**.

The two versions discussed here differ in shape and meaning. The Mankhamba-Mua version displays a phallic shape as opposed to the Dedza version that features a humanoid form with a long neck and a dog's head. Despite their differences, they can be viewed as respectively an explicit and less explicit representation of the male organ. In both cases, one has to be sensitised to the Chewa pedagogy, by which sexual references are expressed through

coded language and exaggerated images conveying these highly secret and sacred realities. The Mua-Mtakataka **Chimbebe** represents a penis in erection. This is achieved with a long tube like construction that is made flexible and can extend and move in different directions. The base of the tube is fixed and corresponds to the height of the dancer standing upright. The frame, made of bamboo covered with various materials proper for the day or the night appearances, forms an oval shape in cross-section. Its width corresponds to that of the dancer's shoulders. The length of the tube corresponds to the height of the dancer as he should be completely concealed inside the tube. The second part of the structure is mobile and flexible. It is made of a series of bamboo rings on which sackcloth has been fixed. It resembles an accordion that can stretch and shrink. The accordion when extended reaches around two metres tall. The base of the accordion is fixed in the upright tube and the end of the accordion is closed with sackcloth to form the glans of the penis. The dancer, hidden in the tube, stretches the long flexible bamboo and pushes the accordion upward and side ways to simulate the male organ in full erection. The dancer, inside the tube, moves sideways across the arena and simultaneously activates the construction following the rhythm of the *chisamba*. The crowd is wild with excitement but also perplexed as they fail to understand how the character's dance is possible!

The Dedza version of **Chimbebe** is less explicit. The body shape resembles a granary of human height. It is covered outside with various materials proper for the day or the night appearances (white sisal or white cloth). The granary is topped with a little dog's head and a long neck that stretches like an accordion. Two stiff arms, made of grass and dressed with jute sleeves, are fixed on the sides of the granary and stand erect. The dog's head features red eyes, standing ears, a long snout and open mouth revealing teeth and a long tongue (see illustration on the jacket of this book). The head is brown and there is white under the neck. The features are aggressive and suggest rudeness. The phallic symbolism is revealed in the dog's neck that stretches two metres high. Its construction and mechanism resembles that of the Mua **Chimbebe**

with the same system of smaller bamboo rings covered with painted jute. When extended, the flexible bamboo allows the dog's head to move in different directions. The structure dances across the *bwalo* activated by a single dancer. Possessed by the *chisamba* rhythm, it rotates, shifts direction, swings and gyrates. The dog's head keeps stretching out, moves in various directions and eventually shrinks back into the body. The Dedza **Chimbebe** appears at night vigils of funeral commemorations and of puberty rites. Its popularity comes from the tremendous entertainment it provides. At initiation vigils, **Chimbebe** can take the place of the elephant structure Njovu when the latter is not available. The blindfolded initiates come one by one to touch the neck of **Chimbebe** (instead of the elephant trunk) in order to receive fertility.

The two versions of **Chimbebe** described above celebrate the power of life and fertility. This power is looked upon as a gift to the community at large and to each individual family group from God and the ancestors. Males transmit this power for the benefit of the group. Optimum fertility is guaranteed by the observance of the rules regulating sexual activity amongst the Chewa. These rules belong to the *mwambo* and they are specifically defined in the *mdulo* complex. The *mdulo* taboos oppose 'hot' to 'cool'. Some members of the community are perceived to be 'hot' because they are sexually active. Others are perceived to be 'cool' because they have not reached sexual maturity or because they have temporarily removed themselves from sexual heat owing to the situations they experience. There is no 'lukewarm' stage in

between. Situations like birth, a woman's menstruation and extreme grief are seen as hostile to sexual activity and are considered as unhygienic. They are a threat to the life of a newborn or as an offence to the rule of solidarity. Close relations and partners of those who suffer these states are bound to express solidarity with them by abstaining from any involvement in sex for a short period. This is clearly expressed in the way **Chimbebe** shrinks back into its casing and remains at rest. This corresponds to the *kudika*, meaning sexual abstinence. Once the lapse is over, sexual relations are resumed and life returns to normality.

The *mdulo* prohibitions are particularly emphasised in the first song sung by the male choir for the **Chimbebe** of Mua-Mtakataka. Sexual taboos are prescribed during the time a woman experiences her period or after she has given birth or during the time of funerals. "*You* (husband) *oh, how do you dare to sleep* (together) *in the house? He has a mind of his own, Mr Very hot!*"[1] The song encourages men to control their sexual appetite and show compassion towards their partners. The song sung for the Dedza **Chimbebe** is less focused on the *mdulo* as such but stresses the importance of the *mwambo* with regard to courtesy and hospitality. "*Mr Very hot, let him wander, wander, the big beast* (the penis)*! It thought it would enjoy a nice evening, but it found its match because of its envy, Mr Very hot!*"[2] The song tells the story of someone who was invited to his neighbour's house for an evening. He betrays his host by committing adultery with the host's wife. The second of the Mua **Chimbebe** songs celebrates the power of life giving and warns the initiates

to prepare their bodies for conjugal relations. "*The big beast has wandered, wandered, the big beast* (penis). *In the heat, in the warmth. The space is small, dark and stained with blood.*"[3] The song describes the penile erection during sexual intercourse. It warns the initiate who will marry soon to be prepared physically and psychologically. During the initiation the girls are taught to massage and enlarge their sexual organs (*kukuna*) in order to facilitate penetration. The Chewa women perceive body preparation as a precondition for fertility and for success in marriage.

This evolution of the **Chimbebe** structure has brought into focus the centrality of the *mwambo* including the importance of the *mdulo* prohibitions and body preparations for women. All highlight the value of harmony between the living and the dead and between the living members of their community. These rules represent a 'quasi-moral order' maintaining the precarious balance of their world, and the delicate balance of the individual and the community. Harmony is the key to their growth and prosperity. It promotes solidarity, self-control and fortitude. Above all, it guarantees serenity because they live as their ancestors have lived. They praise the power of life that guarantees their continuity as a tribe in perpetuity.

[1] "*Iwe iae* (2×) *uyu agone m'nyumba! Izo n'zakenso* **Chimbebe**."
[2] "**Chimbebe** *chipondeponde chinyama. Amati akacheze de, apeza chipongwe de chifukwa cha kaso de* **Chimbebe**."
[3] "*Chapondaponda chinyama* (2×) *chinyama* (2×) *kumbebe, kuntanthama. Bwalo lachepa, akuluwende e, eeeee.*"

Chinkhombe

(a grey female night mask from the Dedza area)

Themes 1) Sexual taboos (*mdulo*); 2) Women's cycle instructions; 3) Women's cycle hygiene; 4) Fertility

Etymology Chinkhombe is a type of shell that is often used as a spoon in Chewa domestic life. Pots and other household utensils symbolise femininity and are often used to discretely talk about female sexuality.

In the Dedza region, **Chinkhombe** is the main mask used for sex education during the female initiation ceremony. The mask of **Chinkhombe** resembles that of Yiyina. The face is that of an owl with 'ears', round eyes and a red bill. The owl is rarely seen but often heard. So, the owl delivers his message of wisdom to the young initiates. Feathers are painted white. Black spots cover the face and a large red mouth is set below the red beak. The red mouth represents the female external genitalia and the

red beak pointing downward towards the mouth is meant to be a penis at rest. The red colour stresses sexual prohibition. The black and white feathers show that womanhood leads to fertility. The presence of red on the mouth and the beak emphasise that fertility can only be achieved through undergoing monthly menstruation. This is the period during which sexual activity is banned under the *mwambo*. The scarf on the head of **Chinkhombe** is made of white cloth to show that after menstruation a

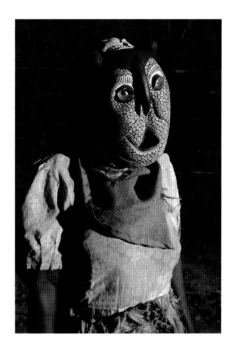

woman is ready to welcome her husband. The three strings of beads on the neck of the mask recall the beads worn about the waist to arouse the husband when the wife is permitted sexual contact.

During the night vigil of the *chinamwali*, the *namkungwi* wears this mask. She wears a *chitenje*, under which she has tied her beads and a small kilt made of sisal. She comes among the initiates at the rhythm of the *chisamba* moving her hips while the women sing, *"This is **Chinkhombe**, this is **Chinkhombe**,"* [1] or the following song, *"The clitoris is long like a raven's beak."* [2] Other masks proper to the girls' initiation, such as Mleme, often accompany her. After the dance, **Chinkhombe** disappears behind one of the houses and removes her sisal kilt to show the initiates that she has had her pubic hair shaved and she is now wearing a white hygienic towel. She explains the function of this cloth to the girls and the sexual prohibition attached to it. Other characters engaging with these themes include Namwali tiye in the Dedza area and Chiwekuweku in the Mua area. **Chinkhombe** is a valued teaching aid to instruct young women about sexual function, menstruation, hygiene and the rules of sexual behaviour through a woman's monthly cycle.

[1] *"Ichi n'**Chinkombe** ae de (2×) ede ae ede ae."*
[2] *"Chimkongo chosololoka chonga ng'onkha."*

Chintabwa

(a pink day mask from the Mua area)

Themes 1) Sexual taboos (*mdulo*); 2) Women's cycle hygiene; 3) Concealment of the woman's period

Etymology Chintabwa means, 'the big flat board'. This word is borrowed from the carpenter's vocabulary in order to teach about women's physiological changes in a euphemistic fashion.

Chintabwa belongs to the very ancient type of Kapoli. He normally wears a feathered headgear and a loincloth to which a long tail-like object is tied. The body of the dancer is smeared with ashes. The tail is referred to as 'the big board'. It is made of rags, is about two metres long and drags behind the dancer as he moves. At times the feathered headgear is enhanced with a small, carved mask painted in red or pink. The mask reveals small eyes in a half-moon shape and a bird beak pointing down towards the mouth. The tip of this beak is painted bright red expressing blood and prohibition. The mouth is a small opening in an inverted V-shape that has no teeth and is also painted red. There are no ears and the entire face is adorned with feathers. The character portrays a nightjar bird (*lumbe*). The behaviour of this bird is studied during the girl's initiation ceremony. The nightjar is presented to the initiates as a clever bird that has the habit of concealing its nest and eggs. Its behaviour is likened to a menstruating woman who must conceal her condition. The bird-like face also spells out the sexual prohibition during menstruation. The feathers on the mask represent the pubic hair surrounding the sexual organs. The bill and the mouth focus on the male and the female organs that must remain separate. The fact that both are painted red suggests menstruation has already started and sex is already banned. The song says, "(What is more visible is what is red,) *the board* (closing the access), **Chintabwa**."[1]

The Chewa visualise the sexual ban as analogous to barricading a door or an opening with a big board (*chintabwa*). The board is a euphemism for the hygienic towel women wear during menstruation. The dancer's attachment at his waist, which resembles the nightjar's tail, is meant to express this. He moves around, forward and backward swinging his tail in a careless manner. **Chintabwa** portrays a woman who is sloppy in not securing her hygienic towel and, therefore, revealing to the public that she is in her period.

A senior man who has been initiated into the female *chinamwali* always performs the character of **Chintabwa**. He usually performs at initiation rites and funerals of important people at which initiations take place. During the initiation, the character emphasises the teaching of the *namkungwi* concerning hygienic rules related to menstruation. The initiates are taught to wear their hygienic towels with care and to make sure that they are properly fixed so that nobody can detect their condition. In his mimicry, the dancer ridicules a woman careless in these matters who needs to go back to be reinitiated a second time because she does not follow the advice given by the *namkungwi*. During the funerals, the character of **Chintabwa**, with his spicy joking tone, provides a welcome entertainment needed to cheer up the mourners.

The character of **Chintabwa** is a reminder of the sexual code and the rules of hygiene surrounding the female cycle. He provides the married couple with practical rules of conduct at such times. The Chewa believe that sexuality is sacred and that sexual taboos originate in the spirit world. That is why practical matters like these must be carefully monitored by their ancestors.

[1] *"Aya ya ya ya **Chintabwa**, **Chintabwa**, **Chintabwa**cho."*

Chiudza

(a day accessory from the Mua area)

Themes 1) Incest; 2) Sexual taboos (*mdulo*); 3) Self-control/discipline; 4) Sexual obsession; 5) HIV/AIDS & sexual diseases

Etymology **Chiudza** is a euphemism for ejaculation.

The character **Chiudza** is featured with a headcover made of dried banana leaves or skins to conceal the dancer's identity. The dancer also wears a kilt made of fertiliser bag laces. The centre-piece of the dancer's costume is a special accessory attached to his waist and protruding from the front of the kilt. This construction consists of a large carved penis in erection, painted black or pink. The glans is painted red and sometimes testicles are added. The pubic hair is rendered with dark animal skins. The dancer may wear no leglets or armlets but his body is entirely smeared with black mud. **Chiudza** carries a two metre long stick to emphasise his promiscuous character.

Chiudza performs only during the daytime. He appears for initiation rites, funerals, and commemoration ceremonies and for the remembrance of the dead (*dambule*). In the arena, **Chiudza** limps and feigns sickness. This is a ruse to hide his criminal behaviour. As soon as he starts dancing, he anchors his long stick in front of him and holds it with one hand or both, moving his pelvis obscenely to the right, left and centre. His dancing style resembles that of Ndapita ku maliro, but **Chiudza** shifts from the right leg to the left and then dances sideways. As he reaches the climax of his performance, his pelvis rotates frenetically and his suggestive movements become more and more explicit. The male choir, joined by the women, sings the following: *"This ejaculation comes from you, **Chiudza**!"* **Chiudza** replies: *"No no!"* People continue: *"It is scandalous to have sex with a child, **Chiudza**!"* [1] The song is sung with some variations depending on the village that performs it. An example is, *"To grab a child,"* or *"To give* (her) *a child."* [2] The song reveals very secret and forbidden matters. A father has satisfied his sexual urge with his own daughter or with the daughter of his wife's sister. The family group of his wife has discovered his unforgivable behaviour. Mr **Chiudza** denies responsibly and pretends that he was too sick to have sex. The variation of the song attempts to camouflage the fact *"he grabbed a child"* or confronts **Chiudza** with the possibility of giving his daughter a child. At the time, **Chiudza**'s wife was bound by sexual taboos. It might be her menstrual period or she was required to abstain from sex (*mdiko*) and was unable to attend to his

sexual needs. Following the ancestors' advice, **Chiudza** should have shown sympathy and solidarity with his wife. He should have exercised self-control by abiding by the rules of prescribed abstinence (*kudika*). Instead, **Chiudza** committed incest with his own child, or one of his wife's family group. Moreover, he is faced with the possibility of giving his own daughter a child. Among the Chewa, incest is considered a major crime and a form of witchcraft. The character of **Chiudza** was invented in *gule* in order to deter people from such criminal behaviour. Through him, the Chewa voice that uncontrolled sexual appetite can destroy a person's life, and lead him or her to addiction, promiscuity and sexual diseases that can be fatal. Chewa morality promotes sexual abstinence and self-control as the key to a long and happy life.

Chiudza was last seen around Mua in the mid 1980s. Several reasons are evoked for his disappearance from the arena. The first reason is to be found in the decline of the annual festival for the dead (*dambule*). Many masks and structures are featured during these festivities. **Chiudza** was one of those. As the economic situation of the Chewa subsistent farmers became more precarious, villages were no longer able to brew the large quantity of sacrificial beer required for this occasion. Slowly the *dambule* festival vanished and with it the major display of masks and structures. Another reason somehow linked to financial constraint and the meagre resources, is the fact that the numerous characters that involved mud-smearing became less popular and were performed less regularly. They were abandoned because of the cost of soap needed for washing after the performance.

A third reason, alleged by some informants, relates to the growth of mainstream Christian churches and the multiplication of new churches coming from outside Malawi. In this rationale, **Chiudza** would have been discarded on account of his shocking look, displaying his 'nakedness' in public. **Chiudza**'s appearance was seen in the 1980s as unacceptable and clashing with changing times and with a mentality qualified as 'modern' and 'Christian'. Consequently, the profound message of **Chiudza** was overlooked or obscured

owing to his sexually graphic appearance. Yet around the same time, the scandals of incest cases were being broadcasted on MBC (Malawi Broadcasting Corporation) radio at peak hours, when the children were not yet in bed. Stories of child 'defilement' are today disturbingly common in the national newspapers. Yet the proclamation of such stories, countrywide and in front of children, does not seem to upset public opinion and alert the conscience of parents. **Chiudza**'s teaching, following Chewa pedagogy and their use of cryptic codes, showed more discretion. Incestuous scandals were classified as exclusively adult talk, hidden from children's perception. Today, child sexual scandals are public headlines. Is the latter approach more effective in controlling such behaviour or have the Chewa lost sight of the value of the *mwambo*?

[1] *"**Chiudza** mwa iwe, ae **Chiudza** ai ai. Zinalaula e. Kuipa kukwata mwana, **Chiudza**."*
[2] *"**Chiudza**, chiudza a, laula e, **Chiudza**, kukwata mwana, **Chiudza** walaula."*

Chivuwo or Vuwo

(a day structure from the Mua area)

Themes 1) Secrecy in sexual matters; 2) Sacredness/joy of pregnancy; 3) Abortion; 4) Witchcraft

Etymology Chivuwo is the Chewa word for pelican.

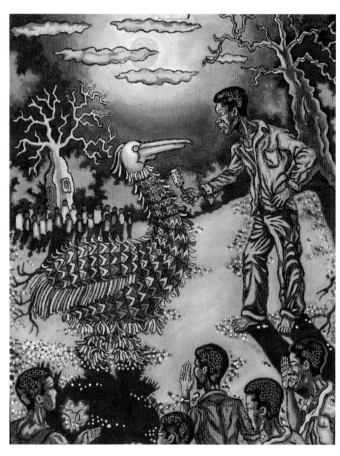

Painting by Claude
Boucher and Joseph
Kadzombe, 2009

bwalo repeating the same movements, following the rhythm of the *chisamba*. Both male and female choirs sing, *"The pelican is white, the bird from the lake. It fishes out small fish (matemba)."* [1]

Several *gule* songs talk about the bird from the lake (water). This signifies that all the structures are constructed at the *dambwe* called *kumadzi* (water), in a secret language known only to the initiates. The pelican is said to be white, which signifies the colour of semen. The neck and the head symbolise the male organ. During the initiation and immediate preparation for marriage, both boys and girls are taught the modality of the sexual act and its purpose, pregnancy. All these instructions are protected with strict secrecy. This secrecy applies to instruction and also to the intimacy of married life. To divulge any of the secrets is called *kuvula* – 'to strip'. The same word, with a slightly different pronunciation also means 'to fish out'. The song talks about *vuwo* – fishing out small fish. These cryptic words have two meanings. Firstly, an adult should not reveal intimate secrets. Secondly, people who are envious and practise witchcraft should not 'fish out' a pregnancy, meaning to provoke an abortion through magical means.

Chivuwo teaches the community the art of keeping secrets, particularly with regard to sexual matters. It also teaches about the sacredness of life and pregnancy and discourages people from practising witchcraft and abortion.

[1] *"Mbalame ya ku nyanja Vuwo (2×) kuyera Vuwo, chivula matemba."*

The structure, representing a pelican, is made of maize husks for the day and palm leaves for the night. It is about a metre high and is activated by one dancer. The material used for construction is stretched on a bamboo frame. It has no discernable wings. The head with its elongated beak rotates on the long slender neck.

Chivuwo performs at initiations, funerals and *dambule*. **Chivuwo** makes a bow after each step. Its head bends down and its tail goes up slightly. It roams around the

Chiwau

(a red and black day mask from the Mtakataka, Mua and Dedza areas)

Themes 1) Promiscuity; 2) Sexual taboos (*mdulo*); 3) Pride/arrogance; 4) HIV/AIDS & sexual diseases; 5) Recent politics

Etymology Chiwau means, 'the one who was burned or disfigured'.

This medium sized mask is typically divided vertically into two halves, one black and one red. The black side expresses that the person was burned. His features have been atrophied by fire. The half-open eye has poor vision. The mouth is slightly distorted and the ear twisted. The red side shows a healthy face with a well-formed eye, eyebrow, ear and mouth. The expression of the mouth is perplexed. The half-red, half-black nose is small, pointed and cut in geometric blocks. Sometimes there is a narrow line of hair made of black goatskin on the top of the mask. At least one Dedza version varies somewhat from this typical colour pattern. Here the mask is predominantly red, with the black on one side more restricted in extent, and covering the area around the eye and mouth, as well as the ear. The Dedza version is bald. Baboon skins may be added to the rag headgear in some *mizinda*, to portray a medicine man. The dancer wears a tattered jute suit. A short kilt made of fertiliser bag laces hangs from the waist. His outfit is embellished with armlets and leglets. If he is portrayed as a medicine man, small containers of

medicine hang from his waist. He carries a long whip, to warn people not to follow his example. The character of **Chiwau** was introduced in the 1960s. His appearance is not restricted to any particular type of ritual. The character comes into the arena steadily swerving his feet. He moves forward brandishing his arms in a way that seems to push aside the womenfolk indicating he wants the women far away from him. In response, the women tease him with the following songs: *"Sex (the penis) is nice in the early morning after sunrise. I will put it in myself, Chiwau,"* [1] or *"Chiwau, you have put it outside! Come, come with it."* [2] As **Chiwau** dances and interacts with the women, the men reveal the unfortunate story that has shaped **Chiwau**'s personality. The Dedza choir states: *"Chiwau was burned. He was pretending he was going to work, but, he managed to get himself burned."* [3] The Mtakataka version adds: *"He was crippled by Chikanga (the famous medicine man)."* [4]

The red of the mask symbolises that **Chiwau** is a stranger and that he encountered heat associated with sex and bad blood. The monkey skin on his headgear and the containers of medicine around his waist indicate that he works as a medicine man. The first song suggests he uses his profession for another purpose, to take sexual advantage of his female clientele.

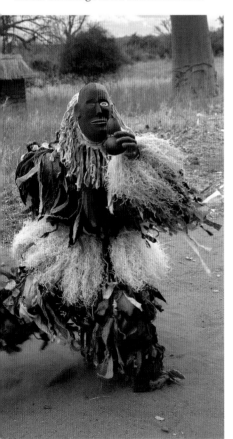

Chiwau claims to be the top medicine man in the country. He surpasses all of his colleagues. His pride, vanity and arrogance distract him from concentrating on increasing his knowledge of plants and herbs. He spends his time enjoying illicit sex with his patients. One day, he had relations with a woman who was undergoing her cycle and hid this from him. **Chiwau** contracted the *mdulo* disease and was in great danger of death. His sexual organs withered under the contact with her bad blood – her heat – and they turned black. This is how he got the name of **Chiwau**, the 'one who was burnt'. Pride in his medicine and power caused him to overlook the medicine of others. He believed he could cure himself but he could not. His condition worsened. In the end, he reluctantly asked for help from the neighbourhood medicine men, whom he had distrusted. They were eager to offer their treatment because they wanted to take revenge and teach him a lesson. They prescribed a potion with which to wash his face. Humbled by the disease, **Chiwau** did what he was told. He discovered that he had been tricked. One side of his handsome face had become full of blisters and was turning black. He lost one eye, and his ear and his mouth became distorted. **Chiwau** was disfigured. He was not only in danger of death but had lost his looks and sex appeal. No woman would have any interest in him now. **Chiwau**'s experience made him fear women forever. Women have crippled him and that is why he pushes women away when he performs.

Shifting blame to women is typical of Chewa mentality. The men deny their social responsibility in this way. The character of **Chiwau** communicates that it is wrong for a *sing'anga* (or anyone) to trust only their own power and wisdom. Pride and arrogance isolate individuals from the advice and assistance of the community. Following only one's own wisdom, '*nzeru za yekha*', the individual shows his stupidity. **Chiwau** lost interest in his profession and wasted his talents by hunting women. He sickened with *mdulo* or other sexual diseases. The character of **Chiwau** stresses the importance of the *mwambo*. His teaching reinforces the sexual interdicts. Sexual relations with menstruating women lead to the 'wasting' disease (*mdulo*) and death. Sexual abuse and promiscuity reap nasty punishments such as venereal disease.

Some areas, such as Dedza, do not perceive **Chiwau** as a medicine man. They interpret him as a simple villager who pretends to go out of the village to seek employment but, in fact, is only interested in being a playboy. In this context, his burnt face symbolises the sexual disease he has

acquired. The majority of *mizinda* look at him as a false, misguided medicine man who indulges in promiscuity.

That one of the songs of **Chiwau** makes reference to Chikanga is also interesting. Chikanga Chunda was a well-known medicine man in the mid-1960s who practised witch-hunting in the Mua and the Mtakataka areas. He is an historical figure, synonymous with the anti-witchcraft movement during the transition of Nyasaland to Malawi and the period of unrest at the time of independence. Chikanga came to expose witches and purify the land from all evil. The character of **Chiwau**, as a medicine man, appears in *gule* around that same period. By a curious coincidence, Kamuzu Banda was also a medical doctor. After he took up his new office as President he gave up the practice of medicine. People recall that at rallies and party meetings Kamuzu Banda was always surrounded by crowds of women he called his '*mbumba*', his extended family. Women moved around the country following their beloved doctor. They were forced to leave children and husbands behind who complained bitterly but had no means of preventing their wives from being pressed into service by the autocratic regime. Husbands who did protest could face imprisonment, even death, under the President's regime. These women suffered tremendously, often deprived of food and shelter. During the day, they risked lorry accidents and being crushed in the crowds. In the evening, they were forced to 'entertain' ministers, party officials and the entourage of the President. Under these oppressive conditions, a social system of legalised rape and adultery was dictated. Kamuzu Banda, who took pride in calling himself a Chewa, did not seem concerned for the *mwambo* (traditions and customs) or the harmful effects of such practices on the family lives of his fellow tribesmen.

The husbands remained at home, powerless and frustrated. In the veiled protest of the great dance, they kept the voice of rebellion alive. In the arena, the medicine man they called **Chiwau** was ridiculed and punished by the ancestors for his immoral behaviour.

[1] *"Mbolo imakoma cha m'mawa kutacha ndiika ndekha Chiwau."*
[2] *"Chiwau mwaika padera, bwera nayo, bwera nayo."*
[3] *"Chiwau, Chiwau de (2×) adawaula, adawaula toto de. Amati apite ku nchito, koma adawaula."*
[4] *"Ogo adapundula, adapundula kwa Chikanga."*

Chiwauka

(a red and black day mask from the Kaphuka area)

Themes 1) Infertility caused by promiscuity; 2) Promiscuity; 3) HIV/AIDS & sexual diseases

Etymology Chiwauka means, 'that which itches' or 'is irritated' or 'has warts'. It commonly refers to plants where contact with the sap or other product of the plant can provoke skin problems, or fire.

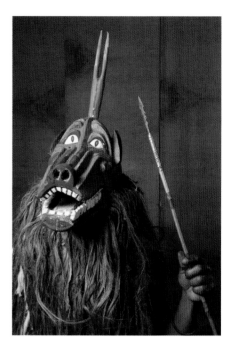

Chiwauka portrays a man who seeks employment in order to support his family. He comes back home without a job but sick with a sexually transmitted disease. He transmits the disease to his wife. As a result the couple becomes sterile. Their contact with fire has resulted in a bitter wound. The mask has an animal-like head with a long snout and sharp teeth. The divided face is painted in three colours (reddish-brown, orange and grey), conveying the idea of burns and blisters. Numerous protrusions and swellings on the mask also convey this meaning. A split horn (painted in red-brown and grey) stands erect on the forehead to portray the cause of the blisters. The ears are set close to the head to show he is deaf to advice. The black sisal headgear gives the mask a frightening appearance. The dancer's body is entirely concealed with long strips of bark. He carries a bow and arrow during his performance at initiation rites. The dancer rotates around the arena and pretends to aim his bow and arrow. The men sing, *"**Chiwauka**, Mr **Chiwauka** was burned. He wants to hunt but he will get burned, Mr **Chiwauka**. Bad luck, **Chiwauka**. He fell on the fire when he was looking at the little animal. The arrow* (penis) *burned **Chiwauka**! This is what happened to him, **Chiwauka**."* [1] This song has a pronounced sexual meaning and teaches the initiate that infertility is the consequence of promiscuity.

[1] *"A **Chiwauka**, **Chiwauka** de e, abambo awauka! Anati akasake liwamba, adzawauka, abambo a*

*Chiwauka. Tsokatsoka **Chiwauka**, **Chiwauka**, chokagwa pa moto popenyetsa kanyama, mpaliro de e a **Chiwauka**. Atere a e de **Chiwauka**."*

Chiwawa

(a grey day mask from Mozambique south of Dedza)

Themes 1) Pregnancy instructions & childbirth; 2) Sexual taboos (*mdulo*)

Etymology Chiwawa means, 'a pain in the neck', 'noisy disagreement' or 'violence'.

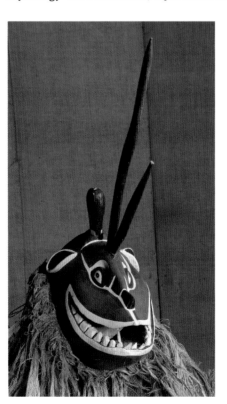

The face of **Chiwawa** is one of an animal-like creature. The predominantly dark grey mask has a large smiling mouth with protruding white teeth ready to punish those who do not respect his teachings. Three red horns (see below) erupt from the head. The red eyes express danger and guile, warning against infringement of the moral code. The ears are flattened against the head and manifest deafness to the same rule. The mane is made of bark strings from the bush, identifying him with the male (the hunter). This male characteristic is made explicit by the bow and arrow he carries. His costume for the day performance consists of a jute shirt and a sort of kilt that reaches the ankles. He wears a large belt, leglets and armlets. For the night performance, he simply wears a loincloth. The character performs at initiation and funeral ceremonies incorporating puberty rituals. **Chiwawa** circles the *bwalo* and gyrates at a fast speed, simulating hunting for sex. The choir sings the following: *"An infertile wife is as delectable as a pregnant wife* (in her last months). *Mr Pain in the neck! Mr **Chiwawa**! Some women want to make trouble* (chiwawa). *My wife refused me. I keep thinking of sex* (in my heart). *An infertile wife is as delectable as a pregnant wife* (in her last months)." [1]

Chiwawa's song describes the condition of a woman who is in her last month of pregnancy. Her condition means she must avoid sex. She fears for the life of the child she is carrying. She has arguments with her husband and refuses him. The character of **Chiwawa** teaches the couple to be considerate to each other, especially at the time surrounding the last few months of pregnancy and the period after the birth. The mask spells out the sexual code to be adopted during such times. It does that with the help of the three horns (at different angles and lengths) atop the mask. The tallest horn is erect and is painted red with a black cap which teaches that normal sexual activity leads to conception and pregnancy. The second horn is drooping and painted red without any black, meaning that the pregnancy is at the seventh or eighth month. Sexual contact should be avoided for fear of harming the child. The last horn is all red and con-

tracted, representing the period that follows birth in which sexual activity is absolutely forbidden until the 'redeeming of the child ceremony' (*kulongosola*) has taken place. The beastly features of the mask highlight the threat to those who neglect the sexual taboos. Conversely, the smile on the face of the mask conveys that good health and blessings await those who abide by the moral code.

[1] "*Mkazi wachimbwira akoma ngati wamimba ode (2×)* **Chiwawa**, **Chiwawa**. *Akazi ena amafuna dede* **Chiwawa**, **Chiwawa**. *Mkazi wamtaya ine dede, chikumbukumbu cha mtima tate, mkazi wachimbwira akoma ngati wamimba*, **Chiwawa**, **Chiwawa**."

Chiwekuweku

(a female night mask from the Mua area)

Themes 1) Marriage, preparation & instructions; 2) Becoming an adult/sexual maturity; 3) Promiscuity; 4) Self-control/discipline; 5) Sexual taboos (*mdulo*)

Etymology **Chiwekuweku** is a ghost that frightens children.

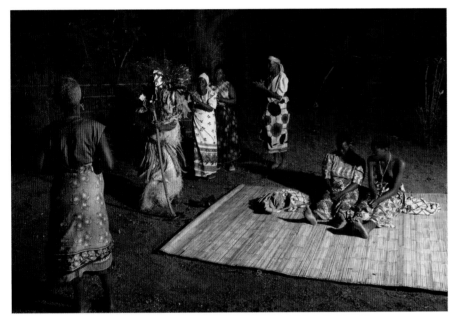

The character belongs to the women and is danced by them. The women's masks are perceived to be at the origin of *gule*. Women claim that *gule wamkulu* belonged to them in the past, before men stole it from them. The 'mother' of *gule* is the *chisamba*, the dance of first pregnancy. The women-danced masks deal with the physical changes of girls in their reaching adulthood and preparation for marriage. These masks, and **Chiwekuweku** in particular, have the function of instructing the initiates during the puberty ritual.

One of the *anamkungwi* adopts the disguise of **Chiwekuweku** during the night vigil before the closing of the initiation. The mask is improvised and made of all kinds of fibres. She wears a man's attire such as shirt and trousers. **Chiwekuweku** portrays a potential husband or any man who is eager to take advantage of the initiate. The character enters the *bwalo* at the rhythm of the *chisamba* while the women dance and sing: "**Chiwekuweku**, *today! Knock! Knock! You girls, let us celebrate the night vigil. Tonight you*

are grown up. Tonight you abandon childish behaviour. Tonight you are grown up."[1] **Chiwekuweku** dances and shakes his pelvis to suggest he is aflame with sexual ardour. There can be interaction with the initiates. For example, the initiate may place her head between **Chiwekuweku**'s thighs, and he leads her as she crawls on her hands and knees. There is a variety of other songs associated with this character that illustrate the social and the sexual advice given to the initiates. "*When you see visitors, you show a long face* (long drooping lips)."[2] (Now that you are growing up you should not pout for visitors but welcome them with joy.) "*The sound of the drum is calling for* **Chiwekuweku**. (The first menstruation is the door to marriage.)"[3] Another song stresses the physical differences between men and women and discourages promiscuity. "*When you look at me you say, I am obsessed with sex, I have also my own organs covered with pubic hair.*"[4]

Chiwekuweku introduces a fictitious future husband. The girl studies his personality and qualities in order to discover how

she can relate to him when married. A similar version of this song discourages her from being duped by a stranger who will leave to her an illegitimate child. "*When you see me, don't say, I have an uncontrollable sexual urge,* **Chiwekuweku**."[5] This means, 'Do not get sexually involved indiscriminately, for fear of falling into the trap of early pregnancy.' With regard to a future husband, the initiate is equally warned not to comply with all of her partner's sexual demands. She has to be watchful over her own condition (her cycle and also before and after childbirth). To welcome her future husband at such moments would endanger him and their own child through the disease *mdulo*. Thus, **Chiwekuweku**'s roles at initiation are multiple. He introduces the initiates to the prospect of growing up with the appropriate behaviour to ensure her future. He warns her about being seduced by strangers and encourages her to be prepared for a serious commitment with a partner she will call her husband. Also stressed is the importance of faithfulness to him and the protection for him against the *mdulo* disease by keeping the *mwambo* and the sexual taboos that will allow their union to last. The extraordinary enactment of the girl crawling with her head between his legs may symbolise the husband's dominance in sexual matters and his prerogative to initiate sex.

On occasions, **Chiwekuweku** will dance with Kanamwali kayera.

[1] "**Chiwekuweku** *lero (2×) go go! Ae odi odi anamwali lero tichezere lero mwakula! Mwano muleke mwakula lero.*"
[2] "*Mwaona alendo (5×), chimnomo lende.*"
[3] "*Ng'oma ikulirayi, ikuitana Abwatsute.*"
[4] "*Ndziti akaona ine, udziti ngwa msala*, **Chiwekuweku**, *sipapanga pa bweya.*"
[5] "*Mukaona ine, musati ndine wa msala*, **Chiwekuweku**."

Chizinga and his wife Msalankhulitse

(a red day mask and an orange day mask from the Tete area)

Themes 1) Generation gap in marriage; 2) Deafness to advice/stubbornness

Etymology The name **Chizinga** comes from the verb *kuzinga*, 'to surround, to protect'. (This mask from Tete is not to be confused with Chinsinga, which has a different etymology and meaning.) **Msalankhulitse** means, 'Shut up. Do not interfere.'

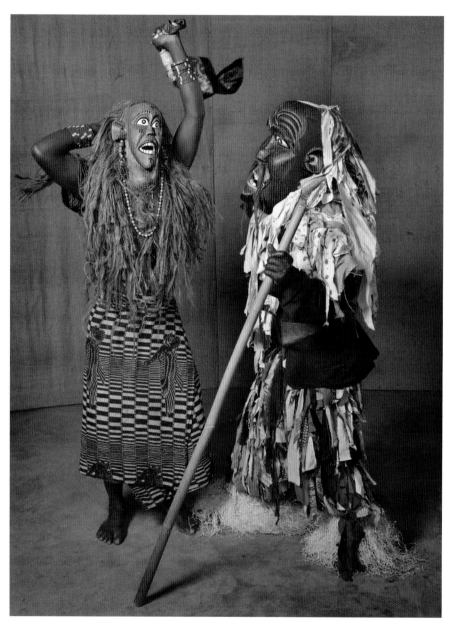

Chizinga is a large red mask with deep forehead wrinkles, a flat nose, and large eyes that peer far into the distance. There is a black moustache and beard. The head is bald and flat with a white circle on the top. These details portray an old fashioned man belonging to the senior generation. He wears a tatter suit of different colours. A large belt highlights the suit partly hidden by a black torn jacket. He carries a stick as he enters the arena with his wife,

Msalankhulitse, and they move to the rhythm of the *chisamba*.

Msalankhulitse is represented as a young girl with an orange face. She has large ears to show that she should be attentive to her husband's wishes, and wears heavy earrings. Her teeth protrude to symbolise that she is eager to voice her opinion. Her eyebrows are defined and she bears numerous tribal markings on her face to portray her as belonging to the newer

generation. She wears a little scarf on her long black hair, a wretched dress, and a filthy *chitenje* over it showing that she has no time to look after herself. She waves her handkerchief to show pride and attraction for her husband.

In the arena, **Chizinga** starts dancing and jumping around **Msalankhulitse** with great energy. She strives harder than ever to impress her husband by moving her hips in a sexy manner, giving the impression of being a woman of loose morality. Toward the end of the performance, she runs away from her husband and goes out of the arena, leaving him alone while the men keep singing, *"What did you think you were doing, old man, by marrying such a young girl? Look at yourself now, old man. You remain alone. She left you hung up to dry, Chizinga. She refused to put up with sexual taboos, the young girl. Is it what you have done, what you have done, Chizinga?"* [1] **Msalankhulitse**'s song echoes in the background with the women singing, *"What I Msalankhulitse have experienced, my friends! I was married to an old man, Chizinga,* (who keeps saying,) *Do you have the gourd of medicine to pour on the bald head of the old man?* (I answered yes, but) *when the medicine is over, I will also be over* (will run away), *Chizinga!"* [2]

These two characters portray a married couple that cannot live in harmony because of the wide generation gap that separates them. The partners belong to different generations. Each generation has its common practices, its own rules (*miyambo*) and its own expectations of married life. The Chewa certify that this kind of marriage does not last. **Chizinga** is supposed to surround **Msalankhulitse** with his love (like a fence that protects her). In return, he is requesting her love and her attention reflected by anointing his bald head. He imposes his rules and dominates her. She is told to shut up (*msalankhulitse*) and to keep her views for herself. She is kept so busy complying with his wishes that she has no time to look after herself. In the end, **Msalankhulitse** cannot bear it any longer. She is a prisoner of his possessiveness and decides to escape in order to have a life according to her own choosing.

Chizinga is portrayed as a senior person full of wisdom and good advice for others

but unable to apply them to his own life. He would discourage others from marrying a much younger wife but he himself failed to follow his own advice. **Chizinga** is a man who is blind to himself and deaf to others' opinion. He is convinced that his opinion is the best and should be imposed on all. **Msalankhulitse** belongs to a different generation. She is perceived as lazy, sloppy, unclean and sexually wanton, a person who recognises no rules of conduct (*opanda*

mwambo). But impressions can be deceptive. She belongs to the new generation that has a different way of thinking and doing things. She believes that she should be allowed some freedoms and to express her own views so that she may be a complete person.

The couple of **Chizinga** and **Msalankhulitse** prove the secular wisdom of the Chewa. Their ancestors certify that marriage between people of generations far apart often ends in failure.

[1] "*Kodi mumati mutani tate andalawa kutenga, kutenga mtsikana tate de? Taonani lero mwatsala nokha andala tate de. Wasiya pa dzuwa a* **Chizinga** *tate. Wakana zodikazo mtsikana tate de o tate. Kodi mwatero, mwatero de a* **Chizinga***?*"

[2] "*Anzanga* **Msalankhulitse***, chomwe ndidaona ine…ndakwatiwa ndi andala a* **Chizinga***. Kodi uli nayo,* **Msalankhulitse** *nsupa yotsira dazi la andalalo? Likauma e tate e tate, ndingochoka ndine a* **Chizinga***.*"

Chokani

(a red day mask from the Pemba area)

Themes 1) Infertility – impotence; 2) Impotence can be cured; 3) Alcoholism/alcohol does not solve problems; 4) Infertile people should not marry

Etymology **Chokani** means, 'Get out and leave!'

This large 36 centimetre mask depicts a husband married at the village of his wife. He is a Chewa with tribal marks but the red colour indicates that he is an outsider. **Chokani** is half bald and displays a painted white circle on top of his head. The face is that of a young man with a growing moustache and goatee. This contrast between old age and youth is done purposely to emphasise that he may not remain married very long. **Chokani**'s behaviour and personality do not qualify him for marriage. **Chokani**

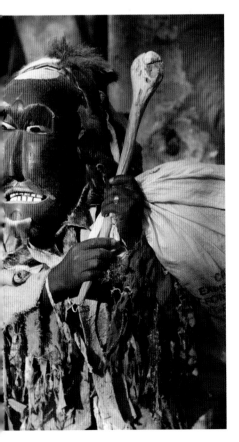

has the bulging fixed eyes of a drunkard, a slender aquiline edgy nose and salient fat cheeks. His mouth is locked in a grimace and the clenched teeth express shame. The chin is strong and square and the protruding ears are set low to highlight his deafness. **Chokani**'s expression casts him as a fool who is not to be taken seriously. The headgear of the mask is made of Vervet and Samango monkey skins to convey that he is a stranger coming from the bush. This is a common description for a husband coming from another village. **Chokani** wears a tatter suit and a large belt, into which he has tucked weapons like a club or a knife. He carries a huge bag in which he has put all his belongings as he is being chased from his wife's residence.

Chokani's origin dates from the end of the 1950s. He appears in a variety of rituals except initiation rites. He enters the arena in a great hurry. He runs quickly, carrying his luggage, which he lays down at the entrance of the *bwalo* before dancing. He pulls out his weapons from his belt and starts threatening the ladies while moving his pelvis lewdly. He quickly becomes carried away, and rotates his pelvis with more excitement and begins to simulate sex. The male choir explains, "*Do not just drown your sorrow by calling for beer* (instead of having sex). *One more round! Beer for everyone!* (Moreover) *he refuses to go to the medicine man. Myself, I want a child! You should not just be calling for beer! Beer for everyone!* **Chokani** (get out and leave)*!*"[1] As **Chokani** finishes his dance, he grabs his luggage and leaves.

The song voices the complaints of **Chokani**'s wife who desperately wants a child. **Chokani** is unable to beget children but shows an obsession with sex in order to hide his impotence. He refuses to attempt

any remedies and he declines to go to the medicine man for help. Instead, **Chokani** drowns his shame in alcohol; he is drunk daily. He spends all his income on drinking and does not support his wife or her family. Ultimately, the head of the family group resolves to end the marriage and sends **Chokani** back to his own village. **Chokani**'s chances of growing old as a married person are slim. He has no alternative but to go back to his mother (if she is still alive) or to his own sisters and to be considered like a child without status or honour. His new name will be *Chitsiru* – the fool. **Chokani**'s comical look is evidence of this scenario. His pronounced cheeks emphasise that he has grown fat because he cannot do anything in bed. He may get involved in another problematic marital union, far away from home where his reputation is not known. The song implies that **Chokani**'s handicap could possibly have been cured if he had consulted a capable medicine man. One of the most vital lessons that the youth can learn from **Chokani**, is that one does not solve one's problems by becoming addicted to alcohol. If **Chokani** had been sober, he would have been more amenable to consulting a learned *sing'anga*. **Chokani** warns young people who adopt the habit of drinking in order to prove that they are 'real men' that once they are hooked on alcohol, it is too late. They forget their family responsibilities and ruin their future.

[1] "*Musamangochita ubwerebwere undizungulire kwa sing'anga toto. Ine ndikufuna mwana, osamangochita ubwerebwere, undizungulire.* **Chokani***.*"

Galu wapenga

(a black or red day mask from the Khwidzi and Mua areas)

Themes 1) Sexual taboos (*mdulo*); 2) Patience; 3) Drug addiction; 4) Uncontrolled anger

Etymology Galu wapenga means, 'the mad dog'.

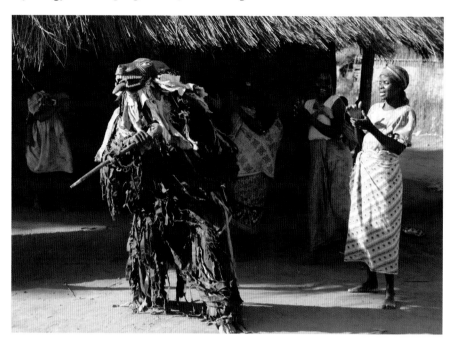

The mask of the mad dog is sometimes carved of wood or made of canvas, bark or skin. It can also at times be made of folded plastic. It has a long snout with teeth, standing or prone ears and sometimes a long tongue hanging out of the mouth. The dancer wears the tatter suit of *gule*. He spends his time chasing men, women, children and drummers about the arena. He dances with great intensity and impressive stamina, swerving his feet and jumping on one leg. While he is busy chasing the audience, the men sing, *"The dog is mad! (3x)"*[1] or *"The dog is mad! Don't bite the child, mad dog!"*[2]

The image of a dog is very derogatory in Chewa society. To call somebody a dog is a severe insult. The character evokes the image of a rabid dog: a person who is under the effect of an evil medicine, drugs or an uncontrolled anger. Such a person becomes completely crazy and is ready to bite anyone.

Galu wapenga was introduced in the Mua area at the end of the 1960s. It portrays a husband who has to keep sexual taboos because a child is sick or his wife has recently had a baby. He has been deprived of sex for a long time and cannot bear it any longer. He wakes up frustrated and angry, and he chases his wife and his children out of their own house.

In such issues relating to children, the ancestors prescribe periods of prolonged sexual abstinence. Husbands must be patient in the knowledge that the time of sacrifice will pass.

[1] *"O tate* **Galu wapenga** *o tate* **Galu wapenga**, **Galu wapenga**."
[2] *"***Galu wapenga*** *tate usamdyere mwana tate* **Galu wapenga**."

Gandali and his wife Namalotcha

(red and orange day masks respectively from the Dedza area)

Themes 1) Sexual taboos (*mdulo*); 2) Sexual taboos for funerals; 3) Duty of chief to abstain; 4) Old age/ageing gracefully

Etymology The name **Gandali**, 'this hide', is a euphemism for the glans of the penis. **Namalotcha** means, 'the one who spends all her time making fancy things', the fancy things being a euphemism for sex.

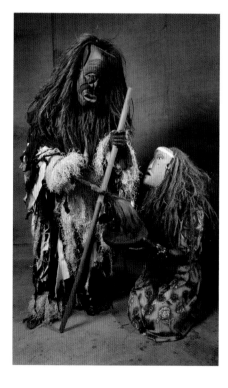

Gandali and **Namalotcha** appear together in the arena, as husband and wife, during funeral ceremonies of a chief and at initiation rites. **Gandali** is depicted as a senior man, a chief, signified by a white spot at the centre of his bald head. The middle of that spot is topped with a black protrusion like a mushroom: it represents a penis without strength. His hair is made of sisal dyed grey. The face shows heavy features with a long black moustache. He wears a fine jute suit with a sisal mane, kilt, armlets and leglets. He carries a stick and a medicine tail. His wife **Namalotcha** is a senior woman. Her orange mask portrays a severe but compassionate face, with tribal marks and greyish hair. At funeral rites she wears a funeral headband (*n'dakalira*) to show that she is in grief. She wears a dress and has beads at her waist. She carries a small pot full of medicine. Like Mariya and Chadzunda, they dance together. As they move from the back stage to the arena, **Gandali** soaks his medicine tail in the pot of medicine carried by **Namalotcha** and blesses the audience. The men sing, *"Some women, when they bend down, their sexual organs are drawn together, they show their nakedness and their hygienic towels."*[1] The women continue with their song: "(He calls her:) *Namalo, Namalo let's*

have sex. Namalo left during the funeral." [2]
Namalotcha, the one 'who spends all her time making fancy things', is overworked with providing sexual services to her husband.

Both songs stress the importance of sexual taboos during the time of funerals. Women should be reserved and avoid provoking their husbands during this period in which sexual abstinence must be strictly kept. The failure to keep such rules will compromise the journey of the deceased and his settling down in the spirit world. The blessing with medicine by **Gandali** is understood as the husbands' gratitude to their wives for protecting their lives, by enforcing these sexual rules. As the couple reaches the arena, both dance with energy and enthusiasm. **Gandali** swerves his feet with force while **Namalotcha** moves her hips skilfully, to show all her love. At the end of the dance, she takes the pot of medicine and breaks it on **Gandali**'s head. **Namalotcha** leaves the *bwalo* in a hurry, while her shameful husband follows her. The songs sung during their performances explain their little play: *"Gandali took his wife to the bwalo. She carries a small pot, a small pot. She took that small pot to the bwalo and broke it* (on his head) *in the bwalo. He was ashamed and went back* (home)*."* [3]
A second song allows us to enter into the intimacy of their married life: *"On his head,*

there is a mushroom. He wanted to have sex but there was no erection until dawn." [4] The women answer back with the following song: *"Mushrooms fade in the sun."* [5]

This cryptic language describes that **Gandali** forced his wife to have sex when she was mourning. His demands for sex are unreasonable considering his old age. He is ashamed to discover that his sexual capacity does not match his urge and desire. He is left ashamed in front of his wife, whom he has forced to break the sexual taboos and prevented from mourning her relatives properly. **Gandali** is old, unable to age gracefully. He still think of himself as a young rooster, but his inability to have an erection reminds him of an inevitable reality: *"Are mushrooms fading in full sunshine?"* The small protrusion on **Gandali**'s head suggests this. The masks of **Gandali** and **Namalotcha** are painted in red and orange to convey this message of prohibition and sexual taboos.

The Dedza and the Mua areas have a large three metre long structure that is also called **Gandali**. The structure is danced by two men and looks little like the rhinoceros it is said to be. White sisal is stretched on a bamboo frame to make the body and black plastic covers it. The legs of the dancers are obscured by dried banana leaves. This structure portrays an angry animal with protruding teeth and two horns emanating

from the top of the head rather than the snout. Eyes may be present. The structure is predominantly black, but the front part of the head is pale and made from woven maize husks. This pale section is also called the 'mushroom', just like the mask. The message of this important structure is identical to that of the characters of **Gandali** and **Namalotcha** of Dedza. Like the elephant, this structure is danced by senior men and is constructed at a special *dambwe*, reserved for it. It is exclusively performed for funeral rites of important people and is used as an alternative to the elephant when it is not available. However, the teaching of the **Gandali** structure focuses more on the duties of the husband than those of the chief.

[1] *"Ana akazi akapolama, nyini amanga mtolo (2×) a e mkhole, a e mkhole! Ana akazi akapolama, nyini amanga mtolo."*
[2] *"**Namalo, namalo** (3×) alipo gule! **Namalo namalo** wasiya maliro!"*
[3] *"**Gandali** de (2×)! kutenga akazi n'kupita nawo ku bwalo, n'kunyamula kamphika, n'kunka nako ku bwalo kamphika, n'kumpwanyirira ku bwalo. Wachita manyazi wabwerera."*
[4] *"Eae pa'mtu pali bowa eae pa'mtu pali bowa amati akwere mwamba, lende lende kwacha."*
[5] *"Bowa ungafote pali dzuwa."*

Painting by Claude Boucher and
Joseph Kadzombe, 2009

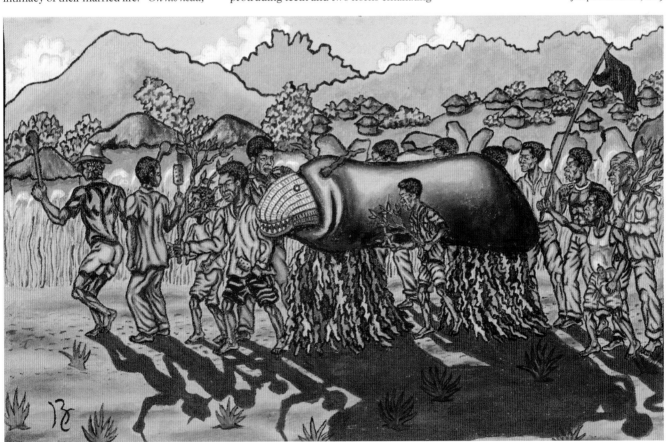

Gulutende

(a black day mask from the Mua and Dedza areas)

Themes 1) Faithfulness; 2) Polygamy; 3) Irresponsibility in marriage

Etymology The exact etymology of **Gulutende** is unclear but may refer to a cow or bitch 'on heat'.

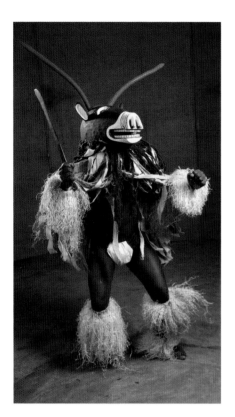

The **Gulutende** character has a cow-like mask with long horns. The creature has protruding teeth and a mane made of rags, and portrays aggressiveness. The colour black reveals nocturnal clandestine activity. The dancer wears leglets and armlets. In the Mua area, he has a short jute kilt and in the Dedza area, a loincloth. He carries a knife. The character swerves one foot at a time, moving his pelvis in a suggestive manner, in order to attract the attention of the ladies. He demonstrates he is sexually 'hot' by running after them in the arena. He imitates the behaviour of a young bull. He shifts dust with his feet, kicks, and manifests his sexual arousal that cannot be contained. This character portrays both men and women who are unfaithful in marriage, and who are always on the lookout for adulterous affairs. **Gulutende** can visit the village at any ritual, whenever *gule* is involved.

The character from the Mua area discourages adulterous behaviour and polygamous marriage for both sexes, and shows that promiscuity ruins other people's lives, as well as their own families. His song reveals this: *"Who snatched **Gulutende**'s wife? Part your legs, let me see if you are pregnant by **Gulutende**."* [1]

The Dedza version of this mask and its song stress the tendency to take a second wife when one can hardly cope with the financial burden of the first family: *"**Gulutende**, look, your companion has cheated you…this is a second marriage, which is enjoyable only during the dry season* (the season of plenty). *Now we are in the rainy season* (the season of famine). *My companion has cheated me!* (He said:) *Now go! The wife of your companion has cheated you, **Gulutende**!"* [2] **Gulutende**'s song speaks of the temporary euphoria of having a new wife. Soon one is confronted with the obligations of providing food and clothes for both families, a situation incompatible with one's economic status. In these cases, the first wife will often be neglected. Attention will go to the new wife, who is typically younger and more attractive. **Gulutende** of the Dedza area protests the unfairness of being abandoned and left without care or security.

[1] "*Watenga ndani mkazi wa **Gulutende**, **Gulutende**, futukula miyendo tione watengera **Gulutende**.*"
[2] "***Gulutende** taona anzako adakunyenga ede ede tate. Ichi n'chiwiri chikoma m'chilimwe. Lino n'dzinja anzanga, anandinyenga. Inu mupita! O de de o de de, akazi wa anzanu adakunyenga **Gulutende**.*"

Hololiya (Dedza)

(an orange day mask from the Dedza area)

Themes 1) Promiscuity; 2) Unity & harmony; 3) Deafness to advice/stubbornness

Etymology **Hololiya** is a deformation of the girl's name, Gloria.

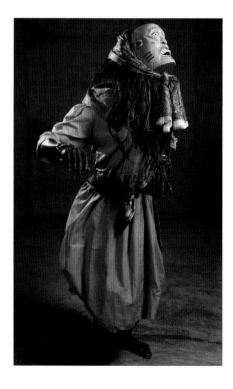

The character is female, although danced by a male. Sometimes the mask is carved of wood and painted orange. It shows the features of a young woman with tribal markings and tattoos, and long black hair like that of Mariya, covered with a small scarf. She wears beads and earrings. At other times, the mask is made of cloth with a very sketchy face. Her dress is that of a young woman with firm breasts. She dances in a sensual manner and excites men as the women sing for her, *"Gloria has gone. Go and get married. Let her go."* [1]

Hololiya portrays a woman whose sexual life is like that of a prostitute and who cannot settle and live a proper family life. She upsets the harmony of the village by being the cause of jealousy and quarrelling in other families. She is deaf to any advice and is on the way to imminent disaster.

This is one of two **Hololiya** characters. It is quite rare for *gule* to depict promiscuous behaviour in a female mask.

[1] "*Wapita **Hololiya** tate de (2×). Napite kaone banja ae toto napite.*"

Hololiya (Mua)

(a carved or cloth day mask from the Mua, Mtakataka and Golomoti areas)

Themes 1) Adultery & rape; 2) Playboy; 3) HIV/AIDS & sexual diseases

Etymology Hololiya is a deformation of the girl's name, Gloria.

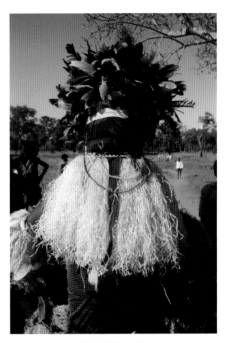

Claude Boucher, Chitulo Village, December 1990

Hololiya is well known in the Mua region as a type of Kapoli originating from the Dedza plateau around the 1940s. It was first introduced in a village close to the mission and was later adopted by many villages around the lakeshore. **Hololiya** resembles Kapoli, especially in the costume and his dancing style. The most notable differences appear in its headcover. It is not made of feathers but displays a carved facial mask or a cloth mask. The original **Hololiya**'s face appeared in dark colours and was later developed into a wide range of colours including white. The features of the face are generally male and youthful. The few facial details include the eyes, the eyebrows, the nose, the mouth and the ears. If the face is shown with a piece of cloth, these details are stitched onto the cloth. **Hololiya** is characterised by a cowlick made of any material, feathers or a cow tail and demonstrates his maleness and his potency. At times, two cowlicks are visible, one in front and one at the back of his head. These emphasise his voracious and uncontrolled sexual appetite. The headgear can be made of a variety of materials such as cloth, a wig or anything else that looks like hair. Two strips of cloth often hang in the space between the two cowlicks to look like the flaps of a colonial hat or appear as earrings. Usually **Hololiya** wears a kilt, leglets and armlets. These can be made of fertiliser bag laces, strips of cloth or even a *chitenje*. The armlets and leglets are often embellished with colourful strips of cloth to emphasise that he wishes to attract women. **Hololiya** usually carries a whip or a ceremonial axe, signs of his masculinity and the castigation of the spirit world.

Like Kapoli, **Hololiya** sings for himself and the women continue the song he has started. However, **Hololiya** sings in a low-pitched voice so there is no doubt that he is a man. In the arena, **Hololiya** often appears in pairs and they display an elaborate choreography. They swerve their feet with great energy and then they move forward, swing around, change direction and walk backward. **Hololiya** performs at any event in which *gule* is involved. In the past, **Hololiya** used to sing only one song but today his repertoire has increased to incorporate various themes. The most ancient song voices the lament of his wife, who suffers because of **Hololiya**'s irresponsible behaviour: "*My husband, behave decently,*

Hololiya Hololiya, no!" [1] **Hololiya** cannot resist women and his wife fears contamination from sexual diseases that he will bring into the home. **Hololiya** discourages adultery.

This version of **Hololiya** differs from that of Dedza. There the character represents a 'loose' woman.

[1] "*Am'na anga dziyendeni bwino Hololiya Hololiya ae!*"

Kamano

(a black day mask from the Mua and Dedza areas)

Themes 1) Sexual taboos (*mdulo*); 2) Laziness; 3) Responsible parenthood; 4) Irascibility; 5) Batwa – Bantu relations

Etymology Kamano means, 'long teeth that protrude'.

Kamano appears in two different versions of the mask and costume, depending on the area of origin. The carved mask from Dedza is predominantly black and bald. It has protruding teeth, piercing eyes, a flat white nose and erect ears like those of a wild animal alert to the noise of the forest. His face suggests dullness and discontent. The headgear of the mask is made of white rags, to express a duplicitous personality. He wears a sleeveless jute shirt and a kilt made of rags over a *chitenje* that accentuates his obscene movements. His costume is completed with white leglets and armlets made of sisal. He carries a club, a spear and a knife as he enters the arena. However, he dances only with the spear in his hand, to suggest that he is a hunter of both wild game and women. The men sing: "**Kamano**, *buy a winter pullover,*

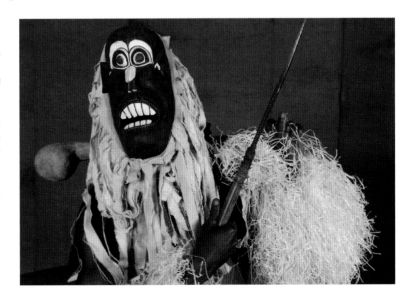

June is fine, but in July there's a cutting wind, buy a pullover." [1] **Kamano** spends most of his time near the fireplace or under the hot sun. He pretends that he is not well and therefore cannot work in the garden. His wife knows very well that he is lazy and that he thinks only of warming himself in bed with her. As a result, another child will soon be on the way. **Kamano**'s secret wish is obvious in his performance. His movements are suggestive. The rotation of his pelvis shows that he is yearning for sexual relations. His weapons, especially the spear, are suggestive of marriage and sex. He is a hunter and his manners are rude. He chases people away as he approaches the dancing ground. He slaughters chickens in order to find meat. In an agricultural economy, like that of the Chewa, meat can only be eaten with *nsima*, maize porridge, the product of farming. Hunting is seen as only a part-time activity. Producing children presupposes that they can be fed. **Kamano** is too lazy for either farming or feeding his children.

The **Kamano** of the Mua region is commonly portrayed with a black cardboard mask or with a black cloth stretched over a wire frame. The face is monkey-like and shows huge eyes and protruding teeth. Sometimes, **Kamano** appears without a mask. The human face is smeared with black mud, to accentuate the white of the eyes. The upper and lower lips are tied with string, to expose the gums and teeth, creating a repulsive 'grin'. The **Kamano** of the

Mua region wears only a loincloth and his entire body is smeared with black mud. He carries weapons like that of Dedza, especially a spear. Sometimes **Kamano** of Mua can carry firewood. In contrast to the Dedza character, **Kamano** of Mua is seen as hard-working, rather than lazy, evidenced in his carrying of firewood. Though the character does not perform in the arena and is only used, like Kampini, as a forerunner of the *gule wamkulu* rituals, he goes about the villages with his weapons, chasing people and forcing them to retreat to their houses. On his way, he 'slaughters' chickens with his weapons. He does not sing or dance and only emits incomprehensible sounds that frighten people. The sexual overtone is also present. When the women meet him on the way, they sing for him, *"Today there will be sex."* [2] **Kamano** replies with vulgar movements to show that soon sexual taboos will be lifted after the current ritual is over.

The character of **Kamano** of Dedza reveals the tensions that arise when a hunting economy encounters an agricultural one. The early Chewa history favoured intermarriage between the Batwa and Banda clans. The fact that **Kamano** is always portrayed as short and dark in complexion suggests that he may be Batwa. **Kamano**'s character could reflect the prejudices of the farmers toward a hunting way of life. The Batwa were renowned for being extremely potent and powerful in bed, pro-

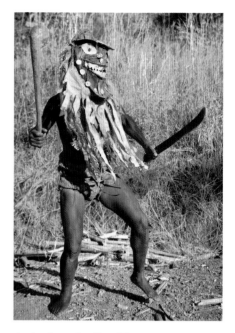

ducing large families. Their hunting lifestyle disqualified them from agriculture and gave them the reputation of being irrevocably lazy. The Batwa were also regarded as aggressive and notably short-tempered at any mention of their short stature. These characteristics are evident too in the Mua version of **Kamano**.

[1] "**Kamano** *(4x) gula juzi, Juni padera, Julayi awazira, gula juzi.*"
[2] "*Lero pali gule.*"

Kamba or Mkulemetsa

(a day structure from the Mua and Khwidzi areas)

Themes 1) Sexual taboos (*mdulo*); 2) Redeeming (*kulongosola*); 3) Fertility

Etymology Kamba is a tortoise.
Mkulemetsa means, 'to be tired from carrying something heavy', referring to the shell of the tortoise.

The tortoise structure **Kamba** is about a metre and half long and close to a metre high. It is activated by one dancer who crawls on his hands and feet. The *mizinda* around Khwidzi village call this structure **Mkulemetsa**. The two structures are similar in their appearance, dancing styles and significance. Their construction differs only slightly. They are used for day or night performances. The shell is made of a bamboo frame on which strings are tied and woven with palm leaves (in a zigzag pattern) or loosely attached in small bunches (night performance). The day costume is woven with maize husks of various colours producing a pattern of square boxes. The head is made of jute bags or grass. The day costume is more realistic,

with eyes, nostrils and a mouth depicted, rarely seen on the night structure. The difference between **Mkulemetsa** of Khwidzi and **Kamba** of Mua is that the first model has a fixed neck and a fixed head. In the Mua version, these are activated with strings. The neck protrudes and is withdrawn into the shell allowing the head to appear and disappear. The legs of the tortoise are made of leglets and armlets completely covering the arms and the hands, the legs and the feet of the dancer. The structure appears for preference during night vigils of funerals, commemorations and initiation rites. **Kamba** moves at least ten times around the *bwalo* in the manner of a tortoise, popping its head and neck out following the rhythm of the drum. For the

Khwidzi version, **Mkulemetsa** stops at the centre of the arena during the initiation rites and the initiates come to grab the neck of the reptile in order to be 'redeemed'. The songs sung for the two versions vary slightly. The Khwidzi men sing, *"Did you see what gets tired, did you see what gets tired…? Stop being impolite."* [1] The Mua men sing, *"Tortoise, tortoise, it moves with the shell."* [2]

The first song is a piece of advice given to an initiate who is not well behaved and shows bad manners. Did you see what gets tired? This refers to the burden a man has to carry during ritual periods of extended sexual abstinence. A husband must abstain from sexual relations with his wife for those times. The second song emphasises that the

tortoise is endowed with its own power and that its shell is light for its owner. The head and the neck of the tortoise are obvious sexual symbols. The initiates of Khwidzi touch the neck of the reptile just as the initiates of other areas touch the trunk of the elephant (Njovu). This signifies that they anticipate the handling of the sexual organ of their future husbands. This *mwambo* is practical advice given by the *namkungwi* in which the future wives are told to excite sexually their husband by caresses. In the Mua area the movement of the head and the neck of the tortoise suggest an erection that should lead to an emission of semen. The shell symbolises the testicles in which the penis disappears when it is at rest. The tortoise model teaches a fact of life: there cannot be any emission if the penis does not go into erection. The *namkungwi* tells the

initiates to imitate the tortoise. This instruction is given in order to detect an impotent husband: if the tortoise does not manage to show the head then this husband cannot be called a man and he cannot beget children. He will only give false hope to the wife and compromise the peace of the family.

The funeral and puberty ritual context also provides the mourners with an extra piece of advice: the withdrawal of the neck of the tortoise teaches sexual abstinence on the occasion of death and other transition rites. These include the female cycle; before and after birth; when a child is away from home or sick; when a child from the family undergoes initiation to puberty; and when a close member of the family dies or is in transition to the spirit world. All of these occasions prescribe sexual taboos (sanctioned with the *mdulo* disease) and require ritual

coolness. The period of abstinence is called *kudika*, 'to wait'. This is one of the important messages of **Kamba**. In the Khwidzi structure it is expressed by its very name: *kulemetsa* – 'to be tired from carrying something heavy'. A husband who is keeping sexual taboos for weeks or months has reason to be tired and burdened. The song of Mua also expresses this. The tortoise moves around with its heavy shell. The same song, however, expresses a second meaning: 'to be heavy with seeds'. This is stressed in the dance by the stretching out of the tortoise's neck and the appearance of its head. The male fluid has been accumulated and concentrated by a long period of waiting and now has to be freed and released in order to re-establish normality and 'redeem' the candidate in transition. This is called *kulongosola*, 'to reintegrate', to reincorporate the new creature into the family circle. This is usually done through ritual intercourse concluding such periods of abstinence.

The tortoise structure reminds the husband that it is his duty to redeem a child or situation. One has to resume sexual relations and re-establish the flow of life, allowing it to continue. The lifting of these bans and the release of power conclude any birth, initiation and funeral rites. It concludes the woman's menstrual cycle and the mourning period after burial and commemoration ceremonies. It is the privilege of the tortoise to remind the married couple of this duty, without inciting the curiosity of the children. Chewa tales inevitably stress the wisdom of the tortoise. The *Nyau* members reinforce that such wisdom comes from the ancestors.

[1] "*Wamuona* **Mkulemetsa** *de (2×) mwano uleke.*"
[2] "*Fulu de fulu de (2×) wayenda n'chigamba.*"

Kanamwali kayera

(a female night mask from the Mua area)

Themes 1) Avoidance of an early (illegitimate) pregnancy; 2) Marriage, preparation & instructions; 3) Sexual taboos (*mdulo*)

Etymology Kanamwali kayera means, 'The small girl is pale.'

The character of **Kanamwali kayera** is part of the visual aids used by the *namkungwi* during the female initiation ceremony. If the initiation is performed on the occasion of the funeral of a senior member of the community (*mpindira*), **Kanamwali kayera** appears during the night vigil while the corpse is lying in state in the house or during the night vigils of one of the subsequent shaving ceremonies. During the funeral pro-

cedures, **Kanamwali kayera** is featured outside the funeral hut where senior women dance and give the puberty instructions. Women use various teaching aids and disguises in order to inculcate their teaching in the young initiates. At the peak of their advice, they introduce Chiwekuweku, meant to represent the future husband or boyfriend. One of the female instructors borrows male clothing and dresses as a man

in shirt, trousers and a palm-leaf hat. In her dance, to the *chisamba* rhythm, she is accompanied by a partner who is **Kanamwali kayera**, also danced by a female instructor. She wears women's clothes to impersonate the young girl and her face and head are whitened with flour or white cloth. Her stomach is padded to imply a pregnancy. The characters dance together suggestively, indicating a sexual liaison. **Kanamwali**

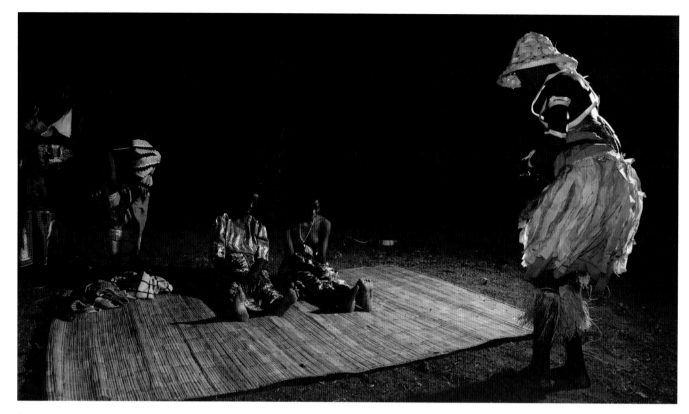

kayera rotates her hips and pelvis while Chiwekuweku moves his buttocks and pretends sexual intercourse. The *anamkungwi* join in the *chisamba* dance with them and sing the following: *"The small girl is pale,* (her condition) *is revealed."*[1] The song implies that the initiate has received full instruction but did not follow the advice of her teachers. The light tone of her skin reveals that she is pregnant. She has been sleeping with Chiwekuweku and is now pregnant without the knowledge of her parents. If the latter

question her, she denies any guilt until her condition is confirmed by the examination by one of the *anamkungwi*. Her case is serious, since she is accused of having 'cut' the village, starting with the chief, the *namkungwi*, her parents and relatives. Her clandestine sex in the bush has endangered the lives of all these people. The instructors' teaching stresses the avoidance of 'hot' and 'cool', which is described as the *mdulo*. A case of this sort requires the payment of a fine of a goat to the village headman, which

lifts the mystical sanction. **Kanamwali kayera** warns the initiates of the seriousness of such crime. It reinforces the belief of the *mdulo* and the social order concerning marriage procedures. Above all, it dramatises the chaos caused by premarital sex and single parenthood. It also warns of the risk of having to deal with the delivery of a baby when a young girl is not fully developed physiologically.

[1] *"Kanamwali kayera ede (2×) kamaonekera."*

Kanchacha

(a brown day mask from the Mua area)

Themes 1) Promiscuity; 2) Success in marriage; 3) HIV/AIDS & sexual diseases; 4) Love

Etymology **Kanchacha** means, 'the cunning one, who runs after men'.

The character represents a senior woman with tribal marks. The mask appears in a variety of colours (red, pink, yellow, orange, white and brown). It can be carved, made of cloth on a metal frame, or simply consist of a headgear of feathers like that of Kapoli. A wig of sisal is often attached to the mask. A small scarf covers part of the hair. She may wear jewellery, beads and earrings. Her outfit is commonly made of a blouse and a *chitenje* or simply a dress. A scarf often moulds to her hips and buttocks. Sometimes the *chitenje* is padded in order to suggest a pregnancy. Her arms and legs are

smeared with white or red clay. She carries a handkerchief or a bunch of leaves.

Kanchacha performs at any important ritual that involves *gule wamkulu*. She dances alone to the *chisamba*, moving her hips in a sensual manner revealing that she is keen to find a boyfriend. While dancing she sings, *"I was not after the beer party, Jessie, no. I went there in order to show sympathy for the dead."*[1] In this song, **Kanchacha** separates herself from the rumours that she is running after so-and-so and that is why she attended the funeral. **Kanchacha** is a type of Kapoli that

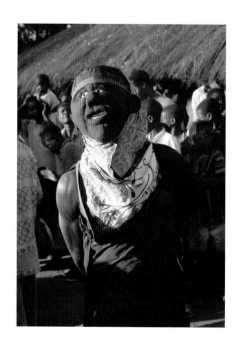

chastises the behaviour of both men and women. The women warn her, *"Kanchacha (the cunning), behave properly. Men make one lose weight, Kanchacha."* [2] This song warns her that marriage is not a sinecure; one has to work to make it a success. One has to think about quarrels, divorce and sexual diseases as well. **Kanchacha** is a married woman who was properly taught by the *namkungwi* at the time of her initiation. This song summarises its teaching, *"Your husband, when you marry, look after him well. When you go to fetch water, look after him well. When you cook the food, look after him well. When you boil the water, look after him well. After all, he is your husband, look after him well."* [3] **Kanchacha** looked after him very well for many years. Her family was a happy one until the day her husband, Ndatola (see glossary), was involved with other women. **Kanchacha** was neglected and eventually

abandoned by her husband. **Kanchacha** chose not to remarry, for fear of going through the same experience again. She decides to imitate her husband's behaviour and run after her neighbours' husbands. She finds her satisfaction in having affairs. She becomes the harlot of the village because she was abandoned. **Kanchacha's** promiscuity generates endless conflicts and quarrels in the community (between jealous wives and flirting husbands). **Kanchacha** is vulnerable to sexual diseases, which she passes on from family to family, compromising health and causing death. She looks miserable and old. **Kanchacha** teaches the community not to follow her example.

 Kanchacha's misery leads her to a 'Damascus road' transformation. She becomes a *namkungwi*. She gives wise advice to her neighbours and to those about to enter family life. She sings, *"When someone asks you to marry, let him write you a*

letter (of official engagement)." [4] This advice is to deter a casual marriage not formally recognised by the village and by the chief. She also advises newly wed wives. She sings, *"Kanchacha, hurry, run fast. Your husband is coming home, Kanchacha."* [5] This gesture is to show her husband her love and her concern. Chewa society perceives promiscuity as a destructive force that is revealed by the character of **Kanchacha**, the promiscuous 'runner'.

[1] *"Sindinadzere mowa a Jese ine toto ndadzera maliro."*
[2] *"Kanchacha, Kanchacha dziyenda bwino iwe wamuna aondetsa eaee Kanchacha."*
[3] *"Wamuna, iwe yerere tenga, akakutuma katunge madzi yerere tenga, kaphike msima yerere tenga, katereke madzi yerere tenga. Awa ndi amuna ako yerere tenga."*
[4] *"Amene andifune andilembere ine e andilembere kalata e."*
[5] *"Kanchacha (2×) dziyenda yenda wamuna akubwera eae Kanchacha."*

Kanjiwa

(a red or pink day mask from the Mitundu area)

Themes 1) Limits & restrictions of *chikamwini* system; 2) Witchcraft; 3) Jealousy/envy; 4) Fairness to *mkamwini*; 5) Potency

Etymology Kanjiwa means, 'a small wild pigeon (or dove)'.

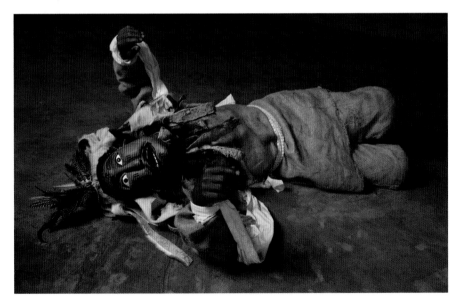

The wild pigeon is noisy and its loud behaviour makes it an easy target for the hunter who appreciates its meat. **Kanjiwa** compares the husband marrying in a matrilineal set up (as *mkamwini*) to the pigeon. He portrays a young husband newly wed into the village of his wife. As a stranger (the red or pink colour) he is as vulnerable as the pigeon. His face is that of a youth, a good looking Chewa with tribal marks. He has dark hair made of black goat skins, slim flattish nose, strong moustache, heavy chin

and small ears. His small, sad mouth displays teeth on the bottom jaw, which express surprise. His bright red irises show the person as insecure. The headgear of the mask is made of goatskins to emphasise that he is like the male goat, the ram, borrowed to increase the herd. On top of his forehead, a tuft of pigeon or dove feathers stands erect. This hair lock has a sexual meaning and portrays his potency as a stranger, as a new husband coming into the family of his wife in order to produce children for it. The

dancer wears a plain jute suit without rags to show that he is of no status. Two white scarves tied to his wrists give him wings like the dove.

 During the performance the dancer moves his arms in an exaggerated fashion and runs quickly, pretending he is flying. At the peak of his dance he collapses as if he has been hit with a stone thrown from a slingshot. He shakes his wings as if he is dying. The other *gule* members carry him out of the arena. A song sung by the men, *"They go, one by one, they are decimated. (This is the end of the village!) I thought that God willed his death. I am surprised (to hear) that he was killed with a slingshot like a wild pigeon! They go, one by one, they are decimated! The small wild pigeon, the poor little wild pigeon!"* [1] To this song the women reply, *"People go, one by one, they disappear. I thought that God caused their death but people kill them purposely like wild pigeons. Yesterday I had a husband of my own who walked about here. (Today) I mourn him, (my) small wild pigeon, (my) poor little wild pigeon."* [2] This last song voices the cry of a woman who has lost her beloved husband and knows that he has been the victim of the jealousy of her family members. He was killed because others envied his qualities and his success.

 The mask of **Kanjiwa** is used for funeral rites and initiation ceremonies. A senior

dancer, able to keep the sexual taboos, must perform it. The character of **Kanjiwa** is ancient. His teaching strengthens the Chewa matrilineal setup and defines the place of the husband in the family group of his wife. As a newcomer to the village of his wife, the husband is an easy target for jealousy and envy. He must be careful not to draw attention to himself or to provoke the members of his wife's family. He cannot show off, prove himself, hold a position of command or be bossy. He must remember that he is a stranger who cannot assume leadership. He must conform, and keep a low profile. Any pretension, pride or arrogance is paid for dearly. If he takes initiative and shows any ambition, he runs the risk of drawing down the wrath of his new family. Its jealous feelings could motivate it to cast a spell on him or use evil medicine to curtail his power and influence. Worse, it might conspire to kill him. Both songs dwell on this theme and suggest that **Kanjiwa** was eliminated through witchcraft because he rose too high and became too loud. **Kanjiwa** warns his fellow *akamwini* to be cautious if they want to live and enjoy the mediocre position of a husband. One can still enjoy the status of being married. The character addresses (through the widow's voice) the members of her own family group telling them to be more considerate and show a little kindness for their *mkamwini*.

[1] *"Kayoyo kayoyo (2×) ede anthu akuthawa. Ndikayesa kuti akufa ndi imfa ya Chauta! Kani akuchita kupha ndi legeni ngati njiwa eae eae kayoyo ede* **Kanjiwa, Kanjiwa.***"*
[2] *"Kayoyo kayoyo (3×) anthu akuthawa! Ndikayesa kuti akufa ndi Mulungu. Ndipo akupha dala ngati njiwa ae ae Amuna angawa dzulo ndinali nawo si awa anaponda apa. Ndilira ine* **Kanjiwa, Kanjiwa.***"*

Kasinja

(a pink mask from the Dedza area)

Themes 1) Sexual taboos (*mdulo*); 2) Responsibility of family heads; 3) Witchcraft; 4) Fertility

Etymology The name **Kasinja** refers to *kusinja*, 'to pound maize in the mortar'.

Pounding maze in the mortar is the task of the women. **Kasinja** is the head of the guardians of the matrilineal group (the maternal uncle, *mwini mbumba*, *malume* or *mtsibwini*). **Kasinja**'s role is to look after the general welfare of the family including health, initiations, marriages, disputes and funerals. This position makes him the representative of the family spirits. He is also the custodian of the rules that regulate family rituals and, particularly, the sexual taboos surrounding these rites. Therefore, his presence in *gule wamkulu* is meaningful. The pink mask is a variation of red, expressing sexual prohibition and witchcraft. His two red curved horns signify that the person who does not follow these rules becomes ever more antisocial and eventually a witch, who causes great harm to the community. The mask shows the face of a senior man: bald with wrinkles, thick black moustache and a goatee. His open mouth has teeth prominent on the bottom jaw, expressing the disciplinary power of the ancestors and the family group. The small ears portray deafness of some family members to his advice. The headgear of the mask is made of white rags and shows that his position as guardian of the family group is rooted in the spirit world. **Kasinja** wears a tattered jute vest and a short kilt made of white sisal. His arms and legs are adorned with armlets and long leglets made of the same material. He carries a small whip to discipline the *mbumba*. During the night performance, the wood mask is replaced by a fibre headcover. As **Kasinja** enters the *bwalo*, he moves around quickly, swerves his feet with tremendous energy, shakes his hips and waves his pelvis frenetically. This indicates whether sex is allowed or prohibited, depending on the circumstances. This movement is decoded by the women: *"Hu, hu! I don't see any disease around!"* [1] **Kasinja** is a variety of Kapoli that takes part in funeral and commemoration rites. He is also present whenever Kasiya maliro performs. The reason for this is explained below. **Kasinja** leads his own singing, in a low-pitched voice (unusual for a Kapoli). He says, *"Kasinja, fold your tail! No* (sex)*! In the village, there is an epidemic, Kasinja. Fold your tail!"* [2] To these words the women continue, *"Yes, gentlemen, stop* (sexual relations)*! This is measles* (epidemic)*! One does*

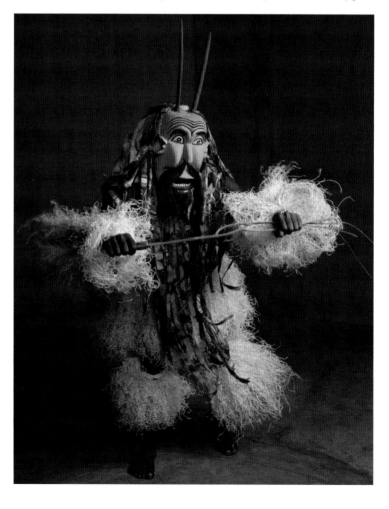

not play with this (plague). *Men are like wild animals…Kasinja, fold your tail!"* [3]

Kasinja's song is a reminder of the duty of keeping sexual taboos. **Kasinja**'s presence in *gule* is linked to the structure of Kasiya maliro, the mother ancestor and main representative of the female group who originate from a common ancestor. **Kasinja** is Kasiya maliro's messenger and the maternal uncle who has the duty to guard over the fertility of these women and see that their behaviour is according to the ancestors' prescriptions. The cycle of fertility among the Chewa is described in terms of opposites: hot – cool, red – white, dan-gerous – safe, forbidden – allowed. All the women he represents (and their husbands) are aware of such rules concerning sexual abstinence. When **Kasinja** appears with Kasiya maliro at a ritual, it means that there is a death, misfortune or a transition period in the community. **Kasinja**'s nickname is '*mchira upinde* – bend your tail', a euphemism for refraining from sexual relations. The failure to keep these taboos brings the ancestors' curse on the community and innocent people suffer. **Kasinja** protects the female group against the danger of infringing the sexual taboos and reminds them of the necessity of keeping continence and coolness (*kudika*). This regulates sexual life and fertility, especially at the time of prolonged sickness and epidemics. As the head of the family group, he should also take the prescriptions seriously for himself. Failure in or bypassing of these rules will be interpreted by his community as a criminal act (witchcraft), in so far as he wishes the death of his own sisters' children.

[1] *"Hu hu, matenda sukuwaona?"*
[2] *"**Kasinja** mchira upinde toto, pam'dzi pano pagwa matenda tate de **Kasinja**, mchira upinde."*
[3] *"Wanthu wamuna, lekani tate de. Ichi n'chikuku, sasewera nacho! Wamuna n'chilombo tate de **Kasinja**, mchira upinde."*

Kholowa and **Mai Kholowa**

(red day masks from the Dedza area)

Themes 1) Infertility – impotence; 2) Adultery & rape; 3) Social stigma

Etymology **Kholowa** is a vegetable dish made of sweet potato leaves. This dish is eaten when there is 'nothing better to eat'. **Kholowa** also is the name given to a sweet potato runner that is planted in the soil for growing sweet potatoes (alternatively, a potato is planted in order to produce runners).

Both images noted above suggest parenthood. **Kholowa** and **Mai Kholowa** perform as a pair and are a form of Kapoli. They have black-feathered headgear. The mask can be made of cloth (like Nyolonyo) and painted red, or it can be carved in wood. When it is carved in wood, the male and female features vary only slightly. The male shows a stupid face, in a figure-of-eight shape. The head has animal-like ears, tremendous protruding eyebrows, expressionless eyes and exaggerated swollen cheeks. There is a tiny, deformed, drooping penis-like nose from which protrudes a sharp white spike. The mask has a thick moustache and a huge crooked toothy mouth. These details convey that **Kholowa** is impotent. The face of **Mai Kholowa** is fat and displays less deformity. Large eyes are set far apart, in a look of bewilderment. There is a tiny nose, bearing a similar spike to her husband's, and an enormously broad mouth showing a smile with teeth on both jaws.

Kholowa wears a short kilt. **Mai Kholowa** wears a *chitenje* and has false breasts in her blouse. Both have leglets and armlets made of sisal or fertiliser bag laces. **Mai Kholowa** holds a mini handkerchief as proper ladies do. She also carries a fake child on her back; the child noticeably lacks a spike protruding from its nose. The couple usually dances together. They perform on the occasion of funeral and commemoration rites. In the arena, **Mai Kholowa** is busy moving her hips (like Mariya) and trying to entice her husband, whose response is indifferent. His dancing is weak and without vigour. They lead their own singing to which the women respond: *"**Kholowa** has given birth to a child! What is his name? N'kakumbuka (I will tell you) if I remember."*[1]

The **Kholowa** pair portrays a family in which one of the partners is infertile. A family without children is a terrible curse in Malawi society. It is likened to being socially dead. Such a misfortune can hardly be hidden and kept secret. An infertile person and a couple that cannot have children are stigmatised with the cruel term of '*gocho*' (impotent or infertile). They are put under tremendous pressure to find a secret partner in order to generate children for the unfortunate pair. The song describes how a child is born to the **Kholowa** family but unfortunately he does not resemble his father: he has no spike in his nose. He is the fruit of adultery. The child has taken the physiognomy of his real father and not that of **Kholowa**, who is revealed to be impotent. In the village, nobody can hide the truth. One day the identity of the true father of the child will be known. This is reflected in the name of the child in the song: *"If I remember"*. Nobody can deny that the runner produces sweet potatoes and that potatoes grow runners. The **Kholowa** family tries to safeguard its honour and reputation from the terrible stigma of infertility. The solution it found remains a second best, like the *kholowa* dish that is a poor substitute for *nsima*. They know that one day its shameful secret will be revealed.

[1] *"**Kholowa** wabereka mwana dzina lake ndani? N'kakumbuka!"*

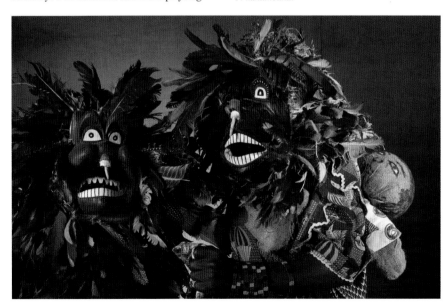

Koweni

(a red day mask from the Mua and Dedza areas)

Themes 1) Limits & restrictions of *chikamwini* system; 2) Fairness to *mkamwini*; 3) Care of the sick

Etymology **Koweni** stands for '*Kwa eni kulibe mkuwe*' meaning, 'Do not complain in somebody else's village.'

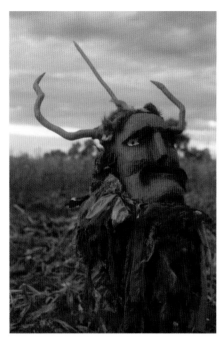

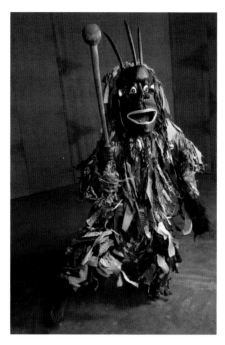

Claude Boucher, Kakhome Village, May 1985

This large or very large red mask represents an outsider, the husband who marries into his wife's family. The mask portrays the face of a senior man with wrinkles, broad forehead, long nose, big moustache and a stupid expression. The head is partially or completely bald, showing a white shine on top. From his head three long horns protrude and stand erect. His eyes and mouth are prominent, to emphasise that he should not speak loudly but remain silent and observe. The Dedza version gives him four to six warts on the cheeks, and the mouth bears teeth. The headgear of the mask is made out of rags. The Mua version adds a goatskin, to show that he belongs to the

household, like a herd member. The stranger wears the tatter suit of *gule* and carries a small axe, a club, a knife or a medicine tail. He can be part of any ritual and addresses the strangers to the village in the following terms: "*At someone else's home, do not shout.*" [1] The Mua character circles and swerves his feet with complex steps. He shakes his head, to show that he is in trouble. The Dedza singers use a similar song, but it has the following words: "*My friend, when he is sick, bring him back to his own relatives. Do not shout!*" [2] The Dedza character's performance is similar to that of Mua but shows less energy. At some point of the dance, **Koweni** collapses and is taken

out of the arena by the other *gule* characters, to the *liunde*. This reflects that he is sick and is being taken to his own relatives.

The two songs stress that it is wrong for a stranger to behave as if he were the owner of another's home. He should show manners and be content to observe, without making comments, remarks or criticism. One cannot rule in someone else's village. This is particularly true for a husband who goes to reside with his wife's family, where he remains a stranger (the red colour of the mask emphasises this). He should not try to impose his own standards. As a stranger, he must keep a low profile and be attuned to the expectations of his wife's relatives. He may have a big head (the large size of the mask) but he cannot use his big mouth to voice his wishes or to organise others. He may have many good qualities and special powers (the three horns on top of his head) but he is both vulnerable and dispensable. His weapons, his biting teeth and medicine tail that symbolise his temper or his previous status, his aggressiveness, and his former position are of little use where he lives. The character of **Koweni** reminds the husband of all of these things. The Dedza version adds a warning to wives and their family groups: They have to look after their husbands and be considerate. They should care for them when they are healthy, not only at the time of sickness. They should have the courtesy to inform the *mkamwini*'s relatives of his illness, so that they may also nurse him.

[1] "*Kwa eni tate, kwa eni iwe yede kulibe mkuwe tate de. Kwa eni kulibe mkuwe de.*"
[2] "*Tate de anzanganu chikadwala kachituleni kwawo ae kulibe mkuwe.*"

Kwakana

(a day mask from the Mua area)

Themes 1) Sexual taboos (*mdulo*); 2) Forced/arranged marriage; 3) Aggressiveness; 4) Infertility – impotence

Etymology **Kwakana** means, 'He was refused.'

This is a large mask, close to a metre in size, painted black and red. It features a combination of a bull and a crocodile head. The mask has three or five horns and a long snout full of sharp teeth. The headgear is made of skins and rags. The two or four heavier lateral horns are black while the middle horn

is smaller, red, and surrounded with fur. The ears are large and carved from the same piece of wood. The dancer wears a kilt, leglets and armlets made of various materials like sisal, jute, banana fibres or grass. His body is smeared with mud or ashes. A club and a ceremonial axe are carried. He enters

the ground with rage because he has been refused. Out of frustration, he moves his feet backward like a rampant bull, spinning around and around like a whirlwind until he falls on the ground as if throwing a fit. He rises in the dust and crawls on his belly. He lifts and shakes his legs, looking foolish and

ashamed. At the end, he moves his pelvis as if he were trying to have intercourse with an invisible partner while the women clap and mock him. The men sing, *"**Kwakana** (he was refused) at his own home, no! She has another husband in mind, Msakambewa. Why should she stop refusing him?"* [1]

Kwakana's song talks about his wife, whose heart is still with her first boyfriend, Msakambewa. **Kwakana**'s wife was coerced by her parents to marry a very unpleasant man. He is ugly, rude, uncouth, and even aggressive like a wild beast (the horns and the weapons he carries show this). When she refuses her husband sexually, he is violent and does not want to listen to her reasons. In her menses (the redness of the mask), she has to refuse sexual intercourse for fear of putting his life in danger. **Kwakana** is stubborn and does not want to listen. He takes her by force, risking his own life (the red horn on the forehead expresses that). As a consequence, **Kwakana** becomes sick, has fits and falls periodically. As he is lying on the ground of the arena, he remembers his wife's warning and shows that he has learned his lesson. He simulates the prohibited intercourse that crippled him with impotence and warns others not to follow his example. The character warns parents not to force their daughters to marry someone against their will. It also invites young girls to be cautious in choosing their marriage partner. The red and black colours of the mask convey sexual prohibition associated with a woman's cycle. It is the duty of the wife to refuse her husband at such times and to show him love by assuring his health and long life. Women often say that husbands are like children, in that they get sexually aroused easily and forget about the consequences of their actions. The long red snout of **Kwakana** displays a multitude of teeth like those of a crocodile. They emphasise the danger of such prohibition. Men will be bitten by the female sexual organs and will contract the *mdulo* disease that will bring them down and eventually kill them. The

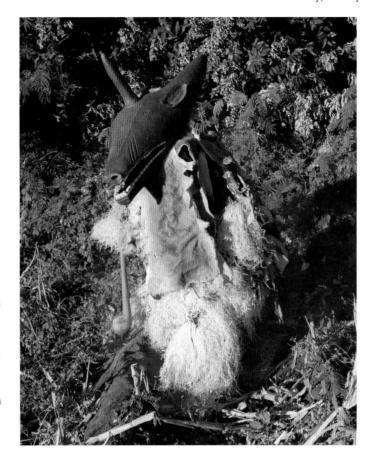

two heavy black horns of **Kwakana** portray the testicles and show (through their elongation) that the male power has to be withheld during such periods. The red standing horn on the forehead surrounded with fur symbolises the pubic hair and the penis.

Kwakana provides a blueprint for family life. He teaches husbands to be understanding and patient when their wives refuse them sexual access during their menses. Uncontrolled anger, quarrels and rape are the vices that spoil the reputation of a husband and force his wife's family to chase him out of his own house and her village. The marriage then ends. Because of **Kwakana**'s repulsive behaviour, the wife

thinks fondly of old friendships or admires other men who show more courteous behaviour to their wives. Lastly, the character depicts the consequences of the *mdulo* disease that the Chewa believe ends in death. **Kwakana**'s fits are symptoms of this disease. They lead to impotence and to a life of being crippled. The role of the ancestors is to protect their descendants and foster life through their teaching of the *mwambo*. Sexual taboos are an integral part of the *mwambo*. Nobody can afford to by-pass them, especially not a fearful and arrogant husband coming from another family group.

[1] *"**Kwakana** e (3x) kwathu yaya wamuna ali kumtima kwa Msakambewa. Alekerenji **Kwakana**."*

Liyaya

(an orange female day mask from the Salima and Nkhotakota areas)

Themes 1) Promiscuity; 2) Women's cycle hygiene; 3) Faithfulness

Etymology The etymology of **Liyaya** is obscure, but could mean, 'that which easily turns sour', 'that which shifts from side to side' or 'what is unsettled'.

This woman's mask is used during the female initiation ceremony as part of girls' sexual education. The elongated mask portrays a young face like that of an initiate (narrow nose, small mouth, tribal marks, nose-plug). The senior woman who performs it dresses herself as a young girl with bangles and a small cloth around her waist in order to emphasise the movements of her hips. In her hand, she carries a fancy handkerchief. She moves across the arena with the women and the initiates to the rhythm of the *chisamba* while the women sing, *"**Liyaya, Liyaya**, sister, what kind of behaviour is that … of accepting any man without protest? Husbands come and go. Is that the way to do at your young age … to be with five husbands? No! No! Is that the way to do,*

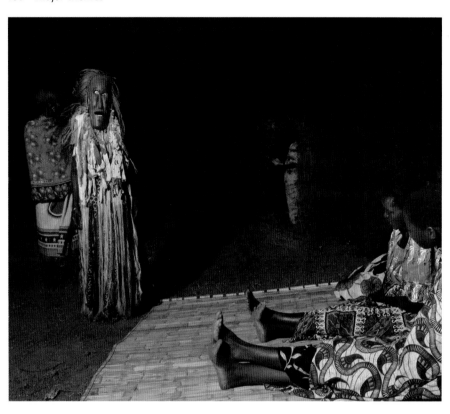

Liyaya?" [1] **Liyaya** dances with all her skill, moving her hips as provocatively as possible. She purposely drops her handkerchief. The handkerchief shows a red mark like that of blood. One of the *anamkungwi* rushes to recover the handkerchief, suggesting that she has dropped her menstrual towel.

The song of **Liyaya** and her little play of dropping a hygienic towel portray her as a girl who despite her initiation instruction ignores the ancestors' advice. Her obstinacy makes her vulgar and promiscuous. **Liyaya** is not clean and does not respect herself or anyone else. She starts menstruating at the bar where she is looking for a boyfriend. She is a woman of loose behaviour, who does not stay with one husband. She marries repeatedly and her life is a ruin. By spelling out the vices of **Liyaya**, the *namkungwi* shows the initiates the type of behaviour they have to avoid if they want to be happy in marriage.

[1] *"**Liyaya Liyaya**, kodi chemwali n'chiani choterocho cha wamuna chosalimbana nawo? Angoti awa bweru, nachoka. Kodi amatero ede de ede de? Kamsinkhu komweka, amuna asanu ai ai. Monga kutero tate de **Liyaya**."*

Mai Kambuzi

(a red women's mask from Linthipe and the adjacent territory in Mozambique south of Dedza)

Themes 1) Sexual taboos *(mdulo)*; 2) Promiscuity; 3) Avoidance of an early (illegitimate) pregnancy; 4) Childcare

Etymology **Mai Kambuzi** means, 'Mrs Small goat'.

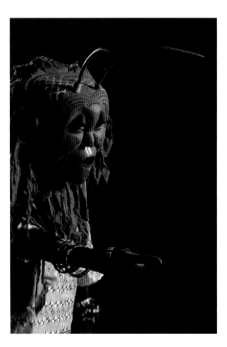

The character is danced by the mistress of initiation (the *namkungwi*) at a special initiation ceremony (*chinamwali cha chimbwinda*) performed for girls who are found to be pregnant at the time of their initiation. Such girls are believed to have endangered the life of the chief and their parents by infringing the sexual taboos (causing the disease *mdulo*). They have hidden their first menstruation from their parents and have behaved immorally. Such conduct leads to a serious court case and a heavy fine. Normally, the girl's parents have to pay a live goat or chickens as compensation. The mask emphasises the goat's features, with horns that are used to poke the initiates. The ears are goat-like. The edge of the face is painted white, decorated with black spots to recall the teachings on the female cycle given by the Chinkhombe character. The central part of the face is cut in a figure-of-eight shape and painted red. The red refers to the *mdulo* complex and the moral code that forbids sex at the time of menstruation. The details of the face show feminine characteristics. The eyebrows are painted in the shape of sunrays. On her forehead and cheeks stand the tribal beauty marks (*zitopole*). Her face is pinched and severe, like that of a senior instructress. The eyes are fearsome and the toothless mouth seems to reprimand. **Mai Kambuzi**'s hair is made of grey-dyed sisal on top of which she wears a white scarf signifying the end of the ordeal in the same way as the end of the monthly cycle. **Mai Kambuzi** wears a ladies dress or *chitenje*. Her buttocks are tied with a scarf to emphasize the sexual movement of her dance (*chisamba*). **Mai Kambuzi** does not have her own repertoire of songs. The usual songs sung for the initiation accompany her dancing. This character is a lesson to the parents to be watchful over their daughters as they approach puberty. They should check the girls' conduct and make sure that the initiation rite is not delayed.

Maino or **Akumpangweni**

(a black day mask from the Mua area)

Themes 1) Limits & restrictions of *chikamwini* system; 2) Uncontrolled anger; 3) Frustration at not getting one's own way

Etymology Maino means, 'the long teeth'.
Akumpangweni means, 'a stranger from the four winds (that is, any direction)'.

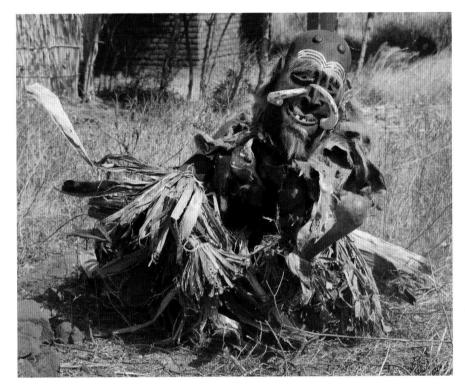

The face of **Maino** or **Akumpangweni** is that of an old man, bald with heavy wrinkles and two long teeth like tusks protruding from the corners of his mouth. His nose is crooked and two lumps of skin hang from his forehead. His clothing is made of banana fibres. He carries in his hands a long knife (or a spear) and a club. Ngoni bells are tied at his ankles. As soon as he enters the dancing ground he is tied to a tree by the neck, as a mad dog would be. He soon breaks loose, chases women, destroys properties and houses with his long teeth and behaves as if completely insane. The women provoke him and sing, *"Maino, you*

are an ungrateful dog!" [1] The men answer with the piece of advice, *"Maino, when you marry in our village, please behave."* [2]

The mask, costume and song show that **Maino** is a stranger, an outsider to the village. Both his features and his way of dressing betray a non-conformist; a person with a mind of his own, who does not want to bend and accept the rules of the family into which he marries. He refuses to renounce his own independence and does not accept being ruled by his wife's relatives. He shows his teeth and character. Out of persistence or stubbornness, he keeps bumping his head into all sorts of conflicts.

The protrusions on his forehead show that his skin has become calloused from these conflicts. The protrusions and the length of his teeth indicate that experience has failed to teach him a lesson. The behaviour of **Maino** is viewed as an example of stupidity and stubbornness. As a stranger and husband, he is welcomed into the village and the family of his wife. There, he is expected to behave as a guest and not as a lord who wants to overrule everyone, mix in internal politics and behave as if he were the head of the family group, even beating his wife and his in-laws. His interference will soon irritate everyone. The family will end the marriage and send him back to his own village. His stubbornness and his inability to learn will perpetuate the same situation when he next marries.

This fearsome character likes to appear at the commemoration ceremonies of important people, emphasising the weak role of the husband in the Chewa matrilineal arrangement as well as the dilemma he encounters when he takes up residence with his wife's family. Rarely is he fully integrated into the village or his talents recognised. **Maino/Akumpangweni** dramatically portrays the role of the frustrated husband whose personality is totally stifled by the group. If he acquiesced, he could profit from the privileges that are tacitly granted to him as a foreigner. His behaviour of protest is interpreted by the group as undesirable and sheer madness.

[1] *"Maino ndiwe galu!"*
[2] *"Maino pa m'dzi pano, ukakwata osakwatira chipongwe Maino iwe tate (2×) Maino,"* or *"Akumpangweni de de de tate pa m'dzi pa eni ukakwata, sukwatira chipongwe, Akumpangweni."*

Mandevu or **Chigayo** or **Wokwerakwera**

(a red day mask from the Mua and Dedza areas)

Themes 1) Promiscuity; 2) Short-lived marriages; 3) Dangers of modernity; 4) Infertility – impotence

Etymology Mandevu means, 'the long moustaches'. Chigayo means, 'the maize mill'.
Wokwerakwera means, 'the one who always wants to climb (to have sex)'.

The mask of **Mandevu – Chigayo – Wokwerakwera** portrays a stranger to the village. His features are those of a foreigner. He is often represented with a western face,

long aquiline nose, pointed chin and long moustache and goatee beard. His mouth bears a smile showing teeth and manifesting self-confidence. A chicken-feather cowlick

tops his otherwise bald head. The headgear of his mask is made of rags covered with a fishing net 'bridal veil'. **Mandevu** dresses in the usual tattered jute suit, meant to

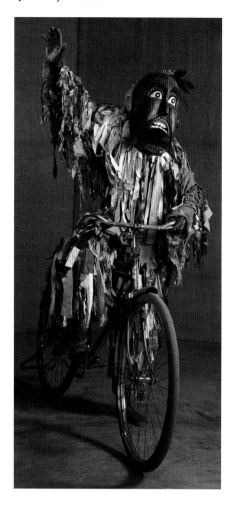

imitate western fashion. He often rides a bicycle and carries a part of a maize mill, a wireless or a medicine tail when he enters the arena. He plays with these for a while, and then he leaves them behind and dances with energy while the men sing, *"Chigayo, the maize mill kills; and kills Nasideya. It kills people."* [1] Then, *"Mandevu bought a bicycle, a secondhand one. There is war, Mr Mandevu."* [2]

These words and the associated objects betray his liking for modernity and foreign things. Unfortunately, he copies the worst of western culture. He left the village a long time ago, seeking employment outside. The cash economy made him lose his head and forget the *mwambo*. The money he earns provides him with the means for buying objects of status like a bicycle, a radio or a maize mill. These impress others, particularly women. **Mandevu – Chigayo – Wokwerakwera** has lost all sense of traditional values. His interest is not in supporting his parents, relatives or family but to find sexual favour with women. **Mandevu** is promiscuous and the women like him because he has money in his pocket. **Mandevu** has become like the machines he owns. He boasts of his sexual potency, which he compares to the power of the maize mill. One of the songs states that he bought a secondhand bicycle. Here it means he will have sex with a married woman. **Mandevu** accepts any partner

regardless of status or health and he keeps having short-lived marriages (suggested by the bridal veil) that lead nowhere. The long moustache and the cowlick symbolise his uncontrolled sexual appetite. He is unable to show faithfulness in marriage so his marriages do not last. He is a cheater and playboy who leaves women disappointed, heart broken and often infected with a sexual disease that could prove fatal. **Mandevu – Chigayo –Wokwerakwera** puts forth the example of those who do not follow the ancestors' advice in sexual matters. They become monsters who kill innocent people and themselves.

The Dedza version of **Mandevu** gives a slightly different emphasis and portrays him as a frustrated sexual predator who has sexual relations with young immature girls or children. This is to hide the fact that his wife refuses him because of his impotence. The character mocks infertility and stresses that such rampant sexual behaviour ought to be severely punished.

[1] *"**Chigayo** oh kupha n'kuphana Nasideya e tate, n'kuononga anthu!"*
[2] *"Anagula njinga yokwerakwera ede tate, nkhondo abwana ede tate **Mandevu**."*

Matako alingana

(a day or night mask from the Mua area)

Themes 1) Performance of gender-based roles; 2) Choice of marriage partner (choice of *mkamwini*)

Etymology Matako alingana means, 'The buttocks are the same.'

The character portrays a baboon. In the night version, the dancer's body is covered with rice stems that imitate the fur of the animal. The tail is made from the flower of a reed that gives a fluffy appearance. In the day version, the dancer wears a carved grey or brown wooden mask that resembles the head of a baboon and a tatter suit that represents the fur. In both versions, the dancer holds wooden arm extensions in his hands, which are covered by the outside costume, and which allow him to imitate the long arms and the distinct gait of the baboon when he walks on his hands and feet in a stooped manner.

Matako alingana walks, leaning forward on its long arms, and jumps proudly, mimicking the baboon's behaviour. It races after the women and chases them in all directions far from the *bwalo*. At times, it lies on the ground on its belly and pretends to sleep.

Accompanying the entertaining mime of the baboon, the male choir sings, *"Buttocks are similar. What is different is their performance on the fire (the way they cook), **Matako alingana**,"* [1] or *"When you look at women my friend, the buttocks are similar but their performance on the fire differs, **Matako alingana**."* [2]

The character of **Matako alingana** is usually performed during initiation and funeral rites, owing to its entertaining show and because of the message it conveys. The riddle expressed in the song suggests that all men and all women are physically similar. They are all born with the same organs proper to their gender. The real difference lies in the dedication with which they perform their respective duties following local labour division (such as how well women cook). At the time of marriage, each one finds his or her own partner. If,

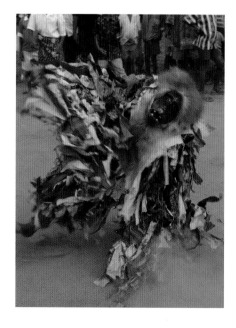

anatomically, all men and all women resemble each other, then what makes them different is their character, talents and the qualities that make up their personalities. There is no need to snatch a neighbour's

partner since one will find the same at home: one cannot rely on outside appearances. As the Chewa proverb says: "*Wangoopa njoka luzi – You were just afraid because of mistaking the string for a snake.*"

[1] "***Matako alingana** pasiyana n'pa moto, **Matako alingana.**"
[2] "*Kuvaona akazi, anzanga, **Matako alingana** pasiyana n'pa moto, **Matako alingana.**"

Mphungu
(a night mask from the Mua area)

Themes 1) Sexual taboos (*mdulo*); 3) Women's rights; 3) Women's cycle hygiene

Etymology **Mphungu** is the Chewa name for the Bateleur eagle.

Painting by Claude Boucher and Joseph Kadzombe, 2009

The Bateleur is a type of eagle with long wings and a very short tail. The bird has a bright scarlet waxy wattle around the eyes reaching down toward the bill. It has the habit of performing stunts in the air such as somersaulting and slow rolling. Here the name of the character stands for an abbreviation of a Chewa proverb, "*Mphungu sataya nthenga – The Bateleur is so greedy that he does not let one feather go astray.*" The image of the Bateleur is applied here to the women who undergo their menses and refuse to share their body with their husband during this time.

In *gule*, **Mphungu** is a type of Kapoli. Chief Maiwaza introduced the character to the Mua area from the plateau a long time ago. He is faceless and wears a chicken-feather headcover (*chiputula*). His body is smeared with ashes, his waist is adorned with a small kilt, and he wears armlets and leglets made of palm leaves. He sings with a high-pitched voice to show that he sides with the women and protects women's rights.

Mphungu is mostly a night character that gives advice during the initiation rites and funeral ceremonies incorporating such puberty rites. The teaching is done using a small reed mat that is tied to his hand. He manipulates and stretches the mat like wings and then folds them back on his belly. The reeds are split in half allowing the white inside of the reed to appear. This white surface is decorated with red dots expressing the female cycle. During the performance, **Mphungu** never walks on his feet. He crawls on his belly to a position next to the drummers and lies down, showing his back. He keeps his arms folded on his chest. Then he rolls back and forth. He ceases rolling and lies on his back. For an instant, he opens his arms and spreads the mat revealing the white side spotted with red dots. He then quickly closes his arms again, hides the mat and resumes rolling back and forth. His performance is accompanied by the drumbeat of Kasiya maliro. Finally he rolls back to the drum-

mers and disappears, crawling in between the *gule* members. Together the men and women sing the song that accompanies **Mphungu**'s mime: "*Let's see the back; as for the belly* (euphemism for female organs) *I have already seen it, **Mphungu**.*" [1]

The song refers to the advice given to the initiates during their puberty. When a woman experiences the beginning of her period she has to turn her back to her husband when she goes to bed. Her position warns him that her condition forbids sex. Relations at that time are seen as dangerous for fear of contracting the *mdulo* disease. This is the meaning of **Mphungu**'s performance. **Mphungu** first shows his back and then he spreads the white mat stained with blood. In this way he indicates the menstrual cycle has started. Sexual activity is forbidden. Besides indicating the physiological change, the small mat is analogous to the hygienic towel and is seen as the gate closing and refusing access to the female organs. The character of **Mphungu** recalls this teaching and warns husbands that it is wrong for them to put pressure on their partners during that time. It also advises wives that it is their duty to be 'greedy' like the Bateleur and not give in to their husband's request. Instead of showing them love they would drag them into death (*mdulo*). It is also their duty to conceal their condition by wearing hygienic towels.

[1] "*Tione kumbuyo, kumimba ndakuona kale, **Mphungu**.*"

Mwiri

(brown male and female day masks from the Dedza area)

Themes 1) Sexual taboos (*mdulo*); 2) Redeeming (*kulongosola*)

Etymology **Mwiri** is the Chewa word for the genet, a once common animal in Malawi.

These two brown masks represent a male and female genet. Their faces partly replicate the genet anatomy and combine the characteristics of both male and female human genitalia. The two animals have been given black and white striped horns. The female bears them on the nose while the male has them on top of the head. Both masks have fairly long ears (longer on the female), big yellow eyes and patches of fur that represent pubic hair. Their headgear is made of rags to show that they represent the spirits of the dead. The dancers' bodies are concealed differently. The male dancer is covered with a jute suit and rags. He carries a knife and a club, symbols of potency. The female character wears strips of bark around her neck and her waist. She carries branches with leaves that have a medicinal purpose. They both wear bells around their ankles. They perform together on the occasion of puberty rituals, and at funeral and commemoration rites that incorporate puberty initiation. They can appear during the night vigil before the initiates are brought back home.

They enter the *bwalo* and simulate copulation by moving their hips and swerving their pelvis in close proximity to each other. They represent the chief and his wife or the parents who have to 'redeem' the initiates, to unlock their fertility, through ritual intercourse at the end of the girls' initiation. The

song that is sung for this occasion says, *"They fail to keep the mwambo. They were not supposed to have sex, the genets. Come and see what has happened to our Chauta* (spirit wife). (The female genet says:) *My children* (the initiates) *are leaving tomorrow … What are you doing, Mr Genet … The initiates* (maidens) *are not yet out of the house* (of seclusion)." [1] The song portrays the couple as irresponsible parents who have failed to keep sexual abstinence and have attempted to 'redeem' the initiates before the puberty rite is over. Instead of unlocking their fertility, they have 'cut' them and given them the *tsempho* disease, which has to be removed with the help of medicine (the leaves that the female character carries). Senior officials who had to perform the 'redeeming' ceremony in the past danced these masks. As soon as they finished dancing in the *bwalo*, they would leave the arena and retire indoors in order to perform the ritual intercourse with their wives.

These masks betray a very ancient origin. The song itself refers to Chauta (here indicating the spirit wife of the Banda). The image of the genet with its spotted body evokes the symbol of Thunga. Makewana the spirit wife had to have sexual intercourse with the priest Kamundi in order to unlock the fertility of the initiates at the end of the rain and the puberty rituals. For this ritual intercourse both were wrapped in

bark cloth and imitated the mating of Thunga and his wife. The two genet characters here seem to suggest a similar practice. Another song offers this interpretation. *"The* (female) *genet was saying: No sex for me … (for the sake of) the initiates. Let my permanent celibacy be interrupted today. Let the male organ penetrate me, genet. This is what has happened to me for the sake of keeping my people happy. The genet is pregnant!"* [2] The song recalls that the spirit wives formerly practised permanent celibacy which was only interrupted by performing a ritual intercourse with their partner at the end of the puberty rites combined with the rain ritual. However, the song adds a surprising element. The spirit wife was pregnant. Her pregnancy was not acceptable according to the Chewa custom. Makewana was normally executed for such an offence. She was looked upon as being unfaithful to Thunga and to her role as spirit wife. Nobody believed that she could become pregnant as a consequence of this ritual intercourse but because she had slept with other officials. Such a crime would bring drought to the country and death to the initiates (*kusempha*).

This event has been interpreted as one of the causes for the separation of *gule wamkulu* from the shrine. Nevertheless, this interpretation suggests a consistent emphasis on the importance of the sexual taboos regulating the puberty rites. The ritual actors, whether they are spirit wives, chiefs or parents are first of all perceived by the Chewa as the guardians of the initiates through their abstaining from sexual activity (*kudika*) and the subsequent lifting of this ban in redemption (*kulongosola*). This is what the mask **Mwiri** from Dedza stresses and tries to inculcate in their audience. The name **Mwiri** (genet) is also used as a nickname for those who do not keep to these prescriptions.

[1] *"Walaka awa mwambo (3X) zosayenera kuziona lero iwowa a **Mwiri** tate de abwere adzaone, abwere adzaone tate de chomwe chinadza ndi Chauta tate de. **Mwiri Mwiri** akuti ayi. Ana anga achoka mawa. Nanga abambo nchiani choterechi, ana akali n'nyumba."*
[2] *"**Mwiri**, ankati amuna toto lero: anamwali anamwali a e! Chonchobe lero ilekeni ilowe, pa nyini pangawa, **Mwiri** tate, ndaona zino, kuti anthu andiyamike. Mimba yaturuka **Mwiri**."*

Mzimu ndilinde

(a pink day mask from the Dedza area)

Themes 1) Sexual taboos (*mdulo*); 2) Banda – Phiri relations

Etymology **Mzimu ndilinde** means, 'I am waiting for the spirit,' which implies ritual 'coolness' in keeping sexual taboos.

Mzimu ndilinde portrays the priestly functions of the chief. **Mzimu ndilinde** is always accompanied by Njati, the buffalo (refer to that entry) in the *bwalo*. In the past these two characters were closely associated with the Banda rain ritual (800 – 1300 A.D.) and the female initiation ceremonies that were linked to it. Their importance seems to have decreased with the emergence of the Malawi – Phiri (around 1300 A.D. onward) and Malawi assumption of control of the Banda shrines. The *gule* and the initiation ceremonies were then divorced from the rain ritual. Today these two characters are seldom seen. If they do appear, they feature in the context of exorcism when there is spirit possession or at the funeral of important chiefs when initiation rites also take place.

Mzimu ndilinde is today a red or pink mask. In the past it was black. This change of colour may manifest the shift from Banda ritual roles to the Malawi political ones and may mock the way Malawi tampered with the Banda rites in order to build their political system. The large oval mask has an expression of surprise or awe. Details of the mask (black hair, black sideburns, black moustache and goatee made of black goatskin) and of the costume are predominantly black, the colour of the rain ritual. The nose is long and aquiline like a beak. The heavy square chin gives the face an ascetic look. The headgear of the mask is entirely made of black goatskins cut into strips except for a white tuft of sisal standing erect on top of the head. This hair lock stresses the ban on sex. Now the character wears a jute outfit (shirt and trousers) stitched with black rags. The dancer carries a beer pot or he leads a live black goat on a string. These demonstrate the rain ritual context. He dances at the rhythm of the *ngwetsa* (the rain dance).

When **Mzimu ndilinde** was involved in the rain rituals he would bring the goat to the shrine and the people followed him. The goat had to be a full grown female that had not yet given birth. It had to be unblemished and black. The animal was slaughtered at the village and the blood was poured into a small beer pot. The blood and the meat were carried to the shrine. **Mzimu ndilinde** was the main celebrant together with Njati. He had to offer the blood and roast the meat. The female initiates collected the firewood. **Mzimu**

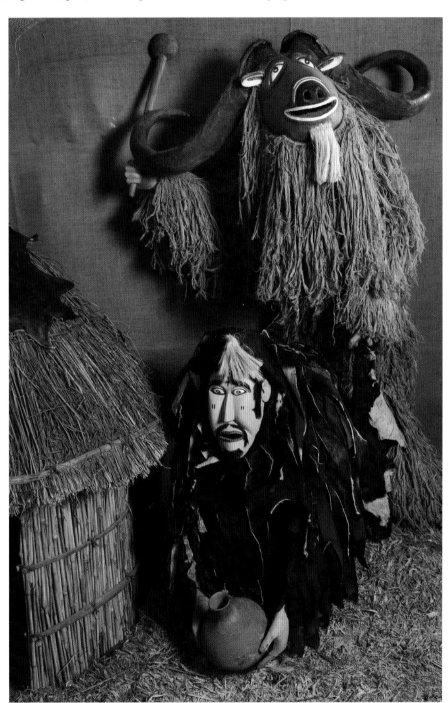

ndilinde kindled the fire by rubbing together the soft and the hard stick (*mpekho*), evoking the mating of sky and earth. As the meat was roasting, the smoke rose to form rain clouds. When the meat was ready and offered, **Mzimu ndilinde** and Njati returned to the village to perform their dance at the *bwalo*. The characters roamed around the arena and spun like Kasiya maliro without swerving their feet. **Mzimu ndilinde** knelt politely in front of the women while Njati spread a black goatskin for them to place their offerings on the ground in front of them. **Mzimu**

ndilinde held a piece of broken pot in which he had collected some ashes from the fire of sacrifice, and blessed the audience by throwing some of the ashes at them. The whiteness of the ashes reminded the crowd of the ritual coolness they should keep for this occasion. The meaning of this pantomime was revealed through the song sung by the audience: *"Rejoice, the buffalo! Let us accompany it so that we might be able to see a small cloud, water from the sky, water! The buffalo is useless, it is useless: the water has dried up! I wait for the spirit* (I abstain from sex), *(Mzimu ndilinde). See he prays to the owner of drought, to Chief Chauta* (God). *Yes, we saw a small cloud in the sky, a small cloud of rain. Let us fight drought, drought, drought! Rejoice, the buffalo! A bit of rain is coming! We have seen miracles, miracles, miracles from God!"* [1]

Mzimu ndilinde and Njati emphasise the supreme role of sexual taboos in Chewa culture with regard to rites of passage, and rain rituals in particular. They seem also to echo silent rebellion of the powerless Banda who were forced to accept the religious changes imposed by the Malawi. The song's allusion to the buffalo and drought is revealing. For the Banda, the wild animal

had to offer itself in sacrifice by falling into the hunter's pit located close to the shrine. Otherwise, rain was withheld and a bloodless human sacrifice had to be performed by drowning some of the initiates in the sacred pool. As soon as the Malawi were in a position to control the rain cult, the Banda rain rituals described above were stopped and replaced by bloody sacrifices in which fire was made within the enclosure of the sacred grove. Similarly, some of the Banda ritual officials were replaced by Malawi incumbents. The two characters and the ritual (described above) clash considerably with the Banda practice and demonstrate how the Malawi subsequently remodelled the rite. Mzimu ndilinde's face was no longer black but had turned red (despite the fact that the costume kept the black colour) to show that the Malawi had become the new owners and the new officials of the cult. Blood was offered and meat was roasted within the sacred space.

The cult had undergone major changes under the Phiri dynasty. One can only presume the *Nyau* members involved in the rain ritual described above were reclaiming their right of ownership over these rituals under the Malawi leadership. They were

voicing their protest over the changes brought about by the Malawi. Today both characters are almost forgotten. Elders who have witnessed their appearance (in the 1910s–20s) consider that the central message of Mzimu ndilinde was to emphasise sexual taboos. Mzimu ndilinde means, 'I wait for the spirit,' or 'I keep ritual coolness (*kudika*) enforced by the spirit world.' Such taboos regulate all rituals including rain calling. The chief who officiates as a priest during the rain ceremony is bound to keep such rules for fear of compromising the ritual. The same applies to all the participants, male or female. Rituals prescribe sexual abstinence as a privileged way of tuning oneself into the spiritual world and asking for its favour.

[1] *"**Njati** yerere tate (2×) oh ee taperekeze. Kantambo tikaone madzi, kumwamba madzi tate de. **Njati** yalala, yalala **Njati** (2×). Tate madzi adauma, a **Mzimu ndilinde** taonani apemphera kwa eni chilala, kwa mfumu a Chauta. Inde de taonera kantambo tate kumwamba tate, kantambo kamvula tate, nkhondo chilala tate chilala tate chilala, Njati yerere. Adza kamvula tate. Taonera mayere, mayere tate, mayere a Chauta."*

Namwali tiye

(a female night mask from the Mua area)

Themes 1) Women's cycle hygiene; 2) Women's cycle instructions

Etymology Namwali tiye means, 'Young girl, let's hurry.'

This mask belongs to the women's treasures, which are used during the girls' initiation rites. Namwali tiye was last danced in the Mua area around 1920. The mask is in the shape of a vagina. It used to be kept by a senior male dancer initiated into the female rite on behalf of the mistress of initiation, the *namkungwi*. It was used only during female puberty initiation. It helped the initiate understand the rules of hygiene. The carved face, featuring the female organs, was hidden under a piece of cloth supported by two strings. The focus of the lesson was to teach the girls how to use the hygienic towel. At the end of her instruction, the *namkungwi* went to the senior man who kept the mask and she put it on for going to the rubbish heaps (*dzala*) or for entering the seclusion hut (*tsimba*). The girls, who were covered with cloths, followed her at the rhythm of the *chisamba*. They sang, *"Young girl, let's hurry, let's see the initiates who have washed* (menstruated)."* [1] While the singing was going on the girls were uncovered so that they could see

the mask. The *namkungwi* removed the piece of cloth tied with a string that covered the red female organs of the mask. She gave the initiates practical instruction in the art of wearing hygienic towels. The women continue to sing the following song: *"Gaol is tough. There is war… what can I do? There is war, save me."* [2] These fantastic images of war and jail allude to the girls' seclusion and the dramatic physiological change happening in their bodies. These initiation events testified that the girls had been properly instructed. Relatives had to redeem each girl with a fee at the end of the initiation. The mask of Namwali tiye from the Mua area is the equivalent of the Chinkhombe mask of Dedza.

[1] *"**Namwali tiye** (5×) tikaone anamwali! Anamwali asamba."*
[2] *"Kuwawa ndende, nkhondo madala, nkhondo; ndiwombole."*

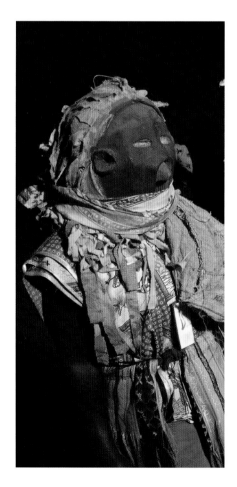

Nanyikwi or Nyikwi

(a fibre day mask from the Mua area)

Themes 1) Sexual taboos (*mdulo*); 2) Respect for the ancestors; 3) Sharing of beer; 4) Batwa – Bantu relations

Etymology The etymology of this name is uncertain. It could derive from *kunyinyirika* – 'to complain'; *kunyinda, kunyindira* or *kunyigula* – 'to open the lips in the utterance of a pitiful sound'; or *kunyikwirira* – 'to carry an impossibly heavy load requiring extra help' or 'to show the teeth' and 'to be ready to bite'. All these eclectic meanings are somehow relevant to the understanding of this character.

The mask resembles that of Kampini. Banana leaves are tied together with the apex turned inside out and smeared with black mud. Sometimes, silver paper eyes are added and a frightening mouth with teeth can be cut in the fibre, to allow the dancer to see. The performer wears a short kilt, leglets and armlets also made of banana fibres. Sometimes he wears a bark loincloth with an attached fake, erect, red-tipped penis. His body is entirely smeared with red clay (*katondo*). **Nanyikwi** always carries weapons (a bow and arrow, a knife or a club). His appearance is frightening and made even more so by the high-pitched "hee, hee" sound he utters.

Nanyikwi neither dances nor sings in the *bwalo*. He only appears at times of funerals and commemoration rites, where he walks about in a bent stance to diminish his height. He surveys the beer being brewed in honour of the deceased. His role is that of a disciplinary character who watches over the beer production and its distribution.

Nanyikwi has been known in the Mua region for a long time but he is not indigenous to the area. Some members of the secret society probably introduced him from Lilongwe or Kasungu, where they went to work on the estates. Because **Nanyikwi** carries weapons and walks about nearly naked, he is perceived as an aggressive spirit, ready to bite (*kunyinda*), physi-

cally or sexually. He is portrayed as a hunter, possibly a Batwa of old (reputed for their hunting skills and sexual prowess). The high-pitched sound he utters (*kunyindira*) has given him the name of 'the one who complains' (*kunyindirika*) or 'the one who carries a load he cannot move' (*kunyikwirira*). That is why he appears in the ceremonies in the late afternoon.

He grabs the villagers' livestock (chickens, ducks, goats and pigs) in full daylight, taking them away to the *dambwe*, where he provides a feast for the spirit world and his fellow dancers. At the *chikhuthe*, where the beer is brewed, he is given his share. This, too, he carries to the spirit world. The villagers allow him to take their livestock and their beer because they look at him as a messenger of the spirit world. He reminds them of their duty of caring for the dead by remembering them. His aggressiveness at times stresses that some spirits are fierce because they have been forgotten by their relatives. The Chewa believe ancestors bless those who remember them, but punish those who forget them by removing everything they own.

Nanyikwi's nakedness, his provocative sexual organ (the red-tipped erect penis) and the red colour of his body reminds people about not breaking the sexual prohibitions for rituals. Infraction of the *mwambo* will compromise the transition of those on

their way to the spirit world, upsetting their future relationship with the living. Frustrated spirits will seek revenge for failing to join their relatives in the spirit world.

Ndapita ku maliro or Nkhuku m'tsekere

(a black day mask from the Mua area)

Themes 1) Sexual taboos for funerals; 2) Witchcraft; 3) High mortality

Etymology **Ndapita ku maliro** means, 'I have gone to the funeral.' **Nkhuku m'tsekere** means, 'Close the chicken in.'

The black colour of this mask expresses prohibition. The mask can be carved of wood but more often is made of cloth or other material. It has a hideous face, grotesquely twisted out of shape. It is topped with two short horns portraying witchcraft. There can be numerous bumps and protrusions and deep grooves on the face. The character wears a loin cloth and his body is covered with ashes. He carries a long stick or a club, which are identified with masculinity and sexual intercourse.

In the arena, he dances with his stick. He shifts both legs at the same time, jumping on one side and the other, as if he is surprised and senses danger. Then he plants his stick in the ground, moving his hips and pelvis as if he is having sexual intercourse. The men sing for him, *"You children, I have gone to the funeral, please close the chicken in."* [1] This is a euphemism for, 'Do not have sexual relations.' In the song, the elder of the family group or maternal uncle gives advice to his married daughters and their

husbands before departing for a funeral far away or before undertaking a journey of several days. He says that in his absence the couples should abstain from sexual relations. The Chewa used to forbid sex when one member of the family was away on the occasion of the funeral of a relative. A couple which does not keep the sexual taboos kills its own children.

The second song sung for **Ndapita ku maliro**, identifies a different culprit for the death of the children: *"You have already*

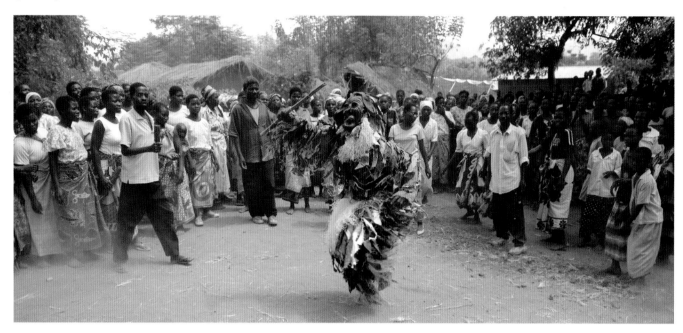

started killing my children. You are a witch." [2] In this case, it is not the head of the family group who speaks but the husbands of the elder's daughters who have been warned about sexual continence. These couples have kept to the prescription and they know that they are not responsible for the death of their children. Nevertheless, their children have died of mysterious causes such as chicken pox or measles. They have gone to the grave one after the other. The parents

have been blamed for the deaths. Now they have discovered that the elder is responsible for these deaths because he or she did not keep the rule of solidarity. He thought he could cheat with the rule of *mdulo* and could bypass these sexual taboos. The elder's lack of discipline is seen as a form of witchcraft and the cause of the children's deaths. In this scenario, the elder is the witch who kills them; the parents are not to blame.

Ndapita ku maliro focuses on the con-

flicts that are inherent in the family group because of the high mortality rate amongst children. Traditionally, the most common explanation for the death of Chewa children is found in the breaking of sexual taboos and in the practice of witchcraft, personified in **Ndapita ku maliro**.

[1] *"Ana inu, **Ndapita ku maliro** (2×)! Nkhuku m'tsekere,"* or *"Musati mukwatane."*
[2] *"Mudayamba kale kundiphera ana anga ndiwe mfiti!"*

Ndege and **Ndege ya elikopita**
(night structures from the Mua area)

Themes 1) Love; 2) Pain of separation; 3) Mystery of death; 4) Recent politics

Etymology **Ndege** means, 'the aeroplane'. **Ndege ya elikopita** means, 'the helicopter'.

The first aeroplane was seen in Malawi during World War I. A plane crashed in Malindi in 1916 and was photographed. The first Rhodesia-Nyasaland Airways plane landed at Chileka Airport in 1934. The villagers around Mua saw their first aeroplanes in May 1933. They appeared above the Dedza escarpment and flew over the railway line that was under construction. They were flying from Dedza to Mangochi. The Chewa who went to seek employment outside the country must have seen planes at an earlier date.

The plane structure was probably introduced in *gule wamkulu* around the mid-1920s and was used exclusively during the night vigils connected with funeral rites. The plane is depicted by a mini structure that resembles a child's toy. It is about a metre in length, made of grass, bamboo, maize husks, palm leaves, white cloth or

Painting by Claude Boucher and Joseph Kadzombe, 2009

white plastic. It has wings and a tail in which a small torch bulb can be turned on and off. The shape of the plane resembles that of a coffin (cf. p. 260). The plane is activated by a dancer wearing dark clothes using a long flexible bamboo stick. An electric wire reaches down to the dancer who moves the stick and activates the bulb with the torch mechanism he holds in his hand. He makes the plane move and change altitude following the rhythm of the drums. The performance of such a structure showed the ingenuity of the *gule* members and contributed to their reputation of practising magic. As the miniature model appeared, the male choir sang, "*I would have gone with it* (him/her) *were it not for these padlocks* (holding me back). *I would have gone to see the plane, this plane, this plane.*"[1] This song recalls one of the songs of Kasiya maliro sung at the funerals. "*God, the mother who gives birth, I would have gone to see Her. I would have gone with Her.*"[2] In these songs, the mourners express their grief for being separated from a loved one. They tell God about their wish of going to the creator with their deceased relative.

People who love each other profoundly find it difficult to be separated by death.

They wish to die together. When a partner in a long time marriage dies, the one left behind often loses the will to live and dies soon after his or her companion. This is called *maferano* or *mtengano* in Chichewa, meaning that they carry each other or die for the sake of each other.

The song compares a trip in a plane to death or the journey to God. Inside these mysterious machines, the person vanishes in the sky and is thought not to come back, as if he had disappeared through death (the shape of the coffin). People who are bound by deep affection and love may wish to die together, but death adds its own secret, to which no one has the key. The structure of **Ndege** expresses compassion and profound affection for the deceased and conveys the wish to accompany him or her into death.

At a later period the structure was divorced from the funeral rites and became increasingly used for many other types of rituals. Its original meaning was obscured and new interpretations were made in the light of current events. For example, Kamuzu Banda decided to end Malawian labour migration to South Africa. Soon after in 1974, a plane full of Malawian workers crashed. This was interpreted

through **Ndege** as a protest against Kamuzu Banda's decision.

From the mid-1980s, the President of Malawi ceased using the roads for his official visits and travelled mainly by helicopter. An airfield was opened at Mtakataka and a Squirrel helicopter was in regular service in the 1980s. This encouraged the Chewa of certain areas to modify the construction of the plane and change it into **Ndege ya elikopita**. The structure of **Ndege ya elikopita** was made of jute sack and black roofing plastic stretched on a bamboo frame three to four metres long. It did not fly as the plane, but moved across the ground at a modest speed. It displays mobile rotors propelled by torch batteries and sometimes has a pilot Kapoli, who opens the door of the helicopter and waves at the audience. The helicopter of Kamuzu Banda conferred a semi-divine status on the President, identifying him with the sky and the rain. After all, he was the eternal and the all-powerful leader who had found the key to the plane, and to death itself.

[1] "*Ndidakanka nawo kachipanda maloko, ndikaona **Ndege** ndegeyo tate ndegeyo tate.*"
[2] "*Namalenga, ndakamuona, ndakanka nawo.*"

Ndomondo

(a day mask from the Dedza area)

Themes 1) Sexual obsession; 2) Promiscuity; 3) Improper behaviour of strangers; 4) Separating husband & wife (dangers of); 5) Familiarity between brother- & sister-in-law (*chilamu*)

Etymology Ndomondo is a Chewa name for the hippopotamus.

This large grey mask of a hippo head has an open mouth with large teeth, swollen red eyes and small ears. The face is wrinkled. The headgear is made of baboon fur and covered with a black animal skin. The dancer wears a tattered jute suit. A small ladle-shaped tail hangs behind. The underside of the tail is stitched with red material. **Ndomondo** carries a branch with leaves to represent food or the ancestors' whip of discipline. The character depicts the hippo that comes from the lake, symbolising 'the stranger in the village'. This is either a husband who comes to reside in his wife's village or an employee working there. The hippo represents an intruder whose behaviour is discourteous and immoral. He commits crimes against those who have welcomed him. He ignores sexual prohibitions.

As **Ndomondo** enters the dancing arena, he collapses and shows men and women alike the little red tail hidden between his legs. The tail symbol refers to either a promiscuous man who invites women to have sex by displaying his sexual organs, or

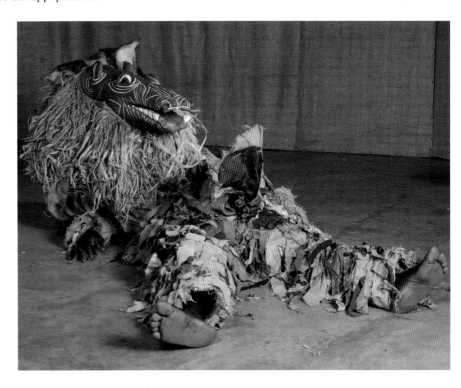

a menstruating woman who incites men to have sex when sex is forbidden and the *mdulo* can be risked. The **Ndomondo** character dances at funeral rites and at special initiations performed for pregnant initiates. **Ndomondo**'s songs stress that intruders can disturb the harmony of the village through immoral acts. *"What kind of relationship is that, **Ndomondo**? To have sex with a young girl who has just grown up! As soon as another has grown up you grab her. What kind of behaviour is this…to be in such a hurry and not spend time with your own wife? Oh, oh, oh, oh! **Ndomondo** used to say… Oh! **Ndomondo** used to say: Take your wife and go with her to your own village. I don't want you here at my home, no! To behave like this is wrong. Don't stay here, no!"* [1] This song advises **Ndomondo** to leave his place of employment and go back to his wife or take her to his own village instead of exploiting

young girls who are barely mature (*kadya makanda*). Another song spells out his sexual obsession in stronger terms: *"He is a dangerous wild animal even to his own kind. Beast, beast, beast!"* [2] A third song adds more grievances to his case. *"What kind of village is this, in which there is no respect for the elders? Who introduced this* (behaviour)*? It came with a stranger from the lake, from the lake. It is the hippo! It is the hippo that came from the lake!"* [3] To this last song the women answer, *"Some have sex even with their sisters-in-law.* (They say:) *Don't mention my name, the one who says, Don't mention my name is the very one who leaves a pregnancy behind."* [4] **Ndomondo** enjoys a joking relationship with his sisters-in-law but now they have become sexually intimate.

The mask, with its open mouth, sharp teeth ready to grab, red obsessive eyes and small ears, shows a person who is obsessed

with sex and who is closed to any advice. The Chewa, in their great dance, call him a hippo, the stranger from the lake. Strangers of this kind are not welcome. A visitor who comes to stay in the village should respect those who welcome him or her and follow their customs and laws.

[1] *"E tate chikwati chanji a **Ndomondo** chokwata mwana, mwana? Kuti atere, inu mwakwata. Khalidwe lanji lotero n'kosakhala kwa eni ake oh oh oh oh? A **Ndomondo** amamnena oh (2×) tenga mkazi wakoyo udzipita naye kwanu. N'panga pano! Iai, uko n'kulakwitsa n'khala pano! Iai!"*
[2] *"Chilombo choopsya eni ake ae (2×) chilombo ae de chilombo, chilombo."*
[3] *"Pa mudzi panji posaopa akulu de ae ae? Chadza ndi yani…ndi wina de wochokera ku nyanja, wochokera ku nyanja de, e tate e tate ndi a Mvuu ndi a Mvuu de ae wochokera ku nyanja."*
[4] *"Wena anachita voti ndi alamu awo (2×). Iai iai musandiulule! Musandiulule yemweyo taonani mimba yaturuka!"*

Njati

(a brown day mask or a structure from the Mua and Dedza areas)

Themes 1) Fertility; 2) Sexual taboos (*mdulo*); 3) Banda – Phiri relations

Etymology **Njati** means, 'buffalo'.

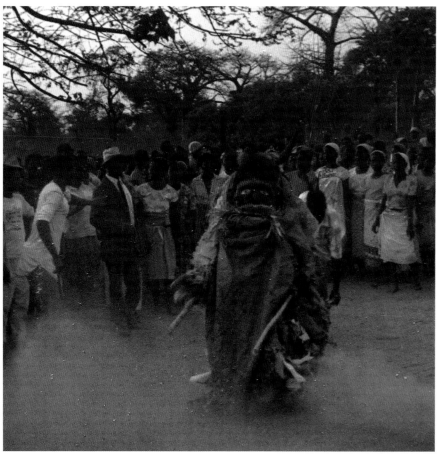

Claude Boucher, Chenjero Village, November 1993

The buffalo has featured in *gule wamkulu* for over 1000 years. The animal has taken various representations, from an animal structure animated by many dancers to one single dancer wearing a buffalo mask or a human mask combining some of the animal characteristics. It is impossible at this stage of our research to tell which form is the most ancient. All of them have been witnessed by various informants in the last 40 years. Each area has its own predilection for a form following its own local tradition. Moreover the presence of **Njati** in *gule* is associated with a great variety of rituals and functions ranging from the offerings at the rain ritual to that of the teacher of the *mwambo* at funerals, commemorations of funerals, initiations and *dambule* (the annual commemoration for the dead). Each of the three representations discussed here highlight a very specific message that still remains focused on the importance of the Chewa morality, the *mwambo*, particularly the *mdulo* complex, which regulates sex in various life situations encountered by the Chewa. The function of these mask representations has been inter-dependent with the social and political events of the time.

The earliest appearance of **Njati** in *gule* dates to the period when the Banda clan had full monopoly over the land now called Malawi (800–1300 A.D.). At this period **Njati** was considered as the rain bull to be

captured in a pit and offered to God and the ancestors to prevent drought or famine. The failure to capture such a bull called for human sacrifice in those days. Young girls were thrown into the sacred pool with stones tied to their wrists and ankles during the initiation ceremony that was combined with the rain ritual. The presence of the buffalo was then evoked in the great dance during the rain ritual. Two types of characters represented it. One was a structure made like a basket and used for carrying home the initiates at the end of the puberty ritual. This structure, still in use in the Mua area up until 1969, was two metres long, one and a half metres high and about a metre wide. It was animated by two dancers. The bamboo frame was covered with a special type of grass for the day performance and palm leaves woven in a zigzag pattern for the night appearance. Legs are visible in the day structure but covered by a fringe for the night version. The bamboo frame imitated the body shape of the buffalo with a stout neck, curved back and standing high at the rump. A long tail coated with grass or sisal was often mobile. The head showed an open mouth with fierce teeth, 60 centimetres long striped horns, ears made of goat skin, and aggressive eyes made with reflective material. The dancers were required to keep sexual continence before dancing the structure. **Njati** left the *dambwe* jumping ferociously and chasing both men and women in the arena, as the male and female choir sang in a canon, "***Njati** oh, a ferocious animal.*"[1] Or a second song: "*The bow is broken; on the other side of the hill there is a buffalo, I want to pierce it... (but) the bow is broken.*"[2] In 1969 the leading voice for the songs was that of Mrs Adaina, the sister of the former chief Msolo Bidasi Msonkho. She was the mistress of initiation then and had been a kind of spirit wife performing rain rituals at the Falls of *Mwali* on the Namkomwe River before the rain cult passed into history. Both songs highlight the fierceness of women (thus compared to the buffalo) when they are approaching their menses. The bow is of no use (broken) because at that period sexual abstinence is imposed on the Chewa community. The structure of Mua, besides providing a ferry for the initiates at the end of their puberty, inculcated in them the key aspects of the *mwambo* for a Chewa woman. These are the sexual taboos ensuring her fertility. Women experiencing menstruation could not take part in the rain ritual.

The other type of **Njati** was a buffalo mask danced by a single dancer. He carried a club in his hands for hunting buffalo and a black skin representing the buffalo skin on which offerings were laid. The buffalo

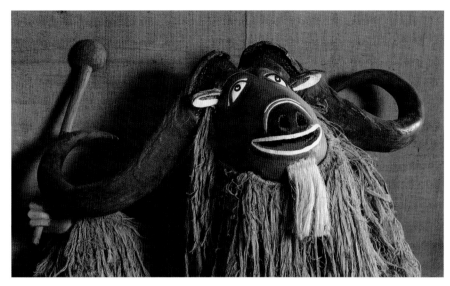

accompanied Mzimu ndilinde, the priest, (refer to that entry) who presented the offerings at the shrine. It danced at the rhythm of the *ngwetsa* (the rain dance). After the offerings were presented, both characters returned to the *bwalo* and danced. As Mzimu ndilinde knelt in front of the women, **Njati** spread the goatskin in front of them indicating that it was time for them to present their offering. As he gyrated around the *bwalo*, the choir sang, "*Rejoice, the buffalo! Let us accompany it so that we might be able to see a small cloud, water from the sky, water! The buffalo is useless, it is useless: the water has dried up! I wait for the spirit* (I abstain from sex), *(Mzimu ndilinde). See he prays to the owner of drought, to Chief Chauta* (God). *Yes, we saw a small cloud in the sky, a small cloud of rain. Let us fight drought, drought, drought! Rejoice, the buffalo! A bit of rain is coming! We have seen miracles, miracles, miracles from God!*"[3]

Around 1200 – 1300 A.D., the rain shrines came under the control of the Malawi dynasty of the Phiri clan and *gule wamkulu* was divorced from the shrines. The Malawi made many substantial changes to the shrine rituals, particularly the introduction of bloody sacrifice as opposed to cool sacrifice of the Banda. **Njati** and Mzimu ndilinde presented the offerings of blood and roasted sacrificial meat at the shrine.

The two characters emphasise the supreme role of sexual taboos in Chewa culture with regard to rites of passage, and rain rituals in particular. As well, they seem to echo the rebellion of the powerless Banda who were forced to accept the religious changes imposed by the Malawi. The songs' allusion to absence of the buffalo and drought is revealing. For the Banda, the wild animal had to offer itself in sacrifice by falling into the hunter's pit dug close to the

shrine. If it did not, rain was withheld and bloodless human sacrifice had to be performed. The Malawi stopped the Banda rituals and replaced them by blood sacrifices in which fire was made within the enclosure of the sacred grove. They also replaced Banda officials by Phiri incumbents. The two characters and the style of ritual changed dramatically under the Malawi. Mzimu ndilinde's face was no longer black but had turned red (despite the fact that the costume kept the black colour) to show that the Malawi had become the new owners and the new officials of the cult. Blood was offered and meat was roasted within the sacred space. One can only presume the *Nyau* members involved in the rain ritual were reclaiming their right of ownership over these rituals under the Malawi leadership and voicing their protest over the changes brought about by the Malawi.

Both characters are now almost forgotten. Elders who witnessed their performance (in the 1910s–20s) considered that the central message was focused on sexual taboos. Such taboos regulate all rituals including rain calling. The chief who officiates as a priest during the rain ceremony is bound to keep such rules for fear of spoiling the effect of the ritual. The same applies to all the participants, male and female. Rituals prescribe sexual abstinence as a way of tuning oneself to the spiritual world and asking for its favour. This remains the key theme of **Njati** and Mzimu ndilinde.

Today when **Njati** appears with Mzimu ndilinde in the arena he lays the black skin on the ground and people deposit their offerings on the hairy side of the skin. These gifts are used as remuneration for the dancers who have prepared the ceremony in honour of senior deceased members of the community.

The Golomoti area has its own version of **Njati** that appears as a single character mainly at funerals and commemoration ceremonies of senior members of the community. The red mask shows a human face with large angry eyes, fearsome mouth full of teeth (sometimes with grass in the mouth) and a heavy beard made of wild animal skins. Two impressively long bull horns protrude from his head. The head gear of the mask is made of wild animal skins such as Vervet or Samango monkeys. The dancer wears a jute shirt and trousers covered with pieces of plastic and old fertiliser bags stitched to the jute outfit. A fertiliser lace kilt is sometimes added to his waist and leglets to his feet. **Njati** carries a club to the arena and chases the people, swerving his feet and brandishing his weapon. The male choir sings for him, "*The bow is broken; on the other side of the hill there is a buffalo, I want to pierce it …*(but) *the bow is broken.*" [4] The song is the same as one for the Mua structure and talks about the husband who had planned to have sex but discovered that his wife was having her period. The image of the bow, the hunter and that of piercing are euphemisms for sex. The buffalo and the hill evoke the wilderness of the pubic hair and the red female organs during her period. The song emphasises in riddle form the importance of sexual taboos and the necessity of keeping continence (*kudika*) on such occasions. The bow is broken voluntarily because it can lead to contracting *mdulo* or *tsempho* meaning the death of the hunter in encountering the wild red buffalo.

Despite the difference of their historical context, the three buffalo characters emphasise the importance of the *mwambo* for both Banda and Phiri clans that comprise today the Chewa society. All of them focus on the themes of fertility. The Dedza representation and possibly the **Njati** structure from Mua give priority to the fertility of the land through rain rituals. The structure of Mua and the mask of Golomoti stress the fertility of the women with regard to their cycle and the sexual taboos surrounding funerals, commemoration ceremonies and initiations, or any other rites of passage requiring ritual coolness. For the Chewa, life comes forth through waiting (*kudika*), as a humble plea to the world of the ancestors, upon which humans depend for help.

[1] "**Njati** *toto de (2×) nyama yoopsya.*"
[2] "*Waduka uta ee, kuseri kwa phiri kuli* **Njati** *m'mati ndikalase waduka uta.*"
[3] "**Njati** *yerere tate (2×) oh ee taperekeze. Kantambo tikaone madzi, kumwamba madzi tate de.* **Njati** *yalala, yalala* **Njati** *(2×). Tate madzi adauma, a mzimu ndilinde taonani apemphera kwa eni chilala, kwa mfumu a Chauta. Inde de taonera kantambo tate kumwamba tate, kantambo kamvula tate, nkhondo chilala tate chilala tate chilala,* **Njati** *yerere. Adza kamvula tate. Taonera mayere, mayere tate, mayere a Chauta.*"
[4] (Song 2 above)

Njolinjo

(a black mask from the Dedza area and Mozambique south of Dedza)

Themes 1) Playboy; 2) Potency; 3) HIV/AIDS & sexual diseases

Etymology **Njolinjo** means, 'the one who stands erect', or 'the one who hops about'.

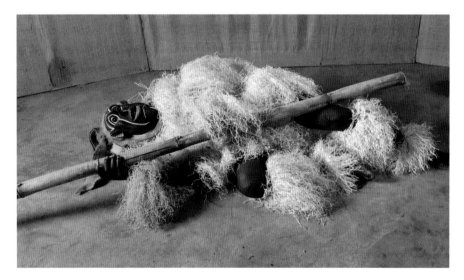

Njolinjo's features suggest those of a potent and sexually active male. He has sensual lips, pointed nose (indicating frequent erections) and black colour (here representing fertility and promiscuity). The tribal marks show he is a Chewa. His full head of dark hair indicates he is a young man. The mane of his mask, made of wild animal skins, demonstrates his sexual impetuosity. **Njolinjo** wears a short jute kilt, white leglets, armlets and a collar made of sisal.

He can be present at any ritual. His main function is to teach and entertain. He enters the dancing arena with a long stick that he uses for acrobatic movements. He climbs it, falls back with it and jumps about using it as a prop. This type of behaviour prompts his name: 'the one who stands erect', or 'the one who hops about'. During his performance, the male choir sings, "*Up! Up! Here is a real man but he jumps* (he is promiscuous)*! It is true – he is called* **Njolinjo** (the penis), *is up* (in erection)*! Yes, my friend* **Njolinjo** *is a real man but he hops about!*" [1] The song suggests that this virile young man has already proven himself by fathering several children. His success in married life becomes his downfall. His popularity with women turns him into a playboy who jumps in and out of beds. He shows off his sexual prowess by climbing the stick and standing erect. Falling down symbolises the shame of court cases and the sexual diseases that follow his misbehaviour. Ultimately he becomes impotent and his penis has to be amputated owing to the progress of venereal disease. A more recent interpretation has him die as a result of contracting HIV/AIDS.

[1] "*Jojo wamuna, koma kujowera. Zoona akuti* **Njolinjo**. *Yakwera ee ee tate ye. Wamuna koma kujowera. Kujowera inde bwanawe* **Njolinjo** *wamuna koma kujowera.*"

Nkhalamba chipembere

(a grey day mask from the Dedza area)

Themes 1) Old age/ageing gracefully; 2) Sexual obsession; 3) Generation gap in marriage; 4) Redeeming (*kulongosola*); 5) Sexual taboos (*mdulo*)

Etymology **Nkhalamba chipembere** means, 'the old rhinoceros'.

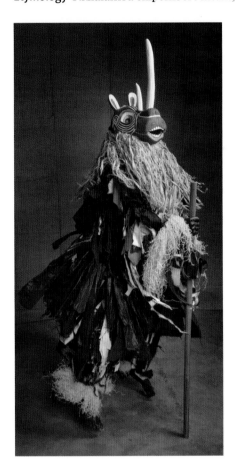

The character features an old man with the appearance of an aged, wrinkled rhinoceros. The mask depicts the rhino's head with standing ears, a mane of bark and a little white skin on top of the mane. Two white horns erupt from the nose. The eyes are red and the mouth shows a naïve smile. The dancer wears a tatter suit, a kilt made of bark strips, leglets and armlets. The old rhino walks with a stick, owing to his advanced age and weakness. Though he is senile, **Nkhalamba chipembere** does not accept his age or the fact of growing old. He still thinks of himself as young, strong and virile.

Nkhalamba chipembere dances only at funeral and commemoration rites. As soon as he enters the *bwalo*, he starts swaying his hips and fixates on sex and young women, as if he is still in his prime. The men's song says, *"The old man, the old man left his old wife to marry a young girl! War, **Chipembere**! What did you do?* (You married) *a girl not yet grown up and* (you) *got the* (*mdulo*) *disease,* **Chipembere**. *Shame, shame, incurable sickness* (that will bring you) *to your end. Oh, war, **Chipembere**!"* [1] To this song the women answer, *"Yes, mad rhino, mad* **Chipembere**.*"* [2]

The character has been created to mock people who do not acknowledge their age. Old men can still aspire to marry young girls. Marriage between partners of different generations is discouraged among the Chewa for a number of reasons. Firstly, the pair will fail to understand each other. Secondly, the older partner will fail to satisfy the sexual needs of the younger partner and put his own health at risk. Thirdly, if 'the old rhino' fathers a child, he may fail to 'redeem' it (through repeated ritual intercourse, *kulongosola*) and be shamed. The Chewa believe that it is irresponsible to father a child, then fail to 'redeem' and care for it. The white skin at the back of the rhino mask stresses the sexual taboos that have to be enforced at the time of menstruation and after birth. The two white horns on the nose of the animal portray the virtuous behaviour that allows a person to reach old age. Jealousy, irresponsible behaviour and promiscuity lead to the grave. The rhino can grow a long horn only if it stays away from mischief. The short horn stands for self-discipline in sexual matters; the fear and avoidance of promiscuity and of sexually transmitted diseases are a guarantee of a long life.

[1] *"Nkhalamba de nkhalamba* (2×). *Adasiya nkhalamba kukwata mtsikana. Nkhondo a* **Chipembere**! *N'chiani mwachitacho? Mwana wosathera! Watenga nthenda a* **Chipembere**. *Chipongwe chipongwe de* (3×) *matenda wosathera oh. Nkhondo a* **Chipembere**!"

[2] *"Eae* **Chipembere** *msala eae* **Chipembere** *msala."*

Nkhandwe

(a day or night structure from the Mua area)

Themes 1) Model of ideal husband; 2) Marriage, preparation & instructions; 3) Potency; 4) Hard work; 5) Faithfulness

Etymology **Nkhandwe** is a jackal.

The structure of the jackal (one and a half metres long and approximately one metre high, including the legs) is carried by a single dancer on his back, walking on his hands and feet. The general shape of the animal is constructed with a bamboo frame. The head is situated lower than the straight back leading to a hump that ends the structure. The flow of lines converges to a fluffy tail that becomes the focal point and the central message of **Nkhandwe**, as a male sexual symbol. In the night costume, the bamboo frame is concealed with grass on which dried palm leaves are woven into a zigzag pattern. A long fringe of similar material partially hides the arms and the legs of the dancer. The animal is por-

trayed with a small head, an open mouth, large ears and a long flexible tail (resembling a palm-leaf broom). The day costume features the jackal with more realism. The bamboo frame, covered with grass, is then dressed with jute sacks. Baobab bark is shredded and woven into long lines. These are stitched on the entire animal's body at 30 centimetre intervals, giving the impression of fur. Each line is partly smeared with black mud producing a contrast of dark and rusty colours. With such a simple technique, the jackal displays stripes. The tail of the beast is conveyed in the same manner. The head and the ears are moulded with reddish goatskin. The eyes are painted white. Short pointed

teeth cut out of an aluminium sheet are inserted in the animal's mouth to express its readiness to bite. A red cloth stitched into a tongue sticks out of the mouth. The structure's base is concealed with a long fringe of baobab fibres, also coating the arms and legs of the person animating it. His limbs are dressed with jute material on which layers of shredded baobab bark form multiple armlets and leglets, imitating the fur on the legs of the beast.

Nkhandwe enhances funeral and commemoration rites that often incorporate initiation (*mpindira*). It is also present at the more formal *chinamwali* (*mkangali*) and at the official day of remembrance of the dead

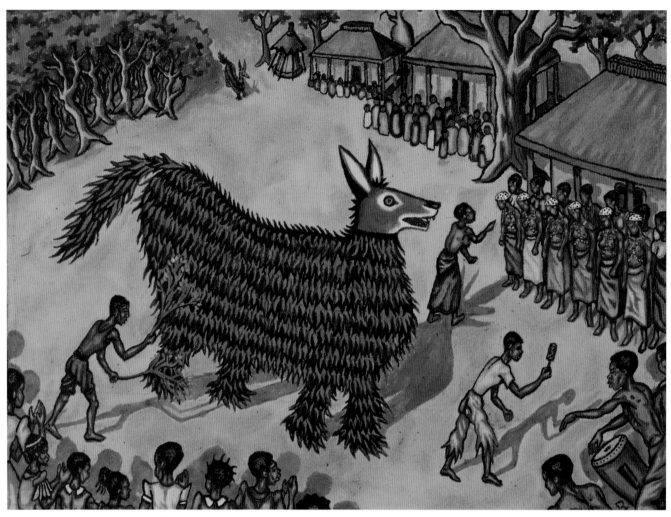

Painting by Claude Boucher and Joseph Kadzombe, 2009

(*dambule*). On such occasions, the jackal circles the *bwalo* and jumps sideways, swerving the feet alternately. The *namkungwi* and the initiates dance behind it, following the *chisamba* rhythm. In this way, the initiates learn to dominate their fear. The men sing the following song: *"The little dog of my father bites: the jackal."* [1] The euphemism of the small dog conveys the father image, the prototype for the future husband. The cryptic song reveals to the initiates the world of marriage. It allows adults to discuss the secretive matter of sex without the children understanding the realities beyond their own maturity. *"The little dog of my father"* is the flaccid male organ undergoing physical change and subsequently *"biting"*, signifying sexual relations and generating children.

In Chewa tales, the jackal is prominent. It is renowned for cleverness, continual activity, its prolific progeny, its diurnal and nocturnal activity and its monogamous lifestyle. All of these themes are internalised to discuss the qualities of a good husband. Like the jackal, the husband has to make use of his head and tail: foresight and potency. At night he is expected to produce, for his wife and her family group, plenty of children. During the day, he has to put his whole heart into his work, produce foodstuffs and provide for his family and children. He has to be faithful to his wife always, as is the jackal with its partner. After the dance, the *namkungwi* and the initiates re-enter the house of seclusion (*tsimba*), and then the initiator explains in greater detail the lesson about **Nkhandwe**. She teaches the meaning of these required qualities and explains their implications with regard to the life of the initiates who are looking forward to marriage. She expands on married life experience and warns them about irresponsible behaviour before their engagement. She discourages extramarital relationships leading to illegitimate pregnancy. She condemns adultery and the flirting that leads to it.

Nkhandwe's teaching is ultimately geared to both genders and to people of any age. It advises both male and female initiates who are preparing for an impending marriage. It also targets junior and senior couples that may have lost sight of their purpose as married people and fallen into adultery and promiscuity.

The jackal structure was common in rituals until the mid 1970s. After independence, the pressure of modernity started intruding into village life. Slowly but surely, many of the animal structures began to vanish with the consolidation of schools and the shortage of labour force and the free collaboration required for their construction. Their loss is to be regretted given their impact on family morality in a period when promiscuity was on the increase and sex was perceived more for personal enjoyment than as a means of cementing the family and the group. With the advent of a more western perception of sex, gratifying the individual, sexually acquired diseases have multiplied and HIV/AIDS is now ravaging the Chewa community. Marriages have become less stable and divorce is on the rise. The *mwambo* and the advice of the ancestors have begun to fade, their voices barely audible echoes to the new generations.

[1] *"Kagalu ka abambo toto kaluma **Nkhandwe**!"*

Nthiwatiwa

(a day structure from the Mua area)

Themes 1) Fertility; 2) Potency; 3) Sexual taboos (*mdulo*); 4) Choice of marriage partner (choice of *mkamwini*); 5) Communion with the ancestors

Etymology Nthiwatiwa is the Chewa name for the ostrich.

The ostrich has not historically been part of the fauna of Malawi. The etymology of the word is therefore obscure. *Nthiwa* in Chichewa expresses a flat surface like the back of the bird. More likely the word comes from the verb *kutuwa* – 'to be white'. *Tuwatuwa* would refer to the idea of whiteness that is the dominant symbol of this structure.

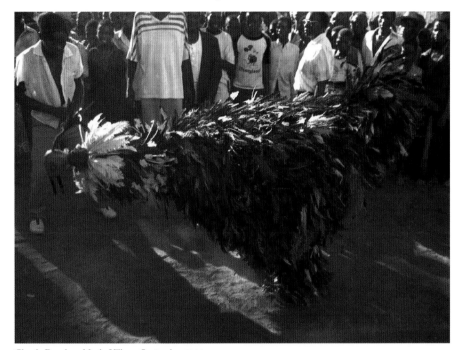

Claude Boucher, Msolo Village, September 1993

The Chewa workers who went to Zimbabwe and South Africa introduced this character into their dance. What struck them about the ostrich were its enormous size and the mobility of its white neck, which they interpreted within their own cultural ethos. The bird they have crafted is closer to the anatomy of a large rooster than that of an ostrich. This one and a half metre tall structure has been created to exalt the power of fertility of the husband. It has similarities to the elephant structure, from which it seems to derive conceptually. While differing in shape, their similarity lies in the mobility of the neck and the trunk. Both are understood to be an image of the male organ. The fact that the ostrich is likened to a cock is significant in the Malawian context. Among the Chewa, the image of the cock is commonly used for a young man who seeks to marry. He looks for a wife who is known as a 'hen'. The rooster is the central image of the marriage rite. The *gule* structure therefore is represented most commonly with a cock's comb.

On the dancing ground **Nthiwatiwa** behaves like the rooster courting hens. It first strikes with the neck and the beak

(*kujompha*) at the women's (hens') heads, then rotates around a woman with excitement as if it is executing a dance (*kutch-etcherera*). This behaviour evokes that of a young man who flirts (*kunyengerera*) with a girl trying to convince her that she should marry him. **Nthiwatiwa** is said to come from afar (the lake or South Africa), *"Nthiwatiwa is white, the bird from the lake, Nthiwatiwa, the bird from Johannesburg, Nthiwatiwa."* [1] This suggests that the husband should come from another family group, not related to the person he wants to marry. The colour and the material used for construction of the bird stresses the idea of potency and fertility. White and black feathers are attached to a bamboo frame. The body is completely covered with black feathers while the neck is made of white ones. The colours express respectively the ideas of fertility and semen, a prerequisite for marriage. This is voiced in the song of the women, *"Nthiwatiwa is white, is white, my mother told me that Nthiwatiwa is white!"* [2] During the initiation to puberty the young girls are taught that they should marry only a potent husband who can produce white sperm, otherwise they will

remain childless. The white neck moves forwards and backwards, an obvious symbol of the male organ that brings forth semen and healthy children for the benefit of the woman's family group.

As soon as **Nthiwatiwa** appears on the *bwalo*, the women clap hands enthusiastically in welcome. They would do the same for an important guest or a visitor of honour. Through their cheerfulness and warmth they symbolically welcome their husbands, the generators of their children. This is made clear during the girls' initiation ceremony when the initiates have to dance around the ostrich with the *namkungwi* and the *mkulu wakumadzi*. Their closeness to the ostrich suggests that they receive their fertility symbolically from their future husbands. It also suggests that both of the officials who dance with them are the spiritual parents who mediate the *mwambo* and their access to fertility.

Their initiation is reinforced with sexual taboos and hygiene rules that are spelled out in the features of **Nthiwatiwa**. We have already noticed the two dominant colours of black and white. A third colour, red, covers the inside of the open beak of the bird. Red symbolises menstruation, which initiates the process of fertility and makes it possible for the semen to produce children. The presence of red inside the beak of the ostrich stresses that sexual contact is forbidden at the time of menstruation and that the infringement of this rule is severely punished by contracting the *mdulo* disease. This suggests that sexual abstinence is a precondition for fertility.

As the bird dances in the arena, the odd feather detaches from the body and falls to the ground. The mistress of initiation immediately picks these up. This simple gesture is a lesson to the initiates in concealing everything to do with their condition (menstruation and hygienic towels). Furthermore, this gesture stresses that sexual matters dealing with the intimacy of the couple have to remain hidden from the public eye (as the *namkungwi* does with the feathers).

By teaching these rules and taboos regulating married life, **Nthiwatiwa** provides young couples with a blueprint for sexual behaviour that is inspired by that of the

rooster. The cock's main duty is to fertilise the eggs of the hen. When **Nthiwatiwa** is performing, it is given maize or flour to eat. It jumps and picks it up from the plate or from the ground. This is an obvious image for sexual intercourse. The husband in the Chewa context has the duty to generate children and 'feed the pregnancy' after conception.

At the *dambule* ceremony, the feeding of the ostrich takes a more spiritual meaning. The bird scratches the ground with its feet and looks for food. It then lies near the graves and picks up the food with its beak. All *gule* characters are the representatives of the spirit world. On this occasion the dead are offered food and beer, as they are an integral part of the village community. Through this food and drink they renew their bond of communion with each other. *Gule* is performed to honour them and show them respect. On the one hand, the dead are placated and invited to remain in the graveyard in order not to interfere with people's affairs. On the other hand, they are begged to remain part of people's lives and to assist them in their daily endeavours, especially with regard to generating children. Both the dance and the food offered are seen as a prayer to the ancestors who have been endowed by God with the power of fertility.

[1] "*Mbalame ya ku nyanja* **Nthiwatiwa**, *mbalame ya ku Joni* **Nthiwatiwa**."
[2] "**Nthiwatiwa**, *njoyera e (2×) adandiuza amai kuti* **Nthiwatiwa** *njoyera e* **Nthiwatiwa**."

Nyanyanda

(a black day mask from the Mua area)

Themes 1) Avoidance between son/daughter-in-law and parents-in-law (*chipongozi*)

Etymology The name **Nyanyanda** refers to 'pubic lice', which can only be removed in secrecy by married partners.

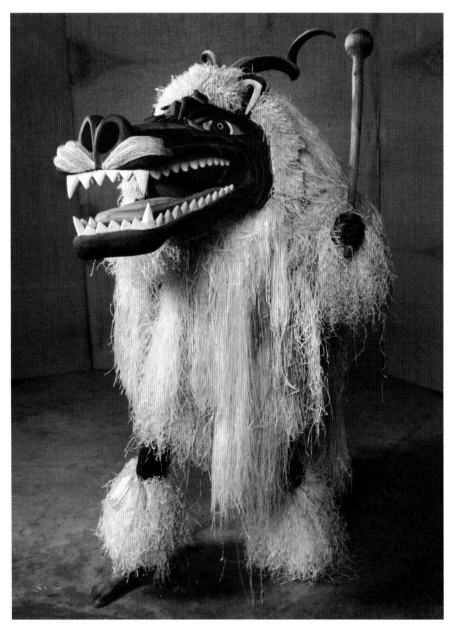

This very large and fearsome head has kudu-like horns and sharp teeth set in a snarling mouth. The mask shows small eyes and large ears to emphasise blindness and deafness. The mane of the kudu is made of dark rags and strips of wild animal skin. The dancer's body is smeared with ashes. He wears a short kilt, leglets and armlets. The character carries weapons such as a knife, club, ceremonial axe or long stick representing the disciplinary role of the ancestors in social relationships. The dance itself shows movements that are uncoordinated and betray hesitation and distance. As **Nyanyanda** enters the dancing ground it utters incomprehensible sounds, to which the women answer, "*The pubic hair of your mother-in-law is full of lice.*"[1] Or, "*I met with some elders who smoked bitter tobacco. (Be careful!)*"[2]

Nyanyanda is meant to inspire avoidance between in-laws. An animal like the kudu is dangerous. One should keep a safe distance. The enigmatic songs of **Nyanyanda** advocate the avoidance relationship between son/daughter-in-law and parents-in-law (*chipongozi*). They should not have a physical proximity, eat together, or approach each other's sleeping mats. Distance should be kept and familiarity forbidden. Their relationship should be strictly formal. Avoidance is the rule in public. These social rules are imposed to prevent any chance of incest between them. This forbidden sex is compared in the song to bitter tobacco that gives terrible blisters. One does not remove the pubic lice of one's mother-in-law or father-in-law for fear it will be interpreted as a sexual advance. **Nyanyanda**'s teaching can be voiced on any occasion when *gule* is performed.

[1] "**Nyanyanda** *pa apongozi pali* **Nyanyanda**."
[2] "*Ndakumana ndi anthu akale wodya fodya wa matuza*."

Nyata

(a day character from the Mua area)

Themes 1) Sexual taboos (*mdulo*); 2) Sexual obsession; 3) Batwa – Bantu relations

Etymology **Nyata** comes from *kumyata*, 'to kneel down; to be polite; to follow the ancestors' advice'. The proverb says "*Gwada umvetse – kneel and listen.*" *Kumyata* can also mean, 'to bend (with a sexual connotation)' or 'to be sticky' like certain substances and fluids, e.g. the leftover of the maize porridge (*mkute*) or a woman's menstrual discharge. The character of **Nyata** conveys all these meanings.

Nyata does not have a facemask. The eyelids of the dancer are pulled back and tied to widen the eyes, making them look frightening. The lips are also pulled back and tied to expose the red of the gums and the teeth. The dancer's face is blackened with pounded charcoal so his features are unrecognisable. A beard made of dyed sisal or animal skin may be added. His hair is covered with a sack smeared with red mud (*katondo*). In some areas the face disguise is replaced with a headcover made of chicken feathers (*chiputula*). **Nyata**'s body is smeared with the same red clay, expressing the prohibition on sex. He wears a small loincloth smeared with red mud or a short kilt, leglets and armlets made of reddish vegetable fibres. **Nyata** always carries weapons such as a spear, club or bow and arrow as symbols of his virility. His bow is often carried in an inverted position, showing it cannot be used, which indicates sexual prohibition. Both male and female singers call him with the following song, "*Did you see **Nyata**, did you see him?*"[1]

Nyata appears in the bush and runs rapidly and aggressively. The women are stricken with fear. **Nyata** does not enter the *bwalo* but chases the crowd from the bush. He is like a hunter of old, possibly a Batwa, chasing game (men and women alike). He does not swerve his feet but moves with forceful, uncoordinated movements. At the

time of the girls' initiation, he flogs those who are ill disciplined and badly behaved with a whip. His red body, fearsome face, semi-nakedness and threatening weapons convey he is akin to a madman or a witch. His uncontrolled sexual urges and per-verted nature make him disobey the ances-tors' advice, the sexual taboos prescribed in the *mwambo*. The Batwa were believed to be sexually licentious. Another song sung by the women reveals his lack of control: "*He roams around* (he has sex), *so they say. In roaming around one gets thin.*"[2] His very name of 'sticky fluid' indicates he cannot control his sexual urge during his wife's menses. His irresponsible behaviour causes him to contract the slimming disease (*mdulo*) and die. The horrifying face of the character suggests the symptoms of the *mdulo* disease.

Nyata's appearance is linked either to funeral commemoration rites or to initia-tion. His teaching is meant to warn the initi-ates about the sexual taboos inherent to married life: "*Gwada umvetse – Kneel and listen (to the ancestors' advice).*" Women in their period and after childbirth are told to refuse their husband. Males are also taught that they will not grow a beard (that is, grow old) if they do not follow these taboos. **Nyata**'s appearance in a funeral context attempts to explain premature death as a consequence of the *mdulo* disease. **Nyata**

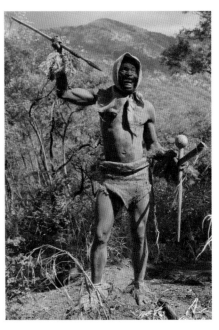

warns the couples about its danger. For the Chewa, disobedience to the ancestors' advice in sexual matters is always punished by the *mdulo* and is believed to be a primary cause of premature and sudden death. One has to 'kneel down and listen' carefully.

[1] "*Nyata Nyata mwaiona Nyata mwaiona Nyata?*"
[2] "*Kuyendayenda akutero kuyenda n'kuwondetsa.*"

Nyolonyo or Nyangulu

(a headcover in various colours from the Mua area)

Themes 1) Sexual taboos (*mdulo*); 2) Fertility; 3) Patience; 4) Recent politics

Etymology **Nyolonyo – Nyangulu** evokes the idea of 'being pulled out' and 'softness like that of the female organs'. The word *panyolonyo* means 'to be the last to follow advice'.

The headcover appears in a variety of colours. Traditionally it was black or white; today other colours are used. The shape is similar to that of Kasiya maliro. The mitre-like hat forms a two-pointed apex crowned with chicken feathers. These represent the head and the tail of Kasiya maliro. The hat is often decorated with bands of red cloth forming an X across the mitre that symbol-ises menstruation and prohibition. The hat itself is normally made of cloth or felt with eye holes cut for the dancer. Sometimes

additional details are added to give the impression of a human face. The entire head covering recalls the shape of Kasiya maliro stressing the idea of the womb and that of the female sexual organs undergoing the female cycle.

Nyolonyo is a variety of Kapoli and wears the same body outfit of small kilt, leglets and armlets. The body of the dancer is smeared with mud or ashes. He carries a small ceremonial axe (*katema*). His dance is derived from that of Kapoli but the chore-

ography and movements are more elabo-rate and sophisticated. There are always two **Nyolonyo** dancing together, with highly coordinated steps following the rhythm of the drums.

The character of **Nyolonyo** is closely connected with the world of women. He stresses their fertility cycle and the *mwambo* taught to them at different periods of their lives. In the arena, the women mirror his dancing. They follow behind him (*pa nyolonyo*) to express their readiness to

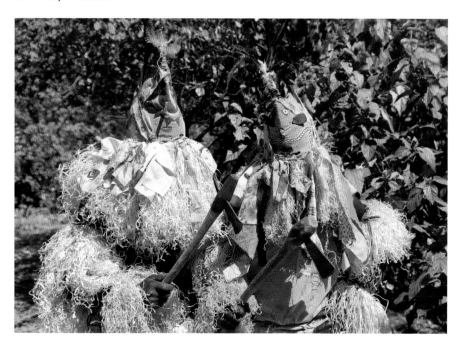

follow his advice. His central message is focused on the *mwambo* and the prohibitions regulating sexuality in various contexts. The core of his teaching is sexual abstinence (*kudika*) and patience (*kufatsa*).

His first song focuses on sexual taboos in a context of grief and mourning at the time of funerals: *"Alas! Alas! Alas! Let us show our oneness with the deceased lying-in-state, by accompanying him* (in abstaining from sexual activity).*"* [1] The second song teaches about sexual taboos in daily family life, in which abstinence is connected with the female menstrual cycle: *"It is stiff* (the penis in erection). *It is really stiff. You, namkungwi* (wife), *do not run away. You said you wanted a wild beast* (her husband)

… look, it is really stiff." [2] In this song the wife refuses her husband because she is menstruating or has had a child recently (red bands on the mask). If the wife is well (indicated by the white or black background on the mask) she should not refuse her husband. This is the advice that she receives from the *namkungwi* and her tutor. The third song tells the woman who has not had the joy of childbirth to have patience, *"Nyolonyo, where did you hear that I am getting married to a stranger? I am still without a child."* [3] This song tells her to wait for the fertile period.

During the days when the Malawi Congress Party (MCP) was the only political party in Malawi, **Nyolonyo** was one of

the characters that often performed at party meetings and political rallies. On such occasions his message took a more political tone, supporting the current political situation and the Kamuzu Banda regime. He states, *"Kanyama Chiume failed."* [4] Kanyama Chiume was one of those who had summoned Kamuzu Banda back to Malawi to be a figurehead for the MCP. Kamuzu Banda turned the tables on Chiume and his colleagues. **Nyolonyo** advises patience. *"Kanyama Chiume failed"* because he had no patience. He should have waited until Kamuzu Banda's death before involving himself in political reform. (Given Kamuzu Banda remained in power into his 90s, that would have been a very long wait!)

Nyolonyo's choreography and elegant dancing recalls the chief, the *namkungwi* or any authority, secular or spiritual, which reinforces the rules of the *mwambo*. Patience and sexual abstinence are key prescriptions for a fruitful family life. They are also indispensable for maintaining the spiritual balance with the world of the ancestors. Political authority comes from them. Any form of opposition to the established order is interpreted as opposing the ancestors and is bound to fail. One has to wait for a new order to be blessed by their authority, instead of creating chaos and disharmony.

[1] *"Kaiya iya iya maliro akali m'nyumba …taperekeze."*
[2] *"Sicho chaima tate, sicho chaima chaima ndoko. Namkungwi usathawe tate chaima uja umafuna chilombo tate chaima chaima ndoko."*
[3] *"Nyolonyo ede tate ede tate ede tate udamva yani ede tate ede tate ede tate. Kuti n'kwatiwa ede tate ede tate ede tate. Kuti n'kwatiwa ndi alendo ede tate ede tate chamsinde."*
[4] *"Kanyama Chiume lero walephera."*

Sajeni

(a day or a night structure from the Dedza area)

Themes 1) Sexual taboos (*mdulo*); 2) Redeeming (*kulongosola*);
3) Responsibility of family heads

Etymology **Sajeni** is a deformation of the English word, 'sergeant'.

The structure measures one and a half metres high and over a metre wide. The body is constructed with a bamboo frame in the shape of a granary on which long arms and a head are added. The head is square and covered with tatters. This small pink mask of 20 centimetres is painted with Chewa tribal marks. It shows eyes and eyebrows, wrinkles, and a long black goatee made of sisal. The mouth is painted in a style to appear strict and severe. The head is topped with black cowlick also made of sisal. The body frame of the sergeant is covered

with grass and jute. Long lines of woven sisal, 20 centimetres apart, hide the undercover. A long fringe on the bottom layer camouflages the feet of the single dancer. Two openings are cut to allow the arms of the dancer to protrude from the body. The arms are also concealed with the same material as the body and are extended with sticks in order to reach close to the ground.

The sergeant appeared for the funeral of chiefs and elders in the past, but the 1960s and 1970s saw its appearance for other types of rituals. The origin of **Sajeni** seems to have

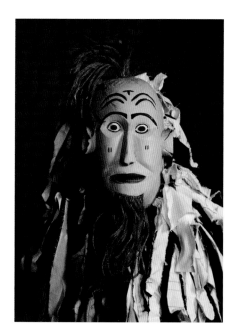

been influenced by the formation of the Kings African Rifles and their involvement in the First and Second World Wars. In the arena, **Sajeni** performs to the *chisamba* rhythm. He roams across the *bwalo*, spinning around, and hitting the crowd with his long arms in fashion similar to Mbonongo. The men introduce him with the following song: *"Things run smoothly with elders. They are the ones who have knowledge, Sergeant. When I see how you have dealt with this child… Sergeant. When I see what you have done… this is his own way of acting. Sergeant got surprised! To have sex when your child was still in a state of coolness!* (when he had not yet reached the state of being acknowledged as a child.) *Sergeant got surprised!"* [1] Another song is used as an alternative: *"Sergeant, you who stand up like a tree and are on the look out for mistakes. The officer, you who keep on saluting* (and say with authority,) *You must answer a case."* [2]

 Sajeni represents the head of the family group (*malume*) who has to look after the *mbumba* just as a sergeant would lead his

men. He has to ensure that the *mwambo* is respected, particularly with regard to the children of his sisters entering into family life. He is the elder who teaches them and controls their observance of sexual taboos throughout married life and particularly before and after the birth of children. Both songs deal with this issue. In the first song, one of the young *akamwini* has taken the initiative of having sex before the pre-scribed time. He has not yet performed the official ceremony of redemption (*kulon-gosola*). He is therefore perceived as killing his own child with the *mdulo* disease. The second song reaffirms his role as the sole authority over the family group when the *akamwini* infringe the rules. They force their wives into sex before the family group has officially given permission. Their irre-sponsible behaviour puts the babies at risk of contracting the *mdulo*.

 Sajeni reminds the young *akamwini* of the authority of the family head. They have to listen to his wisdom and refrain from sex if they want their own children, who are

also the *malume's mbumba*, to flourish and to grow older. **Sajeni** emphasises the importance of the *mdulo* and the supremacy of sexual continence (*kudika*), the tradi-tional method of preserving life and increasing the family group. **Sajeni** reacts against the younger generations who chal-lenge the ancestors' wisdom and think that because they are modern, they know better. **Sajeni** attempts to hold off the modern thinking that considers the rules of sexual abstinence as obsolete and irrelevant. This may explain why the structure of **Sajeni** has today disappeared from the arena … a victory of modernity over the *mwambo*.

[1] *"Nchito ikoma ndi akulu tate de ndiye adziwa nchito tate* **Sajeni**. *Kuona mwatero kwa mwanayu tate ee, kuona mwatero a* **Sajeni** *tate. Ili ndi dongosolo lawo tate de, adabwa a* **Sajeni** *diyere, mwana wosakula, wozizira tate de, adabwa a* **Sajeni**.*"
[2] *"A* **Sajeni** *tate ede uja angoima ngati mtengo tate, angofuna mtopola iwowa tate de. Abwana, abwana angochita manja khoba tate, iwo amene tatiye a* **Sajeni**.*"

Salirika

(a red day mask from the Salima area)

Themes 1) Sexual taboos for pregnancy; 2) Responsibility of family heads; 3) Witchcraft

Etymology **Salirika** refers to a person who cannot be adequately mourned.

This large, red mask has a mournful face. The eyes seem to well with tears and the mouth, disproportionately large with missing teeth, expresses grief. The face rep-resents the head of a Chewa family group, a senior man with a bald head, wrinkled fore-head, tribal marks, long drooping mous-tache and heavy beardless chin. The nose is long and the nostrils are painted black to signal a person who is sexually active when sexual taboos are prescribed. Two black protrusions on the cheeks seem to empha-sise a similar meaning. The headgear of the mask is made of rags to stress the world of the dead. The character wears the *gule* tat-tered suit. He carries a piece of black cloth (*n'dakalira*) coming from the funeral shroud. Another strip of the same cloth is tied around his head to show he is one of the bereaved. The red colour of his face shows that he is aflame with sexual passions and has not kept the sexual taboos imposed by the condition of his niece who was expect-ing. As a senior member of the family, sharing the same blood line, he should have remained 'cool' (sexually inactive) as a prayer to the ancestors for her safe delivery. His involvement in sex is seen as the cause of his niece's death before her delivery.

 Salirika performs only at funeral and

commemoration ceremonies. He enters the *bwalo* with a downcast attitude. He mourns, wiping his eyes with his cloth. He swerves one foot at a time and genuflects, showing grief and submission in the face of death. The male choir voices the grief of the family group: *"This* (person) *cannot be mourned adequately! A woman who dies before she has delivered cannot be mourned adequately! How can a person* (in this condition) *be mourned? No! A person who dies before delivery cannot be mourned adequately. How can a person be mourned? How can her funeral be mourned?"* [1]

 The song refers to the death of a preg-nant woman and her unborn child. Such a dreadful event must be investigated by a diviner for the cause of death. Are evil spirits, witches or the misbehaviour of one of the family members to blame? The redness of the mask suggests that the head of the family group, **Salirika,** is the guilty party. In not keeping the sexual taboos for his niece's pregnancy, his actions become akin to witchcraft. The child cannot be buried inside the mother's womb since they are considered two individuals. Inside the grave, the undertakers will have to open the mother's belly and remove the child to bury it next to the mother in the same grave. The tragedy of such a death calls for consolation

from the spirit world for the grieved members of the family. Above all, the char-acter of **Salirika** discourages the irrespon-sible behaviour of family members that can lead to such deaths.

[1] *"***Salirika** *e* **Salirika** *e maliro a nthumbi* **Salirika**! *Talira bwanji maliro ae toto e toto maliro a nthumbi* **Salirika**? *Talira bwanji maliro?"*

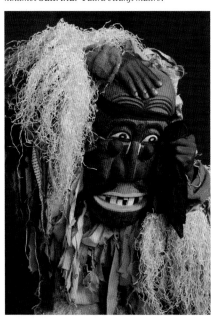

Sirire

(a day mask from the Mua and Dedza areas)

Themes 1) Sexual taboos for children's health; 2) Positive aspects of modernity; 3) Role models

Etymology **Sirire** means, 'to show admiration', and therefore 'to emulate' and 'to desire', even 'to wish well'.

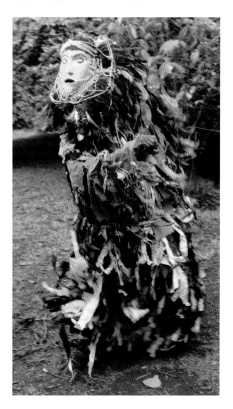

The character describes a person who admires the qualities of his neighbour, with the intention of showing similar behaviour. The small mask displays fine features. Depending on the region and the materials available, it appears in hues of red, orange, pink or yellow. These colours stress prohibition and foreignness. The ears of **Sirire** are normally slightly pointed and large, to resemble European ears. Sunglasses and earrings often embellish the mask and show that the person is emulating western behaviour. The mouth displays a gentle smile of satisfaction. The face is that of a young person, looking androgynous, with no beard and the tribal marks characteristic of women. The headgear, made of feathers of various kinds, emphasises that the person is smart and well groomed. The costume of the dancer in the Dedza region is typical of the *gule* characters: a grass skirt, or a tattered suit, with armlets and leglets. The Mua version represents him with a clean shirt and a pair of trousers or a tattered suit. The hands and the feet are often smeared with red clay, to emphasise that he emulates a European. He carries a small whip, to stress his role as teacher, inviting people to imitate him. His dance shows grace, skill and determination. As his feet stir up the dust, the repetitive movements of his arms express the gesture of tying and untying. This movement refers to the sexual code.

The character of **Sirire** is very often danced by a junior member of *gule wamkulu*. The self-control of the dance and the attractive appearance of the character show that he is well-married, has healthy children, lives in a comfortable home and is prosperous in the village community. He is keen to follow the Chewa traditions and yet is open to modernity and development. He is clean, well dressed (glasses, shoes), and he owns cattle. His lifestyle is the envy of his neighbours and relatives. He extends them a helping hand and encourages them to follow in his footsteps. His song says, *"Sirire, wish* (your) *child well. Wish him well especially at the time he is sick. Wish him well."*[1] This song is an invitation to imitate **Sirire**'s behaviour, particularly in the way he practises sexual continence when his child is sick. The red hue of the mask, as well as the motion of tying and untying, expresses sexual prohibition. When the child is ill, the parents must abstain from sex until the child has recovered.

The character of **Sirire** can be danced on any occasion. He advises that it is prudent and wise to learn from western development and modernity. All the same, one should not forget the advice of the ancestors as one's guiding principle. The Dedza song stresses the same message but also reflects the reluctance of modern generations to be guided by these rules: *"Sirire, Why should I envy, since I have my own children* (alive)? *(This is not the way my wife thinks:) she envies even if she has children and she has them* (alive). *People say the couple is the foundation of the village. Endure! Endure! Those who wish* (their children) *well* (being) *are the key to village development! Endure! Endure!"*[2]

[1] *"Sirire, sirireni mwana **Sirire**. Sirireni mwana **Sirire**, mwana akadwala, **Sirire**."*
[2] *" **Sirire** tate dee ndisiriranji anga ndili nawo dee? **Sirire**, koma **Sirire** dee ndi ana angawo toto de. Asiriranji ana ali nawo aye? Koma ali nawo tate dee **Sirire**. Anthu amati awiri ndiwo amanga mudzi, tate dee o tate e tate pirira, pirira o tate dee a **Sirire** amanga mudzi tate ye pirira, pirira."*

Thunga or Nsato

(a day or night structure from the Mua area)

Themes 1) Fertility

Etymology **Thunga** is a snake, and is the title of the husband of the spirit wife; **Nsato** is the Chewa word for the python.

The python **Thunga** is the mystical snake of God, Chauta, the rain giver. **Thunga** was the husband of the spirit wife *Mwali* during the Banda period. Today, the structure is used for night and day performances during funeral rites and initiations of important people.

The night version is two metres long; the day version is longer at three metres.

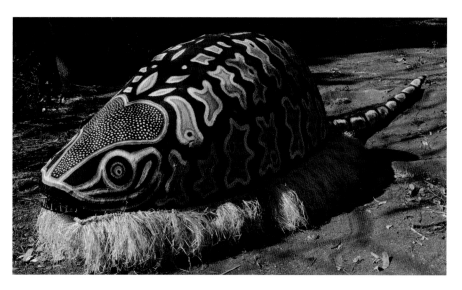

Depictions resemble a snake to varying degrees. The reptile is constructed of a series of bamboo rings of various sizes forming the ribs of the snake. These rings are tied to each other with strings to form a sort of accordion that can be stretched and shrunk at the will of the dancer who crawls in the belly inside the rings. The bamboo structure is covered with sack cloth and is painted with various colour patterns imitating the python skin. The tail is pointed, like that of a snake. The dancer activates the painted carved wood head using a long stick. The day version is covered with painted canvas or jute. It is 60 centimetres high at the head; the tail is flat on the ground. The head displays a fierce open

mouth with teeth, eyes and, somewhat at variance to the features of a snake, small round ears.

In the *bwalo*, **Thunga** moves forward and backward, while the head moves from side to side, as if preparing to strike. The male choir sings, "*Thunga, it carries people. Thunga does incredible things,*"[1] or "*Thunga does marvels near the shore of the lake,*"[2] or "*Do not disappoint us, Thunga! Thunga does incredible things!*"[3] The songs mean that with the coming of the python, good rain will fall and people will be blessed with crops and fertility.

Rain symbolises the fertility from God and the spirit world for humankind. **Thunga**

recalls the power of God and the ancestral spirits in bestowing fecundity to the land by mating with *Mwali* who gives fertility to her people. As **Thunga** comes from the sacred pools, this fertility is manifest in the form of rain or human fertility. The phallic shape of **Thunga** celebrates the male power that can bestow fecundity and produce children.

[1] "*Thunga dede wanyamula anthu Thunga. Thunga walaula.*"
[2] "*Thunga walaula mphepete mwa nyanja, Thunga.*"
[3] "*Thunga dede Thunga usamaname de Thunga. Thunga walaula Thunga.*"

Tsokonombwe

(a brown day mask from Pemba area)

Themes 1) Infertility – impotence; 2) Laziness; 3) Rights of/respect for the handicapped; 4) Sexual obsession

Etymology Tsokonombwe is the name for a type of grasshopper without wings.

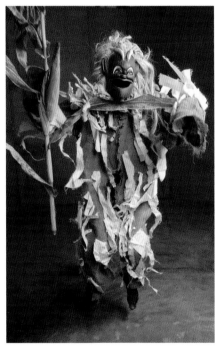

The mask has a small face. The sharp mocking eyes are highlighted by white under the eyebrows. It has a small black nose and an enormously broad mouth with a row of flat teeth on the bottom jaw. Two small white horns, set flat against the head, represent the antennae of the insect. The headgear is made of rags and has a white sisal mane. A shaved animal skin at the back of the headgear imitates the body texture of the insect. The dancer wears an overall suit of jute, appliquéd with tatters of white material. A big white patch covers his bottom, in imitation of the stripe on the

insect's body. He stands on one short stilt, to make him look and move like a lame person. He carries stalks of maize or another crop. He enters the dancing ground to the rhythm of *makanja*, accompanied by the following song: "*Tsokonombwe makes noise* (sex) *the whole night, all night long, how can I sleep, Tsokonombwe?*"[1] He dances and swerves one leg sideways, jumping like a grasshopper, chasing the women. His performance normally is scheduled on the occasion of the shaving ceremony after a burial or at the burial ceremony itself. Sometimes he chooses to perform at puberty initiations and chieftainship rituals, at which the women introduce another song: "*The chief* (the male organ) *has set a trap for me! He spent the entire evening with me. He made sex to me the whole night. Yes, he made sex. He made sex to me the whole day. Yes he made sex. Now I have had enough. I say no! no! I am fed up.*"[2] The women's song continues and asks, "*What kind of penis is this … to perform like this … to perform like this? It is that of an impotent!*"[3]

Tsokonombwe's behaviour is to jump. Through this trait he represents both a handicapped person and an impotent. His lameness prevents him from working and looking after his family. But it does not prevent him being obsessed with women. He is constantly on the prowl. His eyes are sharp and glittering. His big mouth is ever ready to speak highly of himself, to joke and laugh to entice a woman. Once she is trapped by his game, she discovers that he is not only physically lame but also incapable of performing a husband's duty. His impotence makes him 'noisy' at night,

keeping her sleepless. His obsession with sex, day and night, makes him unfit for work. **Tsokonombwe** expresses the vicious circle in which people who suffer from such a handicap find themselves. The Chewa proverb says, "*Tsokonombwe adatha mtunda mkulumpha – A grasshopper travelled the whole country, jump by jump*" (meaning gradually). Chewa traditional wisdom encourages patience and perseverance in hard work. This is not the attitude of our friend **Tsokonombwe**. He only shows perseverance in sexual matters, not in his daily duties. He tries to prove to himself, and to others, that he is potent like anybody else. Through his behaviour, **Tsokonombwe** denies the curse that Chewa society puts on impotence. His open mouth and his smile-like expression are a cry of protest against a community which refuses to recognise him as a full human being.

There is a very different **Tsokonombwe** from Golomoti (refer to Health, food and death).

[1] "*Tsokonombwe amalira chitetete ae oh chitetete. Ndigona bwanji toto ine Tsokonombwe?*"
[2] "*A mfumu andicherera toto de kuchokera madzulo n'kundikwata ine, usiku wonsewo kundikwata ine usiku wonsewo kundikwata ine. Lero pano ndati ai ai ndatopa nazo ea.*"
[3] "*Mbolo yanji yotero de (2×) yotero ndi a gocho!*"

Yiyina

(an orange female night mask from the Dedza area)

Themes 1) Sexual taboos (*mdulo*); 2) Women's cycle instructions; 3) Women's cycle hygiene; 4) Decency & good manners

Etymology Yiyina is a euphemism for the male and female genitalia.

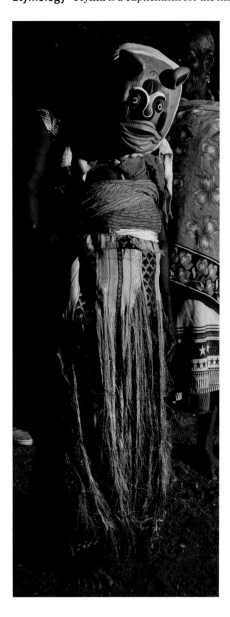

This orange mask is used by the women at the time of the girls' initiation (within or outside the funeral context). It has an owl-like face similar to that of Chinkhombe. The back of the mask is covered with a white or black scarf, depending on whether the puberty ceremony takes place within the framework of a funeral rite (black) or outside (white). The details of the face feature parts of the male and the female sexual organs. Recurring vaginas and clitorises appear on the forehead, inside the ears and the nose. The nose, outlined in black, portrays the penis and the oval black cheeks represent the testicles. The prominent red eyes signify that one must be watchful that the male and female organs should not meet inappropriately. The mouth is surrounded by wrinkles, to show that male and female genitalia complement one another until the woman reaches menopause. The tribal marks on the face were executed in the past at initiations and emphasise that the instruction will transform the girl into an accomplished Chewa woman. The mask is used by the *namkungwi* herself, as a teaching aid during the puberty instructions. She also wears a torn cloth that gapes in the front and allows the female initiates to see her nudity. She dances the *chisamba*, with the characteristic movements of the hips and the buttocks, while the group of women sing: "*Yiyina, look at the nose, it is like a penis. Look at the wrinkle, it is like a vagina. Everything is in the open, even in front of the children,* **Yiyina**." [1] **Yiyina** can appear at times with her husband, Salemera. (Refer to that entry.)

When the dance is over, the mistress of initiation lifts up the torn cloth and shows the initiates that she is wearing a hygienic towel underneath. She explains to them that, when they remove this towel, they welcome their husbands to sleep with them. When the towel is on, they cannot. The meanings of this mask are conveyed in the different shape and colour codes. The basic message is focused on the two sexes touching each other. The presence of red (blood) during menstruation, signals the ban on sexual activity for this period. The owl shape of the mask expresses the hidden reality of the night that should never be revealed. Ultimately, the teaching of the mask and the dancing of the *chisamba* equip the girls with the right etiquette with regard to dressing and to hygiene, particularly at the time of their periods. It also teaches decency and proper manners for grown up women. There is emphasis on avoiding any sexual contact during the menstrual cycle for fear of the *mdulo* disease.

[1] "*A Yiyina tate de a Yiyina yang'anani mfuno ngati mbolo. Taonani katsinya ngati nyini tate de, alaula, alaulira ana a Yiyina.*"

Zoro

(a day structure from the Malirana area)

Themes 1) Choice of marriage partner (choice of *mkamwini*); 2) Limits & restrictions of *chikamwini* system; 3) Alcoholism/alcohol does not solve problems

Etymology Zoro is the Chewa word for elephant shrew. It displays an elongated mobile snout resembling a mini trunk. The animal is solitary or lives in a pair. When threatened, it utters a shrill sound and a loud squeak. Alerted, it runs quickly and jumps in a kangaroo style.

The elephant shrew structure measures one metre high and one metre long. It consists of a brown carved head inserted into a bamboo frame. The meeting of the head and the body is concealed with grass and covered with a weave of maize husks that creates the texture of the body. The head is activated with a handle that allows the head to move sideways and up and down on an extendable jute neck. The shrew's head features a long snout with an open mouth displaying two incisors. The small carved eyes are encircled with white paint for emphasis. The tail of the shrew is made of similar material and exceeds the length of the body.

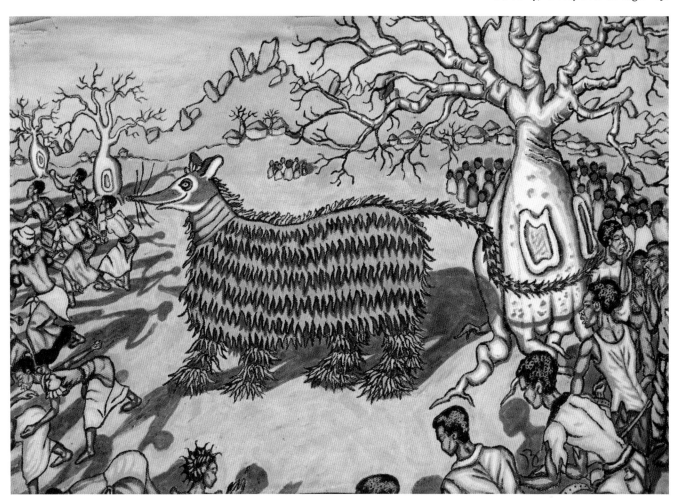

Painting by Claude Boucher and Joseph Kadzombe, 2009

The base of the structure is concealed with a woven fringe of sisal that hides the single dancer activating the structure.

The animal enters the *bwalo* to the *chisamba* rhythm. It rotates in the *bwalo*, jumps and gyrates. Usually the structure of **Zoro** appears at the funeral of an important member of the community or celebrates the commemoration that follows. Initiation (*mkangali*) is commonly performed at such events that requires the wisdom and advice of **Zoro**. As the elephant shrew races through the arena and circles, it moves its head sideways and the male singers tell **Zoro**'s story: *"This man is unable to control his tongue! Therefore his marriage broke down. Wasn't it so? Therefore his marriage broke down. Even the day before yesterday our love was still green! But this is how he really is! As for me, I have reprimanded him, but he never listens. So* **Zoro** *packed his luggage…*(and went), *the old man. The real cause* (behind his departure) *is his big mouth. This is what he wished. This is not the way to behave! Shout and insult people at your own home! He went back to his village … * **Zoro**.*"* [1]

The song of **Zoro** introduces the complaint of **Zoro**'s wife after her husband's departure from her home. The *mkamwini* has left her and her family group after abusing and insulting them. He was drunk as usual. He started an argument complaining about her being under the influence of her parents. He then curses them all for no reason. **Zoro**'s behaviour is intolerable and the parents-in-law protest and openly state that they do not want an *mkamwini* with a big mouth (long snout) like **Zoro**. They cannot accept him any more at their home. They send him back to his own village where he can insult his own people.

The character of **Zoro** protests against a *mkamwini* lacking manners, with a habit of being drunk and insulting his in-laws. His behaviour is judged as unacceptable and his presence cannot be tolerated any longer at their home so he is forced to go back to his own village. **Zoro** teaches the importance of good manners for a husband who resides as a guest at someone else's home. He has to control his mouth, as the proverb says: *"Lankhula, lankhula adachotsa Zoro pa ukwati – Too many words (or Zoro's big mouth) ends his own marriage."* This is a shameful end to their union. **Zoro** emphasises the importance of discretion and self-discipline for a husband who desires to enjoy a stable marriage.

[1] *"Kulankhulalankhula kwawo abambowa n'chifukwa anachoka pa ukwati kani! A* **Zoro** *anachoka pa ukwati dzana lomwe laliwisili tate. Ili n'khalidwe lawo tate. Koma ine chidzudzulireni abambo osamvawa toto ndiye a* **Zoro** *tate amanga mphacha andalawa toto. Uwu n'mlomo wawo. Uku n'kufuna kwawo tate. Kukhala satero. Akadongolole koma kwanu tate. Adanka kwawo a* **Zoro**.*"*

4. Childbirth and parenthood

Childbirth *per se* is not regarded as a community event in the Chewa village. While of great significance to the involved family, and to the community in the longer term, childbirth as an event does not attract the attention or involvement of the *gule wamkulu*. However, the coming of age of girls and the release of their fertility is of the utmost importance and marriage is a prerequisite to the generation of children.

At the great dance, the ancestors convey advice on childbirth and childcare. They have advice to parents and parents-to-be on safe childbirth (**Chikhukhu, Chiwawa**[1], **Lute** and **Mleme**) and how subsequently to raise their children. Childcare advice can be quite specific, such as the care of teeth, in order to avoid social stigma (**Chitsakamire**). Children should be educated and taught discipline and their mistakes should not be over-dramatised (**Gologolo**). In something of an innovation, the changing face of families and the greater role of the nuclear family have been endorsed by one character, **Chuma cha ana**, that petitions on behalf of the children for their inheritance. In contrast, **Malodza** takes a rather conservative line on birth control, advocating traditional methods including abstinence.

Characters danced by women can appear at the instructions for first pregnancy. The dancer will be a senior woman who is beyond child-bearing age. (See for example, **Chikhukhu**).

[1] Sexuality, fertility & marriage

Chikhukhu

(a black and red female mask from the Mua area)

Themes 1) Pregnancy instructions & childbirth; 2) Sexual taboos (*mdulo*); 3) Female infertility; 4) Infertility – impotence

Etymology The name **Chikhukhu** refers to the discomfort and pain that a mother experiences after the delivery of a child, when the uterus contracts and the placenta is expelled.

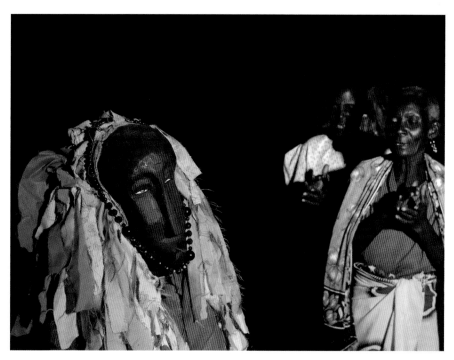

Chikhukhu is one of the female masks that was used and danced by the mistress of initiation (*namkungwi*) at the time of the first pregnancy ritual (*kumanga mimba* or *chisamba*) in order to prepare the initiate for her first delivery. The black and red mask portrays the baby erupting through the membranes at the time of birth. The mask headgear is made of white rags to suggest the care the birth attendant takes in wiping off the blood at the time of birth. The string of red beads around the face enforces the idea of giving birth and the flow of blood. The child is portrayed in red while the envelope is black. The opposition of red and black stresses the sexual code and taboos prescribed during the period that follows birth. The song of **Chikhukhu** contrasts a woman who has experienced childbirth to a sterile woman who will never know the pain of **Chikhukhu**, *"My sister has never experienced the pain of afterbirth because she is barren."*[1]

[1] *"**Chikhukhu**, achemwali sanachione **Chikhukhu** (2×) ndi achiumba."*

Chitsakamire

(a pink day mask from the Dedza area)

Themes 1) Responsible parenthood – care of teeth; 2) Rights of/respect for the handicapped; 3) Frustration of being unmarried

Etymology **Chitsakamire** means, 'that which sticks out (of the mouth)'.

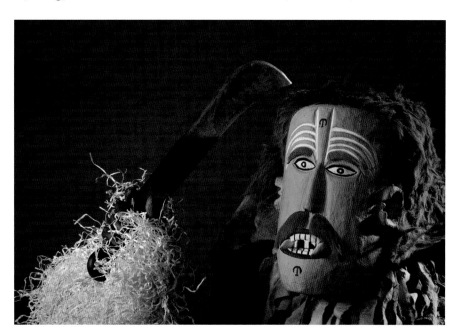

This mask portrays a person with a plump face and a double row of teeth. Two canine teeth protrude from his mouth, like those of a warthog. The headgear of the mask is made of any kind of skin. The dancer wears a black kilt made of sisal and leglets and armlets. He carries a long knife. His behaviour alternates between that of a madman and that of a sulking child. He jumps and shows off but, at the same time, demonstrates shyness. He runs after women and tries to gain their sexual favour, moving his hips obscenely, but the women run away from him. At the end, out of frustration, he goes and kicks the drummers. Then he hides his teeth and becomes shy again. The men explain the reason in their song: *"**Chitsakamire** (the mouth full of teeth), maybe he didn't listen to his parents. Teeth are not normally like that. Usually people do not laugh when they look at somebody, **Chitsakamire**. For me, I would not laugh, **Chitsakamire**."*[1]

The character portrays an adult who is psychologically damaged and utterly frustrated because of his deformity from childhood. His mouth carries two rows of teeth. When he was a child, his parents either did not take care of his teeth, or he did not listen to them, perhaps out of fear, when they advised him to remove his milk teeth. Consequently, **Chitsakamire** grew a second set of teeth and his mouth was deformed. People kept staring at him because of this handicap and mocked him everywhere he went. **Chitsakamire** could not find a girlfriend because he looked like a monster. He is now much older but remains unmarried. He feels an outcast, expressed by the colour pink of the mask. He hides himself in order to avoid being ridiculed. His great frustration has made him aggressive, shown by the knife, and he rebels against society and his own parents. The character of **Chitsakamire** is a reminder to parents to look after the teeth of their children. **Chitsakamire** also invites the Chewa to show respect for the crippled and not to mock them for fear of antagonising the ancestors.

[1] "***Chitsakamire** o tate (2×) chosamva makolo tate. Mano sakhala chotero tate **Chitsakamire** (2×). Anzanu saseka nayang'ana munthu tate **Chitsakamire**! Chikhala ine sindingaseke tate **Chitsakamire**.*"

Chuma cha ana

(a red day mask from the Mua and Mtakataka area)

Themes 1) Recipients of inheritance; 2) Preference of nuclear over extended family; 3) Greed; 4) 'To be' versus 'to have'; 5) Social changes/insecurity

Etymology **Chuma cha ana** translates as 'the wealth of the children', meaning 'the inheritance is for the children'. This implies indirectly that the inheritance is not to be shared among the extended family members.

The large 60 centimetre red mask resembles that of Chimbano except that it carries many more horns. It features a bull-like head with a long snout, open mouth with innumerable teeth and bull-like nostrils. The mask is crowned with fourteen striped horns of various colours (black, white, yellow, red and silver) symbolising the inheritance. Two large bullhorns stand at the mask apex that is covered with a tuft of black fur. Two long bushbuck horns point forward from the same tuft of fur. Another two bushbuck horns point sideways and from above the eyes. Below the eyes and on the muzzle two more bushbuck horns point forward. Two small horns protrude from the nostrils. Four wooden curved horns in plain red stand at the back of the head and direct backward. These four are decorated with tatters. The bullhead displays wrinkles on the forehead and at the partition of the mouth. A silver triangle is painted on the forehead. The dancer wears a tatter suit and carries weapons like a club and a long knife. The suit is completed with a long kilt of fertiliser bag laces, leglets and armlets.

Chuma cha ana is recent in *gule*. It was observed for the first time at funeral and commemoration rites in 2005. **Chuma cha ana** has been specifically designed for these types of rituals because he plays the role of an arbitrator when the family inheritance is shared. This is normally done during the last shaving ceremony, nine months or a year after the funeral. He represents the head of the family group as reflected in the wrinkles. The many striped horns pointing forward represent the many children of the deceased. The youngest children are the small horns that erupt from the nostrils. The four plain red horns situated at the back of the head, pointing backward and carrying tatters, rep-

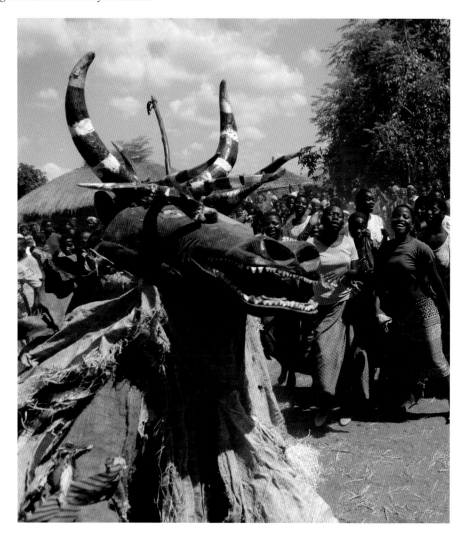

resent the former generation, the siblings of the deceased. They will have been wearing a headband at the time of the funeral (tatters). The maternal uncle is the protector of the children of the deceased. He has the duty of looking after their well-being, even if the father is still alive but especially when the father has passed away and is unable to look after their needs. In the arena, **Chuma cha ana** dances with great determination (in the

Chimbano style). He swerves his feet vigorously and chases the women and those who are trying to snatch the family inheritance, namely the brothers and the sisters of the deceased. The male choir repeats, "*Chuma cha ana, the inheritance is for the children.*" [1] The mime and the song stress that whatever the deceased owned should be left to the children and not to his own brothers and sisters.

In the past, when the Chewa were living in a fairly egalitarian society, dispute over inheritance was not an acute problem. In those days, possessions were few and of little interest. The house of the deceased was destroyed as part of post-funeral ritual. The clothing and the few other items were shredded or broken and buried in the grave with the deceased. With an increasing disparity of wealth and social status, this tradition became rarer and died out roughly three decades ago. A brick house is no longer razed to the ground and the other possessions in the form of furniture, clothing and expensive items (radio, maize mill, tools, bicycle and cattle) are a constant source of argument between family members. Because they share the same bloodline with the deceased, his or her brothers and sisters argue that they should partake in the possessions. Quarrels over family inheritance have particularly multiplied when the person lives in town. Because of higher education or employment, the person is able to generate higher income and acquire greater belongings. If the person has the wisdom of making a formal will in front of an authority, the inheritance will be dealt with fairly. But this formal procedure is still very uncommon in this country. The fact that most people die intestate increases the occasion for quarrels. In the village too, this scenario is not uncommon. The only difference is with regard to the amount and value of wealth that is normally lower.

Chuma cha ana reacts against property grabbing that is on the increase. Today, people find it more difficult to survive economically. Their traditional communal bond and mutual support are weakening and they turn to individualism and the power of money for 'salvation'. Malawi and the Chewa have certainly discovered the value of money. However, they run the risk of inflating the importance of monetary wealth and losing sight of their own spirituality and wisdom. Their world risks being reduced to kwacha notes and the meaning of life, lost. This is especially true for the youth that do not share the values of the previous generation. The extended family values are left behind and people opt for a western notion of family life promoted by the influence of capitalism, consumerism and the mass media and based on the patrilineal nuclear family model. This model permeates society through various agents ranging from foreign NGOs, human rights activists and Christian churches' influence to even Malawi government propaganda.

Another important revolution for the country and for the Chewa is observed in a deep shift on the philosophical level; the clash between 'to be' and 'to have'. The Chewa did not have a word in their vocabulary to express ownership; 'to have' was referred as 'to be with'. The expression implied transience and a community dimension that did not subjugate people to things but kept them open to a world of relationships such as brotherhood, unity, family ties and friendship. These all involved mutuality and support. The value of a person was measured by his/her ability to share and bond with others at different levels. Today, the danger lies in valuing the person merely by what he or she owns, earns or consumes. This warning is indirectly implied in the message of **Chuma cha ana**.

Our character reflects changing times and changing values. Does **Chuma cha ana** promote the importance of the individual above the unity of the group? Should a western family model exclude the extended family? Has the Chewa traditional morality changed or has it simply been expanded? To these questions, the Chewa informants answer that their morality has evolved with time. This character now gives priority to children precisely because they are the majority (in 2007, more than half of the population of Malawi was under 16 years of age) and they are the future of this country. Does this mean that the Chewa moral code has lost sight of its spirituality or has it simply opened up to realities that were beyond the understanding of traditional society? It seems that traditional Chewa society, as conservative as it may be in many respects, can adapt to change and move with the times. It has to rejoice over its gains and perhaps accept some losses.

[1] "*Chuma cha ana tate de (2×) Chuma cha ana.*"

Gologolo

(a day and night structure from the Mua, Dedza and Ntchisi areas)

Themes 1) Children's education; 2) Parents should not over-dramatise children's mistakes; 3) Children as cause of friction in community

Etymology Gologolo is the Chichewa word for squirrel.

It is ironic that this small rodent is featured as a large structure measuring two metres long and a metre high. **Gologolo** appears at a great variety of day and night rituals (funerals, commemoration of burials, enthronements of chiefs, puberty initiations and the festival for the dead). All of these ceremonies involve night vigils and day happenings. The structure consists of a standard bamboo or twig frame covered with grass in order to conceal the identity of the dancers. Construction varies according to the light conditions. The night structure tends to be simplified and stylised, with few details built into the costume. The artisans use a reflective material like dried palm leaves or reed heads depending on what is available in their surroundings. Extra material may be added for day performances to achieve more realism. Details might include jute coated with red or black mud so the body and the reed heads appear similar to the fur of the tail. The animal's head features a mouth, teeth, eyes and ears. Each detail is customized with the appropriate material. The shape of the mammal varies from region to region depending on the artists' skills and perception. The Dedza area portrays it with an arched back, a short neck and a long tail. The Mua and Ntchisi areas represent it with the head continuous with the body, a slanted back climbing into a hump on the rump and a long tail curved upward. The **Gologolo** structure accommodates two dancers, one in front and one at the back.

In the arena, **Gologolo** moves at a modest speed but raises a tremendous cloud of dust. It goes back and forth waving sideways to the rhythm of the *chisamba*. It hurries up, jumps to emphasise its mischievous tendencies that are explained by the songs sung by the men. "*The squirrel has defecated on the veranda! This has made them* (parents) *abuse each other with insulting*

Painting by Claude Boucher and Joseph Kadzombe, 2009

language." [1] **Gologolo** circles the houses and hides on the veranda. Various alternate songs can be used such as, *"The squirrel has climbed up* (the tree), *the dog is after it to bite it,"* [2] or *"You, small beast, you are such a small beast, you squirrel."* [3] The songs emphasise the squirrel's small size, its mischievous nature and lack of maturity. The rodent is perceived as dirty, irresponsible and even dishonest. It digs, steals, scatters foodstuff all over and even messes up the veranda of the house. It provokes the wrath of the dogs and the villagers.

Gologolo's performance evokes children's games and mischief. Their young age and their limited experience is the reason behind their irresponsible behaviour. Parents should realise this and not be involved in children's disputes and arguments. **Gologolo** invites parents to recall their own childhood and not to overreact to children's conflicts and mischief. The large size of **Gologolo** reinforces this logic! The black or red colours of the animal stress that children are dirty and fractious. Games fascinate them and dispute and aggression are part of their discovery of the world. Parents have the duty to correct and guide them and believe that they will grow out of imma-

turity. Neither should children's mischief give parents occasion for quarrels among themselves or with their neighbours. Adults should not take advantage of children's disputes to resurrect old conflicts with neighbours. This would only serve to reveal their own immaturity. **Gologolo** stresses the importance of education. Children should be well taught and disciplined by their own parents. Above all, they should be motivated by the good example of their own parents who live in harmony with one another and with their neighbours.

The structure of the squirrel is very ancient to the world of *gule*. Today, with the disappearance of most of the structures, **Gologolo** has vanished from the arena. It was last recorded in the mid 1980s. Many factors could explain the disappearance of structures. The population's growth has put tremendous pressure on the environment and material is not easily accessible for their construction. Economic pressures also have reduced the available free labour force required for their fabrication. A second, very different, form of **Gologolo** has appeared in Malawi. This version depicts the squirrel as an acrobatic Kapoli, climbing masked figure, scaling long

upright poles or shinnying along a rope stretched between two poles. This form likely originates from Zambia and has performed at Kulamba ceremonies there. Recently this version has appeared at some public events in Malawi, such as the opening of the Lilongwe cultural centre. Given the dramatic nature of the performance, it would not be surprising if this **Gologolo** is seen more and more in future.

[1] *"Gologolo wanyera m'khonde (2×) watukwanitsa."*
[2] *"Gologolo kukwera m'mwamba, galu akuluma."*
[3] *"Kanyama iwe tate, kanyama kotere tate* **Gologolo**.*"*

Lute

(an orange female day mask from Dedza)

Themes 1) Pregnancy instructions & childbirth; 2) Sexual taboos (*mdulo*); 3) Childcare

Etymology **Lute** derives from the woman's name, Ruth.

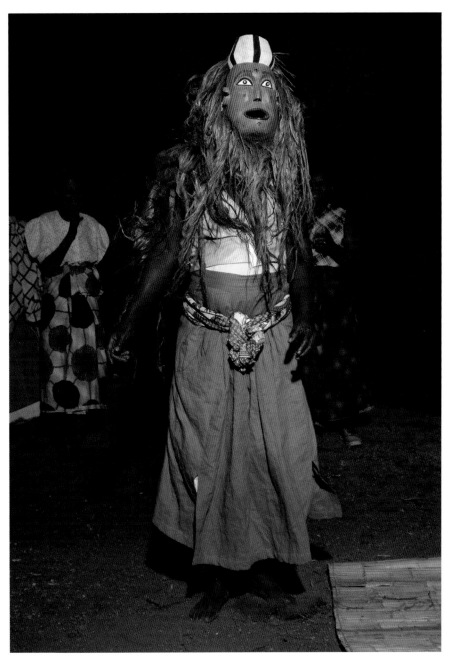

the first day, her clothing shows that she is at the beginning of a pregnancy and her dancing is energetic. On the second day, the pregnancy has reached the last month and her dancing is subdued. She hardly moves her hips because of her condition. On the third day of her appearance in the arena, Ruth has delivered. She carries something on her back that is meant to be a baby. Her dancing becomes energetic again. The male choir sings, "*Let us go and see the baby born today, Ruth, Ruth, let us go and see the baby.*"[1] The women answer, "*My small baby is full of sweet potatoes!*"[2]

This ancient character belongs to the category of masks used by the women for instructing the initiates. **Lute**'s three different appearances unfold the process of pregnancy, leading to birth. For the Chewa, this process is accompanied by a full day of instruction (around the 7th or the 8th month of pregnancy), given by the mistress of initiation (*namkungwi*) and the tutors (*aphungu*). This ceremony is called *kumangira mimba* (meaning, 'to tighten the pregnancy'). The rite is accompanied by the dance of the *chisamba*. The purpose of this ceremony is to prepare the mother for birth and advise her on caring for a newborn child. This advice removes the fear from her heart and helps her to become a capable mother. Both songs refer to the advice given to the future mother. One of the instructions is that a newborn baby should not be exposed to people who are sexually active. The child's fragile and 'cool' condition could make him the victim of the '*tsempho* disease'. The second instruction is that a newborn baby should not be fed with solid food (sweet potatoes).

The character of **Lute** stresses the importance of this rite of passage for a Chewa mother. She will give birth to a healthy child, provided she listens to the advice of the ancestors. The *gule* members have modernised their teaching by putting the traditional advice of the *namkungwi* into the mouth of a European style health adviser. They thus update their ancestral wisdom for greater emphasis.

[1] "*Tikaone mwana e abereka lero (2×) a* **Lute** *de a* **Lute** *de tidzaone mwana.*"
[2] "*E a e kamwana kangaka e a e kakhuta mbata (2×).*"

Lute is portrayed as a medical nurse or a health adviser attached to a mission style hospital or health centre. She wears the black and white headdress of European nurses and her face is orange to show she is a stranger to the area. She has wide staring eyes and a large open toothless mouth, expressing surprise. Her nose is delicate and her chin heavy. Her hair is made of black-dyed sisal. She displays the features and tribal marks of a Chewa woman. She wears earrings and dresses like the other female characters of *gule*. She has breasts and wears a blouse or a dress with a *chitenje* over it. A scarf is tied to her hips and falls on her buttocks.

Lute appears at initiation ceremonies and at funeral rites incorporating initiation. She dances to the rhythm of the *chisamba* on three consecutive days of the ritual. On

Malodza

(a day and night structure from the Golomoti area)

Themes 1) Responsible parenthood; 2) Danger of contraception; 3) Spacing of childbirths by sexual abstinence (*kudika*)

Etymology **Malodza** means, 'an evil tiding or tiding of death', which could imply bewitchment. As a less loaded term, it can simply suggest a bad omen or bad luck (here referring to multiple childbirths).

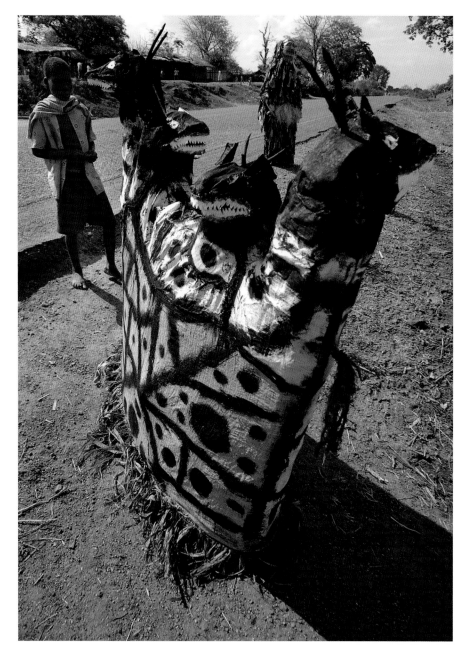

The structure consists of a bamboo frame (one metre high and long and 50 centimetres wide) featuring a goat with multiple heads. For the night representation, the frame is overlain with grass and with palm leaves woven in a zigzag pattern. For the day event, the frame is covered with a white canvas or jute painted with black lines, spots or geometric designs. The animal depicts a he-goat with multiple heads. In

some cases, the goat is featured with a head at each end, looking in opposite directions. Sometimes the animal features three or four heads; the additional two heads are positioned on the necks of the two main heads and look inwards towards each other. The heads are depicted with a wide-open mouth revealing sharp teeth, sometimes with a tongue protruding and grass being eaten. The he-goat's heads are featured as young;

they have large ears and horns. The body shape is rather cubical and as for all day structures, the end of the frame touching the ground is concealed with maize husk fringe dyed black that sweeps the *bwalo* as it moves forward or backward. The animal displays two little tails (one at each end), made of sisal dyed black that can be activated by the dancer inside the structure. Their mechanism allows sideways or up- and down movements. The tails are positioned at about 50 centimetres below the heads and are the only elements that reveal that our animal is a he-goat. The tail is here used as a phallic symbol. This detail is confirmed by one of the *kazukuta* songs that is sung on the occasion of birth. *"What did she bear for the benefit of the village? She bore a he-goat* (a boy) *with white legs* (a healthy boy). *Let me see it."* [1]

At the rhythm of the *chisamba* (like Kasiya maliro), **Malodza** moves swiftly from the dressing room (*liunde*) to the *bwalo*. Once in the arena, it changes its dancing style into forward and backward movements following the directions of the heads. It then pauses for a while and shakes sideways, wiggling the short tails. While the goat keeps changing directions, the male choir sings for it the following: *"Bad luck, these are bad luck* (referring to the heads). *Bad luck, bad luck."* [2] The multiple heads and the song refer to the birth of twins, or of even more children. The presence of the two small tails reveals that these children are boys.

The song emphasises the dilemma of parents who are confronted with multiple births. Their economic situation does not allow caring for so many children. They do not have the necessary resources and the social security to cope with so many mouths to feed and provide for their future education. The sudden arrival of several children represents a serious challenge to their already numerous family and the obligations with which they are already struggling. Moreover, the new additions are all boys; their male gender creates other difficulties because of the *chikamwini* system of residence. Boys are less desirable than girls because boys are seen as hunters and as non-permanent resident members of the village. As soon as they reach marriageable age, they leave and reside at their wife's village and there they look after their family

and children. They have less time and less dedication to care for their parents particularly when the latter grow older. Girls never shift residence; they draw a husband and marry at the doorstep of their parents. They attend their parents' needs despite the fact of having their own family. Moreover, generally speaking, girls are more caring and compassionate than boys. Girls show more docility and are easier to rear than males who are prone to independence. In recent days with the land pressure, the population explosion and the presence of so many orphans within the extended family due to HIV/ AIDS, the majority of families are struggling with the number of mouths they have to feed. (Recall that **Malodza** is portrayed with two or four hungry mouths eating grass). A large number of children is less desirable today than in the past. One has to cope, not only with food security, but also with clothing, health care and further education. These are issues that are progressively becoming a preoccupation for most Chewa families. Some already think of limiting families and spacing children, as they realise that hygiene and health care have improved and that the high rate of mortality has dropped among children.

Family planning has become more widely accepted and many families use contraceptive pills or condoms provided by local health centres and government hospitals around the countryside. Numerous couples are encouraged by the media to make use of contraception in order to limit the number of children. However, it is noticed by many that families who take advantage of such methods often have multiple births once they stop using the contraceptive. **Malodza** takes up this issue in a disguised manner. Popular understanding of sexuality tends to look at contraception as a dam that blocks fertility and accumulates its potency. That storage of power results in twins and multiple births according to their way of thinking. **Malodza** shows ambivalence to contraception, as it is believed to lead to uncontrollable fertility that surpasses its natural course. One ends up with having more children than if one had left nature to take its course.

The structure of **Malodza** was introduced to the Golomoti area for puberty celebrations and commemoration of funeral rites and is unknown to the Mua region. The informants acknowledge that **Malodza** is not originally from this locality.

The inspiration was taken from Dowa where the creator was employed and frequented the local *mizinda* of the area around Ntchisi. **Malodza** is definitely new to the world of *gule* even around Ntchisi. It manifests the creativity of the Chewa in the art of modernising the teaching of the *mwambo*. **Malodza** borrows its shape from Kasiya maliro, the mother of *gule*. At times, Kasiya maliro is accompanied by smaller Kasiya maliro as her daughters. Here in **Malodza**, the daughter has been portrayed as a mother of twins and quadruplets. The *mwambo* confronts the modern world of economic pressures and inflation and here it encounters problems of contraception. It discourages the use of contraceptives owing to their believed side effects, associated with multiple births. Instead, **Malodza** seems to advocate the traditional morality and the *kudika* (abstinence) as the ordained and effective methods of child spacing.

[1] *"Waberekanji kumzinda? Wabereka tonde woyera miyendo. Taleka n'taona de. Wabereka tonde."*
[2] *"**Malodza** tate, **Malodza** awo, **Malodza**, **Malodza**."*

Mleme

(a grey night mask from Dedza)

Themes 1) Fertility; 2) Pregnancy instructions & childbirth

Etymology **Mleme** is the Chewa word for bat.

The small mask represents the head of a bat with an open mouth, sunken red eyes, large round ears and headgear made of goatskin. It is only used at night time during the female initiation ceremony. The character is danced by a senior man although depicting a female bat. The character wears a g-string with a drape of a red and black long cloth reaching the calves. It has armlets and leglets and carries a mini medicine tail and a pot of medicine used for the preparation of the young initiates. This medicine is made of ingredients derived from bats.

Popular belief has it that the bat eats and defecates through the mouth because of its upside down position. The perceived double function of the mouth is here compared to that of the female reproductive organs that allow sexual intercourse and delivery of the child. The **Mleme** character demonstrates the mode of application of the medicine to the pubic area. 'She' moves her hips to the rhythm of the *chisamba* and shakes her bottom, allowing the buttock

cheeks to appear under the cloth to indicate that sexual intercourse leads to pregnancy. The character then collapses and lies on her back to show the black and red cloth. The red portrays menstruation that denotes fertility. The black colour anticipates childbirth. As **Mleme** performs she leads her own song, *"The bat used to say, God has created me so. To defecate, I defecate through the mouth. To fart, I fart through the mouth. God, God created me so."* [1] To this first verse, the women reply, *"To give birth through there* (the mouth), *to have sexual intercourse also through there* (the mouth), *God created me so."* [2] The song suggests that the fertility cycle is a gift from God, and nobody should be ashamed of it.

[1] *"**Mleme** umanena **Mleme** umanena Chauta anandilenga. Kunyeranyera ndinyera kukamwa, kuphwisaphwisa ndiphwisa kukamwa. Chauta de chauta anandilenga."*
[2] *"Uchembere komweko, ukwati komweko tate de Chauta adamlenga."*

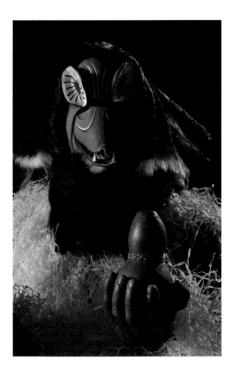

5. Health, food and death

Rural life in Malawi is difficult and premature death from disease or starvation has been a constant companion to the villagers. It is no surprise then that health and death are a focus for the *gule wamkulu*. The characters convey an explanation to the people for their loss and some consolation at times of grieving, especially in periods of frequent deaths (**Asongo**[1], **Imfa sitero**). The advent and spread of HIV/AIDS has exacerbated the ever-present spectre of unexpected death through the loss of young and middle aged adults in their most productive years. Several characters have taken up the theme of the AIDS epidemic, including **Ayemwe atsala adzamange** and **Kadziotche,** and recent interpretations of **Njolinjo**[2]. We discuss HIV/AIDS further under contemporary themes in the Introduction.

The *gule* exploration of physical disabilities and infectious disease is often a simultaneous discussion of the social stigma of such afflictions and the impacts they have on people's lives in the village. We see this for leprosy with **Ali n'matekenya** and for elephantiasis with **Salemera**[3] (with a twist in the latter case). Deafness to advice from others is a common attribute of *gule* characters, especially those who are obsessed with power, but deafness as a physical disability receives little attention (**Pedegu**), and then as a possible excuse for a far worse complaint. **Woipa sakwiya** advises those with any disabilities to accept their handicaps and make the best of their lives.

Food security is a contemporary terminology for a traditional problem. The growth in population in Malawi, the emphasis in recent times on cash crops for export, the growing pressures and temptations of commodity-based society, impacts of Structural Adjustment Programmes and global climate change have all contributed to exacerbate the risk of food shortages for people, for at least part of the year.

Tsokonombwe of Golomoti discusses food shortages and the need for community solidarity in times of hardship. Drought, the primary cause of crop failure, can be seen as a punishment for failure of people to adhere to the moral order of the *mwambo* (**Sitiona mvula**[4]).

Death can have many causes, and recent epidemics such as HIV/AIDS may be recognised, but in the traditional Malawian set-up, one source in particular, in its multiple guises, will be identified frequently by the villagers. This is witchcraft. The use of evil powers and of spells and medicines are a significant *gule* theme, deserving of its own chapter. In practice, the theme of death overlaps so often with that of witchcraft that the two are often indistinguishable.

[1] Witchcraft & medicines
[2] Sexuality, fertility & marriage
[3] Personal attributes
[4] Community, authority & the ancestors

Ali n'matekenya

(a jute headcover from the Mua area)

Themes 1) Social stigma; 2) Right of the handicapped to have children; 3) One should not hide one's handicaps; 4) Leprosy

Etymology Ali n'matekenya means, 'He/she has jiggers,' here a euphemism for leprosy.

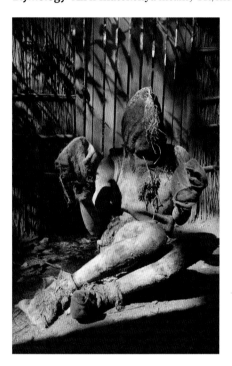

The mask consists of a plain faceless jute headcover. A few holes are pierced in the bag to allow the dancer to breath and to find his direction in the arena. The jute cover is heavily smeared with thick black mud. The dancer's body is bare, except for a dirty jute loincloth and armlets and leglets made of fertiliser bag laces. His entire body is also smeared with black mud. His hands and feet are wrapped with red rags that hide his fingers and toes and convey the impression of being a leper. The colour red expresses danger.

In the arena, **Ali n'matekenya** simulates walking with difficulty owing to his handicap. He pretends that his feet are infested by jiggers. (Jiggers are a type of flea that burrows into the skin, forming a lump.) For this reason, he walks on his heels and not on the soles of his feet. Once he reaches the centre of the arena, close to the womenfolk, he starts swerving his feet with great confidence and gyrates his pelvis lasciviously among the women. He dances as if he is aflame with sexual desire. The men sing for him in a rhythm proper for his dancing. They say: *"Here he comes, the one full of jiggers. Yes, his descendants will die with him! Here he comes, the one full of jiggers."* [1] The women join in the song and dance with him but keep their distance, conscious that his sickness is highly

contagious. They disperse in all directions.

Jiggers are commonly found in areas of Malawi where the temperature is relatively cool. In hotter regions, the fleas cannot live in the soil exposed to the sun. However uncomfortable they may be, jiggers do not bring about death. Persons affected may have difficulty walking and occasionally lose a toe if they are not treated, but eventually recover. However, the song emphasises that his descendants will die with him, meaning he will not have children. People with jiggers are not prevented from marrying and having children. The song therefore talks of another type of sickness common on the lakeshore in the 1920s and 1930s. This sickness is leprosy, which was a plague at that period. Leprosy was believed to be very contagious. Leprosy is caused by a micro-organism, *Mycobacterium leprae*. The first symptoms are insensitive skin, de-pigmented skin patches on the body and ulcerations on the extremities such as the fingers and toes. With the advance of the sickness, the digits could be lost or had to be amputated. The disease could affect the ears, lips or nose. The leper might come to look like a monster and suffer terrible pain, both physically and mentally. Lepers became pariahs who had to move away from their village and take residence at the few leper colonies in the country. A leper had to abandon his social milieu, and sometimes his partner if he was married. If still single, the leper would have difficulty to find a partner and would die without progeny because society would not allow him or her to marry. In our mime, **Ali n'matekenya**, the leper, affects that he is only suffering from jiggers. He conceals his real sickness in order to have access to sex and to marriage. The avoidance reaction of the women in the arena is symptomatic and reveals the mentality at the time.

In 1911, the White Sisters of the Mua Mission built a leprosarium. Up to the 1960s leprosy had reached near epidemic proportions around the Mua area. The leprosarium was crowded with patients who lived in small individual huts forming a gigantic village. There, they received drugs and care. The patients were fully taken in charge by the mission. In the decade that followed, with the progress of medical research on leprosy and the discovery of its main cause, poor hygiene, prevention programmes were established and the villagers

were better informed of the realities of the disease. It was also discovered that not all lepers were contagious. Toward the mid 1980s, a number of patients were rehabilitated to their original homes. Drugs were supplied to their doorstep by motorcycle. The Mua leprosarium was reduced in size and the hospital kept only those few cases that required more attention or surgery. In the late 1980s the leprosarium was closed and the last patients were referred to centres at Balaka or Utale. The leprosarium of Mua remained vacant for a few years until the buildings were converted into a school for deaf children which opened in June 1991.

Informants testify that the character of **Ali n'matekenya** is old and dates back to the 1930s or 1940s. Originally this *gule* character was performed for funeral and commemoration rites and was danced by a senior man. With the disappearance of leprosy, **Ali n'matekenya** disappeared from the arena. It was revived in 2000 for the funeral of an old and very prominent member of *gule wamkulu*. A person from the same generation was able to recreate it as it was 20 years before.

More broadly, the character of **Ali n'matekenya** struggles with the issue of social stigma: a young person touched by leprosy should not be married according to the tradition. No partner would accept to live with a leper. **Ali n'matekenya** claims that he is still a human being and has the right to progeny and marriage despite his handicap. In a final instance, the leper disguised as a man with jiggers teaches that it is not wise to hide one's own handicap in order to find a marriage partner. The secret will be uncovered and the union will fall apart. Facing the conservatism of the village traditions, the victims of social stigma are left with very little alternative but to take refuge in lies and concealment. Begging for pity ultimately strips them of their dignity. Their claim for fair treatment is dismissed by their family members and neighbours who boast of being born "normal". Where do the ancestors stand on such matters? Do they have pity for the afflicted or do they reinforce the villagers' conservative rejection of those who are disabled or physically blighted?

[1] *"Wabwera **Matekenya** eae mtundu watha eae. Wabwera **Matekenya**."*

Ayemwe atsale adzamange

(a coffee brown mask from the Mua area)

Themes 1) HIV/AIDS & sexual diseases; 2) Promiscuity; 3) Faithfulness to the *mwambo*

Etymology **Ayemwe atsale adzamange** means, 'Mr Whoever is left, let him build!'

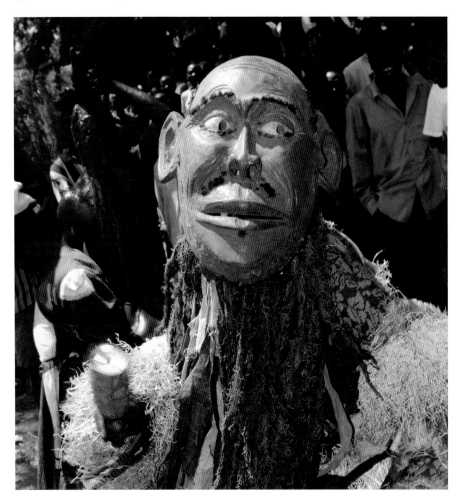

The coffee mask portrays a very old person. The features include a balding head with patchy hair, a wrinkled face, missing teeth and a moustache and goatee. It is a typical Malawian face with a flat nose and the brown colour of the skin. The erect ears suggest an eagerness to listen to the moral code, the *mwambo*. The headgear of the mask is made of jute and tatters and conveys that it carries a message from the spirit world. The dancer wears overalls and at the waist a kilt made of worn blankets to emphasise that he belongs to the past generations. He carries a club and a knife to convey that his longevity can be attributed to self protection procured by closely observing the *mwambo*.

His dancing style and his aggressive movements show two opposite moods. He swerves his feet with extreme intensity for a short period and then collapses. He expresses the exuberance of the youth and then their sudden death. The explanation provided is their turning deaf to the ancestors' advice. The male choir explains the reason for his fall. "*Whoever is left, let him/her build! We will all die. Whoever is left, let him/her build!*"[1] The song talks about the HIV/AIDS pandemic and other related diseases present everywhere in the Chewa countryside. People wonder who is going to remain.

Ayemwe atsale adzamange is a recent character in *gule*. It was created around Mua in 2004, on the occasion of the funeral of a very old sexual educator (*namkungwi*), Nachineya, who had spent her life giving instructions to young girls entering puberty. Villagers were amazed at her longevity and it contrasts sharply to what is happening today. Many of the present generation are dying in their 20s and 30s because they are infected with HIV. Young people neglect the *mwambo* and overlook the instructions they received in their youth. **Ayemwe atsale adzamange** was born in a community that failed to reflect on the example of this *namkungwi* who had spent her life teaching sexual abstinence to generations of initiates. Her longevity was attributed to her respect for the *mwambo* and to her own obedience to those rules.

In her old age, many disciples followed her. Her obedience to the *mwambo* had turned her into a unique and unrivalled model for the young generation. The villagers awaited her last words and will, a tes-

timony to the priceless gift of her presence in their community. Reportedly her last words were, 'Once I am gone, my children, who will build this community?' Her last statement inspired the members of *gule* in creating **Ayemwe atsale adzamange**. The old lady's worry was that once she had gone, no one would continue holding them together in respecting and observing the *mwambo*. Shortly before she died, family members had restored the family graves. This gesture was a symbol of her last will and a dignified response to her last wish. The large communal involvement in this restoration was only possible because these young men had escaped the HIV pandemic. What would have happened if the entire generation had been wiped out?

The character of **Ayemwe atsale adzamange** was created with the intention of delivering her message on occasions when the villagers are a more receptive audience

such as funerals and commemoration rites. Through the character of **Ayemwe atsale adzamange**, she was able to forward her advice to the entire community and beyond, literally from the grave. The creation of **Ayemwe atsale adzamange** and numerous other characters of *gule* show an interesting development of recent times. Sexual education concerning HIV has definitely reached the village. The male secret societies have taken on the responsibility of creating awareness about the pandemic. Is the adult population going to change its sexual behaviour? The way forward for the community is to turn back to the *mwambo*, revisit the teachings and to keep the spirit of sexual prudence. This method has proved itself in allowing elderly people such as Nachineya to live on to an advanced age.

1 "*Ayemwe atsale adzamange! Anthu tonse titha. Ayemwe atsale adzamange!*"

Imfa sitero

(a red and black mask from the Khwidzi area)

Themes 1) High mortality; 2) HIV/AIDS & sexual diseases; 3) Immunity against death

Etymology Imfa sitero means, 'Death does not behave like that,' implying it should not be so frequent.

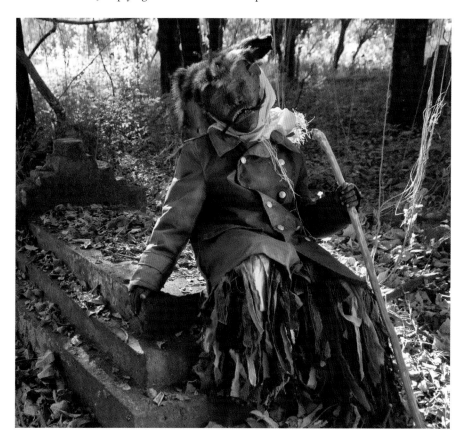

This frightening character has a deformed face lacking distinct features. The eyes are closed and the mouth is distorted with uneven and missing teeth. He has a heavy moustache emanating from the corners of the mouth. His ears are shapeless. The headcover is made of wild animal skin (usually civet). The character wears the usual outfit of *gule*, with rags all over, but covered with a heavy army coat. He carries a stick like an old or sick man. In the arena, he dances but soon collapses, lacking strength. He tries to stand but staggers, moving backward, while the singers explain, *"Death does not behave like that: funerals everyday…tomorrow a funeral, today a funeral. Death does not behave like that."* [1]

The character portrays the horror of epidemics, like that of influenza in the 1920s or of HIV/AIDS today. People die daily and their village is in continuous mourning. **Imfa sitero** is only performed for funerals and commemoration rites. He shows that the villagers cannot cope with so many funerals and that burial rites (*mwambo wa maliro)* lose their meaning when they become commonplace.

[1] *"**Imfa sitero**, kungoti mawa maliro, lero maliro, Imfa sitero."*

Kadziotche

(a cloth day mask from the Mtakataka area)

Themes 1) HIV/AIDS & sexual diseases; 2) Sexual taboos (*mdulo*); 3) Promiscuity

Etymology Kadziotche means, 'Go and burn yourself.'

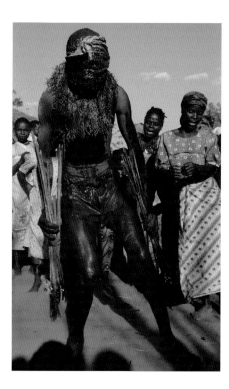

Kadziotche was introduced to funeral rites and commemoration ceremonies in the Mtakataka area in 1999 from Chipoka (Mpunga village). The mask consists of a headcover made of jute or cloth with two holes for the eyes, a tiny erect nose some-times stitched on the headcover and a cowlick made of feathers at the apex. This cowlick suggests the male sexual organ. The dancer's body is rubbed with mud and medicine. He wears a loincloth with a small bag of medicine attached to his waist to protect him from being burned. He carries a bundle of grass and a box of matches as he enters the arena. One of the male initi-ates lights the bundle and **Kadziotche** starts swerving his feet while he touches the lit bundle with his bare hand. Then he puts the fire under his feet, on his legs and arms finishing with his stomach. At the end of the performance he indicates to the audience he will burn his genitals. He passes the fire between his legs. After he douses the fire with his hands and exits the *bwalo* he intones his own song which the women repeat, *"Burn yourself with fire, you orphan child, as if you did not have a mother."* [1] Sometimes, **Kadziotche** lies down on the ground as if he had died before exiting.

Kadziotche's performance within the funeral context features a child who wants to follow his parents to the grave. Both have died from sexually transmitted diseases such as AIDS. They encountered death as a

result of promiscuity and sexual misconduct. The character warns the children and the youth that they should not imitate their parents' behaviour. As the Chewa proverb says, "*Mbuzi ndi mkota – A goat is a she-goat*" (like father like son, like mother like daughter). The child may end up burning himself like the parents thus causing his own death. **Kadziotche** reminds people of the *mwambo* and spells out the sexual code with regard to the *mdulo*.

In rural Malawi, AIDS is often associated with the *mdulo*, the 'slimming disease' or 'wasting disease' resulting from the breaking of sexual taboos that ultimately leads to death.

[1] "*Mtentha moto, mwana wamasiye, ngati alibe amake.*"

Pedegu

(a black or orange day mask from the Mua and Dedza areas).

Themes 1) Deafness as a handicap; 2) Infertility – impotence

Etymology Pedegu comes from, 'pede' meaning 'bighead' and 'gu' expressing deafness.

The mask of **Pedegu** comes in tones of black or grey in Mua and is coloured orange in Dedza. It is characterised by a very large head of over 60 centimetres long, and two large ears that signify his handicap.

The two versions are similar. However, there are differences in the mask features, in the outfit worn and in the meaning. The Dedza version shows him with missing teeth and with thin moustache. He wears a sleeveless jute shirt covered with tatters. At the waist he puts on a kilt made of long rags. He carries a club. His arms and legs are smeared with red clay and are decorated by armlets and leglets. In the arena, he swerves his feet when the drums have stopped. He does not hear the beat and therefore dances when there is no rhythm. The male choir stresses this handicap in his song: "***Pedegu**, he who dances when the drums have stopped. With his big ears, he dances when the drums have stopped, **Pedegu**.*" [1]

The Mua mask is dark grey or black and shows more caricatured features. There are the exaggerated oversized ears, a very long nose, slanting sad eyes, a mournful mouth with no teeth and a striking chin. His face is wrinkled and his head completely bald. His big ears are sometimes made of large pieces of rubber added to the carved mask. He wears a dirty loincloth, leglets, armlets and his body is covered with white ashes. He performs on any occasion when *gule* rituals are occurring. When he dances, he holds two small branches and crosses his arms on his chest adopting a penitential position to express his misery. The song says, "*Indeed they are calling you, **Pedegu**, oh, oh.*" [2] There is no response. **Pedegu** is deaf; he cannot hear. Even when they talk about him he does not hear. He looks confused and shy. He crosses his arms to signify he is dejected. The Mua version sometimes adds another handicap besides deafness. **Pedegu** is impotent. He cannot marry and have children. The women tease him: "***Pedegu**, they* (the girls) *are calling you.*" [3] **Pedegu**

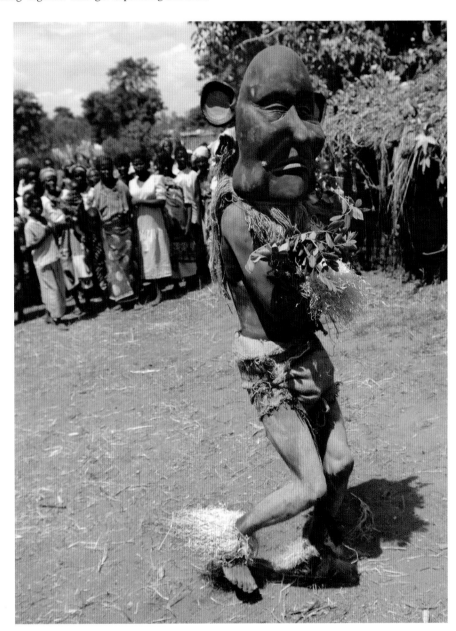

cannot respond because he is impotent. He prefers that people believe his inaction is because of his more socially acceptable handicap of deafness.

[1] "*A Pedegu, ovina ng'oma ataleka de e tate, chikhutu chachikuluchi de, kumavina ng'oma ataleka Pedegu.*"
[2] "*Kuitana e (2×) oh oh oh oh oh oh oh oh Pedegu.*"
[3] "*Kumene akuitanaku Pedegu.*"

Tsokonombwe

(an orange day mask from the Golomoti area)

Themes 1) Endurance; 2) Drought, famine & food security; 3) Cooperation

Etymology Tsokonombwe is a type of grasshopper without wings.

The large 70 centimetre mask features an imaginary creature representing hunger and famine. It is portrayed as a dreadful and a repulsive beast in orange tones to render the brownish colour of the grasshopper. It displays a long snout, an open mouth showing sharp teeth, large eyes, goat ears and eight horns varying in size and pointing in all directions. The horns are striped in yellow, red and black, producing a dazzling effect. The headgear of the mask is made of tatters of different colours and a black goatskin covers the back of the neck. The dancer wears a tatter suit enhanced with a fertiliser laces kilt and carries a club or a knife to convey the threatening effect of famine.

The character of **Tsokonombwe** is recent in *gule* in the Golomoti area. It was introduced in 2002 during the peak of the famine that started in 2001 caused by poor rains and a shortage of food supplies in the country, particularly around the lakeshore. Many villages were affected by hunger and some people died from malnutrition. **Tsokonombwe** made his appearance during the funeral and the commemoration rites of those who were thought to have been the victims of famine. The ugly beast enters the arena aggressively, following the

dancing style of Lambwe. He swerves his feet with power, chases the women, and brandishes his threatening weapons. The male choir introduces the beast: *"The grasshopper, oh!"*,[1] calling its name four times with great insistence. The womenfolk avoid **Tsokonombwe** for fear of being hurt by his weapons and the long span of his threatening horns.

This condensed version of the song recalls the well-known Chewa proverb: *"Tsokonmbwe adatha mtunda n'kulumpha – The grasshopper travelled the whole country, jump by jump,"* (meaning little by little). The song refers to the food crisis during which the majority of the population survived by gathering here and there, small quantities of food at the cost of tremendous hardship. The 2001-2002 situation was particularly serious because the Malawi maize reserves had been sold to neighbouring countries. Food had quadrupled in price. Villagers were left with nothing to sell in order to purchase maize. They could only afford to buy small quantities of food that they had to share with the rest of the extended family. The international donor community came late to the population's rescue. By then, villages had already started eating the new crops and therefore creating

Claude Boucher, Chagontha Village, September 2004

more shortage for the following year.

The ugly creature of **Tsokonombwe** represents the dread of famine and hunger. He epitomise the struggle of the population for food during this difficult period. The Chewa villages survived the period of famine 'jump by jump', by collecting small quantities of maize and by supporting each other. The little they accessed was shared. **Tsokonombwe** teaches tenacity and perseverance during hardship. He particularly emphasises the value of collaboration and mutual support at a time of crisis.

[1] *"Tsokonombwe e."*

Woipa sakwiya

(a black day mask from the Mua area)

Themes 1) One should not hide one's handicaps; 2) Handicaps as pretext for bad behaviour; 3) Dishonesty, theft & robbery; 4) Prejudice/discrimination & do not judge by appearances

Etymology Woipa sakwiya means, 'The person who is born ugly should not pout or sulk.'

The character wears a black mask portraying a monkey or a baboon. The face shows deeply inset eyes and a prominent snout with long teeth. The ears are round like those of a monkey. The headgear attached to the mask is made from the skins of monkeys, including baboons. The body of the dancer was traditionally concealed with the same material. Owing to the shortage of skins, this outfit has been replaced with the tattered jute suit. The dancer carries a branch with green leaves to suggest the bush or the crops that are damaged by monkeys. The character of **Woipa sakwiya** imitates the behaviour of the animal it represents in its dancing. It keeps staring at

people, jumps high, beats the ground with its hands and sometimes climbs trees. The song sung by the men for this performance relates, *"The one who is born ugly (physically or morally), let him not pout. No! The one who is born ugly, let him not sulk."* [1] The opposite message is contained in the women's song: *"The pretty one is not proud. The only one who can afford to show pride is Kachipapa on the way to the graveyard."* [2] It is a serious insult to call a Chewa a monkey or a baboon. These animals never qualify as pretty or beautiful. Their destructive habits make them the enemy of the farmers since they live by raiding people's fields and damaging their crops. For the Chewa, both the

appearance and the behaviour of such animals are considered evil.

The mask of **Woipa sakwiya** tells people not to imitate him. If someone is born ugly or malformed, this physical handicap should not influence his character. One has to accept his handicaps in order to bring joy to others. If someone keeps focusing on his own physical defects, he will fail to open himself to others. **Woipa sakwiya's** first message is that if someone's face is distorted his heart will not necessarily be distorted as well. Secondly, the ugliness in the song may also refer to evil behaviour. In this context, the message is that if someone has made a mistake or committed a crime, he

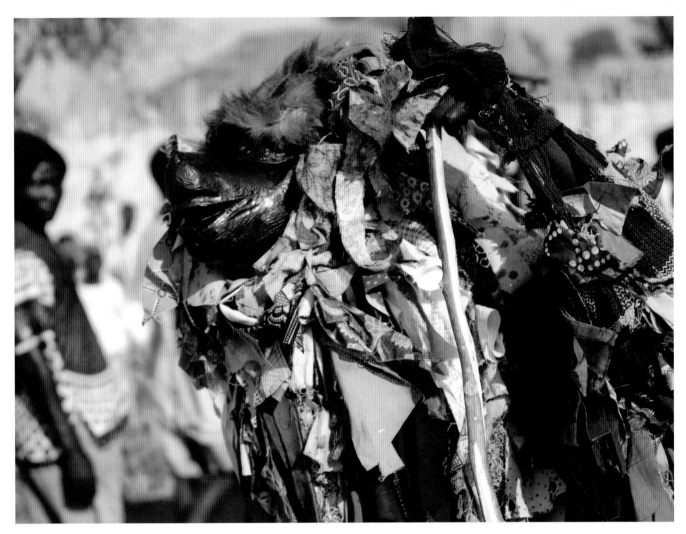

must acknowledge it and not pretend that it did not occur. The third piece of advice **Woipa sakwiya** teaches is that real wisdom lies in not judging people according to outside appearances, which can be inaccurate and deceptive. Ugliness, of any type, does not make a person evil. The opposite is also true, as in the song of the women: beauty does not equate to goodness. The person born with fine features and beauty may take advantage of his or her good fortune and become arrogant and boastful. The women's song reminds us that pride is the privilege of Kachipapa, who represents the family head, and who accompanies the deceased relation to the graveyard, where there is no pride. The baboon or the monkey, in spite of its ugliness and bad habits, still has one point in its favour. It can be the source of entertainment for all. *Gule wamkulu* has given it a place of honour, as a messenger for the ancestors. In Chewa thinking, it is common that the spirits of the dead borrow animal forms to convey their deep wisdom. This is the case of **Woipa sakwiya**. When you are born ugly or evil, do not pout, but instead compensate for your deficiency.

[1] "**Woipa sakwiya** *toto, woipa wena tate* **Woipa sakwiya**."
[2] "*Wokongola sanyada (2×) amanyada n'Kachipapa m'njira ya ku manda ayo.*"

6. Witchcraft and medicines

The belief in witchcraft is entrenched in traditional African cultures and societies. There is reason to suspect that belief in witchcraft is as strong today in Malawi as it ever has been. Indeed, the allegations and fears of witchcraft appear to have increased with the growth in the cash economy and materialism and the commensurate envy and jealousy between individuals. Boucher refers to this growth in paranoia and insecurity in several descriptions, such as **Lija** and **Mfiti idafa n'nyanga**. When in the past all villagers, even the chief, shared a status of limited assets, now some members of the community are able to acquire more possessions and the trappings of wealth. How is it that he or she can do so when I cannot? What magic are they weaving to enhance their lives? What secret powers are in use and how are they derived? Perhaps at the expense of others, perhaps at my expense?

There are two broad but overlapping elements to the use of medicines and the belief in witchcraft. The ordinary villager may refer to a traditional healer, a *sing'anga*, who concocts herbal medicines, generically termed *mankhwala*, made from roots and other plant matter, charcoal, animal parts and even soil. The medicines are used to cure illnesses in the sick, to protect people against bad magic (*kukhwima*), and, in some cases, to divine those who are witches. The witches themselves prey upon the villagers, and every villager is alert to the signs of witchcraft at work. Given one can never be sure of when a witch will strike, having access to protective medicines called *mtsiliko* or *chambu*, is seen as a necessary precaution to safeguard health, property, crops and livestock. Many of the *gule* characters described by Boucher refer to the use of medicines, either to deter people from practising witchcraft or as weapons of its evil trade.

If life in the village is set within, and measured by, the values of the *mwambo*, then *ufiti* or witchcraft is in many ways the *mwambo*'s antithesis. It is the dark to the *mwambo*'s light. To deviate from the guiding principles of the ancestors is to risk movement into witchcraft.

The *mwambo* underpins the community of which people are a part, and yet that in many ways subsumes them as individuals. The traditional Chewa community structure supported people to survive through cross- and mutual interdependencies. In this, no one was encouraged to excel or to distinguish themselves from the rest. To do so was to attract attention, and questions. Today the same fears and suspicions have grown, with insecurity over money, possessions and related status. The 'tall poppy', the achiever, the one who accumulates power or assets by whatever means, can be perceived as placing themselves above the community, as being antisocial. To be antisocial is to set oneself on the path to the worst of all human manifestations, that of the *mfiti*, the witch. It is common too for people to seek causal agents for their misfortunes, be those vicissitudes in health, crops, marriage, family relationships or business, and witchcraft is a frequent culprit. Witchcraft can consequently assume the role of crutch and excuse to all manner of personal afflictions, including many that may relate to the individual's own failings or mistakes. Accusations of witchcraft can also serve as a method of convenient vengeance, pay-back for real or perceived insults or wrongdoings. Thus belief in and accusations of witchcraft serve several purposes in the village dynamic: as a useful scapegoat for an individual's errors or bad fortune, as a singularly effective means of revenge (often used within the extended family group), and as the most extreme mode of control by the community of potentially destabilising individualism. If times are volatile and changing, as they are in modern Malawi, then it is to be expected that fears and accusations of witchcraft will wax. Boucher considers much of this in the entry for **Lija**, the walking belly of human flesh.

For discussions of witchcraft in Africa with application to the Malawian context, the reader is recommended Marwick (1965) and van Breugel (2001). The battle against witchcraft by medicine men and healers is exemplified in Soko and Kubik (2002). Witchcraft is a rich and complex topic but suffice to say here that it is ideal grist to the mill of *gule wamkulu*. Dire stories of witches and witchcraft can be read in Boucher's characters. These are people who have plotted, connived and used all manner of deceit and medicines to achieve their selfish ends. They are murderers and consumers of others, both literally (eating of flesh … see again **Lija**) and metaphorically (exploiting others for their own advancement). They can be intent on power (**Dumbo Achembe**[1], **Mfumu idagwa n'nyanga**) or women (**Mbaula**). They undermine the family group through their evil deeds (**Kamkutera, Kamvuluvulu**[2]). The witch may kill without reason (**Chauta**) and even destroy those who offer them assistance and succour (**Nkhwali**[3]). They can hide under the ruse of respectability (**Chauta amulange**). Greed (**Adapundula**) and various forms of crime, especially violent or sexual crime, or activities pursued under the cover of darkness (**Bokho, Dzimwe**[4]), will be manifestations of the witch. Failure to carry out one's duties and responsibilities can amount to a form of criminal negligence that has overtones of witchcraft (**Kasinja**[5]). The use of threatening language, notably to curse others, is seen as a dangerous ploy and one that may invoke the darker powers (**Mantchichi**). The family head, or *malume*, has responsibility for the success of his *mbumba* (see Community, authority and the ancestors) and will be suspected of witchcraft when misfortune blights the family (**Asongo, Tondolo**). Those who seek and achieve power and wealth will always be suspect (**Chikwekwe**[6]), and using new technologies to do so can compound the suspicions (**Basi**[7]). Ultimately, any behaviour that is deemed 'antisocial' can be a step in the transition from human being to witch (**Mbonongo**).

There is a strong idea of retribution in the Chewa, that evil will reap its just desserts and the practitioner of wrongdoing will eventually get his come-uppance. Witchcraft and medicines can be penalties for bad behaviour. Take for example the unruly, over-achieving *mkamwini* who may suffer extreme penalty by way of witchcraft (**Kanjiwa**[8]). Some practitioners have paid dearly for meddling with *mankhwala* (medicines), by encountering forces stronger than their own or eventually being maimed or killed by their own dark powers (**Chiwau**[9], **Chongo, Mfiti idafa n'nyanga**). In some cases, a form of witchcraft may be the tool of justice (**Walanda minda**). The ultimate price for practising witchcraft is very high, namely to wander the world as a homeless evil spirit, a *chiwanda* (**Chauta**).

While witchcraft is widely believed to underlie much of the misfortune that befalls individuals and the village, there is also recognition that other causes can be at work, and that one must be wary of unjustified witchcraft allegations. **Mfiti ibuula**, a horrible spectre, portrays a witch unjustly accused of killing children who in fact have died because of the transgression of sexual

taboos by the parents. As we see in **Tiopa wa nyanga,** the very old and infirm members of the community are frequent targets for claims of witchcraft. How could this person have lived so long if not by the use of spells?

At times, too, the witch can represent other themes. **Mfiti ilaula,** a dramatic five to six metre high structure, deals more with issues of caution in judging others by appearances, discretion in secrets and modesty, than with witchcraft *per se.* In this case, the witch, as a symbol for negative behaviour and deceit, is acting as a teacher for appropriate conduct rather than strictly admonishing the participation in witchcraft.

If belief in witchcraft is widespread in traditional Malawi, then the patronage of services of medicine men and women, *sing'angas,* is near ubiquitous. The *sing'anga* may be primarily an herbalist,

with skills in dispensing traditional medicines for a variety of ailments. They may lean more to divination, including the identification of evil including witches. There is always a fine line between witchcraft and those who can fight it, as to be effective, equivalent powers may be required. Thus the witch hunter must know his quarry well and be able to face the witch and defeat it. The great dance explores the nuances of handling the powers of medicines and the risks and rewards that may result (**Simbazako**). Historically, the lethal *mwabvi* ordeal provided a measure of reassurance to the people, in that a dead witch was better than one living in the community (**Lija, Tsoka wa nyanga**). Banned by the colonial authorities, the *mwabvi* ordeal was replaced by less summary forms of witch identification (**Lumwira**). In some cases, historical figures, such as famous *sing'angas,* may be woven into the charac-

ter's song (**Chiwau**[10]**, Lumwira, Simbazako**).

The *gule wamkulu* is articulate on the subject of witchcraft as this is something close to the hearts of the ancestors. They battled witchcraft when alive and do all they can to defuse witchcraft amongst their descendants. Whatever the particulars of the story, and the details of the character, what all have in common is that they are adamantly opposed to witchcraft in all of its varieties and perversions.

[1] Community, authority & the ancestors
[2] Personal attributes
[3] Personal attributes
[4] Personal attributes
[5] Sexuality, fertility & marriage
[6] Community, authority & the ancestors
[7] Community, authority & the ancestors
[8] Sexuality, fertility & marriage
[9] Sexuality, fertility & marriage
[10] Sexuality, fertility & marriage

Adapundula or Adapundula kwa Chikanga or Chimnomo lende

(a red day mask from the Kaphuka and Mua areas)

Themes 1) Witchcraft; 2) Greed; 3) Rights of/respect for the handicapped; 4) Evil reaps its just desserts (*choipa chitsata mwini*)

Etymology **Adapundula** means, 'He crippled himself.' **Kwa Chikanga** means, 'by Chikanga'. (Chikanga was a famous diviner in Malawi in the 1960s.) **Chimnomo lende** means, 'the long hanging (drooping) lips'.

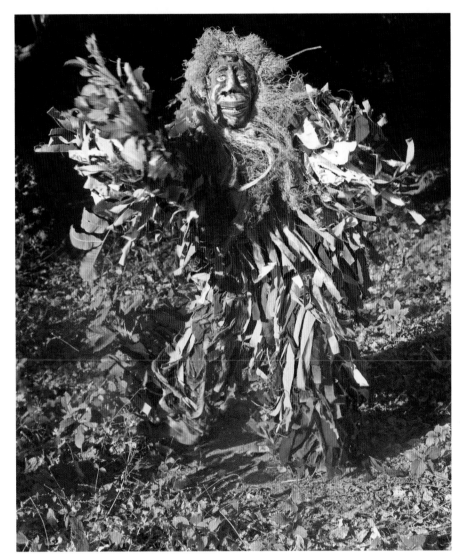

This character depicts a person who has become crippled by greed. The masks from both areas are red to show that the person is antisocial and is a witch. The Kaphuka version portrays a human face, narrow and fierce. He has a bald head, sizeable nose and drooping lips surrounded with a beard and moustache. A huge black wart sticks out from the stem of his nose. The headgear of the mask is made of rags. The Mua version shows the features of a human changing into a witch. The eyes are vague and disturbed. The nose is broad and the lips are elongated to show the transformation into an animal snout (but with human teeth). Many scarifications are seen on dif-

ferent parts of the face. The headgear is made of thick layers of fertiliser bag strips to convey the idea of an animal mane.

The dancer from both areas wears a tatter suit, kilt, leglets and armlets made of fertiliser bag laces. He carries a medicine tail, a club or a whip. The song from Kaphuka explains, "*He was normal when he was born. You children, what has happened came at maturity. He crippled himself.*" [1] The women's song adds, "*Is it because he practises witchcraft or because God created him so? We do not know! God created him* (normal). *He crippled himself.*" [2] The Mua song states that, "*Adapundula was crippled by Chikanga* (a diviner)." [3] The Dedza song

adds, "*He crippled himself because of eating female sexual parts, thinking they were wild cucumbers. He crippled himself.*" [4] These songs attempt to explain this sudden change of personality and behaviour.

The Mua character dances with rapid, unsynchronised movements. He moves his arms and swerves his feet frenetically. He falls. He stands up and madly chases the women trying to grab their legs. The Kaphuka character's performance is more restrained. The songs suggest that there are various reasons for his deformity. He may have mocked the infirmity or poverty of a neighbour, encountering the wrath of the ancestors. He may have practised witchcraft and eaten human flesh. He may have consulted the diviner with the intention of bewitching others or increasing his own power. All of these practices show that he is motivated by uncontrolled ambition and greed. His choice of the 'dark side' changed him into a witch that now plagues the community with misfortune and death.

In the traditional village setup, when a family experiences frequent death, they can be forced by their local authority to consult a diviner. They are lined up and tested to prove their innocence. The diviner inserts his medicine into small cuts he makes on different parts of their faces. The medicine 'smells' witches. If the person is a witch, soon the medicine will bring a change to his face and personality.

The character of **Adapundula** deters the Chewa from greed and warns them of its terrible consequences. *Gule* consistently condemns witchcraft. Greed and witchcraft destroy the very base of society. The lack of respect for handicapped people is seen to result often in a person becoming handicapped or crippled themselves, as a punishment from the ancestors.

Adapundula has sometimes been known as **Chimnomo lende**, but that confuses the character with the Chimnomo lende of the Pemba area, which has a very different context (refer to that entry).

[1] "*Lungalunga pobadwa (x2), ana inu, chakudza chidzera kuukulu Adapundula.*"
[2] "*Kaya ndi ufiti, kaya kaya n'Chauta, kaya n'Chauta ndiye adalenga. Adapundula.*"
[3] "*Adapundula kwa Chikanga.*"
[4] "*Adapundula e tate anadya nyini, anayesa chipwete. Adapundula.*"

Asongo

(a *gule* special effect from the Mua area)

Themes 1) Witchcraft; 2) High mortality

Etymology **Asongo** is a venomous snake, the black mamba.

Asongo is the name of a *gule* special effect presented during performances on an extremely dark, moonless night. Such effects are included at rituals celebrated in full darkness. A *gule* member in plain clothes holds a long flexible branch to which a baobab bark string has been attached. The string is set on fire, creating the impression of a red snake. The hidden dancer runs and moves the fiery snake across the bush, far away from the village. The illusion is perfect. The snake moves at a distance and the audience cannot see the operator or the implements used to enact the illusion.

The male choir expresses the concern of a family that fears that their newborn child will become the victim of the snake. *"Take care* (of the baby), *the black mamba* (is coming)."* [1] The cryptic song portrays the last born as a potential victim of the black mamba and suggests that more of their children have suffered the same fate. In fact, the song is not talking about a snake but about people who borrow the appearance

of a snake. The fiery snake is the epiphany of a witch. It talks about a person who has advanced themselves (*kukhwima*) in the practice of witchcraft. It is a Chewa belief that witches can transform themselves into mammals, birds or reptiles in order to cause death. The song emphasises that the witch has taken the shape of a venomous black mamba whose bite is deadly.

Asongo portrays a village infested with witches and the song confirms the fears of the villagers. Witchcraft represents a common explanation for misfortune and ill health and the high mortality rates among the children. The character of **Asongo** not only affirms that witchcraft exists but reveals the witch to be a blood relation motivated by greed and ambition. Among the Chewa, the maternal uncle is the first person to be suspected for he holds power over the extended family group. **Asongo** warns the villagers against possible danger and rebukes people who are witches that annihilate their own bloodline. A maternal uncle should not take the lives of his sisters'

children for he too will need their assistance in the future. As he grew older, he could have counted on the support of his nephews and nieces. He is shortsighted and selfish and should feel shame.

Asongo has rarely appeared in *gule* over the last three decades. With the improvement of hospital facilities, childcare, vaccination and Primary Health Care, the death rate among children has declined and this could be the reason behind **Asongo**'s disappearance. With improved health services, perceptions of witchcraft have moved from issues of child mortality, to the economic disparity that exists between villagers.

[1] *"Lerere Asongo, lerere Asongo."*

Bokho

(the hippopotamus character from the Mua and Dedza areas).

Themes 1) Witchcraft; 2) Violent crime; 3) Incest

Etymology **Bokho** means, 'hippopotamus'.

Bokho is found in various parts of the Chewa country. It represents a hippo bull with a large head, protruding teeth and small ears. The mask is painted in black and various tones of grey. The costume varies from region to region. In Mua, the hippo wears a mass of long rags and complete animal skins that conceal the dancer's body. Sometimes a tatter suit is worn instead. In the Pemba area, the hippo wears a kilt made of jute or sisal. It has leglets and armlets made of similar material. The rest of the body is anointed with ashes. The character commonly carries a club, a stick or a whip. The hippo is often found in rivers and around the Malawi lakeshore. It is known for overturning fishermen's dugouts and, sometimes, killing some of them for no apparent reason. Farmers know the hippo damages crops at night. People have also observed the hippo's sexual behaviour. They think the hippo bull often kills male young and prefers the company of female offspring. This observation of the animal world has been applied to that of humans: the mask of the hippo wants to stamp out witchcraft, crime and incest.

The **Bokho** character appears in the arena chasing the women. He rotates his arms and threatens the crowd with his weapons. At the end of the dance, he collapses and rolls in the dust. He shivers like an epileptic or suggesting a person caught with an irresistible sexual urge. An elder comes with a bucket of water, cools him off and sends him back to the water, where he belongs. While this pantomime is acted the men sing, *"The hippo has come out, the hippo has come out."* [1] The hippo portrays a person who is proud, selfish and troublesome. He attacks strangers, snatching their property or assaulting them. The hippo is like a psychopath who simply kills for the sake of killing. The Chewa call this type of person an accomplished witch (*mfiti mphera njiru*). The hippo is herbivorous and therefore does not kill to eat. Similarly, the type of witch mentioned above kills out of sheer jealousy, as it does not feed on human flesh. The phrase, *"the hippo has come out"*, portrays the evil person who is not afraid to show himself openly.

In the Dedza area, the men's song presents a completely different theme: *"The hippo bull shows rivalry to its male young and shows preference to its female young. Yes, Yes, This is out of sheer jealousy! (The father hippo says:) No, No, this is not true, it is not like that. It is the mother* (hippo) *who first started to get cross with the daughter. I was very surprised to see that. You are so jealous! Damn her! She went so far as to take our daughter and run away with her, taking her away from me. As far as I am concerned, No, No, it should not be like that! This is family life!* (We should have discussed the matter between husband and wife.) *If only my son were left, I would have taken him with him. This is wrong! This is wrong!"* [2] In this song, the male hippo is portrayed as more interested in the daughter than in the mother. Feelings of jealousy push the mother to continuously scorn the daughter, since she suspects that the girl is sexually involved with the father. The mother decides to leave home and escape with both children. Left alone, **Bokho** complains bitterly. The Dedza version of **Bokho** portrays him as a father who commits incest with his daughter. The observation is borrowed from wildlife. In crowded hippo populations wildlife specialists say that dominant males kill youngsters. The female sometimes successfully repulses these attempts at infanticide. The head bull drives out adolescent males when they approach eight years old and young females generally stay with the herd. The Chewa portray hippo behaviour as promiscuous.

They argue that the bull shows preference for the female young, as the mother shows the same towards the male offspring. They reckon that the bull kills the male young or chases them out of the herd because of jealousy. This is the reason why the hippo is described in the version above as an incestuous father. In Chewa life, incest is perceived as a severe breach to the moral code. It is identified with witchcraft because it is conceived as an attempt to acquire hidden powers. Such a crime will not remain unpunished by the ancestors. In this case, they use the hippo form to unveil such immorality. The song talks about the exodus of the mother and the children from the village. This is a temporary measure. According to the custom, it is the father who has to be sent away and repudiated because of his crime.

[1] "*Bokho waturuka, de de* **Bokho**, **Bokho** *waturuka.*"
[2] "*A* **Bokho** *akana mwana wamwamuna diyere; iwo afuna wamkazi. Inde, inde, koma ndi mtima wansanje, wansanje! Bambo akuti yayi yayi, sidero! Amaiwa ndiye anayamba podana ndi wamkaziyu. Ndadabwatu ine: ndiwe uli ndi mtima wansanje. Iwo alaula potenga mwana wawo n'kuthawa naye, kuthawira ine. Ayi ayi, sidero. Ili n'banja! Chikhala mwamuna watsalayo ndingotenga ndine! Mwalaula, mwalaula!*"

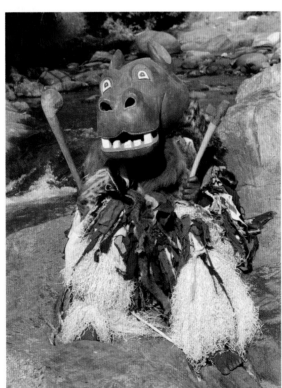

Chauta

(a black and white day mask from the Dedza area)

Themes 1) Witchcraft; 2) Incest; 3) Hypocrisy/split personality/duplicity; 4) Owls as familiars of witches

Etymology Chauta means, 'God'. In this context, the character's name reflects an abbreviation of, 'God has turned against me.'

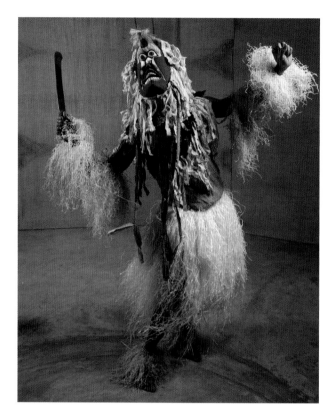

The mask is primarily black, evoking darkness and evil deeds committed in the night. In contrast, the colour white of some features suggests these nasty acts are concealed under an honest appearance. The white sisal hair lock and the dominance of white rags surrounding the headgear reflect this deception. The person portrayed is a middle-aged man with a receding hairline. He has a frowning white forehead. The fearsome eyes protrude and are red, like those of a witch or a man-eating animal. They are set extremely close together. The white black tipped nose is flat and squashed against the face, resembling an owl beak. The broad wide-open mouth displays aggression with teeth on the top and bottom jaws, implying a readiness to devour others (physically or sexually). A slim white moustache emphasises the prominence and the protrusion of the mouth, giving the character a sinister look. The exceptionally high and angular cheekbones divide the features into black and white, giving the mask a threatening, frightening appearance. Tribal marks on the forehead, chin, and cheeks show him to be Chewa. The ears can resemble the ear tufts of an owl, the messenger of death. The owl is nocturnal and commonly associated with witchcraft. Two black, slim 30 centimetre horns standing erect on the head stress the same theme. The dancer wears a fertiliser bag lace kilt, leglets and armlets. A sleeveless jute shirt, stitched with rags, covers the top part of his body. He carries weapons or a long knife. The character performs on the occasion of funerals and commemoration rites. As he aggressively swerves his feet and obscenely moves his hips, the men sing the following: "*Chauta, God has turned against me!*"[1]

The character portrays a witch that kills for no apparent reason. The Chewa call this type of character *mfiti mphera njiru*, a witch who is motivated by jealousy. Witchcraft can be congenital or learned. One becomes a witch by committing immoral acts such as incest or having sexual relations with in-laws. The community understands these crimes to be short-cuts to success and power. This theme is further suggested by the lewd movements of the hips and the white hair lock on the forehead of the character. The hair lock represents the sexual organ of a man who pretends to be virtuous (white) but pursues evil at night. The owl feeds at night and is an omen of death.

Chauta's appearance at funeral rites warns the community that death is not always caused by God. People cannot say that their relatives have died simply because God has turned against them. Jealous and envious witches often cause death. The character of **Chauta** also warns people who behave in an antisocial manner that one day they will also die. If they do not repent and cease to practise witchcraft, they will be denied the right of entering the company of the ancestors. God will turn against them and they will be condemned to become evil wandering spirits (*ziwanda*), perpetuating evil deeds forever and causing misfortune to the community.

[1] "*Ae Chauta (2×) e Chauta wada ine!*"

Chauta amulange

(a red day mask from the Mua and Khwidzi areas)

Themes 1) Witchcraft; 2) Hypocrisy/split personality/duplicity; 3) Danger of ambition

Etymology Chauta amulange means, 'May God punish him!'

The mask has two opposite faces, like the Roman god Janus (and like the *gule* Kapirikoni). A sad face looks forward while a smiling face stares backward. A dividing patch of hair made of black goatskin separates the two visages. Each face is equipped with a pair of ears and a distinctive facial expression. The neck that supports this one head with two faces is covered with fertiliser bags and strips of rags of various colours. The dancer wears the regular tattered jute suit. He carries

murderous weapons like an axe and a long stick.

The sad face is also aggressive and sadistic. The frowning eyebrows highlight his sharp, cruel eyes. The drooping mouth reveals clenched teeth that manifest hostility. The expression of gravity and meanness

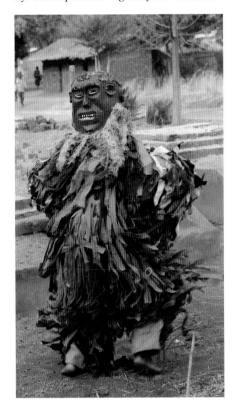

is reinforced by the narrow drooping moustaches that cover the corners of the mouth. The salient cheek bones and the pointed chin conflict with the drooping lines of his face and stress that the character is a fraud and that he only pretends to be sad.

His cheerful face behind shows the same prominent cheek bones and the same pointed chin. The eyes and mouth reveal a forced wide grin, betraying hypocrisy. The narrow moustache points upward, to reinforce this impression.

That the two faces do not feature tribal marks and are red designates the character as an outcast. In the past, the wearing and the dancing of this mask was surrounded by sexual taboos and was only performed at the funeral ceremonies of chiefs and other important people, or at the ceremonies of enthronement into leadership. During the

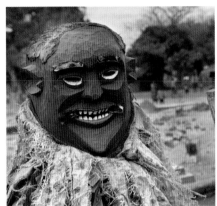

dance, the character swerves his feet vehemently backward and forward as a person who is unsettled and has a double mind. He also swings around the chief or another important political authority of the village while the men sing, *"God, o God…May God punish him!"* [1]

Chauta amulange represents an evil and jealous person who wishes the death of the leader. The song and his very name express the complaint of the villagers who have lost their chief before he had time to prove himself or before he reached old age. They reckon that his death has been caused by witchcraft. The crime was committed out of envy and jealousy by a community member who has a double personality and shows a double face. He even dares to witness the funeral of his victim in order to remove all suspicion. There he puts on a long face and pretends to be sad while behind he rejoices over the death and anticipates profiting from it. The Chewa idiom describes this as 'eating his (victim's) flesh'. The character of 'May God punish him' shows the ancestors' profound disapproval of people who live a double-life motivated by selfishness and greed. Their ambition pushes them to become antisocial and to destroy the very foundation of their community. Their false success is rewarded with loneliness and misfortune. They are outcasts in their own village and they carry with them the curse of God and the ancestors.

[1] *"E tate Chauta mayo!* **Chauta amulange!** (10×)"

Chongo

(a white night mask from the Mua area)

Themes 1) Witchcraft; 2) Witchcraft can be eradicated; 3) Witchcraft harms the practitioner (*choipa chitsata mwini*); 4) Rumours of witchcraft; 5) Forbidden sex; 6) Dishonesty, theft & robbery

Etymology Chongo derives from *chonga munthu*, meaning 'something like a human'. In this case, it is referring to a witch.

Chongo performs only at night during funerals and commemoration vigils. The mask consists of a jute headcover with red eyes and a protruding mouth with teeth. The costume is a suit made of the same material that is well wetted with water. On the suit and the headcover little bark strings are tied that are lit during the night performance. The character displays a huge belly, a common characteristic of a witch.

Chongo is a type of Kapoli but does not share the Kapoli way of dancing. He enters the *bwalo* spectacularly, in flames. He waves

his arms up and down and runs around the arena in order to keep the fire burning. The men sing, *"Chongo… look at the fire in the old village site,"* or *"The witch of strange doings! Come and see!"* [1] **Chongo** manifests powerful witchcraft by the mere fact that fire emanates from his body. Witches are believed to have control over the elements and to use them for their selfish purposes. The word fire is often used as a euphemism for sex. Witches can achieve power through forbidden sex. Witches rejoice at the death of someone because they have the reputation of feeding on the human flesh. **Chongo** is portrayed with a distended stomach that resembles a pregnancy. This large belly has developed as a consequence of trespassing to steal from someone's property that was well protected with powerful medicine. A shrewd *sing'anga* has succeeded in having him under his spell.

The songs above relate to witchcraft, real and perceived. One recounts how witches have invaded a village and have forced the people to move away to a new site because of suffering too many deaths at their old home. Owing to insecurity, people spread rumours that contribute to a mass hysteria. The ultimate message of **Chongo** is that witchcraft can be eradicated. Those who practise it often become the victims of their own powers. Their magic cripples them and their own antisocial activities disqualify them from communion with the ancestors. The character of **Chongo** also shows that many fears of witches are unfounded. Idle rumours of witchcraft are not to be taken seriously. Such uncontrolled fear paralyses the community spirit and causes its members to quarrel, to cultivate mistrust toward each other, and destroys the harmony between the living, and between the living and the ancestors.

[1] *"Iyerere tate onani moto m'binja. A re re re **Chongo** (10×)," or "Mfiti yaya (4×) bwera dzaone."*

Kamkutera

(a red and white day mask from Mua area)

Themes 1) Witchcraft; 2) Choice of marriage partner (choice of *mkamwini*); 3) Hypocrisy/split personality/duplicity; 4) Sexual obsession

Etymology Kamkutera means, 'He has finished the leftovers,' or 'Who has eaten the leftovers?'

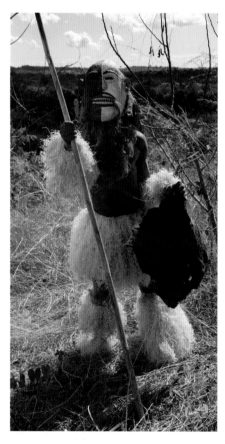

The character of **Kamkutera** appears to be addressing issues of food but this is not to be taken literally. Among the Chewa, meat is highly valued but rarely eaten. Consuming human flesh is perceived as the epitome of antisocial behaviour. Witches feed on it and are believed to offer banquets to their fellow witches on the occasion of a funeral. This character dances at funerals, commemorations and initiation rites. The mask of **Kamkutera** displays an oblong head, painted half red and half white, and the mouth has sharp teeth. It portrays a stranger who comes into the village apparently with good intentions (the half of the face painted white) but soon reveals himself as a witch and a killer (the half of the face painted red). He carries a walking stick to emphasise that he is a stranger and an animal skin that shows he is a diviner (*sing'anga*). He is on a quest to find a wife and a place to start his business. The song reveals this intention: *"**Kamkutera**, give me a young girl* (child) *that I may eat her* (sexually). *"*[1] This request is in accordance with **Kamkutera**'s obvious and obscene pelvic movements in the arena. He is welcomed in the village and stays at the residence of his new wife. In one of the songs, **Kamkutera** boasts about his wedding night: *"The small beads glittered, the small cheeks* (buttocks) *shone. This is what you have seen,"*[2] sing the women. This song refers to a sexual obsession. The family that has welcomed this stranger and given him their daughter soon becomes surprised at his behaviour. Their *mkamwini* and diviner **Kamkutera** keeps asking for meat. He says, *"Give, give, give me the leftovers* (of meat). *"*[3] Soon they start doubting his intentions, as he keeps requesting, *"Great witch, give, give me a child to eat."*[4] His conversations are in bad taste and grotesque. Another song says, *"What kind of village is this, where there is no funeral and nobody provides me with human flesh?"*[5]

The word used in these songs, to emphasise his requests for food, "give, give me", is *'ninkhe'*. It has a double-meaning, also designating the owl that is seen as an omen of death and a symbol of witchcraft. People have paraphrased its cry as, "Give, give me, so that I may chew it." As **Kamkutera** dances in the arena, he carries an animal skin in his hand which is a detecting device of the diviner to find out who is about to die. **Kamkutera** has been discovered. He is not only a diviner; he is a witch and an omen of death to the family group. The son-in-law is often blamed for the sickness and death of his own children. This may be due to his being promiscuous and flirting with other women (reflected in the suggestiveness of his dance). With the death of a child, the family has the confirmation that he is the culprit who kills to find meat or medicine and to be more prosperous in his business. In this case, **Kamkutera** is sent away, or more harm may befall the family and even the entire village. The character of **Kamkutera** is a warning to the family group, to be cautious in their choice of sons-in-law. They should not just welcome any stranger, without knowing his behaviour, family background and original home. Prevention is always better than a cure. One risks introducing witchcraft and death to the family. Instead of increasing the *mbumba* (the extended family) and promoting its welfare, one exposes it to fragmentation and decimation.

[1] *"Ninkhe ninkhe mwana kuti ndimukwate."*
[2] *"Kamkanda mbuu, kathako wali wakaona ndiwe."*
[3] *"Ninkhe (2×) ninkhe **Kamkutera**, **Kamkutera**, **Kamkutera**."*
[4] *"Chimfiti ninkhe (2×) mwana ndidye."*
[5] *"Pa mudzi panji popanda maliro ndapaona."*

Lija

(a night structure from the Mua area)

Themes 1) Witchcraft; 2) High mortality; 3) *Mwabvi* ordeal; 4) Labour migration; 5) Security

Etymology Lija refers to 'the day agreed upon'. The song mentions the word '*lolija*'; the particle '*lo*' suggests a reference to a precise day. Lija conveys what has been agreed upon in the past.

The structure of **Lija** represents a creature of the night, a monster or fearsome ghost. The conical bamboo construction, one metre wide by one metre and a half high, conceals a single dancer from the neck to the feet. His head is dissimulated under a palm-leaf hat with a wide brim, completely hiding his face and identity. The faceless monster shows no front and no back. The conical bamboo shape structure is first concealed with dry banana leaves to which old blankets or jute cloth are added to give the creature a ghostly look. A woven fringe of palm leaves attached to the base of the structure hides the dancer's feet. The narrow end of the cone rests on the dancer's shoulders while his arms (inside the frame) direct the movement of the wide end of the cone and allow it to balance sideways. **Lija** portrays a headless creature without arms or legs. It emphasises a huge fat belly filled with human flesh: it is an abomination, a witch.

 In the arena, the monster spins, moves in opposite directions and above all chases the audience, scattering them. **Lija**'s presence enhances funeral and commemoration rites. The remembrance of the dead (*dambule*) was also an important opportunity for **Lija** to perform. Both men and women receive him with the following song: *"The day agreed upon…a beast of that sort* (or) *grief of that kind. The day agreed upon."* [1] The expression, *"The day agreed upon"*, matches well the funeral context of **Lija** and the mention of extreme grief. **Lija** provides an answer to the issue of causality of death. The answer is *"a beast of that sort"*, here meaning a witch. The song concludes that death was not natural but was caused by a "*beast*" in agreement with other fellow beasts. The very reaction of the audience, escaping the threat of the monster, demonstrates a similar world view of fear. **Lija**'s big belly focuses on the Chewa nightmare of the witch.

 The close family ties and common bloodlines provide the very structure of the family groups comprising the Chewa village. The *mwambo* provides the ideal charter for community living and rests entirely on the values of unity and harmony. These become the ultimate purpose for Chewa institutions and particularly for the *gule wamkulu* world. In opposition, the daily reality differs when individuals ignore or oppose the *mwambo*

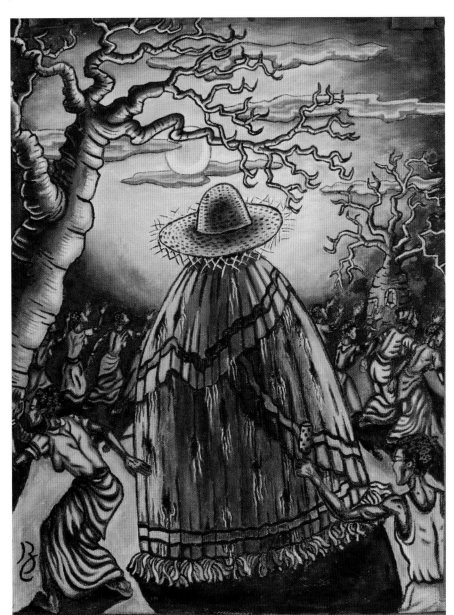

Painting by Claude Boucher and Joseph Kadzombe, 2009

and allow themselves to be motivated by less noble instincts such as ambition, jealousy, hatred and greed. Then, their paradisiacal world turns into a hell of terror and suspicion. Relatives, sharing the same bloodline, turn against each other in order to satisfy their individual pursuits. The peaceful and cohesive living metamorphoses into a mass hysteria by which the dearest and closest kin becomes a monster or a fearsome ghost. This reality is termed by the Chewa as *ufiti*.

This word is often translated, for the lack of a better term, as witchcraft. *Ufiti* suggests a world of paranoia in which every misfortune, sickness and death is read in terms of a personal agent who happens to belong to the group of relatives (the enemy within). Because individuals gave in to their base instincts, they turned into antisocial persons, exploiters of the group to which they belong (family, extended family groups or the village at large). The greater responsibility

one carries within each of these groups, the more one is suspected of turning one's power and authority towards self-interest. Necromancy becomes the epitome of criminality. **Lija** is a monster with a big belly filled with relatives' flesh. Witches are perceived as loners but their individual greed does not prevent them working as a team, even if only on a temporary basis. This is the meaning behind the words of the song, "*The day agreed upon*". Witches share in each other's 'banquets'. They take turns to kill a relative and then share the meat. In the egalitarian world view of the Chewa, personal success, disparity of wealth and advanced age are commonly perceived as the reward for committing hideous crimes. This is symbolically portrayed by **Lija**'s large prosperous stomach. In a world in which health care and hygiene are poor, poverty rampant and mortality rates high, disparity emerges as the ultimate crime and the only meaningful explanation to the cause of death, especially if it comes prematurely.

The historical data surrounding **Lija**'s appearance in Mua in the 1930s demonstrates an increase of fear and concern with regard to witchcraft. Informants certify that **Lija** was unknown on the lake plain before the 1930s. The instigator of **Lija** came originally from the plateau close to the Nkhoma area. He came to the lakeshore to marry and was welcomed as an *mkamwini* in a prominent family group connected with the village authority. The young man was soon valued for his dancing ability and his creativity at introducing new masks and new structures from his home on the plateau. His keen interest and dedication had rendered him eligible for a position of authority within the local secret society. The fact that he had married into the chief's family contributed to enhance his status and promote him to the position of head of the *mzinda*. Over the years, he acquired a reputation as one of the most knowledgeable and most respected *gule* members. He died in 1996 at the commendable age of 85 years old. There is irony in that the man who had introduced **Lija** departed this life a decade later than **Lija** had disappeared from the arena.

The introduction of **Lija** in the 1930s coincided with the ban by colonial powers on the *mwabvi* poison ordeal. As the ordeal was often lethal, British authorities quickly outlawed it. However, the *mwabvi* test, extreme and summary as it was, provided the villagers with a sense of security that the terrifying world of witches was under control. After the ordeal had been forbidden within British territories, people's paranoia increased, particularly with the advent of influenza, and the creation of **Lija** could well have been a manifestation of this phenomenon. With its presence in the arena, the fear of witchcraft takes a new threatening reality by exposing the villagers' vulnerability and by reinforcing the need for protection through medicine. Labour migration outside the country was also peaking in the decades after the 1930s and could have provided, for both suspected witches and those who considered themselves as their victims, a safety valve and a release for the tension generated by the obsessive presence of a beast terrifying the Chewa community.

[1] "*LoLija (3X), chilombo chotere, LoLija.*"

Lumwira

(a red day mask from the Dedza area)

Themes 1) Witchcraft; 2) *Mchape* (purification); 3) Security; 4) High mortality

Etymology **Lumwira** is the name of a female *sing'anga* who was famous in the Dedza area around the 1930s.

The red mask portrays the face of a woman. Red emphasises the fact that she is a *sing'anga* specialising in witch hunting. Four horns (25 centimetres long) protrude from her bald head. Her face is fat, particularly around her double chin. Her vague, large eyes are like those of a seer. The nose is short and aquiline. The moderately sized mouth pouts as if to admonish people. The bottom teeth are apparent. Two black lines next to the nose mark her seniority. The ears are in proportion with the rest of the features but they stand out to show that the person has a special gift for listening to the voice of the spirit world. Chewa tribal marks are seen on her forehead and chin. Scarifications on the cheeks have been replaced by two round black spots that symbolise she has been endowed with special powers from the ancestors. The headgear is made of rags of various colours with a dominance of white to show that her mission is one of purifying the community from evil. The character wears a white cloth extending from the bosom downward.

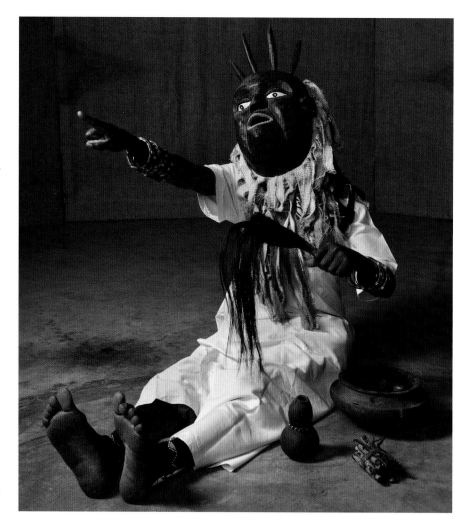

Her arms and ankles are adorned with numerous bangles.

Lumwira enters the arena with her gourd of medicine (*nsupa*), a clay pot, a gourd for drawing water and a medicine tail. She sits down and starts pointing her finger at the audience. She takes the gourds and the pot and starts administering the *mchape* (the cleansing medicine). She roams around the *bwalo* at the rhythm of the *chisamba* and pretends to administer her potion. She then sits and waits for the effect. During this exercise, the men sing, *"Let us go and see the famous medicine woman! She is Lumwira. Let us go and see the medicine woman who has grown horns! She is the one who administers the mchape* (test for purification – washing), *the purification rite that kills witches. Lumwira is the one who knows these matters, come, come, come!"* [1]

In the past **Lumwira** danced for funerals and commemoration ceremonies, especially for those who were thought to have died as victims of witchcraft. Today her presence has been extended to any ceremony, including political party meetings, since her dance has taken on a more folkloric tone.

Little is known about the famous witch finder, **Lumwira**, from Dedza. However, the *Mchape* Movement is well documented. This cleansing movement has a Christian background and is linked to the African independent churches and the African messianic prophets that flourished between the 1930s and 1940s. The *Mchape* Movement entered Malawi around the 1930s via the Mulanje corridor and spread north over the whole country and the neighbouring

regions. Mr Kamwendo, from Mozambique, is credited as founder of the movement. Several followers of his mission and their methods inspired the women. The prophet was called by God to cleanse and free the people. His mission was to cleanse the village from the power of evil and the hatred that is epitomised in *ufiti* – witchcraft. The *mchape* demanded that all horns and medicines employed in witchcraft practice be brought to the *sing'anga* for scrutiny. These were heaped together and the community stood in two lines, according to gender. Each individual passed, one by one, behind the medicine man who watched each of them in his mirror. The reflection of his mirror would reveal to him those individuals who were witches. The exposed witches were forced to drink the *mchape* concoction. This medicine was not supposed to be lethal as was the infusion of the bark of the *mwabvi* tree (*Erythroplaeum guineense*). While the potion was being drunk, the *sing'anga* occasionally invoked Chauta for protecting the community against witchcraft. When the ordeal was over, the medicine man burned the objects collected and warned his patients not to revert to the practice of witchcraft for fear of encountering death. This new form of cleansing came to replace the *mwabvi* ordeal that was banned by the British ordinance at the beginning of the 1930s.

Through the character of **Lumwira**, the Chewa population confirms its need for being cleansed from witchcraft and for peace of mind and security. They claim protection against their greedy and selfish

neighbours, who do not hesitate to cast a spell on others (especially children) in order to achieve their selfish aims. Both the *mwabvi* and the *mchape* tests were practised in order to reveal hidden greed that destroyed the community and compromised peace. The *mwabvi* provided a more lasting effect because it killed the witch and prevented it from resuming evil practices. The *mchape* was less effective since the witch could always be tempted to revert to witchcraft although warned that he/she would die if he/she did so. The song of **Lumwira** and her cleansing activity was inscribed into the *Mchape* Movement. The song insists that her potion killed the witches like the *mwabvi* did. **Lumwira** could have been a witch hunter coming from Mozambique territory where the *mwabvi* ordeal was still practised and the British laws were ineffectual. **Lumwira**, through her cleansing in the arena, wishes to inculcate the fear of witchcraft and of the medicine man. She also deters those who practise magic from continuing their macabre activities, thus reducing the number of murders. The high mortality rate of the 1930s due to influenza may have increased the insecurity in the Dedza District and confirmed the belief that the population was the victim of concerted witch attacks, which required the assistance of a powerful medicine woman like **Lumwira**.

[1] *"E tate tikaone sing'anga womveka tate de! Iwowo ndi a Lumwira ee tate de. Tikaone e tate sing'anga womera nyanga tate e. Ndiwo apatsa anzawo mchape. Mchape wopha mfiti tate e. A Lumwira ndiye adziwa izi, woye woye woye."*

Mantchichi

(a black day mask from Khwidzi)

Themes 1) Witchcraft; 2) Discouraging evil spells & wishes; 3) Unity & harmony; 4) Owls as familiars of witches

Etymology **Mantchichi** is an owl.

The owl mask is black, to signify darkness and evil. The heart shaped face resembles the barn owl, but the mask has red ears that are black striped. **Mantchichi** can have the curved beak of a bird or a broad flat human nose with large nostrils. The human-like eyes are red, showing anger and characteristics of a witch. These wrinkled eyes reveal the person is deprived of sleep owing to night activities. A wide, toothless, v-shaped mouth is below the nose or the beak. There is no chin. Monkey skin and rag headgear signify the bush, the graveyard and the world of the dead. The dancer's long, plain sleeveless jute gown reaches the ground.

Wrapped around the waist is a grass skirt. He carries an axe and a whip and wears ankle bells and armlets. He performs at commemoration ceremonies and funerals. Swerving his feet energetically he presses forward with determination, chasing the women and inspiring fear as he enters the *bwalo*. A syncopated rhythm accompanies the dance. The men sing in a pleading tone, *"The owl has come! I pray that my child may be spared* (may not die)! *The owl has come!"* [1] An alternative song may be used, *"The owl has killed a child* (a young person) *for so-and-so! The owl is happy!"* [2] This song can refer to the name of a real person in the village.

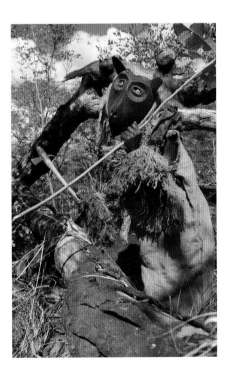

For the Chewa, the owl is the messenger of death. When they see an owl around the village at night and hear its cry, they are convinced that someone will soon die. When death occurs they believe that the owl's bad omen has been fulfilled. As they gather to mourn the death of a loved one, they pray, through the first song, that their own children may be spared the owl's violent intent. The owl is not only the messenger of death but also the incarnation of witches (*afiti*) and evil spirits (*ziwanda*). Chewa believe that when evil persons die, their spirits remain unsettled and transform themselves into suspicious and harmful creatures, like the owl and the hyena. The spirits assume these forms to take revenge and strike down innocent members of the community. They kill in order to satisfy their anger and greed or feed their fellow witches (as it is stated in the second song). Funeral rites are the occasion for paying respect to a relative or a friend. This is a privileged occasion for seeking the meaning of his death. The sudden death of a person in his prime is an enigma, commonly explained through witchcraft. Sometimes unsettled evil spirits are seen as the cause of death. A more common explanation is that death is caused by jealous and frustrated members of the living community. The intricacy of village life brings about frustrations and conflicts. These may be resolved through violence but generally the Chewa are of a more peaceful nature and avoid physical conflict, relying instead on threats and curses. An expression like '*mudzaona*' ('you will see') conveys a menacing intention. Curses are believed to be effective. If death occurs, people suspect the person who has openly threatened his neighbour is responsible. The character of **Mantchichi** discourages people from bewitching each other. Cursing others is taken very seriously and the character emphasises it is wrong to wish evil.

[1] "*Wabwera **Mantchichi**! Mwana wanga asafe toto, wabwera **Mantchichi**.*"
[2] "*Wamphera mwana **Mantchichi** (2×), **Mantchichi** wakondwera.*"

Mbaula or Kam'bulitso or Chauwa

(a black mask with cooking pot on top of head from Mua)

Themes 1) Witchcraft to secure a wife; 2) Covetous behaviour; 3) Hypocrisy/split personality/duplicity; 4) Recent politics

Etymology **Mbaula** refers to a 'charcoal burner'. **Kam'bulitso** means, 'popcorn'. **Chauwa** is the name of a person.

This black mask shows a fearsome face, often hideous, with round glowing eyes, bushy moustache and goatee. Various numbers of horns protrude from the head. On the primary example here, there are eight black horns of various sizes forming a crown. The biggest horn is twisted and has red stripes. Another two black horns protrude from his chin. Two more emerge from the side of his mouth. There are also variants of **Mbaula** where the visage is more human, lacking the horns protruding from the face. What characterises them all is the clay pot of smoking charcoal that rests on top of his head. The face is black to symbolise evil behaviour and ugly motives hidden in people's hearts. These motives have the power to change people's behaviour and even their physiognomy as is displayed in the mask. The headgear of the mask is made of rags and wild animal skins to show the character's antisocial behaviour. **Mbaula** wears a tatter suit with a double kilt at his waist and carries a frying pan and a club. He dances with frenetic energy, rotating and spinning around at high speed. He swerves his feet from time to time while roaming the village collecting and bringing all the women to the *bwalo*. The women are delighted and adore his tricks. He sits down in the arena and his assistant puts some corn grain in the frying pan, roasting or popping them on top of his head. When the popcorn (*kam'bulitso*) is ready, people come and help themselves. After this short demonstration of power, **Mbaula** stands up and continues dancing as before.

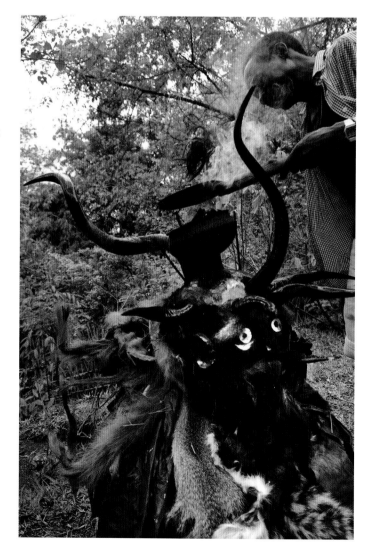

The mask is recent in the Mua region. It was introduced in 1989 into the Nkhoma-Chilenje country (Chief Chauwa) via the lakeshore. The song sung for him happens to mention both names (**Chauwa** and **Mbaula**), *"**Chauwa**, to snatch someone else's wife! Sheer jealousy, **Chauwa**!"* [1] or *"In the time of Kamuzu … we have seen **Mbaula** (the fire damp) in Malawi country (the lakeshore)."* [2] The first song talks of a person who has taken someone else's wife, possibly by magic. The reference to Kamuzu and Malawi in the second song may have a political meaning. The then President Kamuzu Banda had seen **Mbaula**'s performance at the lakeshore during his numerous visits to the Mua area or at Kamuzu Stadium. The link between **Mbaula** and Kamuzu Banda could well refer to the *mbumba* or women that followed the President everywhere he went, leaving their husbands for long periods. These women often ended up in prostitution, entertaining ministers and party officials. The song may imply more and may refer to Kamuzu Banda's relationship with Mama Kadzamira, describing how her previous engagements were broken in order to secure her presence at the State House.

Mbaula refers to fire damp or pit-gas. This is a sudden eruption of smoke and heat in the mines that seems to come from nowhere producing heat without fire or flames. Similarly, the cooker (*mbaula*) known in the villages is a container in which hot charcoals generate heat and energy without flames. The character **Mbaula** emphasises heat coming from within and compares it to covetous behaviour coming from people's hearts. **Mbaula** tells the story of a man who lusted after someone else's wife. He decided he would have her. He used tricks to attract her attention. He enticed her and her relatives with gifts and food hiding his evil intentions (the horns). He provided her household with food at the time of famine (the popcorn). He reserved his evil, the dreadful horns of witchcraft, for her husband. He would frighten or eliminate the husband in order to marry the woman (the club and the horns). His fearsome look and his reputation as a witch were enough to deter the husband from reclaiming his wife.

Mbaula represents a person who hides his evil intentions under the cover of generosity using deception and fear to fulfil his goal. Just as **Mbaula**'s performance fascinates his audience, the women follow him with great excitement but few perceive his malicious purpose. It is only after experiencing the consequence that they realise the extent of the damage. By then, it is too late. The character warns the Chewa of such dangers. Hidden heat (without apparent fire) can nevertheless cause disaster. Covetous behaviour is the mother of all vices and witchcraft is her first born. A witch stands as the opposite of the Chewa value system.

[1] *"**Chauwa** kulanda mkazi wamwini, dumbo **Chauwa**!"*
[2] *"Nthawi ina Akamuzu….taonera **Mbaula** ku Malawiko."*

Mbonongo

(a black day mask from Mua)

Themes 1) Witchcraft; 2) Fear of evil spirits

Etymology The etymology derives from *mbo* or *ngo* indicating the verbal adjective and *kuononga* – 'to damage', thus 'he who damages'.

Mbonongo is meant to inspire fear and discourage witchcraft. The dancer is dressed in a full-length jute cassock dyed black. This creature of the night has disproportionately long arms made of wood and covered with jute and that end with two fingers but no hands. The feet of the dancer are often concealed with thick leglets. His head is covered with a sack made of the same material or a black goatskin. At times, this cover is completed by a cloth mask with enormous eyes, a sketchy flat nose and an angry mouth with pointed teeth. There are no ears or eyebrows. Some regions portray him with a carved black mask and a double face looking both forward and backward. The expression and the details of the faces are identical. His double face expresses his omnipresence. The faces are characterised by large fearsome eyes (made of silver paper), no eyebrows, no nose but two nostrils (through which the dancer sees his way), enormous swollen cheeks and no ears. There is a slit for the mouth but no teeth or lips. A line of rags separates the two faces and represents the hair.

The weird creature enters the *bwalo* like a whirlwind, rotating his arms in an uncoordinated manner and bending them in the opposite direction to that of humans, a characteristic of witches. He spins around, moves in all directions, backward and forward, runs at high speed and chases everyone from the arena. With his long stiff arms, he slaps people (including the drummers) and 'destroys' the drums used for the performance. Usually **Mbonongo** will dance in a pair. They stir up a lot of excitement. The audience runs in various directions and everyone is on the lookout anticipating the sudden appearance of the dreadful evil spirits (*ziwanda*). As they keep appearing and disappearing the men sing, *"**Mbonongo**, gule, you gule wamkulu, **Mbonongo**,"* [1] or *"This wild beast, it even frightens its own relatives, this wild beast."* [2]

Mbonongo portrays an evil person who hides his antisocial behaviour associated with witchcraft (*ufiti*). It shows a person undergoing transformation into the hideous being that is a witch (*mfiti*). Such a creature takes the colour of the night. It moves in all directions at fantastic speed and can even fly. Its limbs are long reaching, with crippled fingers ready to harm any relative. It has no ears because it is deaf to the ancestors'

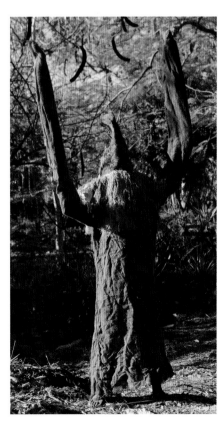

advice. It displays a deformed or double face with wide eyes that see everyone. The large mouth and sharp teeth signify greed and selfishness. Such a person casts lots (*kulodza*, spells using medicines), attacks his neighbour at the roadside, commits adultery and incest, eats the children of his own relatives and indulges in all kinds of antisocial deeds forbidden by the *mwambo*.

Mbonongo's character is said to have been introduced in the Mua area from the Chipoka-Lifidzi region. It is commonly performed on the occasion of funerals (commemoration rites) and initiation rituals. **Mbonongo**'s appearance in *gule* intends to inculcate fear and reinforce the belief in evil spirits (*ziwanda*) (the enemy from outside). As a corollary it is meant to

discourage antisocial behaviour and the practice of witchcraft. Witchcraft is commonly understood as a shortcut to success and represents the attraction for what is forbidden.

[1] "**Mbonongo** *e tate e gule iwe tate e, gule wamkulu e tate e* **Mbonongo**!"
[2] "*Chilombo (2×) choopsya choopsya eni ake tate de. Chilombo choopsya eni ake chilombo, chilombo.*"

Mfiti ibuula

(a brown day mask from Dedza)

Theme 1) Sexual taboos (*mdulo*); 2) Witchcraft not the cause of illness; 3) Responsibility for one's own actions/life

Etymology **Mfiti ibuula** means, 'The witch feels pain.'

This complex mask features an animal-like creature with eight red horns and a long snout with protruding teeth. It is in the gruesome process of devouring a baby. The Chewa believe that young children are often the victims of witchcraft. The mask portrays a child's limb, dripping with blood, hanging from the mouth of a witch. The character dresses in a bark cloth suit and performs during the initiation ceremony, to encourage the initiates and the members of the community to question their own sexual behaviour. Their disrespect for the sexual taboos can turn them into witches. This is shown in the details of the mask and particularly in the different sizes of the horns, their colour and their position. The eight horns describe the process of gestation of the child in the womb from the time of conception until the time of birth. The first erect horn, between the eyes, is topped with a few centimetres of black paint to show that normal sexual relations lead to conception; this is the first month of pregnancy. The second horn is also erect, stands on the snout, and is blacker than the first, meaning that more regular sexual contact is needed to feed the pregnancy that is now in the second month. A tiny bit of black crowns the third, fourth, fifth and sixth horns that stand erect and show red as the dominant colour. These indicate that the couple should reduce sexual activity as the pregnancy progresses. The last two horns are flaccid and are red without a black tip. They describe the seventh and the eighth month, a period when the unborn child can easily be endangered by sexual intercourse.

The Chewa prescribe sexual abstinence from the seventh month after conception until birth and from birth until the child is officially welcomed into the family group during the *kutenga mwana* ceremony. Any breach to these sexual taboos endangers the child and compromises his growth. The

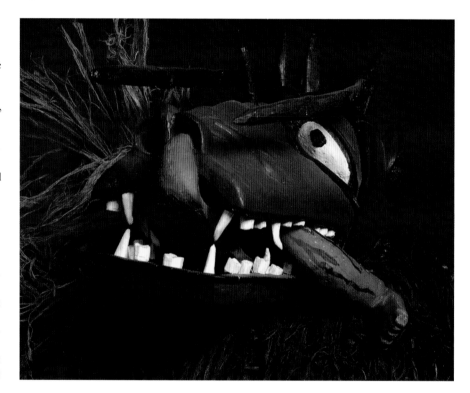

song testifies that witchcraft may not be the cause: "*It is crying: Alas, alas, the witch. I thought that it does not get sick or feel pain. It is crying. It fills me with dread, the witch. I thought that it does not get sick or feel pain. The witch (feels pain), alas, alas.*"[1] The character of **Mfiti ibuula** portrays a witch, wrongly accused, who voices her innocence concerning the death of this child. The character is effectively saying, 'I did not do it but accuse you for your own failure to keep the sexual taboos during the time of pregnancy.'

[1] "*Iti mayo mayo mfiti. Ndinkati sidwala nibuula. Iti mayo mayo. Ikuopsya mfiti ode. Ndinkati sidwala nibuula. Iti mayo mayo mfiti!*"

Mfiti idafa n'nyanga

(a red day mask from the Mua area)

Themes 1) Witchcraft; 2) Witchcraft harms the practitioner (*choipa chitsata mwini*); 3) Social changes/insecurity

Etymology **Mfiti idafa n'nyanga** means, 'The witch died because of too many horns' (because of using too much medicine).

The 30 centimetre red mask portrays a stranger or a person of dubious behaviour. He is represented as a mature man. Wrinkles reveal that his conscience is troubled. His round fiery eyes betray the disappointment of facing death. His straight nose is edgy and pointed. His sardonic and toothless smile evokes deceitfulness. His pointed chin displays two black warts. Similar protrusions appear on his cheeks and on his forehead. These are signs of an overdose of evil medicine meant to protect him as armour against the consequences of his nasty deeds (murder and theft). The headgear of his mask, made of dark skins and stripes of black plastic, evokes the same meaning. Seven black and red striped horns topping his head emphasise that he has acquired significant mystical powers through the use of evil medicine. The smallish ears highlight his stubbornness and his inability to listen to other people's advice. **Mfiti idagwa n'nyanga** wears a tatter suit, the clothing of a gentleman. Nevertheless, his weapons (a club, a hammer and a knife), the instruments of his crimes, contrast directly with the appearance of an honest person.

In the arena, **Mfiti idafa n'nyanga** swerves his feet energetically then suddenly falls, his legs giving way, as if he has been cut down by a mysterious force. The men sing for him, "*A witch died because of too many horns!*"[1] The song suggests that he has become the victim of his own witchcraft. The medicine that he used for protection and concealment of his crimes has turned against him and killed him. He meets his own fate and encounters the very death he inflicted on others. The Chewa summarises this situation in the following proverb: "*Choipa chitsata mwini – Evil deeds follow their maker.*" Evil done to others comes back on his or her owner.

The character of **Mfiti idafa n'nyanga** is recent in *gule*, appearing around Mua at the end of 2001. The character takes his origin from within Mozambique, prompted by the recent Frelimo-Renamo wars. The mask of the witch was introduced in the neighbourhood of Mua on the occasion of the funeral rite of a senior man who was renowned for his dubious deeds. *Nyau* members knew that he was murdered because of his theft of goats. They took the opportunity of his burial to remind the community of the ancestors' advice and stamp out witchcraft. The appearance of **Mfiti idafa n'nyanga** at the turn of the third millennium emphasises the growing insecurity within the country. Growing incidences of murder and theft had increased suspicions and witchcraft accusations multiplied. Itinerant opportunists are perceived to be moving around the countryside looking for a means to enrich themselves, even through murder. Traditionally, witchcraft was inherited through the female bloodline. A suspected witch was always found amongst one's close relatives. Today it is believed that outsiders such as neighbours or complete strangers can also be a potential witch that may attack you through witchcraft. This growing insecurity in the Chewa village motivates the widespread hope that one day the witches should be punished and eradicated and justice will be done.

[1] "*Mfiti idafa n'nyanga o tate, Mfiti idafa n'nyanga!*"

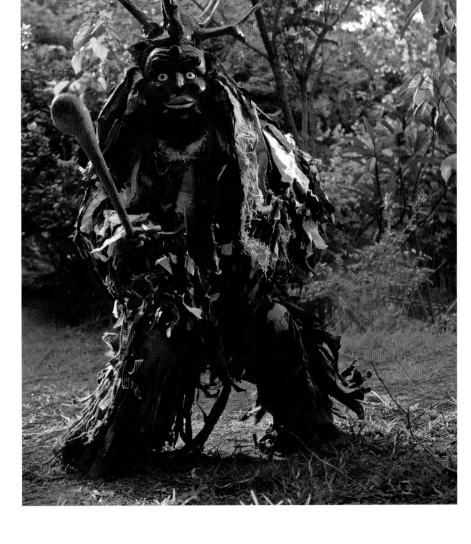

Mfiti ilaula or Tiopa kulaula

(a night or day structure from Mua)

Themes 1) Do not judge others; 2) Discretion in keeping secrets; 3) Discretion in keeping the secrets of *gule*; 4) Modesty; 5) Respect the reputation of others

Etymology Mfiti ilaula means, 'A witch is disclosing itself.' (No witch reveals its own identity.)
Tiopa kulaula means, 'We fear to disclose (what is hidden, reserved to the initiates or grownups).'

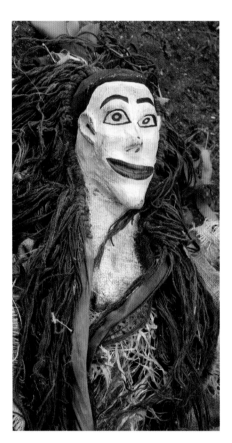

This structure is very ancient in *gule* rituals. It is most commonly performed for funerals, commemorations or *dambule* night vigils. However, the day version is occasionally seen.

Mfiti ilaula consists of a five or six metre tall figure that represents a witch in the form of a giant. In the day version, the body is made of sacks covered with rags. The body has outstretched arms with artificial hands and fingers made of grass wrapped with bark strings (cf. p.18). The night version is very similar except that the body is formed with dry banana leaves while the arms, hands and head are made of grass bundles. A hat covers the head. For the day performance, the head can be carved of wood and painted white. The eyes are small, the mouth a slit and the cheeks protrude. The chin is pointed. The ears are round and project from the head. The headgear is made of long sisal, dyed black, and the neck is disproportionately elon-

gated. The dancer hides himself in the base of the tall construction and operates it with a long bamboo stick. The dancer moves the bamboo up and down, giving the impression that the figure is alive and moving on its own. It goes around the *bwalo* dancing at the rhythm of the *chisamba* while the men sing, *"A witch, a witch has disclosed itself,"* [1] or *"We fear, we fear, to disclose you, oh!"* [2] A third version of the same song is more explicit, *"We fear, we fear to disclose…don't play with children. We fear, we fear to play with children.* (Don't disclose secrets to non-initiates.)"[3] The magic of *gule wamkulu* and the creativity of its members have the power to make an invisible witch appear in public. One of the women's songs expresses, *"Men are* (clever like) *wild animals because they bring* (all sorts of) *wild creatures* (even witches) *from the bush* (into the village)."[4] The song praises the *Nyau* members for their creativity and cleverness at hiding what is secret.

Preparation for the *gule* performance is not to be seen by outsiders or by women. The construction of the structures, the carving of a mask and the dressing of the dancers are to be concealed until the time when everyone comes together and enjoys the performance. If these were to be seen in the open, the magic of *gule* would be gone…no one would believe that the *gule* characters come from the spirit world. The secrecy concerning *gule* is to be equated to that of sex and conjugal relations. The partners' intimacy cannot be exposed in the open. Furthermore, husband and wife may have disagreements during the day but at night they sleep together and renew their union. An adulterer may pretend not to know his partner at the time of the affair but as soon as her pregnancy appears, he is forced to acknowledge his involvement. A person who has been initiated into secret matters at the time of initiation should not reveal them to those who are not initiated for fear of betraying the *mwambo*. Menstruation, pregnancy and childbirth belong to this category of secrets. Confidential matters concerning other people's reputations should not be revealed for fear of betraying their confidence. Any of these disclosures is called '*kulaula*' in the Chewa language and is seen as an insult or

curse. The songs stress that only a witch will dare to expose these matters which must remain secret. Mysteries of life and the adult world should not be exposed in public.

Witches do not respect such realities. They walk about naked and commit the most hideous crimes. Witches show no respect for family ties and the sacredness of blood relationship and kinship. Greed and ambition inspire some people to tap hidden forces for their own selfish purposes and to enhance their power. They transform into witches in the night. Their transformation is not seen but the effects of their evil deeds are felt. They kill and cause misfortune. The only secret they respect is their own identity, that must remain hidden. Witches are mutual enemies of each other during the daytime but, when night comes, they are united out of common interest.

Mfiti ilaula touches upon these various issues. Appearances are deceptive. People may pretend to disagree in the open while in fact they are one (like witches are united by a common ambition). The first message of Mfiti ilaula is one of awareness and caution. One should not hurry to judge a situation. The Chewa proverb says, *"The branches of the Kachere tree are spread out in the sky but its roots are interconnected."* The second message stresses the central values of *gule* teaching. When a young person grows up in life, he/she has to learn the art of keeping secrets. The boys are taught this through the material they collect for the construction of the masks. This training is given to them in order to teach them discretion in social life and, above all, in their future sexual life. It also emphasises modesty and self-respect. Since the Chewa live a communal life in the village, they must keep the sacred duty of protecting other people's reputations and help them to grow to their full stature.

[1] *"Mfiti ilaula tate (2×) mfiti ilaula."*
[2] *"Tiopa kulaula iwe tiope tiope iwe oh tiopa."*
[3] *"Tiopa tiopa sasewera ndi ana, tiopa, tiopa sasewera ndi ana, Tiopa kulaula."*
[4] *"Ana amuna ndi chilombo nyama m'mdondo."*

Mfumu idagwa n'nyanga

(a black day mask from Mua)

Themes 1) A leader cannot rely on medicines; 2) Responsible leadership; 3) Witchcraft; 4) Witchcraft harms the practitioner; 5) Recent politics

Etymology **Mfumu idagwa n'nyanga** means, 'Horns (power) are the downfall of a chief.'

This large black mask portrays a local leader who is featured as a wild animal of unknown species. **Mfumu idagwa n'nyanga**'s fury is evident in the protruding nostrils, large teeth and angry eyes. The mask displays a set of five threatening horns: two short ones erupt from the cheeks, two longer ones stand on the forehead, and a fifth horn, larger than the others and branched, is positioned at the apex of the head. These horns testify that the chief needs to protect and assert his power. The mask shows very small ears as a sign of deafness to the advice of others. The headgear of the mask is made of worn-out fertiliser bags. The dancer wears the *gule* tattered suit. He carries a spear and a long knife. A pouch of medicine is attached to his waist. This means that his authority is based on confrontation (weapons), medicine and witchcraft.

This character was formerly performed exclusively at rituals surrounding funerals and commemorations. The dancer had to keep sexual abstinence before performing. An informant recalls that in 1979, one of the *Nyau* members who used to perform **Mfumu idagwa n'nyanga** was buried with his mask. The new mask was carved to replace the one that was buried but nobody could be found to perform with it and it was sold to another village.

In the *bwalo*, **Mfumu idagwa n'nyanga** swerves his feet for a while and then collapses, reflecting the words of the men's song, *"Horns are the downfall of the chief. Come and see, sister, the chief has collapsed because of his horns."* [1] The song and the mime of the dancer convey that the chief's downfall is embodied in the power of his horns. Horns are traditionally used as containers for storing medicine of all sorts. Such medicines are meant to consolidate one's own power (*kukhwimira*) or to discredit or suppress one's enemy. The chief is suspected to possess such powers. The day before his enthronement he has to encircle the village and the *bwalo* with protective medicine. The day of his coronation he undergoes a ritual bath with medicine meant to protect his own person. The chief is also believed to own medicine that prevents other competitors from usurping his position. If he encounters competition and rivalry, he may store more horns in order to placate his fears and to gain security. The

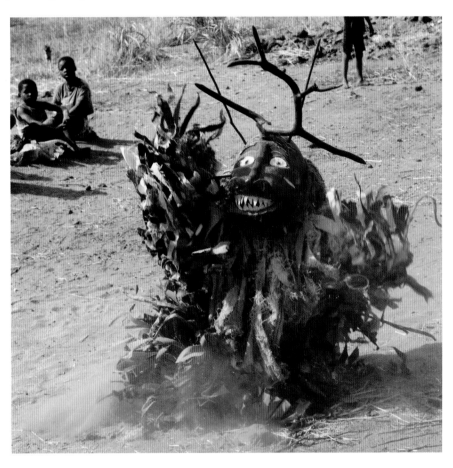

accumulation of too many horns worries the villagers. They think that he may be tempted to bewitch and cast spells on those he considers his potential enemies. These so-called adversaries may own medicines more powerful than his medicine. The clash between 'the horns' of both owners may result in the downfall and death of one, particularly if he failed to keep the instructions prescribed by the medicine man. The medicine may turn against him and kill him.

The use of horns and hidden medicine can also support political leaders at local or national levels. Political enemies and competitors can be dealt with using 'horns' of a different kind. They are more subtle and more adapted to modern times. Among the most popular in Malawi have been bribes, corruption, confiscation of properties, unjust imprisonment, torture, poisoning, car crash, exile and the death penalty. These have replaced the roots and potions prescribed by the medicine man. These also can

turn against those who play evil games bringing about their own downfall. Politicians may believe that their success depends on such tricks. Many generations of Malawians have experienced the ill effects.

Mfumu idagwa n'nyanga teaches that leaders cannot put their trust in medicine alone. They have to count on God's protection and that of the ancestors. They also need the good will of their people. This requires them to work on their relationships and show trust, dedication and humility. Their position depends on their personal qualities of leadership like honesty and dedication to their people. Sometimes people show no sorrow for the death of their chief, particularly if he was cruel, quarrelsome and haughty. They look at his death as deliverance for them and as poetic justice in owning too many horns.

[1] *"Mfumu idagwa n'nyanga o tate dzaoneni chemwali Mfumu idagwa n'nyanga!"*

Simbazako

(a red day mask or structure from the Ntchisi and Mua areas)

Themes 1) Witchcraft; 2) Purification; 3) Support for traditional medicine & *sing'angas*

Etymology **Simbazako** means, 'State your own case.'

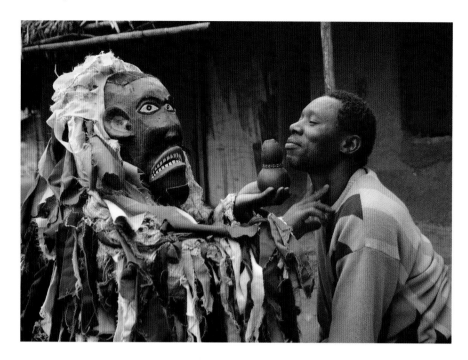

Simbazako portrays a well-known medicine man and diviner (*sing'anga*) of that name of the central region of Malawi in the 1970s and 1980s. He is remembered in the anti-witchcraft movements that have characterised Malawi since the traditional *mwabvi* ordeal was banned by the colonial government. The character **Simbazako** takes two forms – a large structure and a mask.

The three metre structure from the Ntchisi area consists of an inverted two metre wide basket forming the skirt of the character. The skirt is woven with maize husks giving texture. The figure, made of grass or fibres, is mounted at the centre of the skirt. It is in the shape of a human being but the head is more like that of a wild animal with protruding teeth, typical of a witch. **Simbazako** dances at funerals. It enters the dancing arena spinning and moves quickly to the audience where it simulates detecting witches, 'making cuts' in their bodies in order to deter them from practising witchcraft. The bulky skirt supporting the character of the diviner is said to represent a huge rock under which there is a large cave full of witches. Through his power and his control, **Simbazako** has locked up the witches in the cave. The song sung for this character states these powers:

*"Here comes **Simbazako**, let the one* (the witch) *who owns horns* (evil medicines) *get rid of them! Here comes **Simbazako**."* [1]

The **Simbazako** of Mua was inspired by that of Ntchisi but here the character is portrayed by a large red mask. The song sung is the same as that for the Ntchisi structure. The mask has big eyes like those of a seer and a strong mouth filled with teeth to show he is confident in his powers. His face is covered with a multitude of tattoos and scarifications to suggest that his powerful medicine has already been put to the test. As **Simbazako** appears in the arena, he carries a gourd (*nsupa*) filled with medicine and a razor blade for making incisions on those whom he has identified as witches. As he dances, he moves directly into the audience and simulates making cuts on the people with his razor and inserting medicine. The *sing'anga* **Simbazako** of the 1970s and 1980s made incisions on the nose, forehead and chin of his patients to demonstrate that he had overpowered the witches from all directions. He made cuts on the edge of their face to prove that his power wards off any spell. Then he burned the horns and instructed them that the medicine he had put in the cuts would kill them if they resumed their witchcraft activities.

The **Simbazako** of both Ntchisi and Mua demonstrates the strong belief the Chewa have with regard to witchcraft and its evil effects. These characters express the need the Chewa have for purification and protection against evil. They also seek to deter people from practising witchcraft.

[1] *"Wafika **Simbazako** (2×). Ali ndi nyanga ataye, atyire (2×) wafika **Simbazako**."*

Tiopa wa nyanga

(a red day mask from the Mua area)

Themes 1) Witchcraft; 2) Witchcraft to maintain/enhance one's position (*kukhwima*); 3) Link between witchcraft & old age

Etymology **Tiopa wa nyanga** means, 'We fear the one with horns (evil medicine).'

The red, oval but slender mask, with semi-human features, portrays a witch. It shows a narrow forehead with wrinkles, wide eyes with red pupils, round cheeks, pointed ears and an elongated nose. The mouth is slightly crooked to display small sharp teeth on the bottom jaw that reflect a taste for human flesh. The red face is surrounded with an edge of black, to portray that the person is losing his humanity and becoming an outcast. The headgear attached to the mask is made of Samango monkey skins and expresses that the person now belongs to the bush, the world of evil. Four thin horns (30-70 centimetres long) protrude from below the eyes and a longer fifth one (of a metre) sits on the forehead. The exceptional length of these horns and their colour (yellow, black and white) portray witchcraft exacerbated by advanced age (*kukhwima*). The dancer wears the usual tatter suit of *gule*. He carries a club and a long sharp knife or axe to threaten his audience and show his antisocial character.

As **Tiopa wa nyanga** enters the *bwalo,* he swerves his feet with agility and vigour. He then aggressively chases the women with his fearsome weapons. The men express the community's general feeling in the following song: *"We fear the one with horns. We fear you, oh yes, you who have horns. We fear the one with horns. We fear the one with horns."* [1]

The character was created in the Mua region at the end of the 1940s. One of Chief Mlongoti's assistants, Mr Akafa Sabwerera, was suspected of having become a witch owing to his ambiguous and selfish behaviour. He lived alone. His neighbours had moved their houses away from his. No one wanted to live near him because he displayed too much drive to control and rule the villagers. By creating this new character, **Tiopa wa nyanga**, his ambition was curbed.

It is common among the Chewa that people who grow old in a position of authority are suspected of using hidden medicine in order to increase their control over the community. A person believed to own such powers is feared and avoided. The red colour of the mask emphasises that the person who misuses medicine (horns) to enhance his own power becomes an outcast. That person is feared because of his ambition for absolute control. His neighbours fear to lose their freedom and even their lives. The elongation of the face and the mouth characterises the witch for the Chewa. It shows how greed cripples and selfishness pushes a person to be ugly towards others. **Tiopa wa nyanga** warns the villagers that such a person is not fit to live in the village and share the company and friendship of others. He cannot be a full member of the community.

[1] "*Tiopa wa nyanga ede tate, tiopa iwe, tiopa iwe eye Tiopa wa nyanga.*"

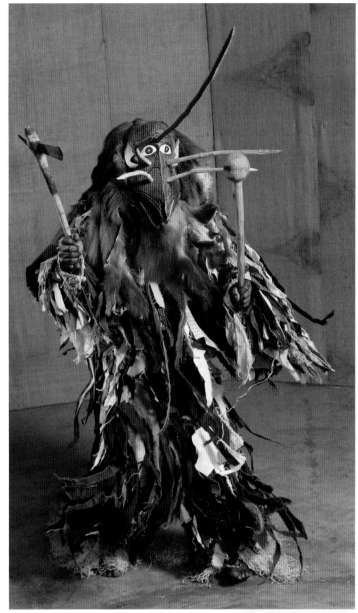

Tondolo

(a brown day mask from the Msinja and the Mitundu areas)

Themes 1) Witchcraft; 2) Jealousy/envy; 3) High mortality; 4) Responsibility of family heads

Etymology Tondolo refers to an unknown animal, possibly a mythical figure. The mask resembles a bush pig.

The brown mask portrays a stylised anteater. **Tondolo** has a long snout, protruding teeth on the bottom jaw and sadistic smile. There are black protrusions on the cheeks, large nostrils and sinister red pupils in the white eyes. The ears are those of an animal and stand erect. A small goatee made of black fur highlights the chin and reveals him to be a senior man, head of a family group. Tribal marks show the character to be Chewa. Two long, slender and

curved red horns extend from near the base of the nostrils. One horn is tipped white; one tipped black. The opposing colours reflect that while others are in sorrow, he is laughing. The red horns, red eyes and black warts reveal the person to be a witch, a user of evil medicines. The mask's headgear is made entirely of baobab bark strips. The dancer wears a tatter suit. He carries a long knife or a whip, and a gourd of medicine is attached to his waist. **Tondolo** performs for

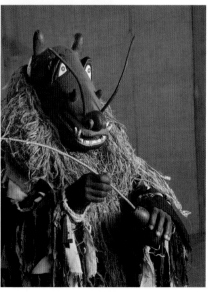

funeral rites. As he enters the arena, **Tondolo** whirls at tremendous speed. While he gyrates, he does not swerve his feet. But when his dance reaches its climax, he unties his divining gourd and stirs the medicine inside the gourd with his whip. He pulls out the whip with medicine and points it in the direction of the women, as if to divine a guilty party. During this time, the men sing for him, *"Why does he kill children? This child has been murdered by this beast! If you want to know about the lot of this child, ask* **Tondolo**. *This is what he does!* **Tondolo**, *you are guilty!"* [1]

The song portrays **Tondolo** as the family head who, as is typical in the Chewa setup, is accused of having killed children in his family by witchcraft. The infant mortality rate is high among the Chewa. This requires a simple explanation. As a rule, child mortality is attributed to jealous family members, suspected of using witchcraft to hurt their family or their neighbours through the death of their children. Poverty, disease, the lack of hygiene and malnutrition are easily overlooked as the plausible cause of death. Instead, the cause is found in the failure of social relationships and the social inequalities within the community. People who own more and have more ambition are often made the scapegoats for such misfortunes. **Tondolo** is simultaneously both the suspected witch and the teacher who admonishes against witchcraft. He wants to deter the villagers from the practice of witchcraft and from the vice of jealousy. The traditional morality of the ancestors emphasises cohesion within the Chewa community and is ill equipped to provide an explanation for the high mortality rate of children. Jealousy is seen as a root cause of misfortunes and a supreme personification of evil.

[1] *"Chapananji mwana tate de, mwanayu tate de chapha ndi chomwechi tate mwanayo tate koma n'a* **Tondolo** *a e ae a* **Tondolo** *ede zomwe achita tate. Mwapalamula!"*

Tsoka wa nyanga

(a black day mask from the Mua area)

Themes 1) Witchcraft; 2) *Mwabvi* ordeal; 3) Unity & harmony

Etymology **Tsoka wa nyanga** means, 'A curse to the one who uses horns (evil medicines).'

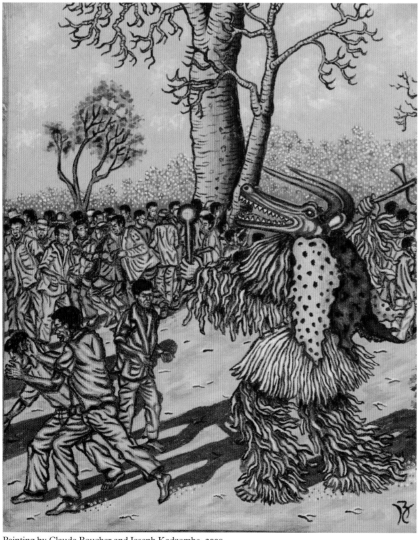

Painting by Claude Boucher and Joseph Kadzombe, 2009

The 40 centimetre black mask imitates a crocodile head with a long snout and protruding sharp teeth on both jaws. The fiery red eyes suggest witchcraft and contrast with the black of the mask that conveys the deeds of darkness performed during the night. Two standing ears are made of skins. The crocodile head has prominent black 60 centimetre long curved horns that point forward. The orientation of the horns differs from those of Chimbano. With this mask they are orientated towards an enemy or a competitor. The headgear is made of a combination of material: jute, tatters and wild animal skins. Despite his frightening head, the character of **Tsoka wa nyanga** dresses in a respectable tatter suit. He carries weapons like an axe, a club or a whip. The display of weaponry suggests that he is a threat to the family group.

Tsoka wa nyanga's dancing style in the arena resembles that of Chimbano but demonstrates more aggression. After swerving his feet with a triple kick, he chases the audience with his weapons and scatters them. The men introduce him with the following words: *"A curse to the one who uses horns* (evil medicines)."[1] The character of **Tsoka wa nyanga** dates from the beginning of the 1990s and is seen occasionally near the southern end of Lake Malawi. **Tsoka wa nyanga** used to play an important role at funerals to provide the mourners with an explanation concerning the cause of death. In the past, if the head of the family group (*malume*) became suspicious about the frequency of deaths within his family group or was puzzled by the sudden deaths of younger people, he would address

the mourners during the funeral and request that a senior woman call for a *sing'anga*. This would be a diviner of reputation, well versed in the *mwabvi* ordeal ceremony. The *mwabvi* ordeal was a test by poison made from the *mwabvi* tree. A witch would die from taking the potent mix while an innocent person would vomit and survive. The British colonial government in the 1930s banned the application of this supreme test but people still went to Portuguese territory to seek help in this regard.

Tsoka wa nyanga reinforces the traditional explanation of causality and attributes certain types of death to witchcraft. Close relatives from the same bloodline are held responsible for such deaths. **Tsoka wa nyanga** deters the village from practising witchcraft and using evil medicine. It further stresses the importance of living in harmony and resolving conflicts within the family group or in front of the chief, before they grow out of proportion and make people wish each other's death.

[1] "*Tsoka wa nyanga tate Tsoka wa nyanga!*"

Walanda minda

(a pink day mask from Mua area)

Themes 1) Evil reaps its just desserts (*choipa chitsata mwini*); 2) Witchcraft; 3) Greed; 4) Justice prevails

Etymology **Walanda minda** means, 'They have confiscated the fields' (referring to those responsible for the irrigation schemes).

The pink mask portrays a European, imitating his hair, whiskers and sideburns all made of baboon fur. He has pale features and a long narrow nose. **Walanda minda** wears a clean shirt and jute trousers covered with rags. The dancer carries in his hand a briefcase ostensibly full of kwacha notes.

While dancing, he holds a medicine tail in his right hand and a handkerchief in the left. He waves them alternately to show off his power. He dances with great energy in order to demonstrate that he is his own master and behaves like a *bwana*. This is emphasised by the way he enters and exits the arena. He never goes to the dressing room (*liunde*) but comes straight from the *dambwe*. As he approaches, the men sing the following song: "*Those who have confiscated the fields are the Europeans from the irrigation scheme. The one* (the witch) *who has killed his brother* (in order to steal his land) *is not going to enjoy the fruit of his crime. They* (the Europeans) *have confiscated the fields.*" [1]

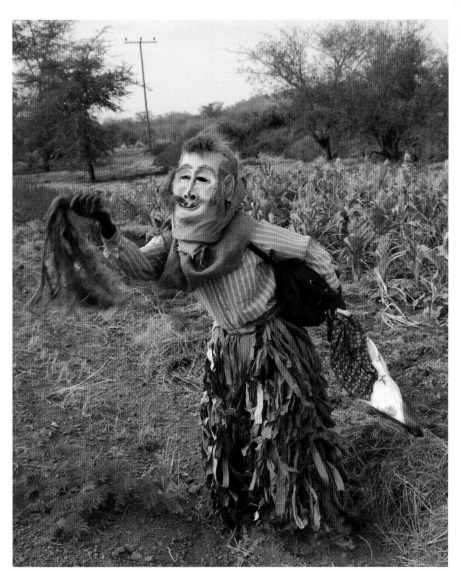

This very recent character (1999) focuses on a new development in the Mua region, an irrigation scheme for growing rice. This scheme began construction in 1997 as a venture of KIER Ltd., a consortium of a British company and a Japanese firm. A dam, irrigation channels and roads were constructed. In order for the project to advance, the British engineers had to confiscate land and give compensation to the land holders. The local people interpreted that the few Europeans in charge of the construction programme had been sent by the spirit world to render justice to those who had earlier acquired these fields unjustly. The song discusses the issue of field ownership. Land had been acquired contrary to Chewa traditional morality, using the secret means of witchcraft.

The character of **Walanda minda** brings the message that traditional morality will triumph over evildoers. "*Choipa chitsata mwini – Evil follows its owner.*" This is the way the Chewa read misfortune. The ancestors have the duty to bring punishment on evildoers. In this case justice is brought through European agents as the instruments of the ancestors who ensure that the *mwambo* prevails and evildoers are punished.

[1] "*Walanda minda azungu a sikimu! Amene adapha mbale wake adaluza e (2×) Walanda minda.*"

7. Personal attributes

Scattered throughout the thematic coverage of *gule wamkulu* are references to the diversity of human traits and behaviours. These may have broader community implications but are also levelled at the individual, both male and female, in advising on what types of behaviour are appropriate and what types are not. The advice of the ancestors is conservative and much as one would expect to hear in any stable, peaceful community where the good of the whole takes precedence over the rights of the individual.

Do not be greedy (**Pombo kuwale**[1], **Walanda minda**[2]). Do not be arrogant or prideful (**Chiwau**[3], **Gomani**[4], **India** and the **Mmwenye**'s, **Ndalama n'ndolo**, **Simoni**[5]). Be honest and do not steal (**Dzimwe, Kanyani, Maloko, Salemera, Woipa sakwiya**[6]). Do not lie or gossip (**Chikwangwala, Nkhuzinkhuzi**). Do not envy or be jealous of others (**Chimnambe, Mfumu yalimbira**[7], **Tondolo**[8]). Do not be two-faced or a hypocrite (**Chipolowe**[9], **Kapirikoni**[10], **Mbaula**[11]). Be peaceable, not aggressive or angry (**Chinsinga, Galu wapenga**[12]), and avoid drugs that may change your character for the worse (**Am'na a chamba**). Show generosity and hospitality and do not be selfish (**Akulu akulu adapita**[13], **Kachigayo, Kanyoni** of Dedza, the **Mtchonas**[14], **Njovu yalema, Pali nsabwe**). Display determination in life, work hard and do not be lazy or a para-

site on the community (**Bongololo, Chakhumbira, Chaseka** and **Mai Chaseka, Kachigayo, Msakambewa**). Do not be prejudiced or too quick to judge others by their appearances (**Chiipira achabe, Salemera**). Consider your actions carefully and do not make hasty, ill judged decisions (**Golozera**). Be modest and respectful of others (**Akutepa**). We hear how self-pity should be avoided (**Akumanda samalira** of Dedza). Everyone must come to terms with their age and physical abilities, and in achieving old age, should be shown support by the members of their family (**Abwerako, Kamatuwa**).

There are characters who advise on exercising care in dealing with others, especially those whom you do not know well (**Nkhwali**). There are some individuals who are so poisonous, archetypes of bad company, that they should be avoided at all costs (**Kamvuluvulu, Ndakuyawa**).

In keeping with Chewa pedagogy, the desirable attributes for a human being are commonly depicted via individuals who personify their antithesis. There are exceptions. **Greya** of Mua and **Sirire**[15] are role models for modern husbands, and **Chadzunda**[16] and **Mariya**[17] for the perfect married couple.

Personal attributes are considered across all of the other major themes. For example,

promiscuity and sexual indiscretions are discussed under Sexuality, fertility and marriage, and the desire for and exploitation of power, under Community, authority and the ancestors. The list of positive and negative traits on which advice is proffered is almost infinite. The selection included by Boucher in this publication merely gives a taste of the range of attributes and of the *gule wamkulu* advocacy for manifesting community-based values in one's behaviour. Given the chequered history of *gule wamkulu* and Western authorities in Malawi, it is interesting to observe so many parallels with moral and behavioural paradigms that we would regard as staple to Judaeo-Christian and Muslim societies.

[1] Community, authority & the ancestors
[2] Witchcraft & medicines
[3] Sexuality, fertility & marriage
[4] History & politics
[5] History & politics
[6] Health, food & death
[7] Community, authority & the ancestors
[8] Witchcraft & medicines
[9] History & politics
[10] History & politics
[11] Witchcraft & medicines
[12] Sexuality, fertility & marriage
[13] Community, authority & the ancestors
[14] Community, authority & the ancestors
[15] Sexuality, fertility & marriage
[16] Community, authority & the ancestors
[17] Community, authority & the ancestors

Abwerako

(a red day mask from the Kaphuka and Dedza areas)

Themes 1) No children in old age; 2) Generation gap in marriage; 3) Old age/ageing gracefully

Etymology **Abwerako** means, 'He is back,' or 'He is coming.' It is suggesting, 'He is back (empty-handed).'

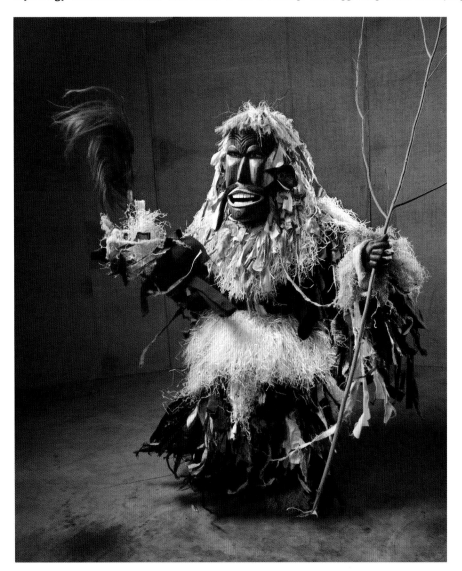

The red mask portrays an elderly man with a shiny bald head, wrinkles, side burns and long moustache. His nose is straight, the eyes set deep in the sockets giving the impression of blindness. His ears are disproportionately large to emphasise deafness. His mouth carries a naïve smile. He has a long tuft of white hair made of sisal falling on the forehead that shows he is too old to produce children. The red colour of the mask emphasises that he has become an outcast as a result of too many marriages. He wears the *gule* tatter suit. He carries a medicine tail to express his senior status and a whip to stress his disciplinary role.

Abwerako dances as if still young and full of energy but this is a ruse to disguise his decrepitude. The women in the arena tease him with the following song voicing the complaint of his new wife: *"He is back, my husband* (the old man), *let us see what he has come back with after having been away for so long. Abwerako, oh, oh. Why is this man always scolding me and still wants to be married to a young girl like me? Why do you scold me, old man? He is just back, Abwerako, empty-handed. He keeps saying, The baby is coming, The baby is coming, oh oh oh."*[1] The men's song voices the parents'-in-law grievance: *"He came back empty-handed Abwerako. I know myself ... without anything. Abwerako, he came back from his seventh wife, my friends. This dear brother of ours, he has come back from his last young wife*

with empty hands (without pregnancy). *He remains idle, Abwerako, without any pregnancy.* (The wife says:) *I've had enough* (of his false promise), (A baby) *is coming, is coming, oh, oh."*[2]

The character portrays an old man who feigns youth but has had up to seven wives. His last wife was a young girl who complained bitterly that because of his advanced age he could not perform in bed. He cheated her by claiming that he wanted a family but he brought nothing for the household. He stayed with her for some time but there was no pregnancy. He keeps saying, 'The baby is on the way,' but of course there is none. His wife and her family reject him and send him back to his own village where his own sisters receive him reluctantly. **Abwerako** envies the young men who can marry young girls but he is too old to produce children, leaving his wives and in-laws disappointed and angry. As a husband, he never provides the necessary items for the household but nevertheless keeps trying his chances to find a wife who would be a mother, caring for him. Each consecutive marriage ends in failure.

The character warns elderly men that they should accept their age and its limitations. They should not play the young rooster who keeps marrying younger women. They know that they cannot give them children. They leave with the words, 'I will be back,' but they never show up again because they are escaping the shame of being childless or of having quarrels with the family in which they marry, with false promises of a baby on the way. Back in their own village, they become a burden to their own sisters. The character of **Abwerako** teaches old people to come to terms with the reality of their own age, and to settle down with a companion of the same age in order to discover love beyond sex. May they grow old and happy together!

[1] *"Abwerako wamunawa, tione zomwe abwera nazo, kutchona konse kuja, Abwerako oh oh. Abambo awa asambukirenji ine, nanga kumafuniranji namwali chotere, muti musambuke andala, angobwerera Abwerako, kopanda m'kaundeunde m'manja. Angoti bwerako bwerako, oh oh oh."*
[2] *"Anabwera chabe Abwerako, akudziwa ndine n'chabe yerere, Abwerako. Abwerako akazi asanu ndi awiri, anzanganu. Achimwenewa kwa namwali kumene angobweraki wopanda kanchito de, de. Angokhala Abwerako. Chabe! Toto ine, bwerako, bwerako, oh oh."*

Akumanda samalira

(a red day mask from the Dedza area)

Themes 1) Immaturity; 2) Responsibility for one's own actions/life; 3) Laziness; 4) Orphans; 5) To blame the dead

Etymology Akumanda samalira means, 'Those from the grave (the dead) do not complain.'

The red mask portrays a Chewa (with tribal marks) who is an orphan. He has never accepted the death of his parents and blames his lot on their departure. Red emphasises his bitterness and immaturity. **Akumanda samalira** is an old man, bald-headed, long sideburns, slender moustache and elongated grey goatee, but he behaves like a child. His parents have died years ago, but his eyes are still mournful and his mouth, with missing teeth, grimaces. He objects to their death and blames them for his failure and poverty. The headgear of his mask, made of white tatters, evokes their departure. His ears are tiny to emphasise his own deafness to sound advice from others. **Akumanda samalira** wears the clothes of an orphan: a sleeveless shirt stitched with tatters and white sisal kilt. His outfit, which is completed with leglets and armlets, manifests that his economic standing has declined since the death of his parents.

Akumanda samalira takes part in any type of *gule* ritual, but his presence is particularly required for funerals and commemoration rites. As he moves to the arena, he shakes his head to convey that he does not accept his parents' death. He swerves only

one leg and then, out of frustration, chases the audience. He pursues the women to take possession of their *chitenjes*. He is too lazy to support himself; he prefers to take advantage of others. The male choir highlight this in their song: *"The dead do not complain! They have gone by. As I told you, they left me* (orphan)*! They left all of us! The dead have gone by! What is the profit to complain or criticise the dead! When they go by! The dead went by!"*[1] Though **Akumanda samalira** is an elderly man, he plays on the fact that he is an orphan. He blames his poverty on his parents' exit to the spirit world. He fails to imitate the dead who do not complain. **Akumanda samalira** does not stop complaining and blaming his dead parents for his misfortune. He tries to attract the pity of his relatives and neighbours. He is too lazy to support himself. He prefers to take refuge in the past and shows bitterness about anything and everything. Through **Akumanda samalira**, the ancestors wrestle with the immaturity of a grown-up who remains a child all his life. He prefers to be an orphan, bitter and idle and wallowing in self-pity, than to look after his own needs and take responsibility for his own life.

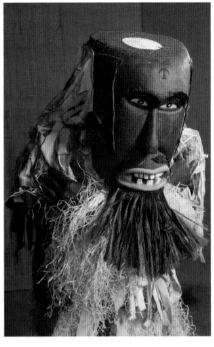

[1] "*Akumanda samalira de, Akumanda adanka kale (2×) adanka kale, paja adasiya ine, ndipo adasiya tonse. Akumanda adanka kale. Kukumba, sakumba maliro aye akapita sabwera. Akumanda adanka kale.*"

Akutepa

(a day or night structure from the Mua area)

Themes 1) Respect for/wisdom from the elders; 2) Discipline & good behaviour; 3) Avoidance of an early (illegitimate) pregnancy

Etymology Akutepa means, 'the one who is flexible and slim', suggesting the idea of swaying from side to side and of bending like a stem of bamboo.

The structure, three metres in height, represents a very tall and narrow-waisted woman in a full-length skirt that touches the ground. The bamboo construction is wide enough to allow a single standing dancer to articulate its movement. The top part (above the dancer's head) is made of a flexible bamboo frame that features the bust, the arms and the head that sway from side to side and bend forward and backward. For the night performance, the skirt is made of palm leaves woven in a zigzag pattern. For the day, a *chitenje* cloth is stretched over the bamboo frame to hide the dancer inside. The bust is made of grass and is dressed with a blouse. The arms are out-stretched,

displaying fingers also made of grass and coiled with bark string. The head is either the mask of Chabwera (surrounded with guinea fowl feathers) or that of Kapoli (made with chicken feathers – *chiputula*). It is topped with a white miner's helmet or a woven hat made of dried palm leaves.

The structure is danced by a senior man and enters the *bwalo* with dignity and solemnity. It rotates gently and bows politely to the crowd. It takes a few steps forward and backward, swaying from side to side, and bows again before continuing its journey across the arena. It repeats the movements following the rhythm of the *chisamba*. Bending and bowing express

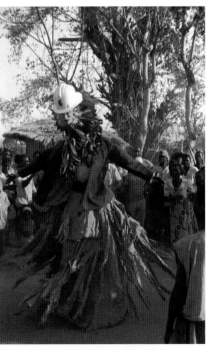

Claude Boucher, Msolo Village, September 1993

good manners and politeness, teaching that a young woman should kneel before the elders.

The structure of **Akutepa** is ancient and is usually performed on the occasion of funerals, *dambule* and initiation rites. The dancing steps of **Akutepa** suggest that she is an exemplary girl, well taught by her family. Her palm hat or white helmet symbolises the initiation cap (*ntheko*), showing that she has reached puberty. The songs of **Akutepa** emphasise another important aspect of her character, *"This is **Akutepa** who is so slim in the middle that she is at the point of breaking. This is **Akutepa**, the one who is flexible and slim"* (meaning, the one who is polite and well behaved).[1]

A second version of the same song runs,

*"**Akutepa**, **Akutepa**, look at **Akutepa**, the slim one, like a long feather of the nightjar."* [2] This allusion to the night jar is interesting. In the puberty rites, the initiate is identified with this bird and is taught to conceal her condition when menstruating, like the bird conceals its nest. The play on words in the song suggests that the initiate has been well taught and practises the Chewa rules of politeness. The song also stresses that the girl is slim at the waist. This means that she is well behaved and has gone through puberty without pregnancy. She has spared her parents the shame of undergoing the *chimbwinda* initiation reserved as a punishment for those who become pregnant before undergoing the puberty rites. The teaching of **Akutepa** stresses the duty of

the extended family in the education of the children, especially girls. They must instil in them respect for their parents and elders. They must teach them from an early age (*kukula ndi mwambo*) good manners, the customs of the tribe and the rule of morality with regard to sexuality. Delay in these teachings may result in shame when their daughters accidentally become pregnant before the solemn puberty rites. **Akutepa** praises exemplary children and parents who follow the teachings of the ancestors.

[1] *"Akutepa Akutepa e, suyu Akutepa: pakati pang'onong'onopa, pachita kufuna kuduka, suyu Akutepa tepa."*
[2] *"Akutepa Akutepa e, suyu Akutepa: pakati pang'onong'ono ngati nzimbi wa lumbe, Akutepa."*

Am'na a chamba

(a red day mask from the Mua area)

Themes 1) Drug addiction; 2) Laziness; 3) Responsible parenthood

Etymology **Am'na a chamba** means, 'the husband who smokes hemp (marijuana)'.

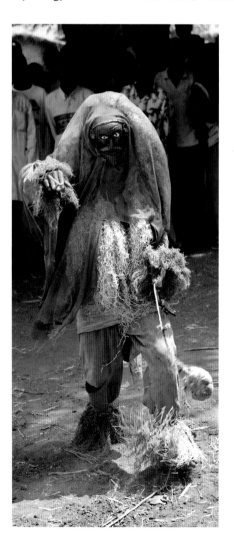

The small 25 centimetre mask in red represents an outsider to the village, namely the husband who marries into his wife's family. The colour not only represents his foreign origin but also his undesirable and disruptive behaviour. The features are those of a young, stupid man with a large forehead with brow ridge overhanging the entire face. The nose is long, straight and narrow, suggesting that of a European. The eyes are made of silver paper and appear glazed, as if the person is blind or doped. The naïve smile and a narrow slit of the mouth are not wide enough to show the teeth, suggesting selfishness and meanness. A cigarette protrudes from the mouth. The chin is strong and angular, accentuating his look of stupidity. The face is narrow and emaciated, the cheeks prominent, and the ears are too small to hear. The rag headgear of the mask is covered with mosquito-netting, resembling a bride's veil. This veil emphasises the fact that he married into his wife's family. The dancer wears the usual tattered outfit of *gule*, a shirt and a pair of trousers made of jute covered with rags. On top of his costume he adds a kilt, armlets and leglets of fertiliser bag laces. He carries a club, a stick or a whip. At times he brings a football and plays like a child. In the arena, **Am'na a chamba** acts insanely. He swerves his feet with exhausting vigour, jumping and changing direction. He moves his arms and his feet in an uncoordinated way. He stops and glares at people, as if wanting to provoke a fight. Then he frantically chases

the women, who disperse in all directions. The cigarette is held firmly in his mouth throughout this frenetic activity. While he is busy entertaining the crowd, the men sing, *"This is the one! This is the one, the husband who smokes hemp. This is the one, the husband who smokes hemp. We will not sleep, there will be havoc* (because of) *the husband who smokes hemp."* [1] The Golomoti version adds, *"A cigarette, a cigarette, let the one who has tobacco give me a cigarette, you, the husband who smokes hemp. Go and cry to your mother."* [2]

This hemp (*chamba*) smoking character is commonly found at any type of ceremony. It is difficult to know when he was introduced in the dance. Elders testify he has been part of *gule* for well over 40 years. The character deters young men from smoking hemp or marijuana. It is seen as a harmful, nasty habit for young people who intend to look after a family. A person addicted to hemp is unable to work and support a family. It is a disaster for the rural Chewa, who live by subsistence farming. If a man cannot till the soil, he cannot feed a family or himself. Worse, a person who is under the effect of *chamba* develops an enhanced appetite and wants to eat frequently. Moreover, his laziness does not encourage him to store food. He eats the little *ndiwo* (relish) that his wife has prepared, depriving their children. His wife complains about his irresponsible behaviour. Then he becomes aggressive and bad tempered, beating his wife. **Am'na a**

chamba's wife feels ashamed of her useless husband in front of her own children and neighbours. She pities herself and she regrets having married him and bemoans her children who must suffer because of him. She fears that he may completely lose

any self-control. The members of *gule wamkulu* created the character of **Am'na a chamba** to curtail the spread of hemp smoking among the youth and to warn husbands of its serious consequences in life and marriage.

[1] *"Ndiwo ndiwo (2×)* **Am'na a chamba**, *sitigona kuli gule tate de* **Am'na a chamba***."*
[2] *"Ndudu, ndudu, amene ali ndi fodya andigawire tatede,* **Am'na a chamba** *ha kauze amako."*

Bongololo

(a black day mask from Chiphazi Village, Dedza)

Themes 1) Laziness; 2) Living off other people (community parasite); 3) Promiscuity; 4) Irresponsibility in marriage

Etymology Bongololo is a millipede.

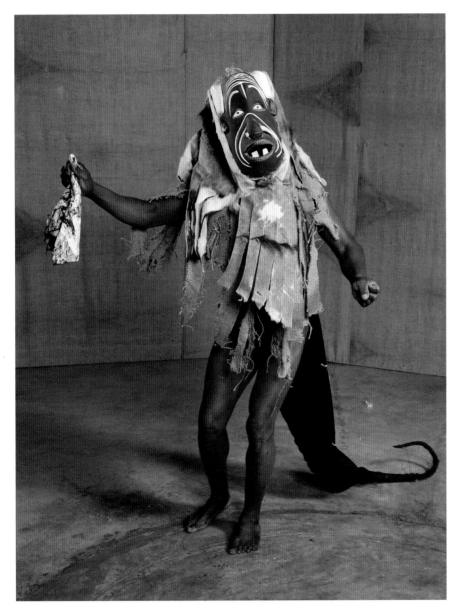

wears a black loincloth with an attached tail two metres long, terminating in a hook, which leaves a mark on the ground like the trail of a millipede. He rotates his hips and pelvis in a sexy manner. Then he jumps at the crowd, wiping foreheads with a filthy handkerchief, dirtying them. The men sing for him, *"Bongololo, where was he during the rainy season?"*[1] The millipede disappears under the ground during the dry season and only reappears after the rains, when the vegetation is abundant and there is plenty to eat. A second song says, *"The millipede needs to move about,"*[2] meaning that he is lazy.

Bongololo portrays a lazy individual who is always absent at the time of funerals, depriving the community of his assistance. However he makes it his duty to attend every commemoration ceremony, where there is plenty of food. He wants to profit at the expense of others. The suggestive behaviour of **Bongololo** implies the same attitude towards fathering children. He makes plenty of them but he is too lazy to care for them. He is promiscuous but leaves no trace behind (the hook). He pretends that he is genuinely in love and intends to marry the women he lures. In the end he abandons them, pregnant and helpless (indicated by the filthy handkerchief that dirties instead of cleans). He disappears 'underground'. The women are left to struggle alone with children. After many years, when things are fine and the children are grown up and settled, he reappears to claim the children as his own and to show pride in the offspring he has never cared for. Then people ask him, **Bongololo**, where were you during the rainy season? Where were you, during the period the mother was struggling alone helplessly? You come to claim what you have not earned, **Bongololo**.

[1] *"O o o, kodi anali kuti nthawi ya dzinja,* **Bongololo***?"*
[2] *"***Bongololo** *ayenera kuyenda."*

This black mask portrays an old man with a bald head rimmed with white hair. His headgear is made of light goatskin that reaches down his neck. His forehead and the jaw are covered with drooping wrinkles and his eyes are dull. His heavy nose is

pierced with a white nose plug. His mouth is that of a lazy person yawning and it reveals only two teeth on his bottom jaw. His ears are nearly non-existent since he is deaf. This mask is only danced at commemoration rites after burial. The dancer

Chakhumbira

(a red day mask from the Dedza area)

Themes 1) Laziness; 2) Lack of ambition; 3) Responsible parenthood

Etymology **Chakhumbira** means, 'He keeps envying.'

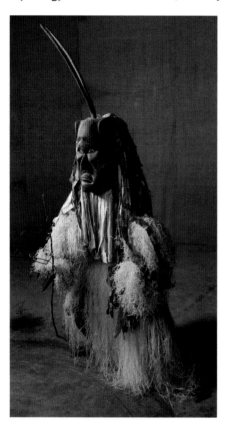

This large mask has a double horn on the top of the head. On one side, the horn is red and pointed. On the other side, it is black and blunt. The face is that of an old man with heavy nose, small red eyes and two thick black warts protruding below his eyes. He is bald with a small black moustache and a big mouth with heavy lips, conveying an expression of surprise at the irony of his name. His costume comprises a long sloppy kilt made of rags and dirty leglets and armlets. He holds a whip. **Chakhumbira** performs at funerals and commemoration rites. He roams around the *bwalo* and dances in a lazy manner, with little energy. The men sing about him, from his wife's perspective, *"Yes, always happy at commemorations but never there at funerals, **Chakhumbira** – he keeps envying – (that is his name) – never envies. If I had envy – I, a poor woman – I would have wealth to divorce him. I am fed up envying my neighbours, **Chakhumbira! Chakhumbira!"**[1]

Chakhumbira's wife complains in the song that her husband is lazy and does not want to work. He lacks ambition and does not envy anyone or anything. He wanders the village without purpose. At home, they live in a shack with no kitchen, shower or latrine. He is good only for eating and producing children. She complains that she has to feed this grown man who does not work or think of her and her children. She envies her neighbours who are married to diligent husbands, who provide for their wives and children. They live in good houses and have a granary of their own. If she were not so poor, she would have found some money for a divorce. To add to this, she is pregnant. He forces himself on her twice a day – this is the meaning of the two warts below his eyes. He knows how to produce but not care for his children – this is the meaning of the double horn at the apex of his head. He is even too lazy to be promiscuous. The spirit of the ancestors supports the case of **Chakhumbira**'s wife and condemns his irresponsible behaviour.

[1] *"Inde tate de, tsangala ku m'meto ku maliro osapita eye a **Chakhumbira**. Kukhumbira, khumbira dee chikhumbukhumbu, kukhumbira adanka uko ena tate a **Chakhumbira**. Mkanakukhumbira. Ndasowa ine, ndakakhala n'chuma, ndakawatula kwa eniake ye dee. Ndatopa ndine kukhumbira kwa anzanga a **Chakhumbira**, a **Chakhumbira**."*

Chaseka and Mai Chaseka

(red day masks from the Dedza area)

Themes 1) Greed (*kudyera*); 2) Living off other people (community parasite); 3) Lack of community spirit; 4) Responsible leadership

Etymology **Chaseka** means, 'he who laughs'.

The two masks dance as a pair and their details highlight that they are a couple. Their main shared feature is a gaping mouth bristling with sharp triangular teeth symbolising laughter and eating. The eyes are wicked, the nose is hideous, and the ears are small and deformed, to express deafness to others. The masks are red to stress the ambivalence of their behaviour. The nose and the mouth are surrounded with black, to emphasise their interest in feasting. Two white wing-like protrusions from the top of the head, with black and red spots, represent funeral gear. They have black-dyed sisal wigs. The dancers wear the characteristic tatter suit of *gule* and carry medicine tails showing their important status. They perform at funerals and shaving ceremonies. They like to dance at the very place

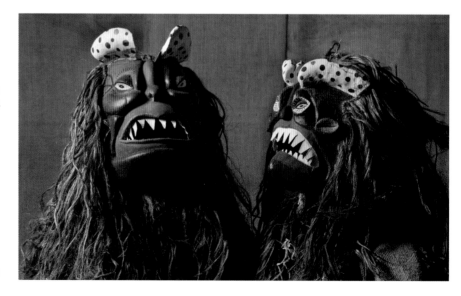

where the food is cooked. They swerve their feet and jump with joy, holding the leftovers of food in their hands. The men sing, *"He has come, **Chaseka** (the one who laughs), ha, ha, full of joy for the shaving ceremony but never there for the funeral, **Chaseka**, oh!"*[1]

The song emphasises that the **Chaseka** pair represent people who are only interested in food and have little compassion for others. They are ever ready to attend a

shaving ceremony because there is plenty of food and drink. They never take part in a funeral because it requires hard work and collaboration. They show no interest in assisting the bereaved but are eager to feast and profit from their misery. They are social parasites, only too happy to receive from the community. The two masks also mock chiefs and leaders who make it their duty to be present at commemoration rites but delegate their subordinates to attend the

funerals and the mourning rites (*kukhuza*). They are leaders who have no interest in their own people and who are more preoccupied with themselves. Their smiles and false courtesies are interpreted by the ancestors and the people as a mockery of the dead and a betrayal of the *mwambo*.

[1] *"Wabwera **Chaseka** de (2×) tsangala ku m'meto de, ku maliro osapita **Chaseka** (2×) oh."*

Chiipira achabe

(an orange day mask form the Dedza area)

Themes 1) Prejudice/discrimination & do not judge by appearances; 2) Value of each person; 3) Fairness to *mkamwini*; 4) Refugees

Etymology **Chiipira achabe** means, 'he who is off-putting to outsiders'.

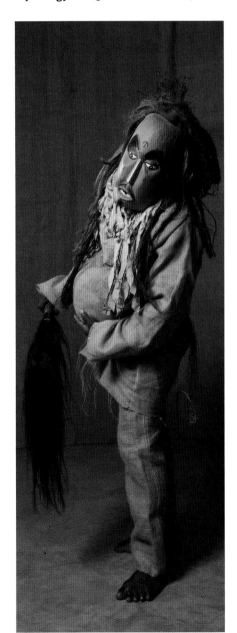

The orange colour of the mask suggests foreignness. The oval mask has the haughty face of a man who considers himself superior. His forehead is prominent but lacking wrinkles. His eyes are partly covered by dark eyelids, showing arrogance and pride. His v-shaped eyebrows suggest condescension. His long slim nose is marked with a fine stroke of white paint, giving him an aristocratic look. The teeth on the bottom jaw of his mouth suggest the use of scornful language. His thin moustache, ridiculously small goatee, and well-trimmed sideburns add to his proud look. The tribal marks on his face identify him as a Chewa. The headgear of this mask is made of black sisal, to represent the hair. The neck of the dancer is hidden with strips of rags. The character wears a shirt and a pair of trousers made of sacking, without any rags. He carries a medicine tail, pretending to be a chief. His waist is underlined with a belt made of cloth, tied in such a way to suggest that its owner has a huge pendulous belly. The belly jiggles with each move of the dancer. **Chiipira achabe** comes into the arena holding his big belly and looking extremely sad. As he starts swerving his feet, his belly shakes and wobbles in all directions, provoking laughter in the audience. The men sing, *"I am off-putting, off-putting to outsiders. At home, people say I am a man. But you say I am worth nothing. My mother considers me her child! The eyes* (tend to) *lessen the husband who marries into his wife's village. The one who puts off strangers, the mother calls him a child."*[1]

The character originated in Mozambique, in the province of Angonia. It was introduced to the Dedza area around the end of the 1980s, when Malawi's borders were populated with many Mozambican refugees. The character per-

forms for funeral and commemoration rites. The song explains the following Chewa proverb: *"**Chiipira achabe**, amake amati mwana – The one who is nasty or ugly for outsiders is called a child by his own mother."* This proverb stresses the strength of blood ties. It also suggests that relationships within the family group can be partial. People tend to judge a person differently, depending on whether he is an outsider or insider. A person born within the family group is taken for granted and accepted, while an outsider is scrutinised, criticised and often the victim of prejudice. **Chiipira achabe** is regarded with suspicion by the family that is not his own. He castigates those people who act or react out of prejudice, overcritical of the stranger but ignoring the weaknesses of their own family members. The wisdom of the ancestors teaches that all prejudices are based on pride and selfishness. No one is completely hopeless. In each human being potential is to be found, if seen through the eyes of love.

[1] *"Chiipira chiipira (2×) koma ndiipira achabe. Kwatu amati munthu. Koma inu mumati ndine wachabe. Koma amai akuti mwana. E tate maso anyalapsya mkamwini e tate **Chiipira achabe** amai akuti mwana."*

Chikwangwala

(a day structure from the Mua area)

Themes 1) Lies, trickery & deception; 2) Unity & harmony

Etymology Chikwangwala means, 'the big crow'.

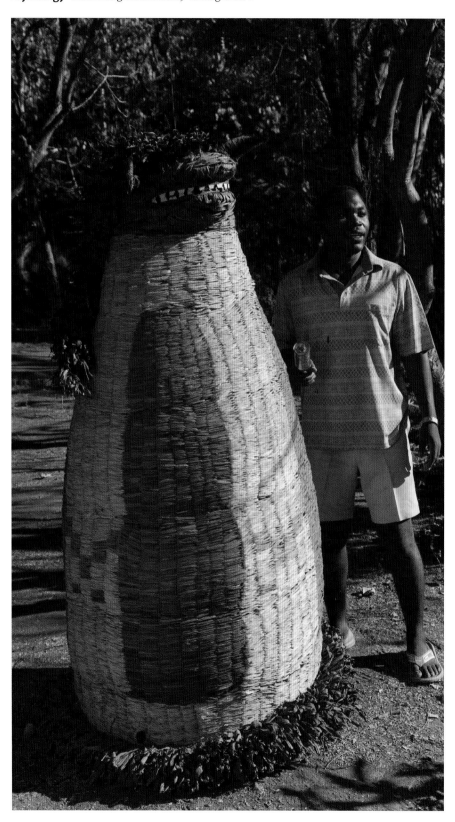

The structure is about a metre and half tall and is built in the shape of an anthill. The base is less than a metre wide, allowing one dancer to stand and walk freely inside the costume and activate the structure. The structure is constructed with a bamboo frame on which maize husks are woven. The body is decorated with windows, spots or bands that are smeared with black mud in order to create contrast with the white husks. The anthill is topped with a head that, contrary to the name, is not that of a bird but rather of a carnivore. The head has sharp teeth, big eyes, long ears, possibly short horns and a tuft of hair, also made with husks, between the ears. The dancer spins around at speed, circling the *bwalo*. The male choir sings, *"**Chikwangwala** (the big crow), let us go (and get married). The one who climbs the anthill saw. What did you see? I saw that your friends cheated you."* [1] The women's group responds, *"(He said) Good-bye, I am going, (and the family answered) Go and never come back again."* [2] The songs describe the experience of someone who was advised by a friend to marry a certain girl. He began enquiring after marriage (he climbed the anthill and saw). He found that he had been misled. His friend betrayed him by hiding the fact that the girl was already married. He had to go to court over the issue and reveal that his friend had misled him. His companion was found guilty and proved to be a liar. When he was leaving the court, a relative of his guilty companion insulted him with obscene words.

The crow is well known for being loud. **Chikwangwala**, with its mouth wide open and its aggressive teeth, chastises people who behave like the noisy crow. They spread lies and bring discord to the village. Through the teaching of the crow, the ancestors discourage those whose deception breeds chaos and disharmony.

[1] *"**Chikwangala** tiye. Wakwera pachulu waona poti? Waonanji iwe? Waona anzako adakunyenga."*
[2] *"Ndikupitatu ine! Dzipita pa nyo pako."*

Chimnambe

(a night character from the Mua area)

Themes 1) Jealousy/envy; 2) Laziness; 3) Irascibility; 4) Lies, trickery & deception

Etymology **Chimnambe** means, 'the big baobab (tree)'.

The baobab tree is common on the plains of Malawi and is distinctive in its wide girth, bottle shape and spindly branches. The fibres of the baobab were used to make strings for construction of the houses and for mats. In the past, clothing was also made of baobab bark, before the advent of cloth. **Chimnambe** describes an artisan who excelled in this art and jealously guarded these skills.

The character belongs to the category of Kapoli as he intones his own songs. The women then take them up. **Chimnambe** used to be performed at the vigils of funerals and commemoration rites for a chief. The day character wore a 'shirt' and a type of 'trousers' entirely woven with banana fibres. His mask consists of a simple headcover made with the same material that shows no detail of the face. The headcover is smeared with black mud. The costume takes the appearance of a stout baobab. The sleeves are made of woven banana fibres that are stiffened to extend the arms like branches. When declined, the sleeves reach as far as the knees. Artificial hands and fingers are attached to these 'arms', to look like the branches of a baobab. Inside the sleeves the dancer holds branches with leaves that protrude well beyond the artificial fingers. The remainder of the costume consists of a series of concentric fringes of banana fibres that cover the 'tree trunk' and 'branches' (the body and arms). More recent day versions can take various forms. For example, it may consist of an outfit completely covered with chicken feathers reaching from the head to the feet or, may be a canvas structure in the shape of a baobab but with an animal head. The night version was more common than the day and used at night vigils. Much simpler than the day option, the night version consisted of knitted banana fibres covered with fresh green leaves or small branches of foliage. The headcover was made of a similar material. Branches were also held in the hands to simulate the tree.

Chimnambe enters the *bwalo* straight from the bush, not from back stage (*liunde*) like the other masked dancers. He aggressively proceeds to the arena making a humming sound. He makes a quick and angry move forward following the rhythm of the drums, lifting his disproportionately long arms. Then he takes three steps backward, bringing his arms down swiftly to

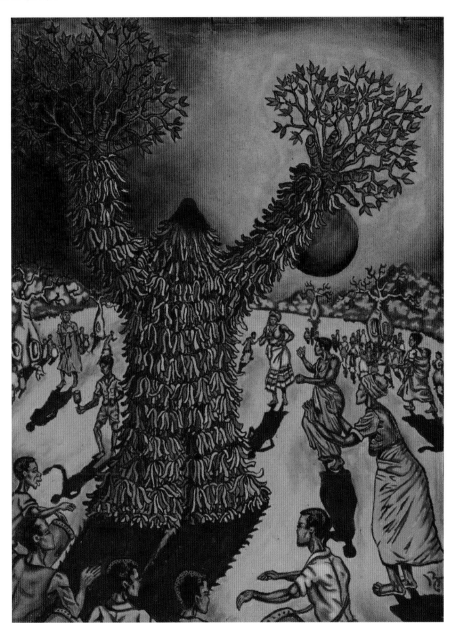

Painting by Claude Boucher and Joseph Kadzombe, 2009

show discontent. With this double movement he chases everybody around the arena and slaps them with his arms, something in the manner of Mbonongo (but rather less agile and less violent than that character). In the process, he may tear the clothing of people who do not step out of his way. At the end of his performance, to demonstrate his frustration, he even chases the drummers and prevents them from playing. As soon as he appears in the arena the women

sing, *"Oh!* **Chimnambe** (the big baobab), *oh!"* [1] while **Chimnambe** grunts or growls. Soon the women chase him away with *"You, go away,"* [2] and they curse him obscenely. In response, he chases the women.

Chimnambe is chased and chases because he is consumed with jealousy of others. His long stiff arms depict this celebrated jealousy. He is also lazy. He does not want to work and help himself. He prefers

to snatch what others have acquired. This is why *gule* members have portrayed him as fat as a baobab. Moreover **Chimnambe** has a predilection for being bad tempered and showing uncontrolled aggression. He tears the clothes of those that are well dressed so they may resemble his wretchedness. **Chimnambe** is not married. The girls are put off because of his uncouth behaviour and his lies. He enjoys gossip and to slander his friends. He is jealous of their marriages and spreads stories about their partner's fidelity. **Chimnambe** is jealous and envious of everything and everybody, and he quickly victimises innocent people. He demonstrates this by slapping and beating the drummers.

People like **Chimnambe** are antisocial and purposely make themselves outcasts. They cannot become *mkamwini* in the village or be chosen for a position of authority such as chief. As soon as their ugly behaviour is discovered, people realise that such people deny their own humanity. The Chewa proverbs warn: *"Wakaduka alibe anansi – A jealous person has no friends,"* and *"Kali kokha kanyama – He who is alone is an animal."*

[1] *"E e e* **Chimnambe**. *Oh, oh, oh, oh, oh."*
[2] *"Choka!"*

Chinsinga or Chiphale or Chinkhutukumve
(a red day mask from the Mua and Dedza areas)

Themes 1) Uncontrolled anger; 2) Deafness to advice/stubbornness; 3) Respect for parents; 4) Obedience/disobedience; 5) Selfishness/self-centredness

Etymology **Chinsinga** means, 'to be a bound prisoner', or 'the man of many prisons'. **Chiphale** means, 'big bald head'. **Chinkhutukumve** means, 'great cloth ears', and refers to deafness.

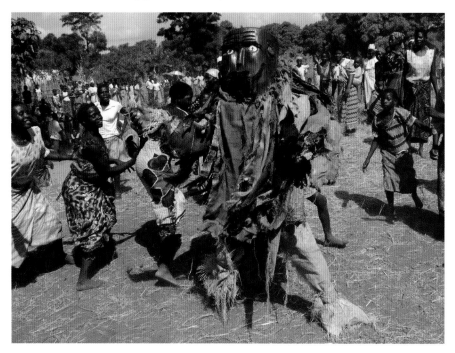

Chinsinga portrays a person who is consumed by selfishness and stupidity. The red colour of this large square mask expresses anger. The flat top of the head conveys stubbornness and disobedience. A bump often protrudes on the flat upper surface of the head to emphasise **Chinsinga**'s deeply entrenched vices. The large and numerous teeth express aggression. The prominent ears highlight deafness to advice. **Chinsinga**'s face is that of a senior man who is wrinkled, bald, and has a greyish beard made of monkey skin. **Chinsinga** appears in the arena dressed in a tatter *gule* suit, carrying a long knife and a club. He runs about chasing both men and women, sometimes slapping them. Toward the end of his performance, the men give him a clay pot full of water that he carries on his head for a while until he lifts it and breaks it over his head to express his rage and frustration. The water cools him down for a short while. Then he grabs the pieces of the broken pot and throws them at the women.

The various songs reveal his state of mind. The Dedza version says: *"***Chinsinga***, no! The child who frightens his own parents. This child is a wild animal. What can I do? My child is a wild animal.* **Chinsinga** *(the father) says: My child is a wild animal, a wild animal. He frightens his own parents, who have given him life.* **Chinsinga** *(the father) says: He is a wild animal who frightens his own parents, a wild animal, a wild animal."* [1] The Mua version continues: *"I was about to fetch live charcoal in the shelter when I became mad. Namkungwi, don't run away, because*

Chinsinga *started getting mad. He is really mad,* **Chinsinga**.*"* [2] The women's song draws the morality of the *gule* character: *"My husband is like a small winnowing basket. (He is always on the road; he never stays at home.)"* [3] The song implies, 'I was wrong to marry such a man.'

The first two songs describe **Chinsinga** as an adult who has endless rows with his parents who are old and weak. He is impolite and rude to them. Worse, he is aggressive and does not hesitate to physically abuse them. They try to warn and correct him of his uncontrolled temper, his inclination to laziness and drunkenness, and his frequent involvement in fights. **Chinsinga** does not listen. His stubbornness and infractions take him from court to court and land him in prison on several occasions. This is when he got the nickname of **Chinsinga** ('the man of many prisons').

Chinsinga caricatures people who have grown up in life selfish and ungrateful for the care of their parents. The women run from **Chinsinga** in the arena because he has become dangerously antisocial. As a marriage partner, he is someone that the extended family will not tolerate for long. According to the Chewa, such a monster must be kept at distance because he voluntarily chose to be an outcast.

[1] *"***Chinsinga*** toto de,* **Chinsinga** *toto de, mwana aopsya eniake, eniake. Mwanayu n'chilombo, chilombo. Nditani ine tate. Mwana wanga n'chilombo tate. A* **Chinsinga** *amanena tate e; mwana wangayu n'chilombo, chilombo chiopsya eni amene tate, mwini wom'bereka tate. A* **Chinsinga** *akuti n'chilombo chilombo tate chilombo chiopsya eniake, tate chilombo, chilombo (2×)."*
[2] *"N'mati ndikapale moto kuninde e tate, wayamba (2×) msala. Namkungwi, osathawa, wayamba msala* **Chinsinga**.*"*
[3] *"Wamuna ali kwanga nk'alichero, ai nk'alichero ai nk'alichero."*

Dzimwe

(a reddish brown day mask from the Dedza area)

Themes 1) Dishonesty, theft & robbery; 2) Adultery & rape; 3) Witchcraft; 4) Evil reaps its just desserts (*choipa chitsata mwini*)

Etymology Dzimwe means, 'a wild animal with a full belly'.

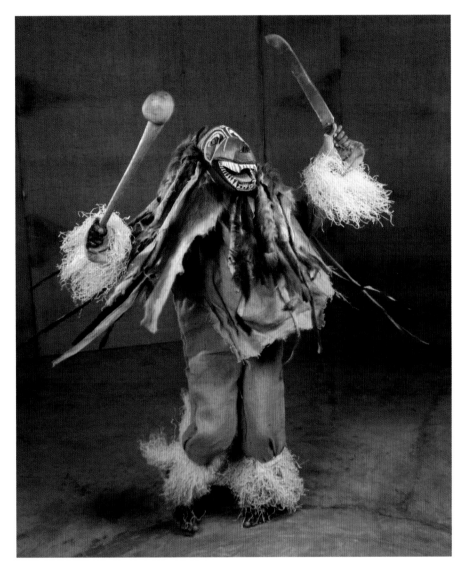

The features of the mask resemble those of a hyena. For the Chewa this animal is associated with a thief or a person who performs defloration. The 45 centimetre long mask portrays a hyena's head with short round ears, red open mouth and sharp teeth. The nose tip is black and the cunning slanting eyes are bright red depicting an evil and antisocial person. The forehead of the animal is wrinkled with lines circling the eyes depicting an old person. The headgear of the mask is made with the skin of a wild animal associated with stealing such as the genet or a monkey. The dancer wears jute overalls without any rags or ornaments. There is an opening in the suit for his genitals to be visible during the dance for the night performance. The dancer carries a club or stick as weapons. As he enters the arena he spins around, swerves his feet lazily, jumps and chases the women, running after them trying to take away their *chitenjes*. In this outburst of sexual heat, **Dzimwe** displays his sexual organs at night, during the night vigils of funerals and commemoration rites. He never exposes himself during day ceremonies. As **Dzimwe** appears in the arena, the men sing, "***Dzimwe**, to move about* (at night), *to steal as you do, **Dzimwe**, not to be seen at night-time but to be visible during the day; he will die without being sick, the old man. This is not the way to move about! He will not say good-bye. He went following his own heart, my dear. This is not the way to behave! This is what took* (killed) ***Dzimwe**.*" Another song says, "***Dzimwe**, a thief doesn't become rich. We have seen his pubic hair* (sexual organs) *on his lower belly. A thief doesn't become rich.*"[2]

Like the hyena, **Dzimwe** is nocturnal – active during the night and sleeping during the day. When he goes out at night, he is secretive about his suspicious activities and he does not want to be observed. The nocturnal behaviour of **Dzimwe** implies theft and rape. **Dzimwe** carries dreadful weapons in order to break into houses. He steals chickens and goats and is proud of his skills as a thief. In his dance he steals ladies' *chitenjes*. The second song says, "*A thief doesn't become rich.*" When he steals at night-time, he goes naked, so that he may not be recognised. When he is in need, he even sells his own clothes. His indecent dancing portrays him as a corrupt antisocial person. His stealing of *chitenjes* is more than mere theft and implies adultery and rape. When his neighbours or relatives ask him why he sleeps during the day, he pretends he has a headache or a hangover. They know he is lying and hiding his immoral activities.

Gule members have created the character of **Dzimwe** to warn people that they will not live long enough to reach the age of having wrinkles if they behave like him. Sooner or later they will be caught or be killed. For the Chewa it is wrong to move at night imitating the behaviour of the hyena. The ancestors punish such behaviour because it is typical of witches and evil spirits who are the enemies of the community.

1 "*Kuyendayenda tate a **Dzimwe**, kutolatola kwanuko tate toto tate. A **Dzimwe** tate, odzasowa usiku a **Dzimwe**, usana naoneka. Tate e adzanka osadwala andala tate e. Kuyenda satero tate. Iwowo osalawira tate. Ananka ndi mtima wawo, diyere. Kukhala satero tate chinatenga a **Dzimwe**.*"
2 "*A **Dzimwe** tate de (2×) wakuba salemera, taonera mabvuzi pa chinena e tate de. Akuba salemera.*"

Golozera
(a red day mask from the Mayani area)

Themes 1) Irascibility; 2) Deafness to advice/stubbornness; 3) Limits & restrictions of *chikamwini* system; 4) Irresponsibility in marriage; 5) Potency

Etymology Golozera is unclear: it could mean, 'the pointer' or 'a ridge in the garden'.

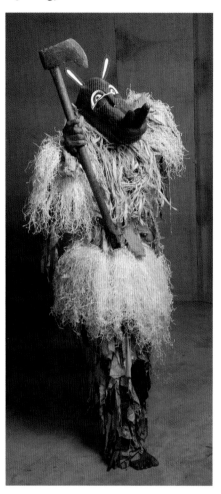

This red mask features the head of an anteater. The snout ends in two black protrusions and a red-tipped black horn, clearly analogous to the testicles and an erect penis. The thin, straight ears stick out conspicuously, to show his deafness or inability to listen. In addition to the snout, there is a red nose close to the eyes resembling a penis at rest and two round-spots on the cheek are another pair of testicles. The headgear of the mask is made of bark that has been soaked in muddy water and turned dark. The dancer wears a tattered suit and carries an axe. During the puberty ritual (and funerals and commemoration ceremonies that incorporate puberty rites), he enters the arena in a bad mood. After dancing enthusiastically for a while, he goes alternately to the men and women at different corners of the arena, insulting them with obscene gestures and dance showing his foul mood. During the time **Golozera** expresses his frustration and protest, the men sing the grievances of Golozera's wife: *"He went away, **Golozera**, with his big head, alas, haltingly. Let his stick go with him, his clever stick, his powerful penis … the penis that fosters life. I will dry up* (remain poor and without sex), *for he went away, **Golozera**."*[1]

In the song, the wife bemoans that **Golozera** has left home. She has lost his good qualities of hard work in the field and his great potency in fathering a large number of children. She deplores being left alone with all the work and her children. The

anteater is a powerful animal that is clever at digging the ground with amazing speed. The Chewa also believe it to be a powerful animal at night, during sex. This is the reason why they compare it to a good farmer and have given him a penis-like snout. **Golozera**'s wife is full of praise for her husband's abilities. The only thing she regrets is that he is deaf to the opinion of others and cannot admit when he is wrong. He cannot apologise or forgive. He is quick tempered and when he quarrels, he makes hasty decisions. The villagers sing a song, which does not belong to the repertoire of *gule*, condemning those who are unable to listen: *"You, my child, **Golozera**, they have shaved your head like* (they do) *to a pig."*[2] He simply left his wife with all the work and the large family. Through the behaviour of **Golozera**, the anteater, the ancestors warn the initiates that people of such character do not last long in married life and usually divorce. In the case of **Golozera**'s wife, she and her family group are left with a heavy burden they cannot carry. If **Golozera** had listened, this problem of communication could have been avoided and he would still be contributing to the well-being of the family.

[1] *"Apita a **Golozera** ya yawe tetegu tetegu. Ndodo yao ipite ee tetegu…ndipo ndodo yanzeru edee…ndipo mbolo yokoma…mbolo yawo yamoyo o…ee toto de e. Ndingofota ndine. Apita a **Golozera**."*
[2] *"Mwana wanga iwe, **Golozera**, adachita chopala ngati nkhumba."*

Greya
(a day mask from the Mua/Mtakataka area, which may occur in many colours)

Themes 1) Determination; 2) Persistence; 3) Model of ideal husband

Etymology Greya means, 'Mr Grey', and designates a type of greyish cloth reputed for its exceptional quality in the past. Around 1880 this cloth was an article of trade given to porters as payment. At a later period, Malawian workers would hire out their services in the South African mines in order to acquire this precious cloth called 'greya'. The villagers considered those who came back with this cloth modern and wealthy.

Several characters of *gule wamkulu* are connected with this grey cloth. Their popularity definitely increased around 1910-1913, when the total number of Nyasaland workers outside the country was more than 25,000. The famine of 1912 and an increase in the hut tax contributed to the numbers working afield. There are two local versions of **Greya**, one from Mua and one from Dedza. Both are called by the name of the

cloth but portray very different people and behaviour. They have in common the fact that they have been away to work.

The Mua/Mtakataka version can appear in a variety of colours (often yellow or pink) and depicts a stranger in the family of his wife. He has been outside the country where he has assimilated western culture. He wears bird feathers headgear, dominated by guinea fowl feathers producing the greyish

colour of the valued grey cloth. The mask of **Greya** from this area portrays a smart, clean and clever young man. These features resemble Sirire, from whom the character originates. His eyes are bright and full of ambition. His nose is long and thin, resembling that of a European. His smiling mouth depicts a peaceful (no teeth) person who is anticipating his own success. **Greya** is beardless. His chin conveys meekness and

gentleness. He wears the usual tattered jute suit, distinguishing him as a well dressed person who appreciates the fashionable grey clothes and their quality. He carries a rattle and a whip, instruments of castigation by the ancestors, on his way to the arena.

Greya of Mua is part of any ritual and

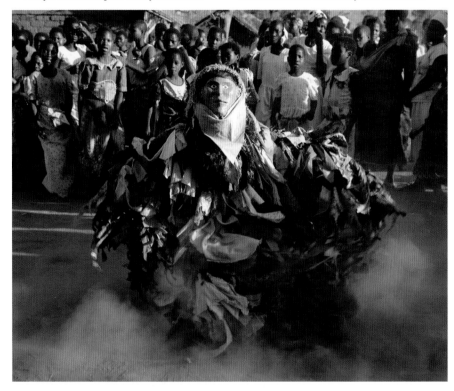

performs with enthusiasm and style. He swerves his feet with tremendous energy and sustained effort. He has stamina, good manners and a sense of achievement. The men call for him with pride, *"Greya… Greya."* [1] He wants a great future for himself and for the family into which he

married. At the same time he has learned that pride and selfishness are enemies of the *mkamwini*. He is successful in his marriage and gets along well with his parents-in-law. He is faithful to his wife. He has powerful medicine that can even make his wife pregnant with his child while he is away in South Africa (an interesting positive spin to a potentially volatile issue!). **Greya** of Mua is an example of perseverance in married life. His work outside has not turned his head. He is honest and shows he can look after his wife and her extended family well. He supports them all without pretence or arrogance. He is meek, humble and considerate to all. In return he is appreciated by his wife's *mbumba* and lives in peace with them. The character of **Greya** from Mua and Mtakataka is proposed as the perfect image of the *mkamwini*. **Greya** revolutionised the image of the model husband in the first decade of the 20th century. He continues to be proposed as a model, even if the economic circumstances of today make this model very difficult to realise.

The **Greya** of the Dedza area describes a less attractive personality, a promiscuous womaniser returned home from work outside the country. The two versions both address issues of a husband's responsibilities, but using diametrically opposing character depictions.

[1] *"Greya Greya."*

Kachigayo

(a pink or red day mask from the Dedza area)

Themes 1) Irresponsibility in marriage; 2) Selfishness/self-centredness; 3) Living off other people (community parasite); 4) Dishonesty, theft & robbery; 5) Promiscuity

Etymology **Kachigayo** means, 'the small mill'.

This red or pink mask features a distorted face. The protruding teeth are carved in the shape of beaters of a maize mill in order to portray egoism and self-centeredness. The head is bald, with a narrow forehead suggesting a lack of intelligence. The nose is quite angular with narrow nostrils. The eyes are glaring and bulbous, protruding from their sockets. The sideburns are painted black as is the very fine pencil moustache. The cheeks are exaggerated and flaccid. The mouth is enormous and filled with rows of large teeth. **Kachigayo**'s behaviour betrays negative and destructive outside influences.

Kachigayo is an employee at a local maize mill. He receives a salary with which he is supposed to support his family. At the end of the month **Kachigayo** comes home

empty-handed. He does not help his wife in the garden since he has regular employment. He keeps his salary for himself and insists that his wife and her relatives should feed him. His behaviour leads them to ostracise him. In revenge, he secretly steals their provisions and property. The protruding teeth and the etymology of the name emphasise **Kachigayo**'s eagerness to eat and his tendency to grab what does not belong to him.

Kachigayo wears patched clothes as if he is destitute and earns nothing. He comes into the arena wearing a hat but he keeps grabbing the audience's hats and scarves. His uncoordinated movements in the dance are like someone who is under the effect of drugs. His way of dancing is provocative with women. He makes suggestive move-

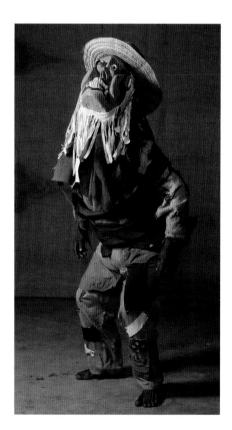

ments towards the *chitenjes* of the ladies, suggesting he is not only selfish but also promiscuous. The men sing, *"The small mill, (the miller) he mills, he married at the mill. (This is where his income goes.)"* [1] He takes advantage of his work as a miller to find girlfriends and obtain sexual favours. He gives them his wages and the items that he has stolen from his wife and her family. Many of the women who come to grind their maize are lured by him and welcome the tokens he gives them. They are impressed by the various stolen items he wears like the hat which partly disguise his wretchedness. His protruding teeth become a euphemism for adultery. When his wife, who is overburdened with work, is asked by the neighbours where her husband is, she answers, "My husband **Kachigayo**, he mills, he married at the maize mill."

Kachigayo is a parasite who lives at the expense of his wife and her family members. The money economy and the job market provide him with an alibi for not cultivating with his wife. He found a job but his income is used to satisfy his selfish interests. He still expects to receive support from his wife's family though he does not contribute to their welfare. **Kachigayo** epitomises an undesirable *mkamwini* (husband), about to be banished from their midst. His appearance in the arena is his last warning before the family takes action.

[1] *"Kachigayo ea nagaya ea anakwatira pa chigayo."*

Kadzidzi

(a black and white day mask from the Nathenje and Mitundu areas)

Themes 1) Laziness; 2) Gluttony; 3) Responsible parenthood

Etymology **Kadzidzi** is the Chewa name for the wood owl.

The mask portrays an owl face with large round eyes, a curved beak and little pointed ears. The headgear of the mask is made entirely of birds' feathers. The dancer wears a kilt around his waist and a collar, both made of bark. The major part of his body is left bare and exposed. Curved wooden claws are fixed to his hands and his feet. **Kadzidzi** performs at funerals and commemoration rites that are combined with initiation ceremonies. He has the duty to castigate the badly behaved initiates. **Kadzidzi** enters the arena at the rhythm of the *chisamba* and he climbs the tree at the centre of the *bwalo*. Up there he sings, *"The owl, the very one that cries from on high. The one that is awake during the night because he is lazy. He failed in marriage, the owl. (He says:) Scratch me here and scratch me there, the owl."* [1] As he sings, he slowly comes down the tree and once he has reached the ground he starts dancing. He moves his hips suggestively, rotates his pelvis frenetically and provokes the audience with his sexy movements while the men sing for him, *"The owl, woo …the night bird. Why is that? Is it out of laziness or out of sickness? He sleeps during the day and he is awake during the night. (He pretends that) this is the way God made him, the owl."* [2]

Both songs stress the bird's anomalous behaviour that inverts the day and the night. Its nocturnal activity renders it suspicious and is perceived by the Chewa as someone who is lazy. The day and the night are understood as a metaphor for the rainy and the dry season. The owl is seen as lazy because it sleeps during the day and is only active at night. A lazy farmer does not cultivate during the rainy season. He pretends to be sick during the day but miraculously recovers at night time. He is not too sick to eat like a glutton and spend the night having sex with his wife, giving her many children. He justifies this by saying it is the way God made him. The second song concludes that **Kadzidzi** is unfit for married life. He cannot feed his children. Through the behaviour of **Kadzidzi**, the ancestors warn the initiates who are about to marry that laziness is a disaster for a marriage and a family.

[1] *"Iii **Kadzidzi** (3x) uja alira mwamba tate, uwo ukhala usiku tate chifukwa cha ulesi tate. Kukanika banja tate, chalaka a **Kadzidzi**, iii m'dzandikande, m'dzandikande, iii m'dzandikande, m'dzandikande **Kadzidzi**."*
[2] *"A **Kadzidzi** (3x) ndiwo aja ayenda usiku tate. Chifukwa ninji tate? Ndiwo aulesi, matenda. Kugona agona masana, kuyenda ayenda usiku tate. Chauta adamlenga **Kadzidzi**."*

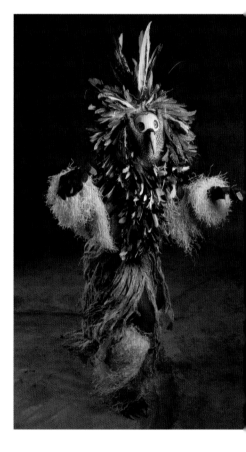

Kamatuwa

(a grey day mask from the Mua area)

Themes 1) Old age/ageing gracefully; 2) Do not cry over the past; 3) Respect for parents; 4) Respect for/wisdom from the elders

Etymology **Kamatuwa** means, 'the small dirty one'.

Kamatuwa belongs to the Kapoli family of *gule*, who sings for himself in a high-pitched voice. He is one of the advisers (*namkungwi*) sent by the spirit world to share their wisdom with the village during funerals and initiation rites. In the past, **Kamatuwa** did not wear a carved mask but instead wore a headdress made of chicken feathers. He danced completely naked. His body was covered with white ashes. The dancer was always a senior man.

This character is rarely seen today having

lost the popularity it had in the Mua area around the 1940s. Today, when it does appear in public, it wears a grey wooden mask and headgear made of animal skins and assorted bird feathers. The colour grey shows that the person does not wash and is destitute. The combination of skin and feathers suggests the person has lost his identity. He is neither bird nor mammal. The presence of skins emphasises the person was a hunter, a 'real man' (in a sexual context) in the past. The use of feathers is characteristic of Kapoli associating him with the *namkungwi* of the tribe. The face is that of an old man. The forehead is narrow and nearly non-existent. A long aquiline nose dominates the face, paired with two white, lifeless, half-moon eyes. The combination of these details suggests a flaccid penis and two 'burnt out' testicles. The toothless mouth smiles in resignation. The face displays no eyebrows, no beard and no moustache. It also has no ears signifying old age brings about deafness. Hair grows all over his face including the forehead, the nose and the chin. The presence of hair over the features reinforces the sexual interpretation of the face. The grey hair of the old man stands for the pubic hair surrounding his sexual organs.

Kamatuwa wears a tiny loincloth exposing the thighs and the buttocks, and leglets and armlets. **Kamatuwa**'s nakedness in the past conveyed the following message: one should show respect for the elders and not mock their nudity even if the potency of their sexual organs has waned. The dancer's body is covered with ashes showing that he is old, destitute and dirty. The presence of ashes (besides expressing poverty and lack of care) implies the old man's imminent death and his entry into the spirit world.

During his dance **Kamatuwa** carries some weapons (sticks or spears) that recall he has been a hunter. That image of the hunter is a symbol used for talking about marriage. Today, **Kamatuwa** is old, poor and single. He is hardly a man. The songs he sings during his performance confirm this. He says, *"Look at him today, the small dirty one, today, the small dirty one. He is naked, the small dirty one."* [1] Or in another song, *"In the past I was eating maula* fruits* (with people of my generation).* [2] Both songs stress **Kamatuwa** is dirty, poor, naked and old. He dreams about the old days when he was married. The expression of eating the *maula* fruits with the people of his generation is a euphemism for saying he could have erections and have sex with his wife. Today he is old, impotent and a widower.

(* The name of a tree, *Parinari curatellaefolia*.)

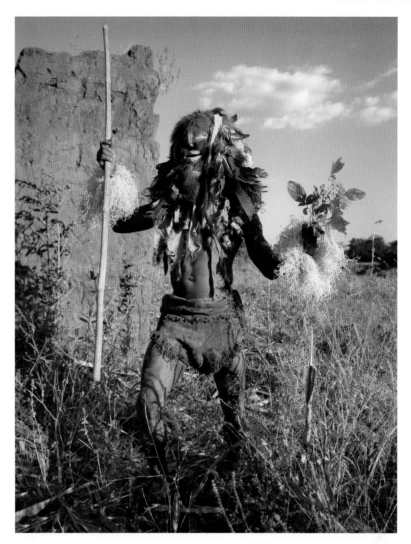

Kamatuwa enters the *bwalo* brandishing his spear, a sign of potency. He soon becomes feeble however and bends down like an old man. He grabs his legs. He then stands up and swerves his feet with hesitation and little strength. He moves around the ground slowly with his arms at his back. He stares at the womenfolk for a while and then backs away, shamefully, as if he were saying to himself, 'At my age I am too old to be interested in women.'

Kamatuwa represents a person out of step with time. He is an old man who has lost his wife. His children are married and do not care for him. They do not give him water or soap for him to wash. **Kamatuwa** is destitute. He is nostalgic for the days when he was happily married and enjoyed the companionship of his wife. He appreciated the care she gave him and the intimacy they shared. Today he is alone, a victim of his ungrateful children and in abject poverty. He warns the younger generations that they have to care for their parents and show them due respect. They should neither abandon them nor mock their age

and senility. He tells them to realise one day they will grow old and encounter the same fate. The Chewa proverb says, *"Chawona mnzako chapita, mawa chiwona iwe – Bad luck hit your friend yesterday, tomorrow it will hit you."* Treat your old parents the way you would like to be treated when you reach their age. **Kamatuwa** provides old people with the advice: One must gracefully accept growing old as it is part of the human condition and it ultimately leads to ancestorhood. It is also unwise to pretend still to be young when experiencing the decline of one's faculties. A person who gets involved with women at an advanced age suffers the ridicule of the village. Ultimately, wisdom and infertility are preparation for the transition to join the ancestors. The power of the ancestors increases and is passed back to their descendants through fertility that does not depend on sexual intercourse as experienced in this life.

[1] *"Mwamuona lero **Kamatuwa**, wamaliseche, **Kamatuwa** e, **Kamatuwa** e."*
[2] *"Tinkadya maula kale, maula e maula e maula e."*

Kamvuluvulu – Chivomerezi - Kanamvumbulu

(a red day mask from Mua)

Themes 1) Caution with strangers; 2) Danger of ambition; 3) Selfishness/self-centredness; 4) Witchcraft; 5) Opposing Kamuzu Banda (supporting political change)

Etymology **Kamvuluvulu** and **Kanamvumbulu** mean, 'the small whirlwind'. **Chivomerezi** means, 'earthquake'.

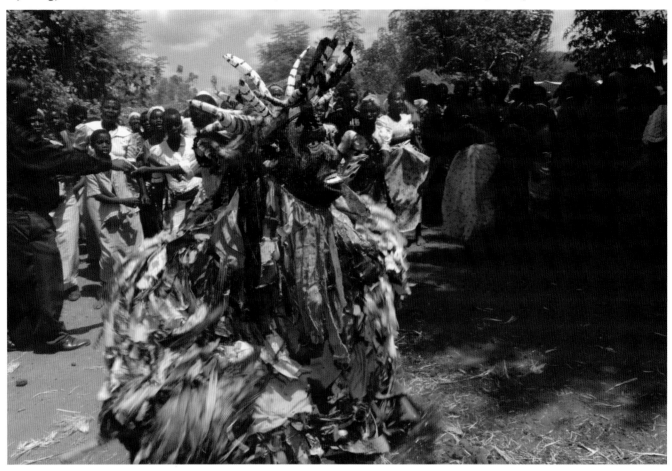

This red mask portrays a young man crowned with eight red horns of various sizes. The headgear is made of wild animal skins, especially those of the Samango monkey. These details indicate that he is an outsider to the wife's village and family group. His beardless face and the absence of tribal marks reveal that he is a young man who has recently married into the village. His devious smile shows no teeth. The multiple horns indicate that he wants power. He is ambitious. Two of the longer horns on the apex of the head, with white and black tips, betray that he is well-versed in the art of witchcraft. These show that he has a hidden agenda, disguised behind a pleasing appearance. The dancer usually wears a tattered *gule* suit, decorated with rags. Leglets and armlets made of fertiliser bag laces complete his outfit. He carries a club to show he may use violence to achieve his aims. In the arena, he is outgoing, uncouth and rough. He spins around rapidly like a whirlwind. He makes his way among the women and he tries to impress them with his acrobatic style. The men sing for him: *"The small whirlwind. Did you see him? Alas, the small whirlwind* (he leaves troubles behind)*!"*[1] At first the women seem to enjoy his presence and are attracted by his handsome appearance but soon they combine forces and chase him out of the village, realising that he is a cheater and a man of questionable behaviour.

The character of **Kamvuluvulu** comes from the Kasungu and Lilongwe areas (Kasiya village) and was first introduced in Mua in the late 1980s. The character performed for funerals and commemoration rites. Today he is commonly seen at political party meetings. **Kamvuluvulu** is a young husband recently married into a Chewa village or a stranger who has come to work in the village. He first shows good manners and honesty but soon transforms into a whirlwind of destruction. The man is ambitious, selfish and unscrupulous. He is a master at lying and cheating. He provokes quarrels. He does not hesitate to cast spells on others and use evil medicine in order to achieve his selfish aims. Soon, the villagers realise his evil intentions and chase him out of their village. The character of **Kamvuluvulu** warns the Chewa community that people who cultivate pride and ambition are a threat. They can easily destroy the precarious peace. The use of secret powers and witchcraft can render the village vulnerable to misfortune and even death. **Kamvuluvulu**'s origins in Kasungu could also easily carry political overtones and point at the first President of Malawi, H. Kamuzu Banda, whose growing power over the 1980s turned into a dangerous whirlwind and earthquake.

[1] "***Kamvuluvulu*** *o tate (2×) unamuona ogo tate* ***Kamvuluvulu***."

Kanyani

(a red day mask from the Dedza area)

Themes 1) Dishonesty, theft & robbery; 2) Promiscuity; 3) Unity & harmony

Etymology Kanyani means, 'the small baboon'.

The mask's face is partly human, partly animal-like. The ears protrude, canine teeth project from the mouth, and swellings project below the deeply set eyes. These details characterise the baboon. Moreover, the headgear of the mask is made of baboon skin. To complete the costume, the dancer wears a kilt around his waist, a collar, leglets and armlets made of black-dyed sisal. He holds a branch as he enters the *bwalo*, showing he comes from the bush. He rotates his waist, exhibiting inappropriate and obscene behaviour. He swerves one leg and lashes out with his branch aggressively. The men sing for him, *"The baboon of the dambwe is a monster, which frightens even its own relatives."* [1]

The mask is used at the time of funerals and commemoration ceremonies. It portrays a baboon that is renowned for its thievery of crops and overt sexual behaviour. Among the Chewa, the term 'baboon' (*nyani*) is used as an insult, especially when one is angry with someone else. The character of **Kanyani** depicts a person who is good-for-nothing, a 'crook', a thief, a liar, a cheat, and an adulterer. **Kanyani** uses the animal behaviour to stamp out dishonesty in all its forms and to encourage harmony in the community.

[1] *"Chilombo choopsya eni ake tate de (2×). Nyani wa ku dambwe tate de tate de chilombo choopsya eni ake."*

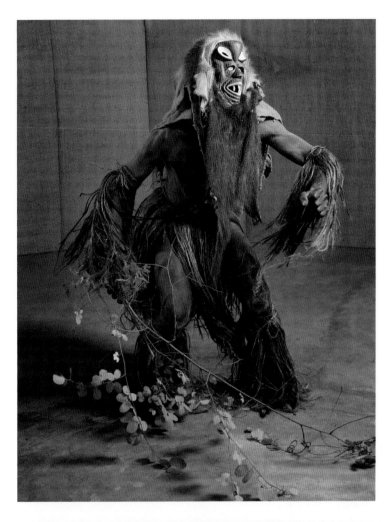

Kanyoni

(a reddish brown day mask from the Dedza area)

Themes 1) Selfishness/self-centredness; 2) Sexual obsession

Etymology Kanyoni represents a small bird (possibly the Red Bishop, *Euplectes orix*).

This version of **Kanyoni** depicts a small bird. It sings at different times of the day or night, announcing dusk or dawn, or at various times of the year, announcing the seasons. The indiscriminate singing behaviour of the bird is likened to a person who has no sense of self-control. The red-brown medium sized mask portrays a bird with the characteristics of a senior man of the village (painted white hair, tribal marks and grey moustache). The round eyes are those of a

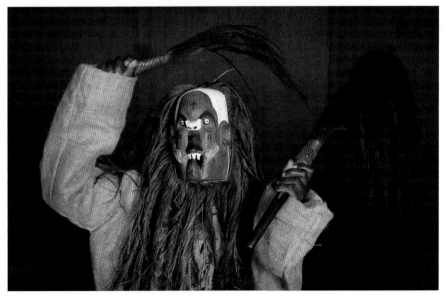

bird and the flat white nose resembles its bill. The mouth is cut in a 'w' shape, with aggressive teeth on the top jaw, to manifest a bad temper. The mask's headgear is made of sisal, dyed black or grey. The character wears a long jute robe, tied at the waist with a black cotton belt. He carries two medicine tails, to give the illusion of wings. He circles the *bwalo*, swerves his feet and moves his hips with great excitement, following the drum beat characteristic of the *khunju* rhythm. Simultaneously, he rotates his medicine tails, demonstrating his passion. The men sing, *"Some even wake up during the night, as if there will be no tomorrow…no*

Kanyoni! This is not the way to behave! He started yesterday, the whole night and early this morning! (He thinks) *He is a real male! He wakes up, keeps* (me) *awake* (forcing me to give him sex until morning), *Kanyoni, Kanyoni, oh, oh!"* [1]

The song of **Kanyoni** tells of a husband who has no control over his sexual appetites. His wife complains that she can find no peace at night, as she is woken up continuously in order to satisfy his selfish demands. **Kanyoni** performs for funerals, commemoration rituals and initiation rites that accompany those events. The character reminds couples that selfishness

is the enemy of married life.

It is puzzling that **Kanyoni** in the Dedza area has been interpreted mainly as the little bird described above. Down on the plains (such as in the Mua area), the same name is applied to a character invented to mock a famous Dedza area District Commissioner, Mr Henry Kenyon Slaney (see History and politics).

[1] *"Ena achita dzuka usiku tate de e ngati mawa kulibe tate e ede e. A **Kanyoni** satero. Iwo ayamba dzulo, ndi usiku ndi m'mawa tate de. Amuna **Kanyoni**! **Kanyoni** iwo achita dzuka, achita akhala tsonga tate e **Kanyoni**, **Kanyoni**, **Kanyoni** oh oh!"*

Maloko

(a dark brown mask from the Mua and Salima areas)

Themes 1) Dishonesty, theft & robbery; 2) Violent crime; 3) Greed; 4) Dangers of modernity

Etymology **Maloko** means, 'padlocks'. These refer to the earrings of the mask, which are small padlocks.

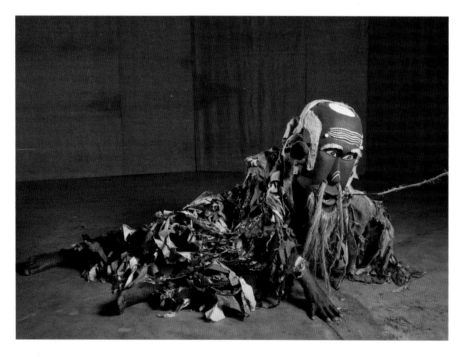

The dark brown mask, identified with darkness and hidden activities of the night, is that of a senior man with wrinkles and a heavy long beard. The face shows an ambiguous smile. His earrings, made of padlocks, reveal that he is burglar. The character wears the tattered suit of *gule*. He has tied a heavy belt around his waist in which all kinds of weapons are inserted (long knife, stick, club and bow). These represent the secret weapons and tools of a burglar.

When **Maloko** arrives at the *bwalo*, the other characters of *gule* tie him to a tree, as if he were dangerous, and only release him for

the dance. As soon as he is free, he jumps and shows aggressive behaviour, not allowing anyone near him. He chases both men and women. Often his performance is scheduled towards the end of the dance. The *gule* ritual can end with him chasing the entire audience including the drummers. The men sing to him, *"Lend me the keys so that I may open the padlocks, the padlocks."* [1] The women answer back with their song, *"Catch him, my brother-in-law, he is mad, he is really mad, even if he is just coming back from treatment* (at the medicine man). *No, he is really mad."* [2]

Maloko is a dangerous criminal. He

hides himself in thick bush along the road and assaults strangers who pass by. He threatens them with his weapons, beats and robs them and leaves them for dead. He secretly carries the stolen goods to his house, locking everything in his bedroom with heavy padlocks, hiding the keys and pretending that he has not been out of the house. In public he behaves like a beggar who owns nothing. **Maloko**'s presence in the village is duplicitous. He feigns to live by the values of the group and to abide by the *mwambo* of the ancestors, but in fact is an outcast, a socially sick person. He has rejected the communal morality code; greed motivates him. This type of behaviour became more common in the Chewa villages after independence. The pressure of modern life increased the incidence of theft. The repeated cases of robbery and murder make **Maloko**'s relatives suspicious. When they threaten to search his house, he says that he has lost the keys. They conclude that he has gone mad and seek help at the local doctor (*sing'anga*). To their disappointment, they realise that his actions are of his own free will. The ancestors dramatise his behaviour. They play out his foolishness and greed in the arena in the hope of bringing back sanity. The miscreant may recover his reason.

[1] *"Bwerekeni makiyi tikatsegulire **Maloko** (2×). **Maloko** **Maloko** **Maloko** ae (2×). Bwerekeni makiyi, tikatsegulire **Maloko**."*
[2] *"Tagwirani alamu ae ae, toto ayamba msala. Ayamba msala toto de kuchokera kwa sing'anga. Toto de ayamba msala."*

Mmwenye and his wife Mai Mmwenye, and India

(orange day masks from the Dedza area)
(red, orange or yellow day mask from Mua)

Themes 1) Unity & harmony; 2) Role models; 3) Pride/arrogance; 4) Rudeness

Etymology Mwenye means, 'a person from India'. **India** refers to the country.

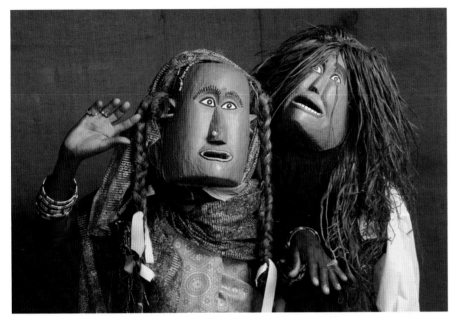

Mwenye and **Mai Mmwenye** represent an Indian and his wife. The male figure shows fine features with a straight nose, mouth with fine lips and a thick, pitch-black hairstyle made of sisal. He wears a fancy shirt and a smart pair of dark trousers. A medicine tail he carries portrays his rank as an Indian trader. The woman's face has heavier features. She has a nose plug made of 'jewels', intricate earrings and necklaces. Her sisal hair is plaited and tied with ribbons. She wears a pair of white trousers with a costly dress worn over them in the Asian style. Her neck is wrapped with a long piece of silk-like cloth, imitating the Indian dress code. Her arms are covered with bangles and her hands are decorated with heavy rings. Following Indian custom, both characters have a third eye painted with red pigment on their foreheads. The couple dance together in the arena. They imitate the Indian way, where the wife always accompanies the husband. The orange colour of the masks portrays their foreignness and their lighter skin colour than that of Africans. The man dances with the same vigour as Chadzunda. His wife is shy and rotates reservedly around her husband. She moves her hips in a subdued manner. As the couple dance the men sing, *"You Indians, it is true that Catholics and Protestants* (are brothers). *Some dance during the day, others during the night. The*

Indians (are also brothers, just as) *Catholics and Protestants are one."* [1]

This song shows that though cultures and religions are different, basically, people are one. The dance performed during the day and the night is in fact the same dance. The song draws a parallel between *gule wamkulu* and the Christian churches. Though they manifest differences, they are intrinsically alike. The Chewa of Dedza may have been struck by the liturgical celebrations of the Indian community that often take place at night. They also have noticed that they are well dressed at these celebrations. Indians are preoccupied with ablution and purification rites, especially for the Muslims and the Hindus. At such events, the wife always accompanies her husband. Asians are generally wealthier than the Chewa and, therefore, have more means for the education of their children. They have better houses and own businesses. These are the qualities that the two Dedza characters praise and wish to promote among their people.

The Mua area has also created its own version of the Indian. The character is called **India** and appears in tones of red, orange and yellow. **India** was created around 1988, when an Indian company called *Hindustan* came to rebuild the lakeshore road from Salima to Balaka. The character is only male and single. The mask resembles that of

Mmwenye but may lack the 'third eye'. Instead of wearing a clean shirt and a pair of trousers, he wears the classic outfit of *gule* consisting of a tattered jute suit. His dance is also similar but the songs sung for him are different. As he enters the arena the men sing, "*India, the homeland of the Indians, India.*"[2] The women comment, "*I have been to India. Now that I am back, I go to Lilongwe so that I may forget about India."* [3]

The dominant Indian group that supervised the road construction at Mtakataka belonged to the Brahman caste. Their behaviour showed their sense of superiority and condescension towards their lower caste colleagues. Their proud and haughty attitude gave them the reputation of despising their fellow Indians, as well as their Malawian workers. Their behaviour led to much misunderstanding in daily dealings with their employees. The song refers to the tensions that arose. The Malawians want to escape for a while in order to forget and recuperate. The Chewa have portrayed this behaviour in the character of **India** by showing the Indians as unfriendly, lacking in tact and manners, rude and selfish. The character of **India** was invented in order to discourage such behaviour among the Chewa. Even Malawians could display such

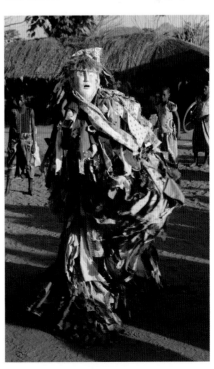

pride because of their educational background, their tribal origin or their prominent status. This attitude of forming castes and classes isolates people from each other.

Ultimately, the characters of **Mwenye** and **India** reinforce the teaching of the ancestors that unity should prevail over differences

and disparity. People are one in spite of their differences of skin, culture and religion. Some of these differences are seen as virtues to be highlighted and imitated. Others are vices to be discouraged. Through the teaching of the ancestors, the way to unity is paved for the next generations.

[1] *"Mwenye Mwenyewe, Aroma ndi Adachi yerere. Ndi ndi zoona wena avina usana wena avina usiku. Mwenye, Mwenye ndi zoonadi; Aroma ndi Adachi ndi zoonadi."*
[2] *"E e e ku India, dziko la amwenye (2×) ku India."*
[3] *"India aye, kupita ndapita. Ndingopita ku Lilongwe ndikaiwale."*

Msakambewa or Kondola or Chizonono

(a red day mask from the Mtakataka and Dedza areas)

Themes 1) Laziness; 2) Dangers of modernity; 3) Promiscuity; 4) Importance of family ties; 5) HIV/AIDS & sexual diseases

Etymology **Msakambewa** means, 'the mouse hunter'. **Kondola** derives from *ku Ndola*, 'to Ndola'. **Chizonono** means, 'gonorrhoea'.

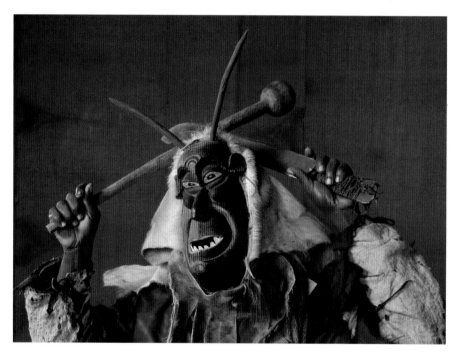

The mask is always red in colour to emphasise sexual heat. **Msakambewa** is ugly and deformed. Numerous protrusions and black warts erupt from his face. The mask has a number of horns, sometimes long, sometimes short, as if they were in the process of growth. At times, horns protrude from the chin. Features may include wrinkles, aggressive teeth, moustache and beard. The headgear of the mask is always made of wild animal skins and rags. **Msakambewa** carries weapons. In the past, he used to wear a kilt on which wild animal skins were stitched. Today he wears torn clothes, to show he has battled his way through thick bush. At the beginning, **Msakambewa** represented a hunter who had no time for domestic duties and avoided them. Instead, he chose to go hunting but returned with mice, not big game. He was nicknamed **Msakambewa** by his neighbours to stress that he was too

lazy to do other work and took refuge in the pastime of hunting mice. The features of the mask display the fearlessness and toughness of a hunter, determined in his decision and unconcerned about what other people say. This is expressed by the presence of horns and black protrusions on his face. They identify him with the bush and the game that he hunts. As part of the mask attachment, he wears wild animal skins and carries weapons such as a knife or club in his hands. These details suggest a strong personality marked by individualism and self-determination. The song sung for his appearance in the performance evokes his memory and states his death with a tone of irony: *"**Msakambewa** went; he died because of his hunt."* [1]

Later, **Msakambewa** became identified with **Kondola** ('to Ndola'), meaning his hunting field was widened. From the bush he went to work in the copper mines of

Ndola in Zambia. *"You, **Kondola**, you went on foot to Ndola."* [2] He never returned (*kutchona*) and eventually died there. The same attitude of self-determination and fearlessness pushed him to escape from his domestic duties and the life of the village, to seek employment outside Malawi. His new name of **Kondola** carried the same undertone of laziness and stubbornness. Employed in the mines he earned a salary that enabled him to discover town life and the evils that lurk there. As one of the songs, *"**Kondola**, the one who killed our brother,"* [3] suggests, he may have had a propensity toward violence. There he gained the reputation of a womaniser. Soon he was known by another nickname, **Chizonono** (the one who is contaminated with gonorrhoea). His wife laments, *"We have seen, we have seen. In the village where you are going you will find gonorrhoea (chizonono) to fetch back. We have seen a prostitute."* [4]

These different names are inter-related, showing continuity in their meanings and an evolution of the community through changing times. Behind each of these three names, one detects the same mocking tone. The person who had convinced the village that he was a real hunter came home with only mice, while the mine worker who left home to earn money came home with a sexual disease that could contaminate other members of the community and lead to death. As the character dances, he mimes hunting mice: he keeps jumping and crawling on his belly, pretending that he has caught one. He loves to show off and parade, swerving his feet with determination and selfish pride. He is particularly fond of chasing women who, in turn, tease him with their song: *"Come, I say, come, if you have one (penis), come!"* [5] Then the women run away, showing they want to escape contamination. In brief, the character of **Msakambewa** wants to stamp out laziness, disguised under the camouflage of being active. The character

reflects unease about employment outside the country. Such work brings income that can help the family, but there are extreme dangers. One may forget one's home (*kutchona*) or become promiscuous and bring back sexually transmitted diseases. His teaching is appropriate at any ritual where *gule* assists the teaching of the ancestors.

[1] "*Msakambewa adamuka de ede adamuka de ede. Asaka nyama Msakambewa. Adamuka ede de asaka nyama.*"
[2] "*Iwe Kondola de, anayenda ulendo wa pansi de Kondola.*"

[3] "*Kondola oh (2×), oh Kondola, Kondola amene adapha mbale wathu.*"
[4] "*Taona taona e (2×) kwa Mchanja kumene upitako kukatenga chipata, chizonono. Taona, taona hule.*"
[5] "*Bwera, ndikuti bwera ngati uli nayo ndikuti bwera, bwera, bwera.*"

Ndakuyawa

(a red day mask from the Pemba area)

Themes 1) Bad company; 2) Playboy; 3) Drug addiction; 4) Gluttony; 5) Dishonesty, theft & robbery; 6) Witchcraft; 7) HIV/AIDS & sexual diseases

Etymology Ndakuyawa derives from *ndakulapa* meaning, 'I have got to know you.'

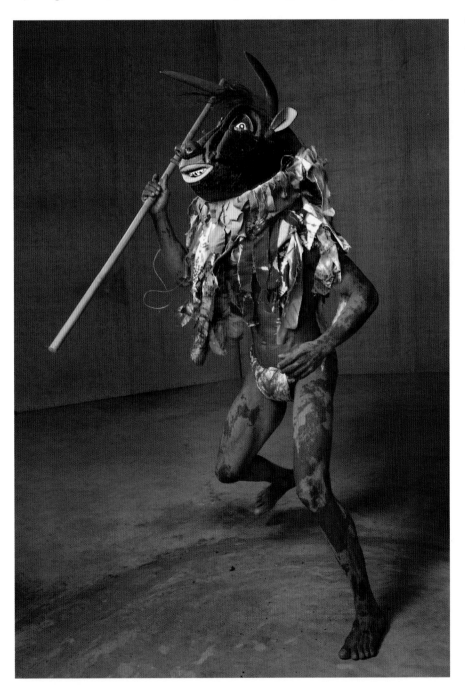

This red mask features human and animal characteristics, conveying his ambiguous behaviour. Human characters are obvious in the shape of the eyes, ears, mouth, teeth, nostrils and the tuft of hair on his forehead. The protruding snout, the two black horns and the six wart-like protrusions on the face are borrowed from animal anatomy. The dancer's body is smeared with mud and he wears a white loincloth, armlets and leglets. He carries a stick.

As he enters the dancing ground, the men sing, "*Ndakuyawa* (I have got to know you), *you keep saying, I have got to know you. You can only say this after you have walked with me. As for me, I have stayed with him, I have seen for myself. No, I do not want to be with him anymore, Ndakuyawa, Ndakuyawa.*" [1] The mask teaches that one has to have experience of a person before making a judgement on him.

Ndakuyawa is the ultimate bad companion with whom no one should consort. His many weaknesses are reflected in the way he performs in the arena. He is restless and unpredictable as if he has been smoking *chamba* (hemp). He shows obscene behaviour, runs after women and flirts, lifting their *chitenjes*. He acts like a playboy who treats life like a joke. Both his behaviour and his appearance reveal that **Ndakuyawa** is addicted to drugs and is contaminated by venereal disease (the warts). He is a glutton and a thief (the long snout and the teeth). He practises witchcraft (red eyes, horns and the warts that are seen as growing horns). As a colleague, he will have a destructive influence on his friends and bring them deep trouble. Such a person is to be avoided once his true character is known. Thus the Chewa wisdom says, "*Ndakuyawa ulinga utayenda naye – I have got to know you: you have walked with him.*"

[1] "*Ndakuyawa tate udziti Ndakuyawa n'kulinga utayenda nane ee tate. Ine ndinayenda nawo. Tate e ndaona ndine toto de. Sin'dzankanso nawo a Ndakuyawa, Ndakuyawa.*"

Njovu yalema

(a grey mask from the Salima and Nkhoma areas)

Themes 1) Selfishness/self-centredness; 2) Unity & harmony

Etymology Njovu yalema means, 'The elephant is tired.'

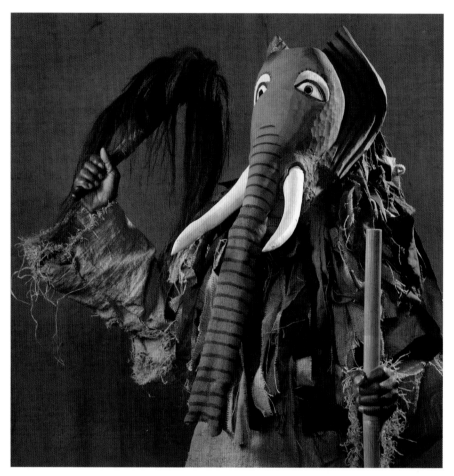

The elephant is the biggest of all the animals and is often seen as the symbol of the chief in Chewa folklore. **Njovu yalema** portrays a chief who is tired of judging cases of people lacking good will and refusing to live in harmony.

Njovu yalema performs at the funeral and commemoration rites of chiefs and other persons in positions of authority. The mask features an elephant head with a mobile trunk. The headgear of the mask is made of jute and black rags. The dancer wears a white shirt and trousers made of jute that resemble the heavy legs of the elephant. No tail is to be seen. The dancer carries a stick and a medicine tail symbolising the authority of the chief. He dances with dignity, moving forward and backward, to the rhythm of the *chisamba* to show his authority. The song sung for him recalls, *"Chief small elephant has refused* (to judge the case at his court). *He told the complainants, At my court, no!* (You are hopeless,) *this is an old case, and I cannot judge it, since you are brothers and sisters and you have no elders among you – they have all died. Chief small elephant is tied with such cases: he says, no, no, no!"* [1]

The elephant's message targets members of the family group who are constantly bickering because they do not recognise any authority amongst them. They do not want to listen to each other, preferring to take control themselves. When a case of witchcraft or greed arises among them, they fail to settle the matter within the family, referring the case to the village chief. The chief also fails to help them because they are not prepared to recognise and respect his authority. He may refer them to a higher court but even this is not going to help.

The character of **Njovu yalema** reprimands those who do not value authority and fail to live in harmony because of their individualism, selfishness and self-centredness.

[1] *"A Kanjovu akukana de (2×), bwalo langa lino toto. Anthu inu nkhaniyi n'yakale toto ine. Kanjovu akukana tate de. Inu pa chibale panu tate, chifukwa akulu anatha tate, a Kanjovu akukana e tate. Afumu a Kanjovu akuti atopa nazo tate toto toto."*

Nkhuzinkhuzi

(a night structure from the Khwidzi – Salima area)

Themes 1) Gossip(ing); 2) Lies, trickery & deception

Etymology Nkhuzinkhuzi is the Chewa word for the noisy starling.

This structure is made in miniature form and stands about 30 centimetres tall. It is activated by strings like Sitiona mvula and is only used for night performances, in order to disguise its mechanism. It moves forward and backward on a string activated by two men while the male choir sing, *"Nkhuzinkhuzi, stop doing this … this way … it will bring discord."* [1]

The noisy starling is the image of a person who gossips and spreads lies. **Nkhuzinkhuzi** reminds the community of the Chewa wisdom, *"Manong'onong'o amapha ubwenzi – Lies break good relationships."*

[1] *"Nkhuzinkhuzi ta'mba usiya zotere njirazo (2×). N'kapasule."*

Nkhwali

(a miniature night structure from the Mua area)

Themes 1) Naivety; 2) Witchcraft; 3) Discernment

Etymology **Nkhwali** is Chichewa for the francolin, a ground-dwelling bird.

This small structure is about 50 centimetres long and constructed in the shape of a francolin, a ground nesting bird. It is activated with strings by the character Kapoli. It can be made with a variety of materials such as jute painted white, palm leaves or maize husks that are stretched on a bamboo frame. The head protrudes and is painted red, like that of the types of francolin common in Malawi (the red necked and Swainson's francolins). Closed wings and a short tail are normally added giving more realism to the bird. Kapoli dances and pulls it with his hidden string pretending that the bird follows him. At some point of his performance, he catches it and holds it in his hands while he sings, *"Francolin, be careful,* (remember that in the proverb) *the snake caught you because you showed too much pity. This is the way people perish."* [1]

Originally, this structure appeared during the night vigils for funerals and commemoration rites. It can only be performed at night because the mechanism used for pulling the bird should not be seen by the audience. The song recalls a well-known Chewa proverb: *"Chisoni chidapha nkhwali – Too much pity killed a francolin."* The francolin is clever but full of compassion. One day it was caught in a bush fire. It was about to fly off to safer ground when it met with a snake. The snake could not escape the fire and pleaded with the francolin for help. The snake asked to drape itself around the francolin's neck, so that it could be flown away from the fire. The francolin showed pity and rescued the snake. When both had reached safety the francolin said the snake could get down and be on its way. The snake chose not to unwind from its neck. On the contrary, it kept pressing harder and harder, strangling its saviour. The snake had found a good meal in addition to being rescued.

The structure of the **Nkhwali** reminds the mourners that they should not imitate the francolin's behaviour. People can abuse another's kindness. One has to be on guard with people who ask for help and pretend to be friends but then turn against the very person who showed them kindness. This false relationship can lead to trouble and even to death. In a funeral context, **Nkhwali** can imply that the deceased did not die from a natural death but was a victim of witchcraft. The deceased showed too much kindness and too little discernment before helping a person in need, who proved to have evil intentions.

[1] *"**Nkhwali**, n'chenjera paja idakupha njoka chifukwa cha chisoni: wanthu watha!"*

Pali nsabwe or Kadzinsabwe

(a black day mask from the Mua area)

Themes 1) Poverty; 2) Prejudice/discrimination & do not judge by appearances; 3) Compassion to the unfortunate

Etymology **Pali nsabwe** means, 'There are lice.' **Kadzinsabwe** means, 'the one who is full of lice (the miserable one)'.

Pali nsabwe is a type of Kapoli who wears a black mask. He has the features of an old man who is bald, wrinkled, has missing teeth, and is dirty and unshaven. He wears a tattered suit, a kilt made of plastic bags at his waist and a torn blanket on his shoulder. He carries a walking stick to show his feebleness. He has ashes all over him and looks poor and miserable. His face is sad and close to dejection. He comes into the arena carrying a small load like an itinerant wanderer. He sits down and starts to sing, *"My clothes surprise you! I dress like this because I am poor. I am full of lice."* [1] He stands up, starts dancing backwards, and forwards. His movements are uncontrolled and he seems a fool. He nevertheless shows friendliness. He intones a second song accusing the crowd, *"You have denied me nsima* (maize porridge) *at the funeral because I am wretched and look awful."* [2] The crowd repeats, *"He is full of lice, he is full of lice."* [3]

This character usually appears at funerals where he reprimands the community for judging people on their appearance. **Pali nsabwe** went to a funeral out of sympathy for a friend or a relative. He was denied food because of his appearance and his abject poverty. Instead of feeding him before those who were well nourished, people were put off by his appearance and let him go hungry. **Pali nsabwe** reminds the community that the unfortunate exist and that they need to be helped. The ancestors are pleased when these people are remembered.

[1] *"Zovala zangazi ndingovalira umphawi de de* **Kadzinsabwe**.*"*
[2] *"Mwandimana nsima ya pa maliro kuipa ndaipaneko eae kude kude."*
[3] *"**Pali nsabwe** eeee eeee **Pali nsabwe**."*

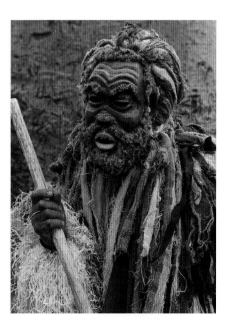

Salemera

(a red day mask from the Dedza area)

Themes 1) Dishonesty, theft & robbery; 2) Prejudice/discrimination & do not judge by appearances; 3) Rights of/respect for the handicapped; 4) Elephantiasis

Etymology **Salemera** means, 'they are not heavy' (referring to the testicles).

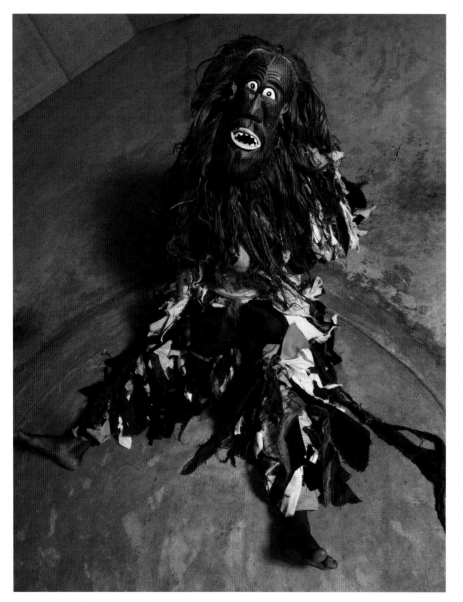

penis with a red tip. He is suffering from elephantiasis. The men's song explains how his infirmity came about: *"Are they not heavy, your testicles? No, they are not heavy to their owner. Did he become crippled (for no good reason)? No, no, he chose himself to be so because he stole in someone's garden. The testicles are not heavy to their owner! This is an insult! He did not buy (want) them. They are not heavy to their owner!"* [1] The women voice the warning of his wife, Yiyina, *"**Salemera**, No! These (vegetables) belong to someone else. (Stealing) will make you crippled. So his wife Yiyina kept on saying: This man with his habit of stealing, one day he will become crippled. There it is, now look at the big penis and the pubic hair (revealed to view). He became crippled but the testicles are not heavy."* [2] The first song describes how **Salemera** became afflicted. He stole in someone's field that was protected with powerful medicine. His infirmity is the consequence of his theft. The people mock him asking if elephantiasis of the testicles is easy to carry. The women's song focuses on his wife's version of his misfortune. Yiyina had warned him of the danger. **Salemera** remained deaf to her advice.

Salemera and Yiyina perform for funerals and initiation rites. These comical characters help to release tension at the time of grieving. The couple teaches about the danger of stealing. One should respect other people's property which may be protected with medicine. The price for stealing can be very high. A corollary message is that while bad luck may result from stealing, not all infirmity is caused by misbehaviour. People who suffer from a handicap can easily be discriminated against and ostracised (the colour red). One should not mock or judge the handicapped.

[1] *"A Salemera toto de (2×) machende Salemera mwini wake, adapundula aii aii. Sadapundule koma zofuna dala uku ku munda kwa eni. Machende Salemera mwini wake. Ichi n'chipongwe, sadachite chogula! Koma machende Salemera mwini wake."*
[2] *"A Salemera, toto de izo n'za eni tate de zidzam'pundula. Paja amanena akazi awo a Yiyina kuti abambo kugwiragwira kwawoko kudzam'pundula e tate. Chaoneka chakuti...e tate chaonekera chimbolo e tate, chaonekera chibweya. Adapundula tate de a machende Salemera."*

Salemera is portrayed as a wrinkled old man, completely bald and with a moustache and goatee. His staring eyes and his open mouth with few teeth convey surprise. The mask displays two black spots on the cheeks and two black nostrils, which represent testicles afflicted by disease. The short nose represents the penis between the swollen testicles. The headgear of the mask is made of sisal (dyed black). **Salemera** wears a tatter suit and a big heavy belt. He carries a stick. His wife, Yiyina, can accompany him in the dance.

Salemera displays uncoordinated movements while the *chisamba* is played. He swerves his feet, loosens his belt and takes his huge 'testicles' out of his trousers. He may even hoist them over his shoulder. The testicles are made of black cloth to which is attached sisal pubic hair and a tiny cloth

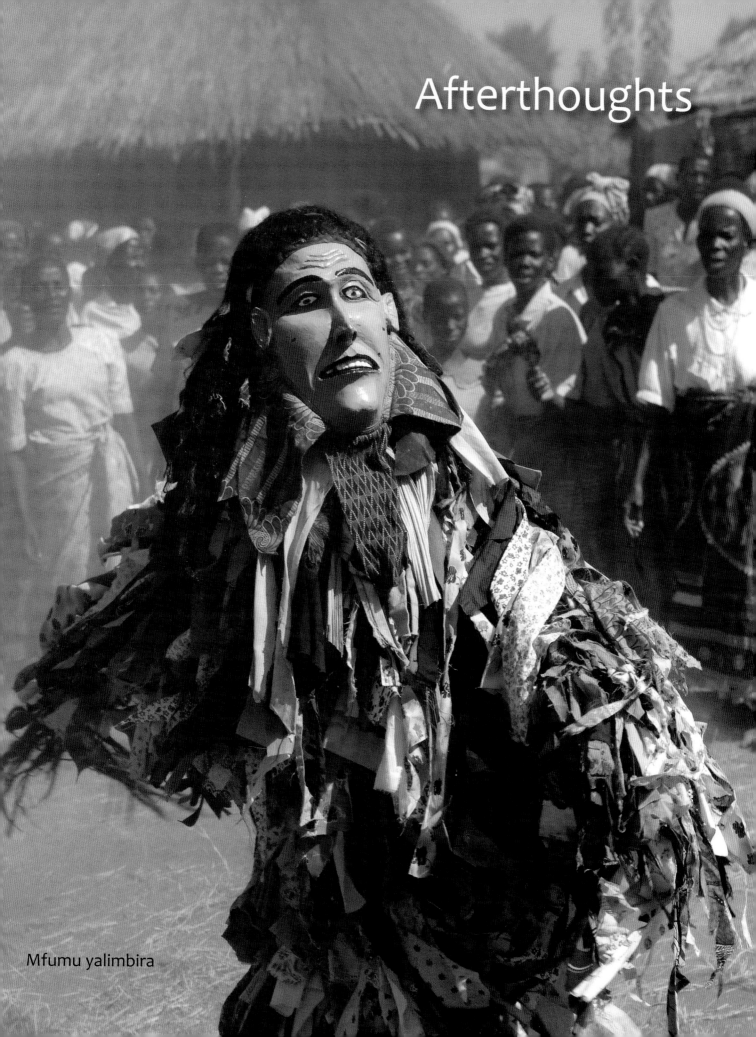

Afterthoughts

Mfumu yalimbira

Afterthoughts
The ironies and future of *gule wamkulu*

Gary Morgan

Claude Boucher's research reveals many things about the *gule wamkulu*, and through the dance, about the Chewa people themselves. It is notable that the presentation, meanings and history of *gule wamkulu* all reveal a series of opposites and ironies, which define the contributions of the great dance to the community and the attitudes towards the dance over recent times.

Many of the *gule wamkulu* characters identify the positives or negatives of certain behaviour by demonstrating the opposite. Irony is intrinsic to the *gule wamkulu* method. The arrogant, money-flashing playboy is a dangerous and destructive person not to be emulated and that message will come from the actions and associated songs of precisely that type of individual. Witchcraft is the worst of all human behaviour and how better to demonstrate this than through the appalling presentation of a witch character? Many characters are satirical and laced with mockery, but to the uninitiated may appear to be advocating the behaviour they in fact condemn. The mock violence and grotesque appearance of so many dancers can seem shocking and threatening. And this is precisely what they are meant to be, to remind the community of just how nasty and destructive such behaviour can be. This advocacy of the *mwambo* through characters that are its antithesis has been the root cause of many of the misconceptions of the great dance.

Given that the messages of the great dance are overwhelmingly conservative, in keeping with the wishes of the ancestors, there is irony in the plasticity and variability of *gule wamkulu*, and its ongoing evolution and re-invention, with ever-appearing new characters and no absolute formula for depiction of widely performed characters. There is a great deal of artistic licence in *gule wamkulu*, reflecting the local situation and the individual creativity of the mask and structure makers and the dancers. Thus we see the irony of a lively and innovative form of artistic expression used to convey a strongly conservative message.

In the gender balance of *gule*, the dominance of male characters and expression of male protest can be seen, somewhat ironically, to reinforce the female based matrilineal power structure of the Chewa. Depicting men in their frustration and despair as agents of community harm does not advocate well for their empowerment. Rather, it conveys to women the additional responsibilities of coping with men who cannot control themselves and whose passions unconstrained are a danger to their own lives, the harmony of the community and the *mwambo*.

There is irony in the misperceptions of the *gule wamkulu* that have characterised the attitudes of non-Chewa powers and that continue to find voice in the contemporary media and thus presumably the thinking of at least some non-Chewa Malawians. The visual and aural effect of *gule wamkulu* can be

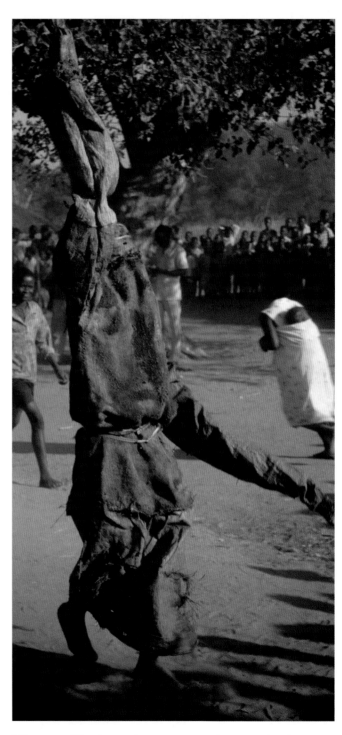

Mbonongo. The threatening appearance of many of the witch characters has suggested to some that *gule wamkulu* itself is a form of witchcraft. In fact, witches in the great dance always condemn the practice.

one of a primordial pagan ritual, replete with horrid half-human, half-beast demons contorting in bizarre, often sexually suggestive dances and threatening the people around them. For those who had no grounding in the rationale of the dance, perceptions arose that this was an evil dance, a dance of black magic and witchcraft. As we see through Boucher's research, while the dance most certainly can be sexually suggestive, it is the antithesis of evil magic and witchcraft. The ironic use of beastly and witch-like characters to preach behaviour at variance with that on show condemned *gule wamkulu* to decades of misunderstanding from the colonial authorities and missionaries. There is a residual element to this as evidenced in some contemporary media coverage that continues to associate the *Nyau* with witchcraft when, in fact, they have been strong opponents of the dark arts for centuries.

The conflict with the Christian church is hardly surprising since traditional faiths of any sort could be seen as competitors for the hearts and minds of potential Christian converts. The role of ancestors as intercessors to God has never rested easily with mainstream churches. Yet the unease with *gule wamkulu* has gone deeper through, first, the impression of dark pagan rituals and, second, through the growing perception of the overt sexual themes in many of the songs. While the church-*gule* friction is not surprising, there is some irony in this as well. So many of the messages of the dance, delivered through aggressive or comical or pathetic human or semi-human characters, align so well with conservative Western values as espoused by the church. The core objective of *gule* is a peaceful, respectful, harmonious community, committed to the moral code of the *mwambo* that in many respects so closely resembles the value systems, including the Ten Commandments, of Judaeo-Christianity. The Gospel may be missing but the respect for God and for one's neighbour is strong.

In November 2005, the great dance of the Chewa people was proclaimed by UNESCO as a 'Masterpiece of the Oral and Intangible Heritage of Humanity'. This is the equivalent for intangible heritage of World Heritage listing for sites of international significance. The designation recognised the richness of expression of the dance and its significance to the Chewa people. *Gule wamkulu* has been acknowledged as part of the cultural legacy of all mankind.

What does this mean for the future of the *Nyau* and the great dance? Outside, especially Western, influences and 'modernity' bring much that is threatening and little that is positive in the eyes of the ancestors. What they certainly bring are pressures that irrevocably modify traditional practices and values. *Gule wamkulu* has not been immune.

Boucher's presence in the Mua, Mtakataka and Golomoti areas for close to four decades provides a unique case study of the challenges regarding *gule wamkulu*'s ability to maintain secrecy and integrity. This may not be the experience in other areas of Malawi. However, this sustained presence, together with a wide variety of informants, provides a vast study of both continuity and discontinuity with regard to the evolving nature of *gule*.

In the beginning, Boucher was informed that *gule* only operated through absolute secrecy and that those who infringed this rule received severe punishment, resulting even in death. Any person who betrayed this primary rule was murdered at the *dambwe*, and his corpse was never brought back to the village for burial. Burial took place secretly in the bush and reports were circulated that the individual had become the victim of an attack by wild animals.

By the 1970s, such disciplinary rules were judged to be uncivilised and unchristian and so were modified slightly in severity. If a dancer's identity was revealed in the *bwalo* owing to accident or injury, he had to disappear physically from the area for some time or for good depending on the severity of the exposure. Often the dancer would seek employment in another area of Malawi or even abroad. Some would never come back, thus creating a new home for themselves (see **Mtchona**). Others would come back after a period long enough for the villagers to have forgotten the original incident.

The 1980s brought minor changes and an observable slackening of these rules. One sign of what was to come was the appearance of commercially made rubber masks in the dance, which demeaned the artistry of the traditional carvers and their clever use of semiotics in the masks' features. The age for initiation was dropped from pre-marriage to teenage. However, secrecy was still prevalent regarding songs, riddles and the cryptic language of *gule*. The initiation period still consisted of a full week in seclusion, involving comprehensive explanation of the *mwambo* and its relevant songs. The women and the younger girls involved in *gule* were compelled to follow their own initiation into puberty in order to participate actively in the dance or merely to observe the occasion. By this time, many of the senior members and those who held roles of responsibility (elders) were getting fewer and fewer.

As we reach the period of the 1990s, the world of *gule* was becoming more dominated by a younger generation, thus leaving a smaller group of elders to uphold the *mwambo*. With the advent of democratisation and the major political changes that followed in the country, the world of *gule wamkulu* was further altered. The new concept of multiparty democracy and the abuse of this freedom were to promote individualism and economic success. This meant a decline in the value of the *mwambo* for the sake of economic advantage that could be acquired through *gule* performances. The widespread adoption of Christianity led further, in some instances, to the cheapening and trivialisation of the *mwambo*. Other forms of community engagement began to compete with the rituals for public interest: for example, the weekend football match increasingly occupied the hearts and minds of the community, and older traditional practices were often relegated to a secondary status.

At this time several modifications were made to the *mwambo*. The age of initiation was lowered to 10 or 12 years of age. The period of seclusion was reduced to a bare minimum of a few hours. The focus was put on memorisation of the *gule* terms rather than the understanding of their meaning. The boys' initiation involved just the paying of a fee, which allowed an indi-

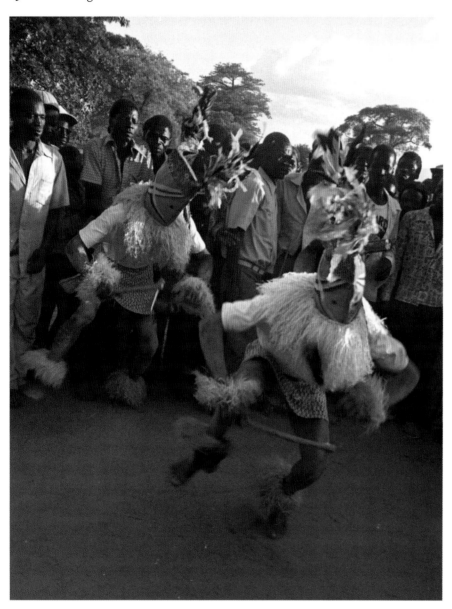

Today, *gule wamkulu* is more and more a form of entertainment, often detached from its original role as a teaching and spiritual conduit. Dancers practise choreography and accompany public gatherings such as political rallies. **Nyolonyo** traditionally dances in a pair.

Claude Boucher, Msekeni Village, October 1999

vidual to be considered an adult, yet did not provide the required education for him to mature fully. Elders became more concerned with the financial advantages of their position, neglecting the advice that accompanies the process of growing up. Indiscretions concerning secret terminology were tolerated, and the elders turned a blind eye to mistakes, looking upon this as normal and more in line with modern day attitudes of freedom.

From 2000 to 2010, the previous generations of initiates had already become adults and were eligible, in their respective villages, for leadership positions within the *gule* structure. They had now become the office bearers and the elders despite their limited knowledge and shallow understanding of *gule* spirituality. These inadequacies became more apparent in the way they conducted their duties as *akumadzi*, *atsabwalo* and *akunjira*. This era continued to show a growing leniency towards maintaining secrecy.

It was at this time that they began to admit children of 9 to 10 years old into initiation, which took place inside their own homes and outside the context of a *gule* performance, for the sole purpose of getting money from their parents. Explanation was reduced to the bare minimum, with emphasis being put almost exclusively on the memorisation of *gule* secret vocabulary. This form of initiation led to little long term participation in future *gule* dances and rituals. Young girls not yet initiated were tolerated at any performance and were even allowed to take an active role. They led the songs in the arena and even took the place of the senior *namkungwi wa ku mzinda* and the regular *namkungwi*. In some areas they were even allowed to do the *chingoli* sound reserved for the male initiate. One had the impression that *gule* had got out of hand and that control had shifted from traditional senior custodians, both male and female, into the hands of children and younger "leaders" who looked at *gule* primarily as a means of generating income.

Former *gule* characters were often forgotten, being resurrected only for special occasions, albeit with obvious alterations due to lack of knowledge or because the intricacy of their construction had been forgotten. *Gule* characters often entered the *bwalo* inappropriately dressed and not sufficiently smeared with mud; also, historically significant characters which were reserved solely for senior dancers were now relegated to children. Novelty was considered more attractive then investigating the meaning of previous characters. As a whole there was a tendency to create new characters which appealed to more contemporary issues; multiplication of chiefs, allocation of coupons and distribution of fertiliser, HIV/AIDS, sharing of inheritance, and political change. Priority was given to restoring the memory of recently deceased "heroes", making them into models of faithfulness to their own Chewa identity. There was also a concerted effort to discredit the work of political leaders.

Alterations to existing masks, rhythms, drumbeats and songs provided the opportunity for launching new characters that would soon win the popularity of the villagers and become widespread, reaching the broader Chewa community. Owing to increased mobility through public transportation, *gule* members were inspired by what they encountered to bring back some characters that would become popular also in their own villages, sometimes altering their meaning. Despite the shallow understanding of the younger generation it is clear that young people are still guided by the faint voice of the ancestors, which compels them to be critical about some aspects of their generation. They are still able to work in small teams together with the mask carver, *akumadzi*, *atsabwalo* and the *namkungwi* to explore the *gule* way of voicing the message they want to convey to their community, by changing existing songs with the addition of new words or by composing new songs to similar melodies. They continue to plan the choreography, the dancing steps and the costumes. *Gule* is ever innovative and manifests signs of continuity and discontinuity, just as it has surely done throughout its long history.

From Boucher's observation, there are fewer characters appearing today than thirty, or even ten, years ago. The legions of the spirit messengers are in decline. Mtonga (2006) suggests a range of actions that may assist in preserving some integrity to the dance, including support of carving traditions and education of new carvers and performers, developing museums, funding major cultural events and establishing cultural associations. UNESCO is attempting to rekindle interest and quality control in *gule wamkulu* through a series of projects and events across the three *gule wamkulu* nations. The strategy includes regular, and possibly competitive, dance festivals. Will these renew the dance or simply force its metamorphosis into something very different from its fundamental purpose? Will *gule wamkulu*

become ever less relevant at the village level, where its spirituality lies, and become a dance spectacular of aesthetic and athletic entertainment and curiosity but devoid of its spiritual heart?

Ultimately it will rest with Malawians, and the Chewa in particular, to decide the place for *gule wamkulu* in their future. The attendance of the spirit dancers at Primary Health Care sessions in the 1990s reflects how *gule* can mesh with modern societal needs. Today there are reports from parts of Malawi of the *zilombo*, the "wild animals" of *gule*, appearing from the bush to escort truant children to their school, and of dancing to raise funds for much needed school supplies. The ancestors have turned their attention to the needs of a modernising Malawi.

There is some evidence of *Nyau* practices and culture 'crossing over' from village appeal to the academic and middle classes of Malawi, as is revealed in Samson Kambalu's irreverent autobiography, The Jive Talker: Or How to Get a British Passport (Jonathan Cape Ltd, 2008), in which he describes his creating a Cicero-inspired *gule wamkulu* character during his attendance at Malawi's prestigious Kamuzu Academy.

Malawi too shows some strong signs of recognizing the value of its cultural heritage. The Chewa Heritage Foundation was recently established, and with government and private support is encouraging public engagement with Chewa culture, including the *gule wamkulu*. Chewa heritage centres are opening. The *gule wamkulu* continues to respond to contemporary politics, with an ever-more international flavor. In 2011, U.S. President Barack Obama joined the *gule* pantheon. Yet tensions remain as to what is, and is not, authentic culture. The performance of *gule wamkulu* at non-traditional events such as weddings and political gatherings has been condemned as either demeaning the intent of the great dance, or encouraging undisciplined behaviour in that the dancers are not subject to the regimen of a true performance. There have been stories of *gule* dancers engaged in assaults on women while in their *gule* costumes.

The impacts of globalization extend even to the ancestors. The effects of taxes, inflation, increasing petrol prices and reduced international aid all conspire to place pressures on the continuation of traditional practices. Global climate change is likely to cause more, and more severe, extreme events such as droughts and floods in Malawi as elsewhere in Africa. How will the Chewa, and *gule wamkulu*, evolve to cope with these changes?

No one can know the future. However, although it is certain that Claude Boucher has described *gule wamkulu* as it will never be seen again, it is abundantly clear that *gule* keeps blossoming: it inspires theatre, visual arts, caricature and pop culture. This book reminds us that despite the fact that *gule* has been constantly oppressed at different periods it manifests a unique dynamism and constant desire to recreate itself.

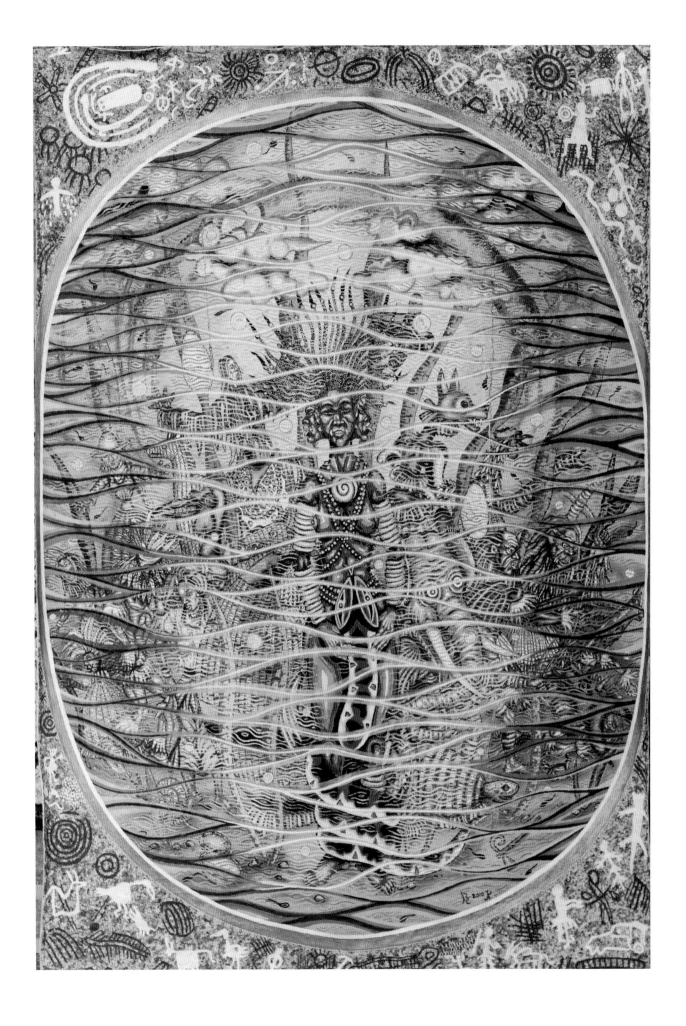

Mwali, Thunga and their Children

Painting by Claude Boucher and Joseph Kadzombe, 2010

Mwali is our Great Mother from our distant past and she cares for us. She teaches us the *mwambo*, the wisdom of our people. From her we learn to grow into genuine Chewa men and women. When the land is dry and thirsty, our Great Mother Mwali dives into the Sacred Pool and begs rain for us from God-Mphambe, her husband. She intercedes with her predecessors who have been spirit wives and have been put to rest at the bottom of the pool. Her request is acknowledged by God-Mphambe, who gathers the rain clouds and stretches the rainbow across the sky. He makes himself visible in the form of Thunga, the mystical snake, his messenger.

Mwali and Thunga come together. Thunga is so fertile and strong that his power overcomes Mwali's barrenness. She is the mother of countless children, both male and female. Mwali gives birth to Chadzunda and Njovu-Ajere, our chiefs, fathers and husbands. Mariya, our sexual instructor, and Kasiya maliro, our primary female ancestor, were also conceived through their union.

Chadzunda and Mariya are our parents together with our ancestors, Njovu and Kasiya maliro. They hold a place at the head of our spirit world. In the water, the spirits feed on tadpoles. They can be fished out of the sacred pool when we celebrate an important event in our village. Our bait comprises chicken eggs. We hook one of them and bring him/her back to the arena to teach our children good behaviour and to abandon selfishness. They dance for us at dusk and at night. (A) They help our children to grow up strong and wise. (B) They restore our minds when peace is threatened. (C) They instruct our leaders and chiefs and assist them in preserving our unity and harmony. (D) They carry the spirits of our departed to the world of the Ancestors and transform them into our protectors and mediators. They are so many and so varied. We have names for each of them.

(*On the right*) Kamba (A), Mdondo (A), Nthiwatiwa (A), Chimbebe (A), Lambwe (A), Kwakana (C), Galu wanga chimbwala (A), Kalulu (A,B,C,D), Ndege (D).

(*On the left*) Kapoli (A,B,C,D), Kalolo (A), Mai Kambuzi (A), Nkhono (B), Akutepa (A), Chinkhombe (A), Nkhandwe (A), Nang'omba (C), Mfiti ilaula (D) and many others.

They all pass to us their specific message and help us to be better people and more united so that we can resemble our Great Earth Mother Mwali and her husband Thunga, the Lord of the Sky.

The border

Before we settled in this land of sacred mountains and pools, we encountered other people, black like pitch and short like children: the Mwandionera pati[1]. They spoke a strange language, almost like coughing: Chikafula. They were skilful hunters and gatherers of seeds and fruits. They used a variety of rocks for tools.

Like us they were inspired by the welcome of those rock shelters hidden in the hills and the serenity of those quiet pools of water. They loved these sites so much that they made them their homes, their shrines and even a place to lay their dead.

There, in the intimacy of those stones and boulders, they instructed their young by daubing inscriptions, mainly with red minerals and animal blood. They taught the facts of life and prepared them for marriage. They conducted rain rituals and prayed for the success of the hunt. They left on those rocks an encyclopaedia of instructions and deep wisdom. They taught us to use the same blackboard made of stone, where we added our own signs and compositions. We daubed them with a mix of white kaolin and bird droppings.

We also use our own daubings to instruct our youth, boys and girls. Some of these shelters became a hiding place for our treasures and sacred masks. We lived among the small people and shared in their skills and wisdom. We taught them our own skills of forging iron and growing food, and in return they allowed us a glimpse of the secrets that allowed them to survive for ten millennia: the secrets of their spirituality. We gazed together in the water of these pools and perceived the mystery that lay hidden within.

These rocks were no more dead stones but alive and telling their own story ... and also ours.

[1] Meaning, "Where did you first see me?", a word play on their small stature. These are the Akafula people.

Some rock shelters tell the story of our predecessors and of our own Chewa code of moral values and behaviours, the *mwambo*.

Paintings attributed to *gule wamkulu*.
Leslie Zubieta, Namzeze shelter, October 2006

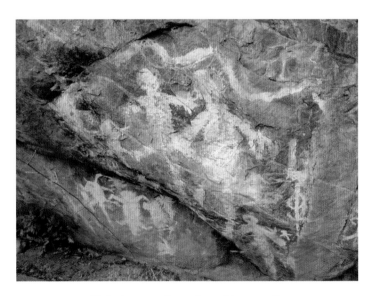

Paintings attributed to *chinamwali*.
Leslie Zubieta, Kampika shelter, October 2006

Appendix: Informants

The following people provided information about the characters and practices described in this book

Ali, James (Mr)	Madziansatsi village
Alvares, Ivan (Mr)	Blantyre
Banda, Ponsiano (Mr)	Nyoka village (Mchinji)
Bernado, Atanazio (Mr)	Chimalizeni village (Angonia, Mozambique)
Bidasi, Zakeo (Mr)	Kambuluma village
Charlos (Mr)	Kafulama village
Chemadi, Mose (Mr)	Sando village (Khwidzi)
Chidzangwangwa, (Chief)	Mchanja village
Chikaola (Mrs)	Chikaola village (Dedza)
Chimarizeni, Bernardo (Mr)	Fonte Boa (Tsangano, Mozambique)
Chimkoko, Kabuthu (Mr)	Kafulama village
Chimwala, Fabiano (Mr)	Chagontha village
Chindiwo, Alano (Mr)	Kanchamba village
Chipojola, Yakobe (Mr)	Kambuluma village
Chitukula, Deziderio (Mr)	Kalindiza village
Chitukula, James (Mr)	Kalindiza village
Chitule (Chief)	Chitule village
Dafuleni, Oskar (Mr)	Njolo village
Daniel, Fostino (Mr)	Kanyera village
Dini, Edward (Mr)	Sando village (Khwidzi)
Divas, Samson (Mr)	Kanyera village
Diverson, Lupiya (Mr)	Chilasamungo village
Diverson, Richardi (Mr)	Chilasamungo village
Dziko, Arikanjelo (Mr)	Kanyera village
Gabriel, Levison (Mr)	Bwanali village
Gabriel, Robati (Mr)	Bwanali village
Galion (Mrs)	Mtakataka
Garang'ombe, John (Mr)	Chikoleza village
Gervazio, Joseph (Mr)	Sando village (Khwidzi)
Gidison, Limbikani (Mr)	Tembetembe village
Gwangwa, Chizani (Mr)	Mchanja village
Gwape, Mathias (Mrs)	Msolo village
Hulten, Piet van (Fr)	Lilongwe
Inkiyere, Dzanja (Mr)	Chitule village
Inkiyere, Zini (Mrs)	Chitule village
James, Jamitoni (Mr)	Maiwaza village
James, Robati (Mr)	Kaphala village (Dedza)
Jibu, Friday (Mr)	Kanchamba village
John, Charlos (Mr)	Kanyera village
Joseph (Mr)	Msolo village
Kachipapa (Mr)	Kafulama village
Kachipapa, Edina (Nanyozeka) (Mrs)	Kafulama village
Kadewere (Mr)	Kambululu village
Kadzombe, Joseph (Mr)	Kanjovu village
Kafwafwa, Oscar (Mr)	Diana Estate (Kapiri)
Kakhome (Chief)	Kakhome village
Kalios, Jamiton (Mr)	Khwidzi village
Kamba (Mrs)	Mtakataka
Kapichi, Piason (Mr)	Msolo village
Kapito, Pilise (Mr)	Michezi village (Mangochi)

Kayere, Ladislas (Mr)	Kafulama village
Klemense, Aukelio (Mr)	Njolo village
Kwalirakape, Gregorio (Mr)	Kalindiza village
Lusiano, Joseph (Mr)	Msolo village
Magombo, Chimbamba (Mr)	Kafulama village
Magombo, Petulo (Chief)	Kafulama village
Magombo, Rafael (Mr)	Ndelema village
Mariko (Mr)	Chitukula village
Martin, Evesi (Mr)	Kalindiza village
Martin, James (Mr)	Msolo village
Mathotho, Juliano (Mr)	Tembetembe village
Mbakwawani, Karoni (Mr)	Mbandambanda village
Mbaya, Harrison (Mr)	Tembetembe village
Mdondwe, Patrick (Mr)	Kanyera village
Mkanamwano, Simeon (Mr)	Kalindiza village
Mkaumba, George (Mr)	Chitule village
Mpamu, Florensio (Mr)	Kalindiza village
Mpira, Thomas (Mr)	Kalindiza village
Mponda, Finias (Mr)	Chitule village
Mponda, Giriti (Mrs)	Chitule village
Msambachamba, Matswayi (Mr)	Chilasamungo village
Msuka (Chief)	Msuka village
Namzeze, Abele (Mr)	Kalindiza village
Ngwimbi (Chief)	Ngwimbi village
Nikodemo, Lute (Mrs)	Chagontha village
Nthara (Mr)	Tembetembe village
Panyani, Harry (Mr)	Kafulama village
Panyani, Kadyampakeni (Mr)	Kafuluma village
Sani, Jibu (Mr)	Bwanausi village (Zomba)
Sanduluzeni, Kapuzeni (Mr)	Chatewa village
Sapuse (Mr)	Mlongoti village
Seba, Charlos (Mr)	Kanyera village
Senza (Mr)	Tembetembe village
Simoni, Piyo (Mr)	Msolo village
Sinkhathala, Raja (Mr)	Maiwaza village
Spindulo, Fransisko (Mr)	Munyepembe village
Suwande (Mr)	Chikombe village
Suzinyo, Brake (Mr)	Kanyera village
Suzinyo, Rufeo (Mr)	Kanyera village
Thawale, Chikwama (Mr)	Tembetembe village
Thawale, Gervazio (Mr)	Tembetembe village
Thawale, Jaliya (Mr)	Tembetembe village
Thawale, Killion (Mr)	Kafulama village
Tsulukuteni, Gaetano (Mr)	Maiwaza village
Un-named informant	Chitukula village
Valentino, Petulo (Mr)	Msolo village
Vitali, Kanthunkako (Mr)	Maiwaza village
Wailesi, Andrea (Mr)	Mchanja village
White, Amawonda, (Mr)	Msolo village
Wilson, Jenala (Mr)	Kunyera village
Zigwetsa, Leza (Mr)	Msolo village
Zigwetsa, Zakeo (Mr)	Maiwaza village

References and further reading

Foreword

Aguilar, L.B. de (1996). *Inscribing the Mask: Interpretation of Nyau Masks and Ritual Performance among the Chewa of Central Malawi*. Studia Instituti Anthropos 47. University Press: Fribourge.

Boucher (Chisale), C. (1976). Some interpretations of *Nyau* societies. Unpublished M.A. dissertation. School of Oriental and African Studies: London.

Curran, D. (2005). *The Elephant has Four Hearts: Nyau Masks and Ritual*. Presentation House Gallery: Vancouver.

Kaspin, D. (1993). Chewa visions and revisions of power: transformations of *Nyau* dance in Central Malawi. In: Camaroff, J. and Comaroff, J. (eds.) *Modernity and its Malcontents. Ritual and Power in Postcolonial Africa*. pp. 34–57. University of Chicago Press: Chicago.

Linden, I. (1974). *Catholics, Peasants and Chewa Resistance in Nyasaland 1889–1939*. Heinemann: London/Nairobi/Ibadan.

Mlenga, D.K. (1982). Nyau Initiation Rites in Dowa District. Unpublished seminar paper. University of Malawi: Zomba.

Morris, B. (2000). *Animals and Ancestors*: *an Ethnography*. Berg: Oxford/New York.

Mvula, E.T. (1992). The Performance of *Gule Wamkulu*. In: Kamlongera, C. (ed.) *Kubvina: Dance and Theatre in Malawi*. University of Malawi: Zomba.

Probst, P. (1995). *Moral Discourses and Ritual Authority in Central Malawi*. Das Arabische Buch: Berlin.

Rangeley, W.H.J. (1949–1950). The *Nyau* of Kotakota district. *Nyasaland Journal*. 2(2): 35–49, 3(2): 19–33.

Schoffeleers, J.M. (1968). Symbolic and social aspects of spirit worship among the Mang'anja. Unpublished D.Phil dissertation. Oxford University: Oxford.

Schoffeleers, J.M. (1976). The *Nyau* societies: our present understanding. *Society of Malawi Journal* 29(1): 59–68.

Sembereka, G. (1996). The place of *gule wamkulu* in dreams attributed to spirits, nominal reincarnation and spirit possession: the Nankumba experience. *Society of Malawi Journal* 49(1): 1–31.

Introduction and Afterthoughts

Aguilar, L.B. de (1996). *Inscribing the Mask. Interpretation of Nyau Masks and Ritual Performance among the Chewa of Central Malawi*. Studia Instituti Anthropos 47. University Press: Fribourge.

Boucher (Chisale), C. (2002a). *The Gospel Seed. Culture and Faith in Malawi as expressed in the Missio Banner*. Kungoni Art Craft Centre: Malawi.

Boucher (Chisale), C. (2002b). *Digging our Roots. The Chamare Museum Frescoes*. Kungoni Art Craft Centre: Malawi.

Breugel, J.W.M. van (2001). *Chewa Traditional Religion*. Kachere Monograph 13. CLAIM: Blantyre.

Curran, D. (2000). The elephant has four hearts. Nyau masks and rituals. In: Curran, D. and Probst, P. (eds.) *Iwalewa Forum* 1/2000. Arbeitspapiere zur Kunst und Kultur Afrikas. pp. 7–15. Rüdiger Köppe Verlag: Bayreuth.

Kambalu, S. (2008). *The Jive Talker: Or How to Get a British Passport*. Jonathan Cape Ltd: London.

Kaspin, D. (1993). Chewa visions and revisions of power: transformation of the *Nyau* dance in Central Malawi. In: Camaroff, J. and Comaroff J. (eds.) *Modernity and its Malcontents: Ritual and Power in Postcolonial Africa*. pp. 34–57. University of Chicago Press: Chicago.

Lewis-Williams, J.D. and Pearce, D.G. (2004). *San Spirituality: Roots, Expressions and Social Consequences*. Double Storey: Cape Town.

Linden, I. (1974). *Catholics, Peasants and Chewa Resistance in Nyasaland 1889–1939*. Heinemann: London/Nairobi/Ibadan.

Morris, B. (2000). *Animals and Ancestors: an Ethnography*. Berg: Oxford/New York.

Mtonga, M. (2006). *Gule wamkulu* as a multi-state enterprise. *Museum International* 58(1–2): 59–67.

Ncozana, S.S. (2002). *The Spirit Dimension in African Christianity. A pastoral study among the Tumbuka people of Northern Malawi*. Kachere Monograph 10. CLAIM: Blantyre.

Ott, M. (2000). *African Theology in Images*. Kachere Monograph 12. CLAIM: Blantyre.

Pachai, B. (1972). *The Early History of Malawi*. Longman: London.

Phiri, D.D. (2004). *History of Malawi: From Earliest Times to the Year 1915*. CLAIM: Blantyre.

Probst, P. (2000). Picture dance: reflections on *Nyau* image and experience. In: Curran, D. and Probst, P. (eds.) *Iwalewa Forum* 1/2000. Arbeitspapiere zur Kunst und Kultur Afrikas. pp. 17–32. Rüdiger Köppe Verlag: Bayreuth.

Quack, A. (1990). Enkulturation/Inkulturation. In: Cancik, H., Gladigow, B. and Laubscher, M. (eds.) *Handbuch religionswissensschaftlicher Grundbegriffe* Bd. II: 283–289. Kohlhammer, S.: Stuttgart, Berlin, Köln.

Schoffeleers, J.M. (1968). Symbolic and social aspects of spirit worship among the Mang'anja. Unpublished D.Phil dissertation. Oxford University: Oxford.

Schoffeleers, J.M. (1976). The *Nyau* societies: our present understanding. *Society of Malawi Journal* 29(1): 59–68.

Schoffeleers, J.M. (1997). *Religion and the Dramatisation of Life: Spirit Beliefs and Rituals in Southern and Central Malawi*. Kachere Monograph 5. CLAIM: Blantyre.

Schoffeleers, J. M. and Linden, I. (1972). The resistance of *Nyau* societies to the Roman Catholic missions in colonial Malawi. In: Ranger, T. and Kimambo, I.N. (eds.) *The Historical Study of African Religion*. pp. 252–273.Heinemann: London.

Smith, B.W. (2001). Forbidden images: rock paintings and the *Nyau* secret society of central Malawi and eastern Zambia. *African Archaeological Review* 18(4): 187–211.

Tindall, P.E.N. (1968). *A History of Central Africa*. Longman: London.

Yoshida, K. (1993). Masks and secrecy among the Chewa. *African Arts* 26(2): 34–45.

Zubieta, L.F. (2006). *The Rock Art of Mwana wa Chentcherere II rock shelter, Malawi: A site-specific study of girls' initiation rock art*. Research Report 83. African Studies Centre: Leiden.

Zubieta, L.F. (2009). The rock art of Chinamwali: Material culture and girls' initiation in south-central Africa. Unpublished Ph.D dissertation. University of the Witwatersrand: Johannesburg.

Descriptions

Bin Saidi, A. (1936). The story of Amini Bin Saidi of the Yao tribe of Nyasaland. In: Pelham, M. (ed.) *Ten Africans*. pp. 139–157. Faber and Faber: London.

Boucher (Chisale), C. (1996). The Chamare Museum (The Regional History of the Area around Mua). Unpublished manuscript.

Breugel, J.W.M. van (2001). *Chewa Traditional Religion*. Kachere Monograph 13. CLAIM: Blantyre.

Denis, L. (Undated). Le Dictionnaire de Chinyanja. French-Chichewa dictionary. Unpublished manuscript.

Hetherwick, A. (ed.) (1951). *Dictionary of the Nyanja Language*. United Society for Christian Literature. Lutterworth Press: London.

Lamport-Stokes, B. (1989). *Blantyre: Glimpses of the Early Days*. The Society of Malawi: Blantyre.

Langworthy, H.W. (1969). A history of Undi's Kingdom to 1890: aspects of Chewa history in east central Africa. Unpublished Ph.D dissertation. Boston University: Boston.

Langworthy, H.W. (1971). Swahili influence in the area between Lake Malawi and the Luangwa River. *Journal of African Historical Studies* 4(3): 575–602.

Linden, I. (1974). *Catholics, Peasants and Chewa Resistance in Nyasaland 1889–1939*. Heinemann: London/Nairobi/Ibadan.

Linden, I. (ed. and transl.) (1975). Mponda Mission diary, 1889–1891. Part IV: The Ngoni defeat and missionary departure. *The International Journal of African Historical Studies* 8(1): 111–135.

Lindgren, N.E. and Schoffeleers, J.M. (1978). *Rock Art and Nyau Symbolism in Malawi.* Department of Antiquities Publication No. 18. Ministry of Education and Culture. Government Press: Zomba.

MacCracken, K.J. (1992). *Britain and Malawi: A Hundred Years.* British Council: Unknown place of publication.

MacMillan, H. (1975). The African Lakes Company and the Makololo, 1878–84. In: MacDonald, R.J. (ed.) *From Nyasaland to Malawi: Studies in Colonial History.* pp. 65–85. East African Publishing House: Nairobi.

Marwick, M.G. (1965). *Sorcery in its Social Setting: a Study of the Northern Rhodesian Chewa.* Manchester University Press: Manchester.

McIntosh, H. (1993). *Robert Laws: Servant of Africa.* Central Africana Ltd: Blantyre.

Morris, B. (1998). *The Power of Animals: an Ethnography.* Berg: Oxford/New York.

Mua Mission diary. Unpublished manuscript. Pontificio Istituto di Studi Arabi e d'Islamistica: Roma.

Ntara, S.J. 1973 [1944 original]. *The History of the Chewa (Mbiri ya Achewa).* Translated in English by W.S. Kamphandira Jere. Notes by Harry W. Langworthy. Franz Steiner Verlag GMBH: Wiesbaden.

Phiri, K.M. (1975). Chewa history in central Malawi and the use of oral tradition, 1600–1920. Unpublished Ph.D dissertation. University of Wisconsin: Madison.

Rangeley, W.H.J. (1952). The Mother of all People. *Nyasaland Journal* 5(2): 31–50.

Ross, A.C. (1997). Some reflections on the Malawi 'Cabinet Crisis' 1964–65. *Religion in Malawi* 7: 3–12.

Rotberg, R.I. (ed.) (2001). *Hero of the Nation: Chipembere of Malawi: an Autobiography.* Kachere Book 12. CLAIM: Blantyre.

Schoffeleers, J.M. (1999). *In Search of Truth and Justice: Confrontations between Church and State in Malawi 1960–1994.* Kachere Book 8. CLAIM: Blantyre.

Scott, D.C. (1892). *A Cyclopaedic Dictionary of the Mang'anja Language spoken in British Central Africa.* Foreign Mission Committee of the Church of Scotland: Edinburgh.

Shepperson, G. (1966). The Jumbe of Kotakota and some aspects of the history of Islam in British Central Africa. In: Lewis, I.M. (ed.) *Islam in Tropical Africa.* Oxford University Press: Oxford.

Sinclair, I. (1987). *Field Guide to the Birds of Southern Africa.* Struik: South Africa.

Soko, B. and Kubik, G. (2002). *Nchimi Chikanga: The Battle against Witchcraft in Malawi.* Kachere Text 10. CLAIM: Blantyre.

Tangri, R. (1975). From the politics of Union to mass nationalism: the Nyasaland African Congress, 1944–59. In: MacDonald, R.J. (ed.) *From Nyasaland to Malawi: Studies in Colonial History.* pp. 254–281. East African Publishing House: Nairobi.

Williamson, J. (1974). *Useful Plants of Malawi.* Montfort Press: Malawi.

Mask Name Index

Major themes: (1) History & politics (2) Community, authority & the ancestors (3) Sexuality, fertility & marriage
(4) Childbirth & parenthood (5) Health, food & death (6) Witchcraft & medicines (7) Personal attributes

Theme Index

Major themes: (1) History & politics (2) Community, authority & the ancestors (3) Sexuality, fertility & marriage
(4) Childbirth & parenthood (5) Health, food & death (6) Witchcraft & medicines (7) Personal attributes

About the Contributors

Arjen van de Merwe is a professional independent photographer, based in Blantyre, Malawi. After being a jazz musician for over ten years he decided on a radical career change. He went to Fotogram photography school in Amsterdam, specialising in NGO projects world wide and in musicians. In October 2005, he moved to Blantyre, Malawi. Here he widened the scope of his photography with commercial photography, while photographing for NGOs and international organisations remains his core business. He has published in Elle USA, the Irish Times, Aftonbladet. Dutch publications include NRC, Volkskrant, Vrij, Nederland, Groene Amsterdammer, Telegraaf, Parool, Live XS, Fret, Slagwerkkrant, Ravage, Highlife. Malawian publications include the Nation, the Daily Times, Traveller Magazine, City Side Magazine. He has supplied images to major press agencies including AP (Associated Press) and ANP (Algemeen Nederlands Persbureau). He has carried out assignments in Asia and Africa for BBC, Unicef, UNFPA, Interact Worldwide, DSW, WPF, Marie Stopes International. He won the 2007 World Aids Day Photo Contest of Blantyre Newspapers and the American Embassy in Malawi. He is currently affiliated with Still Pictures photo agency in London. He is vice-secretary of the Photographers Association of Malawi (PHOTAMA), photojournalism lecturer at Malawi Institute of Journalism (MIJ) and photo editor of the Big Issue magazine, Malawi edition.

Gary Morgan studied science in Australia and holds a Ph.D in zoology. He worked as a marine scientist at the Western Australian Museum in Perth, Australia, before becoming a senior manager at Te Papa Museum of New Zealand in Wellington. In 1995, he and his wife Susanna travelled extensively around the world, including three months through Africa, which sparked an enduring interest in the continent, its wildlife and its cultures. He returned to Australia and worked for two years in the National Parks Service of New South Wales, where he developed policy and managed several reserves in Sydney. He moved to the Australian Museum in Sydney as Associate Director, managing the science and collections departments, before becoming Executive Director of the Western Australian Museum in early 2000. There he led museum developments, including the opening of two new museums, for the next four and a half years. He has been a museum and heritage consultant in Australia and in the United Arab Emirates, before coming to Malawi with his wife Susanna in 2006 as part of an Australian funded aid programme. For two years, Gary worked with Claude Boucher Chisale in digitising the collections of the Kungoni Centre and in editing the publication, *When animals sing and spirits dance*. Through his career, Gary has enjoyed the excitement of cultural and scientific research and, even more, the communication of new knowledge to diverse audiences. He is currently Director of the Michigan State University Museum, in East Lansing, Michigan, USA.